D0469300

THE SARTORIALIST
Scott Schuman

PENGUIN BOOKS

PENGUIN BOOKS

Published by the Penguin Group
Penguin Books Ltd, 80 Strand, London WC2R 0RL, England
Penguin Group (USA) Inc., 375 Hudson Street, New York, New York 10014, USA
Penguin Group (Canada), 90 Eglinton Avenue East, Suite 700, Toronto, Ontario,
Canada M4P 2Y3 (a division of Pearson Canada Inc.)
Penguin Ireland, 25 St Stephen's Green, Dublin 2, Ireland (a division of Penguin Books Ltd)
Penguin Group (Australia), 250 Camberwell Road, Camberwell, Victoria 3124,
Australia (a division of Pearson Australia Group Pty Ltd)
Penguin Books India Pvt Ltd, 11 Community Centre,
Panchsheel Park, New Delhi – 110 017, India
Penguin Group (NZ), 67 Apollo Drive, North Shore 0632, New Zealand
(a division of Pearson New Zealand Ltd)
Penguin Books (South Africa) (Pty) Ltd, 24 Sturdee Avenue,
Rosebank 2196, South Africa

Penguin Books Ltd, Registered Offices: 80 Strand, London WC2R 0RL, England

www.penguin.com

First published 2009
6

Copyright © Scott Schuman, 2009

The moral right of the author has been asserted

Designed by Stefanie Posavec
Printed and bound in Italy by Graphicom srl

ISBN: 978-0-14-311637-0

THE SARTORIALIST

Scott Schuman

'The place
to be seen!'
MARIO
TESTINO

Scott Schuman just wanted to take photographs of people that he met on the streets of New York who he felt looked great.

His now-famous and much-loved blog, thesartorialist.com, is his showcase for the wonderful and varied sartorial tastes of real people across the globe. This book is a beautiful anthology of Scott's favorite images, accompanied by his insightful commentary. It includes photographs of well-known fashion figures alongside people encountered on the street whose personal style and taste demand a closer look.

From the streets of New York to the parks of Florence, from Stockholm to Paris, from London to Moscow and Milan, these are the men and women who have inspired Scott and the many diverse and fashionable readers of his blog.

To my Father, Earl Schuman –
simply the most influential
man in my life.

The Sartorialist, at its core, is about fashion, but I don't often think of 'fashion' when I look at my photos.

I have been sharing photos with my audience on a daily basis for the past four years, and over the course of that time I have begun to see my images more as a social document celebrating self-expression than as a catalogue for skirt lengths or heel heights.

The comments on The Sartorialist website make the blog a living fabric. The audience interaction made me realize the variety of interpretations the same look can provoke. I might be totally entranced by a young lady's hairstyle, while someone else won't be able to stop looking at her flipflops.

It's all about self-expression. I rarely shoot a look where I love all the elements. I don't need to love the whole look: I just need to identify the one or two elements that mean something to me, and then capture it in the romantic way I see it. In that way I think I am 'visually greedy'. Like most of the designers I know, they can hone in on the trim-detail of a vintage dress and simply disregard the rest. Let's just say it's a positive and less judgemental way to look at the world.

I hope that, as you look at the images in this book, rather than giving a look a 'thumbs up' or a 'thumbs down', you will focus on the elements that could inspire you. Maybe you'll find inspiration in a colour combination, or maybe in a play on textures or a mix of genres, for example 'punk meets eskimo'.

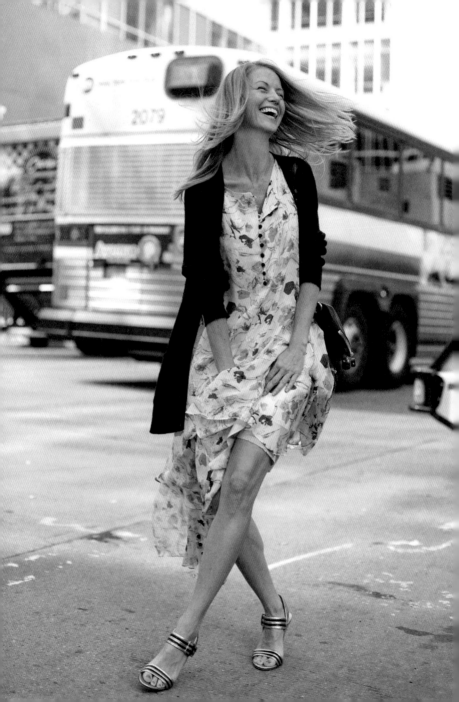

I like people to draw their own conclusions, to find their own inspiration without the influence of a guiding hand. That's why you won't find a lot of text in this book. My inspiration comes from contrast and variety. I'm proud that this book celebrates style through a wide range of ages, income levels, and nationalities. On the surface these individuals are very different, but they somehow share a common bond in the execution of their sartorial expression.

What constitutes great personal style? This is one of the questions I get asked the most. We tend to think that to achieve great personal style someone must have perfect clarity about who they are and what they stand for. I politely disagree. I think conflict about who you are often leads to even greater expression. That is why young people, or the young at heart, are those that inspire or move fashion forward. They are still struggling to find themselves: 'Am I a rocker? A footballer? Or a little bit of both?'. These contradictions produce the most interesting looks.

I hope that, while looking at the images in this book, you will begin to see fashion and style in a different light: that you make it yours, let yourself get inspired and experience a deeper enjoyment of your own sartorial expression.

Scott Schuman

Ignorance is bliss

Lino is a charming raconteur, spinning tales of world travel and youthful misadventure. At least I think he is. He doesn't speak English and I don't speak Italian. We communicate on a very basic level, but I find this simple language barrier quite useful when I'm shooting people. I mean, I want to capture something about the people I shoot but at the same time I am totally open to creating my own version of who I think this person is. Let's be honest, the reality rarely lives up to the romance, and I am OK with that – I think we all could benefit from letting ourselves get lost in the romance of an idea or perception instead of having to know every excruciating detail of reality.

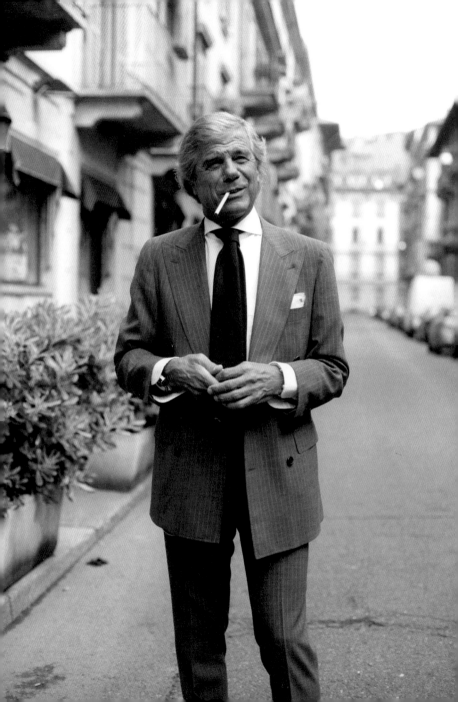

Bryant Park, New York

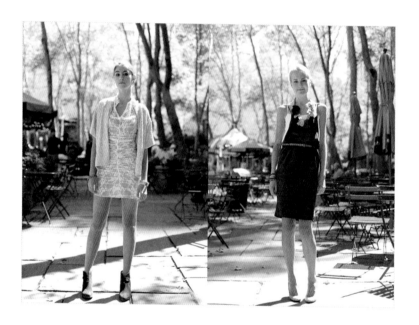

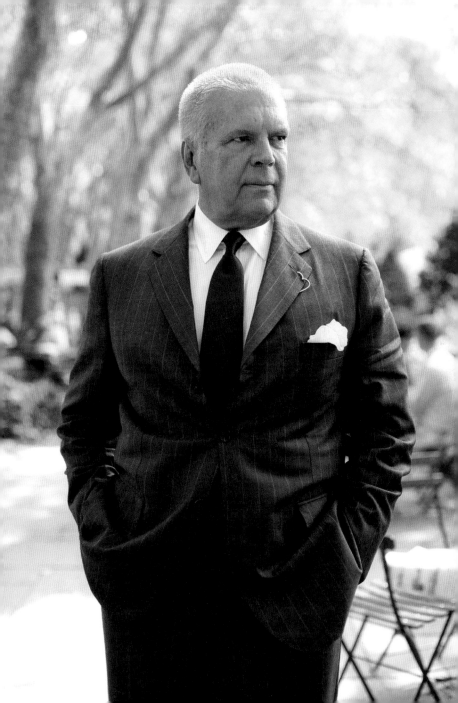

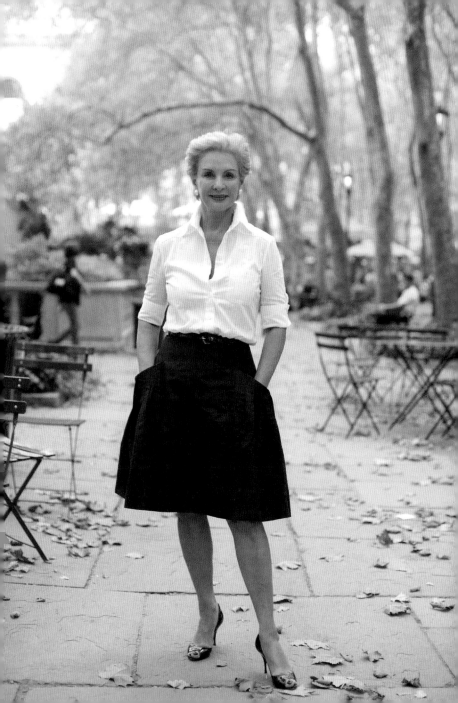

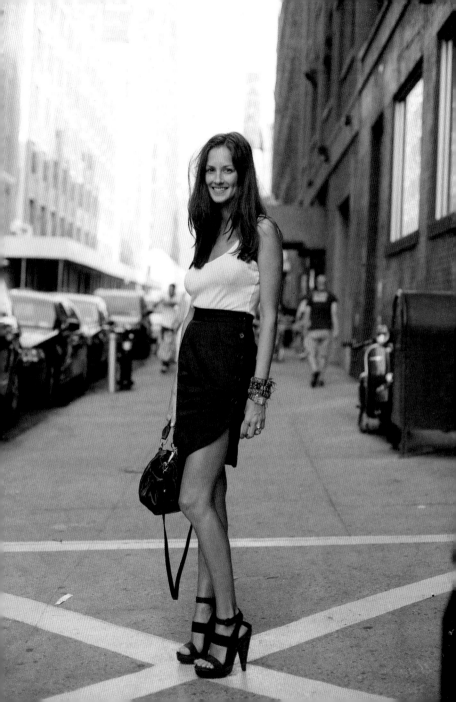

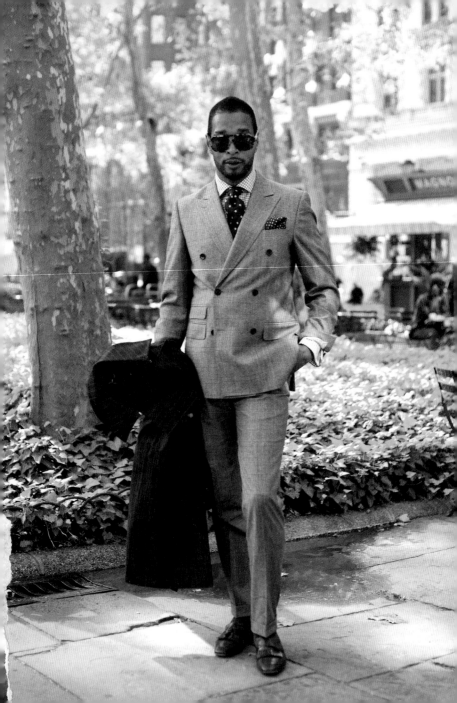

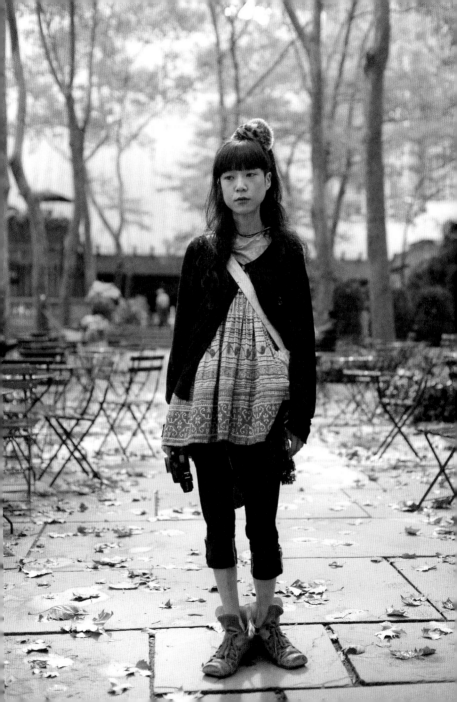

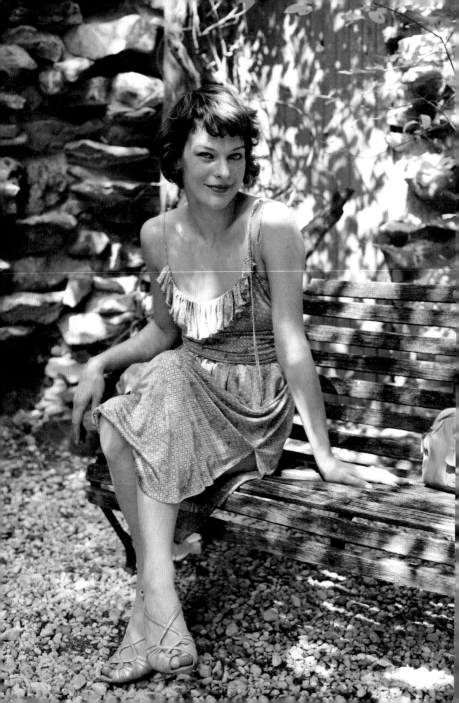

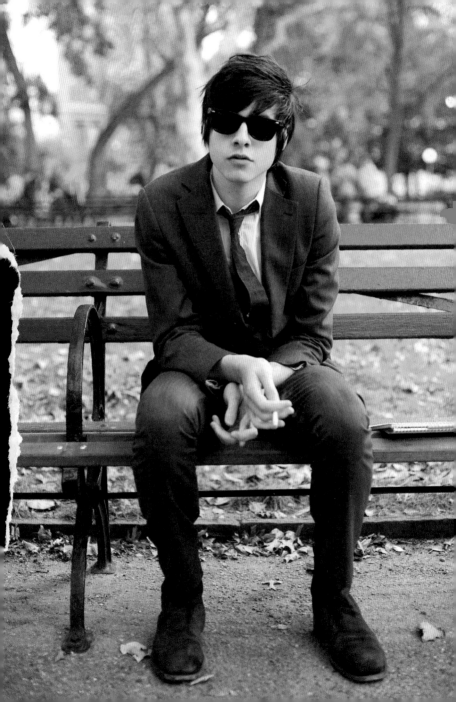

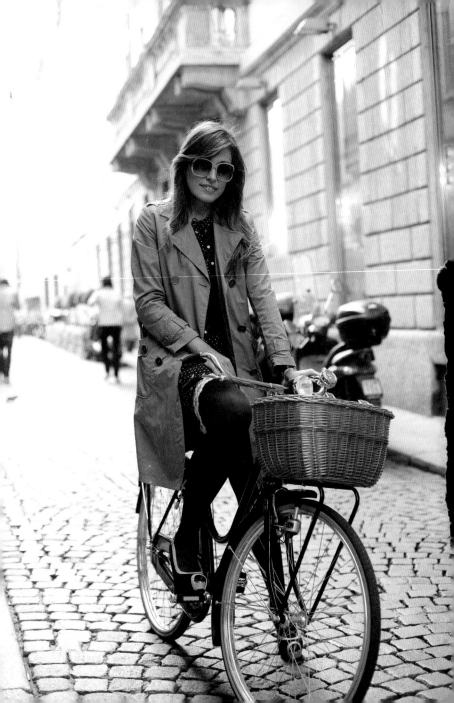

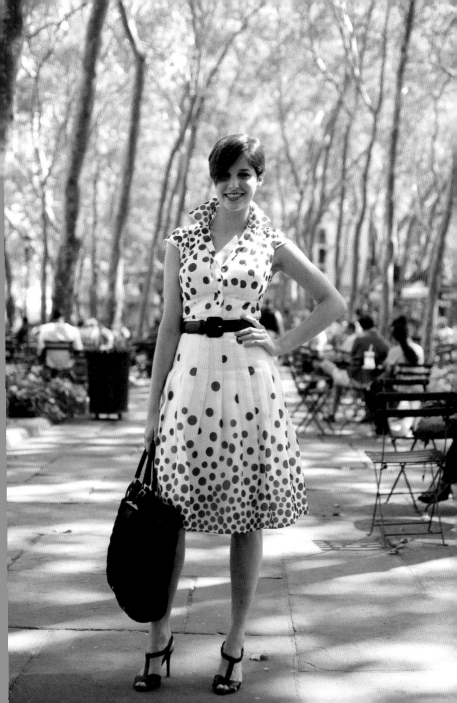

Unexpected style, New York

When I saw this girl, I wanted to shoot her because I liked the unexpectedness of her style: those rolled-up jeans with a dress, her stillness, and those shoes – how many fashion girls would pick those shoes? But when I posted the picture on the blog, most of the conversation about the shot focused on her weight. It was fascinating to read how different the reactions were between the American/European comments and the Asian comments. For me, the image will always be about her stillness, not her weight.

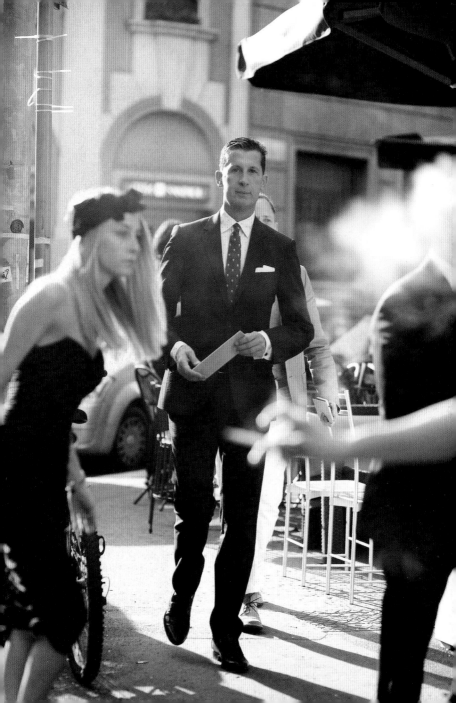

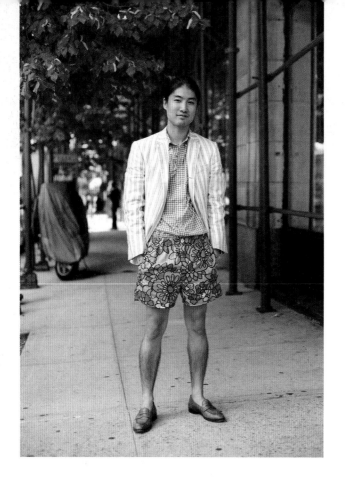

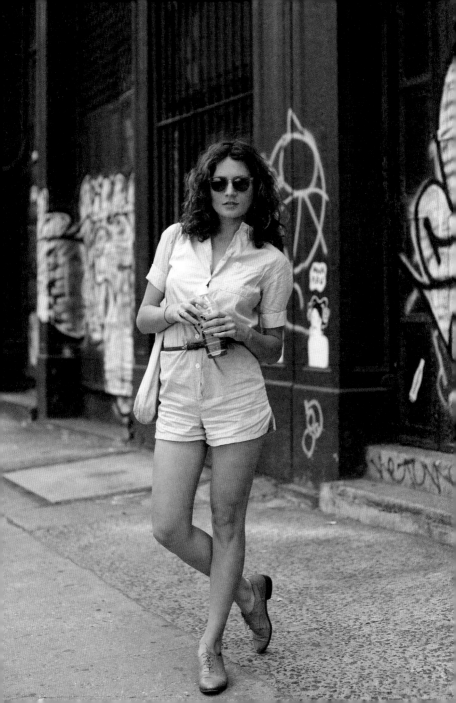

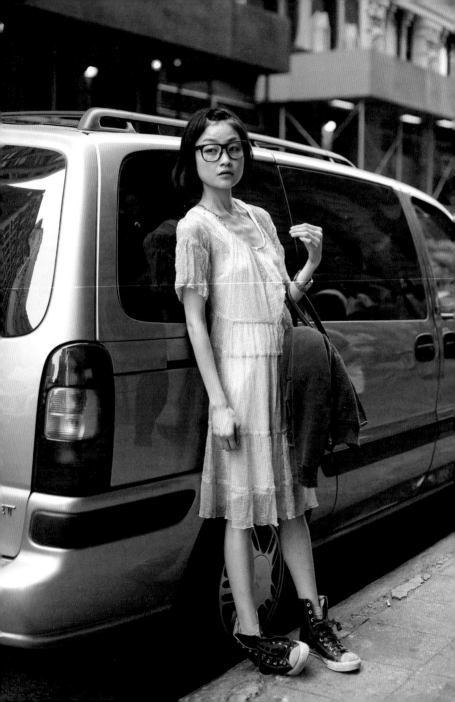

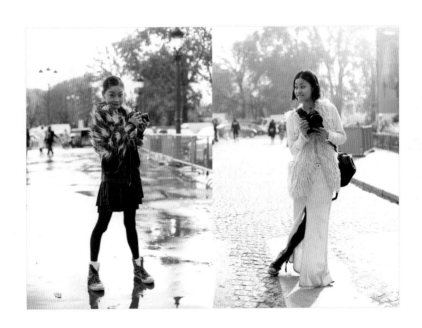

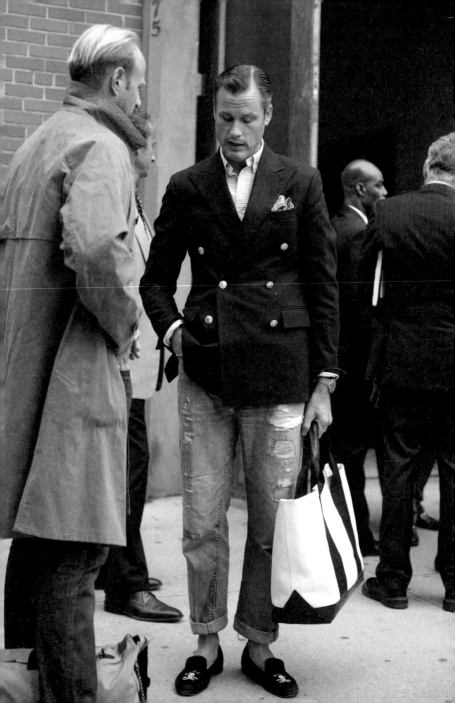

Visually greedy

I think most of us are like stylish hermit crabs: we change our outershell to camouflage our way into certain social positions. We 'dress the part'. When you accept this idea, fashion/people watching becomes less judgemental and more about being 'visually greedy'. It becomes less about what that person is wearing and more about what the elements of the look can mean to your own personal style. 'Visual greed' is one of the reasons I don't usually put the name of the person or labels that they are wearing on my blog – they simply don't matter to me. For instance, this gentleman was shot outside a recent Ralph Lauren fashion show. I know he works for Ralph and I know that Ralph 'encourages' employees to dress in a certain 'Ralph Lauren-ish' manner. So is his look *real* personal style? I don't know and I won't judge him on that, but I will allow myself to be inspired by the concept of a Navy blazer with totally distressed jeans or crisp side-parted hair that always seems to look modern. In a way, being 'visually greedy' allows you to separate the personality from the 'look' and puts the pressure on you to figure out how to harness that stimulus instead of just grading others as 'pass' or 'fail'.

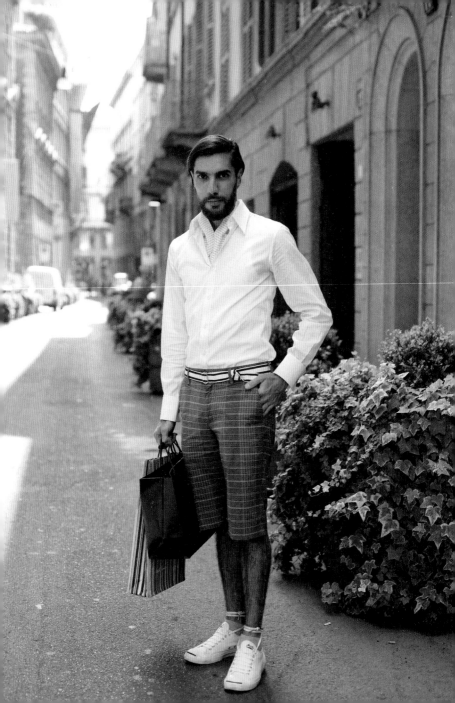

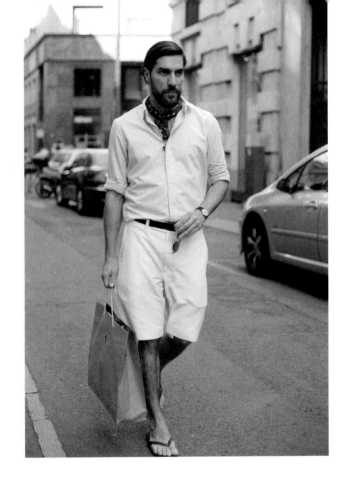

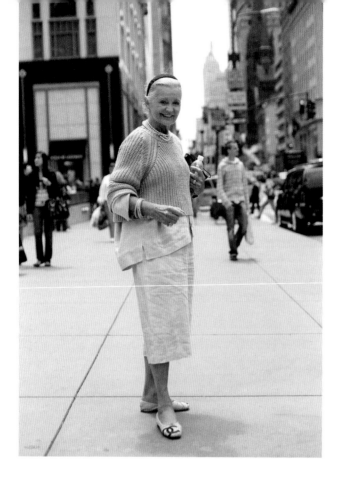

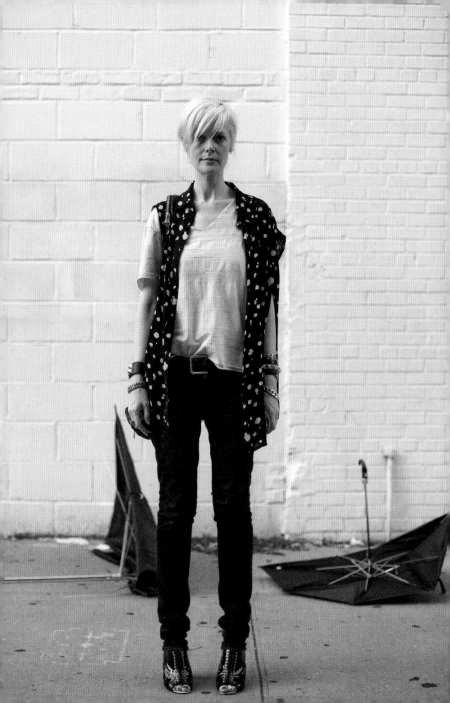

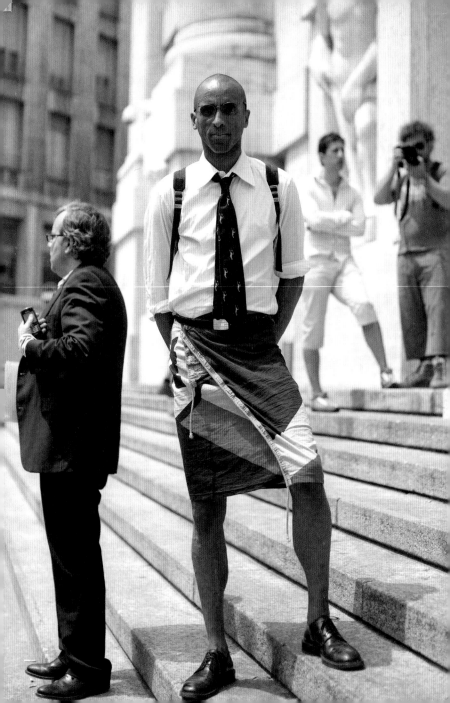

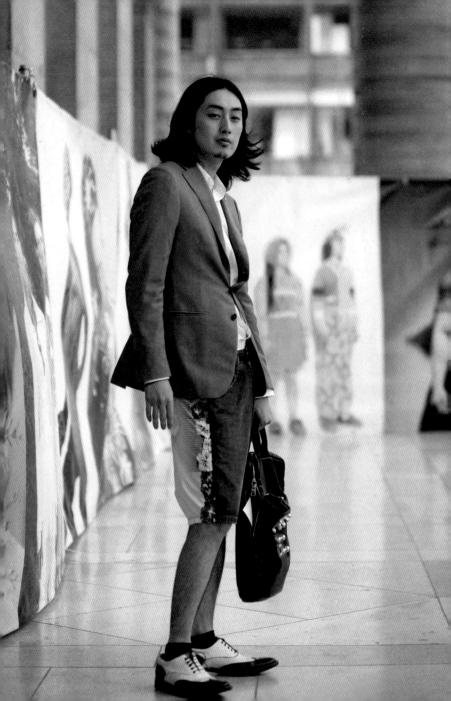

The Seed of Style, Paris

For me, this photo is all about a person whose mind and style has matured more quickly than his physical body has grown. I think he said he was thirteen years old, but he has the style of a nineteen-year-old and the face of an eight-year-old. My only regret is that, just off to the right-hand side of the shot, his mom is holding the ice cream cone she'd just bought for him. Unfortunately, when I posted this shot on the blog the majority of comments were about the $1,200 sneakers he was wearing.

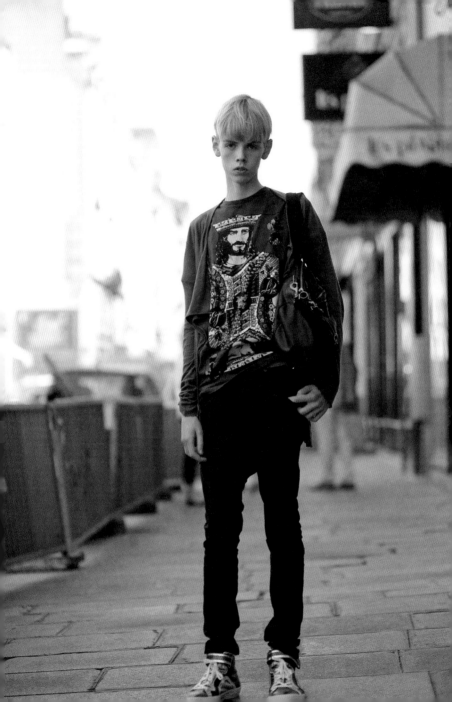

Carine Roitfeld

Carine is the Editor-in-Chief of French *Vogue*, and one of the most influential people in the fashion world. She does a great job of reflecting her personality on the pages of her magazine. I really respect how, in a business that can make women feel insecure, she surrounds herself with a team of women of equal beauty and style.

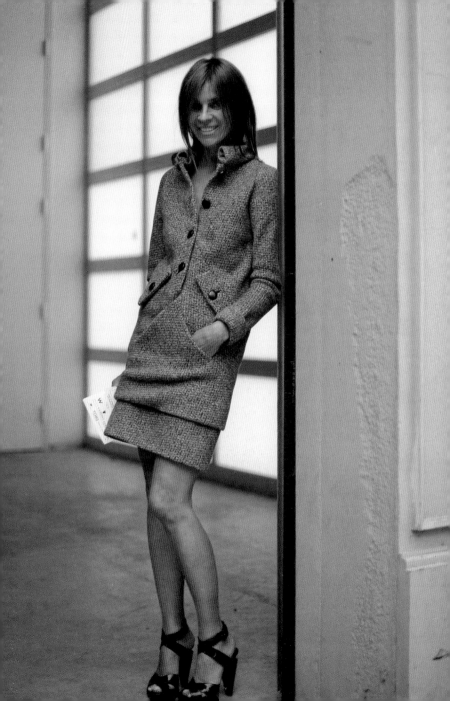

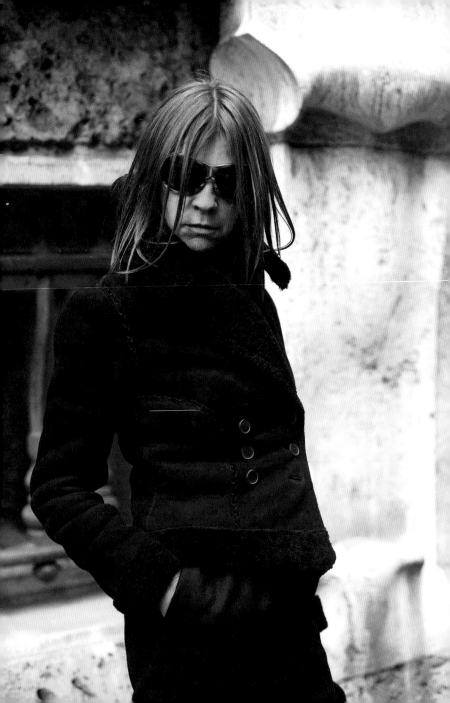

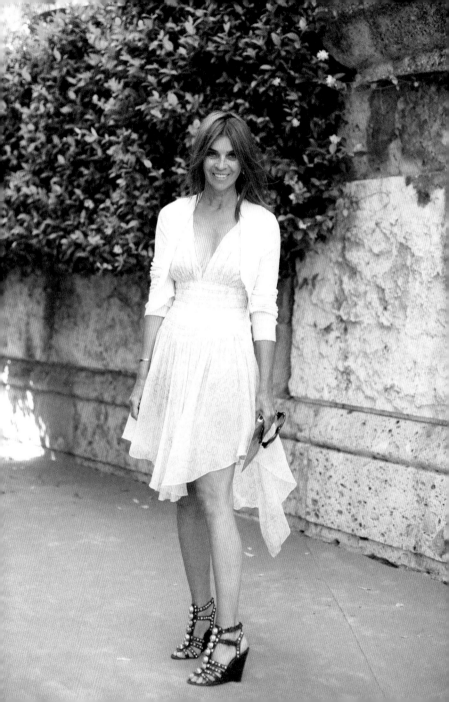

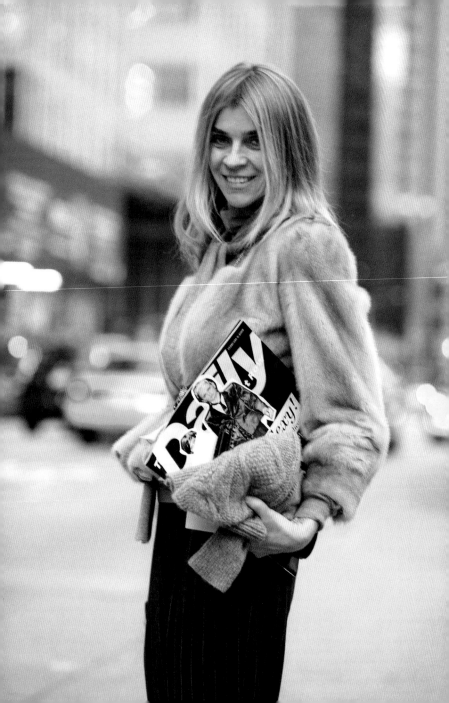

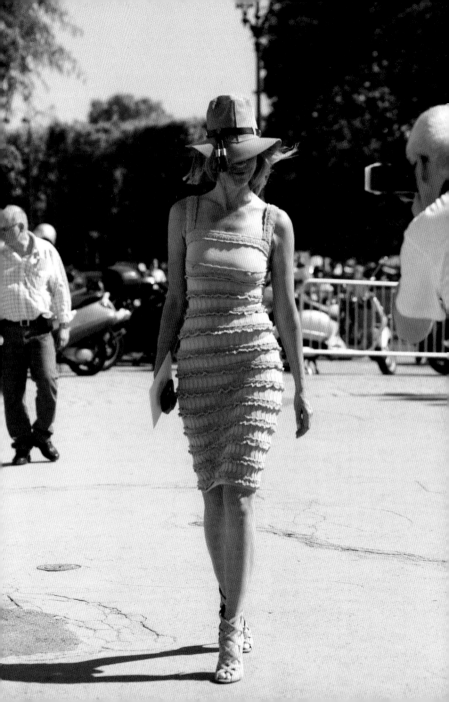

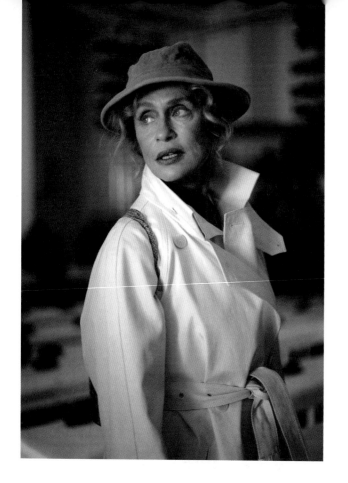

Lauren Hutton at Calvin
Klein, New York

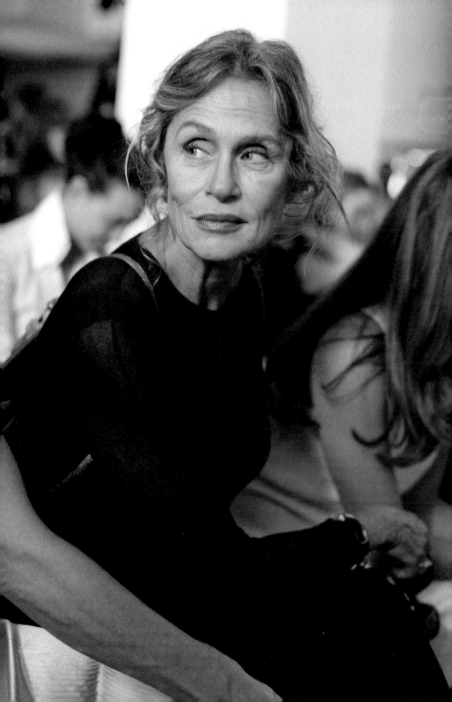

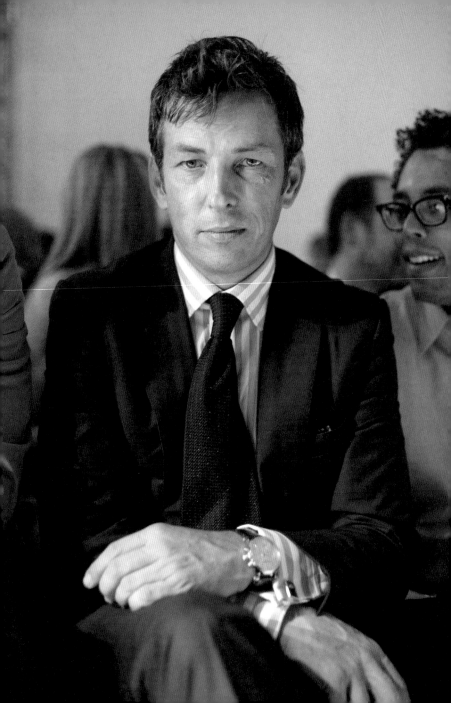

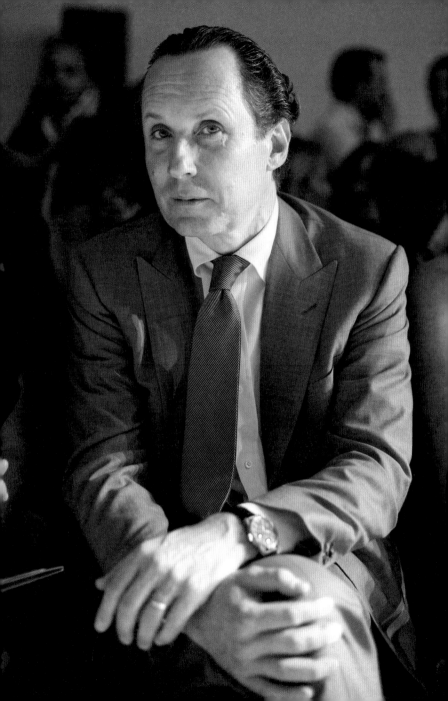

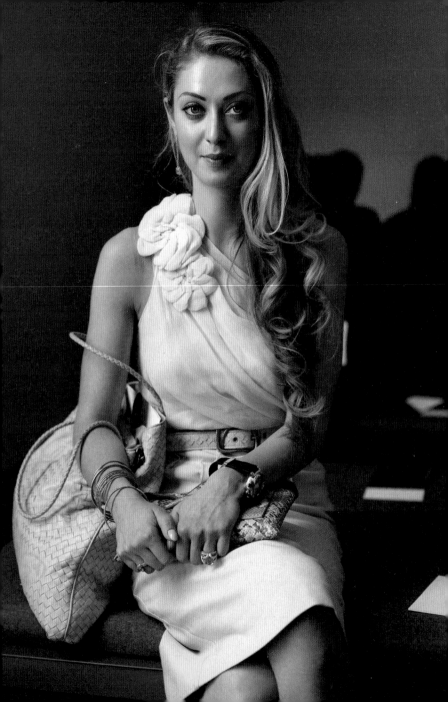

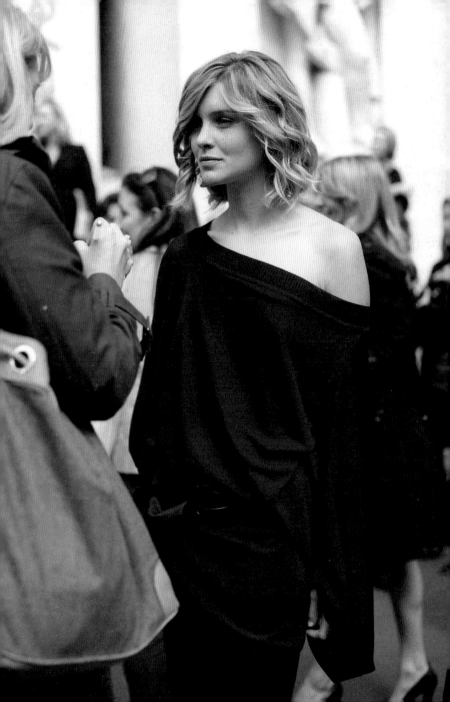

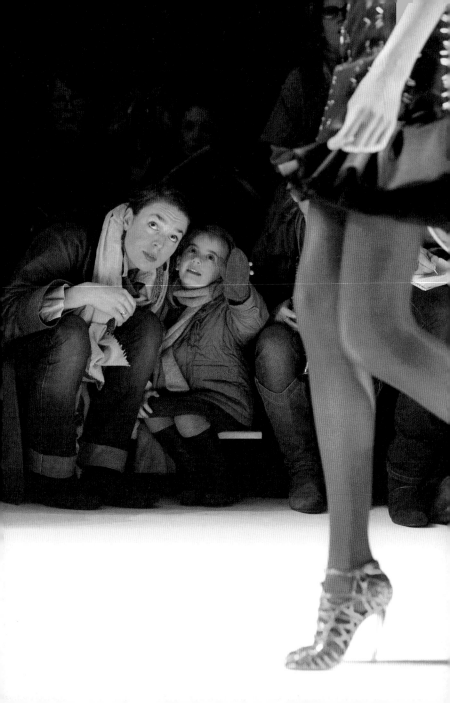

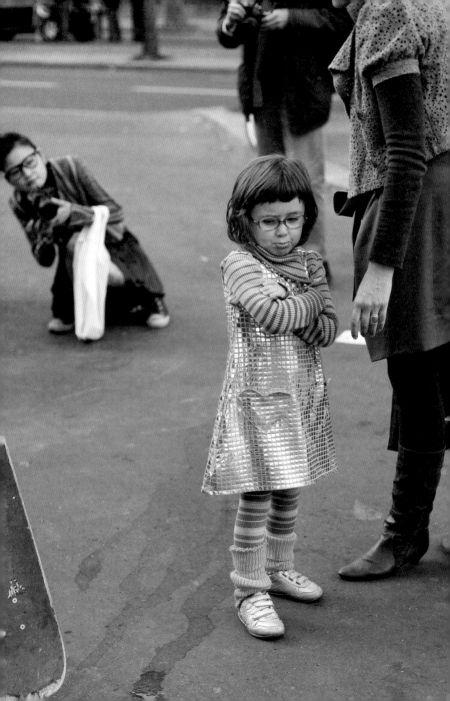

Just after the show, Paris

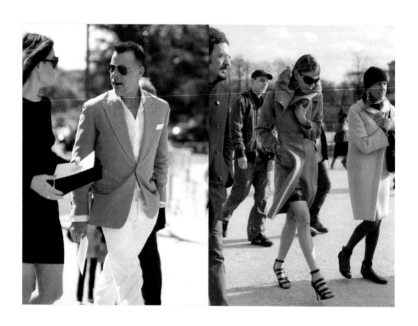

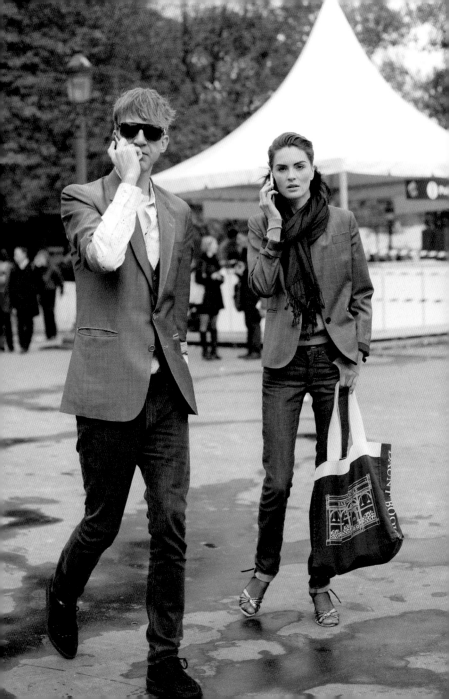

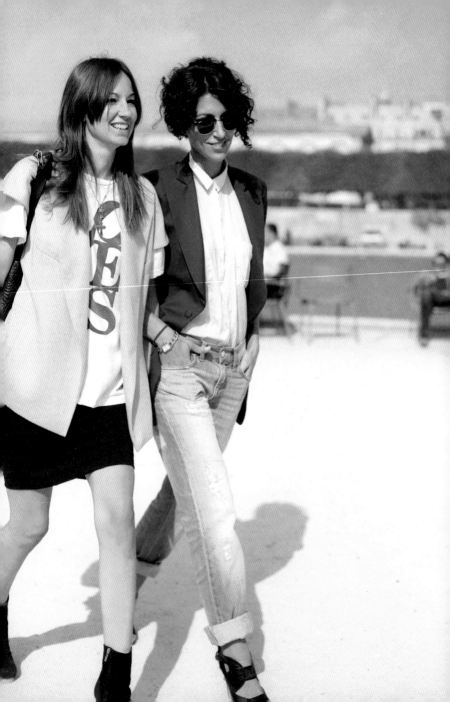

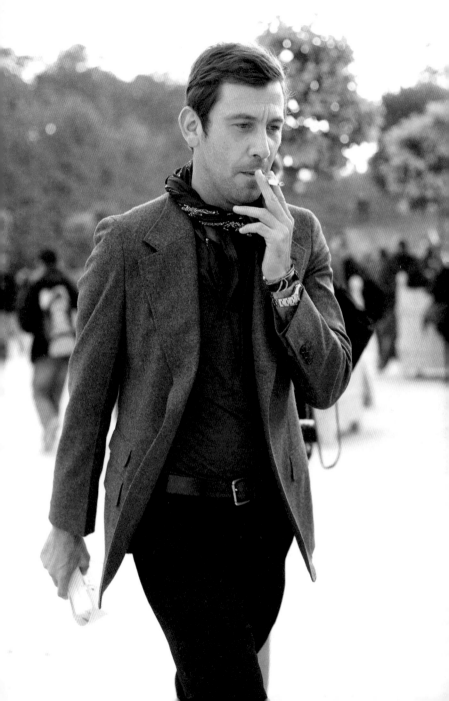

Beppe Modenese,
Milano

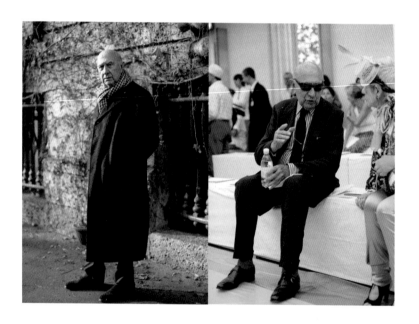

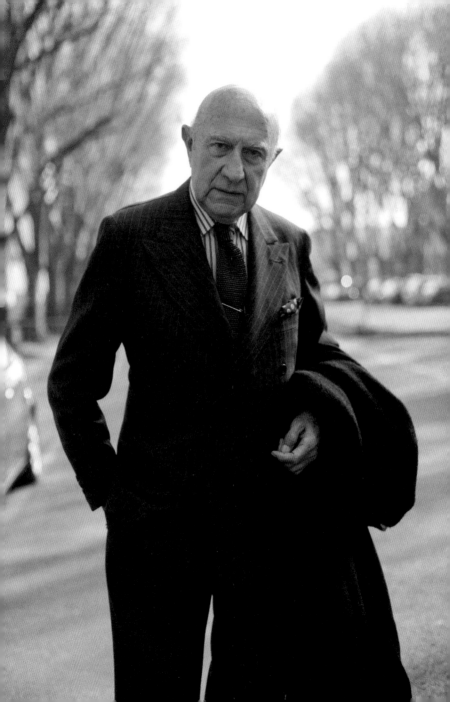

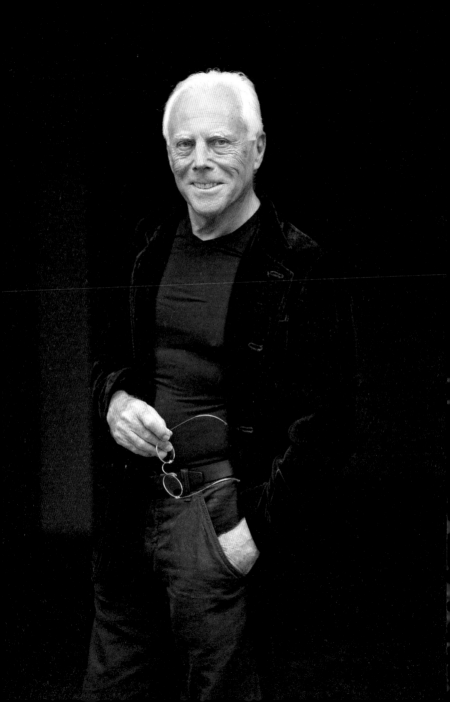

Giorgio Armani, Milan

My biggest fashion influence growing up in the 1980s was Giorgio Armani. I have always been fascinated not only by his designs but equally by his ability to project and protect his personal image and style.

The first time I went backstage at his fashion show in Milan, I saw this ability in action. Mr Armani (as he is called) was surrounded by photographers waiting to take a few candid snaps after the show. Mr Armani, however, would not look up at the cameras until he had adjusted his tee shirt, his pants and his hair and made sure he was backed by his preferred black background (better for his beautiful white hair). No one was taking his photo until he was ready for them to take his photo.

About a year later I saw Giorgio walking down the street in Milan (actually, I saw his giant bodyguard first) and tried to persuade him (and the bodyguard) to let me take his photo. I told him I could do it very quickly and threw out references to Style.com and *GQ* but still he was not convinced ... until I said/motioned that we should do it 'over there' in front of a dark alcove so that his hair would really standout against the dark background. That got him.

George

Everyone I know agrees that George has great style. Masculine, refined, classically advanced. Yet the actual items are surprisingly simple and consistent. Using a deceptively uncomplicated colour palette, George sets himself apart from the trad/khaki/prep set by playing with the proportions of classic items and focusing on the 'how' of wearing clothes – extra high roll on a shirt sleeve, a deep cuff on khakis, or never wearing socks, but always, always with the sunglasses.

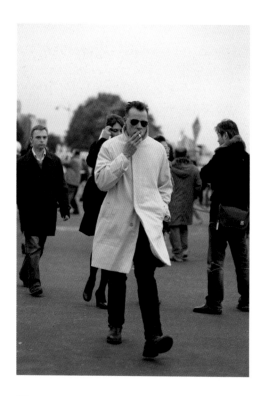

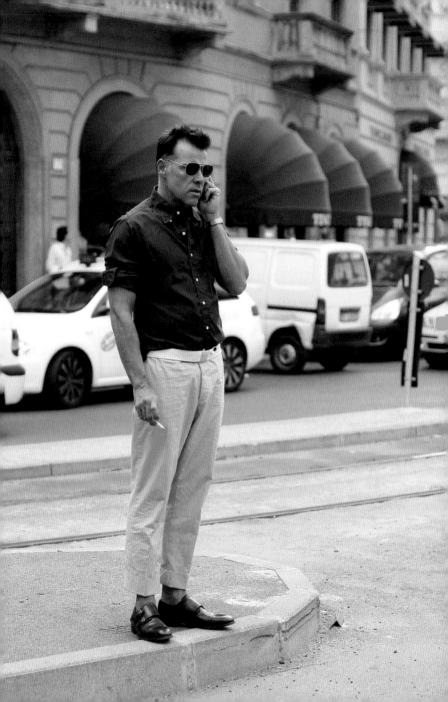

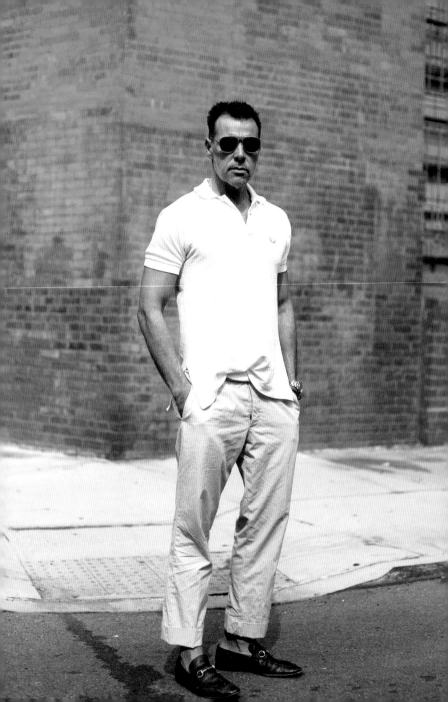

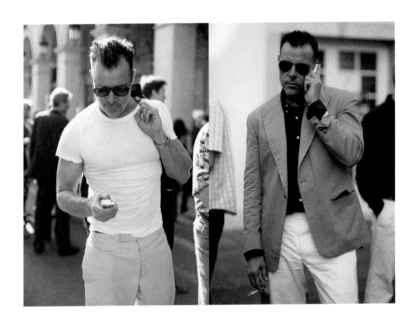

Girls on a
school trip,
Paris

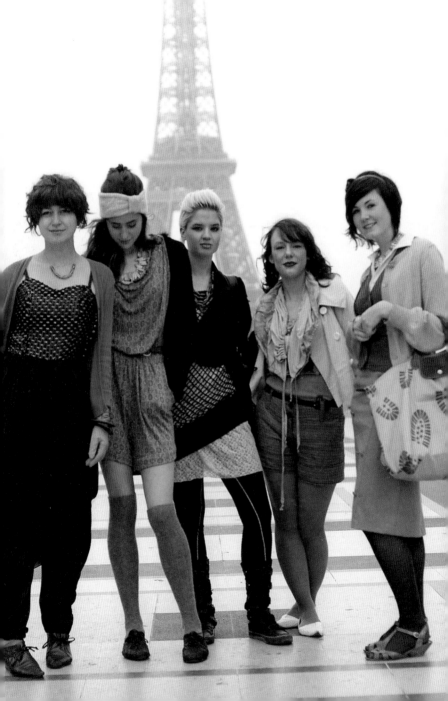

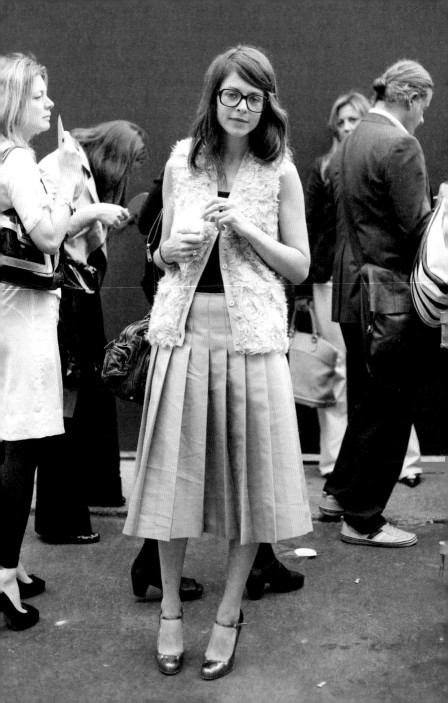

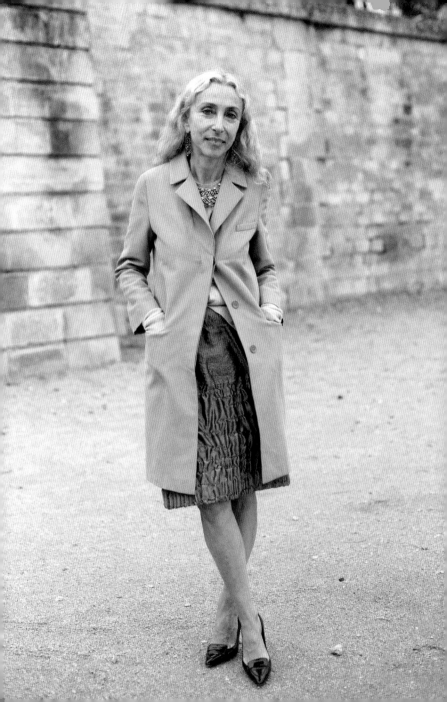

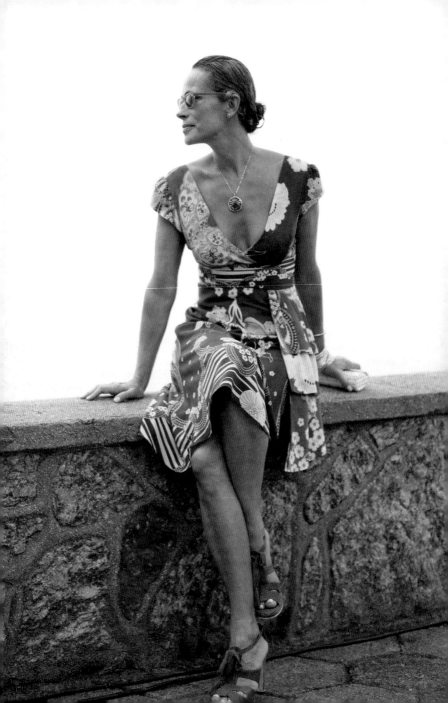

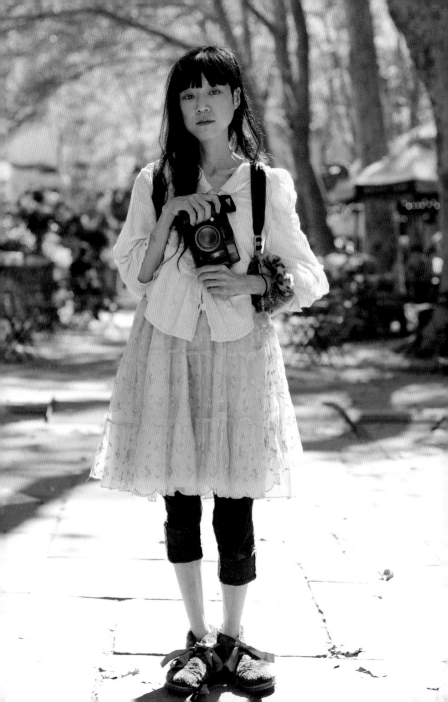

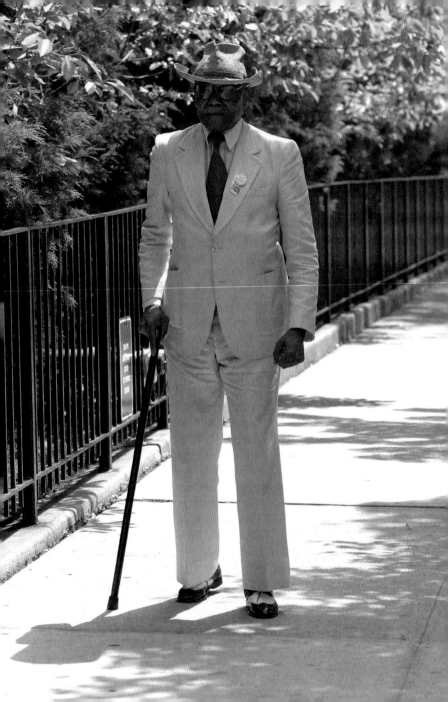

Sunday Morning, Harlem

While I was preparing to take this gentleman's picture I asked him about his fine summer suit, expecting to hear he'd had it for ever. Instead, he told me that ten years ago he was a drug dealer. When one of his customers couldn't pay for her drugs, she threw this suit at him in payment.

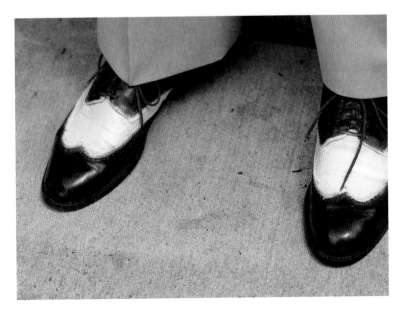

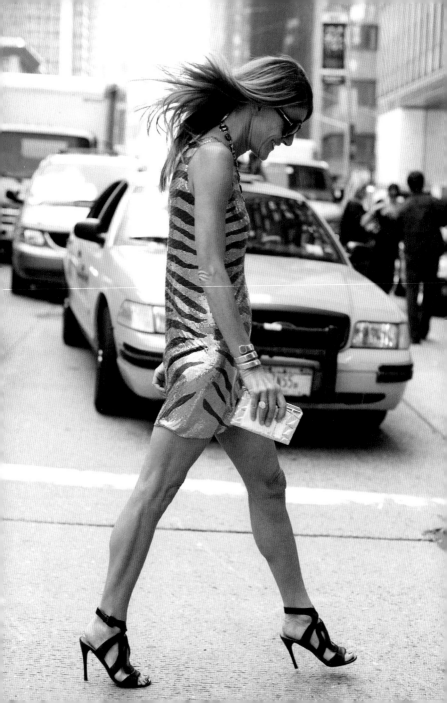

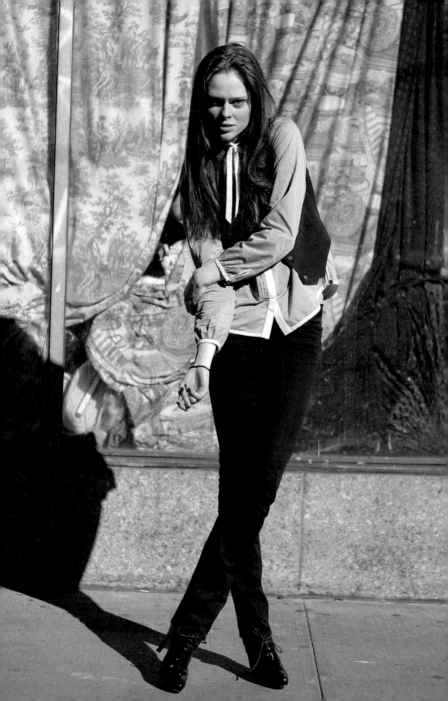

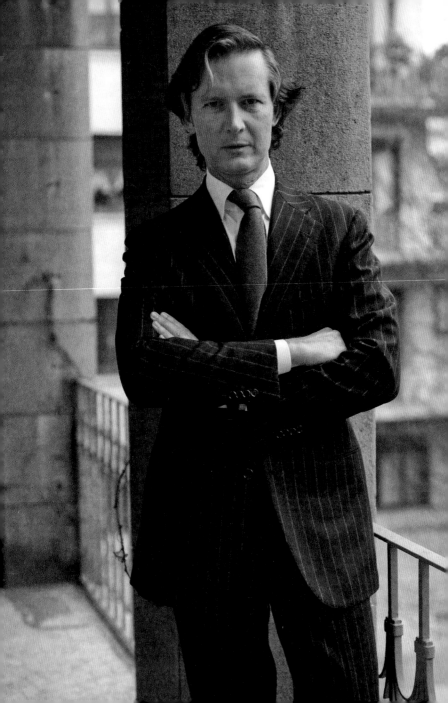

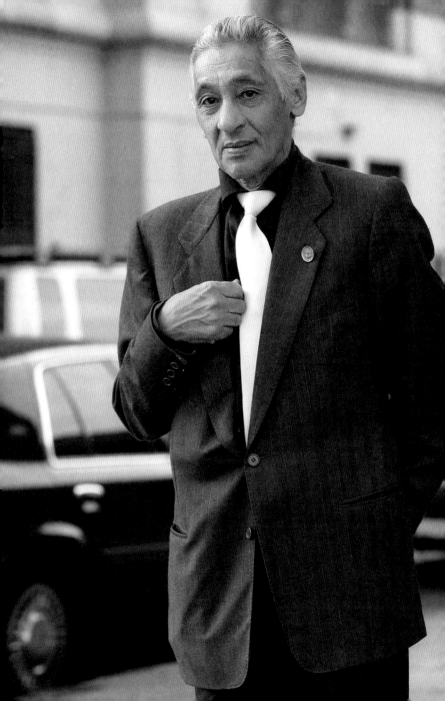

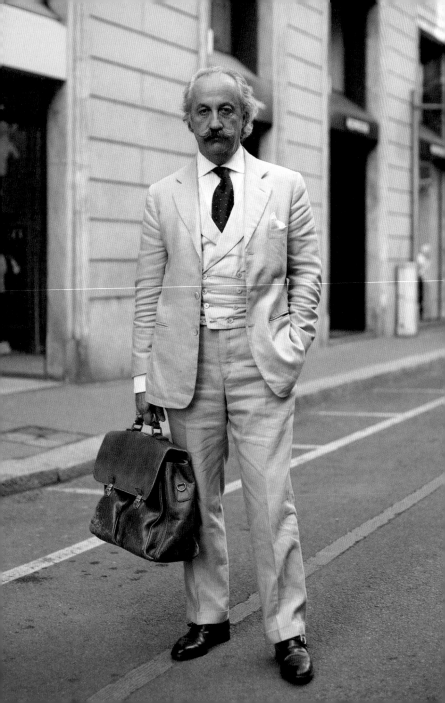

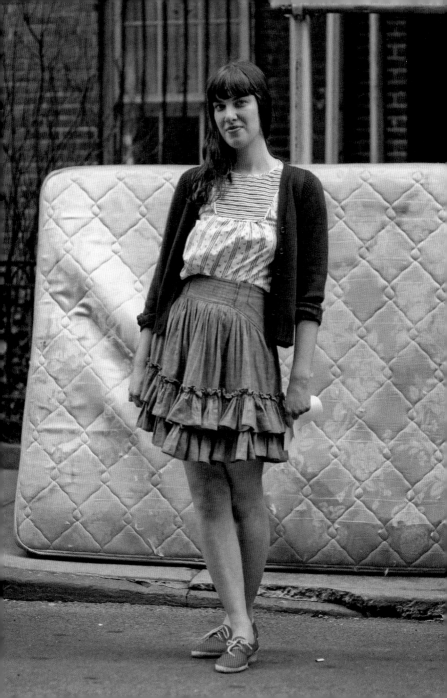

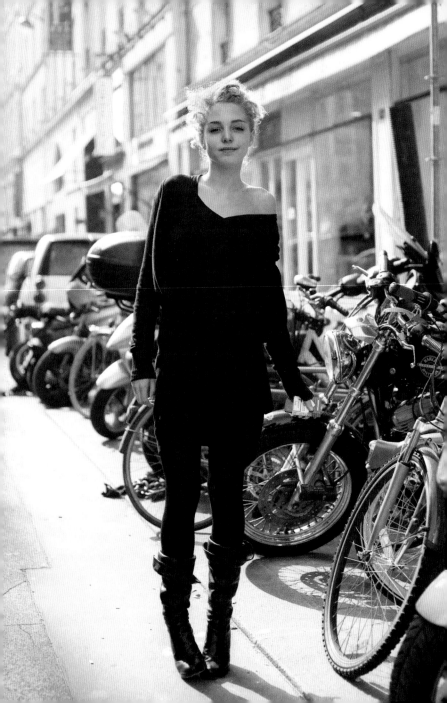

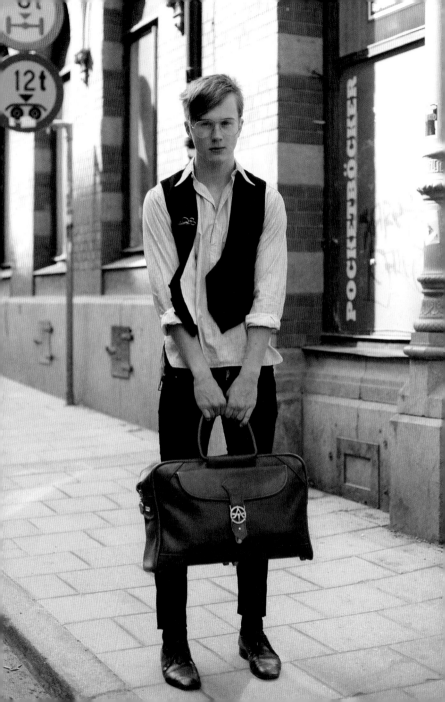

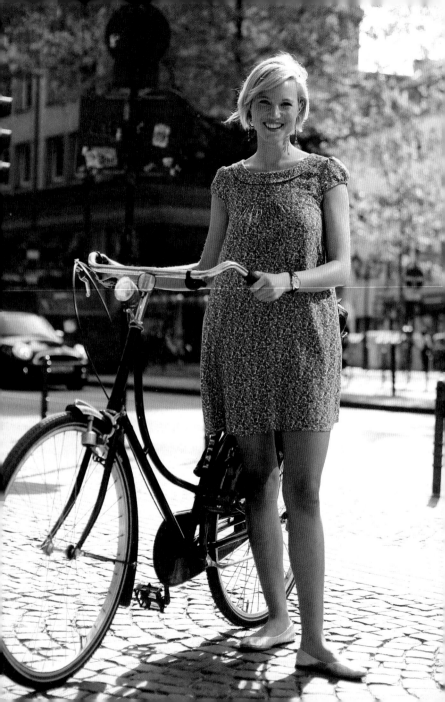

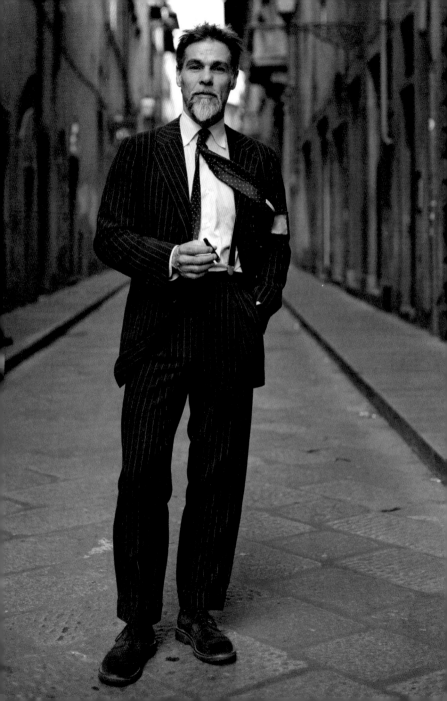

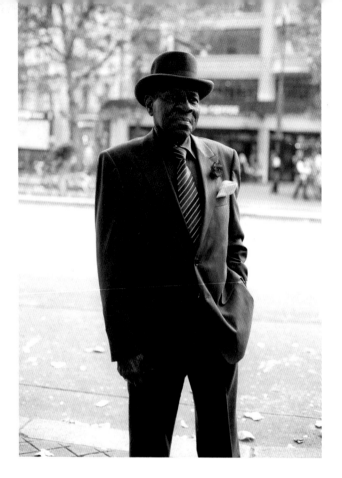

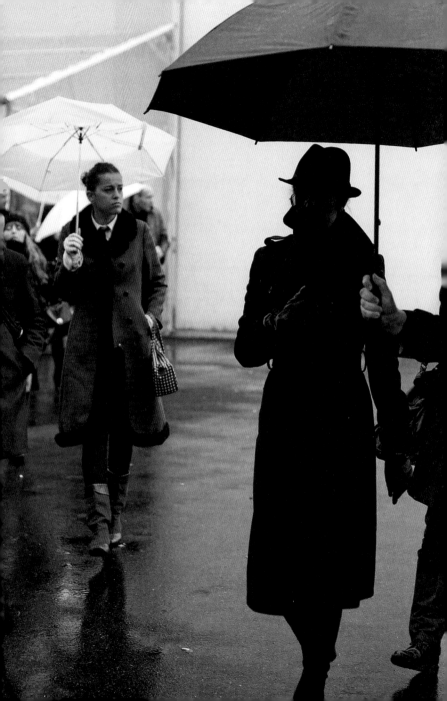

Evolution or Revolution?

I shot this young man on one of my first trips to Milan. He speaks very little English, so our communication is usually very brief and takes place only once or twice every six months, during the men's fashions. I remember really loving his kinda cowboy/hippie-via-Kyoto vibe, but after I took this shot I lost track of him and hadn't seen him around the shows for a while. At least I didn't think I had seen him. Apparently at some point between seasons he changed his look to such a sharply tailored Master of the Universe vibe that I completely failed to realize it was the same person. I would see this guy at the shows and we would share one of those professional courtesy head nods, but I still didn't get the transformation until I was reviewing some old images while one of his recent photos was on my computer screen. It is a weird feeling when you put 2 and 2 together and get 4 ½.

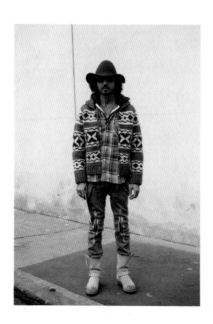

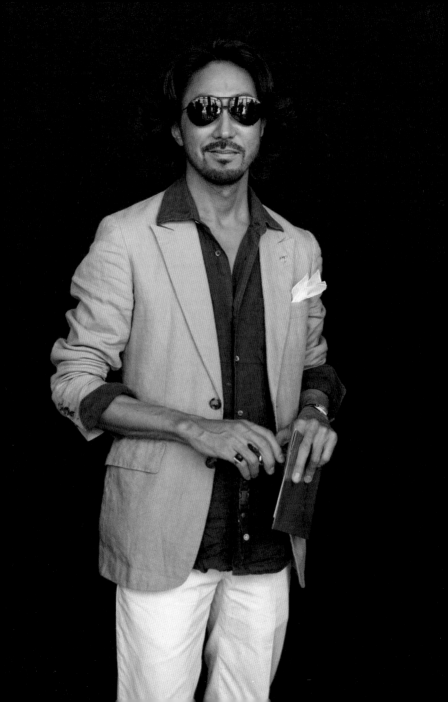

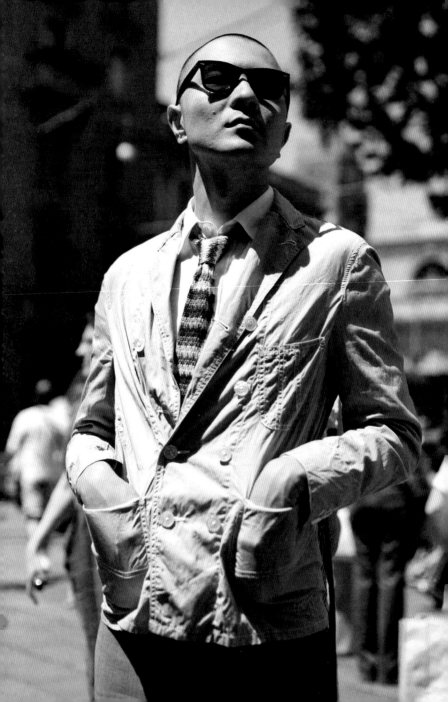

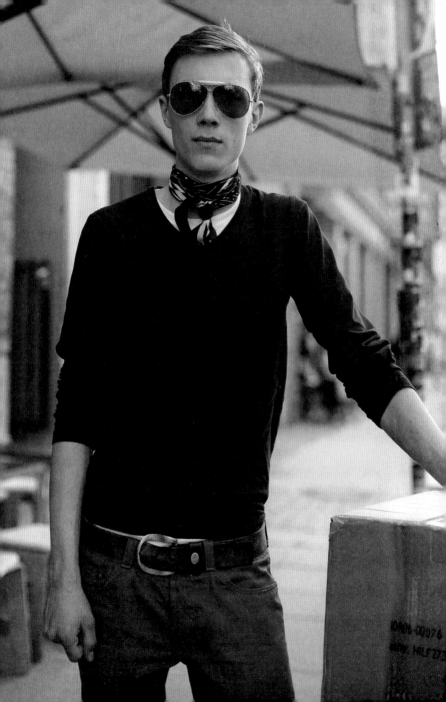

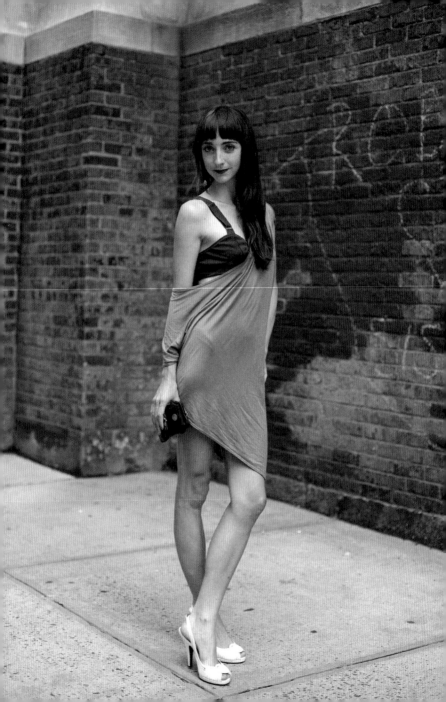

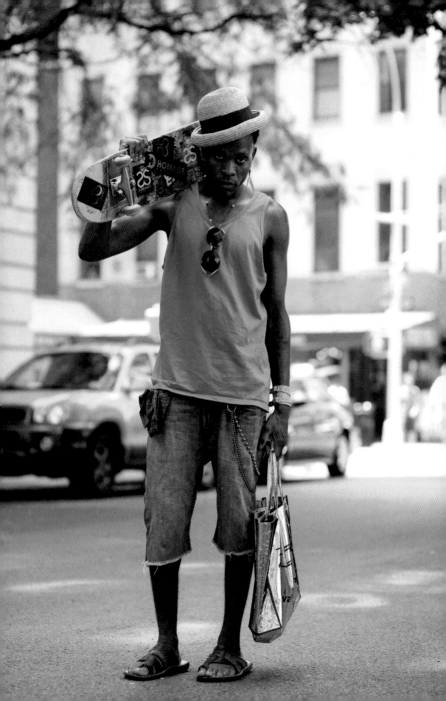

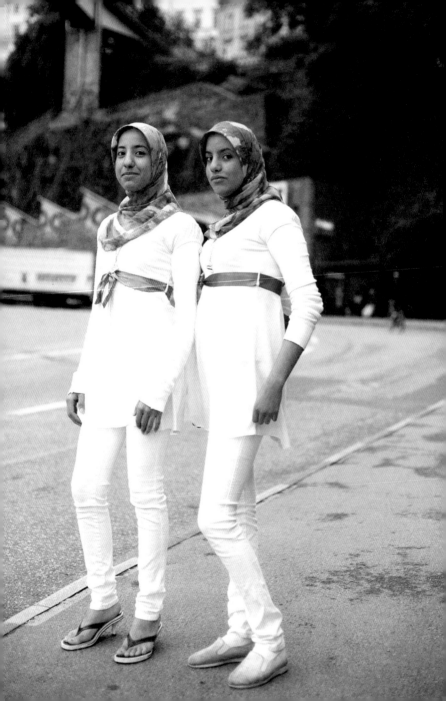

Typical Teens, Stockholm

I saw these two exiting a subway station in Stockholm's Södermalm neighbourhood. I really was unsure whether I should take their photo, but finally I decided it was just too perfect to pass up. They looked so exotic to me and yet somehow familiar. They spoke mainly Swedish with just a touch of English, however their predominant language was the language spoken only by a tiny, very special group – TEENAGER! It quickly became clear to me that what was exotic about them was not their traditional dress with just a subtle nod to modern girly fashion but actually the for ever unknowable world of teenage silliness and giggles. Regardless of how they looked on the outside, they would fit in at any 10th-grade class anywhere in America or Europe, or even on the moon.

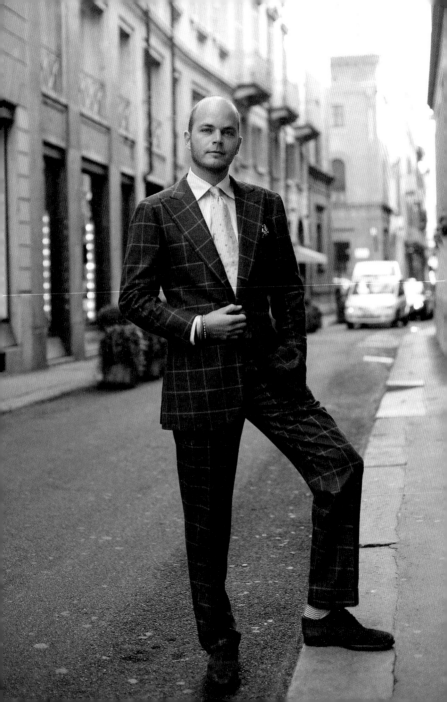

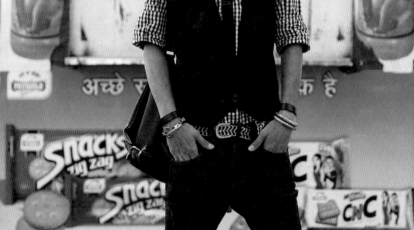

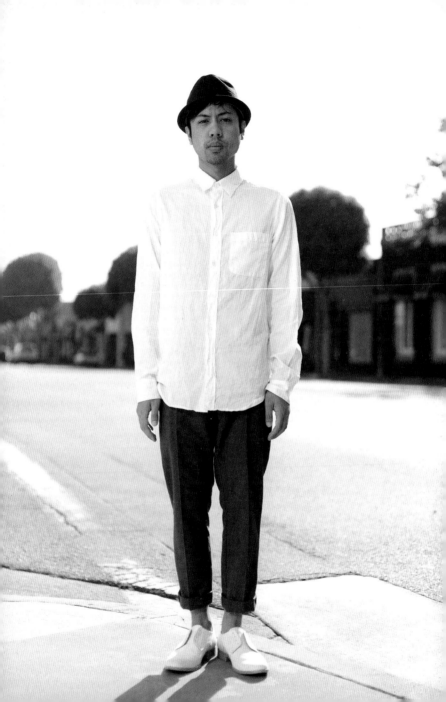

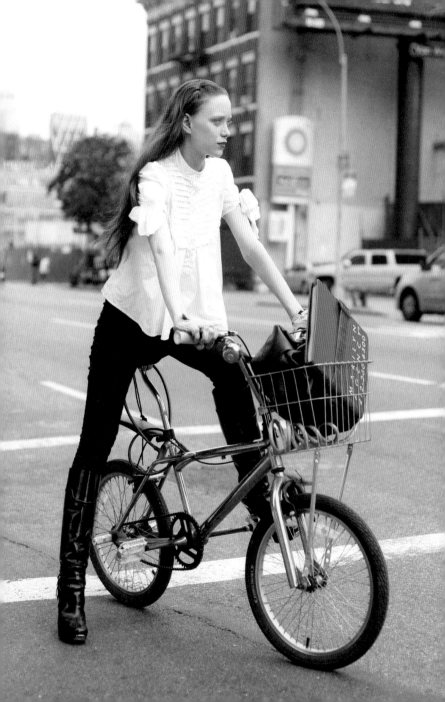

Williamsburg, Brooklyn

I ran two NYC marathons during the late 1990s. I remember that while I was running (slowly) I made a mental note that someday the crowds watching the marathon would make up a great visual tapestry of New York personalities for photography. A decade later, when I was first learning photography, I decided to follow the marathon route to try to capture some of the characters of the five boroughs. Somewhere close to Williamsburg, Brooklyn I spotted this Hasidic gentleman watching the passing runners. I didn't speak to him but indicated that I wanted to take his photo. Whatever religious differences separated us, these were easily bridged by the dude-ish head nod that is instantly understandable to any New Yorker regardless of cultural affiliation. To my utter surprise, when I raised the camera, instead of taking a pious stance of serious religious strength he pushed his hat forward on his head and took a Hollywood Rake-worthy lean against the phone box. His posture said more about his personality than any item of clothing ever could.

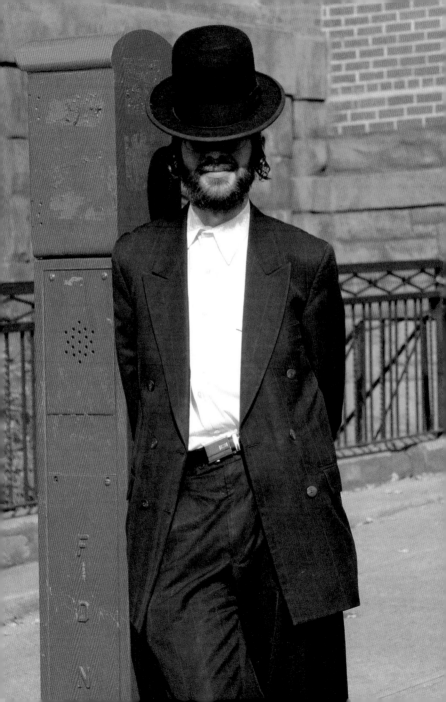

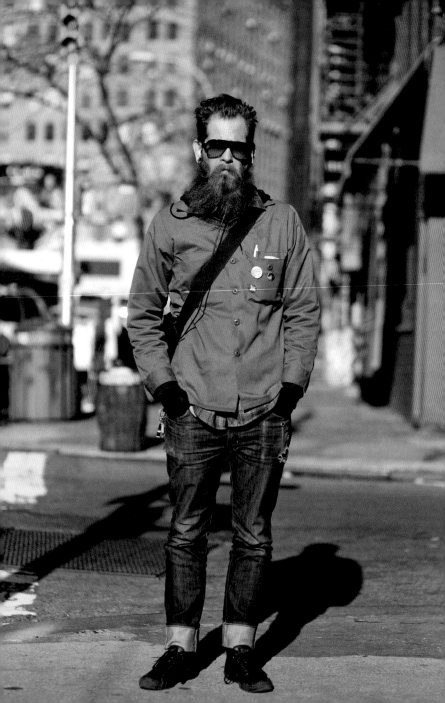

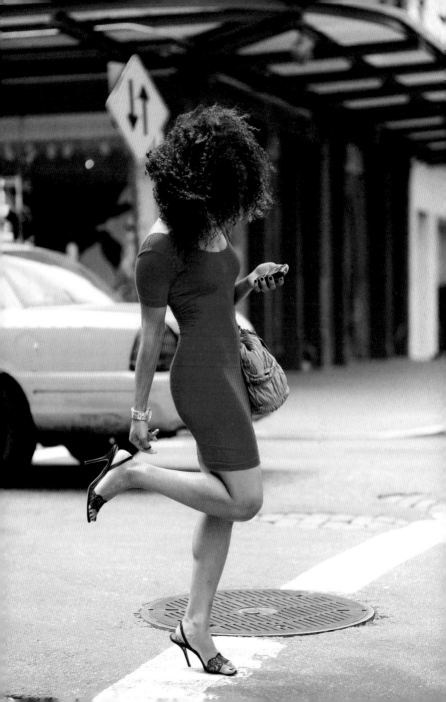

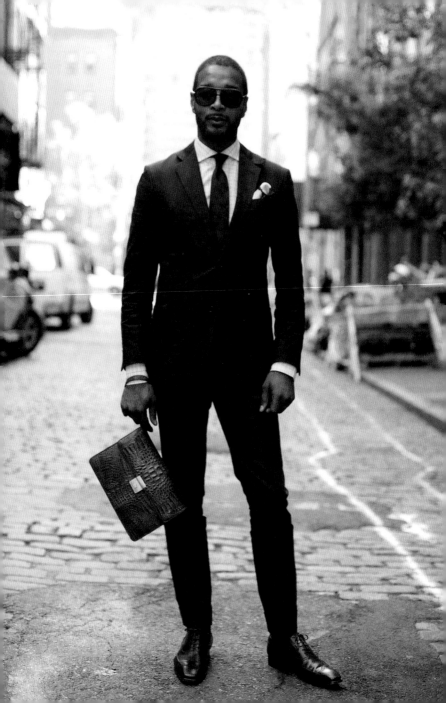

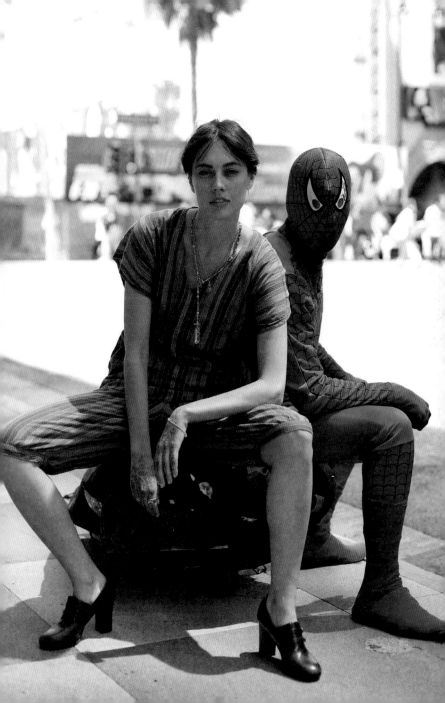

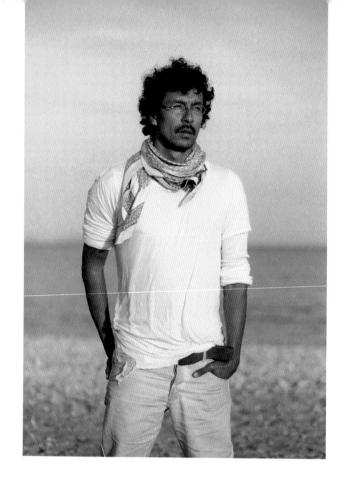

Hyères, France

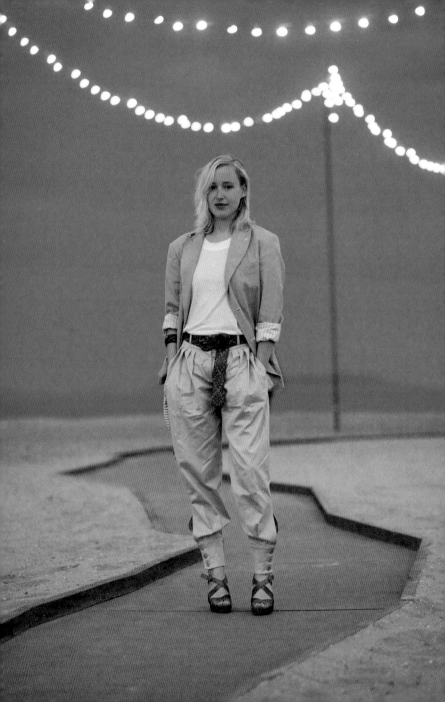

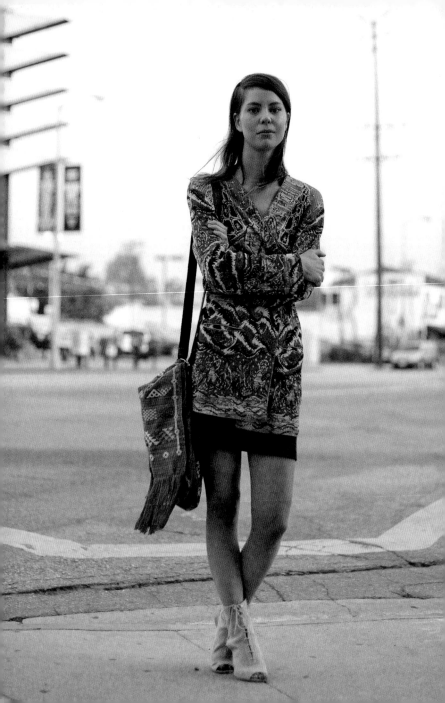

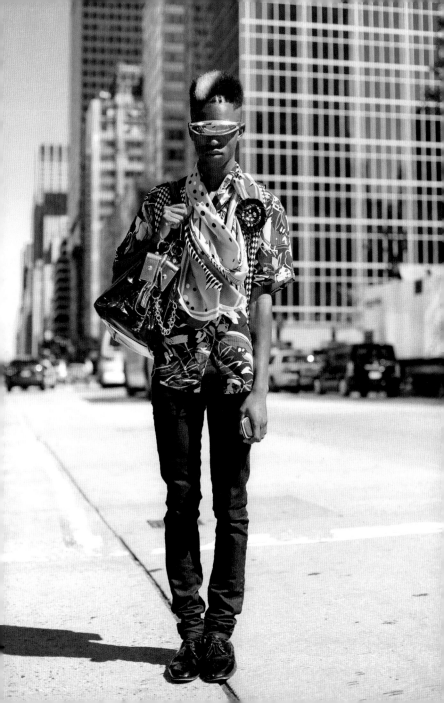

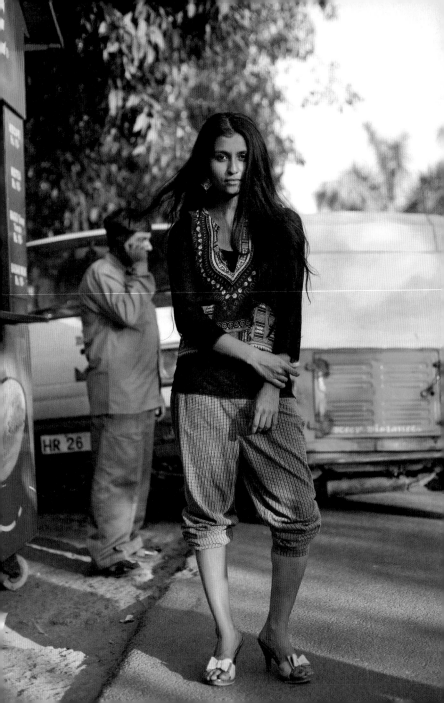

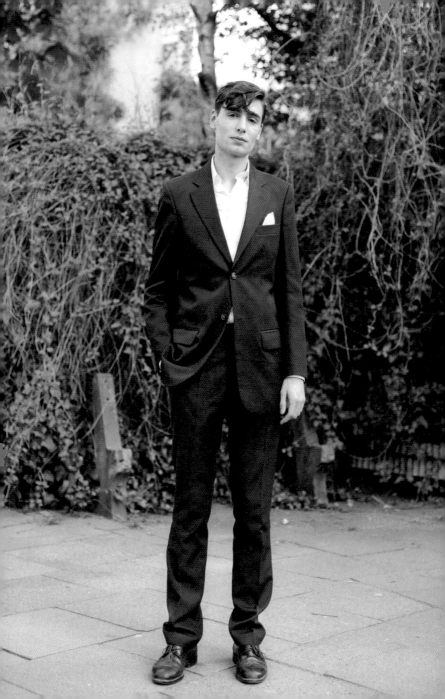

Near the Duomo, Milan

I shot this on my first trip to Milan for The Sartorialist. It was one of those moments when I used to think, 'If I only had a camera,' but this time I did! I only got one shot off, which is a little soft in focus but, to me, still perfectly captures that idea of *la dolce vita* – cycling while smoking at the end of a beautiful day, dressed in a perfectly cut suit. *Grazie Milano!*

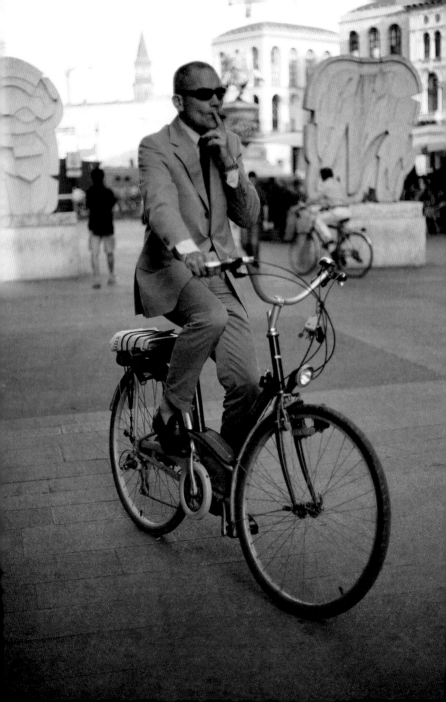

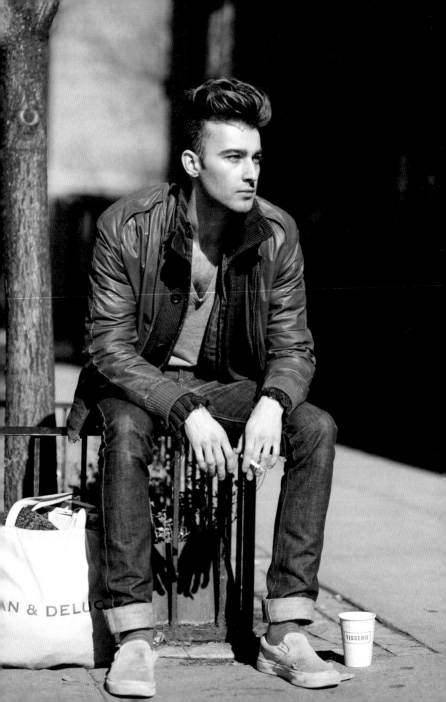

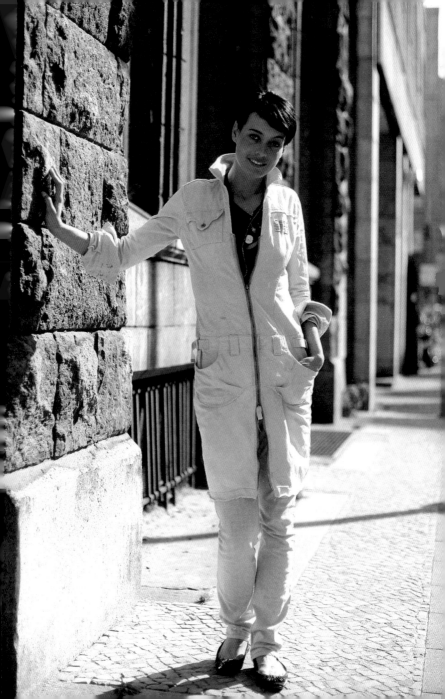

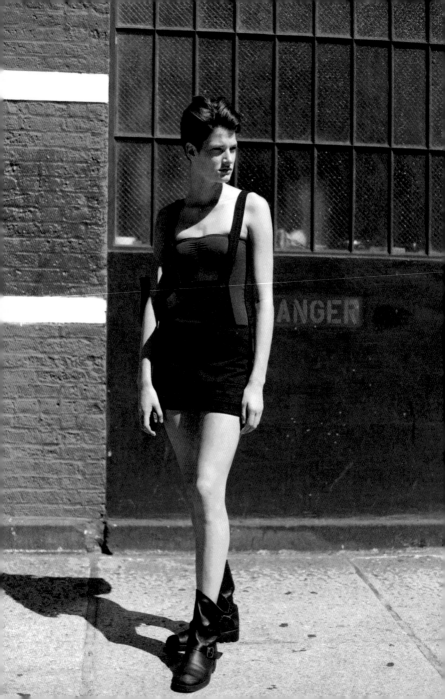

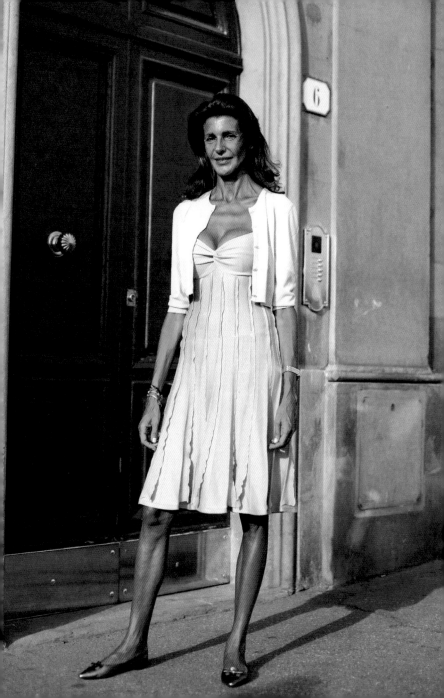

Of all the 'vintage style' shots
I've taken I like this one most.
Some people just live a vintage
life, and this gentleman is one
of them. He talks with a slight
vintage staccato, and he sings that
way too. I think it's romantic to
have that kind of commitment
to a way of life.

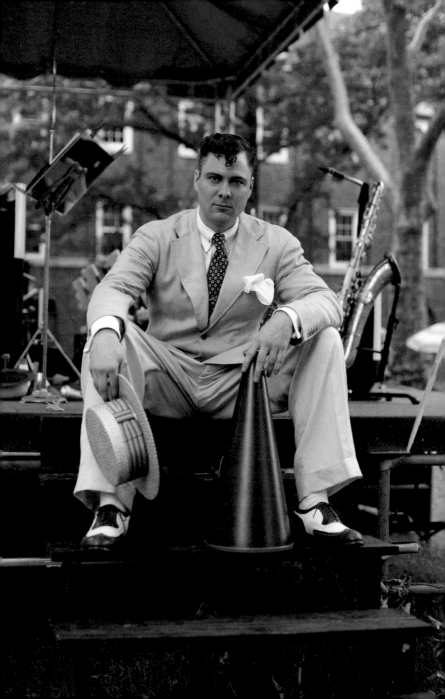

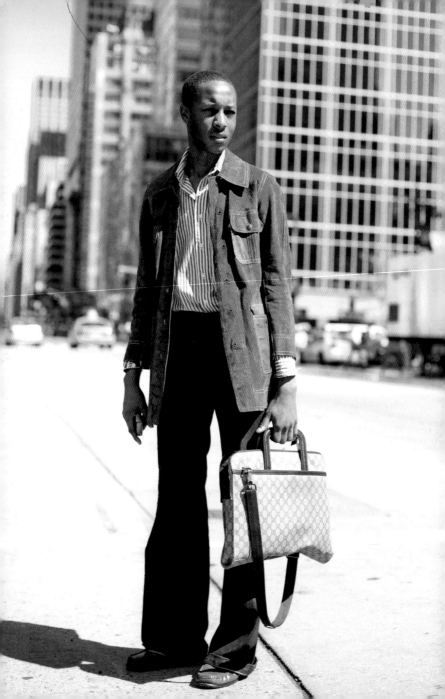

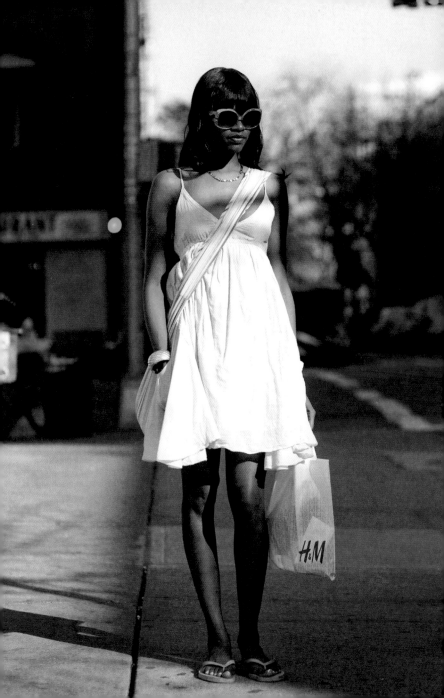

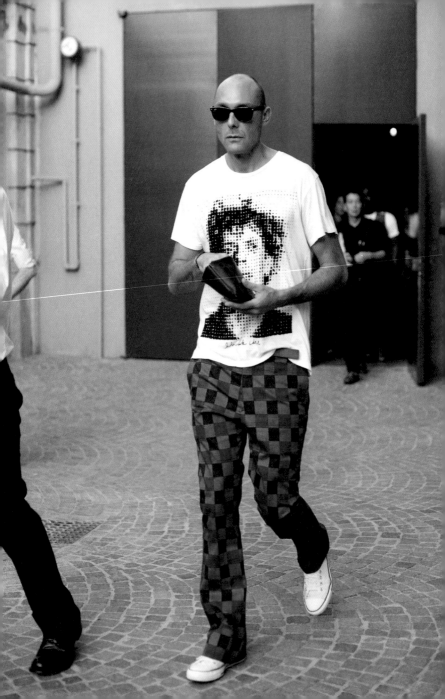

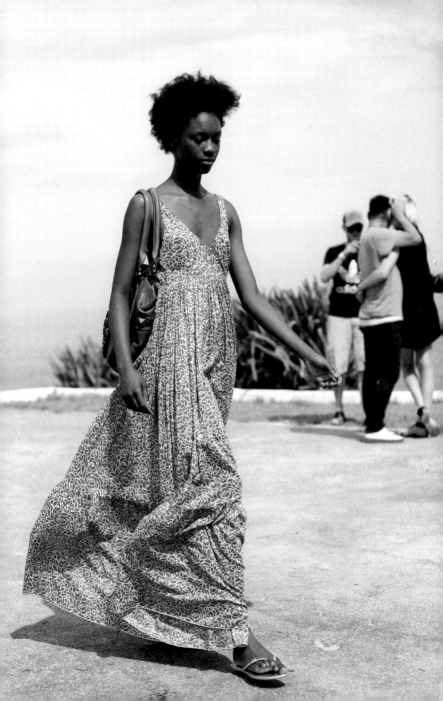

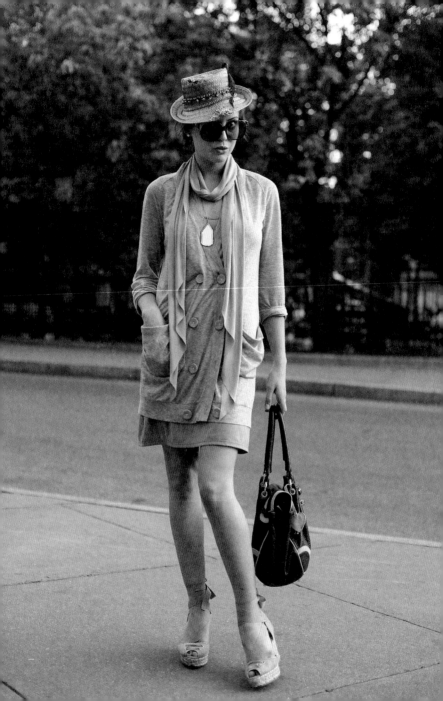

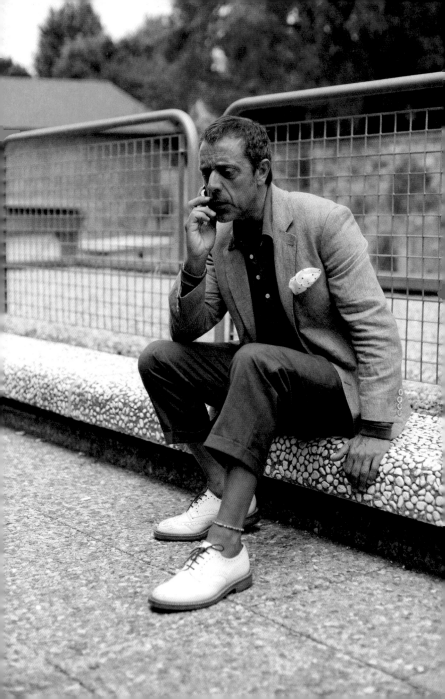

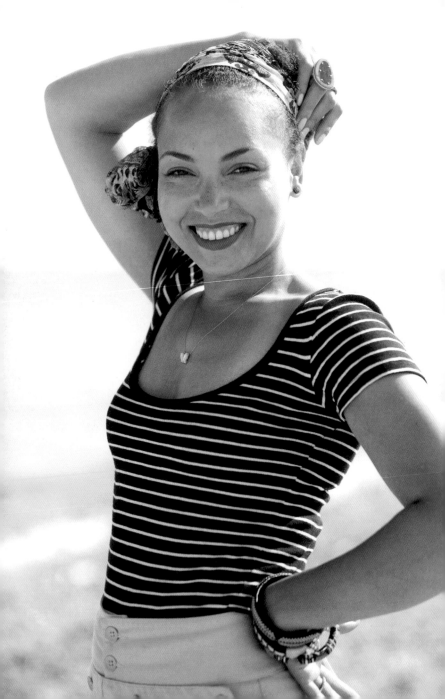

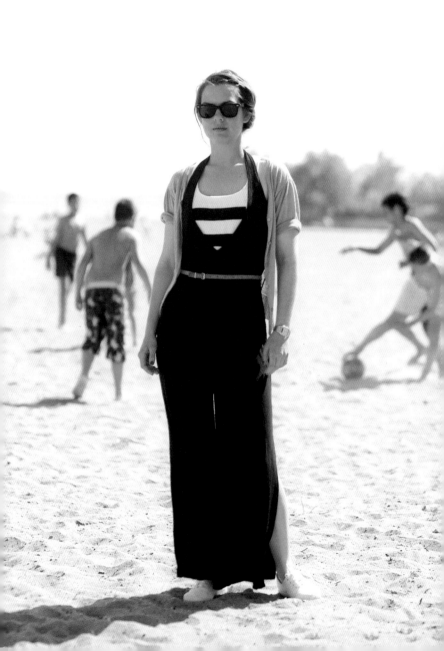

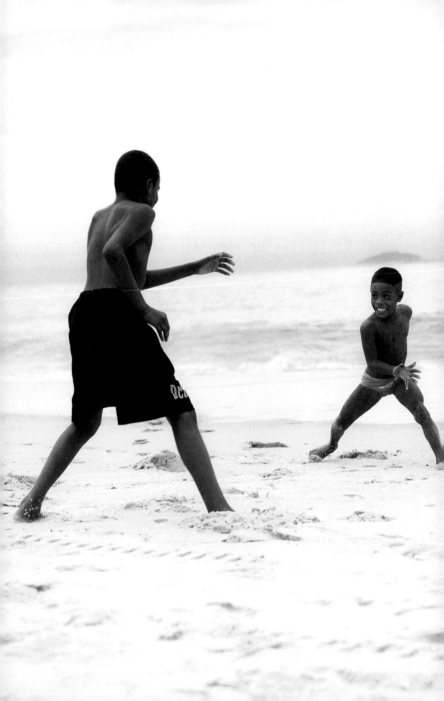

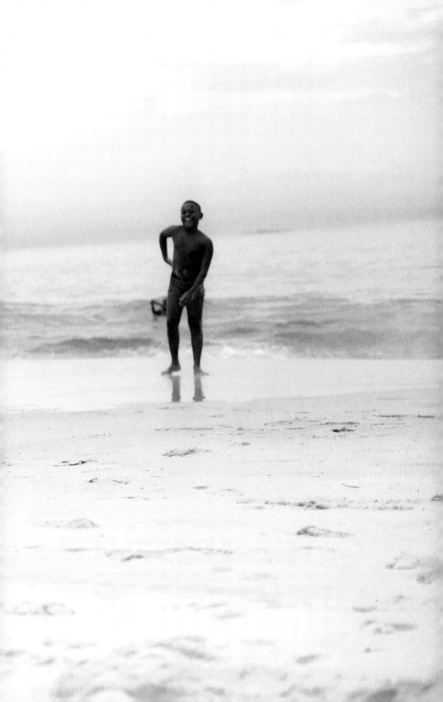

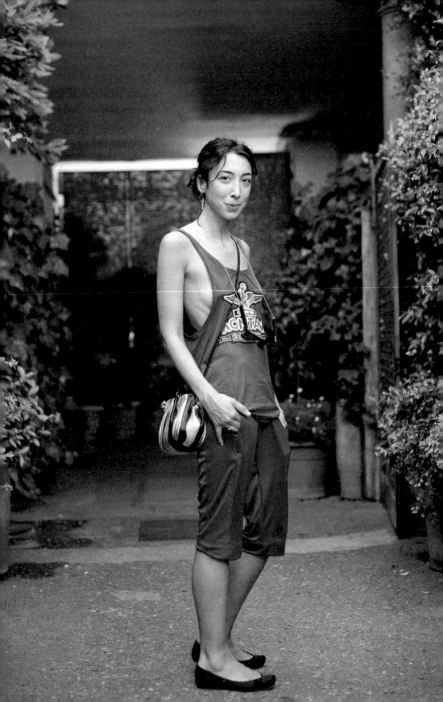

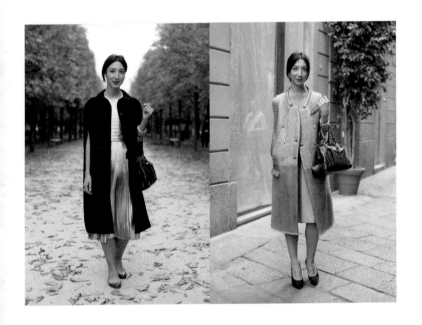

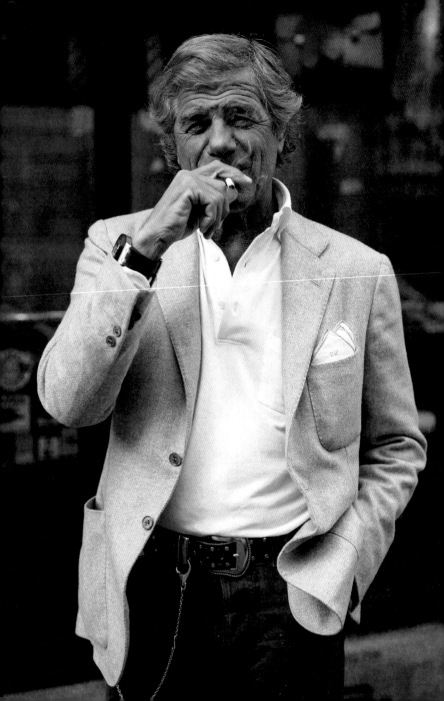

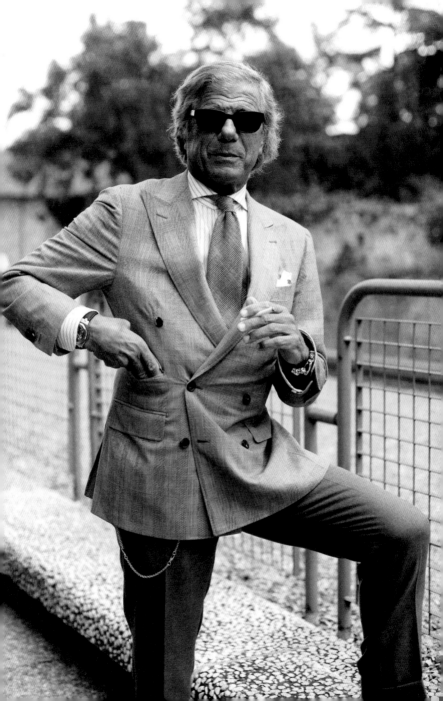

The Boutonnière, Florence

How many guys still wear a flower in their lapel buttonhole? This is one of those style elements that if executed overzealously would be too contrived and obvious, but this gentleman has perfected a certain nonchalance about it that allows it to go almost unnoticed.

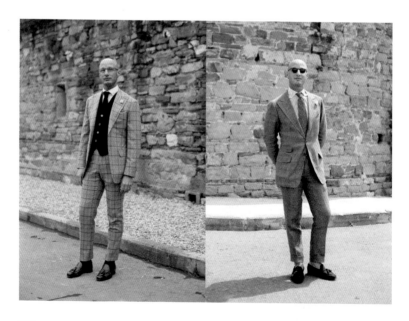

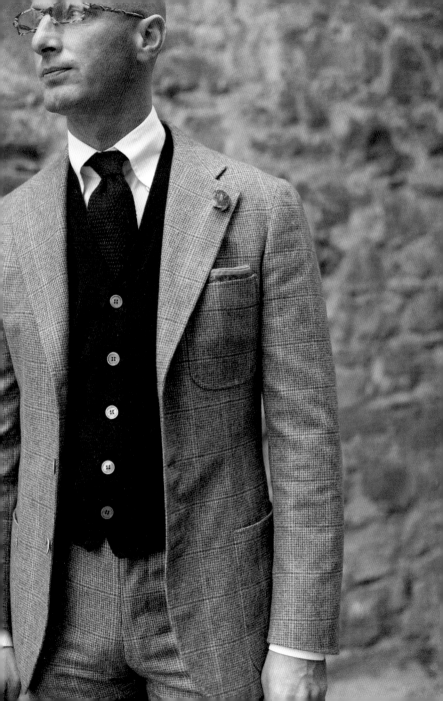

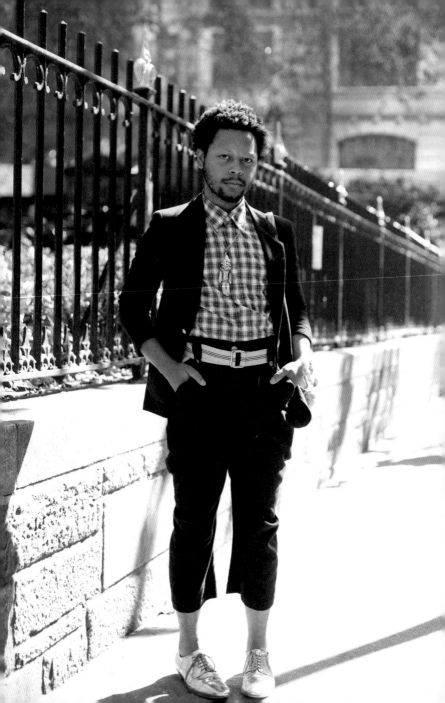

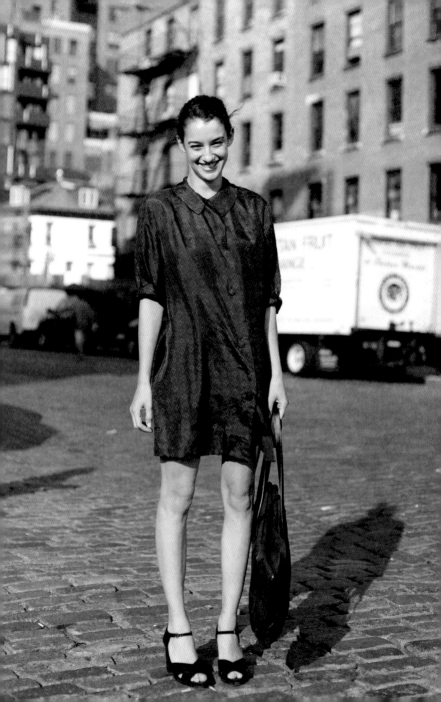

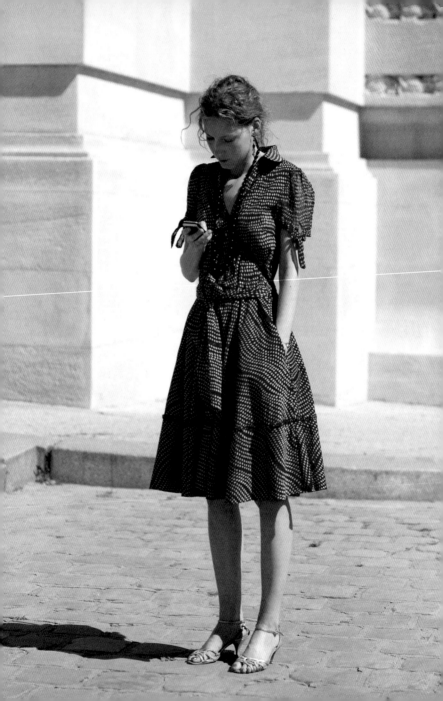

His Dad's suit,
Milan

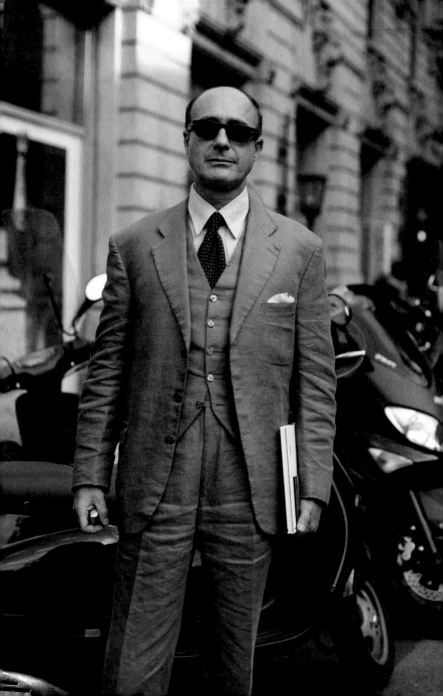

Giovanna

Below is the first shot I took of Giovanna, around 2006. Since then I've shot her many times. I love how she keeps evolving her style – hair up, hair down, hair straight, hair curly. She isn't afraid to take risks and try something new, and yet at the core she always looks like Giovanna.

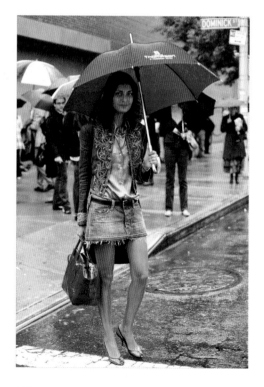

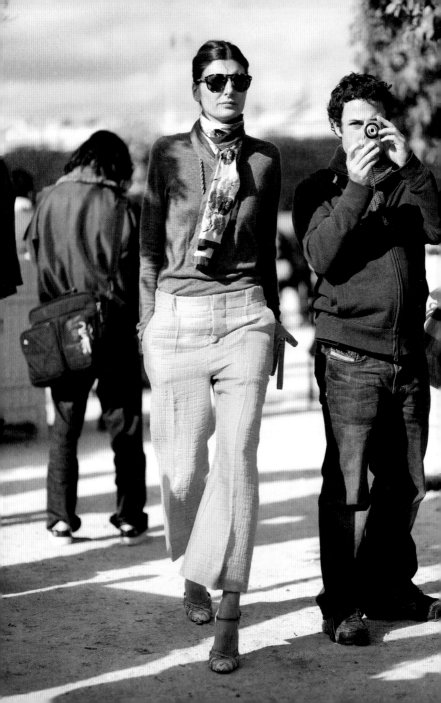

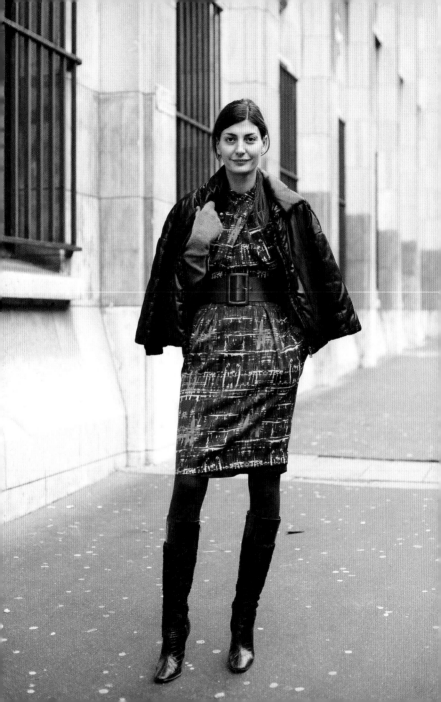

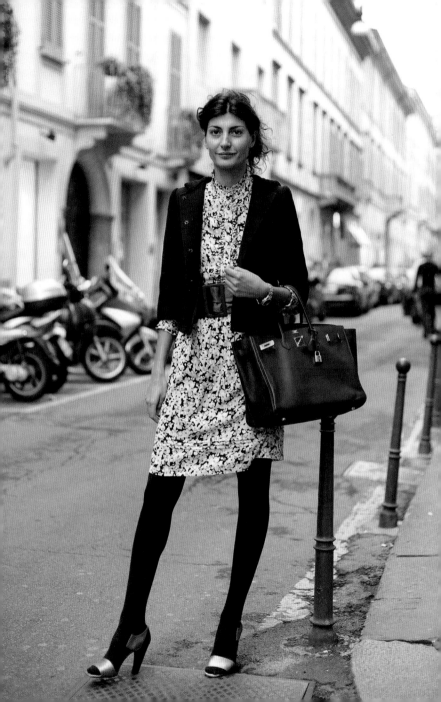

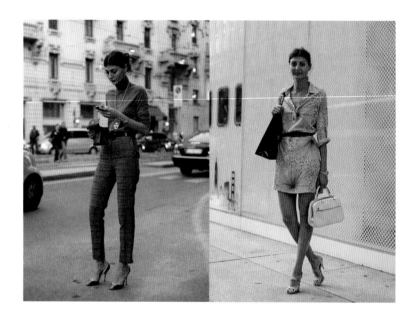

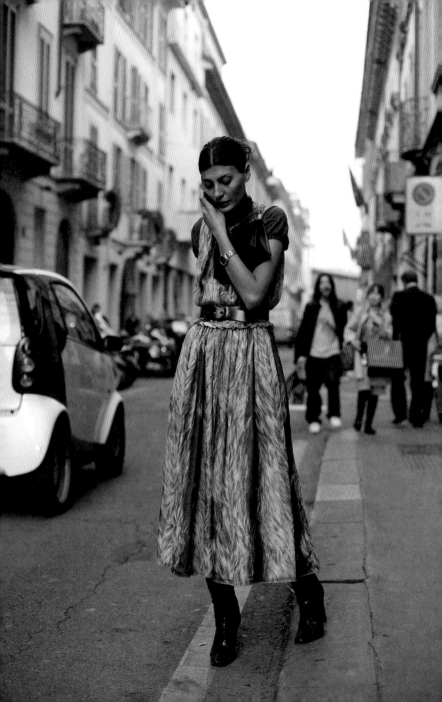

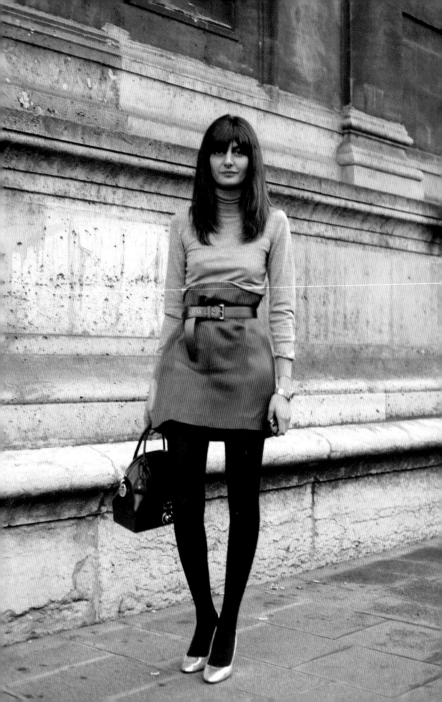

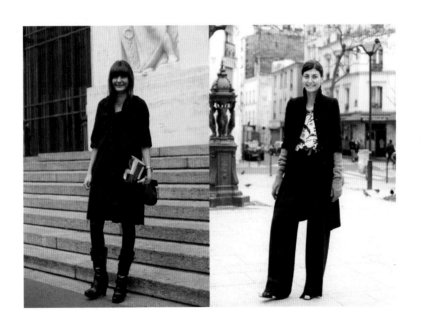

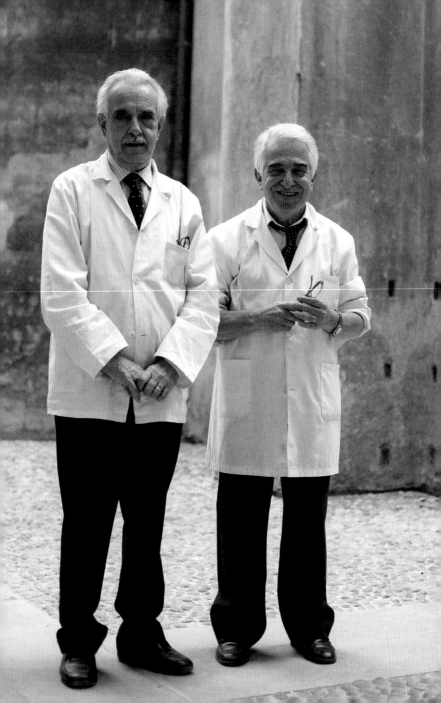

Barbieri, Milan

A few years ago I was in Milan and badly needed a haircut. Close to my hotel was a perfect little barbershop, which I had been wanting to try for years. Actually, I didn't need a haircut that badly, but every time I passed this place I would stop and watch these two gentlemen plying their craft in the same manner, and probably in the exact same spots, as they have done virtually every day for the past thirty years. There is something about the quiet, repetitive simplicity of barbers or tailors that I find very touching.

These young men don't speak English, so my haircut was pretty much in their hands – it was a challenge to give even simple direction. The most charming part of the whole process was when they covered me in three very clean, very crisply ironed towels – one across my legs, one front to back on my shoulders and one back to front on my shoulders. Like any true New Yorker all I could keep thinking in this process was, 'Wow, they must spend a ton on laundry service. Their margins must be paper thin!'

I am just glad that places like this still exist (even if I have to go all the way to Milan to enjoy them).

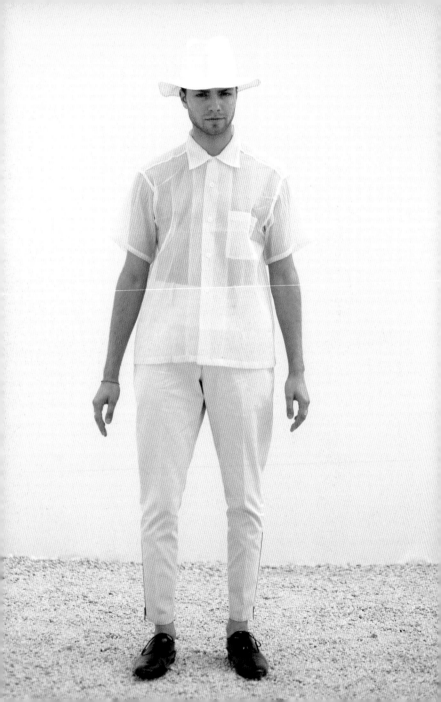

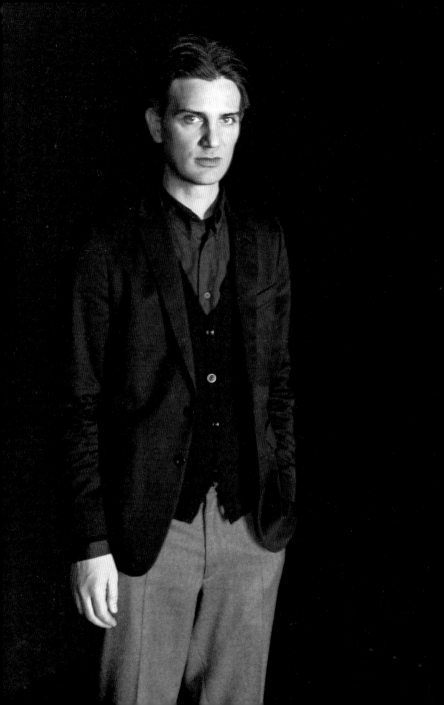

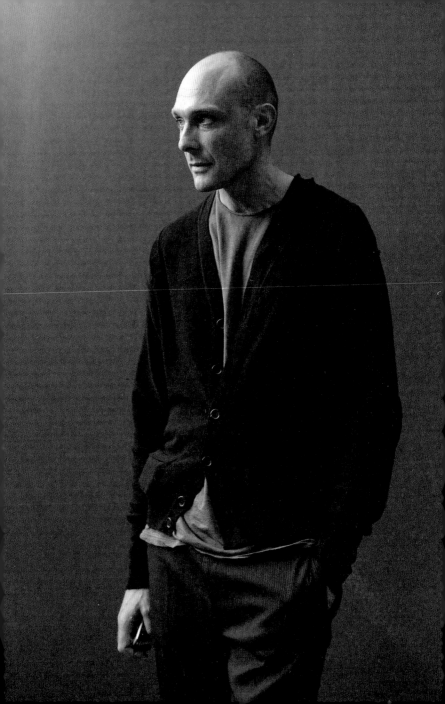

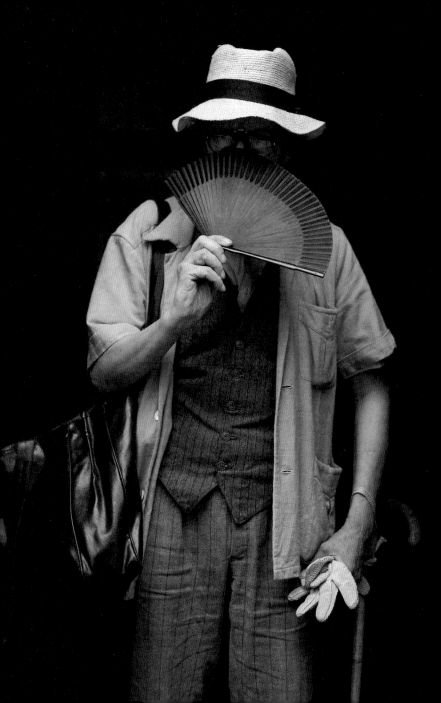

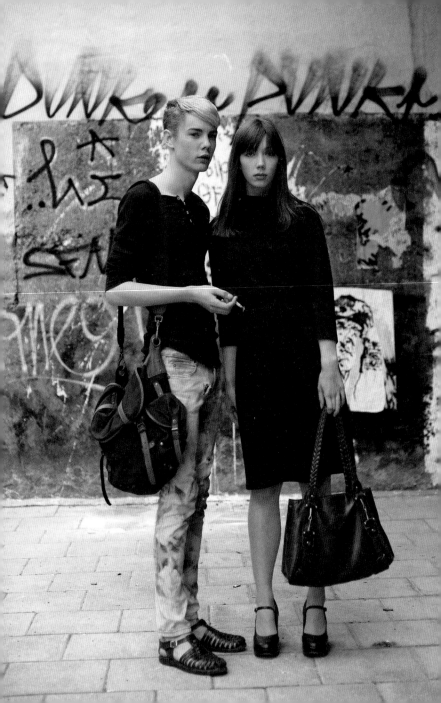

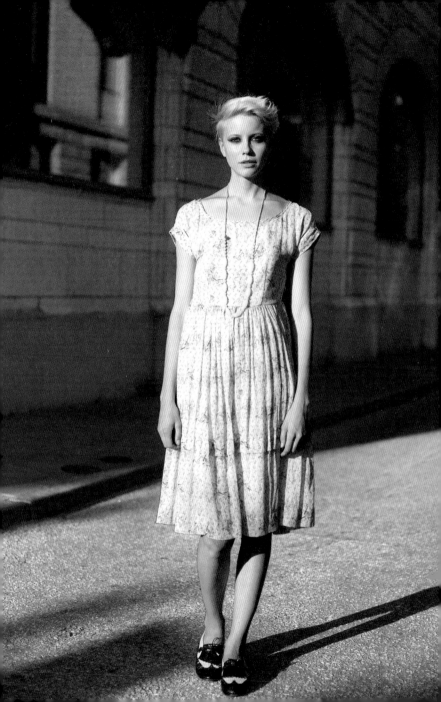

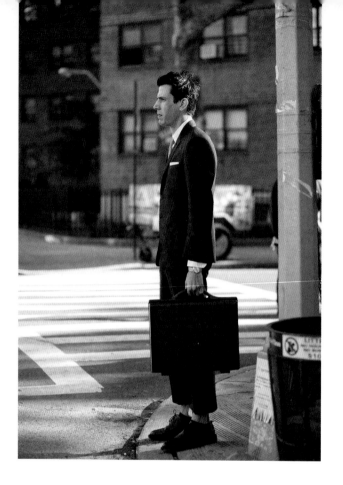

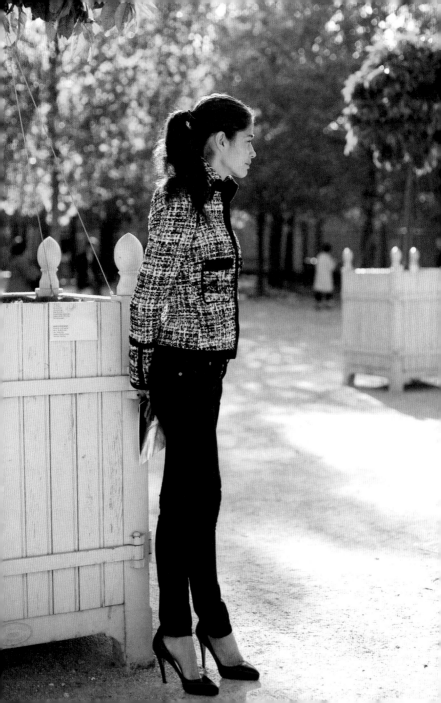

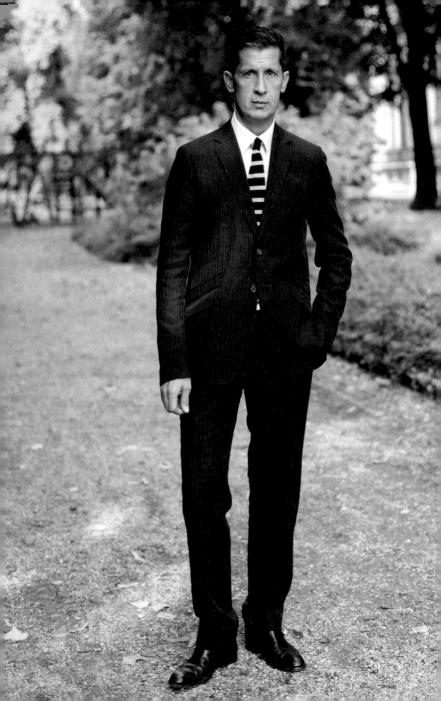

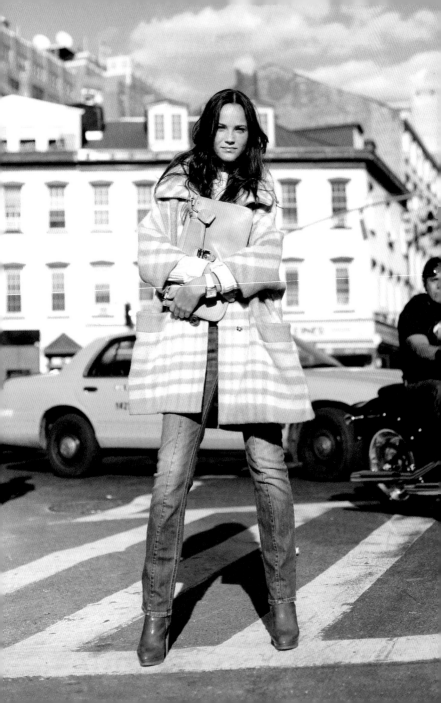

An early editorial, New York

This is an image for British *Elle*, October 2007, one of my first editorial shoots. Interviewers have often asked if 'street style' blogs have affected the photography of glossy fashion magazines. I have found that most of fashion editors are keyed into the minute social changes in visual images and have been very open to reflecting this new way of shooting in the pages of their magazines. One of the things I have been proud of is that if I am shooting for a glossy like *Vogue* or *GQ* I don't need to change my method of shooting. I often ask hair and make-up artists to stand down the street and around the corner so they are not popping in to touch up the subject between shots. Sometimes their perfection can lead to a perfectly boring shot.

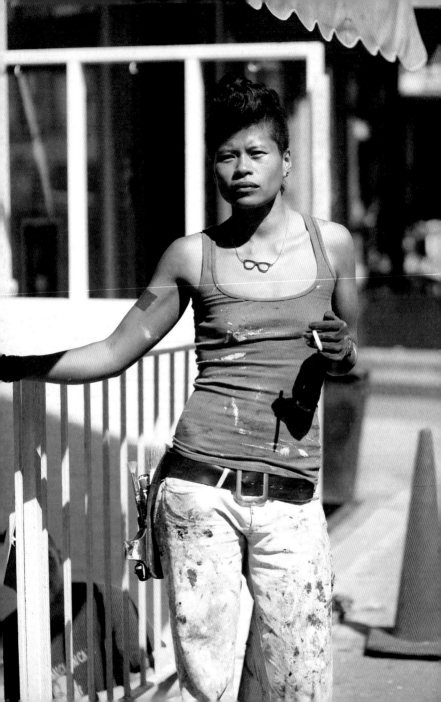

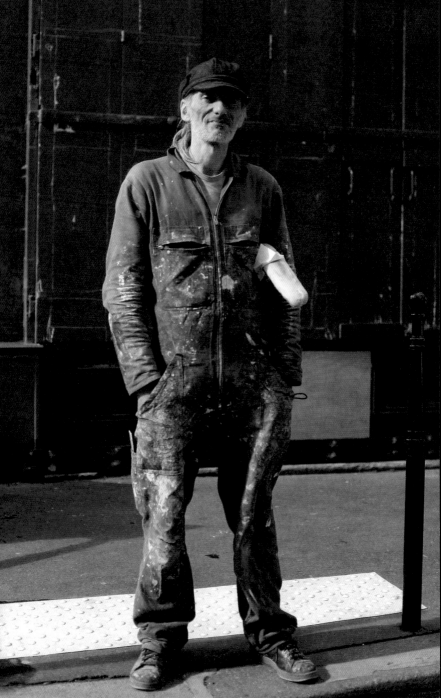

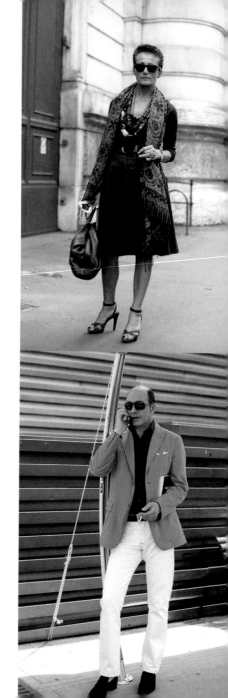

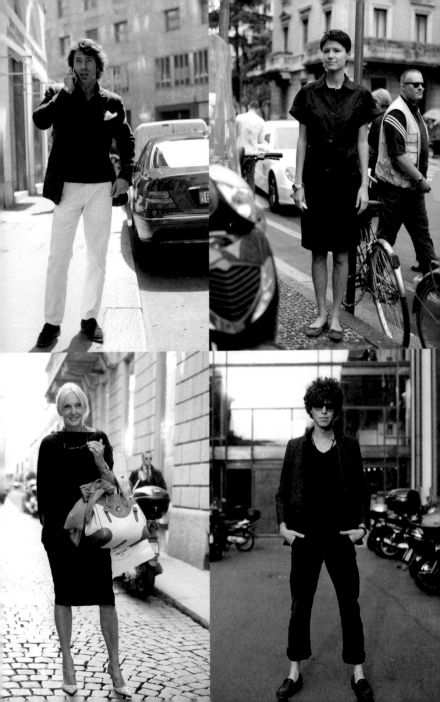

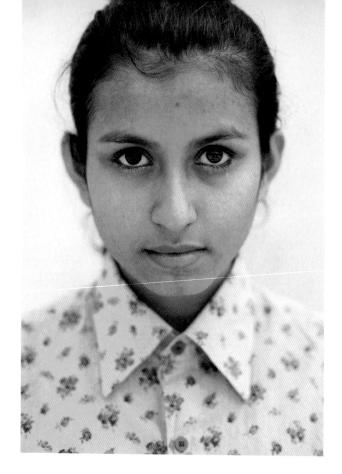

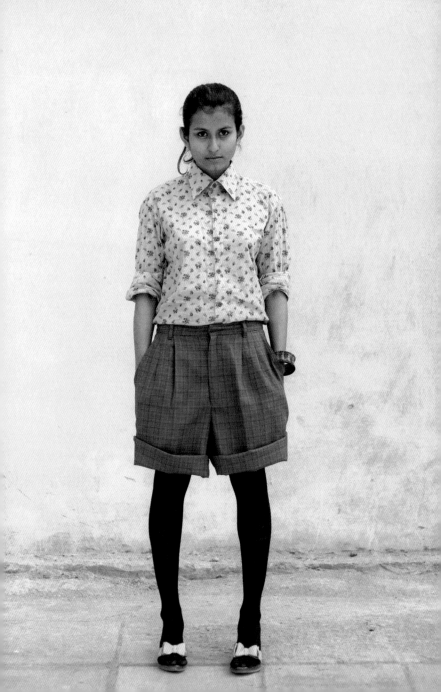

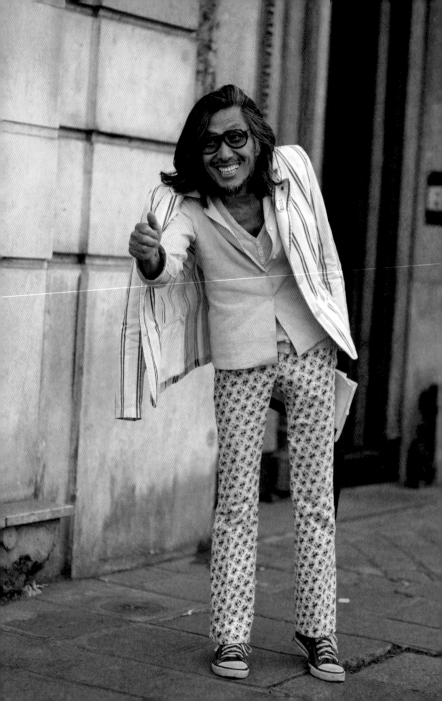

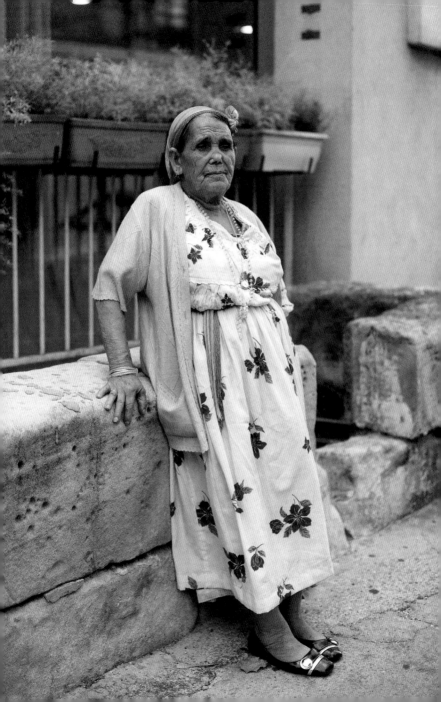

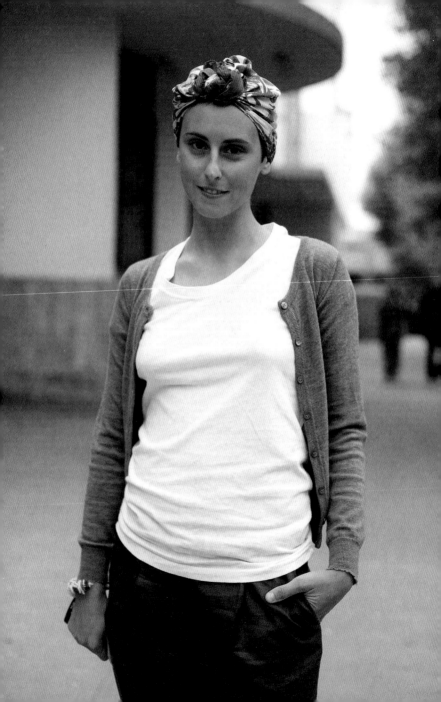

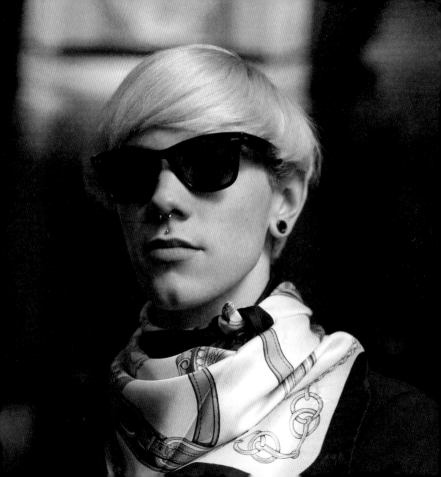

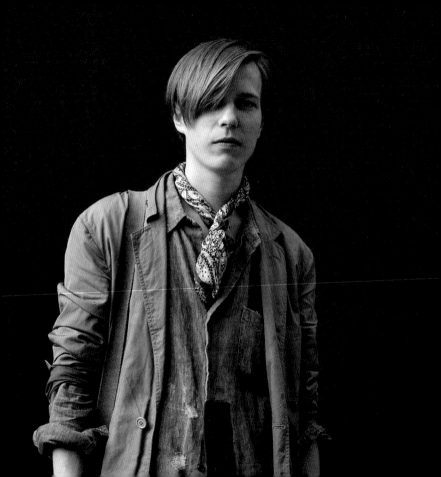

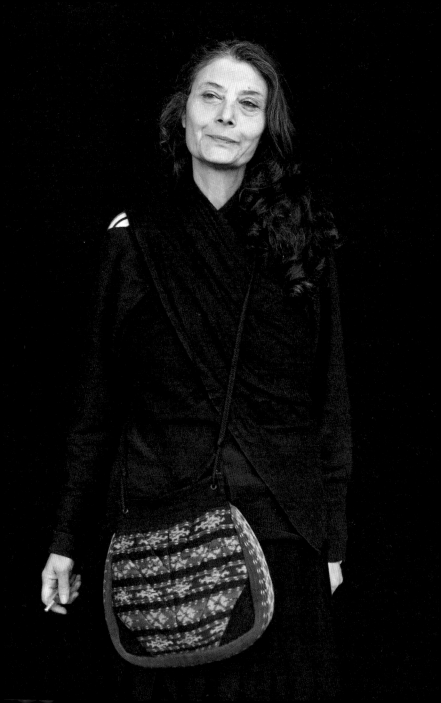

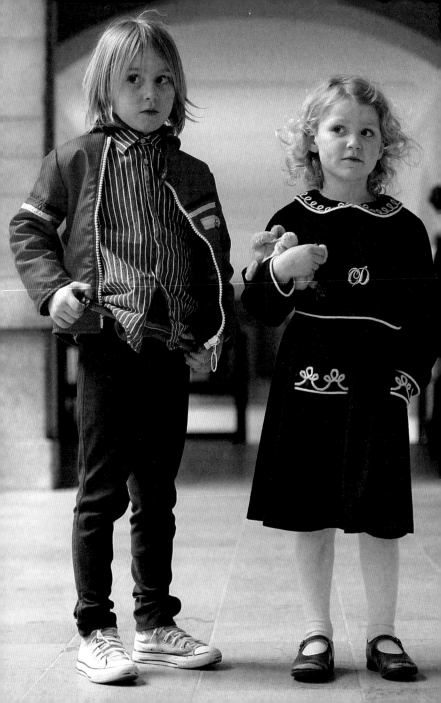

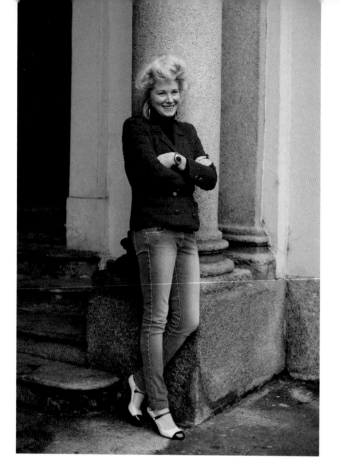

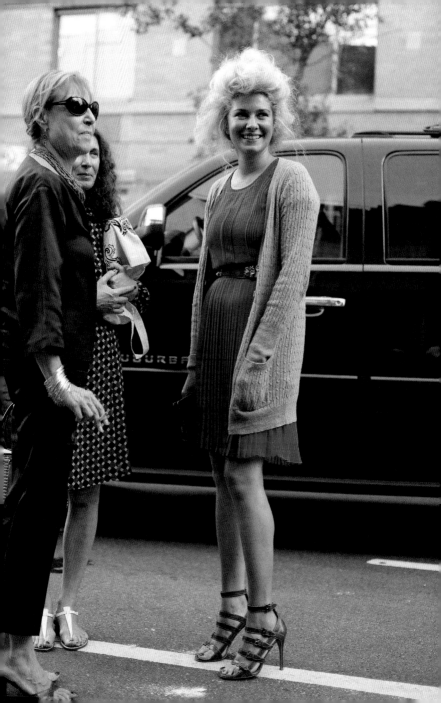

Julie, New York

This is Julie. She is one of my favourite subjects to shoot for the blog. Often when I post a picture of her she receives comments like, 'Oh, she is *sooo* perfect, so chic, a modern Audrey Hepburn.' Well, she is very chic, but she is far from perfect, physically at least. Julie has one leg slightly shorter than the other, has very slim arms, and walks with a very slight limp. However, she has never let her physical challenges alter her appearance or diminish her presence. This young lady stands tall. In a world of fashion that celebrates a certain kind of beauty, I have so much respect for the people who don't let their non-fashion-world physique stand in the way of expressing the beautiful person that they know themselves to be. I find that type of inner strength the most captivating of all, and it is a major reason why Julie is on the cover of this book.

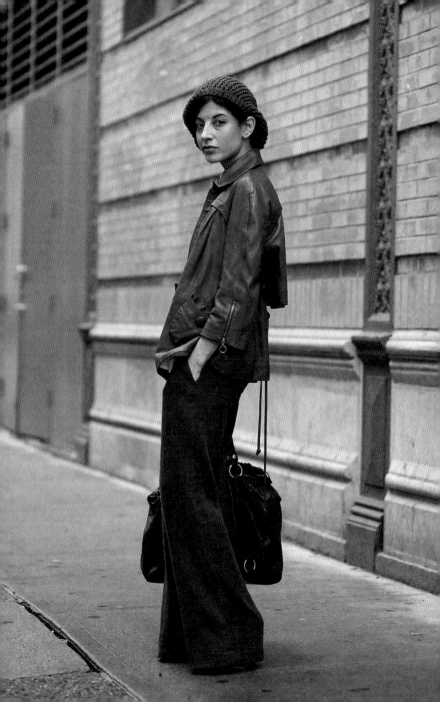

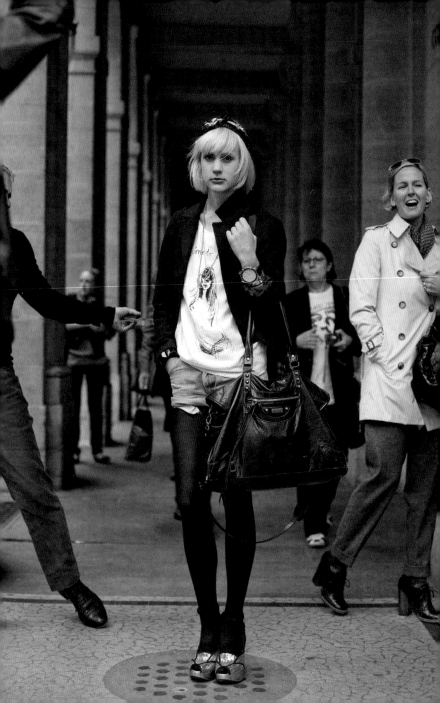

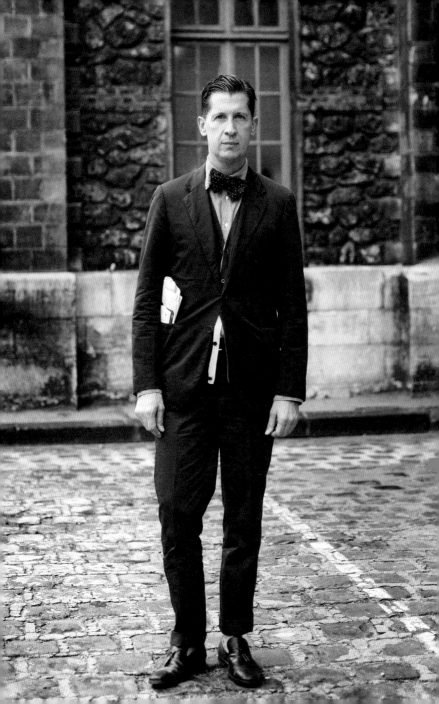

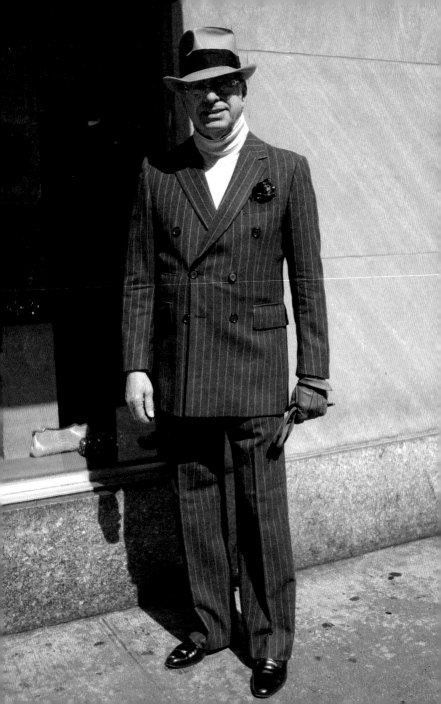

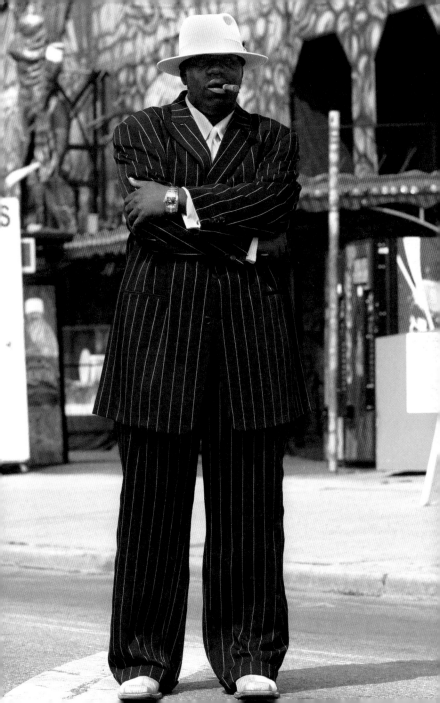

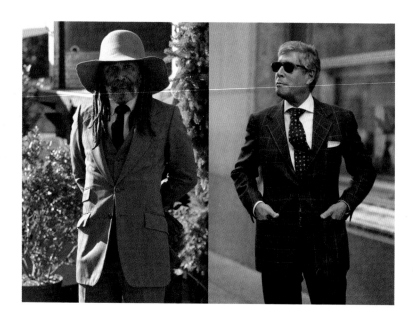

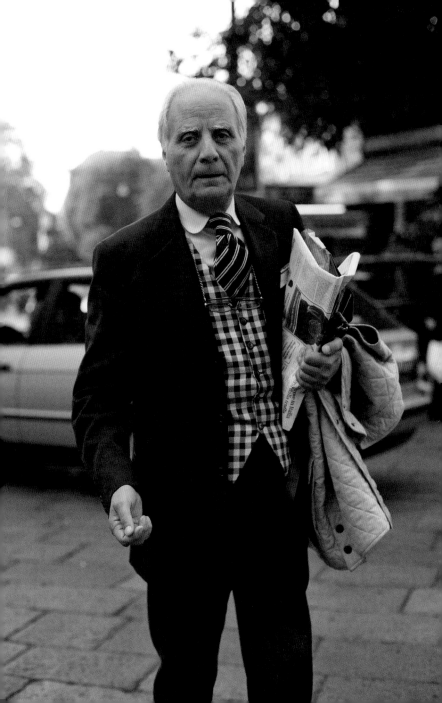

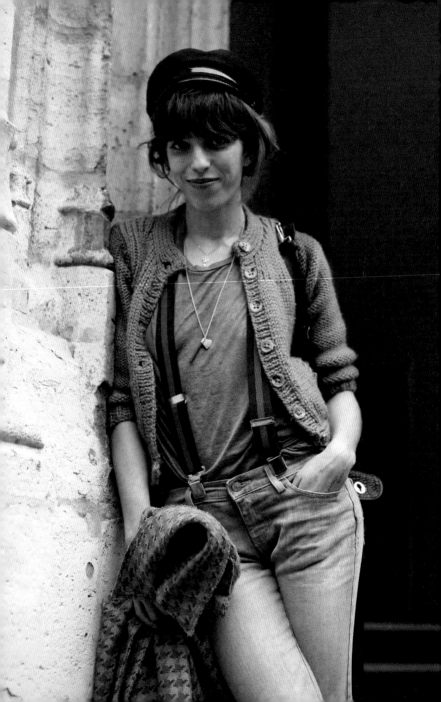

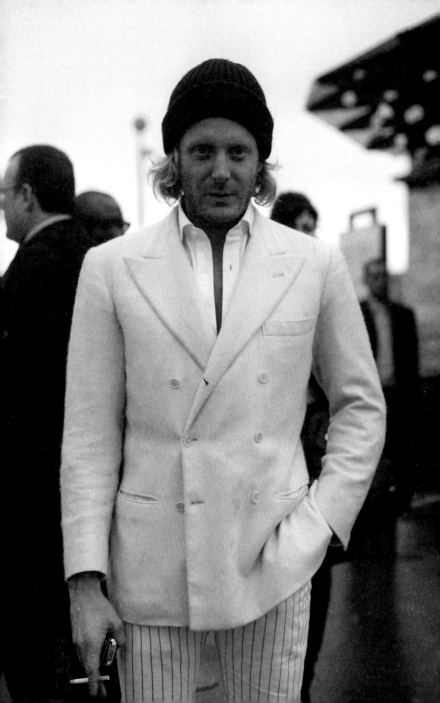

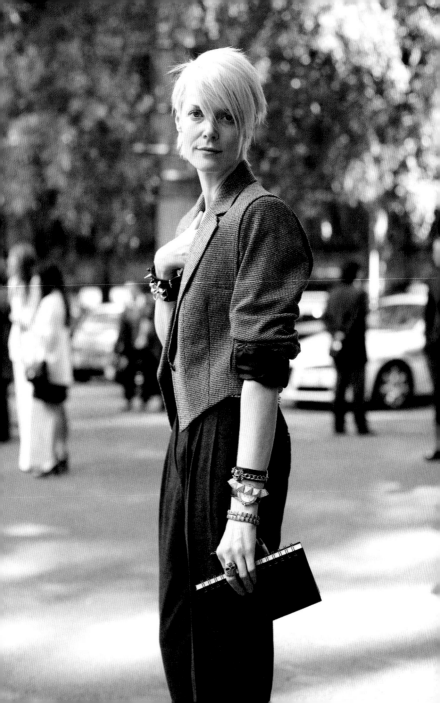

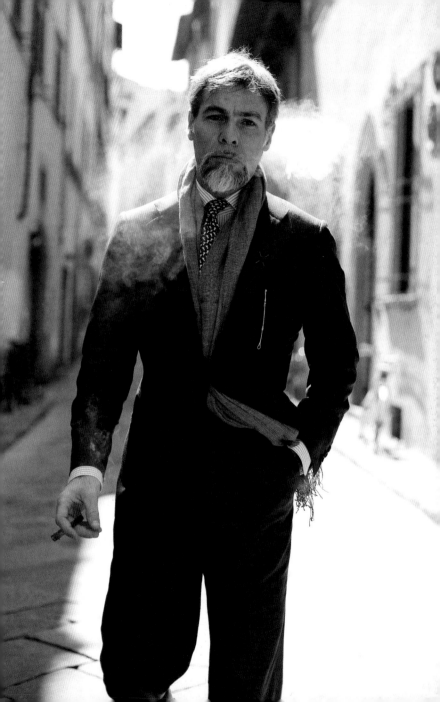

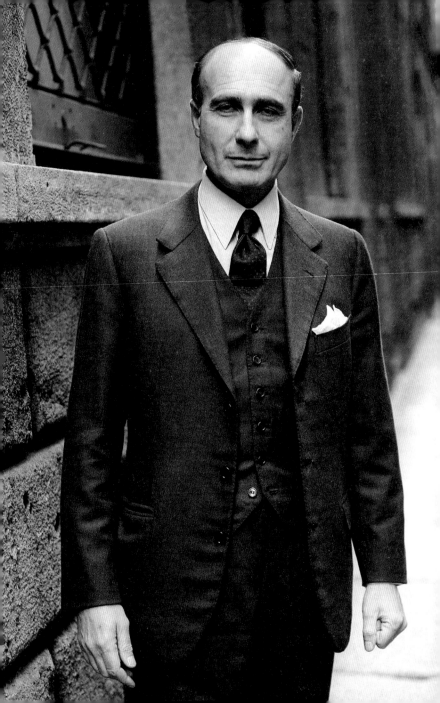

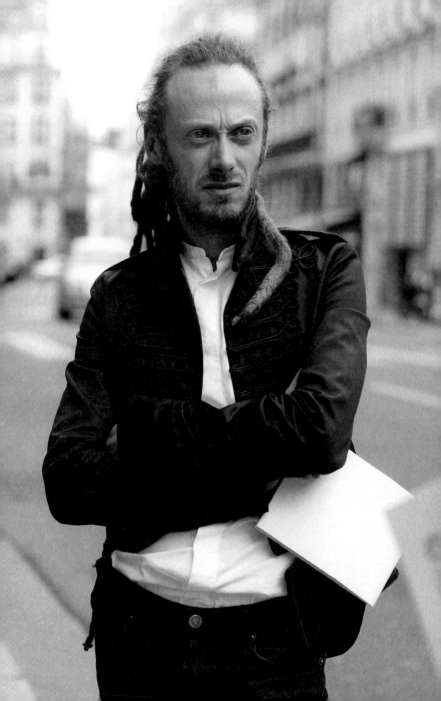

The last shot, Stockholm

People in Stockholm have a reputation for being quite shy and a little closed to outsiders. That is fine for me, because I think that lends an intimate gentleness to my Stockholm images. This young lady was very shy and self-conscious while I was taking her photo. I tried all my tricks to try to loosen her up, but none worked. I did notice that whenever I pulled the camera away from my face to look at the LCD monitor on the back she would finally relax a bit. I told her I needed just a few more frames and we were done. She agreed but continued to look very tense. After a few shots I said 'Got it!' and started to put the camera down. Just at that moment this smile spread across her face and I quickly grabbed the shot before she realized what was happening. That is a smile of pure relief – which is good enough for me.

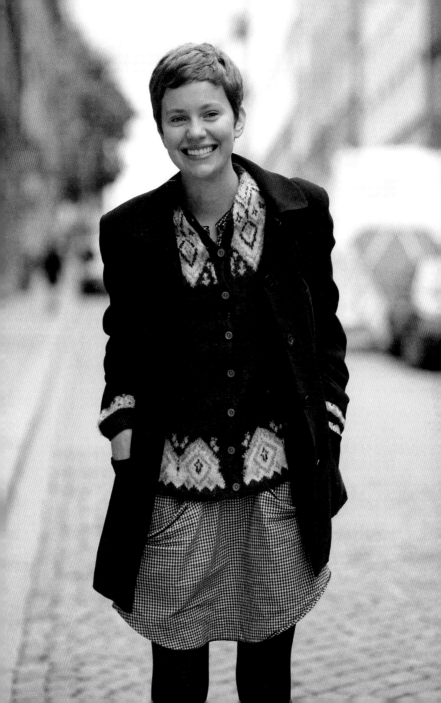

Creased jeans, Florence

In America the only people who crease their jeans are cowboys. I am not a big fan of 'cowboy style', so when I saw this very chic gentleman in Florence sporting creased jeans I was disconcerted. His execution of the creased jeans was different (Italian – dark denim; cowboys – faded denim) but am I that shallow to be so easily swayed? Yes, I am. A few days later I saw another Italian gentleman wearing creased jeans. I asked him if he always wore a crease in his jeans. His friend laughed and said, 'This guy even creases his underwear.'

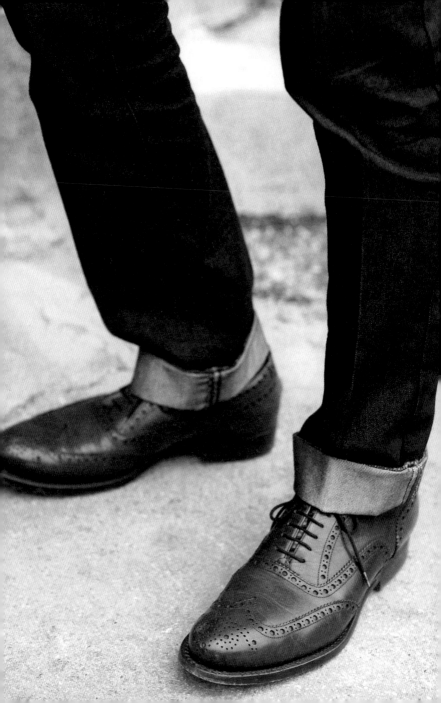

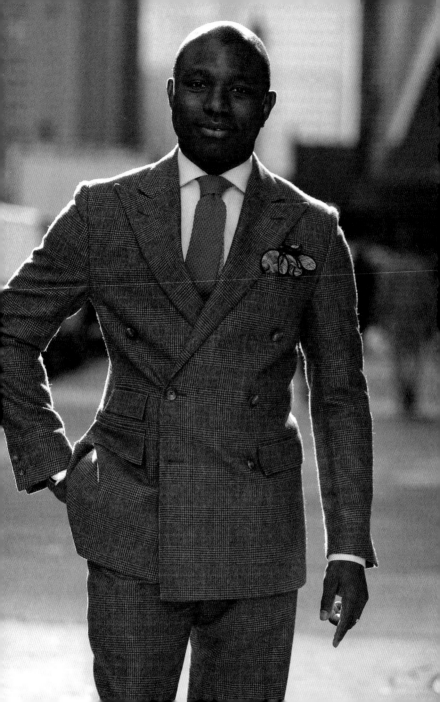

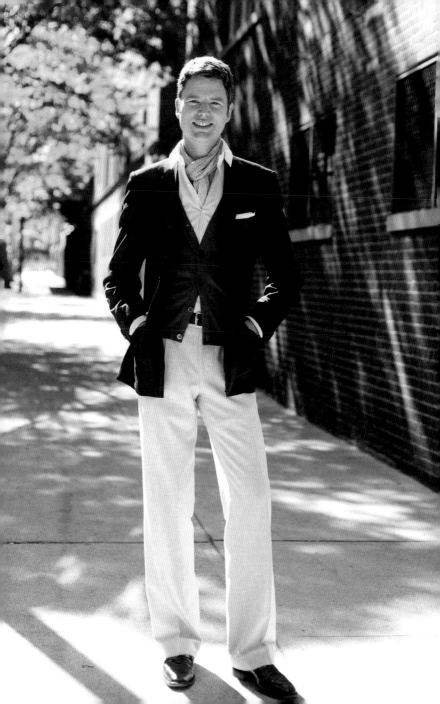

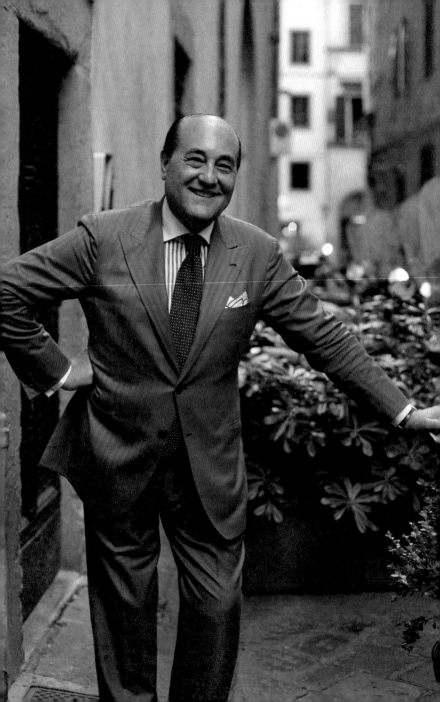

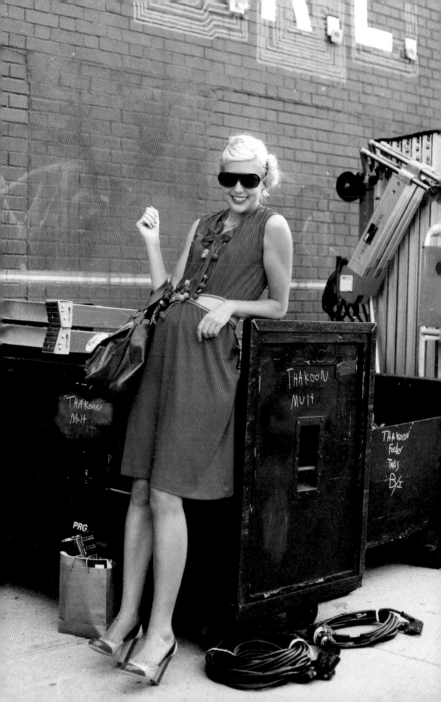

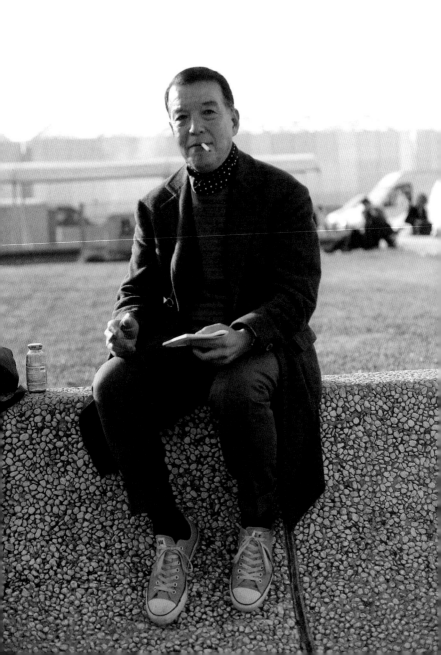

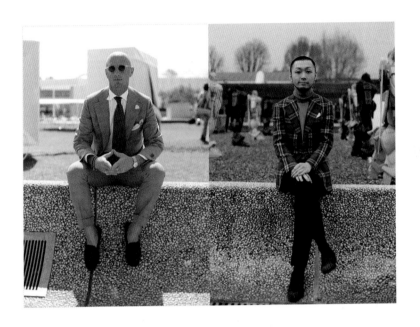

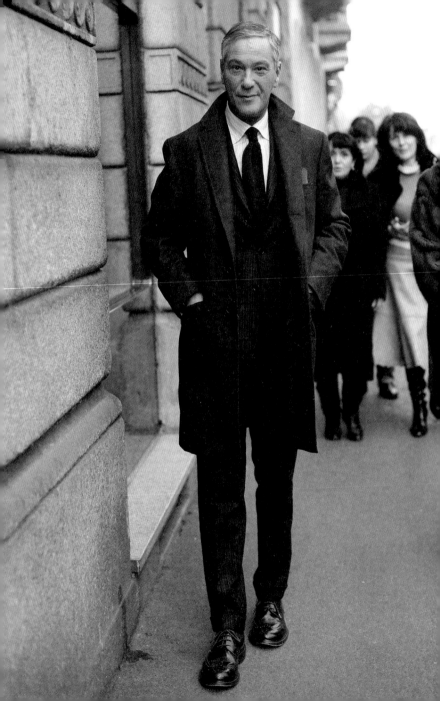

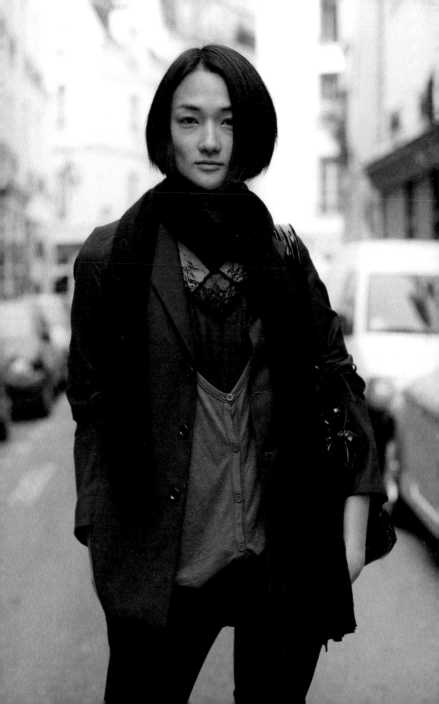

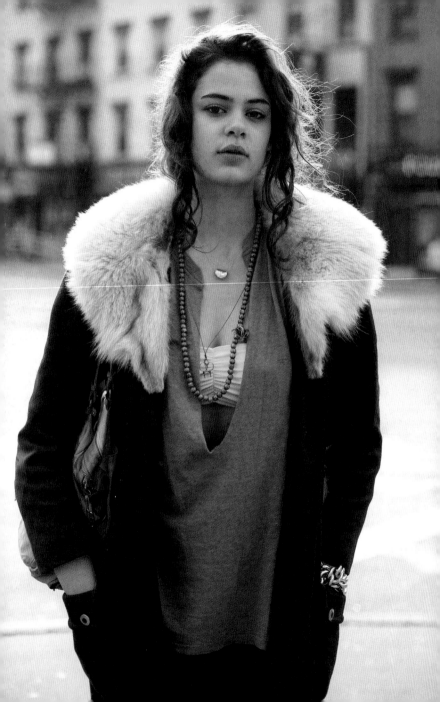

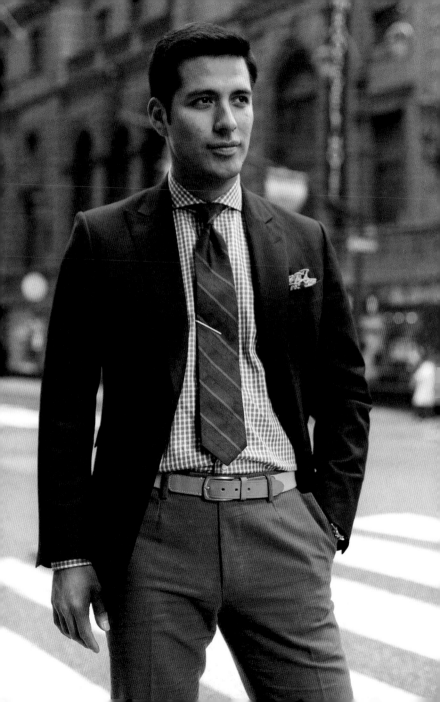

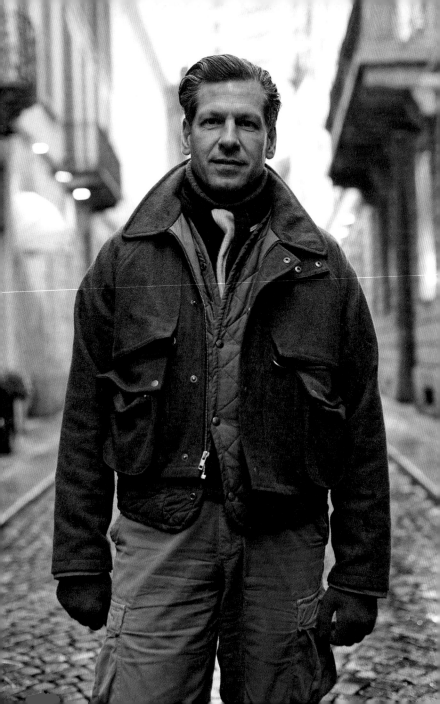

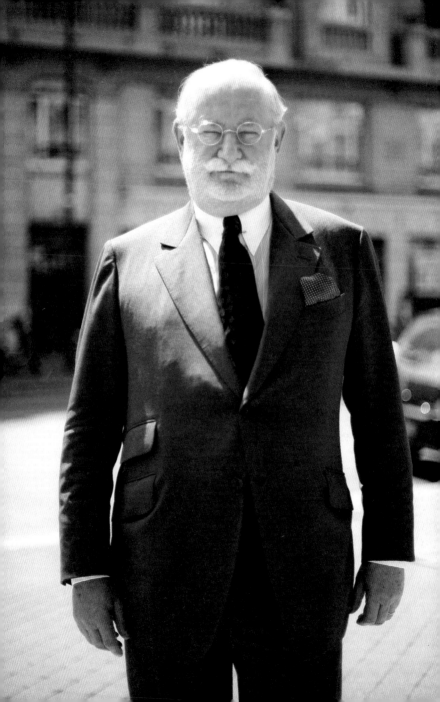

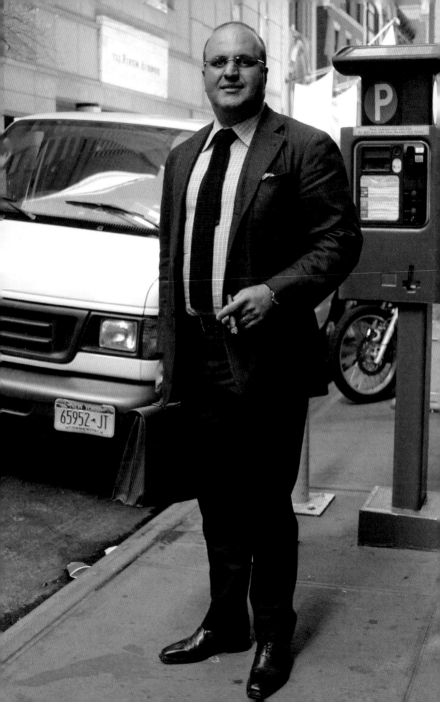

'Bald fat man', New York

This is one of my first breakthrough shots for the blog. The response that this post received confirmed in my mind that I was on to something.

I saw this gentleman on Fifth Avenue around 56th Street. Instantly I could tell from the Italian cut and sophisticated colour and fabric of his jacket that he was special. I stopped him and asked if I could take his photo, and he looked at me suspiciously and replied, 'Why do you want to take a picture of me? I am a bald fat man.' Now, I am a very polite and positive person, so I started to reply that, 'No, you are not ...'; but then I caught myself and instead replied, 'Yes, but you are a well-dressed bald, fat man.'

That caught him off guard. I followed up my first response with, 'So, is that southern Italian tailoring?' It was, and I knew it was, and my recognition of that was what won him over. A longtime friend of mine, David Allen, once told me that one of the basic needs of people is to be understood. I think that the fact that I seemed to understand this man and what he was trying to communicate through his style is why he agreed to let me take his photo.

As a result of this shot appearing on my blog I received lots of emails from guys around the country saying they had a body shape similar to this gentleman's. They would print this photo and take it to their local department store and say, 'I look like this guy, but not quite – help me!' I think what most of them found was that they were able to achieve a similar elegance, not by spending a ton on custom tailoring but by focusing on a few subtle alterations that helped their suits fit their body type.

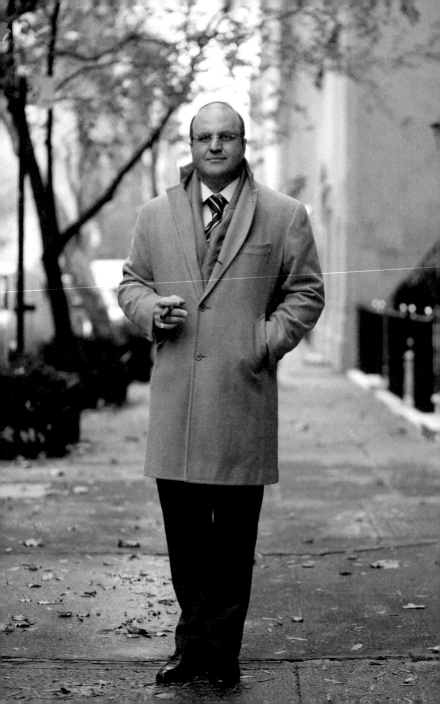

Kanye

Kanye is one of the few 'stars' I shoot consistently, maybe because we are both from the Midwest and I totally relate to his fascination with style and design. On a deeper note, what I appreciate is his utterly naked ambition to succeed artistically and how he has used style and design to craft his message. I relate to his ability to blend macho aggressiveness with a refinement that allows him to easily move between the worlds of hip-hop and haute couture.

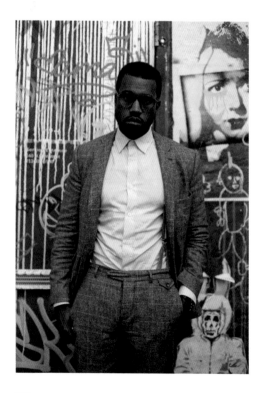

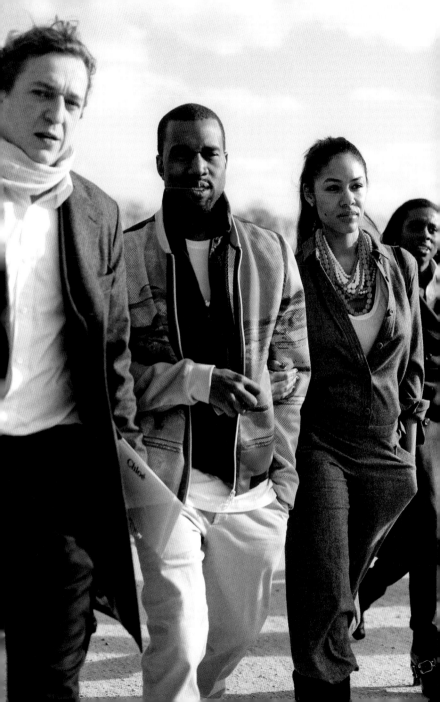

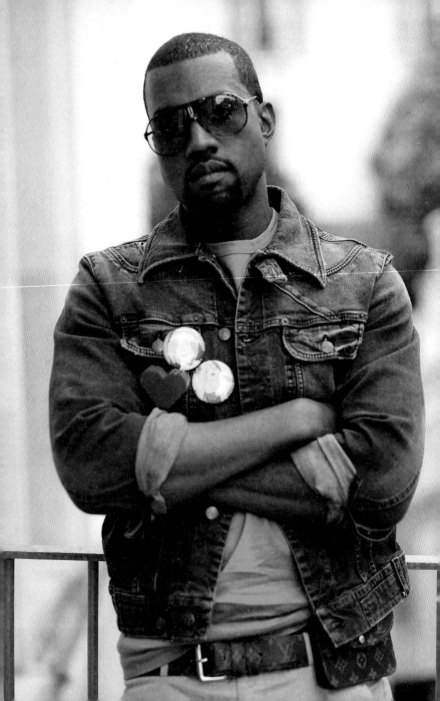

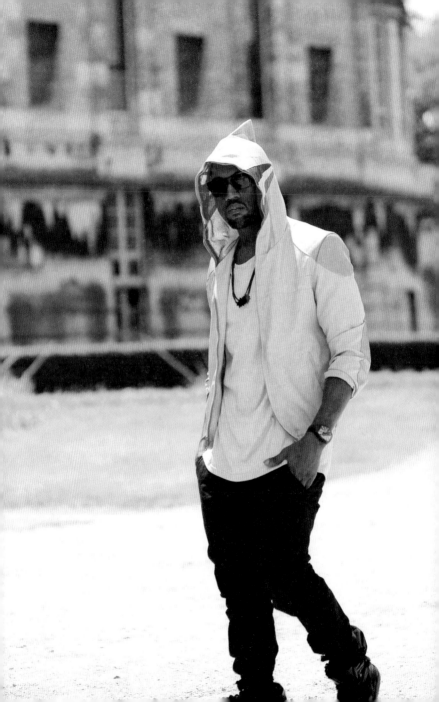

Molto elegante, Milan

I saw him as he was coming out of the subway. Usually, old guys like this don't speak English. The first time I approached him he shooed me away, but I knew it was going to be a great shot so I followed him a while, still trying to get his picture. Luckily, someone came by who helped explain that I wanted to take his picture. When he finally said yes he pushed back his coat so that I could see how his jacket matches his hat. I like to think he was out for his evening stroll, still wanting to show himself in the best way he can.

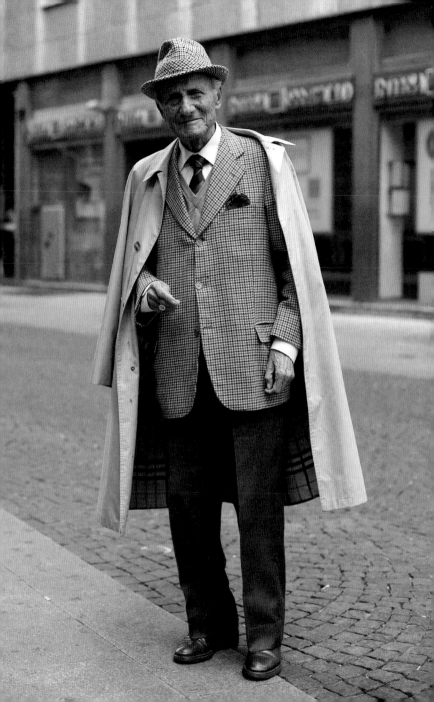

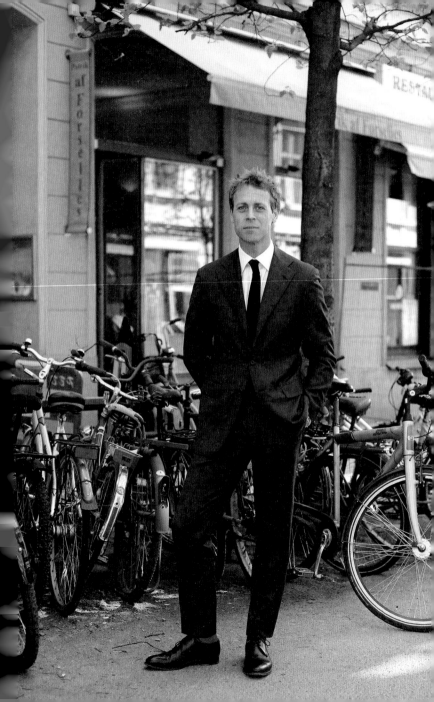

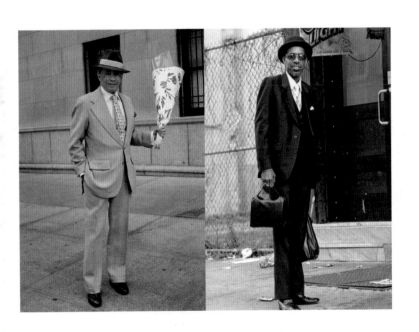

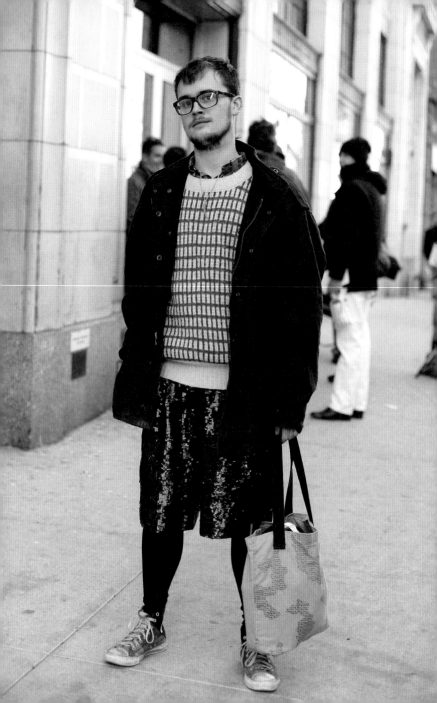

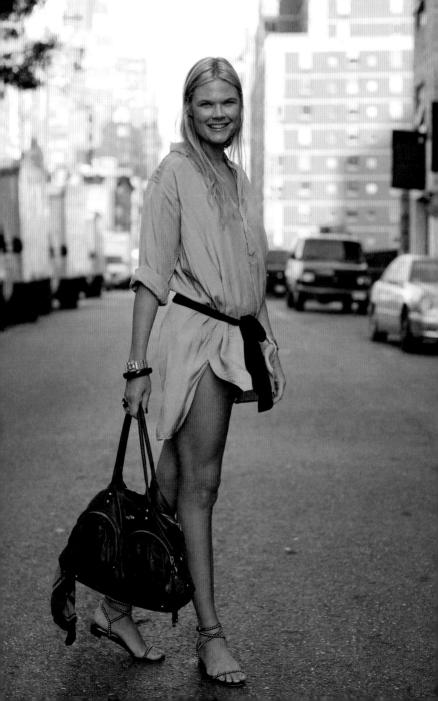

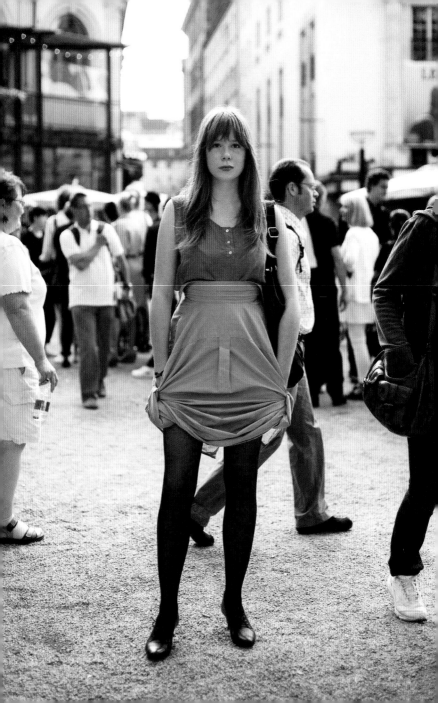

Shirt as skirt, Stockholm

I love DIY design, especially if it doesn't seem like DIY. This young lady used one of her dad's shirts as a reconfigured skirt. What I love about it is that it doesn't immediately read as 'fashion-student-getting-arty'.

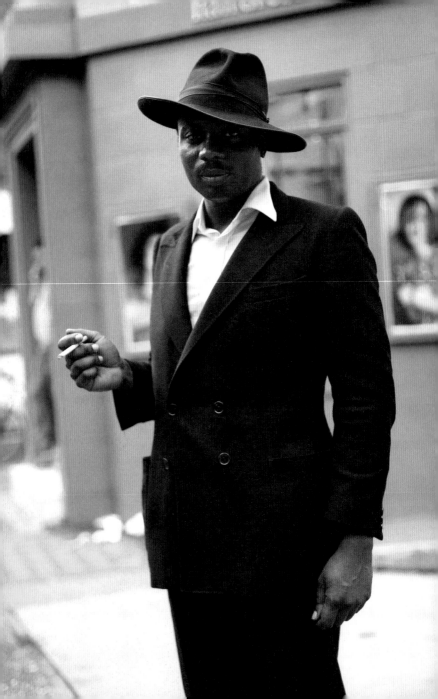

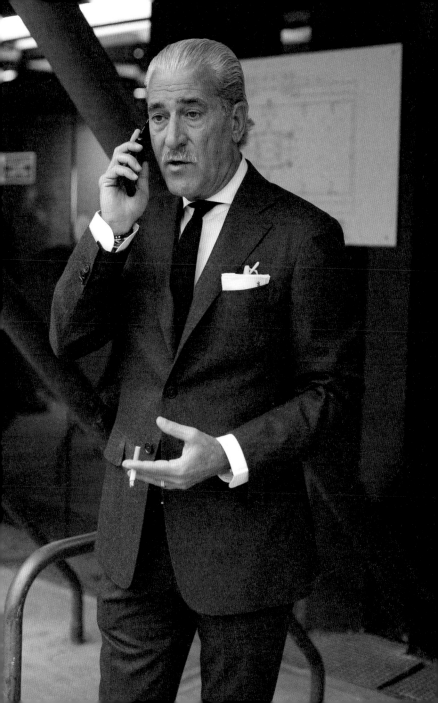

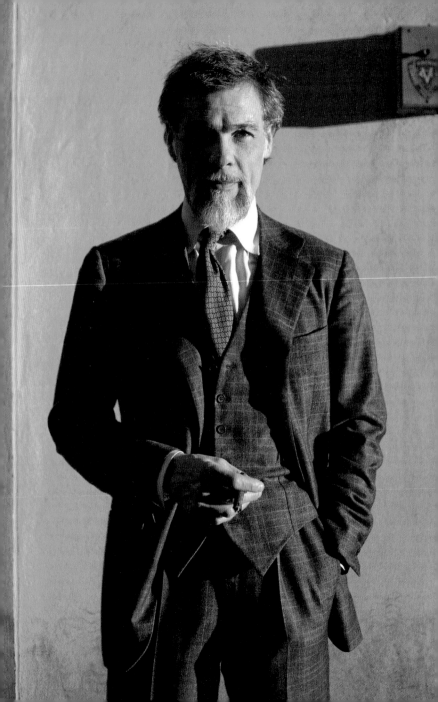

The concept, Florence

This young man, Simone, reminds me of Robert De Niro in *Angel Heart*. There is a sinister sexiness to him. He has a charming smile that can lead to trouble.

When I started The Sartorialist it was expressly to capture the allure of guys like this, who I would see around in New York or wherever but rarely in the pages of high-fashion magazines. To me, a guy like this is so much more inspirational than a typical nineteen-year-old model who, in real life, only wears jeans and a dirty tee shirt. Simone has a swagger and a style that is so subtle that it is hard to define – you just know it when you see it.

After doing this for a while you realize that the key is to focus not just on what the subject is wearing but to take it to a more meta-level, of 'Why am I reacting to this?' Simone is a perfect example, because he's equal parts exquisite tailoring and macho swagger. Sometimes it is not the designer label but a gesture or a physical stance that exudes a covetable level of chic.

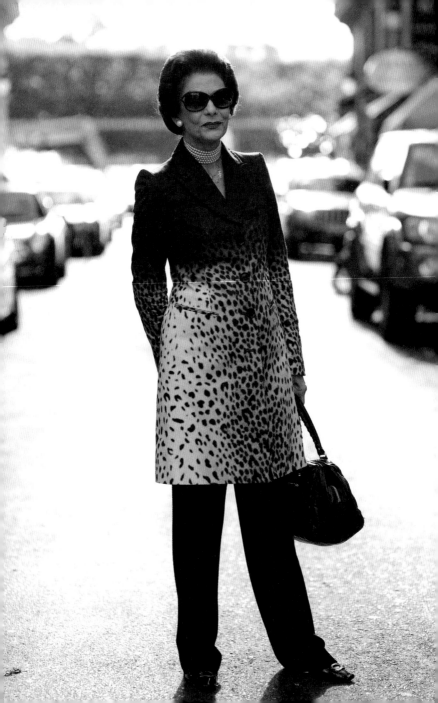

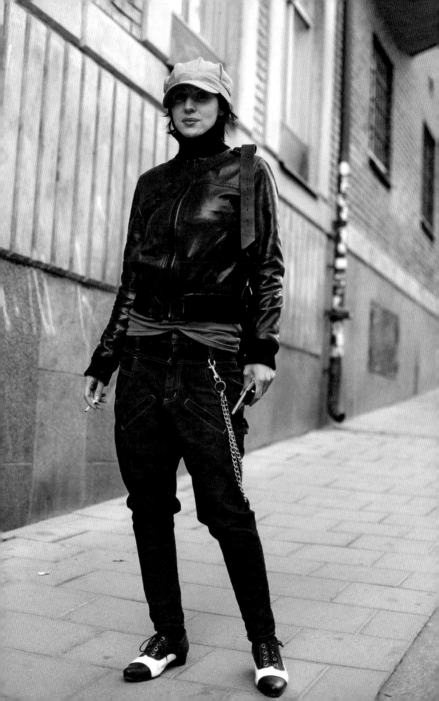

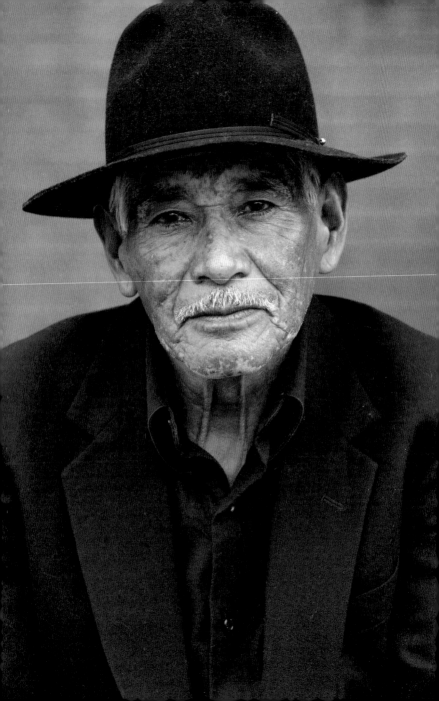

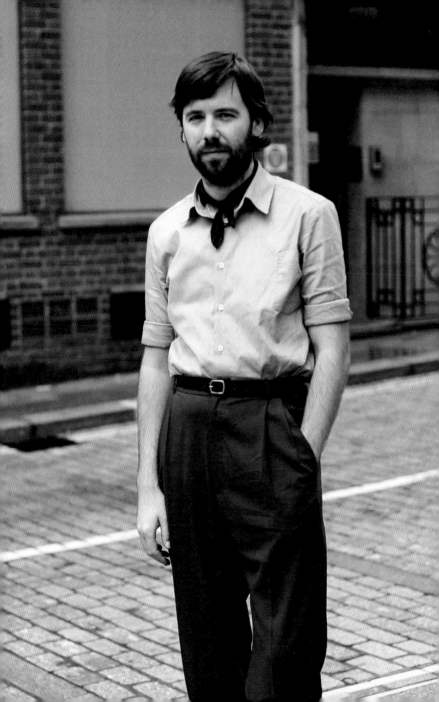

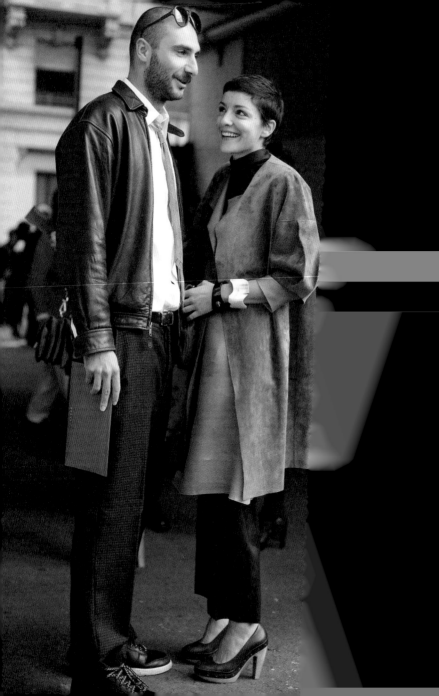

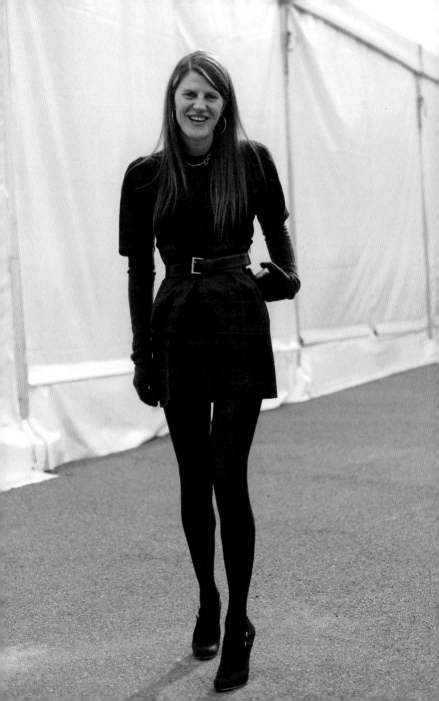

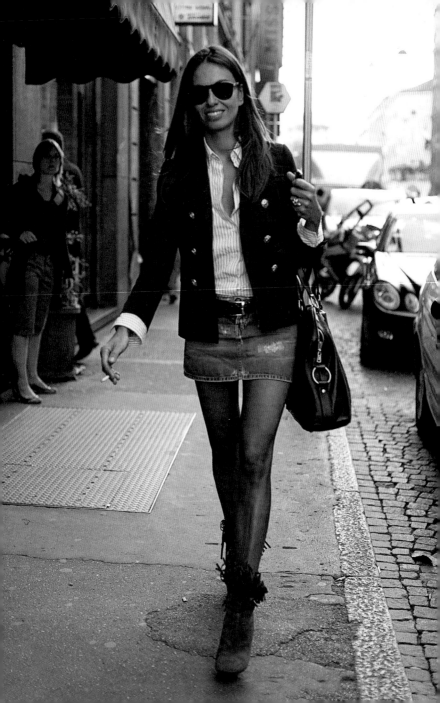

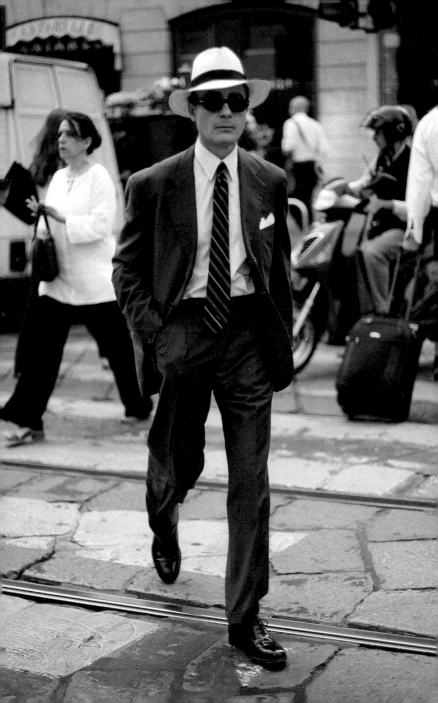

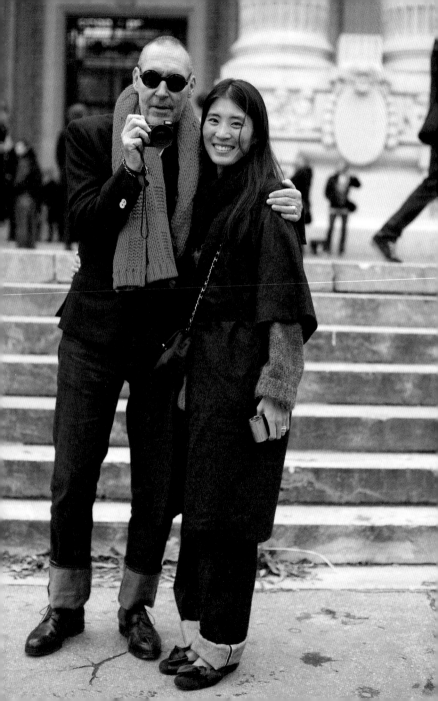

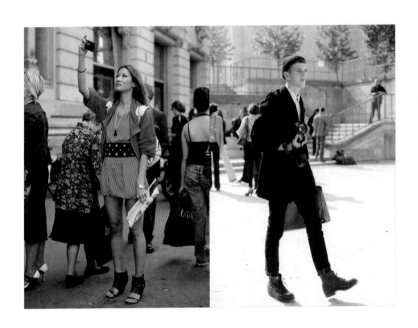

Five dollar doctor's coat, Stockholm

I saw this young man walking down the street in a very hip area of Stockholm, and I thought for sure this guy was a model. He looked like he'd just stepped off a Prada runway – slim, stylish clothes, incredible high cheeckbones and extremely stylized hair. There are lots of male models from Stockholm – I think it is a calculable portion of their gross domestic product. As it turned out he wasn't a model and was simply on his way to try to sneak into a party. As we talked I kept looking at his coat and finally asked if it was Prada or Jil Sander. It had the clean lines and austere colour that are hallmarks of those two collections. Apparently, it was a doctor's lab coat that he picked up for $5 at a flea market. I had never seen such a cool lab coat or at least not such a cool lab coat that colour. I didn't think to ask him if he had dyed it himself.

Again, his ability to carry off this look so well was not about the coat itself but how he wore it with a cool nonchalance. I know if I tried to wear a lab coat outside as a regular coat I would feel so self-conscious that people would think that I had just stolen something.

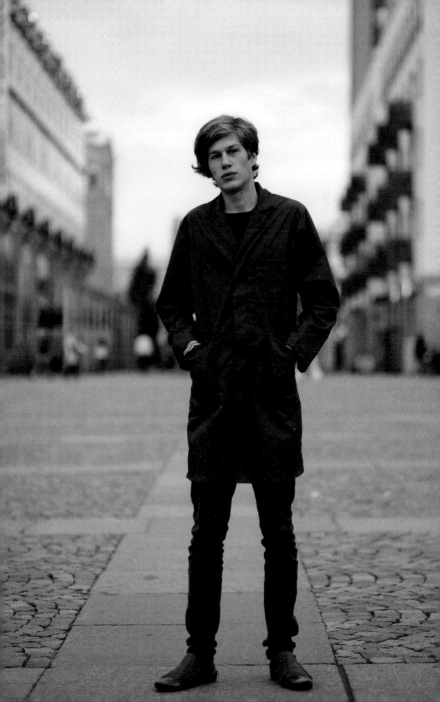

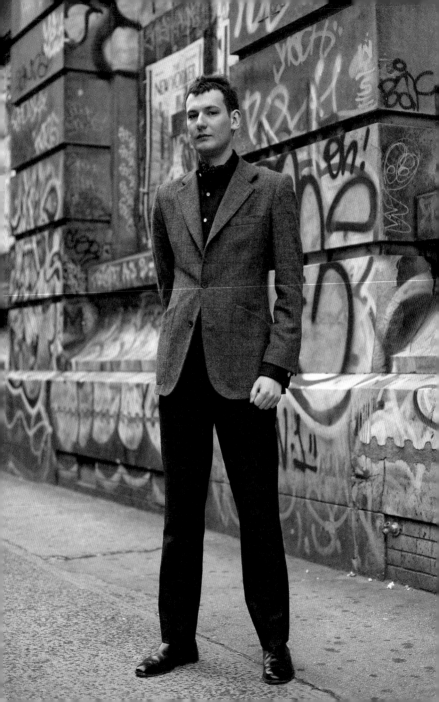

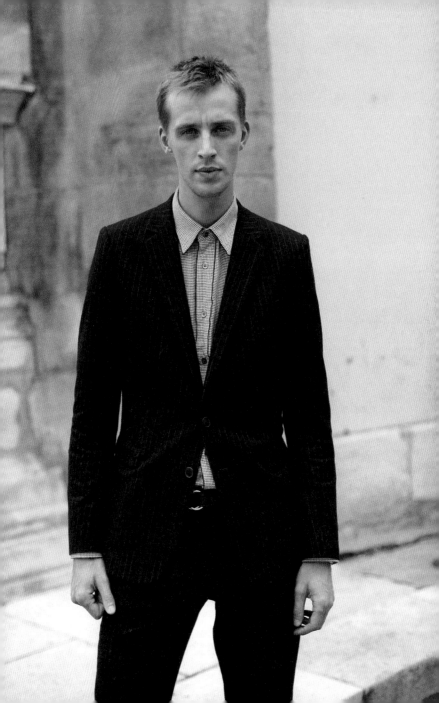

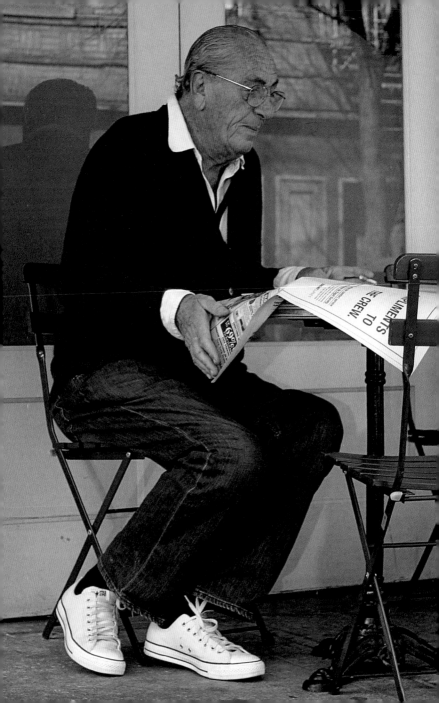

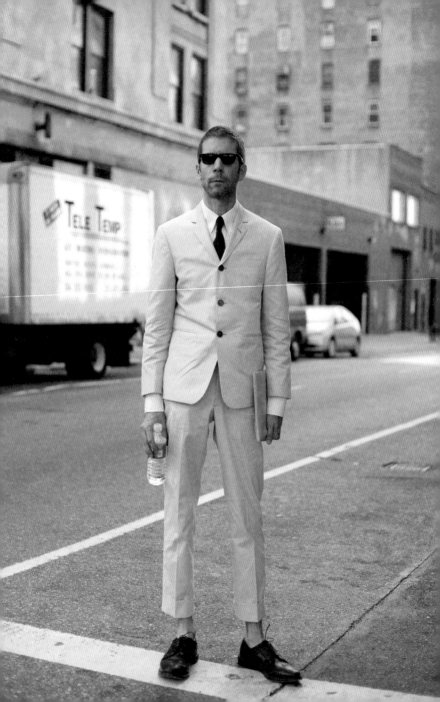

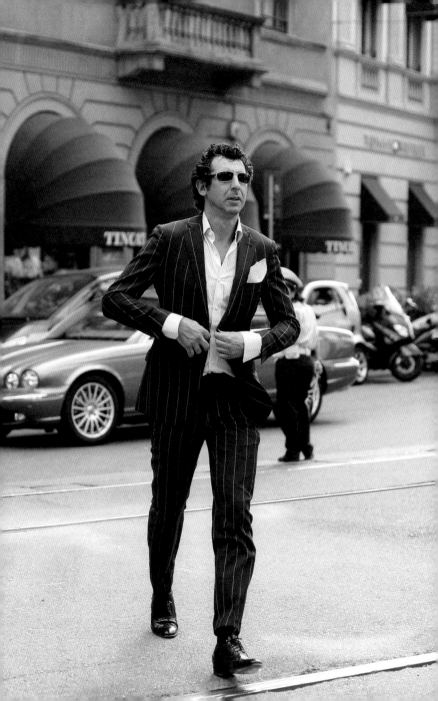

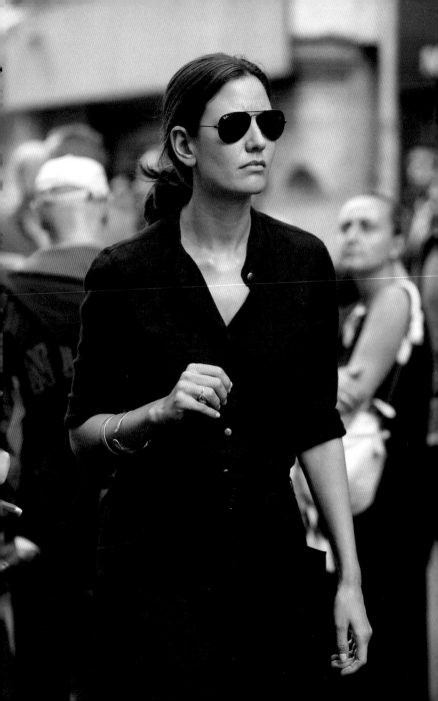

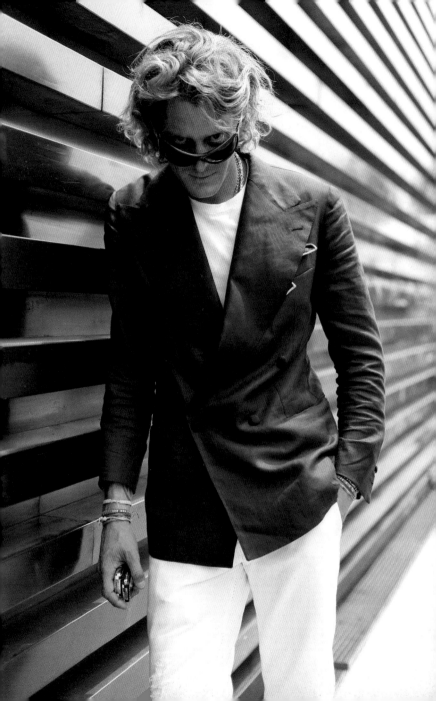

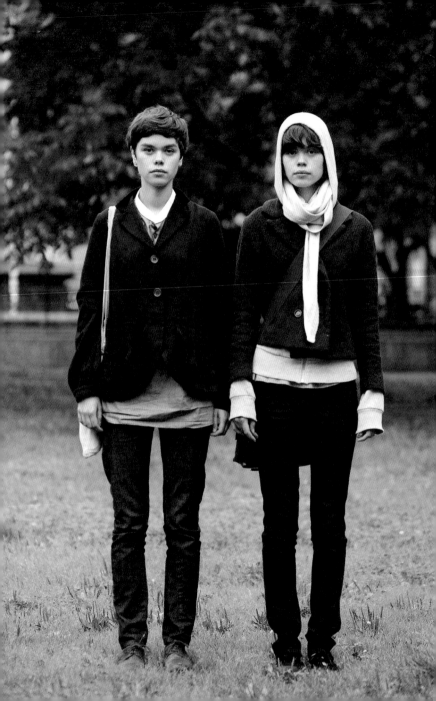

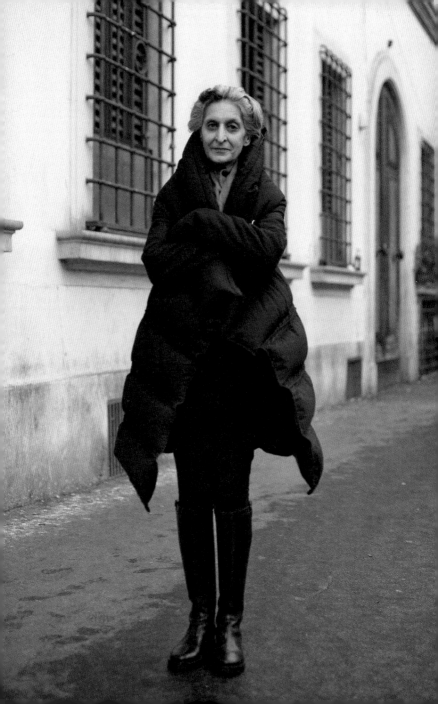

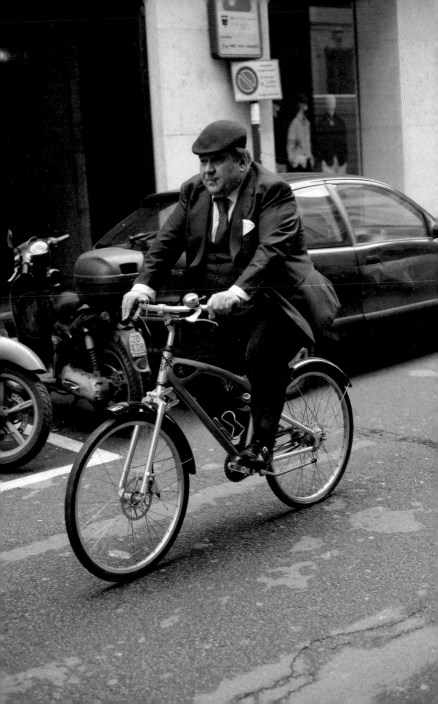

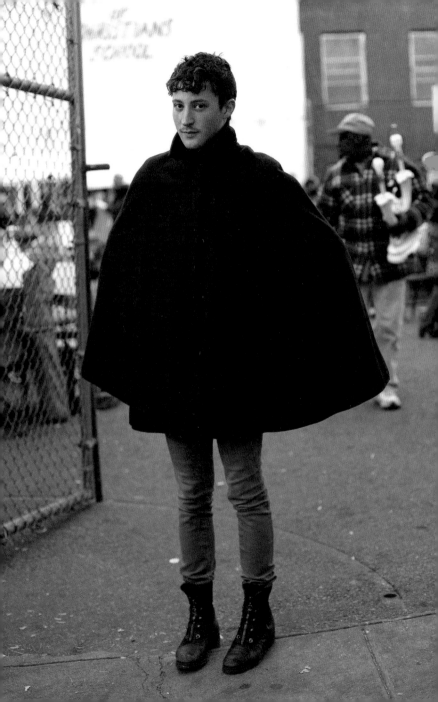

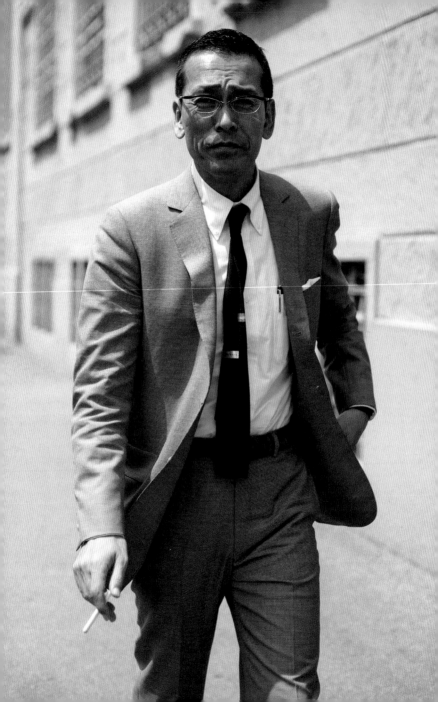

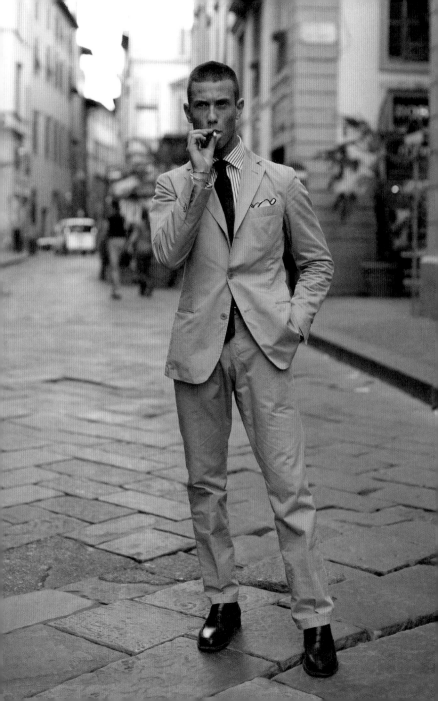

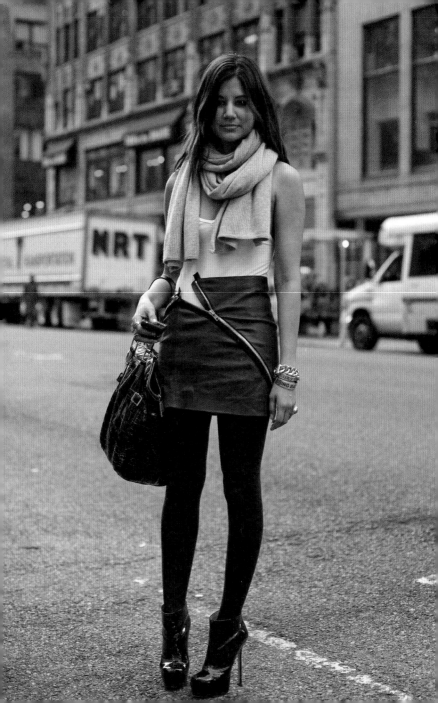

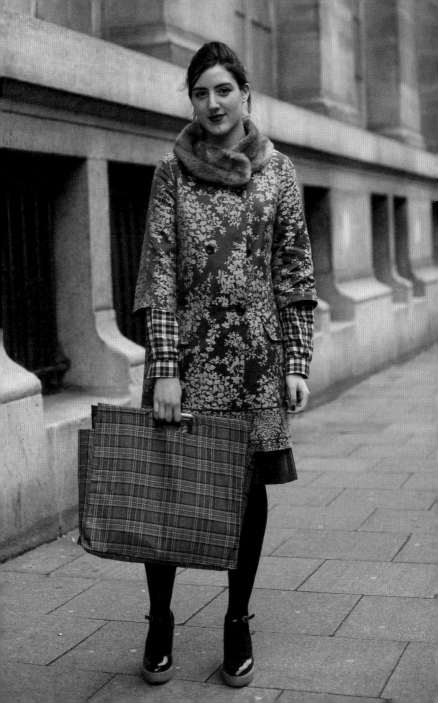

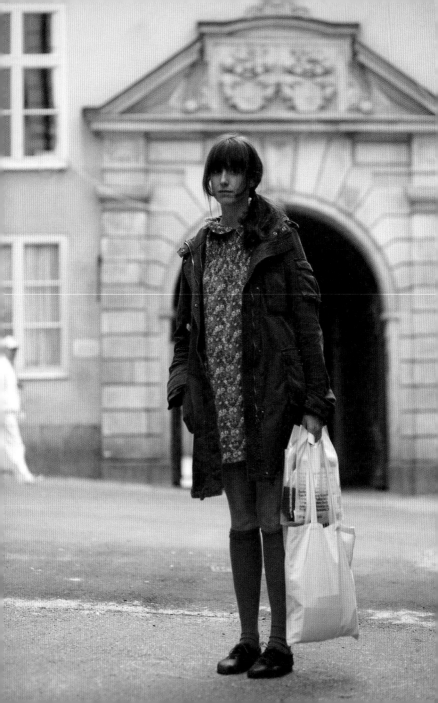

Conflict of expression, Stockholm

I was in Södermalm, the hipster area of Stockholm, and saw this young lady walking quietly down the street. She had a very shy demeanour and yet she was very noticeable to me because she just wasn't dressed like the other trendy young women of Stockholm. Stockholmians have great style, but they are also extremely fond of following the locally accepted 'hot trend' and not straying from the three or four current looks. Anyone that is outside of the accepted 'cool' is instantly noticeable.

When I asked to take her photo she was hesitant but accepted on the condition that we step around the corner so no one could see her. She was very shy, but I thought it was charming that she had a difficult time looking directly at the camera. I think that most people feel that great style has to be big, obvious and make a loud statement about the wearer. I often hear people say that someone has to really know themselves to attain and communicate a great personal style. Yet a young lady like this shows that a conflict in personality – wanting to remain anonymous and yet consciously dressing in a noticeable way – can lead to equally great expressions of personal style.

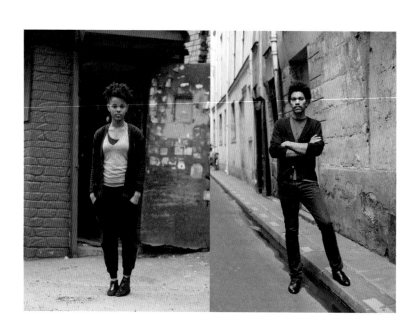

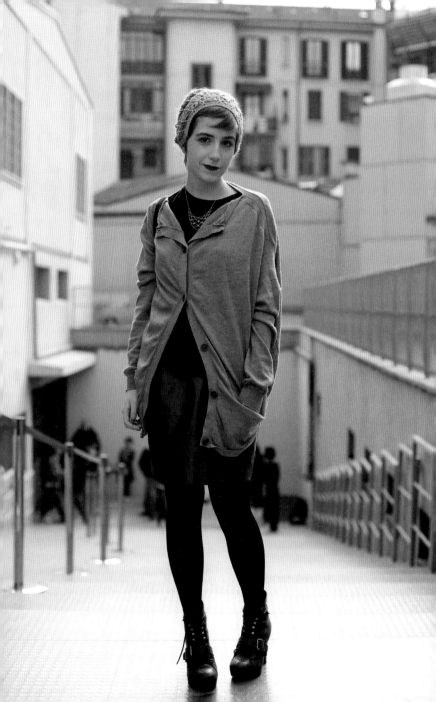

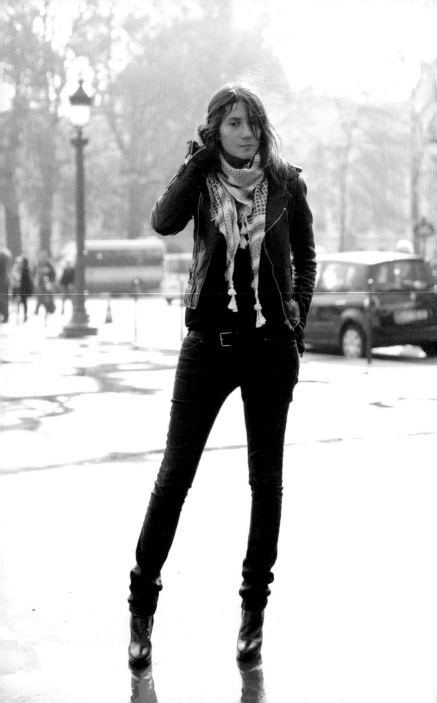

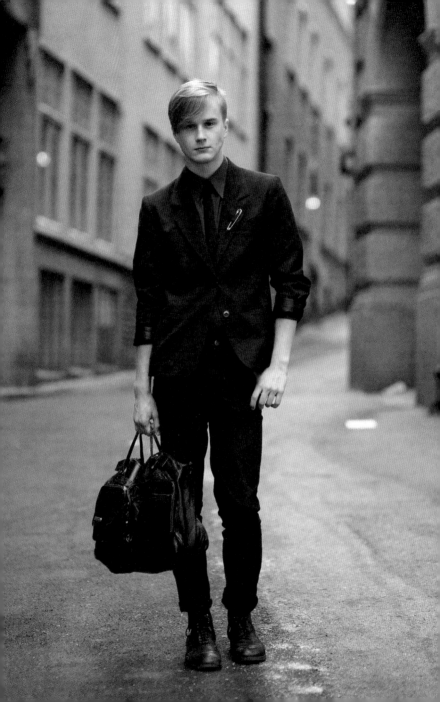

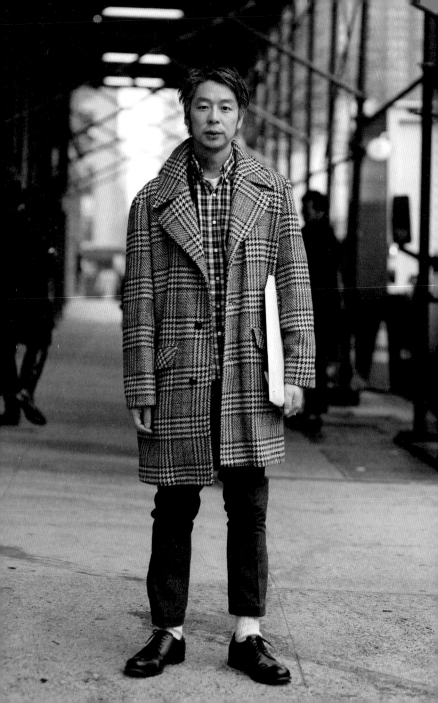

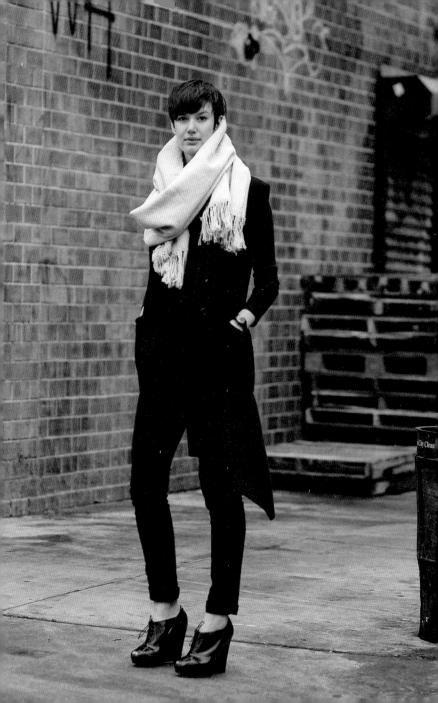

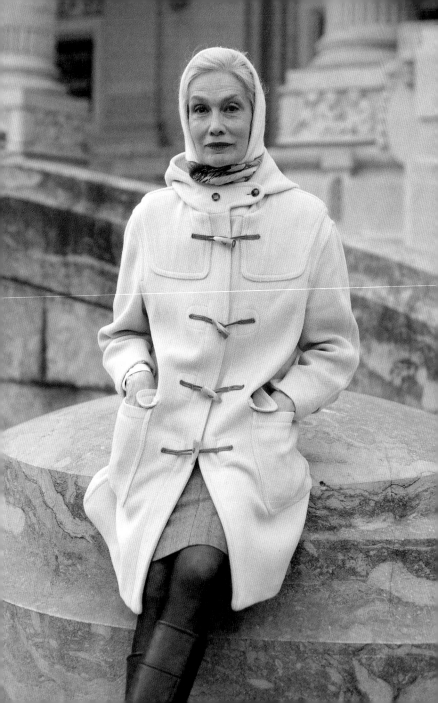

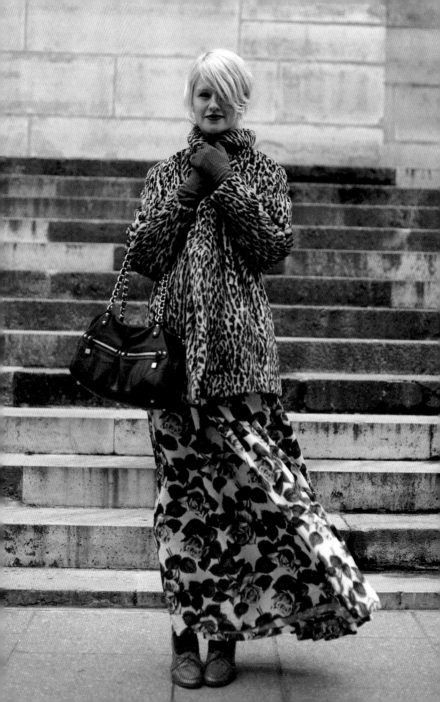

The original,
New York

Bill Cunningham is the modern master of fashion street photography. I can't say that he had a direct influence on my photography, but he has had a strong impact on my fashion awareness since I first moved to New York in the early nineties. When I moved to NY after college I never imagined I would end up as a photographer. When I looked at Bill's photos each Sunday in *The New York Times* it was not with a photographic eye but with a fashion eye. If I am ever able to carry on in his tradition it will be because I am able to capture street style not with a photographer's eye but with a fashion editor's eye, and that is what Bill has done so successfully at the *Times*.

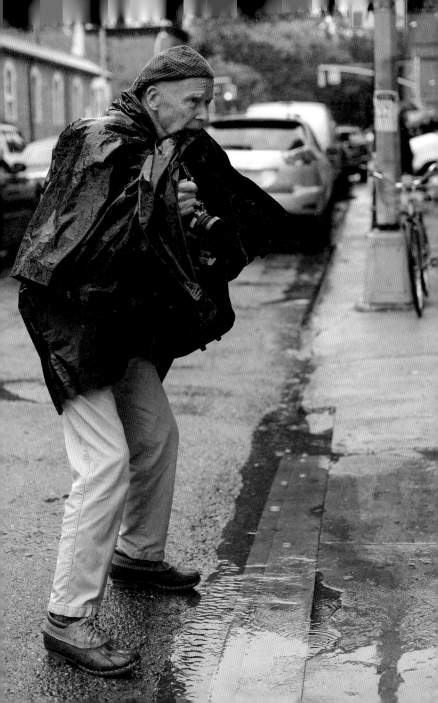

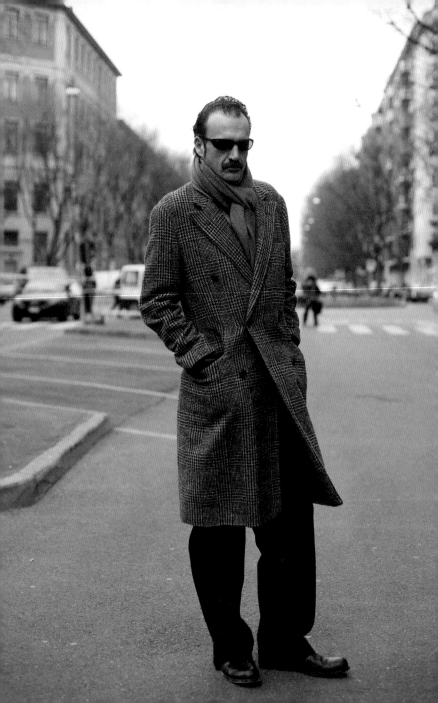

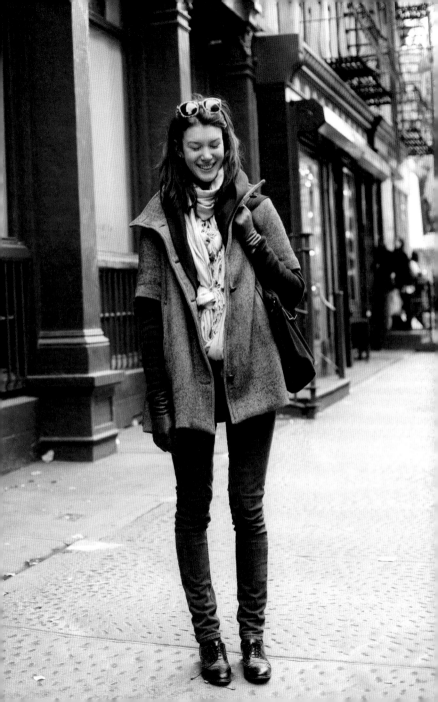

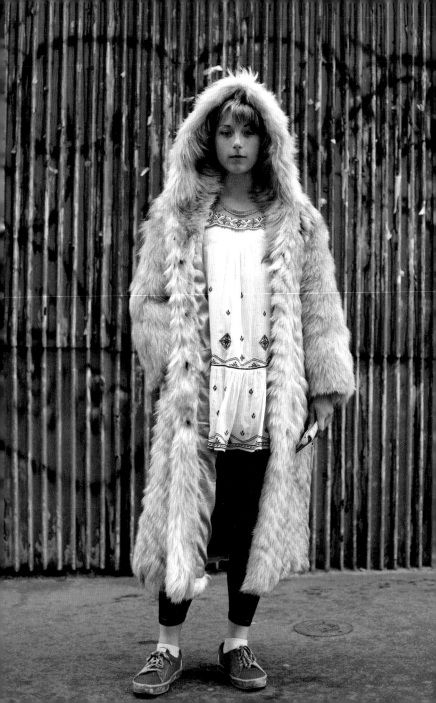

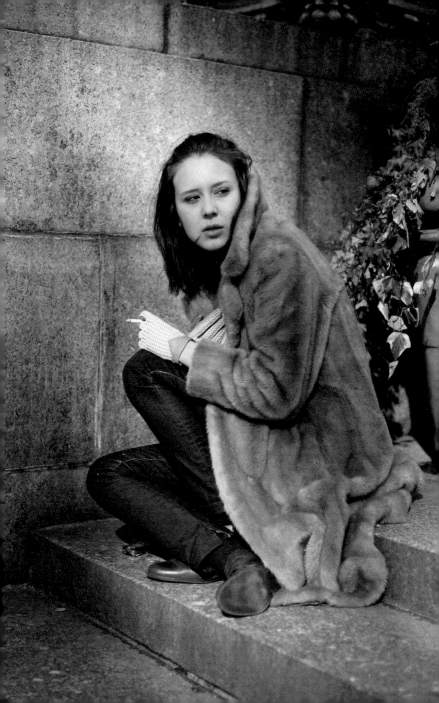

Creative uniformity, Milan

Even in the rigidly uniformed Italian military there are small allowances made for the expression of personal style. I loved how these young men could created a visually cohesive unit while still being able to express a sense of personal flair by intricately weaving these golden braids around the jacket's buttons. I can just imagine the internal contest to outdo each other with the most intricate pattern.

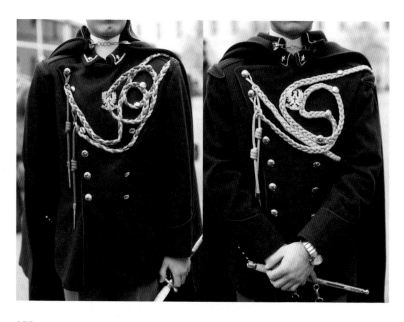

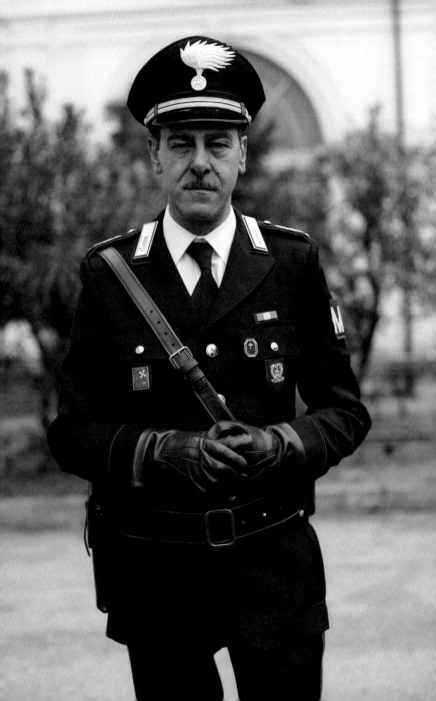

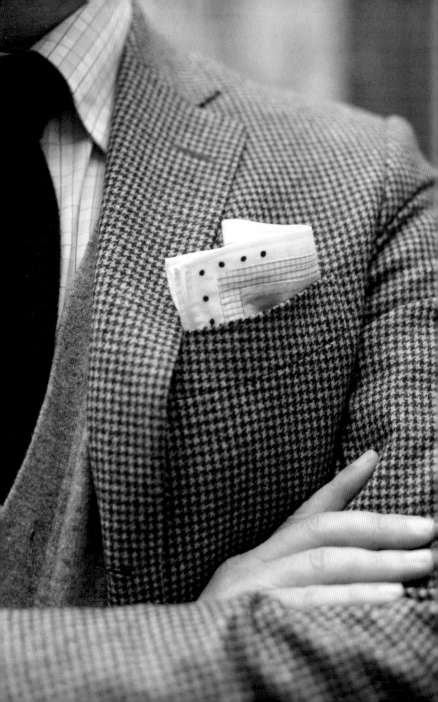

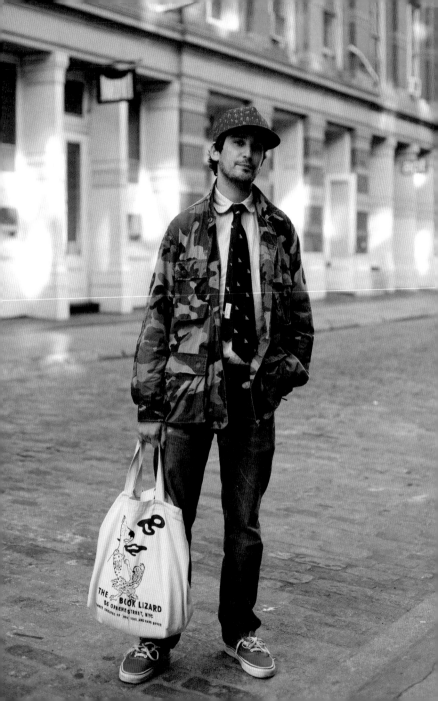

Luciano Barbera, Milan

Mr Barbera has such a wonderfully classic Italian style. What he does stylistically is so subtle that the untrained eye can easily miss it. One thing that he is well known for is wearing his watch on the outside of his shirt cuff, alla Gianni Agnelli. Though few will notice one of his brilliantly orchestrated shirt/tie/jacket combos, everyone spots that watch on the outside of the cuff. It seems funny to me that something so practical as that is considered by most as affected. I guess for those people function follows fear.

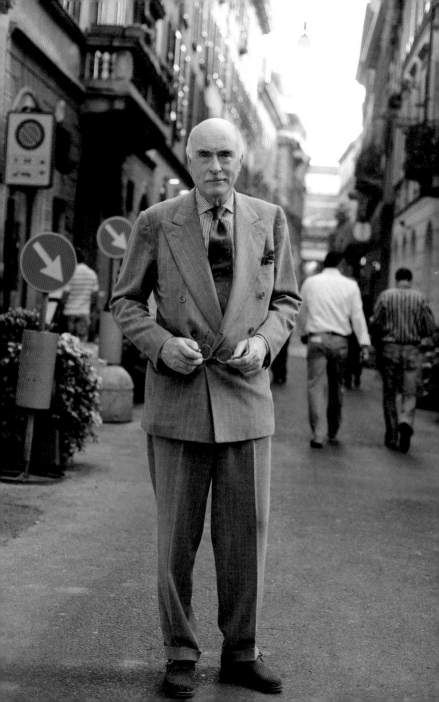

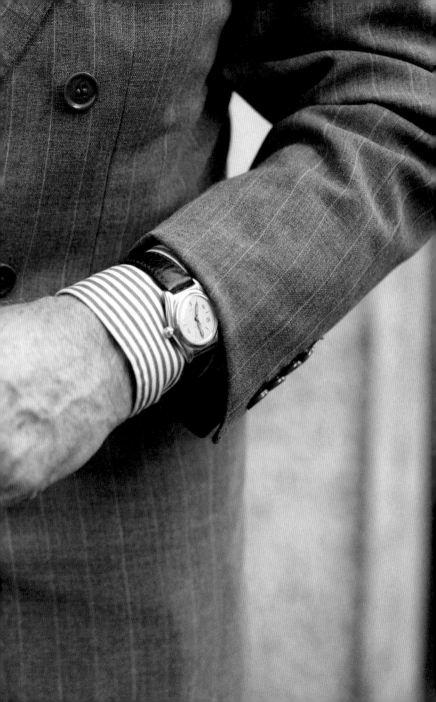

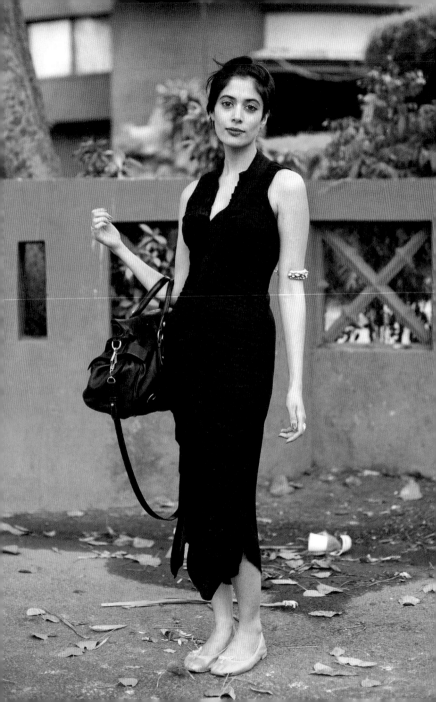

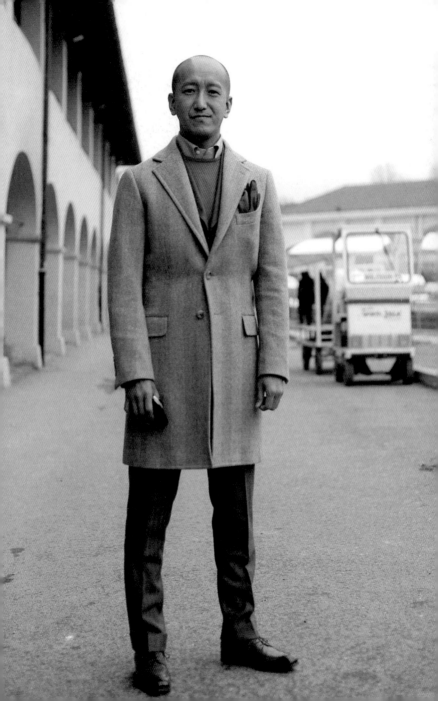

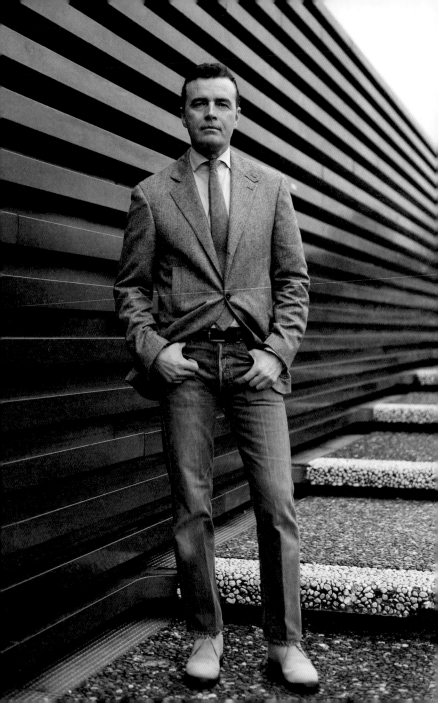

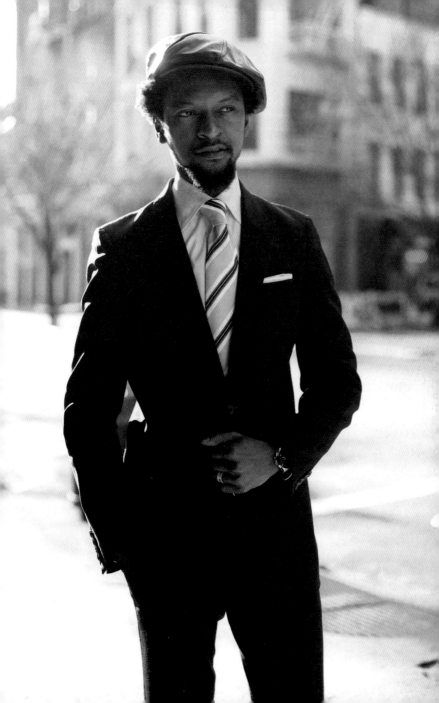

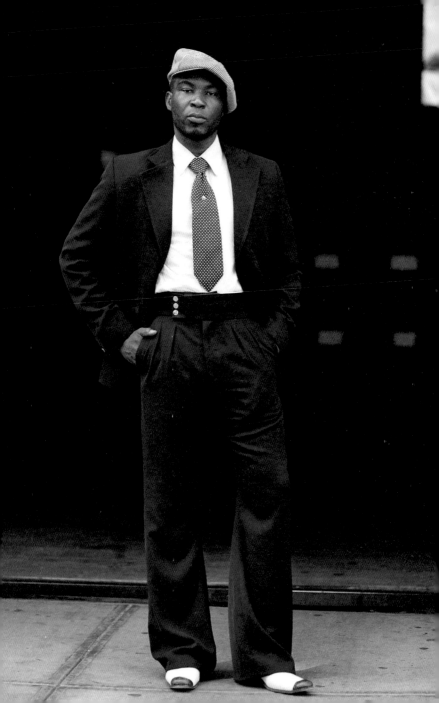

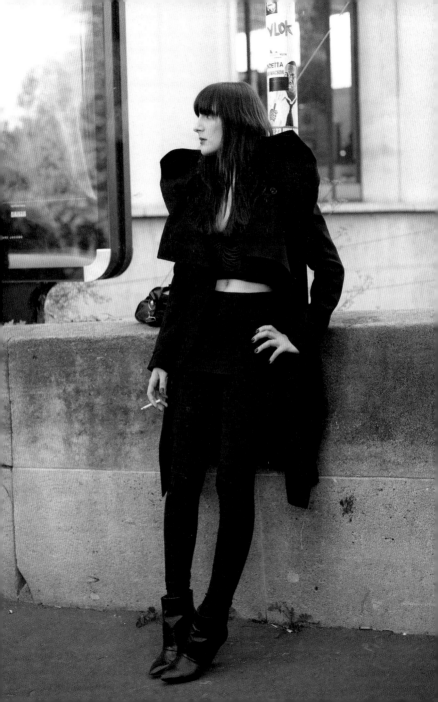

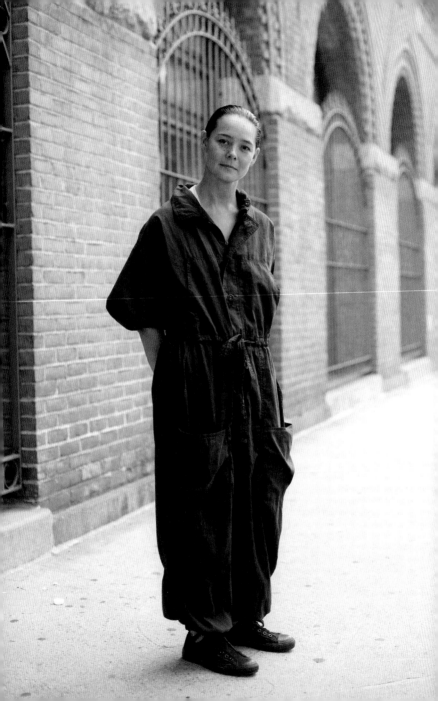

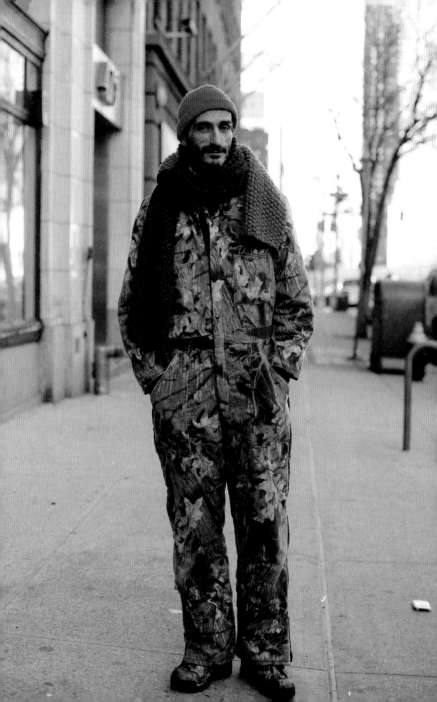

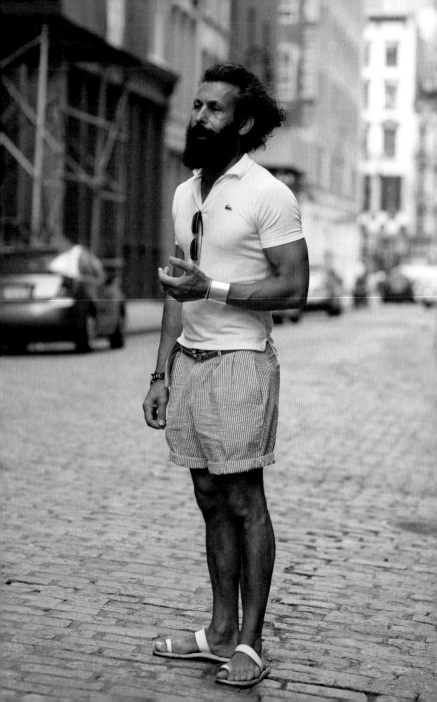

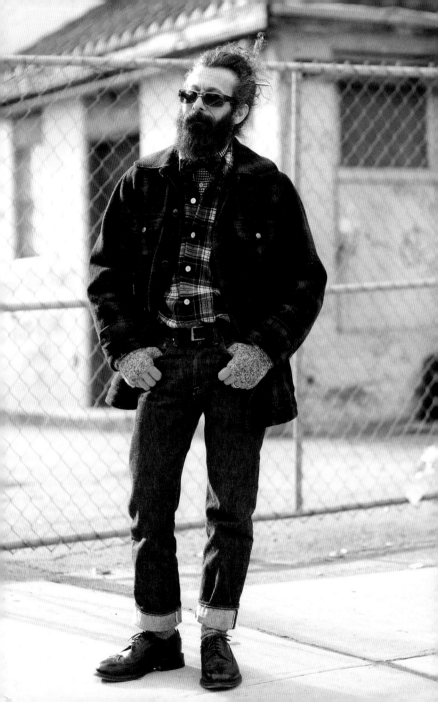

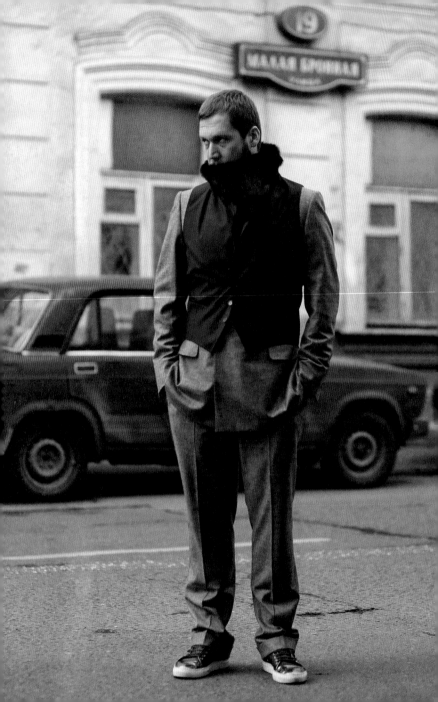

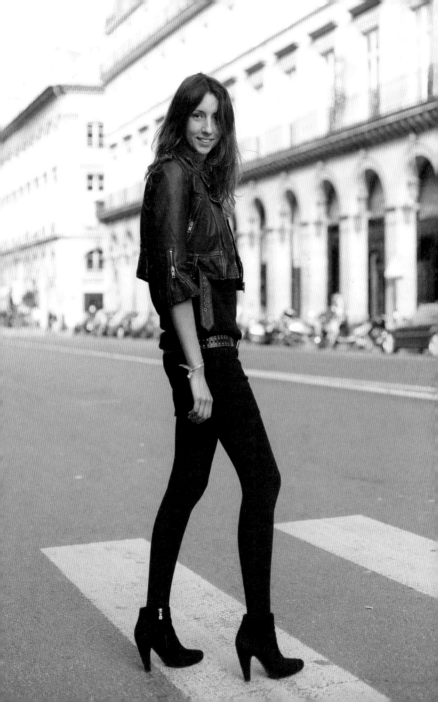

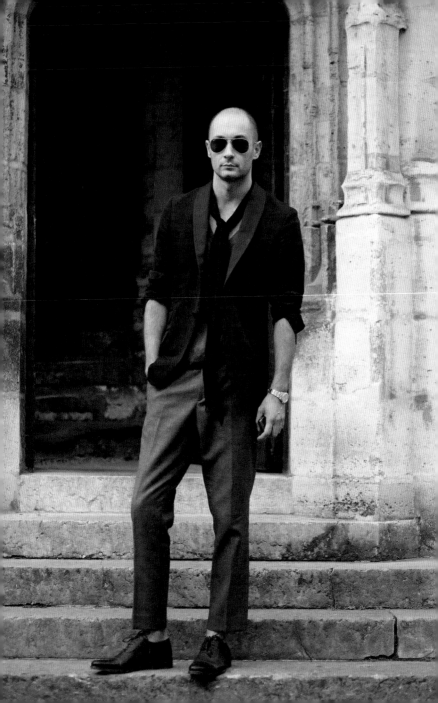

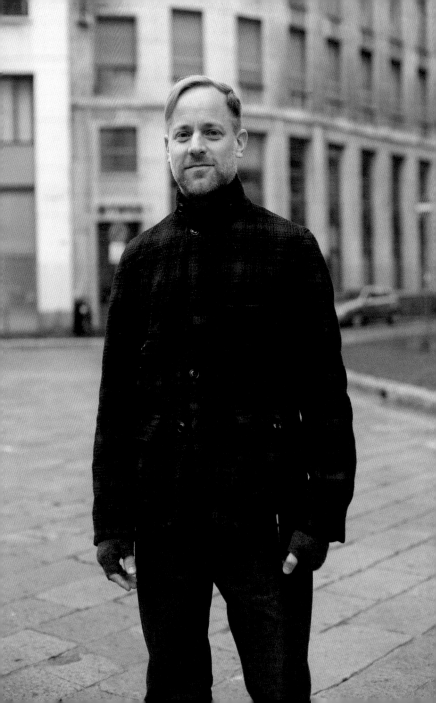

Eva

I absolutely love to shoot Eva; she has one of those killer smiles that just melts your heart. To be honest, though, a lot of girls have a great smile. Eva somehow combines an Audrey Hepburn charm with the style of a budding star stylist. She has one of those personal styles that is maddening to try to describe. She can wear a look that on paper should never be tried but that somehow on her just works – I mean, it just works. I have had friends try to duplicate some of the looks that she has created but with disastrous results. When the basketball player Michael Jordan was at the top of his game, they used to say, 'You can't stop him, just try to contain him.' Well, with Eva, don't try to copy her; just try to enjoy the show.

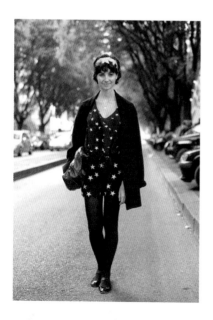

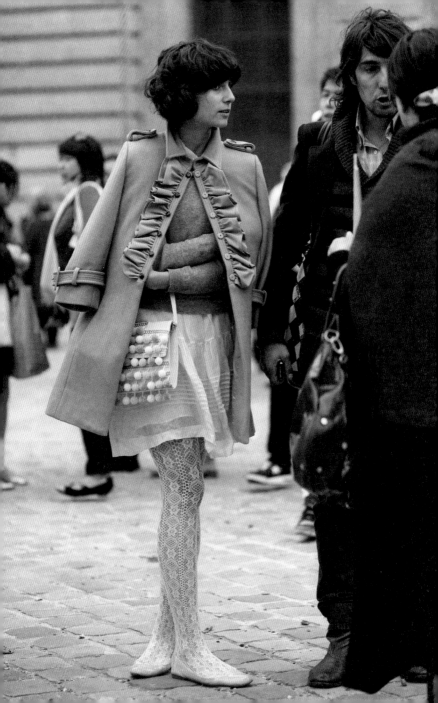

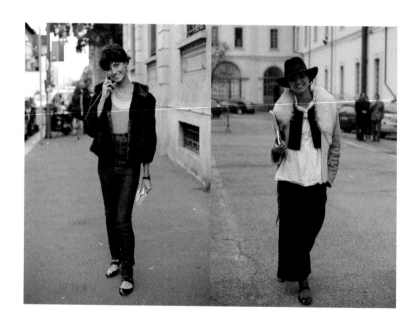

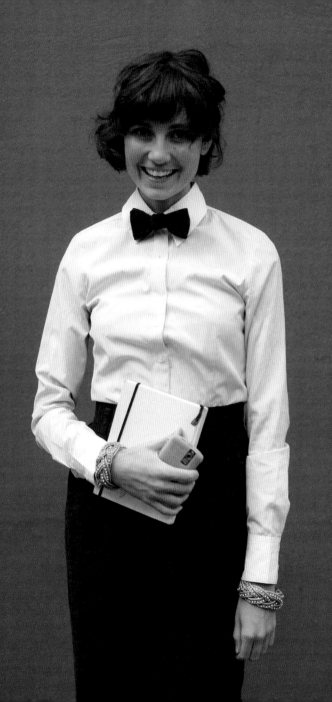

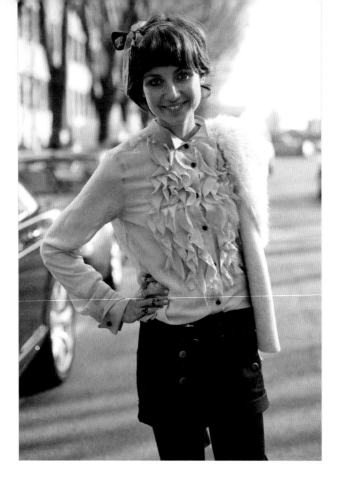

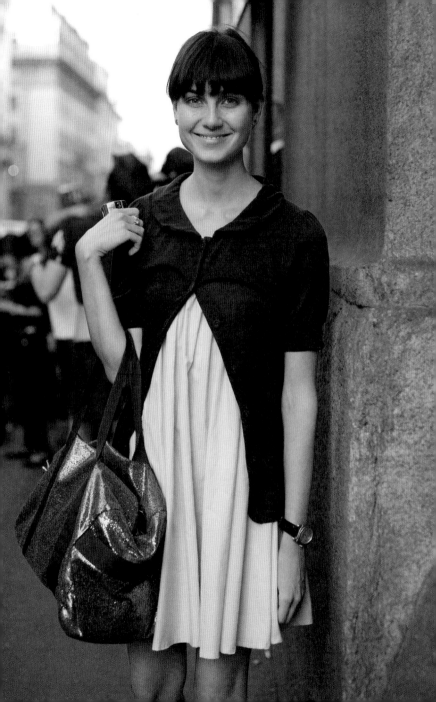

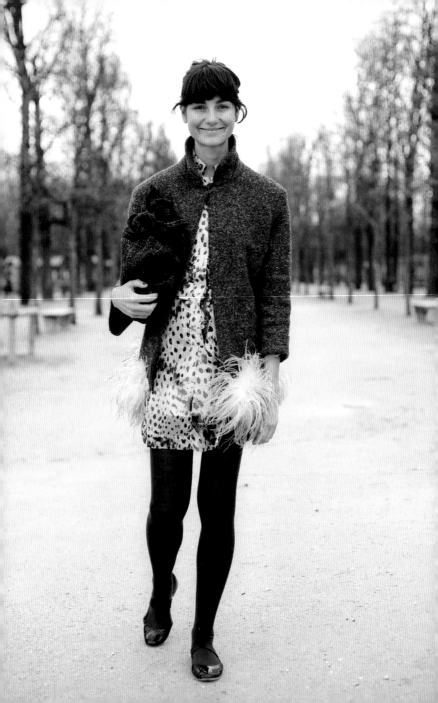

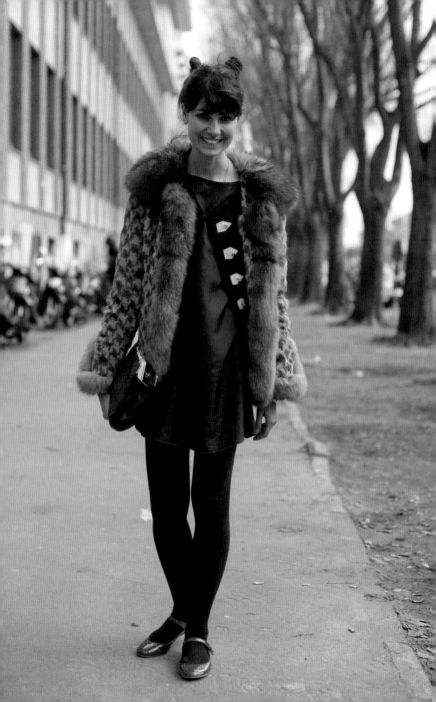

Studio A, Paris

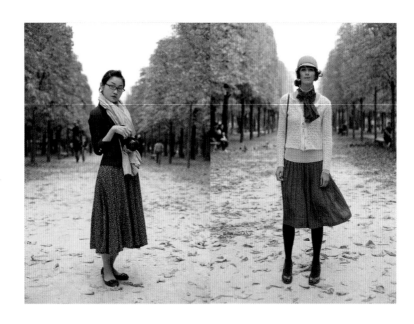

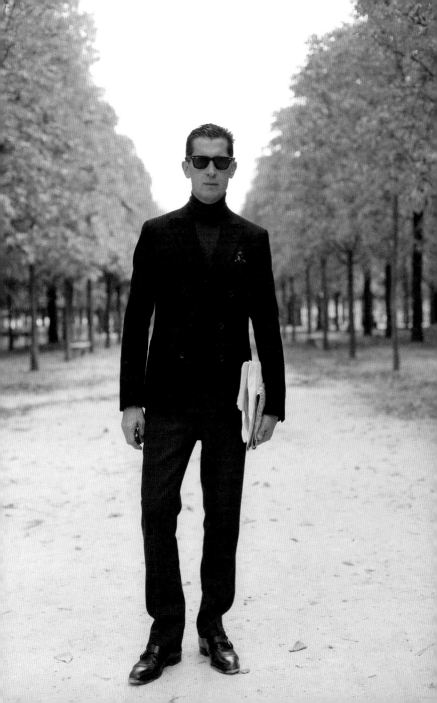

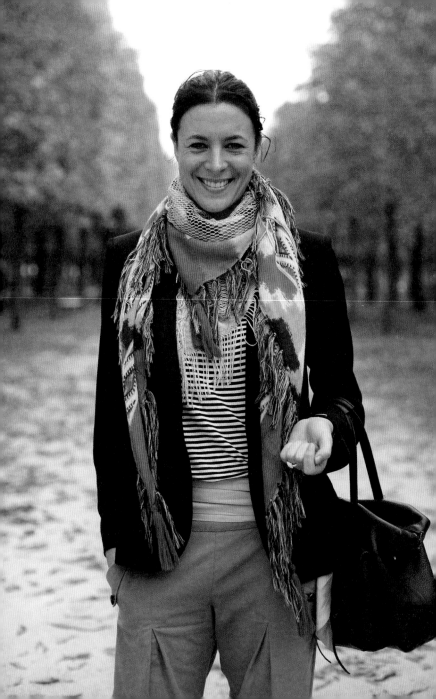

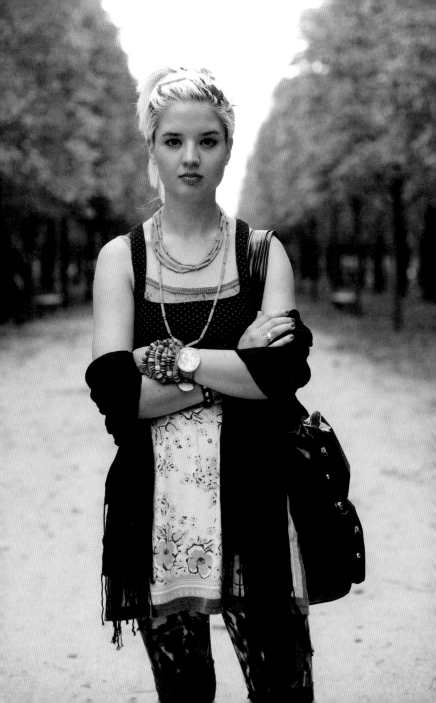

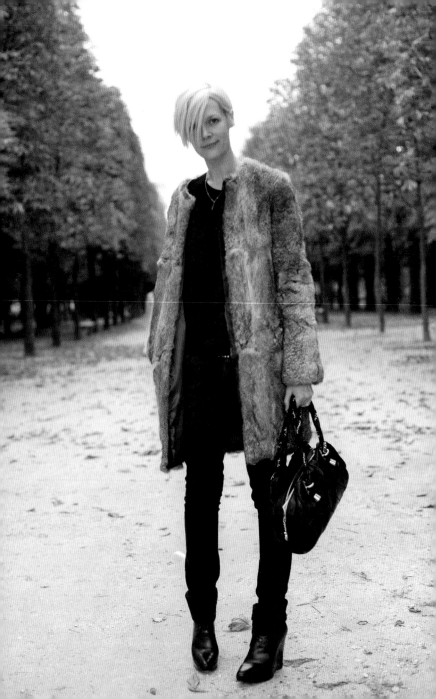

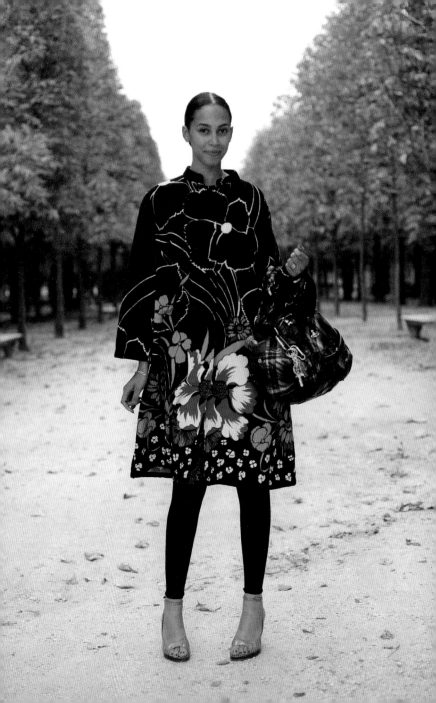

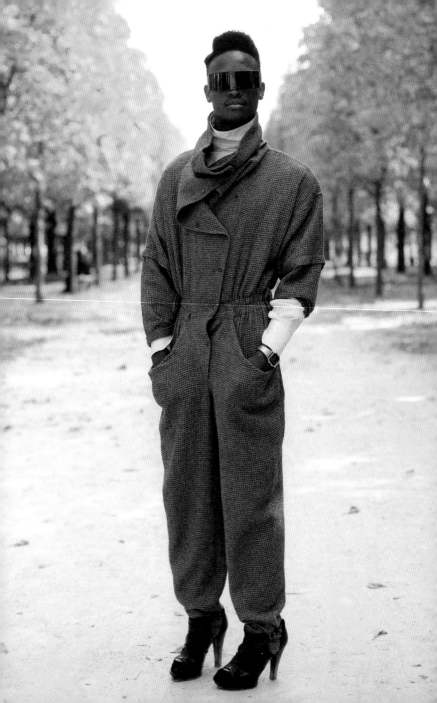

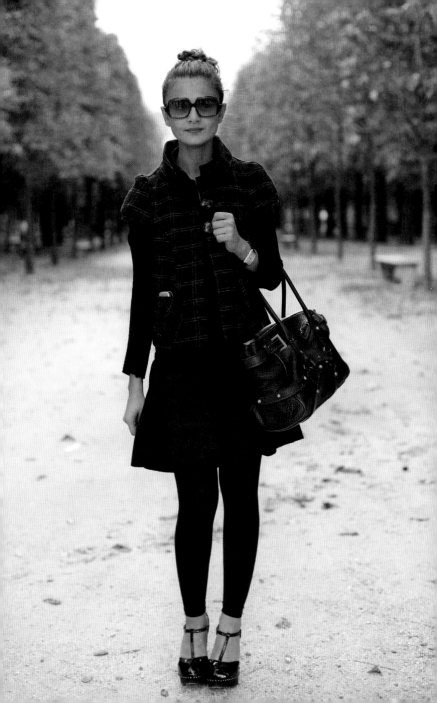

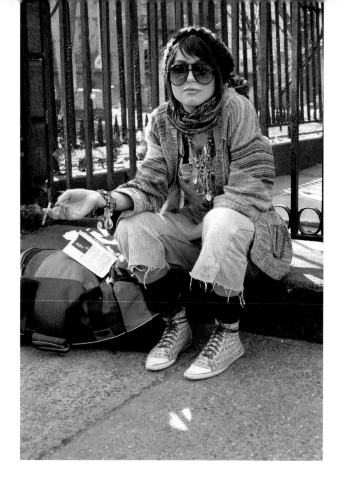

One Year Later, New York

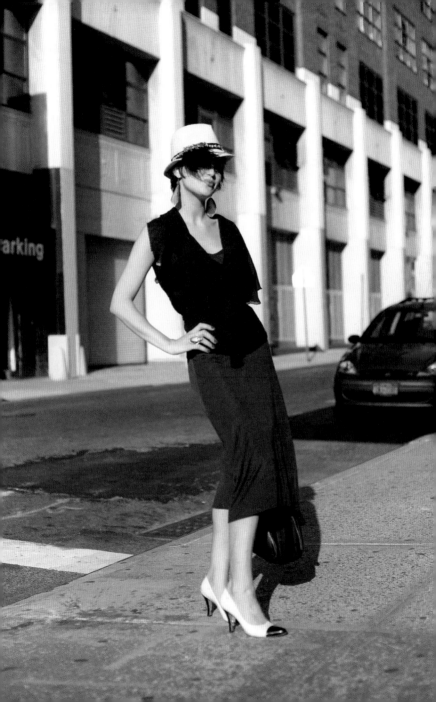

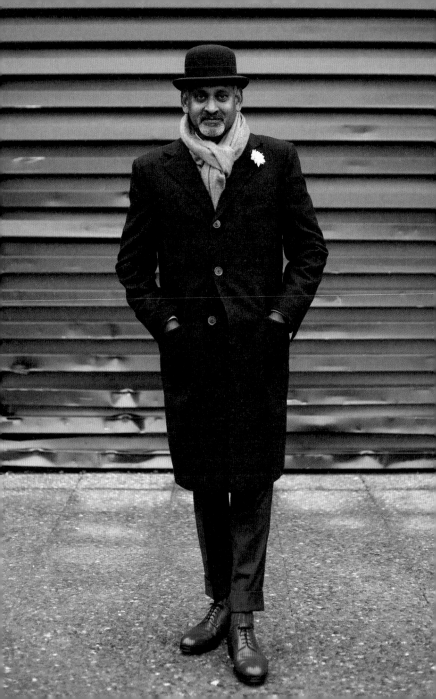

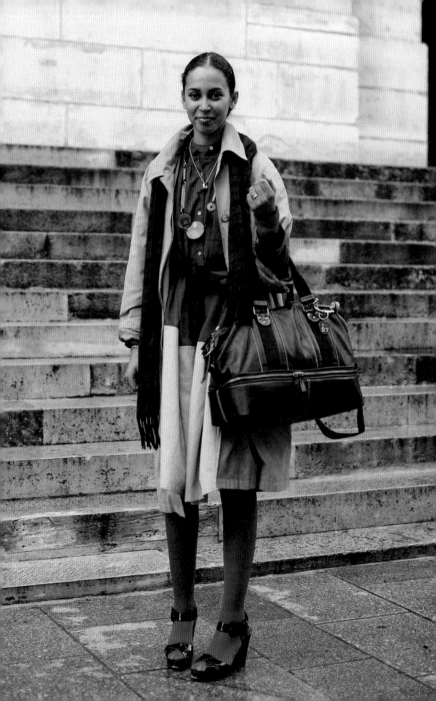

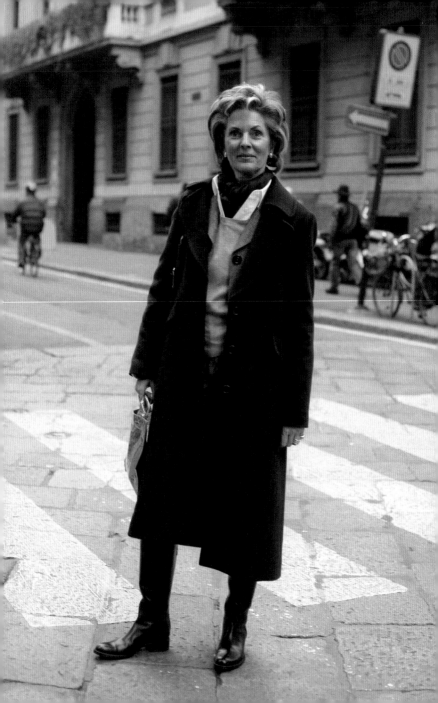

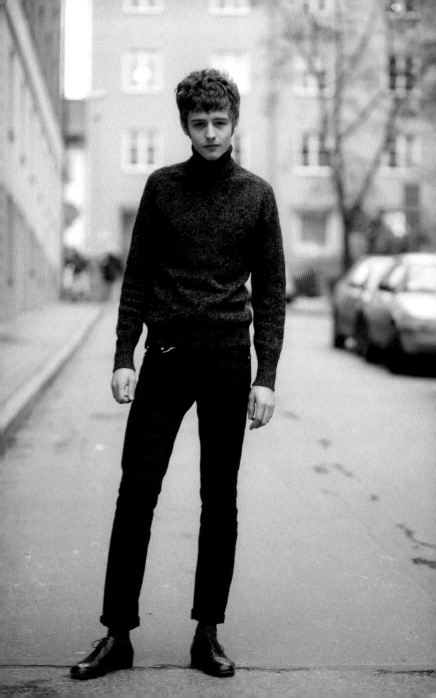

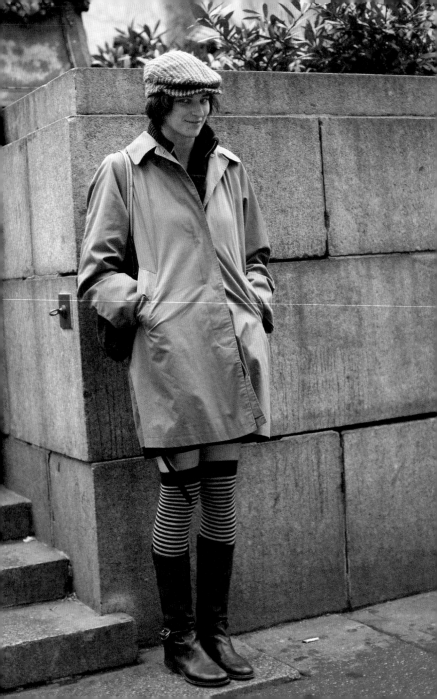

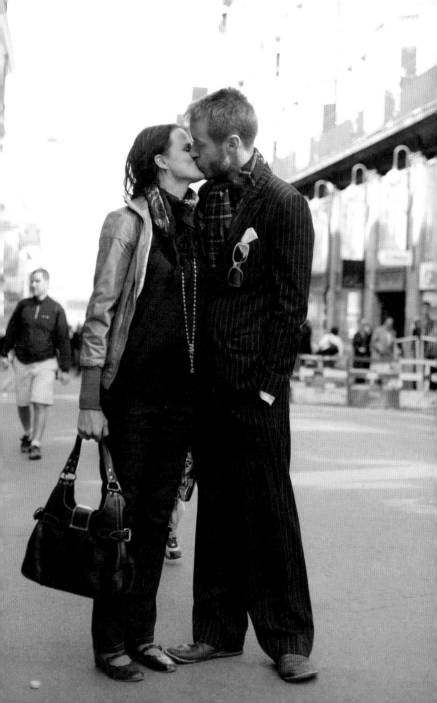

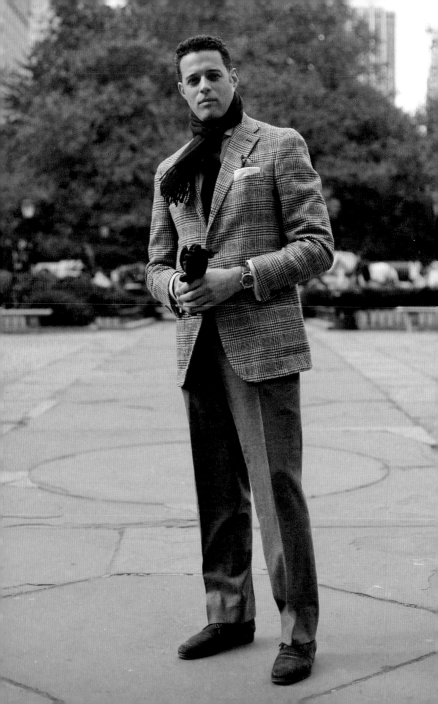

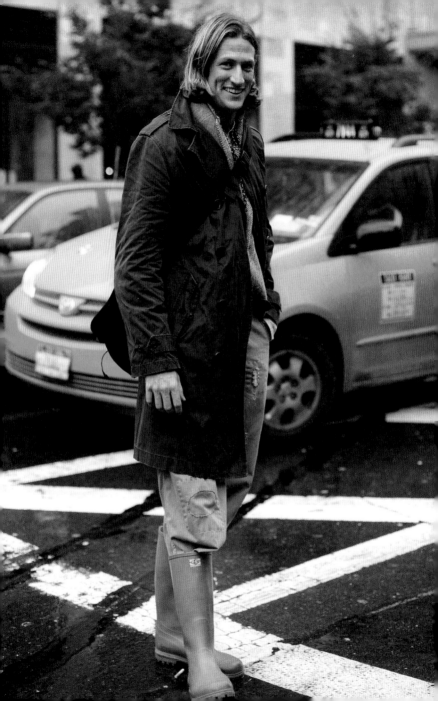

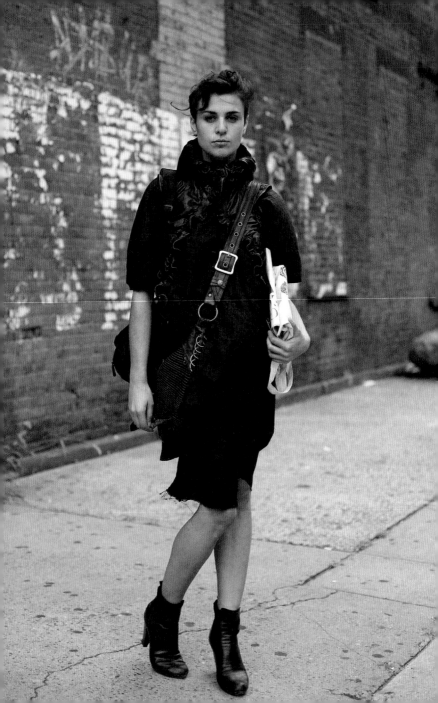

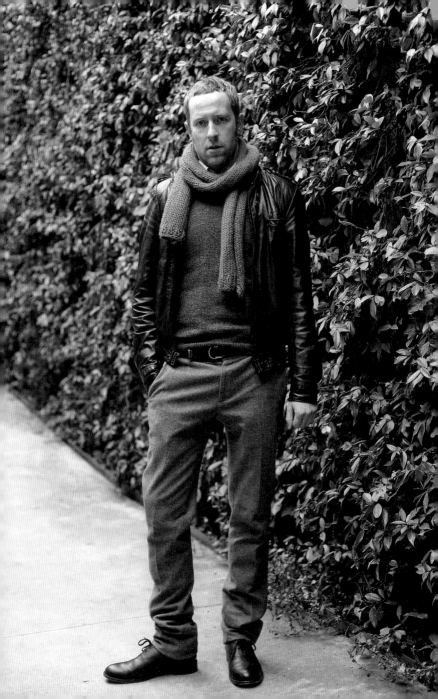

Luca Rubinacci, Florence

I hate to put so much pressure on young Luca Rubinacci but, to me, he needs to be the future if Neapolitan tailoring is to survive. Luca is the third generation of Rubinacci tailors, whose store is in the heart of Napoli. Luca has developed a style that is both a celebration of hand craftsmanship and funky Italian boho playboy. Luca loves talking about a hand-rolled lapel or vintage fabrics, but he is just as happy talking about a recent kite-surfing trip to South America. I guess what Luca has done is take the preciousness out of a bespoke lifestyle. So many modern guys become stiff when they put on a suit. Luca on the other hand wears a suit like he wears pyjamas (not like I know if he wears pj's or anything).

What I think people respond to in my photos of Luca is one part style and two parts pure swagger or, as the Italians say, *spezzatura*!

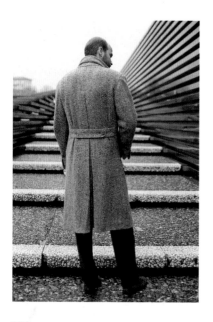

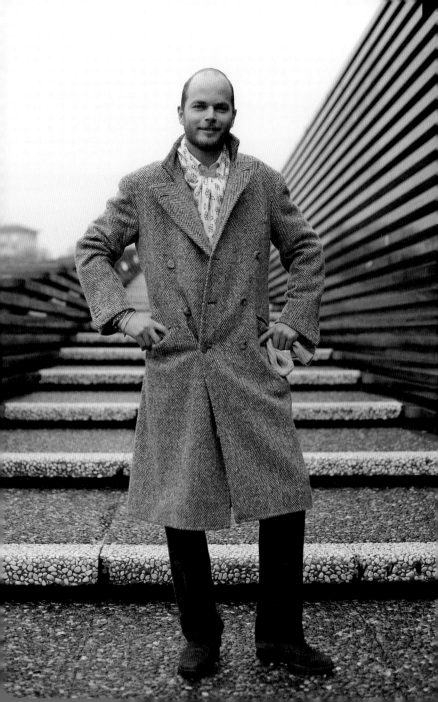

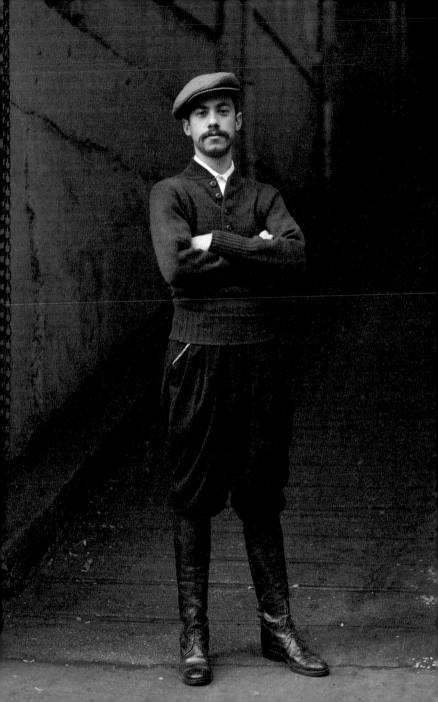

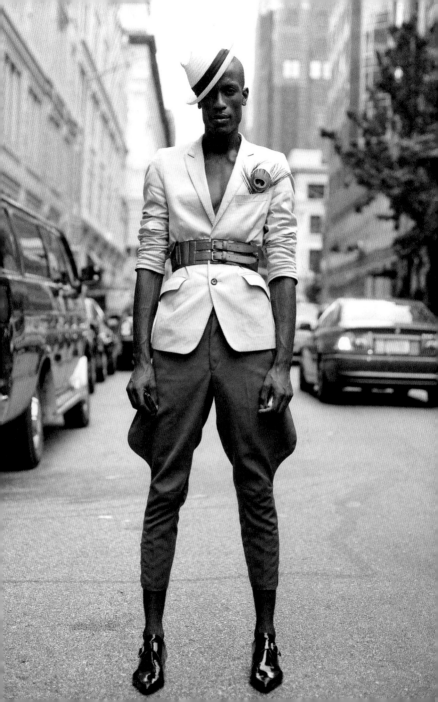

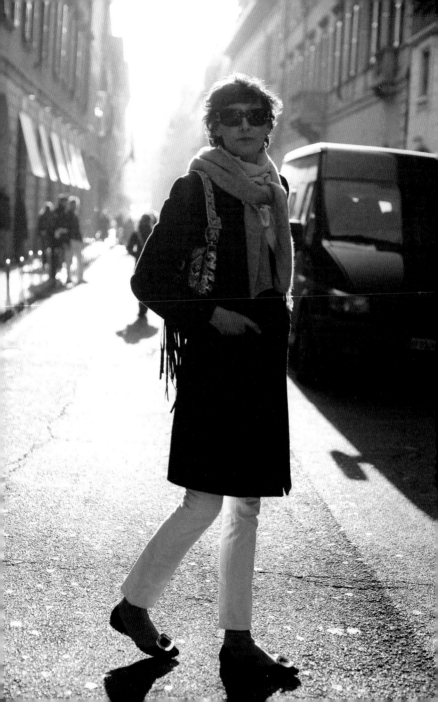

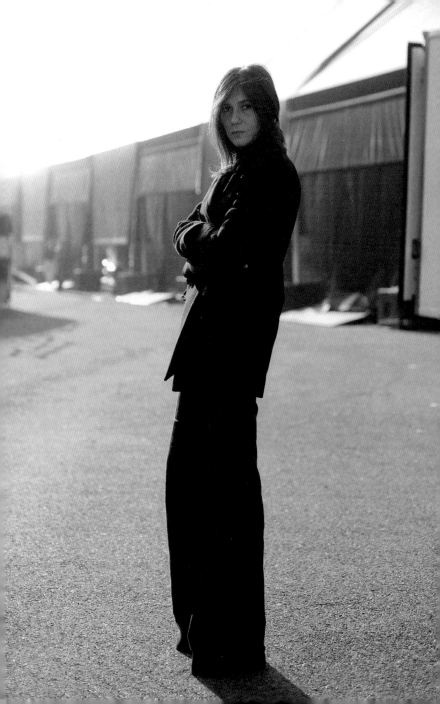

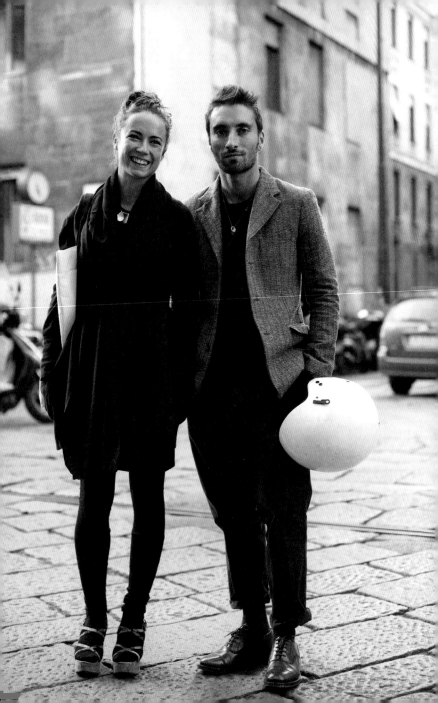

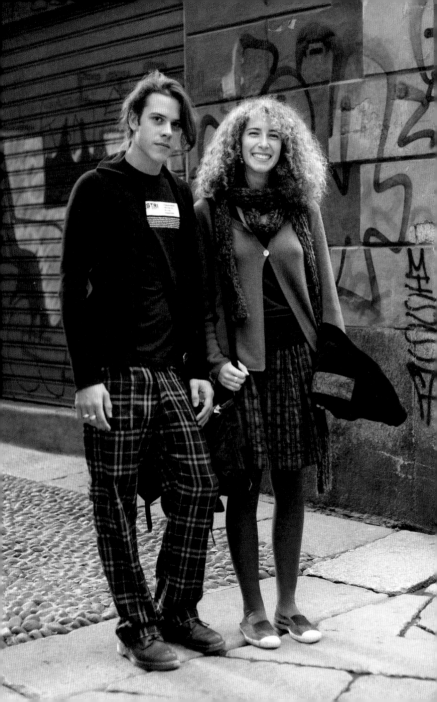

Polka dance, Milan

It was an early Friday evening in Milan and the men's fashion week had just ended. Walking back to the hotel I heard polka music coming from somewhere nearby. I don't often associate polka music with Milan, but I soon realized it was coming from the church I had just passed.

Inside I found a collection of retired Milanese dancing around like it was their high school prom. Age was not a factor here. You had the same cliques of girls standing on one side looking at the boys and the boys on the other side looking at the girls. There was such an energy and such a joy for life in that room. In this case though that joy was fuelled by Viagra not Everclear.

As I continued to watch I found this gentleman, not really dancing, more just shuffling to the music. He had such a stoic elegance and an undeniable virility to him. I really wanted to shoot him, but the dance floor was very crowded. I didn't want to change the atmosphere in the room so I decided to only take two tries at getting the shot. As the gentleman rounded the far corner of the room he was hidden behind a mass of the other dancers' arms and legs. Luckily, just as he approached the last possible spot I could shoot him in, the crowds separated and I caught him in all his reserved splendor.

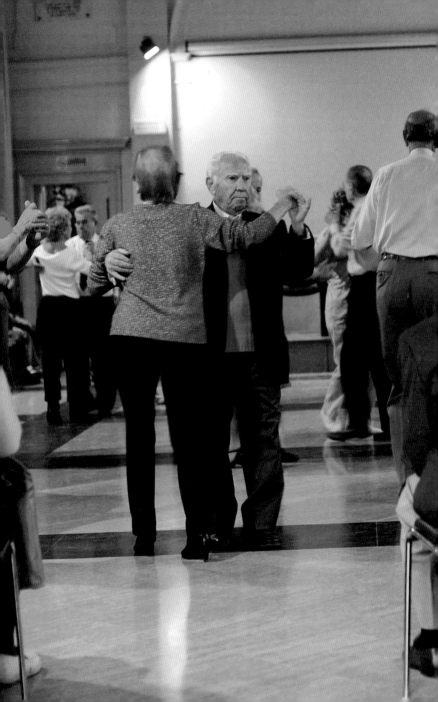

Loudly Vague

I am fascinated by androgyny. I think it is the vagueness that is so appealing. I appreciate people that don't feel the need to clearly communicate who they are to the outside world. We have called this period the 'Information Age' and so their comfort in remaining mysterious is wonderfully foreign.

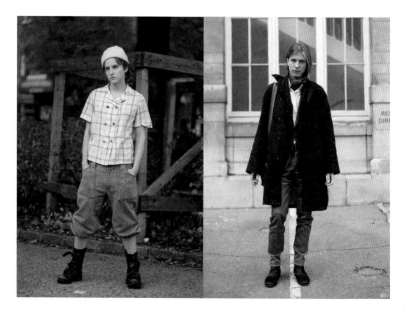

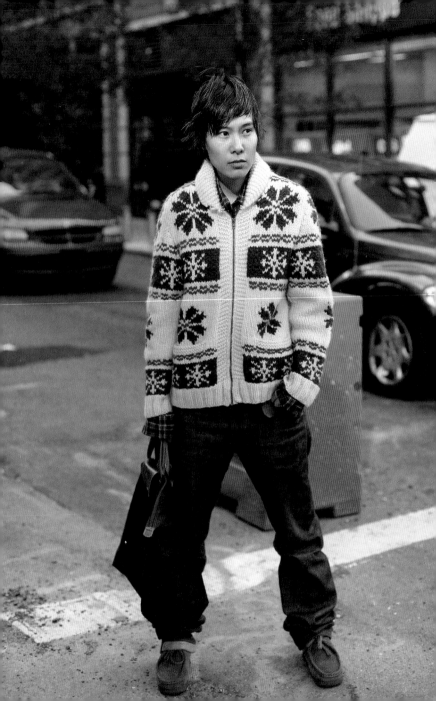

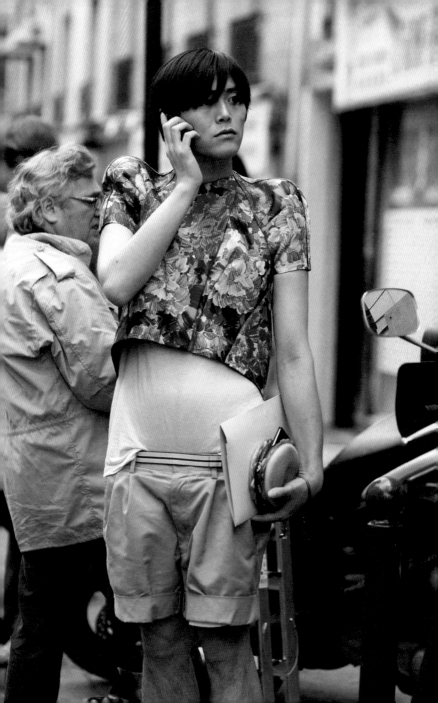

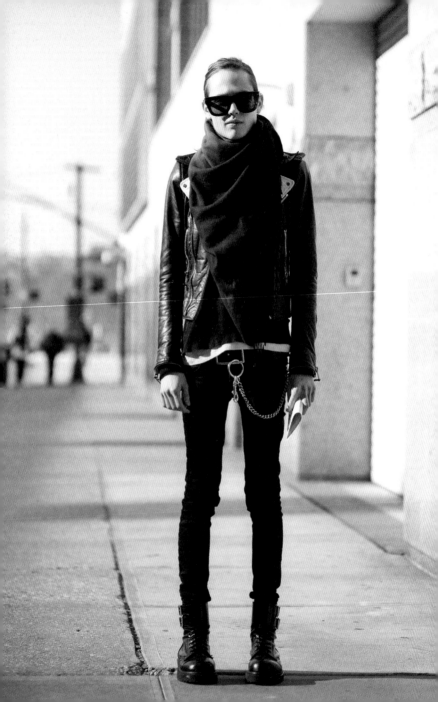

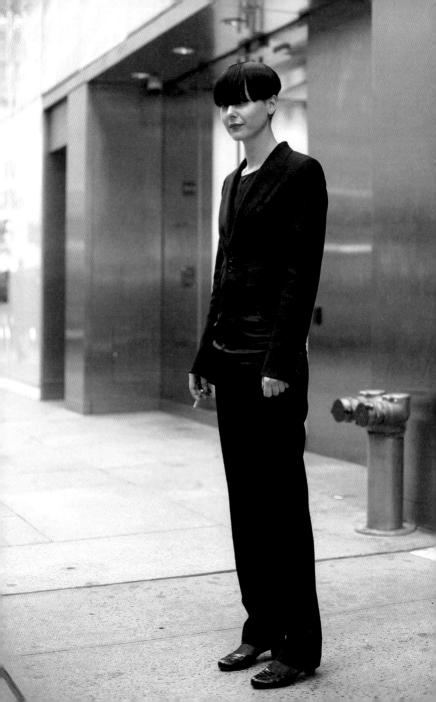

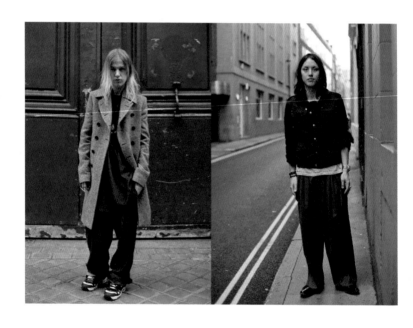

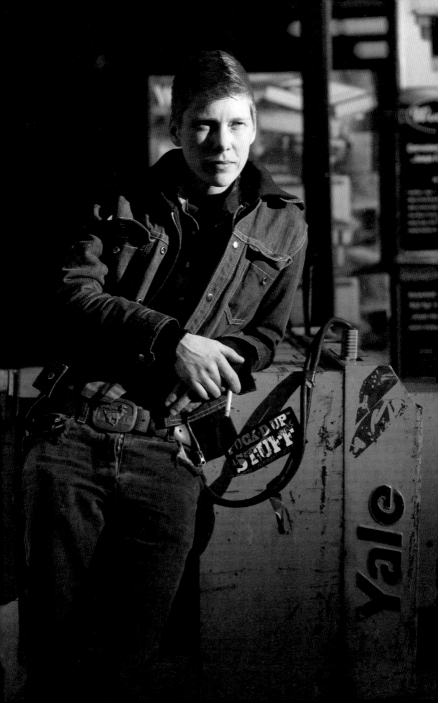

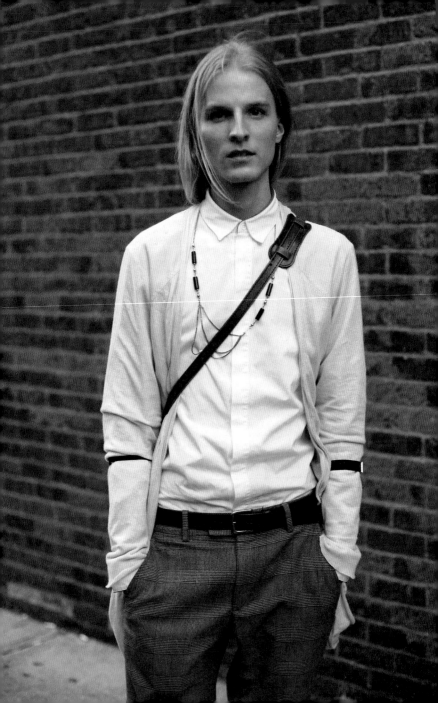

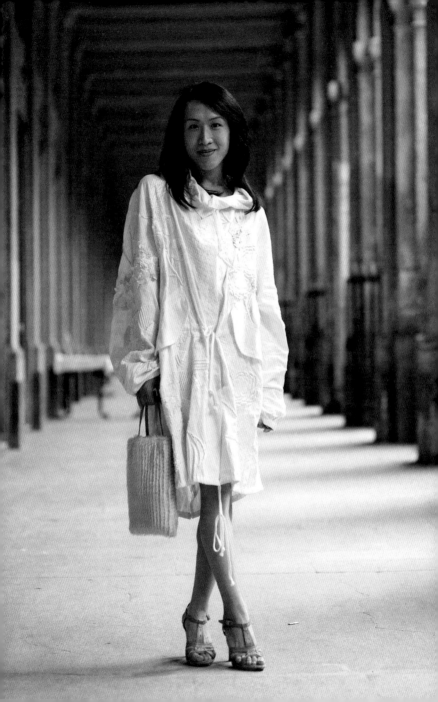

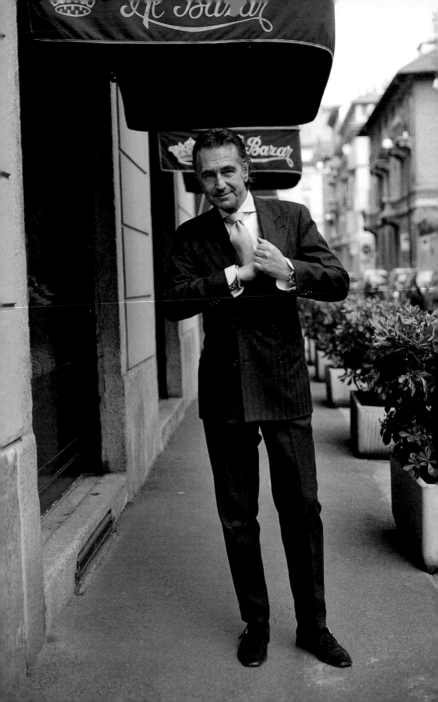

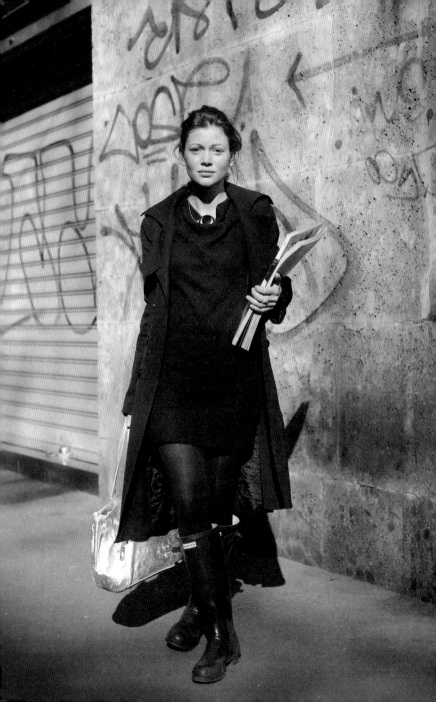

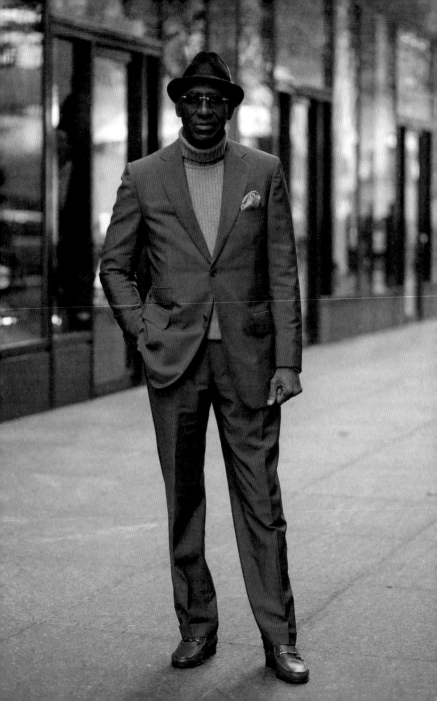

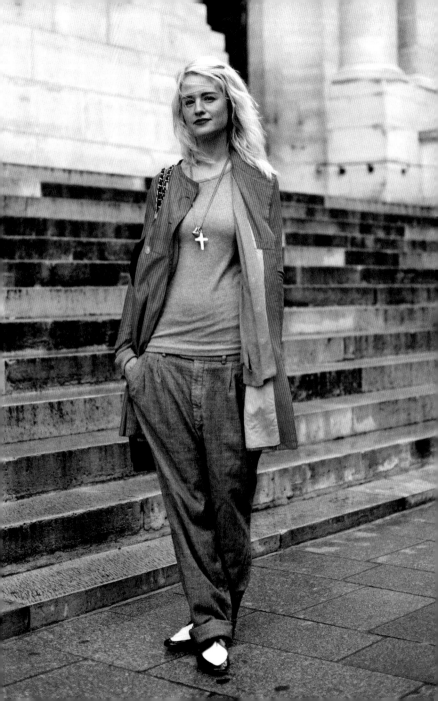

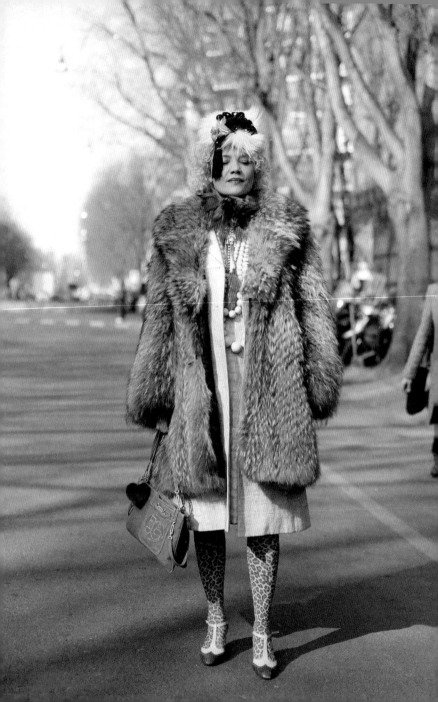

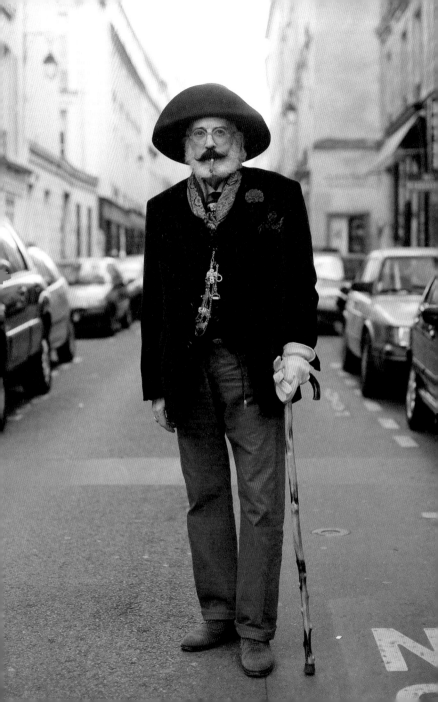

Rich man? Poor man? New York

When I am out on the street shooting I like to keep my eyes scanning as far down the block ahead of me as possible. This way I can have plenty of time to decide if I want to shoot a potential subject. I remember when I saw this gentleman in the distance. As he came closer and more clearly into view, all I could think was, 'Is this guy poor or just eccentric?' He was wearing a lot of elements that people might call hobo chic – the beard, the knit cap, the patches on his jeans. By the time he was only a few feet away I could clearly tell that this beard was too perfectly manicured, the khakis too perfectly patched and the overall fit of his clothes too perfectly dishevelled to be unintentional. As it turned out, he works for Ralph Lauren in their creative services. I think it is funny what we consider to be an unmistakeable outward sign of wealth or poverty. In the US, if a guy has a salt and pepper beard and a knit cap, almost regardless of the rest of the outfit, he will be judged a hobo – that mental image is still so strong in American culture. A year or so later I included this photo in my first one-man exhibition, at Danziger Projects. One of the newspaper critics who reviewed the show mentioned that it was nice that I had included a homeless man among the other high-style people portrayed in the exhibit. I just didn't have the heart to let the critic know that the homeless man probably made twice as much money as he did.

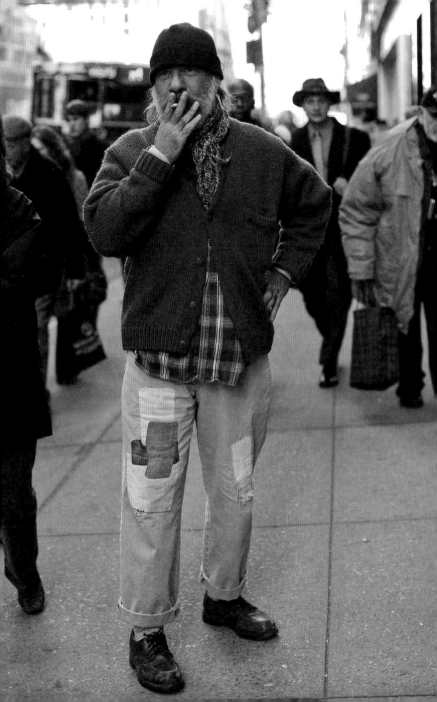

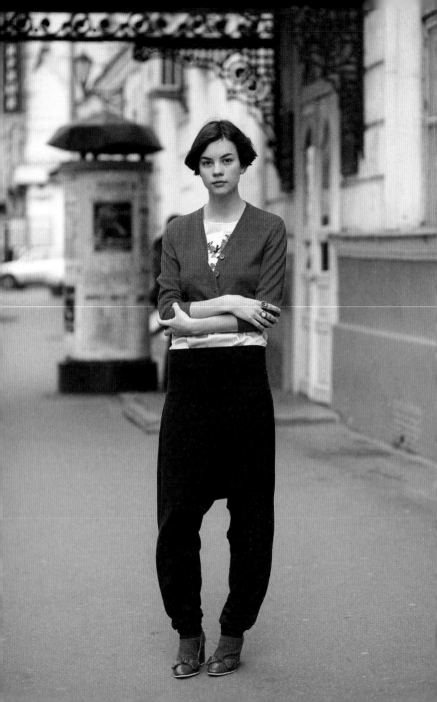

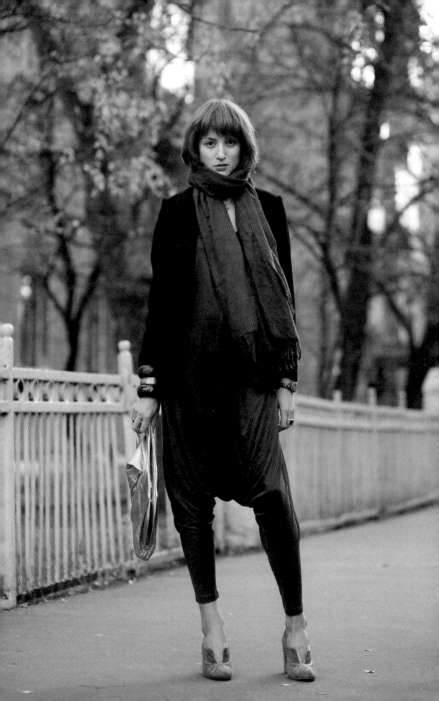

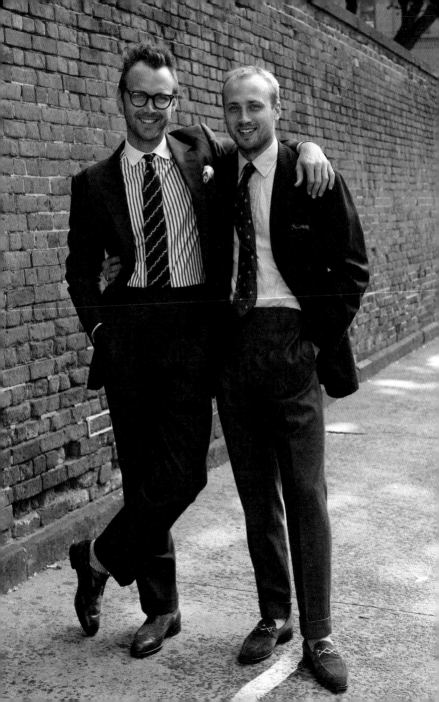

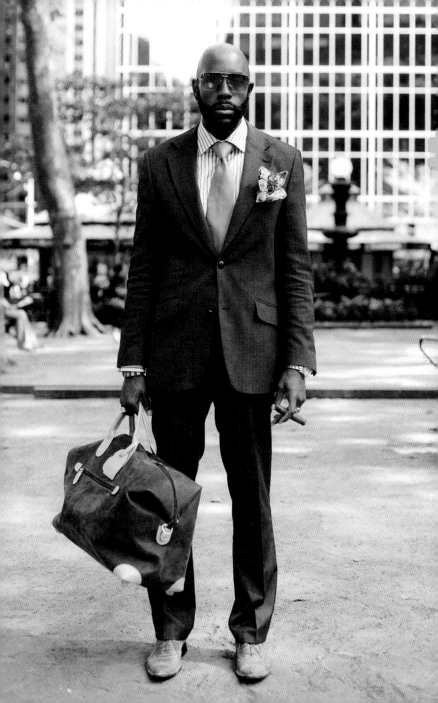

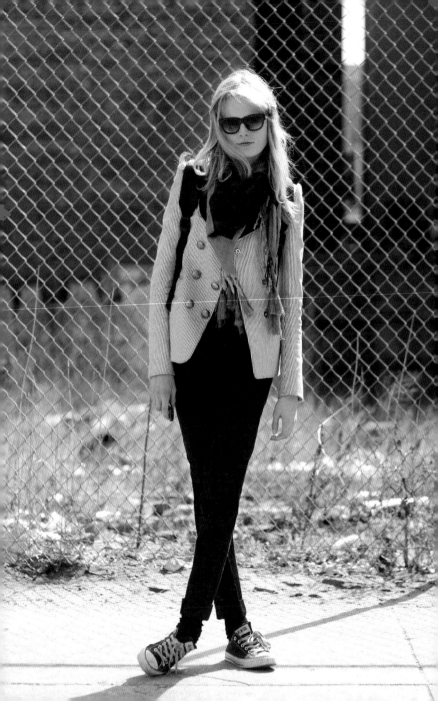

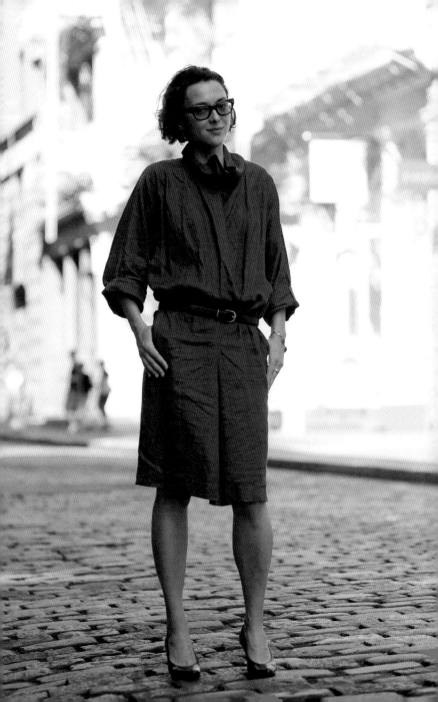

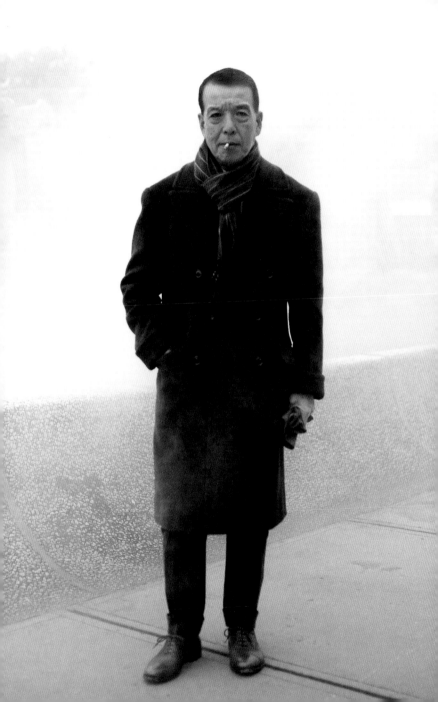

This guy just exudes masculine charisma. I don't know if clothes make the man, but would he look as cool if his clothes didn't fit so perfectly? A lot of the comments on the blog are from people who want to 'look like him when I get older'. I am so proud that I have created a blog that celebrates how to grow old gracefully and stylishly. We are all only going in one direction; why not stop fighting the ageing process and learn to flow with it?

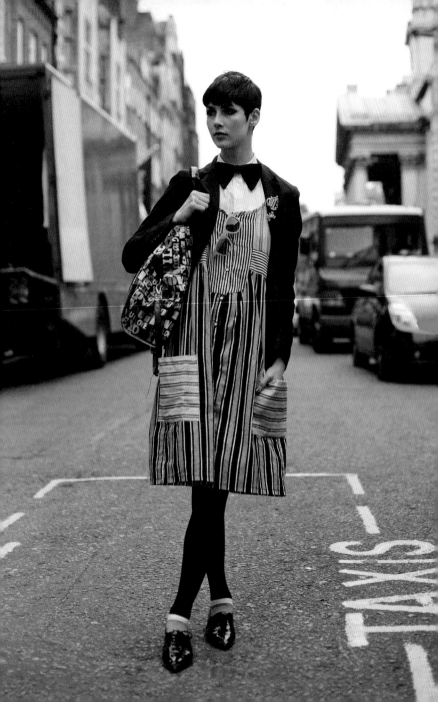

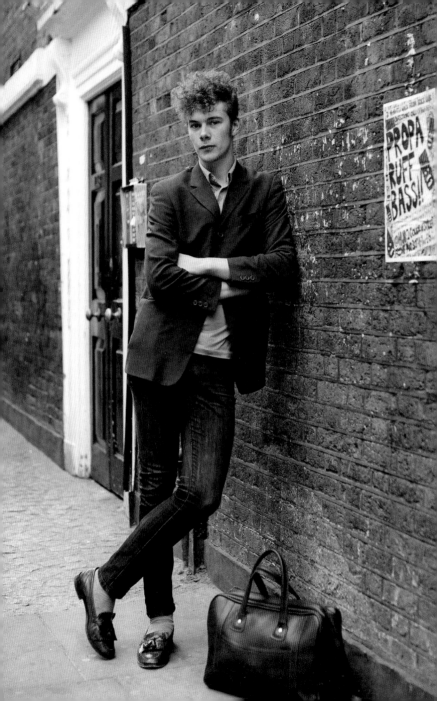

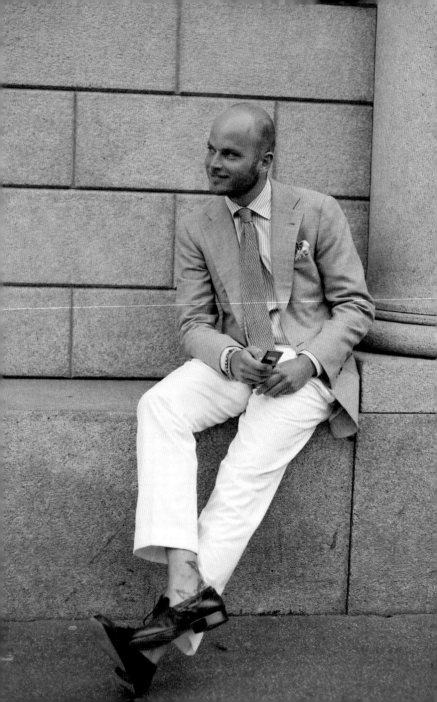

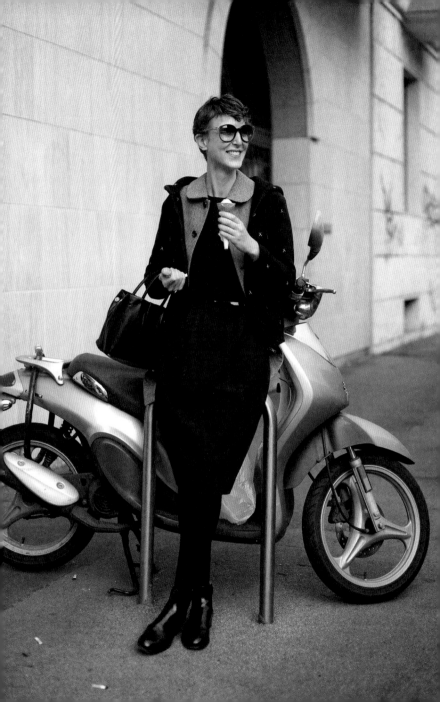

Lynn Yeager, New York

Often, larger-sized women feel alienated from fashion – which isn't very surprising. Where I feel larger women make a mistake, though, is by trying to play the fashion game using the rules stated by magazines that show size 2 eighteen-year-old models. This young woman, Lynn Yeager, always looks so chic to me. She wins at the style game not by following current trends but by understanding and utilizing all elements of design – colour, pattern, texture, proportion – in her look. Her style might be a little over the top for some, but when you see her the complexity of her look draws you in, and one of the last things that you notice is her size.

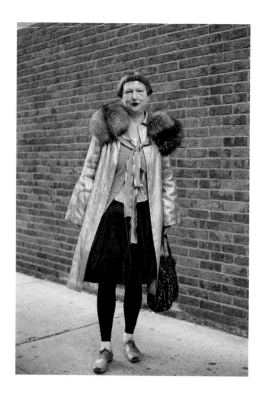

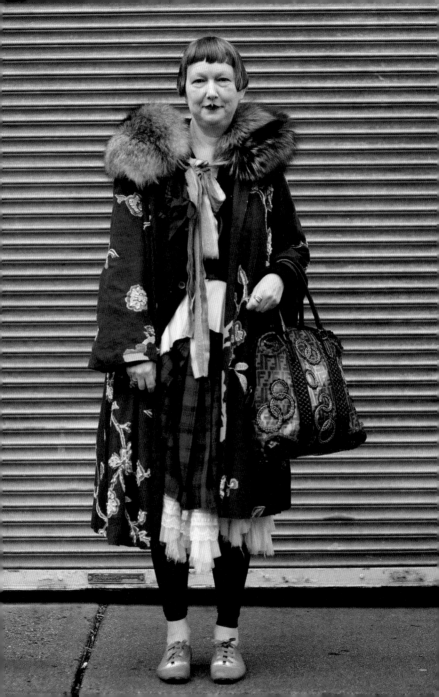

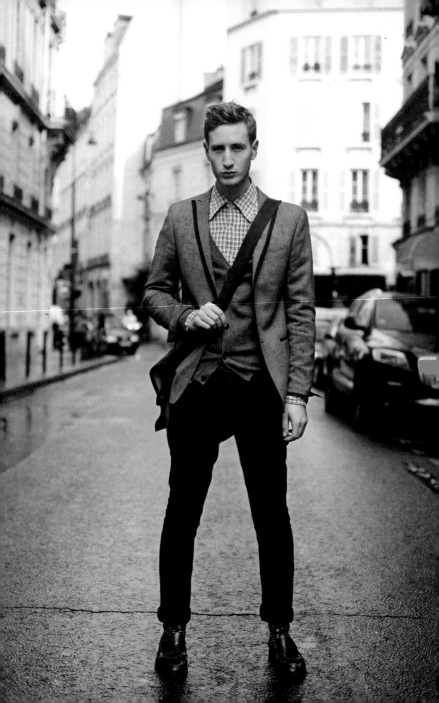

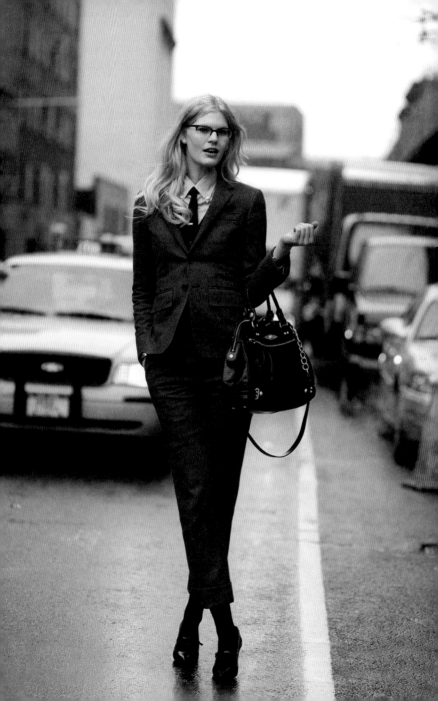

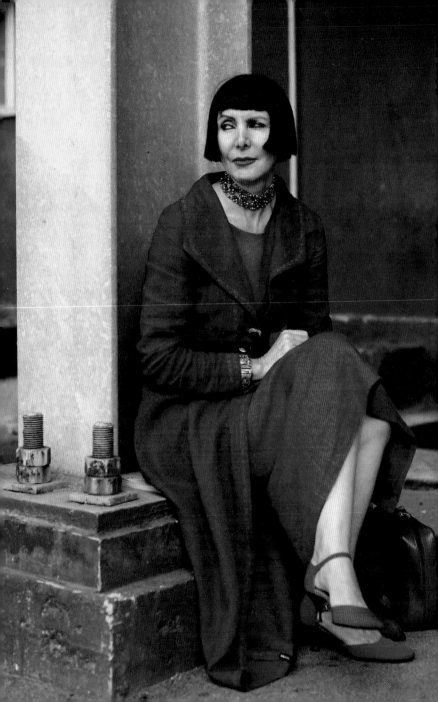

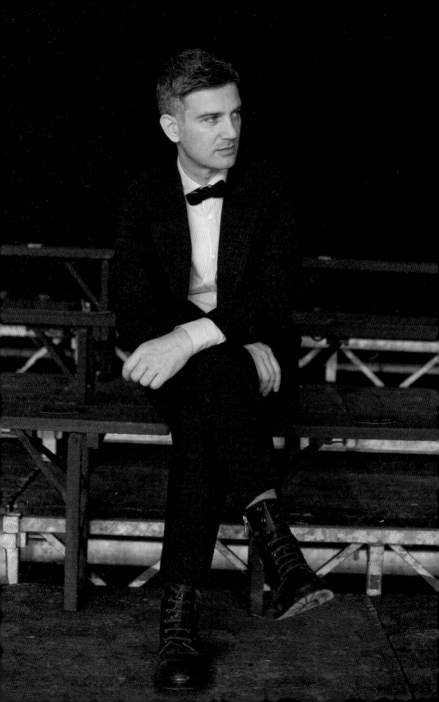

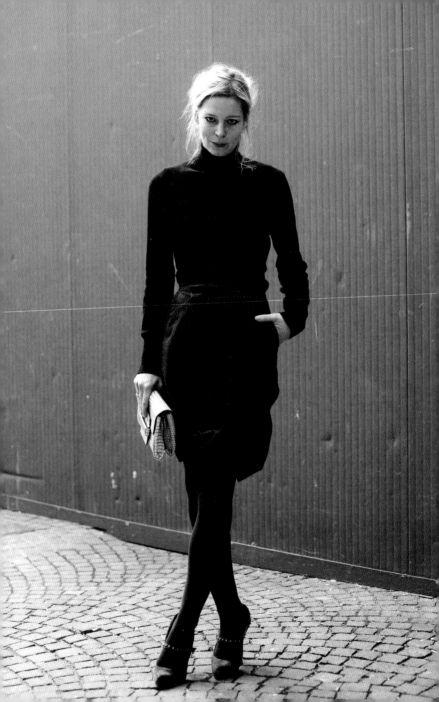

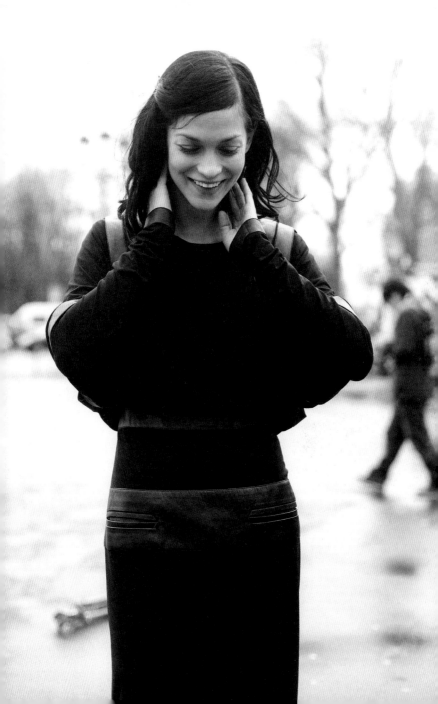

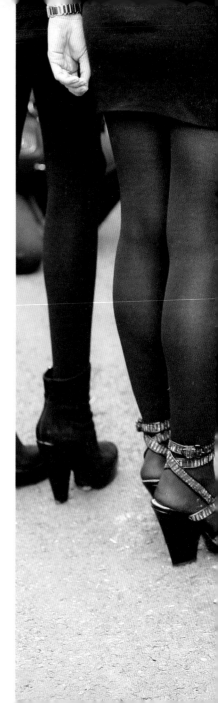

The legs of
French *Vogue*

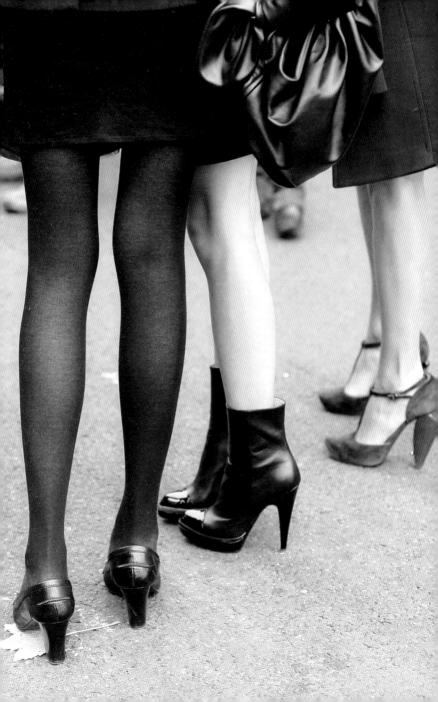

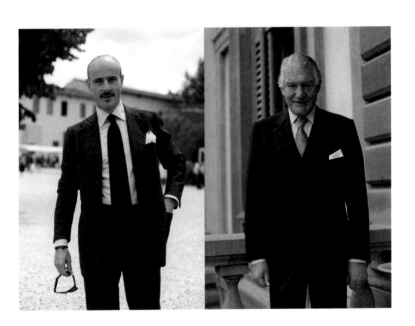

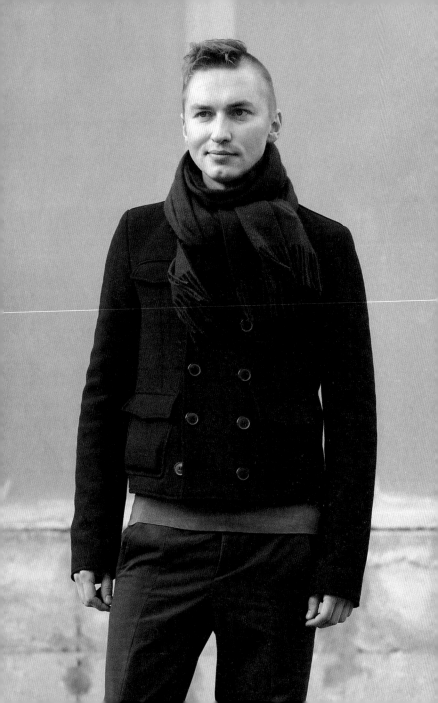

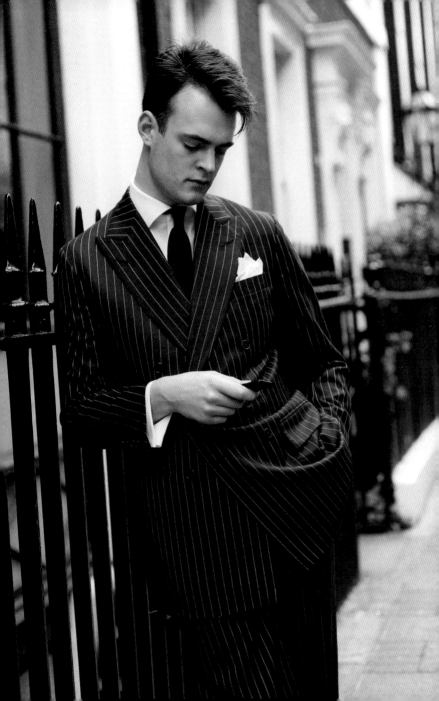

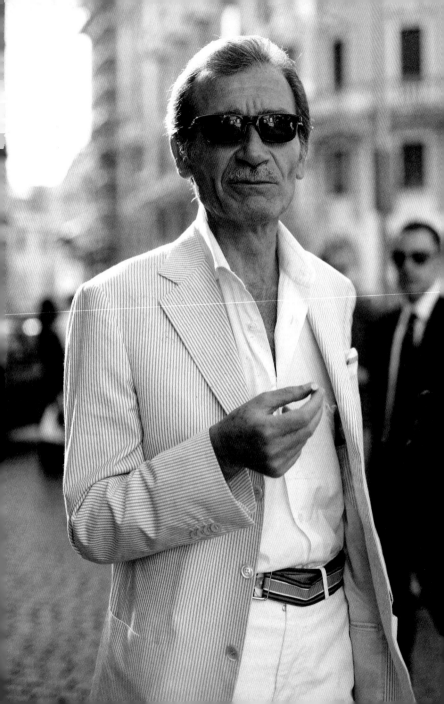

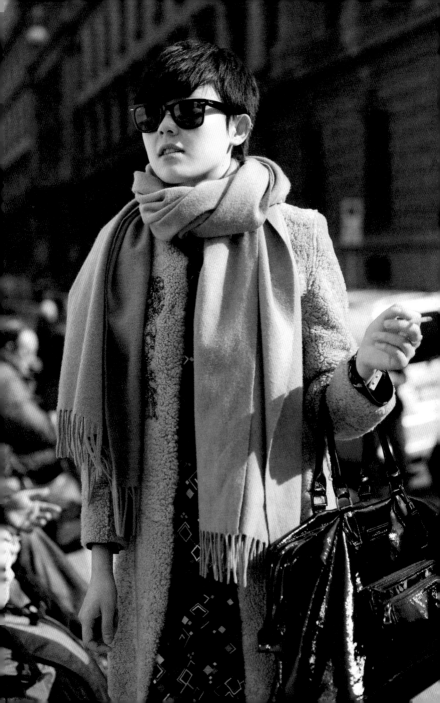

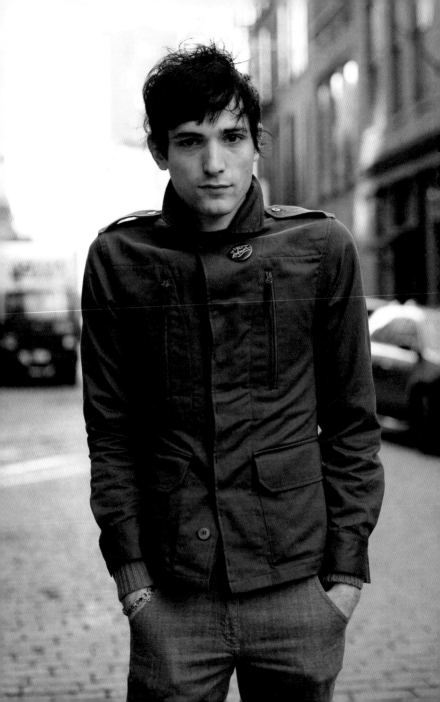

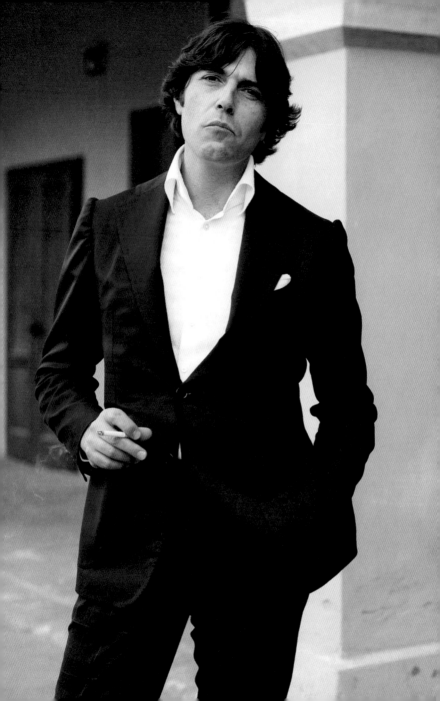

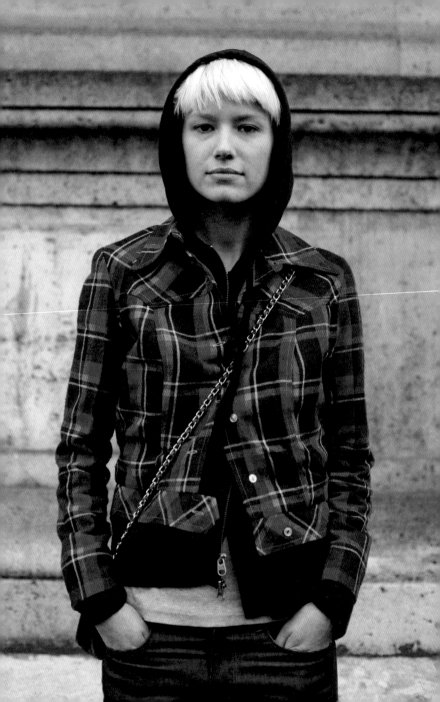

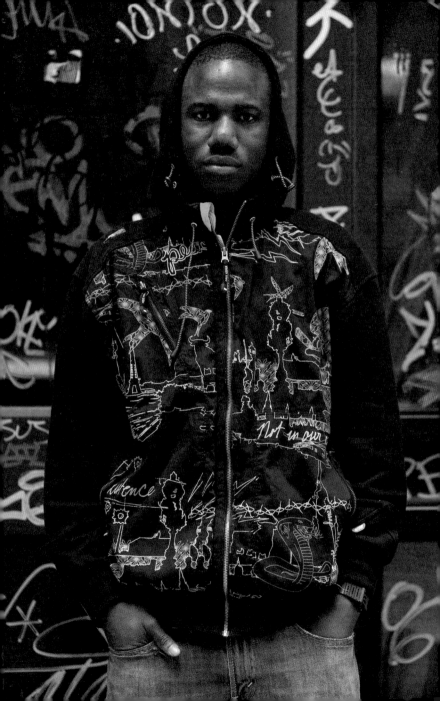

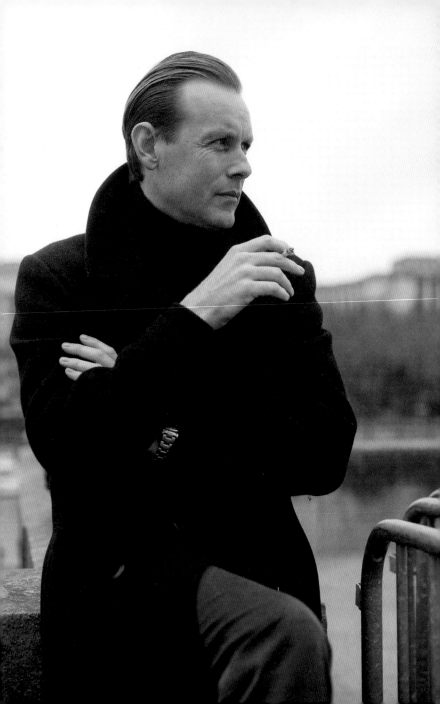

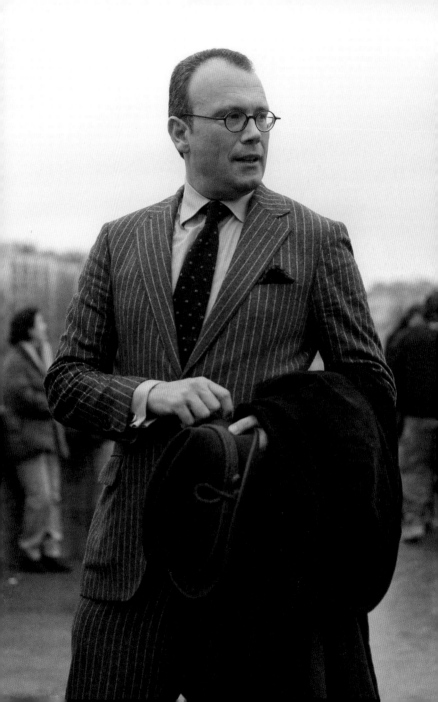

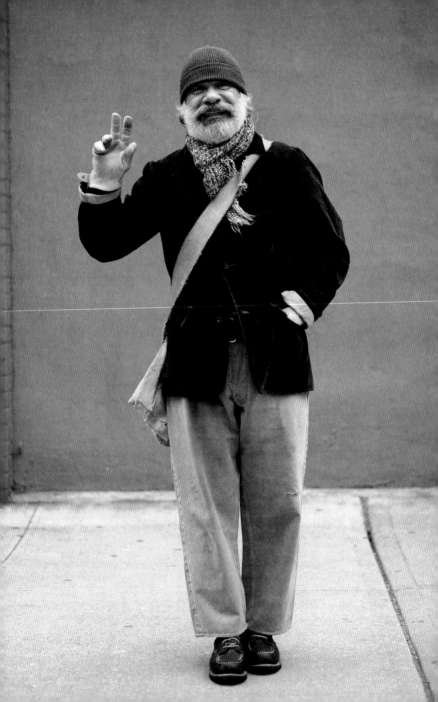

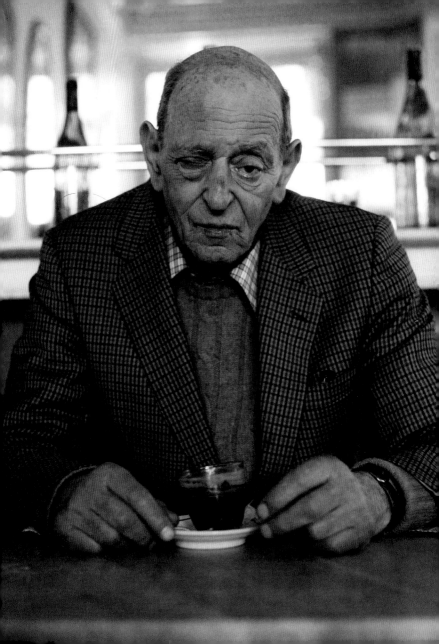

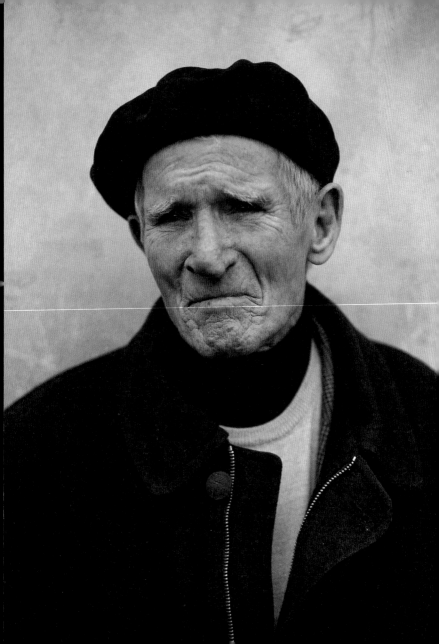

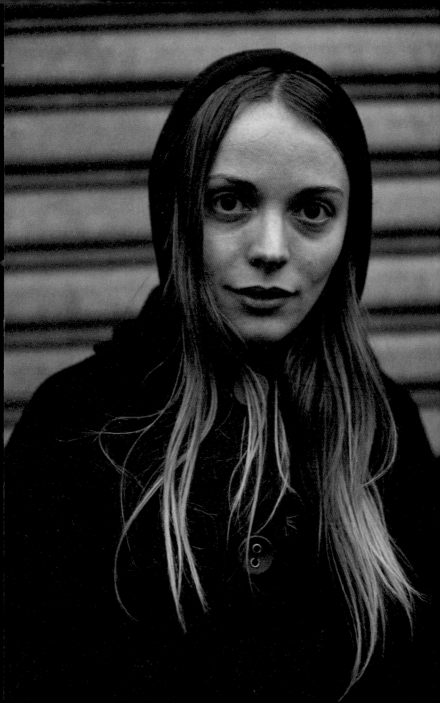

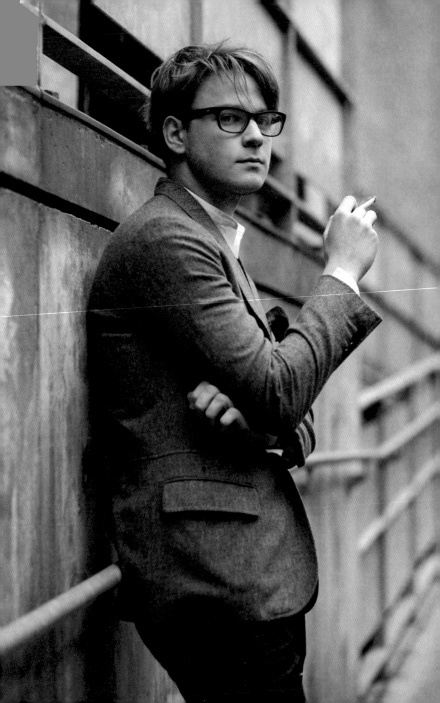

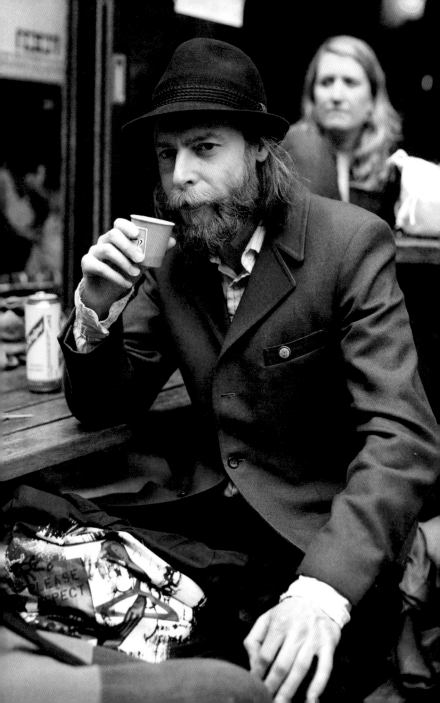

Robert

Robert is one of the few fashion editors whose appearance I am always curious to see each day during show season. His look is never precious or overly manicured; he really lives in those clothes and he makes his clothes work for him. They say women always want to show you their newest purchase and men want to show you their oldest. Robert seems to me to fit that idea: he is always more interested in an unusual mix of textures or colours than he is in what is on the runway that season.

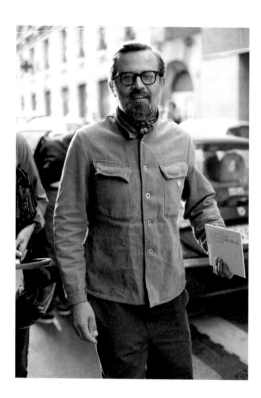

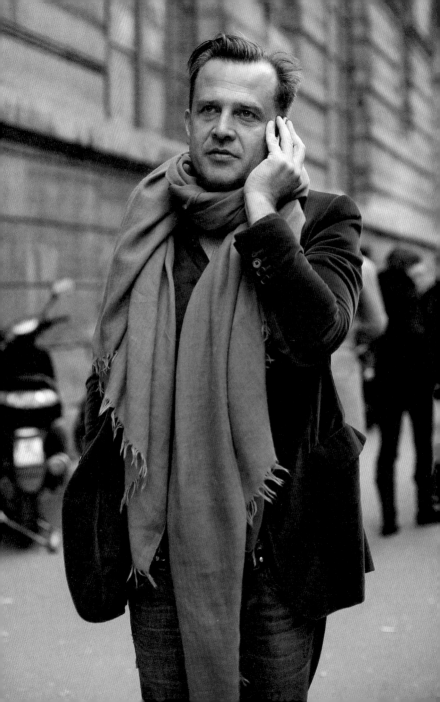

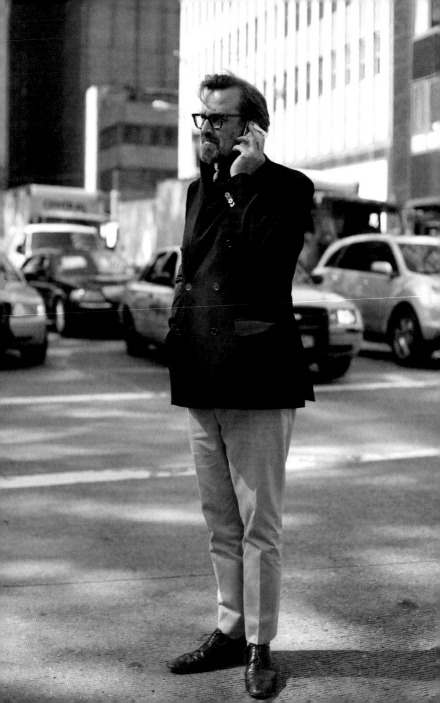

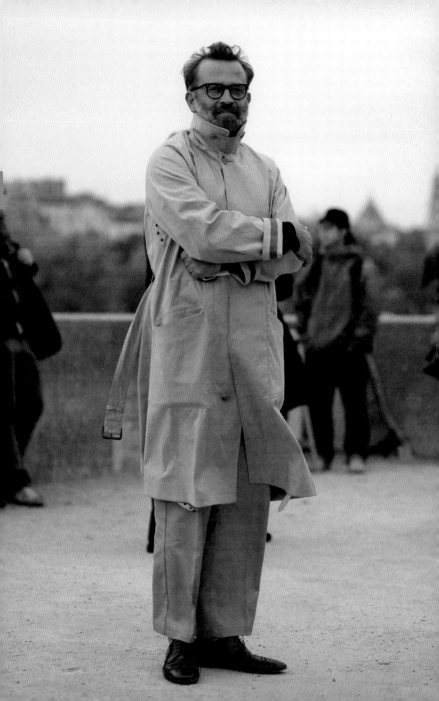

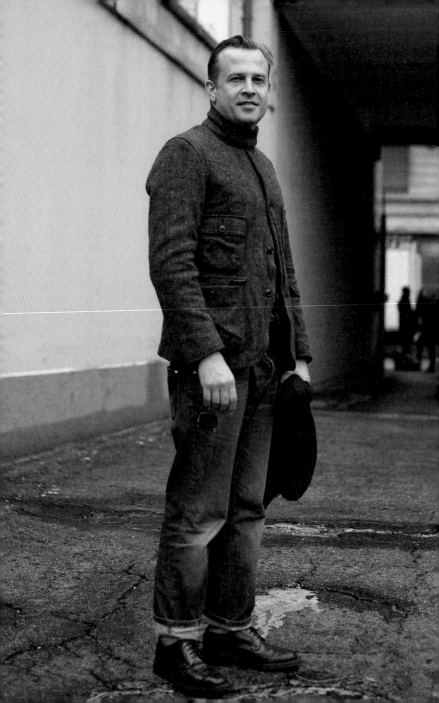

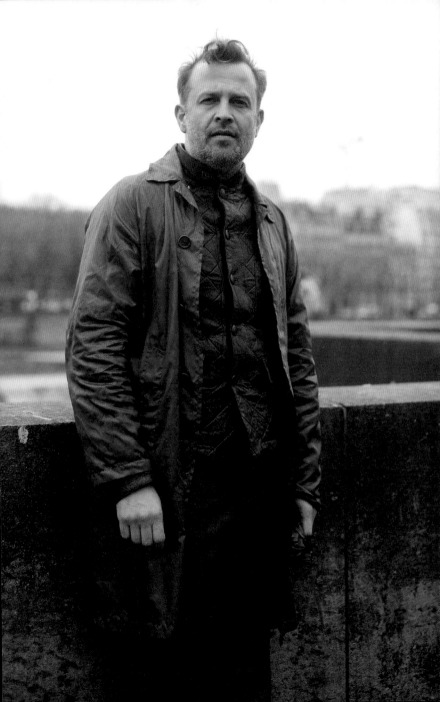

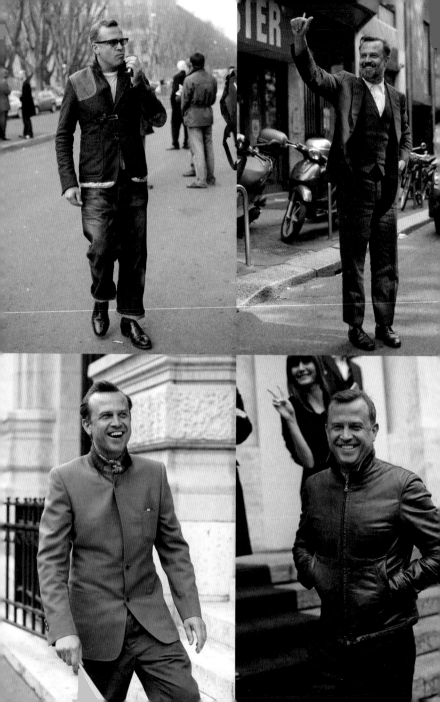

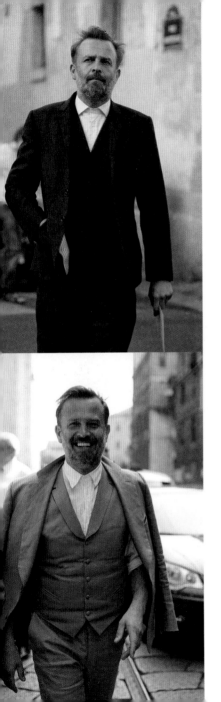

407

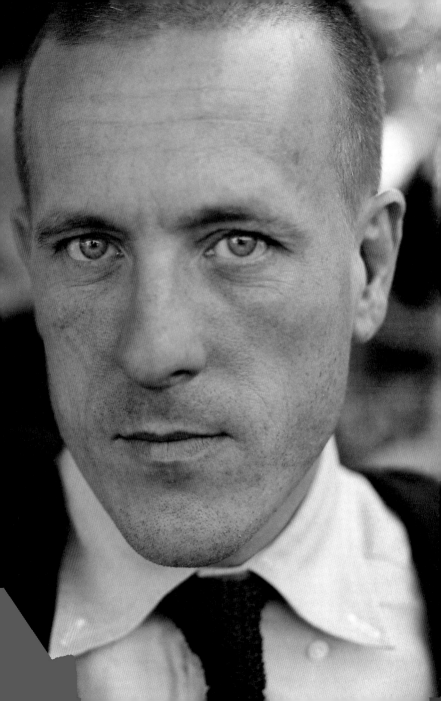

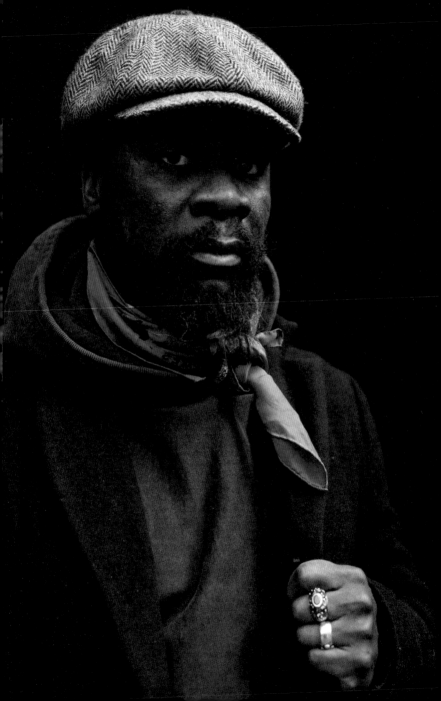

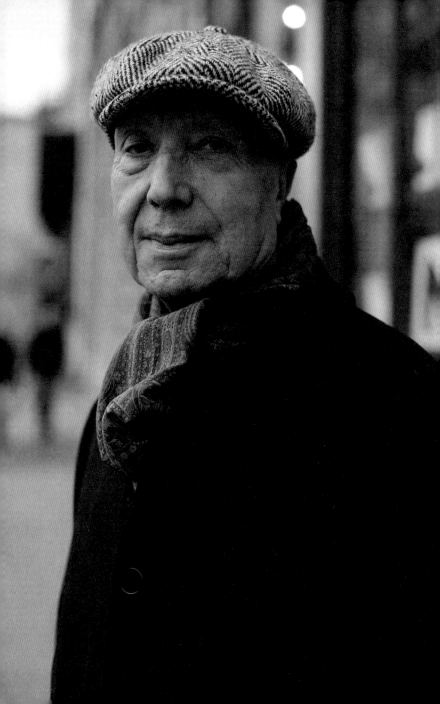

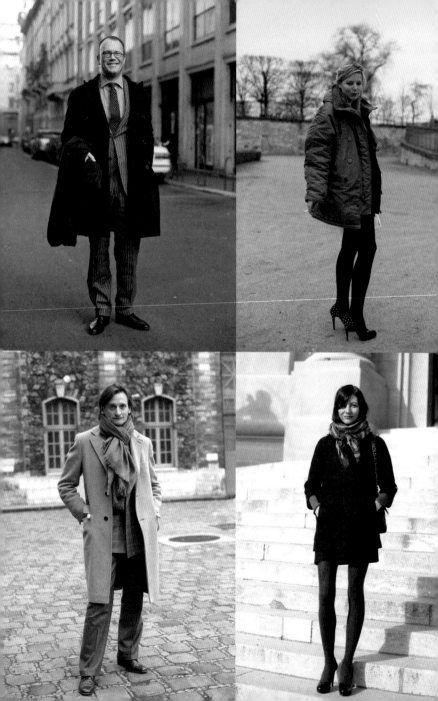

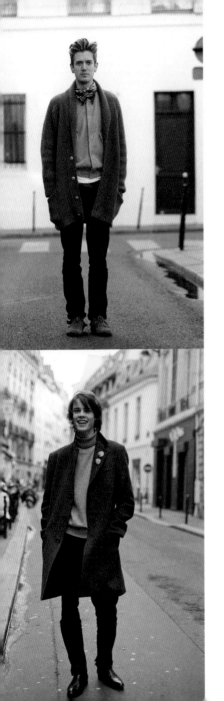

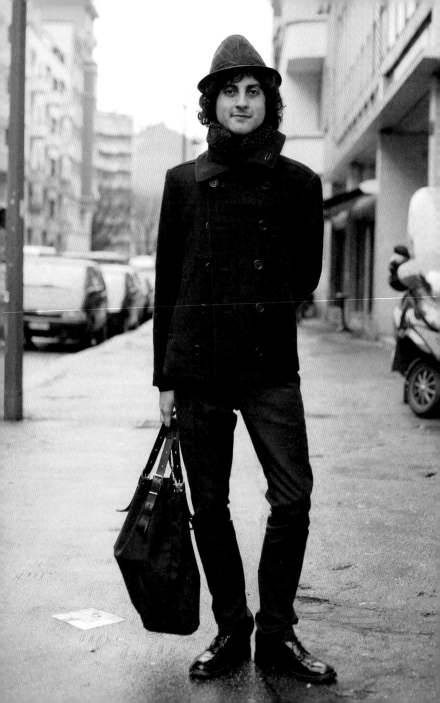

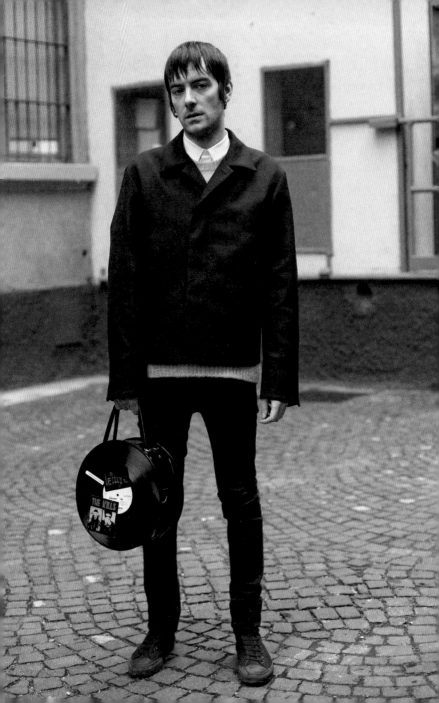

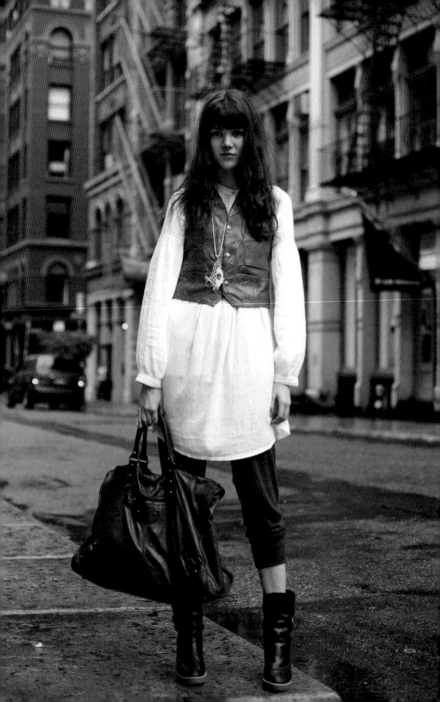

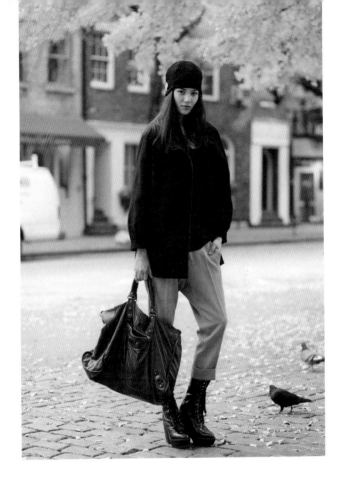

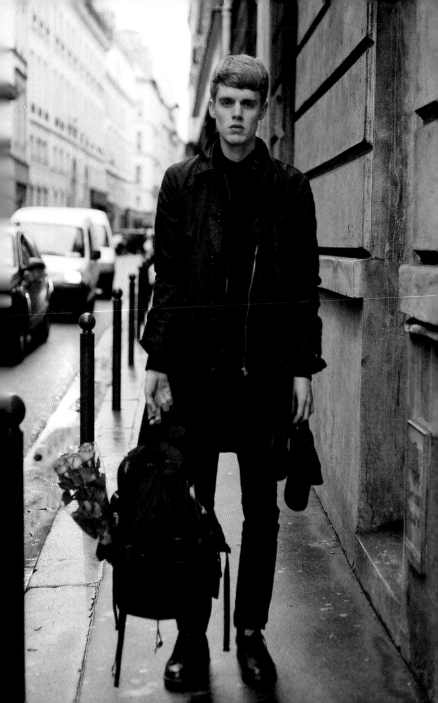

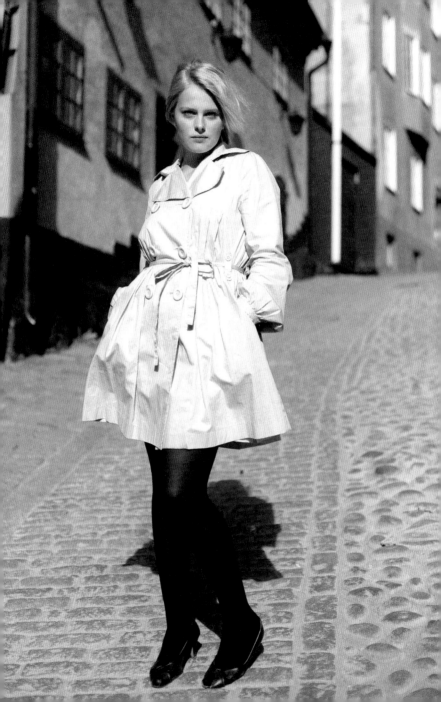

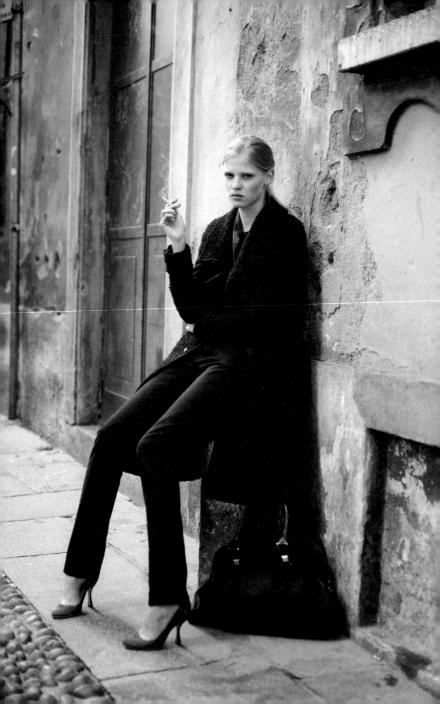

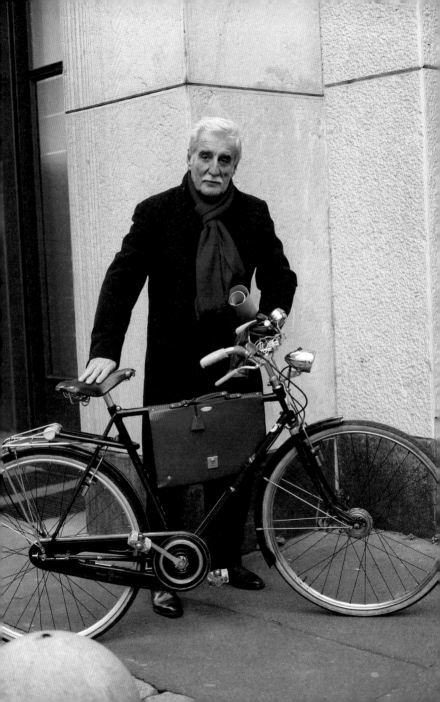

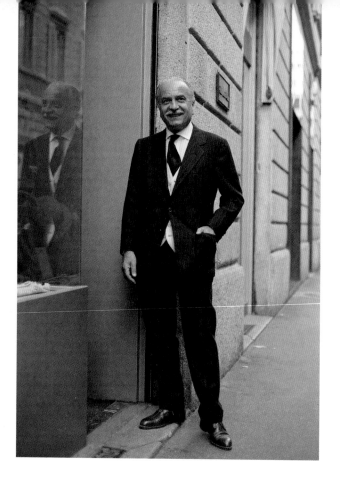

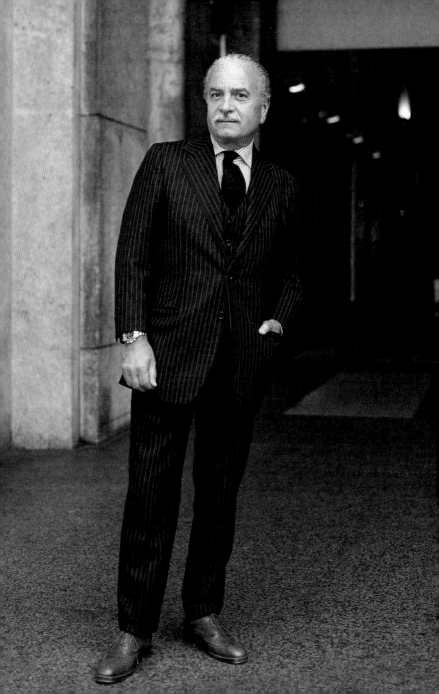

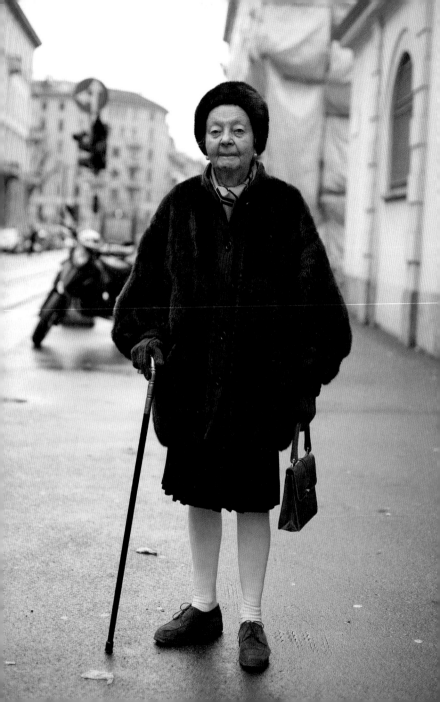

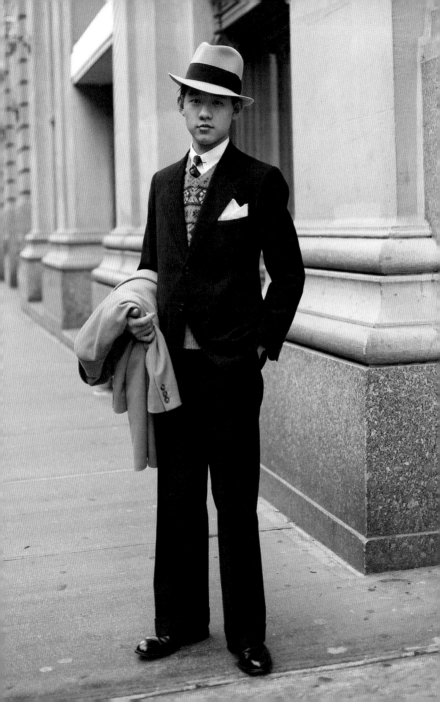

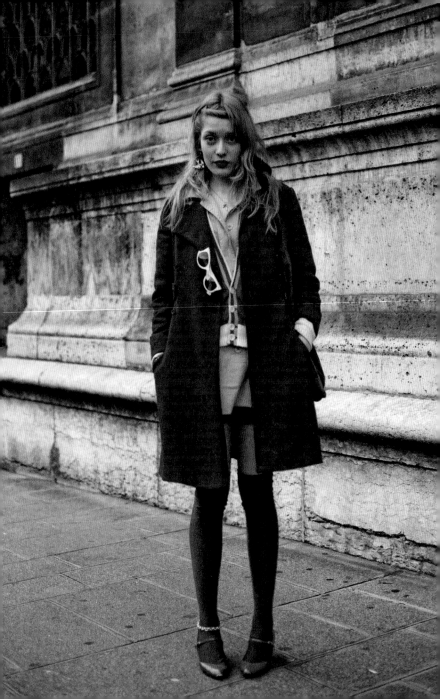

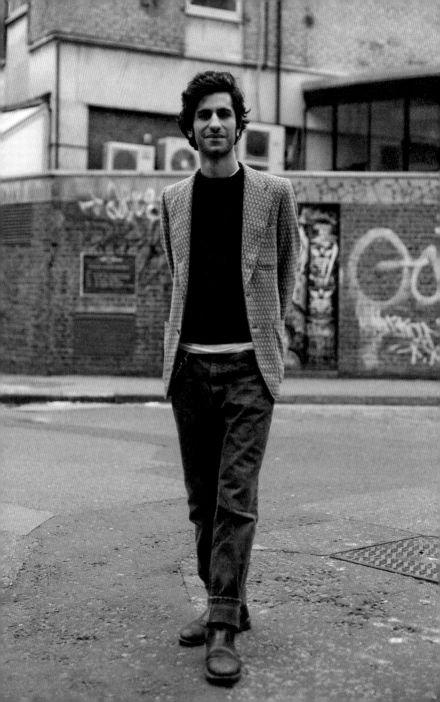

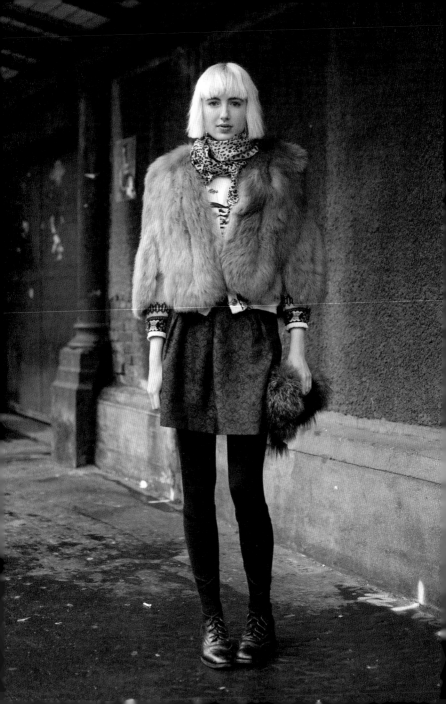

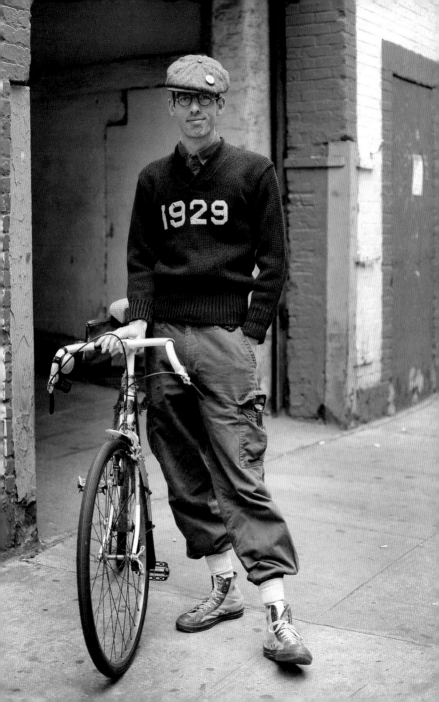

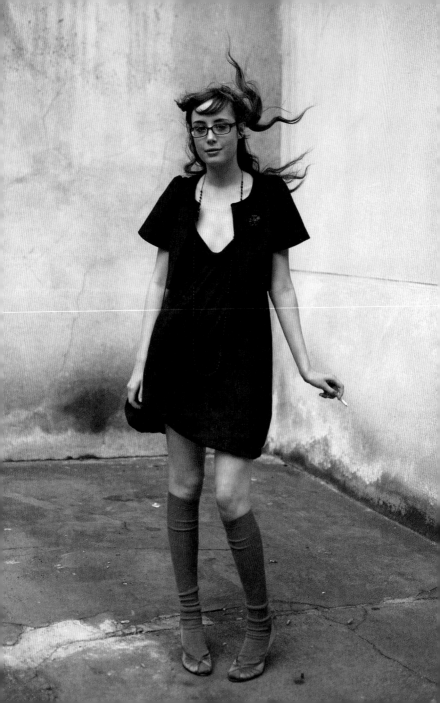

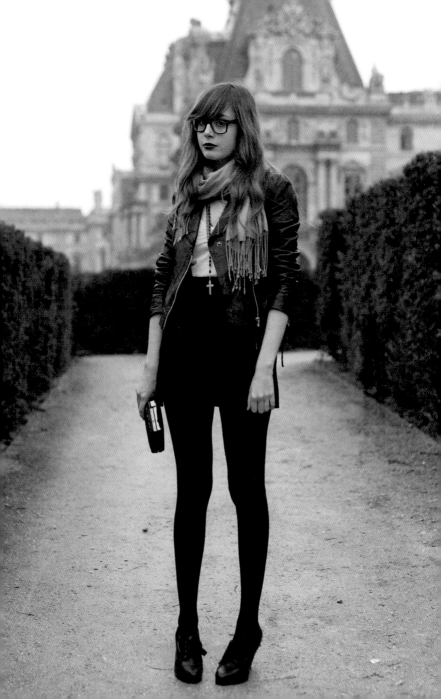

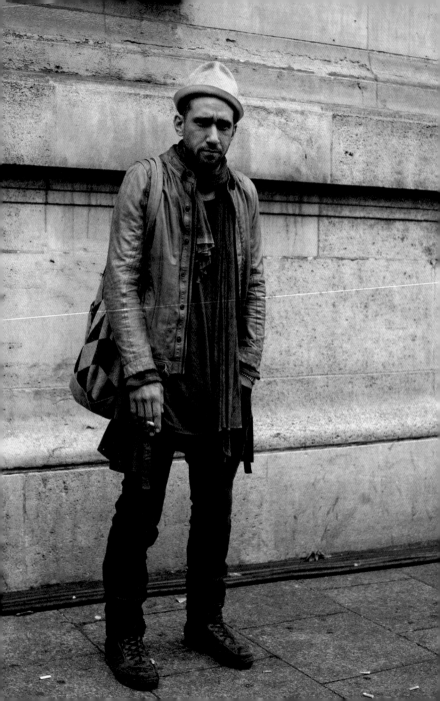

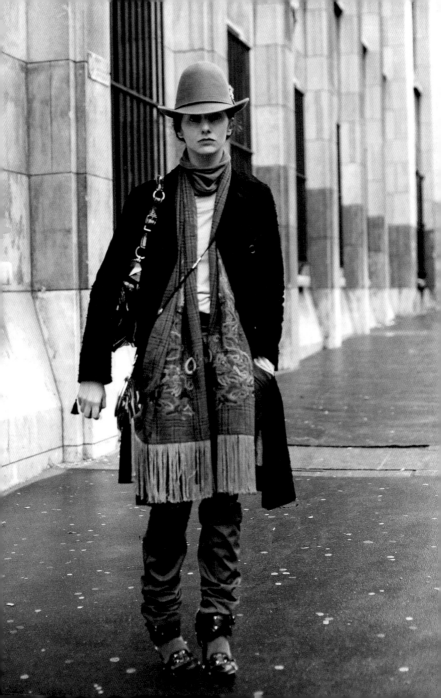

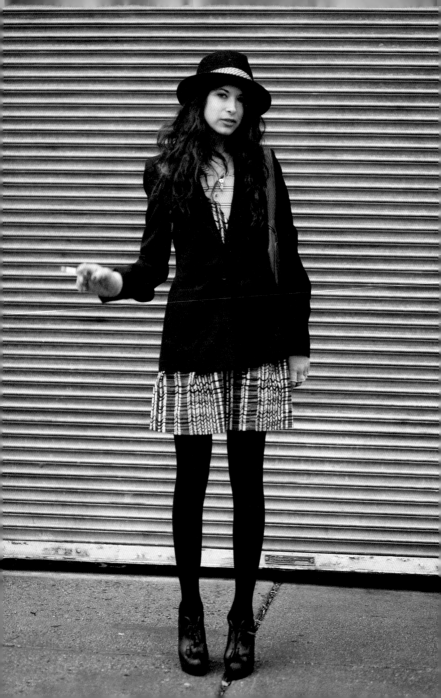

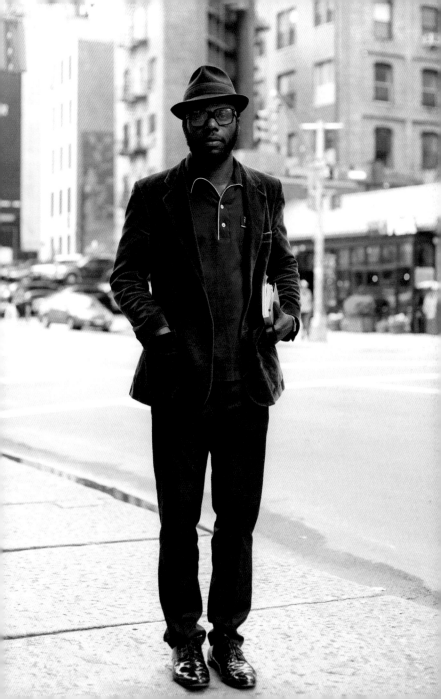

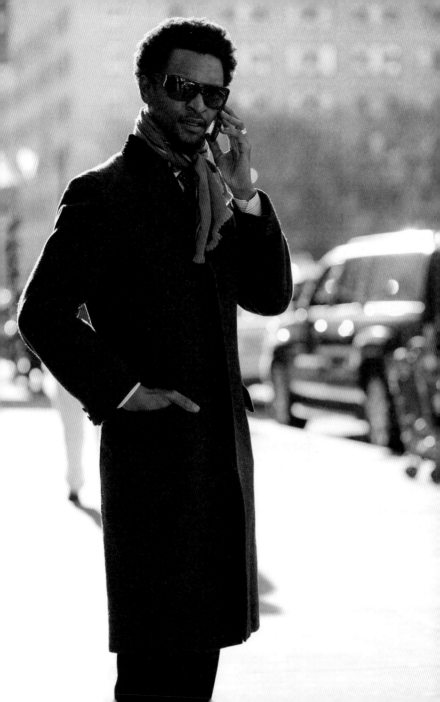

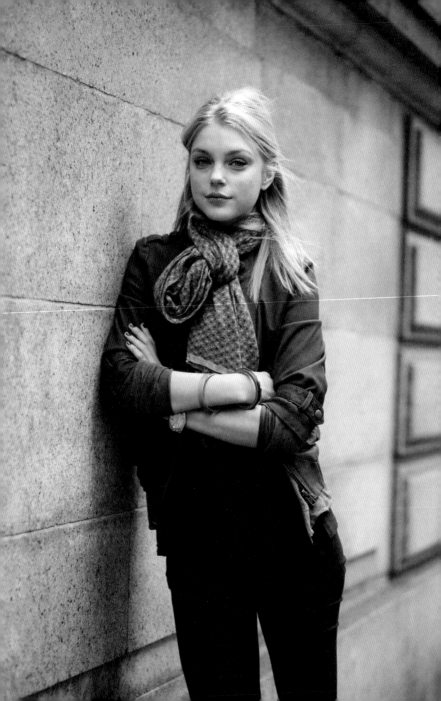

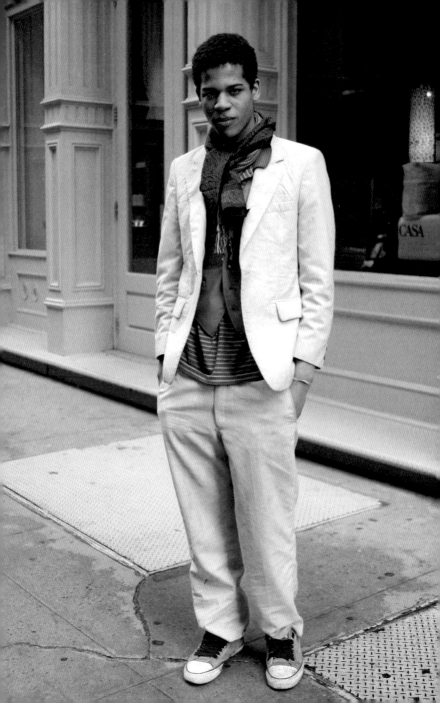

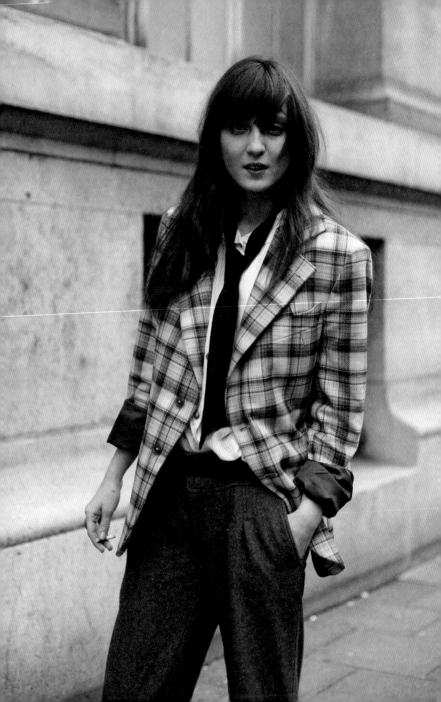

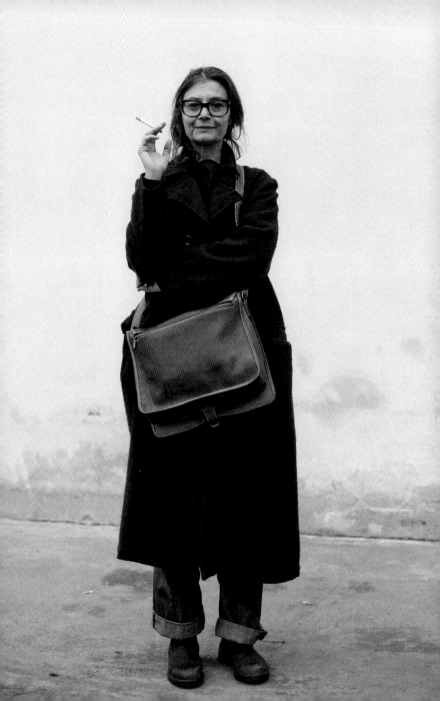

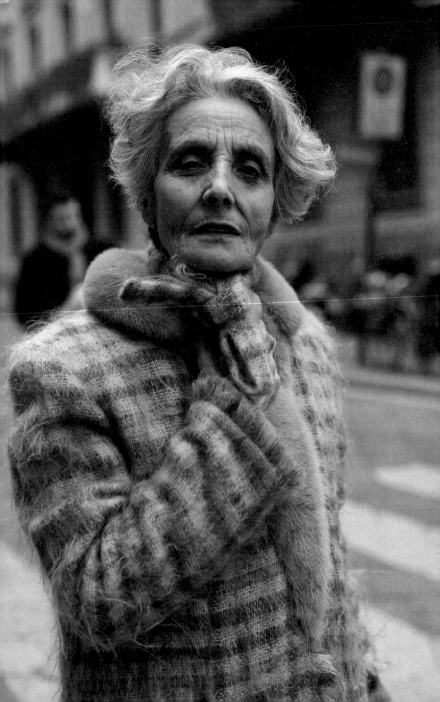

'Mi bruta', Milan

I saw this elegant woman on one of the most chic shopping streets in Milan. It didn't take me a moment to know I had to ask her if I could take her photo.

It is tricky as a young man to approach an older woman on the street for any reason, especially if you don't speak the same language. First you have to try to calm their suspicions, and then you must try to communicate your request. Luckily, I don't look too scary, so I approached this young lady and pointed to the camera and then to her, making the international sign for 'take a picture'. Of course, she thought I wanted her to take a picture of me – that happens often. Once she realized that she was the intended subject she protested: *'No, mi bruta.'* I knew enough Italian to understand that she felt she wasn't pretty enough to be photographed. I wasn't sure of the Italian word for 'beautiful', so I did what every American would do – I just added an 'o' to the end of the word. *'No, molto beautifulo!, molto elegante!'*

Well, this went back and forth for a several moments. I could see that if I kept this up for much longer I was in danger of her thinking I was hitting on her. Finally, I gave up, smiled and began to walk away. After a few steps I heard a simple 'Excuse,' and she motioned for me to take the photo.

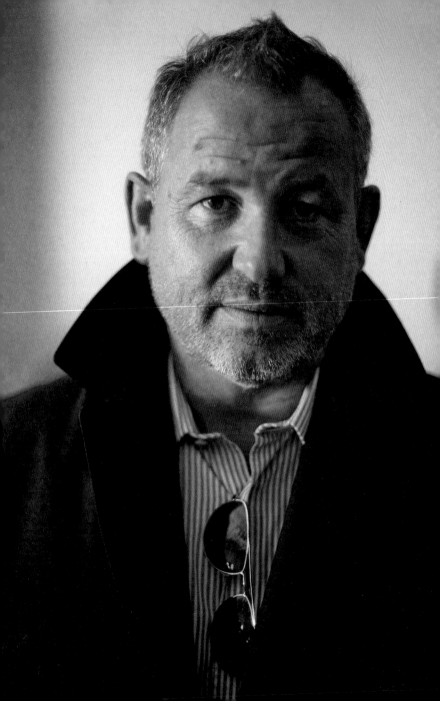

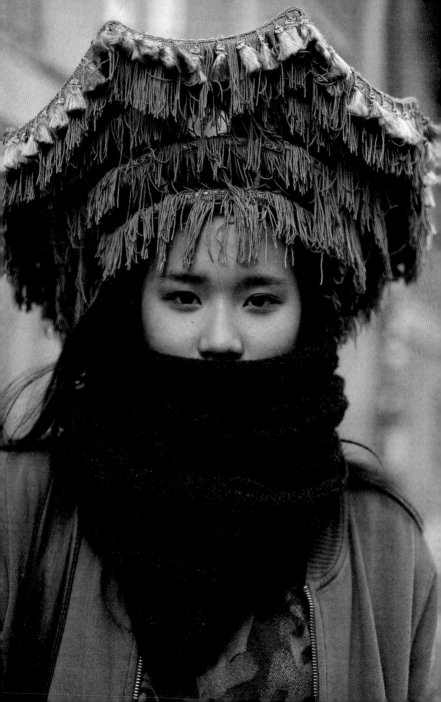

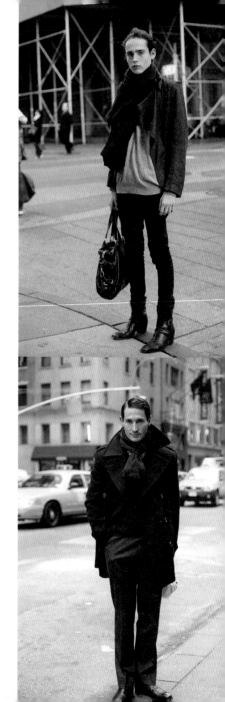

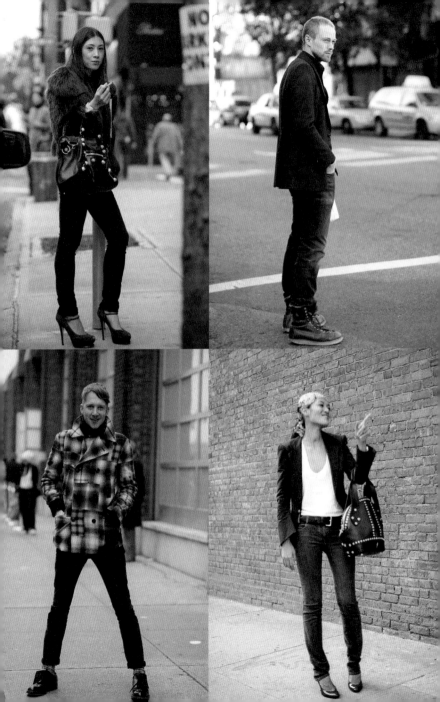

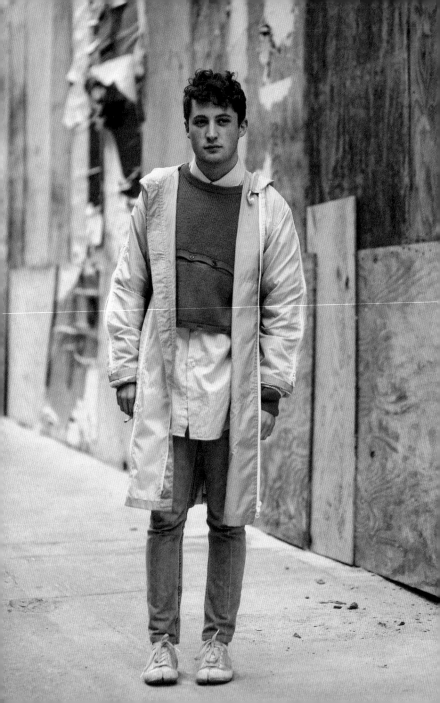

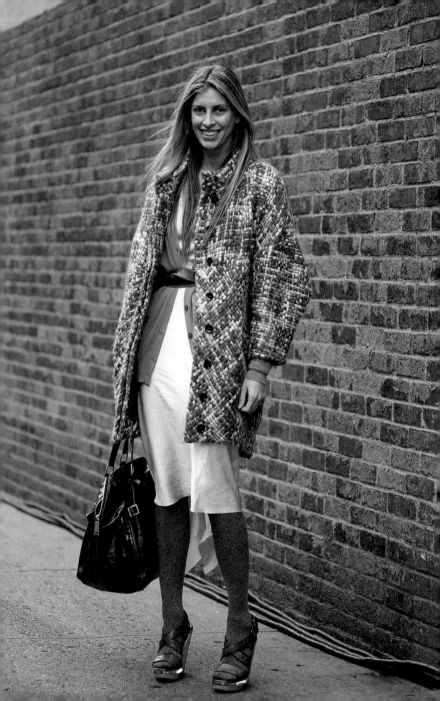

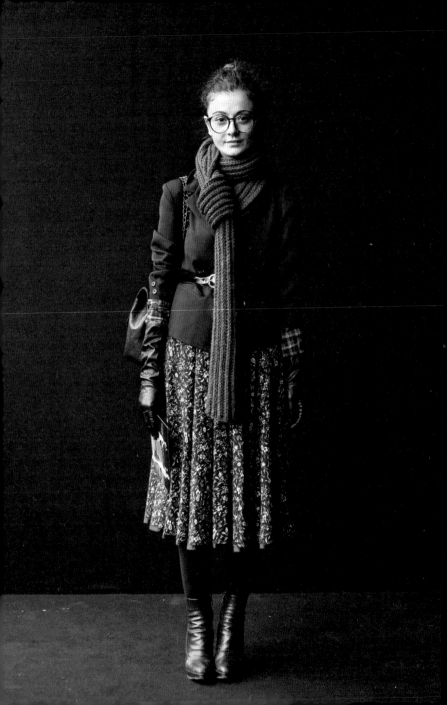

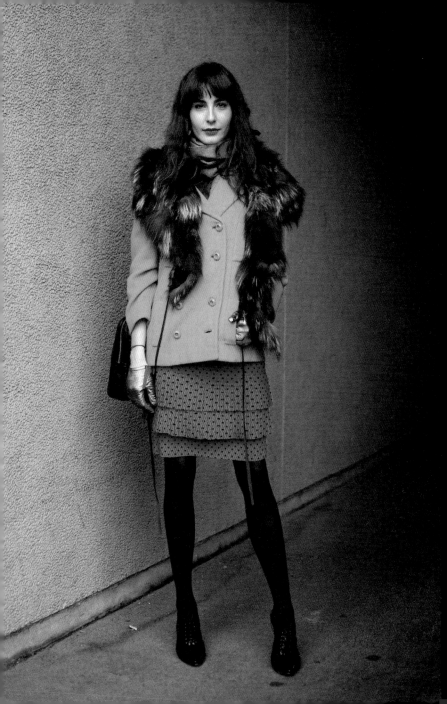

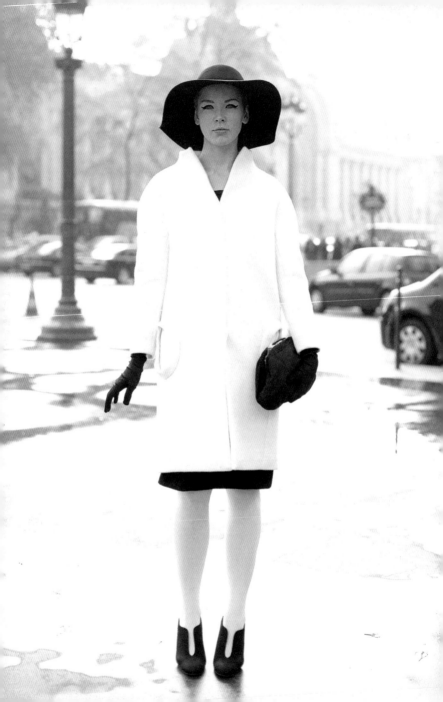

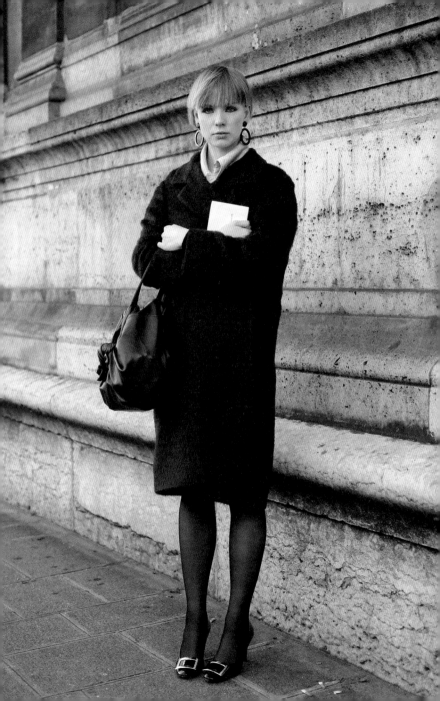

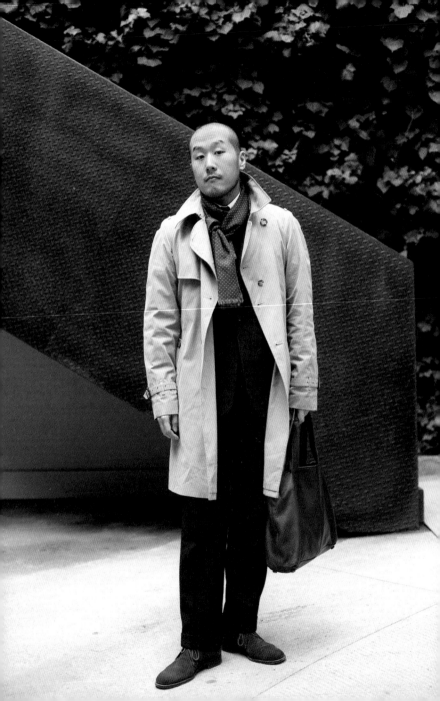

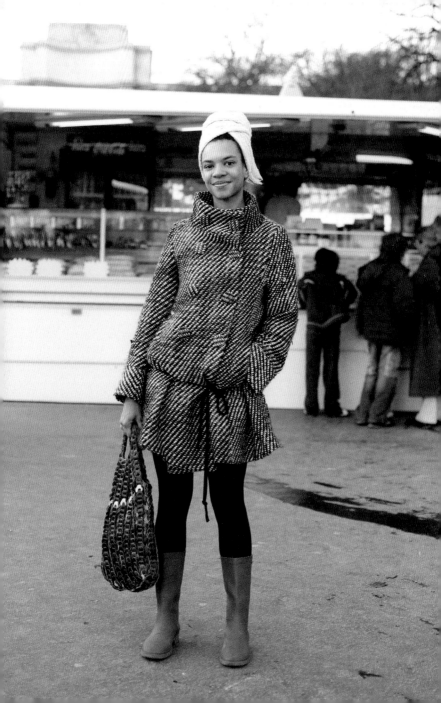

Je ne sais quoi, Paris

French girls have such an effortless way of making everything they wear seem exotic and sexy. I agree that part of it is an innate cultural way of looking at fashion, but what cannot be underestimated is the languid physicality of French women. They can say as much, if not more, about themselves with a simple hand gesture or seductive tilt of the head than just about any nationality of woman known to man. These two styles would look cool/nerdy chic on an American or Swede, but on a mademoiselle they still ooze sexiness.

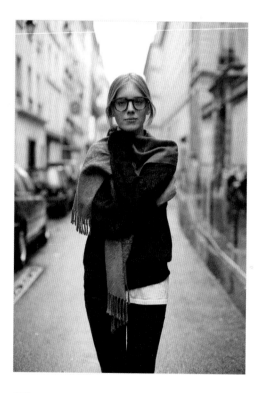

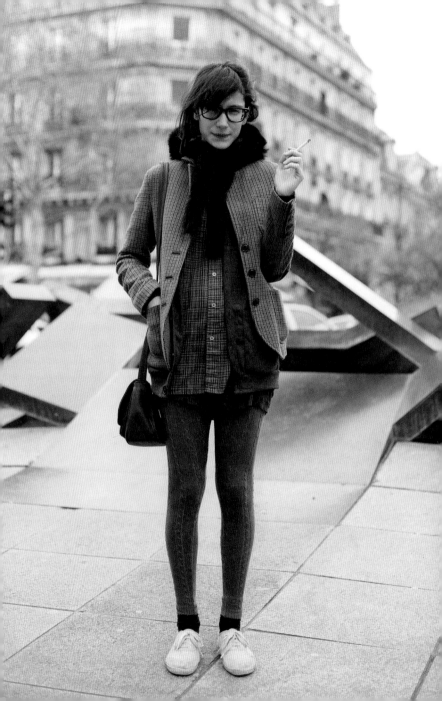

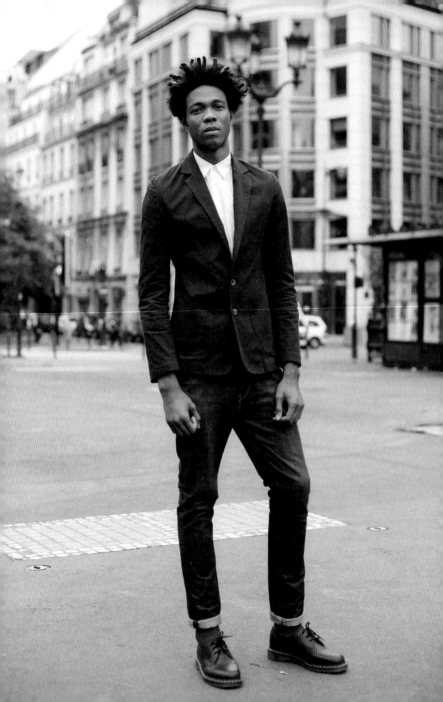

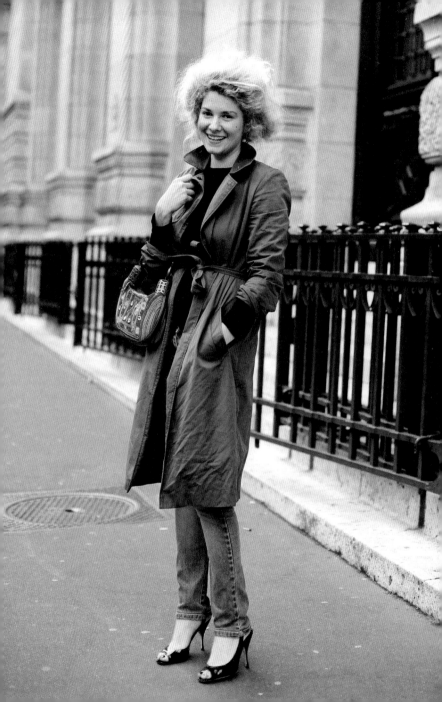

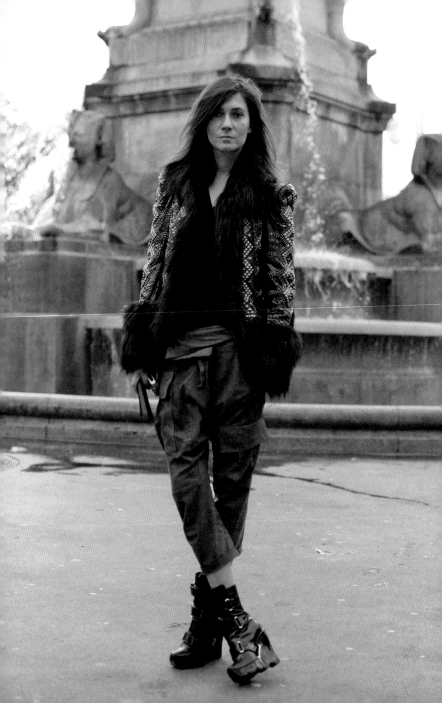

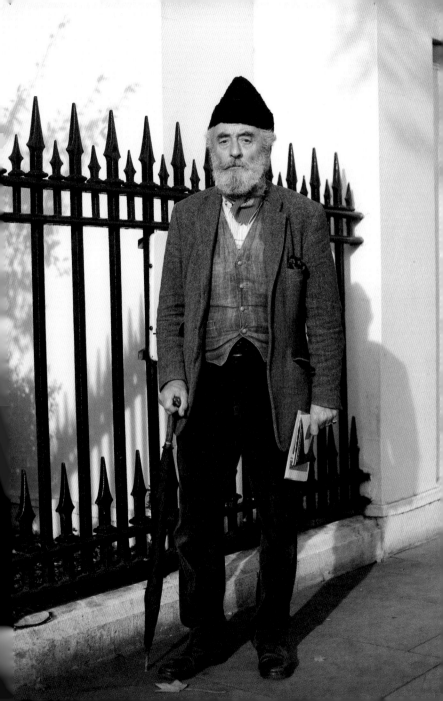

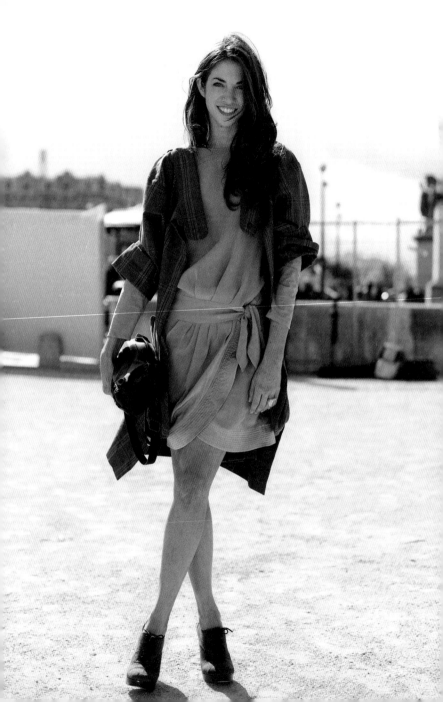

Signs of Life, Paris

I was chatting with Susan after I took this picture and mentioned that I thought her hair was just beautiful – her best feature.

She thanked me and said that she had once lost her hair because of cancer. She now purposefully keeps it long because she feels it is such a gift to have it back and, for her, it's a sign of life.

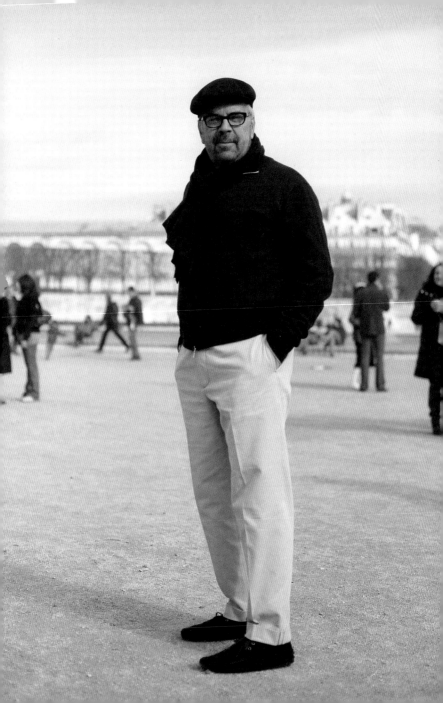

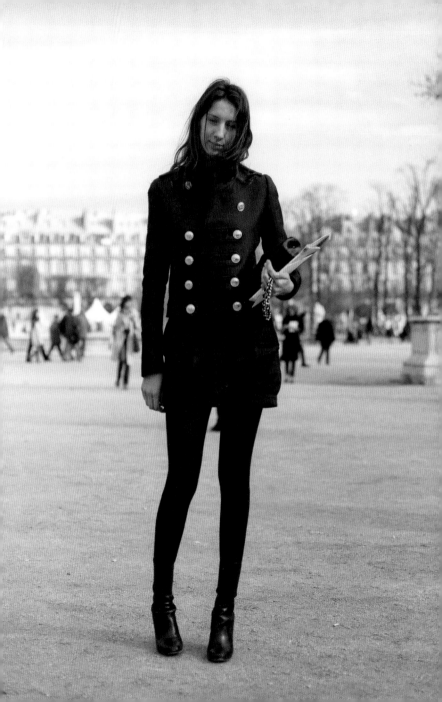

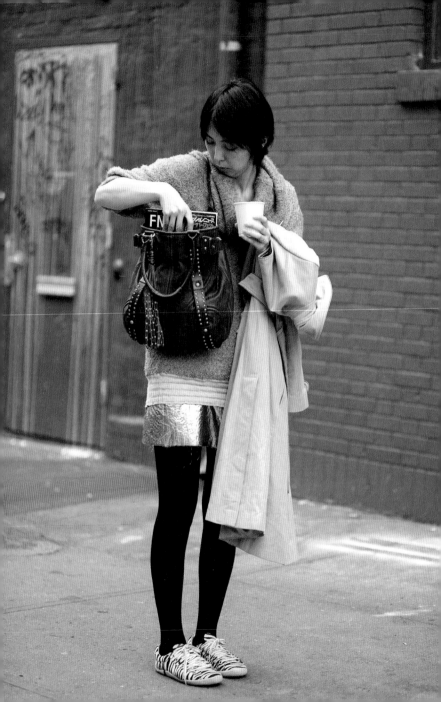

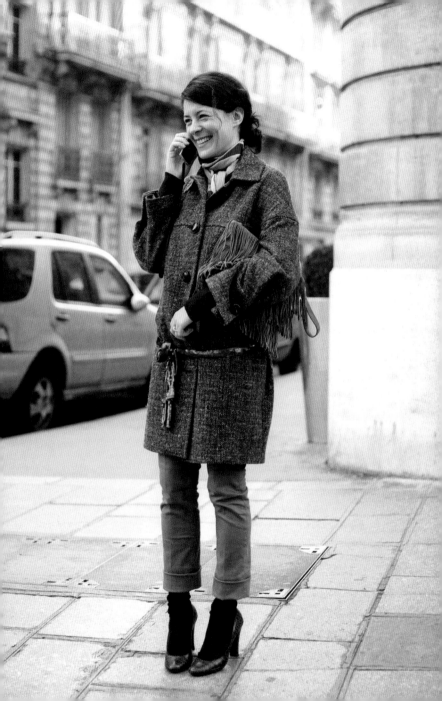

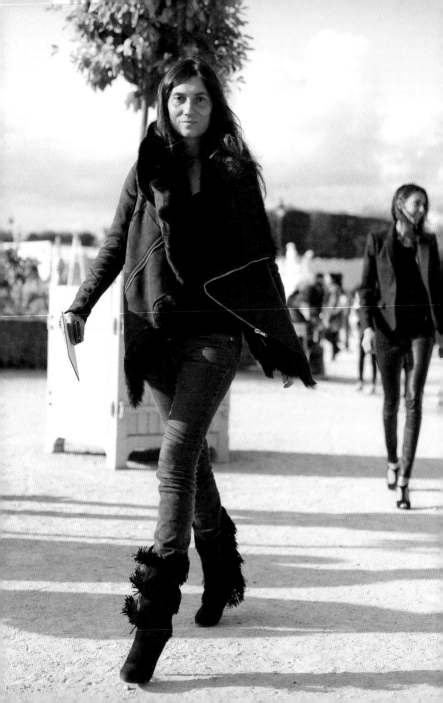

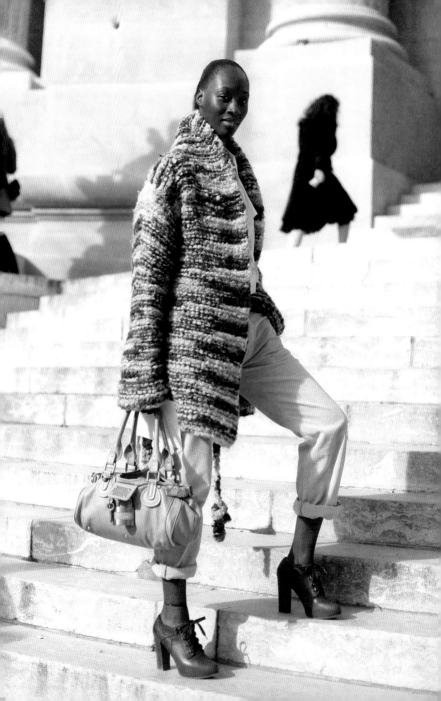

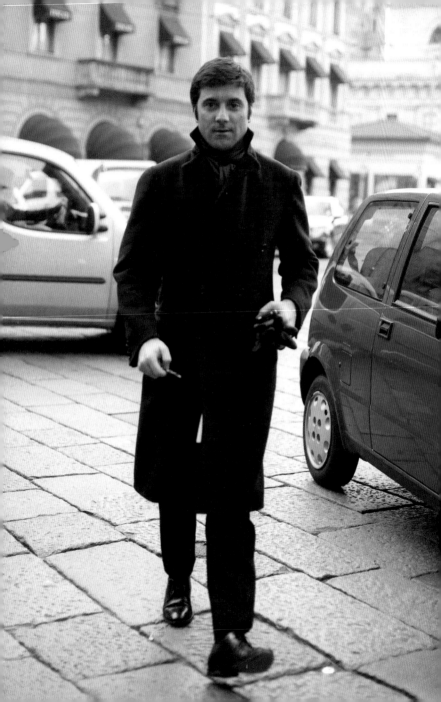

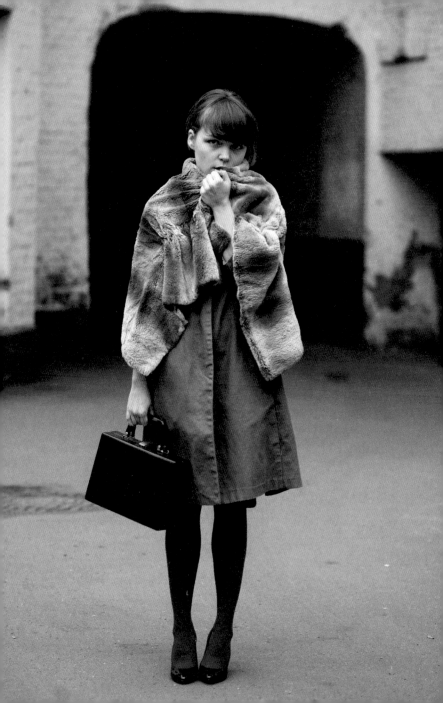

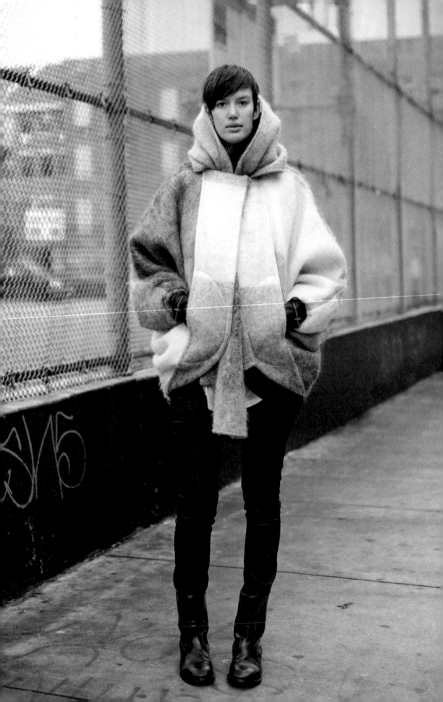

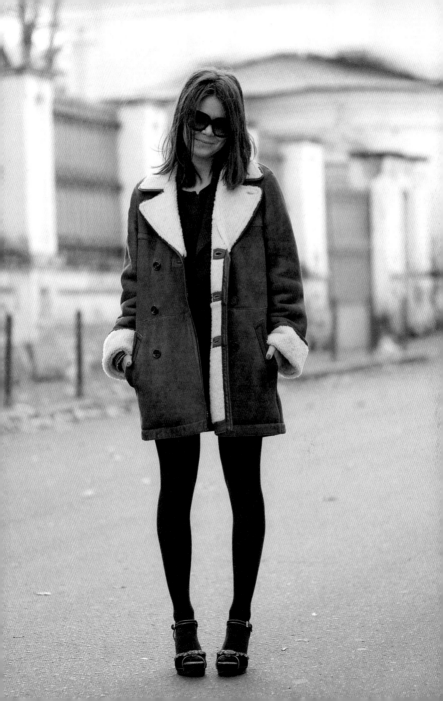

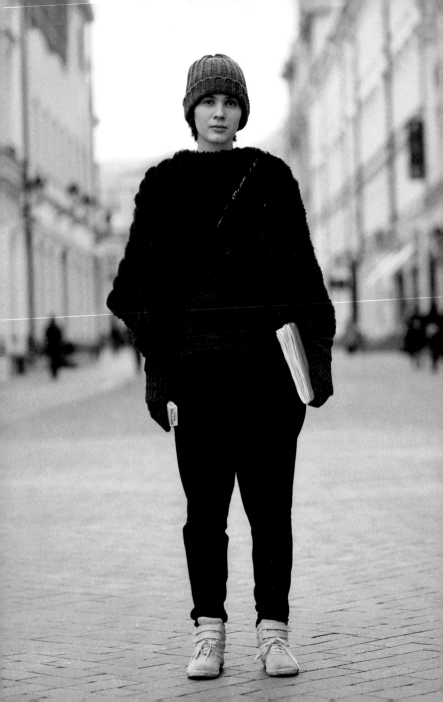

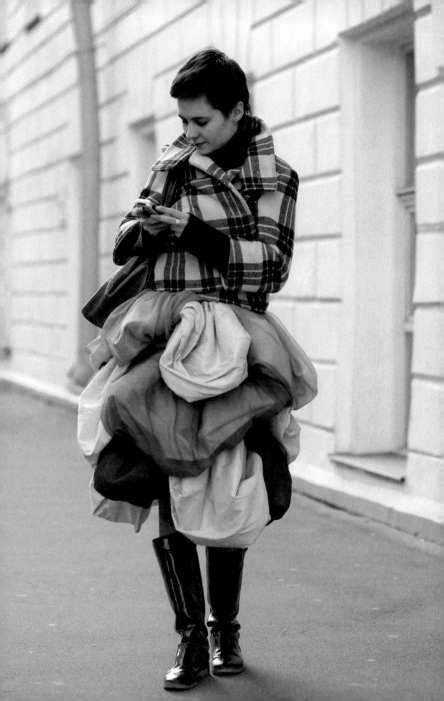

My daughter. I didn't
tell her to pose like that.
Sometimes you're just born
with a special something.

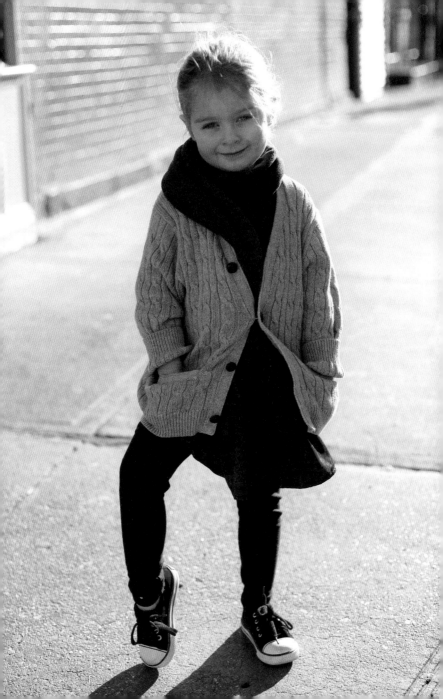

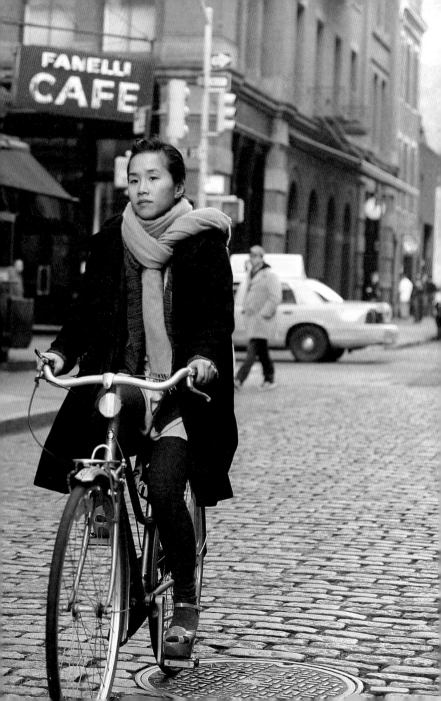

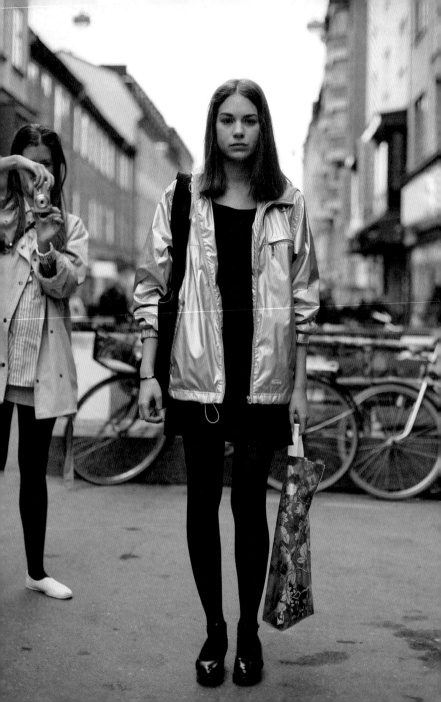

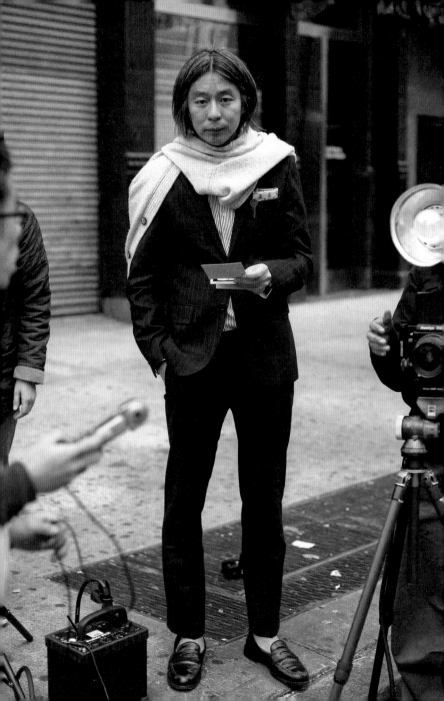

Couture Clash,
New York

A cop out would have been to keep this whole look super-luxe by pairing this beautiful cashmere coat with some type of equally luxe cashmere knit or silk blouse. However, Gloria never takes the easy way out and instead mixes (or clashes) it with a $20 American Apparel neon yellow nylon anorak. That, to me, is the real essence of modern New York style.

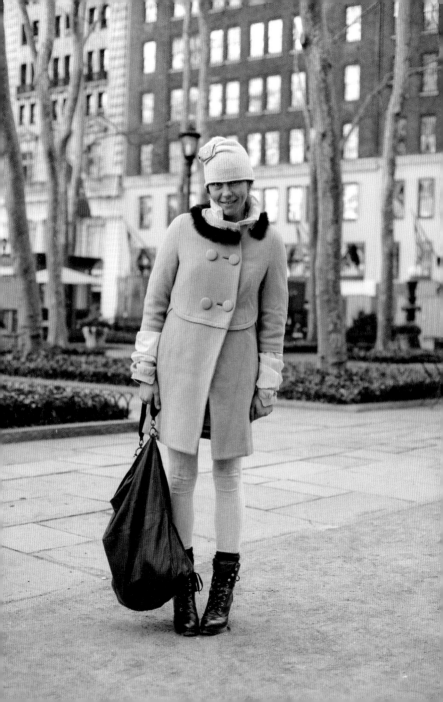

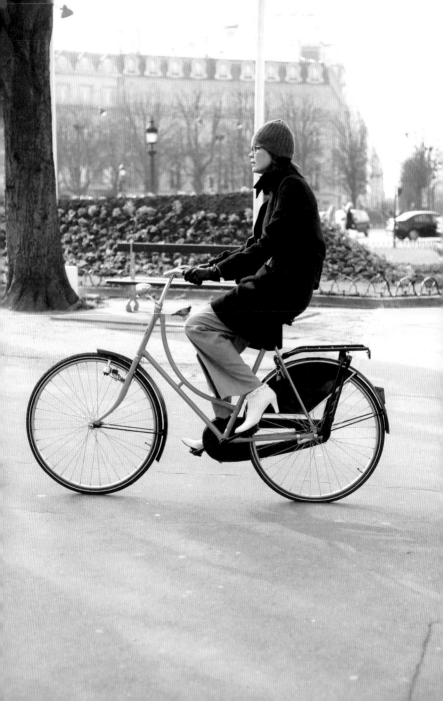

Avenue Montaigne, Paris

I was talking on the phone when I saw her coming up and about to ride past. I love how chic she looks with the boots and this beautiful coat. I really only had a split second to get the shot – this is one of the few times I got the focus dead right first time. I think people really like the bike shots because there's this implied sportiness to being dressed up and bicycling that you just don't see that much any more. It's so romantic to think people are jumping on their bikes dressed like this every day.

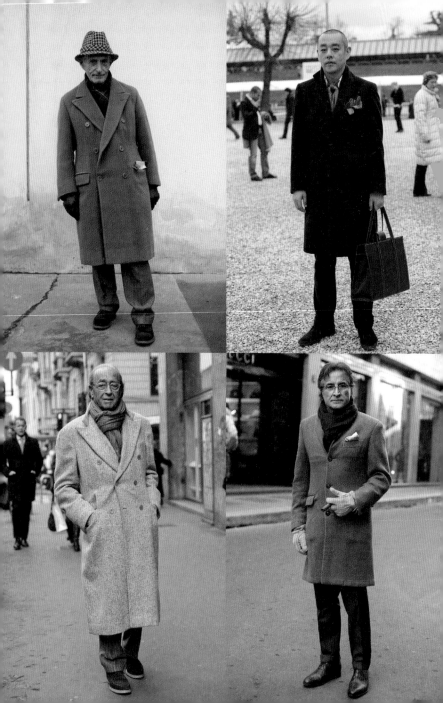

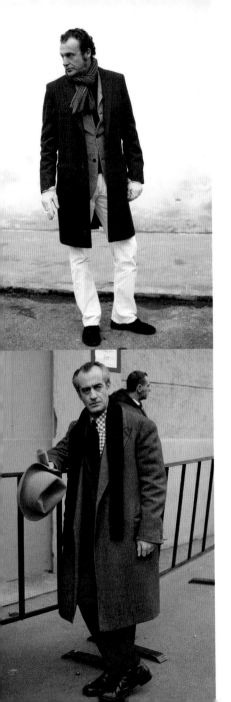

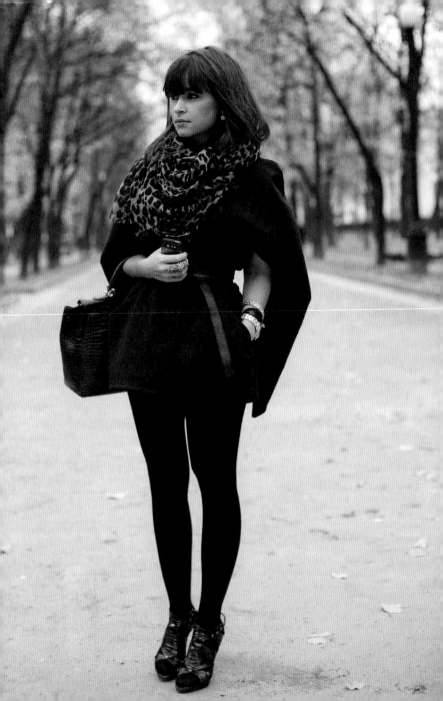

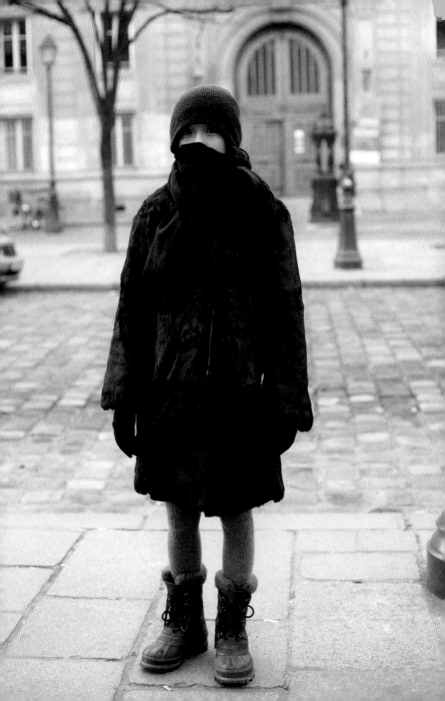

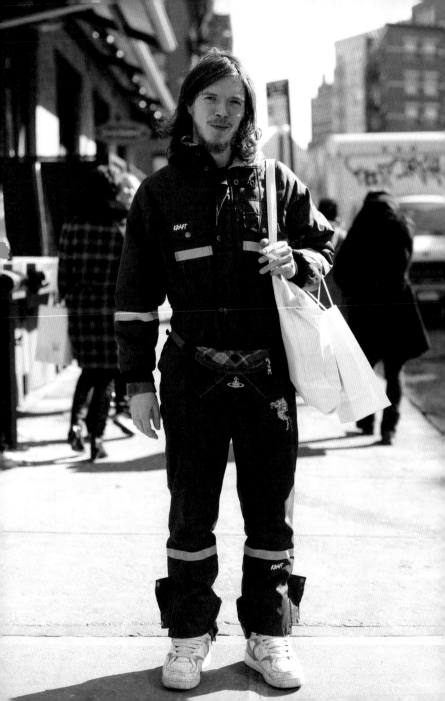

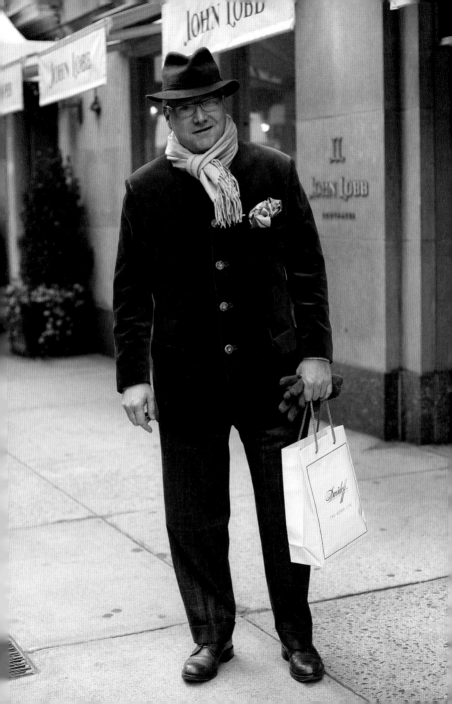

Party boys, Paris

When I am walking through Paris or Milan I always keep my eyes wide open, because it seems that a great shot can happen around every corner.

I remember that for this photo I had a little time between shows and I figured I would take the long way to the next location.

I was in a nowhere area of the Left Bank on a tiny street, and as I passed an even smaller intersecting alley I noticed two curious shapes about 100 yards down the way. Usually, the first thing I notice is the general shape or proportion of people, and maybe colour combinations. It took a moment for my eyes and mind to resolve the image (I don't have great natural vision) as I passed the alley. Since most people are dressed in such a typical manner, if I see something unusual (even in the distance) that takes me a moment to visually register, then my curiosity gets piqued. In this case my inquisitiveness was rewarded by two hipsters who had a unique, updated Romantics/Teddy Boy vibe.

Sometimes people say that I shoot too many 'fashion world' people – these guys, as it turns out, are well-known party boys in the London fashion scene. However, when I first saw them they were just vague, interesting silhouettes in the distance, and only later did I learn that they were known figures in the fashion world.

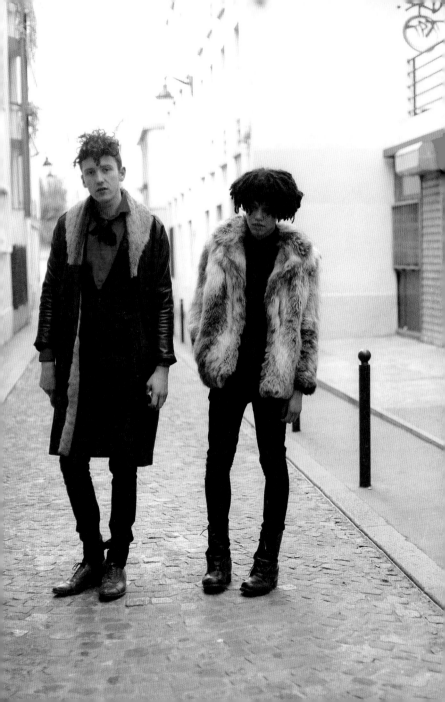

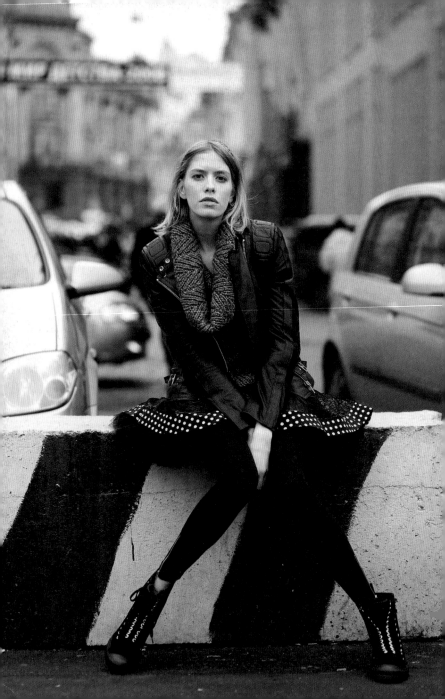

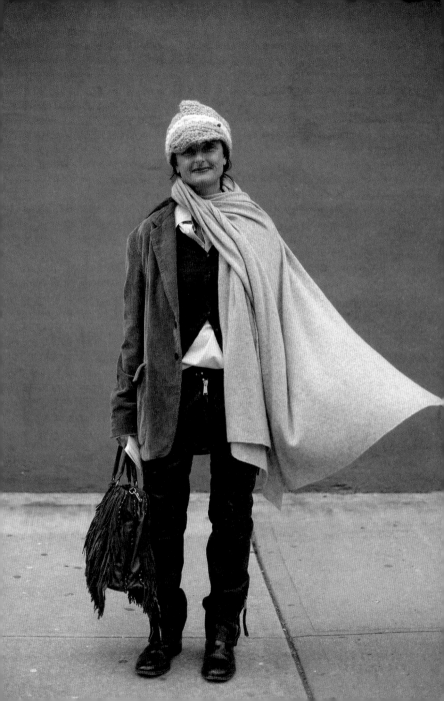

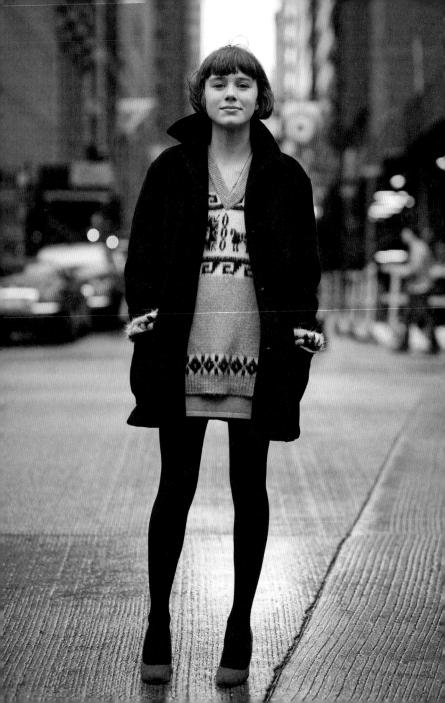

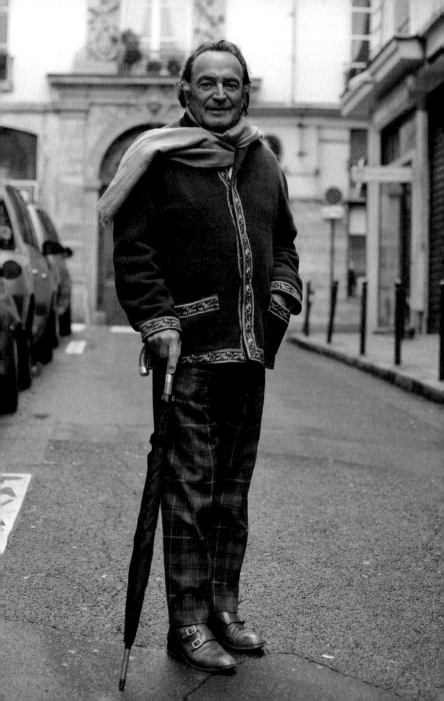

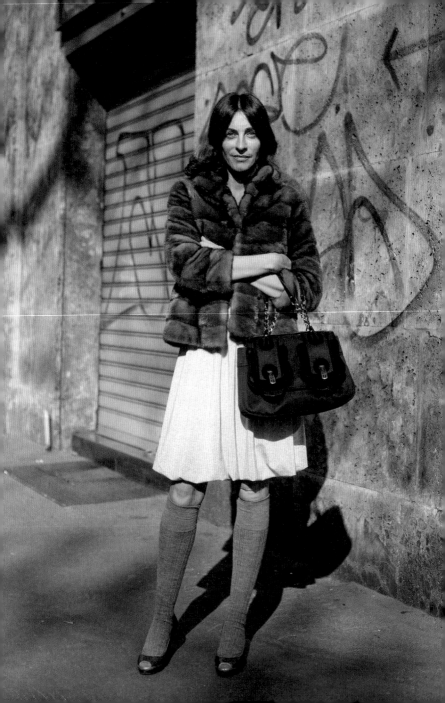

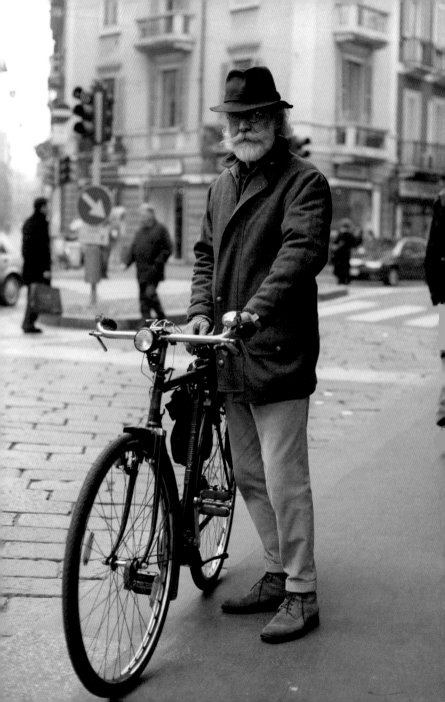

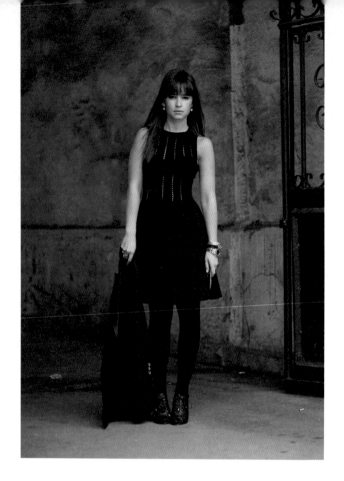

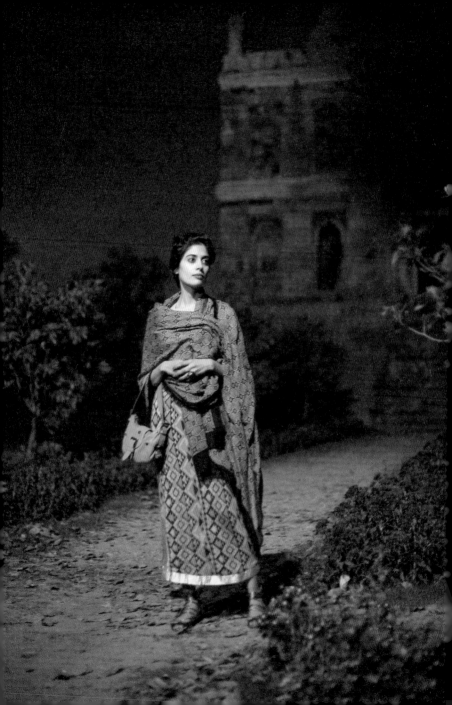

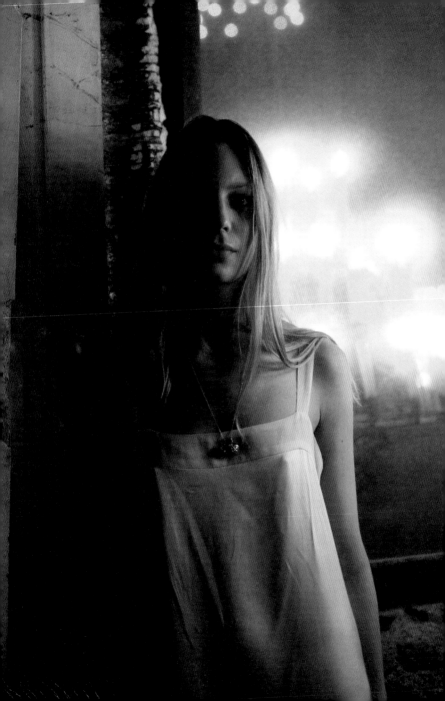

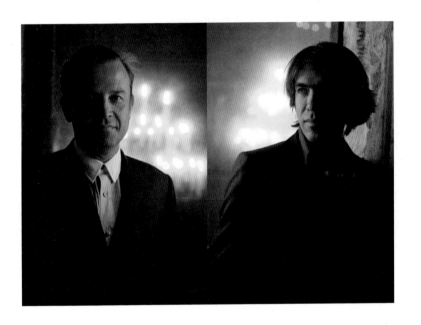

505

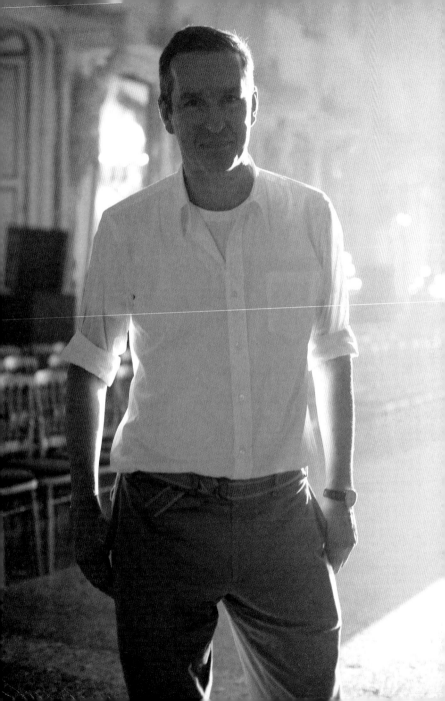

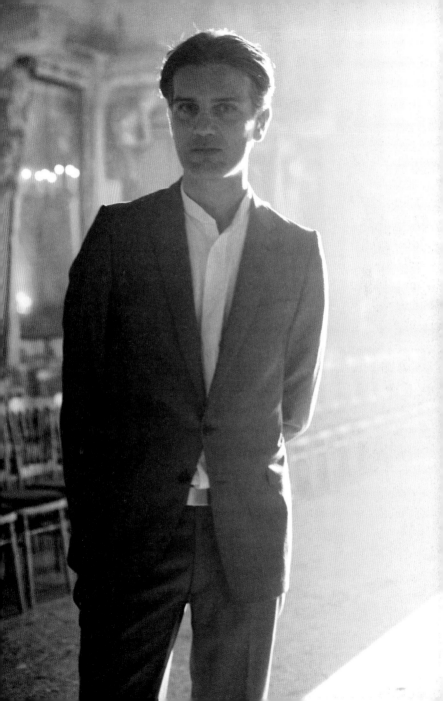

Index

second edition

Communication Networks Management

KORNEL TERPLAN

Prentice-Hall International, Inc.

 © 1992 by Prentice-Hall, Inc.
A Simon & Schuster Company
Englewood Cliffs, New Jersey 07632

Printed in the United States of America

10 9 8 7 6 5 4 3 2 1

ISBN 0-13-151838-0

Prentice-Hall International (UK) Limited, London
Prentice-Hall of Australia Pty. Limited, Sydney
Prentice-Hall Canada Inc., Toronto
Prentice-Hall Hispanoamericana, S.A., Mexico
Prentice-Hall of India Private Limited, New Delhi
Prentice-Hall of Japan, Inc., Tokyo
Simon & Schuster Asia Pte. Ltd., Singapore
Editora Prentice-Hall do Brasil, Ltda., Rio de Janeiro
Prentice-Hall, Inc., Englewood Cliffs, New Jersey

Contents

Preface

The number of domestic and global communication networks is continuously expanding, and networking is increasingly becoming mission critical for corporations. Network management must, therefore, ensure that the network is operating efficiently at all times, to avoid any problems in the operation of the organization.

Despite the considerable implications that most of the wide, metropolitan, and local area networks are ineffective and frequently fail, network management receives too little attention. One reason is that computer systems and communication networks have reached a level of complexity and power that exceeds human abilities to understand, predict, and thus, manage.

The only way to change this situation is to concentrate on critical success factors of network management, which include network-management functions, instruments, and human resources. Although there have been numerous dissertations, articles, reports, and papers dealing with network-management questions, one can find a very limited number of more thorough, integrated treatments such as books that deal with the network management in its complexity. There has been a need for a reference that bridges the gap between the viewpoints of telecommunication and data-communication management, communication analysts, technical services, network designers and planners, and network scientists regarding communication networks management. Some of the principal issues that fall in this area are:

- What are the network-management requirements of users?
- What are the principal directions for network management?

- What is network management in both a broad and narrow sense?
- What are the basic and extended network-management services?
- What are appropriate performance indicators for service levels and efficiency? Are they independent of particular installations?
- Who is the right person for the position of network manager, the data-processing or the telecom manager?
- How can we plan and configure a communication network? What kinds of constraints (e.g., cost, performance, service level) have to be taken into consideration?
- What is the information demand for fault, configuration, performance, security, accounting management, and network-capacity planning?
- Who is responsible for service-level agreements?
- What kinds of tools do managers, technicians, operators, and network-support specialists have to support operational, tactical, and strategic decision making?
- How can we integrate human factors into network performance?
- How should one integrate the management of various communication forms such as voice, data, video, and word?
- What network standards should be implemented?
- How should performance- and configuration-related information be integrated?
- How should a network-management data base be established and maintained?
- Who are the major players of network-management instrumentation?
- Are users willing to outsource network-management functions, and if yes, which ones, and who are the outsourcing partners?

Based on my consultant and project experiences, this book attempts to find answers to the majority of these questions. Besides bridging the gap between practical and theoretical points of view about network management, the principal goals of this book are the following:

- To define the network manager's responsibilities for operational, tactical, and strategic decisions
- To subdivide the network management's responsibilities into six key components: configuration, fault, performance, security and accounting management, and network planning
- To summarize principal functions and time frames, and the methodology for each component
- To give recommendations based on practical experiences for implementation considerations
- To integrate all responsibilities into a network-management center, based on a mainstream or sidestream approach

- To advise on how to select and integrate instruments
- To consider the human factor in the methodology by defining qualifying experiences
- To suggest organizational changes for accomplishing the goals for each component
- To give estimates about future trends in networking and network management
- To recommend alternatives for establishing and maintaining network-management data bases
- To design a network-performance reporting system
- To give guidelines for cost justification evaluations
- To determine the network-management needs by user clusters, categorized by size, support of communication forms, present instrumentation, staff of network management, present status, and high-priority problems?
- To show network-management directions for integration, centralization, automation, and repository support
- To show the criteria outsourcing network-management functions

I have structured the book to deal with these issues in 15 sequential segments, as described next.

Critical success factors, such as network-management functions, instrumentation, and human resources, are addressed in Chapter 1. Network-management status and requirements on behalf of users are discussed and evaluated in accordance with these critical success factors. Critical needs, present problems, and expectations for managing voice and data networks are summarized by user clusters representing very large, large, medium, and small customers.

Chapter 2 addresses generic network components, their connectivity and manageability. Network architecture is defined as a design philosophy integrating hardware and software components with a set of layers and protocols to functionally define and control the network. In the early days of networking, no sophisticated control mechanisms were required, because the information-transmission processes were visible to everybody. However, to improve overall efficiency, integrity, and security, a number of design criteria such as connections, establishments, rules of transfer, order of messages, security, handling long messages, and adapting fast senders to slow receivers had to be implemented.

International committees have made fair progress in separating networking responsibilities layerwise. Simultaneously, all powerful mainframe manufacturers are trying to penetrate the marketplace with their own architectures. This book addresses the question of whether one of them could become the de facto industry standard and, if so, why.

The next logical step to consider after architecture alternatives is intro-

ducing communications network components. These components include source, destination, and relay nodes representing communication processors, modems, multiplexers, concentrators, terminal control units, user terminals, and gateways. They are covered in the detail required to pass judgment on their performance impact.

The network planner and manager are very frequently confused by the large number of trade-offs to be considered in transmitting information. Besides traditional communication lines, satellites, light-wave, microwave, and radio communications are becoming feasible. But how feasible are they, and where is their use meaningful in comparison to value-added services?

Chapter 2 ends with the state-of-the-review of proprietary, de facto, and standard architectures. OSI, SNA, and TCP/IP seem to dictate and control the market.

Chapter 3 addresses the architecture of a generic network-management product. Its components such as unified user interface, presentation services, network-management application elements, management application level protocols, shared and proprietary services, data repository, and network-management gateways for native network-management systems are discussed in some depth. This discussion is followed by introducing proprietary and de facto network-management architectures offered by IBM, Unisys, Xerox, Novell, Tandem, Bull, 3Com, Banyan, Proteon, Sun, and Codex. After addressing principal service elements of OSI-based network-management recommendations, leading architectures from AT&T, DEC, and Hewlett-Packard are demonstrated. SNMP examples and migration paths to more cooperative network management solutions are included as well.

Both the technician and the manager have to learn about tools, how to choose among them, and how to use them in order to get the most information out of the communication network. The next portion of the book is devoted to these problems. There are three classes of tools for managing communications networks:

- Data-gathering devices (hardware, software, line, application, modem, multiplexer, DSU/CSU, LAN, and communications monitors, Chapter 4)
- Data-reduction and network-analysis instruments (monitors, reporting software, data bases, information systems, and administration tools, Chapter 5)
- Prediction tools (statistical techniques, queuing models, simulation, benchmarks, and terminal emulation, Chapter 6)

Particular attention is given to software, communication and LAN monitors, queuing models, and remote terminal emulation.

Software monitors constitute a class of programs for measuring hardware, systems, or applications software. They are resident in store and can be activated or deactivated by the user. Accordingly, these tools are used to handle systems and network monitoring, and questions regarding problem programs.

Using the monitor output, hardware/software reconfiguration and/or problem program optimization can be achieved. Programs with high life expectancy and with long and frequent runs are the first subjects for optimization.

Communications monitors—a generic term for response time, line, modem, multiplexer, and network monitors—are becoming increasingly important. Such monitors are employed to collect special data on network service and utilization-related measures. They are connected to the communication interface. Since these interfaces are designed to connect to communications equipment, monitor connection is easy and unlikely to disturb the equipment being measured.

Communications monitors' structures and principal components used for collection, processing, and display of information are discussed in detail. Improvement of network transparency and availability can be expected through use of communications monitors.

The capabilities of the communication software for extracting information from the network are also addressed. In addition, special features for controlling homogeneous and heterogeneous networks are included.

LAN monitors address a brand new area where products and implementations are relatively rare. The monitoring techniques and indicators are similar to those well understood in the wide area, but the throughput and real-time processing requirements are completely different. Examples are given for both Ethernet- and Token-Ring-type local area network instrumentation.

For evaluating future networking alternatives, queuing models appear promising. Based on workload projections and network configuration, what-if questions for service and utilization alternatives may be easily answered.

When an external computer is used to provide the workload on an interactive computer network service, the computer performing the testing is known as a remote-terminal emulator, and the entire network being tested is the system-under test. The capacity can range from one terminal to the maximum number the service can support. Remote-terminal emulation may be an appropriate test tool when there is a specified number of access ports that the service must provide.

Although the statistical treatment of data is important in all measurement and evaluation endeavors, the volume of data that may be collected by an emulator necessitates the complete specification of what data are to be recorded, how the data analysis and report generation is to occur, and how the correctness of the data-reduction software is to be established.

For successful network management, related data should be continuously collected in all principal network components. This information is preprocessed and used for different purposes in operational, tactical, and strategic network management. These levels of network management involve three fundamental types of management decision:

- Operational: immediate decisions
- Tactical: short-term decisions
- Strategic: long-range decisions

In order to support these decision-making processes, six activity areas are of prime importance:

- Configuration management for providing data for all other activity areas (Chapter 7)
- Fault management for supporting operational decisions (Chapter 8)
- Performance management for supporting tactical decisions (Chapter 9)
- Security management for ensuring low risks of operating the network and its network-management systems (Chapter 10)
- Accounting management for supporting costing and charging (Chapter 11)
- Network-capacity planning for supporting tactical and strategic decisions (Chapter 12)

Configuration management is a set of middle- and long-range activities for controlling physical, electrical, and logical inventories, maintaining vendor files and trouble tickets, supporting provisioning and order processing, managing changes, and distributing software. Directory service and help for generating different network generations are also provided.

Fault management is a collection of activities required to dynamically maintain the network service level. These activities ensure high availability by quickly recognizing problems and performance degradation, and by initiating controlling functions when necessary, which may include diagnosis, repair, test, recovery, workaround, and backup. Log control and information distribution techniques are supported as well.

Performance management defines the ongoing evaluation of the network in order to verify that service levels are maintained, identify actual and potential bottlenecks, and establish and report on trends for management decision-making and planning. Building and maintaining the performance data base and automation procedures for operational control are also included.

Security management is a set of functions to ensure the ongoing protection of the network by analyzing risks, minimizing risks, implementing a network security plan, and by monitoring success of the strategy. Special functions include the surveillance of security indicators, partitioning, password administration, and warning or alarm messages on violations.

Accounting management is the process of collecting, interpreting, processing, and reporting costing and charging oriented information on resource usage. In particular, processing of SMDRs, bill notification, and charge-back procedures are included for voice and data.

Network planning is the process of determining the optimal network, based on data for network performance, traffic flow, resource utilization, networking requirements, technological trade-offs, and estimated growth of present and future applications.

For all relevant areas of network management, personnel's duties, infor-

mation requirements, job contacts, and qualifying experiences are covered in depth. Expert systems are discussed and evaluated in terms of applicability as a support tool for any of the personnel's responsibilities.

Chapter 13 is dedicated to network-management directions and solutions. The directions detail strategies for integration, centralization, automation, and maintaining a data base. Leading network-management products are grouped around proprietary solutions such as NetView, Net/Master, and SNMP-based products; OSI-based products such as Accumaster, EMA, and Openview; and user solutions such as Vision from Boeing, Allink from Nynex, and Concert from British Telecom.

Last, but certainly not least, the economic benefits of implementing network management functions are addressed; specifying these benefits is essential for obtaining management's endorsement of network management projects. Cost-justification calculation techniques are provided for potential savings in the following areas: hardware and software reduction, increasing turnover rate, reducing decision-making risks, and postponing new equipment purchases save money in the long run are also presented. These are:

- Response-time improvement
- Greater system visibility
- Well-balanced systems and networks
- Improved security
- Higher end-user availability

This final section concludes with a case study in which the return-on-investment index is computed for the installation of an automated network-management system for fault management.

SUMMARY

Although there are various textbooks available in the area of computer performance and network architectures, none of them addresses the area of communications networks management. The primary object of this book is to provide a detailed practical guideline for corporations and professionals in the area of communication networks management.

Network managers, planners and administrators, telecommunications managers, network analysts, and operators are the primary audience. The information provided is valuable for information systems managers as well.

The practical guidelines presented include *methodology* for all principal areas, such as:

- Configuration management
- Fault management

- Performance management
- Security management
- Accounting management
- Network-capacity planning
- Selection criteria for all available and applicable *tools*
- A checklist for responsibilities and qualifying experiences of personnel involved in any of the areas

However, the text does not include an in-depth discussion of queueing theory, simulation procedures, protocols, layered network architectures, a detailed tools description, and organizational guidelines.

The details of responsibilities, functions, and features of instruments and qualifying experiences of the personnel will change in the future, but most of the principles will remain. Therefore, the reader should concentrate on the principles of the network-management methodology.

The text, which resulted from my research and consulting work is easily adaptable for developing undergraduate and graduate college and university courses.

ACKNOWLEDGMENTS

Three principal sources gave me great help in writing this text: the Network Management and Network Management Systems service from Datapro, based in Delran, New Jersey, which assisted me in determining the right depth for the overall structure; the EDP Performance Management Handbook, published by Applied Computer Research, located in Phoenix Arizona, which assisted me in evaluating the applicability of tools and techniques; and the Network Capacity Management Course, designed by me and sponsored by The Institute for Computer Capacity Management, based in Milpitas, California, which helped me to include practically oriented cases into the text.

I am particularly grateful to the companies AT & T, Boole and Babbage, GTE Information Services and IBM for supporting my work with reports, case studies and practical recommendations.

I would like to thank Edith Csontos of Price Waterhouse Australia, Professor Ivan Frisch from Brooklyn Polytechnic, William Gilbert Director from AT&T, Phil Howard President of Applied Computer Research, Jill Huntington-Lee, Senior Editor from Datapro Research, Koos Koen General Manager of Informatica in South Africa, Peggy Loos District Manager of AT&T, Jacques BenSimon President of Logtel Communication in Petah-Tikva Israel, Wim Verdock Consultant in Holland and Chuck Williams Manager from EuroDisneyland for reading parts of various drafts and for giving their valuable comments.

Lastly, I would like to thank Prentice Hall and Lisa Garboski for help and for the excellent editorial work of the manuscript.

DENOTATIONS

A_i	Number of arrivals	MTBF	Mean time between failures
AT	Attenruation	MTOR	Mean time of repair
AV	Availability	MTTD	Mean time to diagnosis
B	Number of information bits per character	MTTR	Mean time to repair
B_i	Busy	NFU	Natural forecast unit
BLU	Basic Link Unit	O_i	Output rate
BU	Budget	OV	Overhead
C	Average number of non-information characters per block of transaction	P	Probability that a block will be retransmitted
		PIU	Path Information Unit
		PU	Physical Unit
CH_E	Erroneous information character	R	Modem or line transmission rate
CH_U	Characters transmitted, but not delivered	RCC	Resource Capacity Coefficient
CH_N	Characters received, not sent	ROI	Return on investment
		RT	Response time
CH_D	Characters delivered, but duplicated	RTS	Ready to Send
		SCO	Standard cost
Ch_T	Total characters transmitted	S_i	Mean service time
		ST	Service time
C_i	Number of completions	S_{TR}	Service index
CO	Costs	T	Elapsed time
CTS	Clear to Send	T	Time interval between blocks or transmissions
Db	Decibel		
ER	Error rate		
ER	Explicit Route	T_i	Time indexed
$F(x)$	Distribution function	TG	Transmission Group
$f(x)$	Density function	T_N	Network processing time
FDX	Full Duplex		
HDX	Half Duplex	$T(NP_{E,X})$	Buffering time in network processors and relay nodes
I	Number of cycles		
I/O	Input/Output		
L	Total block or transaction length		
		TP	Throughput
LD	Load	TRIB	Transmission Base Unit
LU	Logical Unit	$T(S/D)$	Buffering time in

	source/destination	u_i	Service rate
	devices	UT	Utilization
T_{SUB}	Subsystem processing	V_i	Visit ratio
	time	VR	Virtual Route
T_w	Waiting time	λi	Arrival Rate
U_i	Utilization		

Critical Success Factors of Network Management

The advent of hybrid communication architectures, open network structures supporting total connectivity, integrated voice/data resources, software defined networks, bandwidth management systems, LANs, MANs, WANs, T1, T3, and ISDN implementations brought out an awareness of the inadequacies of existing network-management instruments and techniques, rendering certain communication networks practically unmanageable.

In this chapter, after defining the depth and scope of network management, the driving forces for improving network-management functionality will be summarized. The extended list of network management requirements for both data and voice networks, which is based on responses to user surveys, will follow. To meet user's needs effectively, most organizations need to start by surveying the present status of their network-management procedures, applications, instrumentation, and human support. The degree to which these critical success factors are met will decide the fate of the enterprise's network management. The three success factors include (1) applications for configuration, fault, performance, security, accounting, and planning management; (2) instrumentation; and (3) human aspects of building and keeping the network management team together. Finally, typical user profiles and strategic directions are briefly discussed.

1.1 DRIVING FORCES FOR IMPROVING NETWORK MANAGEMENT

Network management means deploying and coordinating resources in order to plan, operate, administer, analyze, evaluate, design, and expand communication networks to meet service-level objectives at all times, at a reasonable cost, and with optimum capacity. Over the last few years, some of the issues have been addressed by different manufacturers, but unfortunately their solutions are neither complete nor applicable to all situations.

Most organizations have recognized the strategic importance of their communication network and its management. In most cases, better control ensures a higher level of performance and this performance corresponds with higher productivity. In addition, higher productivity often translates into bottom line financial improvements. This leads us to consider what the principal driving forces are for investing and spending more on network management.

- Controlling corporate strategic assets: Networks are an increasingly essential part of the enterprises's day-to-day business activity. The rapidly declining costs of personal computers and departmental computing power is increasing the number of intelligent network elements to be connected and controlled. Completely new networking applications are available to users, but without proper control, their full power and usefulness are barely tapped.
- Controlling complexity: The constantly growing number of network components, users, interfaces, protocols, and vendors have left many managers with little or no control over what is connected to the network. In particular, LAN-based servers and stations (clients) are most frequently beyond the scope of central control.
- Improving service: Users are requesting the same and even better service level, despite growth and changing technology. New users require support and training, and they have high expectations, considering telecommunication solutions as typical examples of standards, availability, and performance.
- Balancing various needs: Those who manage networks are expected to satisfy certain business needs such as supporting new applications and customers, providing improved connectivity and ensuring stability and flexibility. At the same time, users' needs, such as availability, reliability, performance, stability, and visibility have to be met in a network-management environment where there is a lack of procedures and tools, skills are limited, and and there is a serious shortage of personnel.
- Reducing downtime: Ensuring continued availability of networking resources and services is the ultimate goal of enterprise communication. Network management solutions have to ensure this capability by efficient configuration, fault, and maintenance management.

- Controlling costs: Network management needs to keep an eye on all costs associated with data and voice communications. The network manager is expected to spend only a reasonable amount of money, which still may be considerable. Today, the average enterprise spends approximately 3% to 5% for network management. This may climb as high as 12% to 20% by the mid-1990s. These percentages are in relation to the total communications budget. If cost management is under control, service levels may be improved without increasing costs.

1.2 WHAT USERS WANT FROM NETWORK MANAGEMENT

Based on surveys with a number of users including large, medium, and small environments, what they require and want may be listed as follows:

- Assurance of continued end-user service, characterized by availability and quick response time, despite growth and change: End-users are interested in maintaining a certain agreed-upon level of services, which may necessitate connecting end-user devices to local and/or remote computing facilities by point-to-point, multipoint communication links, or by using LANs, MANs, or specific communication solutions. Manageability at this level requires powerful measurement techniques in both logical and physical components of the networks. Changing technology and growth rates must not impair the level of service.
- Capability to heal, bypass, or circumvent failed network elements as automatically as possible by integrating physical and logical network management: Early detection and powerful alarm correlation techniques should help diagnose problems quickly. As a result, the right strategy to repair, bypass, or circumvent failed components may be rapidly selected and implemented. Artificial intelligence will play a key role in this activity. Constant availability of individual diagnostic tests, preferably from any point in the network, is desired as well.
- Capability to operate fully even when important network elements have failed: Powerful backup components and procedures for both the physical and logical segments of the network are expected to help in resuming service with no or minimal performance impairment while troubleshooting failed components. Network management is expected to guide and supervise this activity as part of fault management.
- Capability to monitor and diagnose unsatisfactory conditions in the entire network, including systems software and applications: Performance monitoring is expected to embrace a broader scope than ever before. Not only physical and logical network components, but also a portion of the server's software, data-base activities, and applications need to be included. By doing so, real end-to-end network management may be offered to users.

- Real-time or near-real-time analysis of network performance: Not only historical data for performance trending and thresholding, but also real-time or near-real-time information is requested by users. Early recognition of performance bottlenecks, and corrective actions including load balancing, parameter changes, and selecting alternate routes, may help to return the level of service to the expected range. Powerful measurement techniques with low overhead data collection combined with efficient real-time processing are the key prerequisites.

- Statistics and historical data automatically saved in a standard data base with vendor-provided formats for analysis and also provision for users to support their own analysis formats, screens, and applications: This requirement addresses two items: first, to offer portability, a general-purpose data base is recommended for use as a repository; second, for satisfying specific needs, flexibility is requested in terms of processing, presentation, and reporting. By supporting a standard data base and its interface, electronic data interchange may be supported as well.

- Straightforward interface with human operator, providing nonredundant fault notification: Users request the elimination of the large number of various vendor-dependent console devices, interfaces, presentation services, and operational procedures. Users expect a general-purpose platform, supported by the majority of vendors, first. In further steps, event and alarm consolidation, correlation, and finally integration across different systems are on users' request lists.

- Increasing operations productivity by controlling quantity of staff, number of operations sites, and skill levels: Due to a serious shortage of human resources, users are looking for solutions that can help to stabilize the number of employees required despite growth and new applications support. Staff reduction is high priority in some voice-only networking environments. People are also looking to artificial intelligence as a significant means of supporting human work that can provide some consistent assistance in problem determination. One of the scenarios for the next century is a lights-out network control center. The path to such a reality is via automated and unattended operations.

- Providing a powerful network management data base for supporting operations, administration, analysis, and planning: Users are looking for a central information repository as an ultimate solution. This repository or management information base (MIB) is expected to store all relevant information about components, procedures, operational rules, projects, and so on. Users expect this to be a relational or object-oriented data base. They expect this data base to store objects' instances, connectivity data, and status. The data base then forms the basis of the documentation system.

- Rapid, continual response to changing network applications, subscribers, devices, tariffs, and services: Dynamic adaption to the ever-changing environment is a key item that drives network management expenditures.

While awaiting the development of a central information repository, users will very likely compromise on a directory service, with other words acting as an umbrella connecting all existing data bases and files. Performance expectations are modest at the beginning. X.500 seems to be an interesting alternative in this respect.

- Dynamic expansion and reconfiguration of network capacity using bandwidth management techniques: Cooperation between users and suppliers is expected to improve substantially. Users want to gain insight into networking segments they do not own or control. To remain competitive, leading suppliers will very likely offer the opportunity in the form of importing/exporting data. Electronic data interchange is considered the real target.

- Use of one network-generation source: By consistent naming and network addressing conventions, there is no need to have too many "views" of a network. Different views have grown historically as different management products have set other specific definitions of management depth and scope. If the configuration data base is considered the single and only source of generating the network, the development of unnecessary contradictory names and addresses can be avoided.

- Improved security of the network and also of the network-management system: By properly allocating budgetary resources toward securing applications, systems, transmission facilities, and equipment, the security level may be set higher than before. Network-management products are expected to offer monitoring, automated alarming, partitioning, and password capabilities. Network-management system security is also important because of its central and strategic role.

- Increasingly accurate and simplified accounting data: To supervise spending and control costs, users request timely access to accounting information for both data and voice networks. It is envisioned that station detail maintenance records will be provided to users by suppliers on a near real-time basis.

- Implementation of generic applications: Users are actually looking for generic applications across single functions, groups of functions, and instruments. Such application packages may be purchased or leased by the user.

- Integrated network management: Users are requesting increasingly higher levels of integration. This means integrated solutions across communication forms, multiple network architectures, processing systems and network elements, geographical areas, multiple vendors, and private, virtual, and public network management instruments.

- Centralization with distributed implementation: Users tend to prefer a central network-management solution, with implementation of certain "local" functions controlled by the central facility. In particular, users generally request a solution for managing remote local area networks by means of some distributed monitoring features.

- Practical implementation of solutions based on international standards: To avoid the confusion of using too many proprietary solutions, international standards are preferred, but not at any price. Users generally request the co-existence of leading de facto standard solutions, such as IBM's NetView with OSI-based solutions or AT&T's Accumaster. In addition, SNMP may be considered for peer-to-peer connections.
- Integrated reporting of data flows and capacity trends, as well as standard performance metrics: Users are expecting powerful reporting features with a minimal number of periodic paper-based reports, but with the opportunity of accessing data elements and generating ad hoc reports on indicators needed for a specific application area. Standard data base and access features are highly ranked.

Table 1.2.1 summarizes the preceding list and makes an attempt to set priorities and weights to each item as perceived by typical data and voice network users.

TABLE 1.2.1: Summary of Network-Management Requirements

What Users Want from Network Management	Data Networks	Voice Networks
1. Ensuring end-user service level	+++	+++
2. Capability to heal, bypass, or circumvent failed elements	++	+++
3. Capability to operate despite elements' failures	++	+++
4. Monitoring	++	+++
5. Real-time performance analysis	++	+
6. Statistics and historical data availability	++	++
7. User interface	++	+
8. Operations productivity	+++	++
9. Network-management data base	+++	+
10. Change management	++	+
11. Bandwidth management	++	++
12. Network generations from one source	++	+
13. Improved security	++	+
14. More accuracy and simplicity of accounting data	++	+++
15. Implementation of generic applications	++	+
16. Integration	+++	+
17. Centralization with distributed implementation	++	++
18. Conformance to OSI standards	++	+
19. Integrated reporting	++	+

+++ very important strong need
++ moderately important moderate need
+ important weak need

1.3 WHAT WE FACE TODAY

There is a serious gap between what users require or want and the present status of network-management applications, instruments, and use of human resources. What one may observe at the global level is displayed in Figure

1.3.1. When analyzing data and voice networks costs, the results show a continuous decrease in equipment cost and an increase in communication costs. The equipment cost decrease is due partially to large-scale integration at the hardware level and partially to standardization results at the software level. The increase in communication costs is explainable as part of the progress of distributing computing power and data bases with the consequent push to connect surprisingly high numbers of stand-alone user devices. Surveys confirm annual growth rates at the end-user device level in the range of 35% to 45%. The trend of ever-increasing communication costs is expected to continue as not-networked personal computers and local area networks continue being hooked together with the increasing variety of networking options. The alarming fact, however, is that people costs are rapidly increasing. The reasons may be found in one or more of the following: networks never get smaller or less complex, resulting in a demand for more human resources; higher skill levels of analysts and planners are paving the way for higher salaries; expanding the scope and depth of service to users requires still more people, especially in the operating area. There is a push from companies' management for budgets that are more evenly distributed between data processing and communication resources.

In terms of the basic communication forms, the current situation may be characterized as follows:

- Voice is strictly centrally managed and not yet ready for integration.
- Data is both centrally and decentrally managed; there is interest to include voice and image management.
- Image including word is strictly decentrally managed; image is beginning to be ready for electronic mail.
- Video is strictly centrally managed; at the moment this communication form is limited to innovators.

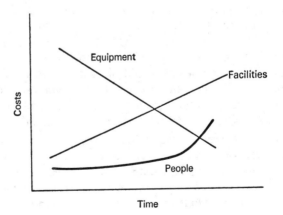

Figure 1.3.1 Cost trends.

In summary, the integration process over multiple communication forms will very likely take many years. Data and voice integration will happen first, driven by shared communication facilities and integrated equipment.

The following section summarizes the principal issues by applications, instruments, and human resources.

Network management applications issues

1. **Separate logical and physical network management**

 Physical network management involves failure notification, problem detection and identification, problem isolation, and problem resolution of physical entities. These entities include the circuits, lines, modes, multiplexers, switches, front-end processors, and other hardware components. Logical network management focuses upon the logical connection between the user and the ultimate network destination, generally the application. Two principal components of logical network management are session awareness and traffic flow visibility.

 Figure 1.3.2 shows two examples that demonstrate how complex the physical network segment may become for ensuring end-to-end logical network management. At present, both worlds are completely separated and supported by rather different instruments.

2. **Separation by network architectures**

 Each leading architecture, such as SNA, DNA, DCA, and DSA, has a proprietary solution to logical network management. Unfortunately, the solutions are not interchangeable. For connecting architectures, gateways are frequently utilized. But gateways are not yet expected to connect network-management-related information. The most likely reasons are performance and limited life cycle expectation of gateways.

3. **No alarm management**

 Users are looking for standardized alarm information for detecting problems. What they get today is a vast array of messages and events generated by almost all network elements. Filtering, differentiation by severity, on-site interpretation, and correlation are virtually not offered by vendors of network-management solutions. The result is overloaded operators, slow problem determination, low productivity due to downtime, and highly inefficient troubleshooting. Figure 1.3.3 illustrates a communication resource offering bandwidth to multiple logical architectures. A resource failure results—due to lack of correlated alarm management—in starting four separate troubleshooting actions.

4. **No procedures for measuring end-user service level**

 Now only portions of end-user response time may be measured. Transport delays in LANs and packet-switched networks cannot yet be measured. In particular cases, users are expected to combine and consolidate measurement data from different sources. Approximately the same is true with measuring availability. Either network elements are not able

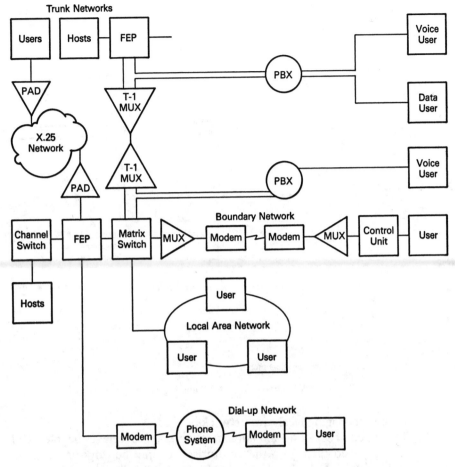

Trunk Networks

Example 1: Logical connection between host and data user: Host - Channel Switch - Front-End - Matrix Switch - Link 1 MUX - PBX - Data User.

Example 2: Logical connection between users and users on token ring: Users - PAD - X.25 Network - PAD - Front-End - Matrix Switch - LAN Manager - User.

Figure 1.3.2 Network structure and logical network management.

to measure their own status and performance or there are no instruments to collect and consolidate data from collection devices.

5. Not enough automation

This issue is related to alarm management with respect to volumes of data generated and forwarded to operator display. Considering the variety of messages approximately up to 1000 by type architecture, and the ability of generating inactive-type of messages by all components owned by the failed component, operators may easily get thousands of messages within the shortest period of time. Message processing facilities, easy rules for message suppression, and automated reactions to simple networking events are not yet in place.

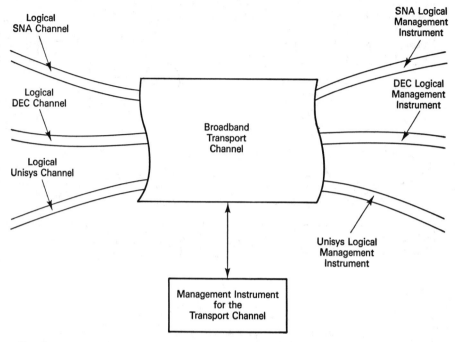

Logical
SNA Channel

SNA Logical
Management
Instrument

Logical
DEC Channel

DEC Logical
Management
Instrument

Broadband
Transport
Channel

Logical
Unisys Channel

Unisys Logical
Management
Instrument

Management Instrument
for the
Transport Channel

• Four Instruments
• No Correlation
• Multiple Alarms for the same physical problem

Figure 1.3.3 Supervising physical and logical components.

6. Lack of managing local area networks

The speed of selecting and implementing LANs overtakes people's ability to embed them into the enterprise's overall network-management architecture. At the moment, LANs are usually administered by users, and troubleshooting is handled by vendors or by technical support personnel. The results are downtime, finger pointing, and little hope for integrated solutions. This situation is less visible when LANs are interconnected by new techniques using bridges, routers and brouters, and bypassing WANs (Wide Area Networks). In such cases, network management has to start from scratch.

Network management instruments issues

1. No configuration data base

Configuration-related data are stored in various files and data bases which are not connected and not synchronized. Data are grouped around users such as the purchasing department, troubleshooter, network administrator, or planner. There are far too many views about the network, as shown in Figure 1.3.4, resulting in conflicting and contradictory naming and addressing structures.

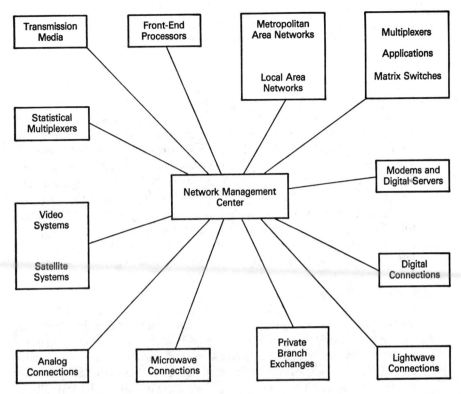

Figure 1.3.4 Multiple network views.

2. **Fragmented products and too many consoles**
Each product has its own territory which may overlap with others. Platforms, architectures, and protocols are proprietary with little hope for rapid acceptance of standards. Vendors are not really interested in integration due to their preoccupation with their own market forces and financial goals. For short-range solutions, console emulation is the most promising area.

3. **Too many paper-based reports**
Network-management personnel is often tempted to generate an unnecessary number of reports. Proprietary and third-party products promote this trend by offering a large variety of presentation options and powerful graphs. Instead, a central repository with access and view options would be necessary, but is rarely found in network-management organizations.

4. **Customer support desks are poorly equipped**
The usual picture in network-control centers is that the customer support desk's staff is generally overloaded and poorly equipped and the staff is often impolitely attacked by users. The staff often has too many consoles to observe. Usually, components of basic instrumentation (automated call distributors, large screens, speaker phones, automated trouble-

ticketing features, short-codes for checklist, and comfortable chairs with legroom) are missing. The space is often cramped and uncomfortable for the staff.

5. **Competing architectures**

Early integrated products, led by IBM's NetView in the de facto standards area and by AT&T's Accumaster in the OSI standards area, are considered competitors. However, these solutions may also be considered peer-to-peer partners with information exchange capabilities. The industry is still waiting for OSI-based network-management standards which are incorporated into products as well. Altogether, users are confused about the question of what company is the "master integrator" and who is in charge of designing and implementing applications that are connecting the network elements level to subintegrators and to integrators. Figure 1.3.5 illustrates this strategic confusion.

Network-management human resources issues

1. **High personnel turnover**

High turnover always affects the consistency of services rendered to users. The result is an additional need for hiring, cross-education, and training. Transition and training inevitably affects the high quality level expected by users. Frequent reasons for turnover are lower-than-expected salaries, inadequate benefits, lack of job security, lack of recognition, bad atmosphere, poorly equipped environment, bad quality of assignment, and no clear direction for future career development.

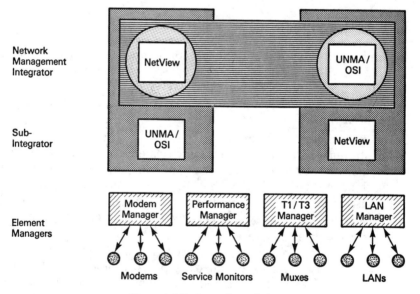

Figure 1.3.5 Strategic confusion.

2. **Increasing quantity of staff**

 As networks show no signs of getting smaller and less complex, the demand on human resources is growing rapidly. It is extremely difficult to find, train, and keep qualified staff. As networks become more complex, people who are really able to operate them are becoming scarcer. Automation and adequate instrumentation may help to control but are unlikely to reduce the number of staff.

3. **Changing responsibilities and assignments**

 The ever-changing environment requires frequent changes in job assignments and responsibilities. This may add to instability in the organization structure unless job rotations have been planned in advance. Unfortunately, ad hoc decisions dominate and organizations are more reacting than acting. Neither the users nor the network-management organization feel they are responsible for supporting LAN-related network-management functions.

 In summary, even when the right people may be found for the right jobs, they are not getting less expensive. At the moment, people are the most expensive and scarce resource, consuming over 35% of all expenditures.

1.4 CRITICAL SUCCESS FACTORS FOR NETWORK MANAGEMENT

Critical success factors are those few key areas of activity in which favorable results are absolutely necessary for an organization to reach its goals. The goal for managing networks is to maintain end-user service levels and thus ensure that the network is operating effectively and efficiently at all times in order not to cause any problems in the corporation's short-, middle-, and long-range operations.

Critical success factors for network management are:

Processes and procedures: Sequence of application steps including guidelines for how to use tools necessary to execute network-management functions

Instruments: Hardware and software, or both, for collecting, compressing, databasing information, and predicting future performance of network components

Human resources: Individuals involved in supporting network management functions

The following sections will address each of these critical success factors individually.

1.4.1 Network-Management Processes and Procedures

Figure 1.4.1 [TERP89C] shows the most important network-management subsystems based on the recommendations of international standard organizations. The subsystems consist of a number of well-defined functions that are supported by many processes and procedures in practical implementations.

Configuration management is a set of middle- and long-range activities for controlling physical, electrical, and logical inventories, maintaining vendor files and trouble tickets, supporting provisioning and order processing, managing changes, and distributing software. Directory service and help for generating different network generations are also provided.

Fault management is a collection of activities required to dynamically maintain the network service level. These activities ensure high availability by quickly recognizing problems and performance degradation, and by initiating controlling functions when necessary, which may include diagnosis, repair, test, recovery, workaround, and backup. Log control and information distribution techniques are supported as well.

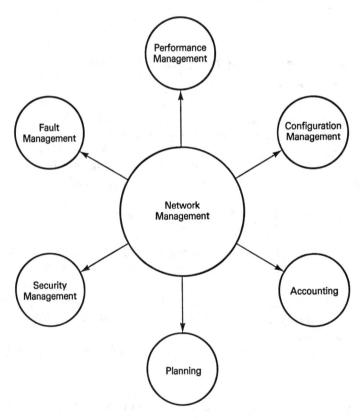

Figure 1.4.1 Principal network-management subsystems.

Performance management defines the ongoing evaluation of the network in order to verify that service levels are maintained, identify actual and potential bottlenecks, and establish and report on trends for management decision making and planning. Building and maintaining the performance data base and automation procedures for operational control are also included.

Security management is a set of functions to ensure the ongoing protection of the network by analyzing risks, minimizing risks, implementing a network security plan, and by monitoring success of the strategy. Special functions include the surveillance of security indicators, partitioning, password administration, and warning or alarm messages on violations.

Accounting management is the process of collecting, interpreting, processing, and reporting costing- and charging-oriented information on resource usage. In particular, processing of SMDRs, bill notification, and charge-back procedures are included for voice and data.

Network planning is the process of determining the optimal network, based on data for network performance, traffic flow, resource utilization, networking requirements, technological trade-offs, and estimated growth of present and future applications. Sizing rules and interfaces to modeling devices are also parts of the planning process.

Chapters 7 to 12 will address these network-management functions individually.

1.4.2 Network-Management Products Overview

To classify products in the area of network management, a three-layer approach will be introduced (HUNT89). The base layer consists of network elements. Network elements are those components of the communication network that need to be managed. These are PBXs, LANs, computers, multiplexers, modems, CSUs, DSUs, switches, bridges, routers, brouters, gateways, communication facilities, network services, terminals, terminal servers, facilities, and local loops. In many cases, network elements contribute to management by providing information about status and performance.

Network elements may have the built-in capability of generating event reports, alerts, or alarms. If not, external monitoring devices have to be attached to the elements or to the standard communication interface.

The most important monitoring devices include accounting packages, response-time monitors, modem, DSU, DCU, line, switch, LAN, PBX, software, application, and hardware monitors.

The second layer consists of network-element-management systems. These are systems and software—that may be embedded in a network element itself or in a service node or dedicated processor—that are used to administer and manage network elements. Two-way communication is supported in most cases. A subset of compressed data will be used for early warning and for supervising the total operation in real time. Expert systems

may be used for heuristic decision making based on preprogrammed knowledge. These data are distributed to operators and have only a predefined life cycle. These functions may be taken by the Integrator layer as well.

The third layer consists of integrated network-management systems. These are offerings that tie together the network element management systems. These systems enhance the information collected by the Network Element Management Systems by presenting the network manager with a unified, user-friendly interface. Figure 1.4.2 shows that instrumentation architecture, including data basing and planning extensions. The data-basing segment needs to be translated, using an easy-to-understand command language, into the format required by the data base.

Outputs of the data base may be used for generating periodic network performance-oriented reports. The performance data base should be more than just a set of flat files put together somehow and maintained at predefined time periods. Users are looking for a real data base with reasonable resource demand, report generation, inquiry, and data-compressing facilities. Most widely used options are general-purpose relational or object-oriented data bases or a special product. In the first case, the population and customization may require substantial work. In the second case, the user has to compromise on higher purchase and maintenance prices, but considerably fewer customization efforts. There are many examples for both alternatives. In addition, a metalanguage approach may be required for improving portability. At the planning level, the user would like to benefit by getting information from the data base for predicting future service levels and resource utilization. Additional restrictions may be summarized by workload forecast, quantifying new applications, service expectations, and feasible technological alternatives. Analytical modeling, simulators, emulators, statistical techniques, decision support systems, and expert systems may be included in this category.

The final output is the proposed future configuration, detailing nodes, topology, and transmission alternatives. Decision support systems and expert systems may be included in this category.

The most important objectives of an integrated architecture are to (BIAR83):

- Provide a method of accessing information that is designed for the appropriate user.
- Minimize the amount of input by the user and therefore reduce the chance of input errors.
- Supply standardized outputs in an easily readable format.
- Allow the user the ability to produce user-defined reports.
- Allow a maximum amount of flexibility with the type of equipment being analyzed.
- Provide an easy and quick means of changing the type and characteristics of hardware, software, and workloads being analyzed.

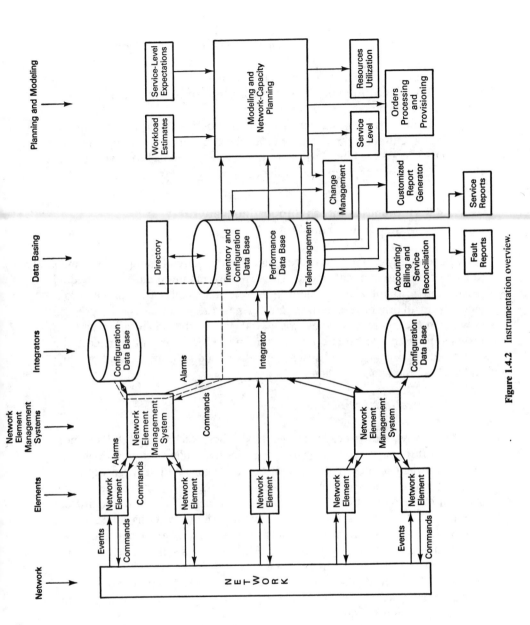

Figure 1.4.2 Instrumentation overview.

- Provide the ability to quickly analyze different types of hardware, software, and workloads.
- Allow the user the ability to quickly pinpoint performance problems.
- Allow the user the correlation of service and utilization indicators.

But an integrated architecture is not yet available. The user is supposed to use and combine different kinds of instruments for collecting and analyzing data, and for predicting future performance.

Recent trends show the same level of distribution of the data base to the network-element-management systems level. Also, certain planning functions with limited scope may be assigned to this level. Chapters 4 to 6 will address the instrumentation topic in greater detail.

1.4.3 Human Resources Supporting Network-Management Functions

Beyond any doubt, teamwork is definitely required for human resources to support network management. The tasks are manifold and no individual person can accomplish all of them, not even in a small networking environment. As in all other areas of the company, network management is successful only when the people feel they are a vital part of the organization and are matched up with appropriate job assignments. Specific areas that need to be addressed are organizational structure, personnel qualifications, and building and keeping the team together.

Organizational structure

Currently, many organizations have their technology staffs report through a director of technology or engineering, while the operations staff reports through a data center operations manager. Within these organizational structures, the lowest common management point is often the general manager of the company or division. The recommended organizational structure is to follow the various network-management functions addressed in section 1.4.1. Some progressive companies are even organizing their network management as a single resource. Managing this single resource from a common group facilitates efficient exchange of ideas.

Exactly following the functional areas is not easy. In most cases, multiple functions are assigned to the same group. For a sample organization, the following groups are typical:

Network control center

Customer Support Desk: Personnel must possess a combination of good problem-solving skills and interpersonal skills. Both of these skills must be considered equally important. The user requires an individual who can solve

his or her problem. For many users the support desk is the only contact they have with the network. The bridge between the support desk and technical support must be automated, at least in part.

Technical Support: Technical support personnel must possess specific knowledge of systems and components and therefore have technical background. However, two different types of personnel are required. The individuals who are responsible for operating the network—including routine tasks, like fixing line errors, programming, and using datascopes—are closer to technicians.

An analyst is also required for methodical network troubleshooting. He or she views problems from a removed perspective to achieve a solution. The analyst should also possess interpersonal skills to interact with management in the presentation of network status and availability. Design and implementation of automated procedures for operating the network and modeling for planning the network are skills that may also be included.

Network Dispatch: Frequent visits to remote user locations requires special skills. Network dispatch personnel must possess detailed technical knowledge and a high degree of interpersonal skills. This is a difficult position to fill correctly because of the unique skill mix required.

In summary, these three activity areas cover fault and performance management.

Network administration

Inventory and Configuration Management: The individuals working in this area must possess the ability to see the big picture. The jobs also require clerical and "people" skills.

Security Management: Besides some technical background on monitoring techniques and devices, this job also requires clerical and interpersonal skills.

Accounting Management: In most cases, data and voice are targeted together. Personnel in this area need knowledge of the entire organization's accounting techniques, some technical knowledge to understand the data collected for accounting purposes, and some knowledge of how accounting packages work. Both clerical and interpersonal (e.g., costing and negotiating service-level agreements) skills are required.

Network planning

Network Design: These individuals must possess a high level of technical knowledge of state-of-the-art networking technology and how modeling techniques and products work. Application background and some know-how about statistical techniques is very valuable.

Capacity Planning: Good verbal communication skills are required in talking to designers, business planners, and users. Some technical knowledge is required for understanding the current workload, for projecting workload, and for determining the major capacity upgrade points.

Table 1.4.1 shows another option which more closely follows the network-management subsystems and functions.

Dealing with personnel is a very complex process. In the first step, team members have to be identified on the basis of functions to be supported for network management. This identification process includes documentation of the following requirements:

Job description: A clear definition of the primary requirements and responsibilities of the position.

Responsibilities: The major work elements of the position in the job functions category. These are the day-by-day activities that constitute this position.

Job contacts: The groups and individuals with whom this position will have frequent contact. These include both corporate and outside inter-faces.

Qualifying experiences: The personal, technical, and experience capabilities necessary for this position.

Training: The training courses and programs that will be most beneficial to the individual in this position.

Career path: Future positions that would reasonably be projected for the individual who is successful in this position.

TABLE 1.4.1: Network-Management Organization Overview.

Network-Management Organization

Network-Operational Control	Network Administration
Help-Desk Operator	Inventory Coordinator
Network Operator	Change Coordinator
Technical Support	Problem Coordinator
	Service Coordinator

Network Management

Network-Performance Analysis	Network-Capacity Planning
Performance Analyst	Business Planner
Network Management	Advanced Technology Analyst
Data Base Coordinator	Modelling Coordinator

Compensation: Yearly salary range for this position. Ranges vary by company and geographical location.

In the second step, the right candidates have to be found using efficient advertising and effective interviewing techniques. To avoid future dissatisfaction, hiring is recommended only if mutual benefits can be justified. The third step includes all activities on behalf of top management that help to keep the network-management team together. The following list of priorized criteria may help:

- Salary and benefits
- Job security
- Recognition of accomplishments
- Support of dual ladder career paths
- Periodic and effective training and cross-education
- Quality of job assignment
- Support of functions by adequate instruments
- Realistic mission statements
- Quality of working environment
- Employee control, including handling complaints and solving personnel problems

The weights may be different, but the general scope of the criteria is almost the same in all the network-management environments. Table 1.4.2 displays a sample profile of the network manager.

TABLE 1.4.2: Profile of Network Manager

Duties:

1. Supervise and monitor the performance of network management.
2. Estimate cost and resource requirements for information system services.
3. Review and approve design of system procedures.
4. Perform planning and scheduling for system resources.
5. Develop, implement, and enforce procedural and security standards for system functions.
6. Evaluate performance of system resources and report results to management.
7. Plan and direct acquisitions, training, and development of network-management personnel.

External Job Contacts:

1. Other managers within information system.
2. Users responsible for applications systems.
3. Vendor representatives.

Qualifying Experience:

1. Prior experience in statistics, mathematics, accounting, computer science, or equivalent.
2. Training in advanced practices, skills and concepts, administrative management, supervisory technique, resource management, budgeting, and planning.

1.5 NETWORK-MANAGEMENT MARKET SEGMENTATION

After a compilation of requirements, instrumentation, and status overview, the requirements have to be segmented by typical groups of customers. Segmentation may be based on the market value or the revenue streams of the corporations. It is recommended to distinguish four enterprise clusters, which may be characterized in terms of general networking as follows:

Cluster 1: Very strong customer
1. Size is about 50,000 or more network elements.
2. Besides traditional components, such as front-end processors, there are modems, concentrators, heavy use of matrix switches, high-bandwidth multiplexers, local area networks, and PBXs with the ultimate goal of hierarchical and distributed processing.
3. Multiple gateways between the master and other architectures for increased connectivity; peer-to-peer connections are required.
4. Evolutionary migration to digital backbone-type networking services for integrating data, voice, image, and later, video.
5. Occasional use of MANs.

Cluster 2: Strong customer
1. Size is between 10,000 and 50,000 network elements.
2. Besides traditional components, such as front-end processors, there are modems, concentrators, heavy use of matrix switches, high-bandwidth multiplexers, local area networks, and PBXs with the ultimate goal of hierarchical and distributed processing.
3. Occasional use of gateways for improving connectivity; peer-to-peer connections are required.
4. Evolutionary migration to digital backbone-type networking services for integrating data, voice, image, and later, video.
5. Rare use of MANs.

Cluster 3: Medium customer
1. Size is between 3000 and 10,000 network elements.
2. Use of front-end processors, modems, concentrators, matrix switches, high-bandwidth multiplexers, and local area networks, but at the beginning without integrating PBXs into overall data networking; support of distributed processing for a few mission-critical applications.
3. Occasional use of gateways for improving connectivity; peer-to-peer connections are occasionally required.
4. Evolutionary migration to fractional digital backbone-type networking services for integrating data, voice, image, and later, video.
5. No use of MANs.

Cluster 4: Weak customer
1. Size is below 3000 network elements.

2. Straightforward architecture with very few switches and multiplexers; support of distributed processing for a few mission-critical applications on LAN-basis; no integration of data and voice.
3. Gateways are very rare.
4. Point-to-point topology still dominates.
5. No use of MANs.

In terms of sharing physical resources by logical networks, the conclusions are:

Cluster 1: Due to heavy expenses, they tend to accomplish more resource sharing. But, due to complex interrelationships and lack of configuration data bases, it is a slow process. T1, fractional T1, T3, E1, J1, and ISDN help in this respect.

Cluster 2: Basically, everything is true as indicated for Cluster 1. However, because of probably fewer number of logical networks, the resource sharing can be accelerated. In both Clusters 1 and 2, the number of architectures supported determines the speed of progress for resource sharing.

Cluster 3: These customers are slower in implementing T1, T3, E1, J1, and ISDN. That is the reason for staying with a few logical networks supported separately by physical resources. There is probably one master architecture with few low-level gateways toward other architectures.

Cluster 4: Typically physical and logical networks are identical. Further resource sharing is hardly needed.

Network management solutions are considered as follows:

Cluster 1: Very strong customers
1. Due to complex interrelationships, there is heavy use of both physical and logical network-management products from market leaders.
2. The implementation of more integrators is expected.
3. Vendors will support at least one of the integrators due to the strong voice of the customer.
4. More investment in fault, configuration, and performance management.
5. Some investment in accounting, security management, and planning.
6. Support of de facto and OSI standards for minimizing future risks.
7. Rapid move to integrated consoles.

Cluster 2: Strong customer
1. Still heavy use of both logical and physical network-management products from market leaders.

2. Few integrators will be implemented.
3. Vendors' support for one of the integrators is very likely.
4. More investment in fault, configuration, and performance management.
5. Some investment in accounting, security management, and planning.
6. Support of de facto and some support of OSI standards for minimizing future risks.
7. Rapid move to integrated consoles.

Cluster 3: Medium customer
1. Physical and logical network management in balance, but fragmented.
2. Integration of network-management solutions is under consideration, but is not the highest priority.
3. Some investment in configuration and performance management. More investment into fault management.
4. Little investment in accounting and security management. Investments in planning differ by company.
5. Fewer instruments altogether for supporting network management.
6. Rapid move to integrated consoles.

Cluster 4: Weak customer
1. Simple networks with few network-management applications.
2. Physical network management in addition to logical network-management support from the (only) architecture are sufficient.
3. Fault management is the primary target of instrumentation.
4. Integrated consoles are under consideration.
5. Few instruments altogether for supporting network management.
6. Integration of network-management solutions is a low priority.

While network management will be the responsibility of a central organization, administration and control of LANs and distributed systems may continue to reside at the local level. In large local networks, moves and changes, local problem resolution, and simple management will be more efficiently discharged at the local level. However, control of smaller networks may be centralized where the work group or office has limited staff.

Besides centralization, on-premise network management is preferred. Centralization is tightly coupled with integration using more mainstream than sidestream management techniques. The requirements are evaluated for each cluster using Table 1.5.1. Problems and voids can be seen in Table 1.5.2. The entries are the same as discussed in section 1.3 of this chapter.

Chapters 7 through 12 will address the human resources demand individually quantified in FTEs (full time equivalent) for each of the clusters introduced here. Also, instrumentation will be differentiated by clusters.

TABLE 1.5.1: Evaluation of Network-Management Requirements by User Clusters.

What Users Want from Network Management	Cluster 1	Cluster 2	Cluster 3	Cluster 4
1. Ensuring end-user service level	+++	+++	++	+
2. Capability to heal, bypass, or circumvent failed elements	+++	+++	++	+
3. Capability to operate despite elements' failures	+++	+++	++	+
4. Monitoring	+++	+++	++	+
5. Real-time performance analysis	+++	++	++	+
6. Statistics and historical data availability	++	++	++	+
7. User interface	+++	++	++	+
8. Operations productivity	+++	+++	++	+
9. Network-management data base	+++	+++	++	++
10. Change management	++	++	++	++
11. Bandwidth management	+++	++	+	+
12. Network generations from one source	++	++	+	+
13. Improved security	++	++	+	+
14. More accuracy and simplicity of accounting data	++	++	+	+
15. Implementation of generic applications	+++	++	++	++
16. Integration	+++	+++	++	+
17. Centralization with distributed implementation	+++	+++	++	+
18. Conformance to OSI standards	+++	+++	++	+
19. Integrated reporting	+++	++	++	+

+++ very important strong need
++ important moderate need
+ nice to have weak need

1.6 NETWORK-MANAGEMENT STRATEGIC DIRECTIONS AND BENEFITS

The principal directions of network management are integration, centralization, automation, and repository support. Integration has to be accomplished across multiple communication forms, multiple vendors, multiple network architectures, private, public, and virtual networks, LANs, MANs, and WANS, across multiple processors, applications, data bases, and network-management products. Centralization offers the opportunity of central control supported by shared or dedicated processors in combination with distributed implementation of certain network-management functions, such as filtering, problem detection, data compression, and change management. Automation aims for simplification of the operator's tasks by improving productivity, error minimization, problem prediction and prevention, and speeding up recovery using various

TABLE 1.5.2: Problems and Voids with Network Management by User Clusters.

Network-Management Applications Issues	Cluster 1	Cluster 2	Cluster 3	Cluster 4
1. Separate logical and physical managements	S	S	C	P
2. Separation by network architectures	C	C	P	P
3. No alarm management	S	C	C	C
4. No procedures for measuring end-user service level	S	S	C	C
5. Not enough automation	S	S	C	C
6. Lack of managing local area networks	S	S	S	S
Network-Management Instrumentation Issues				
1. No configuration data base	S	S	C	C
2. Fragmented products and too many consoles	C	C	P	P
3. Too many paper-based reports	P	P	P	P
4. Poorly equipped customer support desk	C	C	C	P
5. Competing architectures	C	P	P	P
Network-Management Human Resources Issues				
1. High turnover	S	C	C	S
2. Increasing quantity of staff	S	S	C	C
3. Changing responsibilities and assignments	C	C	P	P

S = Severe problem
C = Critical problem
P = Problem, but not critical

tools, techniques, and facilities. Artificial intelligence is expected to play an important role in future automation.

Repositories are expected to be everything to everybody. Besides configuration data bases, performance data, vendor data, and trouble tickets may also be integrated. In addition to inventory data, connectivity information and dynamic indicators are expected to be included. Chapter 13 will address each of the strategic directions in greater detail.

If network-management functions, procedures, and instruments are properly implemented, and human resources are properly assigned responsibilities, the Information Services Organization will benefit in several ways:

- Visibility of the networking topology
- Correlated alarm management
- Facts for service and utilization indicators

- Visibility of cost elements
- Sizing facilities and equipment on the basis of quantified demand

By doing so, unnecessary costs, excess capacity, inefficient network management applications, inappropriate topologies, and unsatisfied users will be avoided.

2

Networking Trends

After briefly summarizing present networking status and expectations for the next 10 years, generic network elements, such as servers and clients, equipment and facilities are introduced using the categorization by CPE (customer premises equipment), LEC (local exchange carrier) and IEX (inter-exchange carrier), or PTT (postal telephone and telegraph) domains. The connectivity matrix leads to classifying networks by different alternatives of the client-server relationship. Enterprise networking will be considered as an objective to bring multiple communication forms under one umbrella within the same corporation.

In terms of client services, three levels are differentiated: physical connectivity, and basic and value-added services. Advanced bandwidth management alternatives and software-defined and virtual networks are also included. Standardization will play a key role in future networking. De facto and international standards, performance impacts of network elements, architectures, and services are briefly addressed.

2.1 NETWORKING STATUS

The present networking status can be characterized as follows:

- Sectionalization of communication networks by applications, suppliers, communication forms (voice, data, video, facsimile), users, networking segments, and by geography. Figure 2.1.1 shows typical network segments.

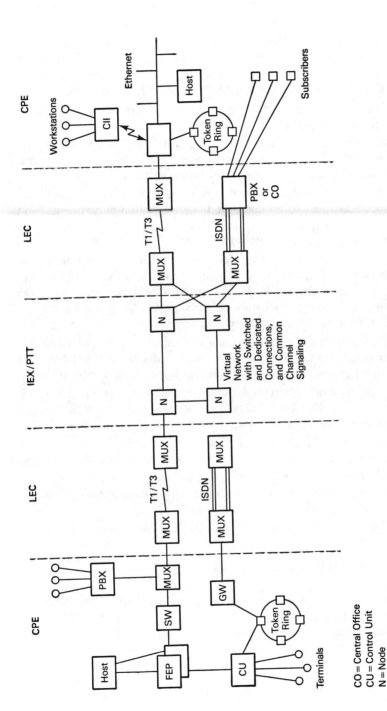

Figure 2.1.1 Networking segments.

CO = Central Office
CU = Control Unit
N = Node
MUX = Multiplexer
SW = Switch
GW = Gateway

- Lack of integrating the logical and physical networks causing serious problems of economy. More than 50% of users have to deal with more than four, and 35% of users with more than eight different networks.
- Lack of integrating multiple vendors networks into one unique enterprise network due to incompatibility problems caused by the fact that manufacturers generally develop their own communication systems and architectures to provide interoperability among their own devices.
- Uncontrolled growth of certain networking segments due to unregulated influence by manufacturers.
- Transmission of information is still being done using analog techniques. But conversion to digital and light wave is on the way. Significant price reductions and quality improvements are expected.
- Personal computers have penetrated almost all levels of organizations— from the individual, to groups of individuals, within departments, and across and between functional units and establishments. But not all of the personal computers are networked yet.
- Complexity of networks is continually growing, and hybrid communication architectures, multi-tiered network structures, LANs, PBXs, integrated voice/data resources, T1, T3, and ISDN implementations have brought inadequacies of existing network management tools and techniques to attention as certain networks become unmanageable.
- Structures and architectures in local areas are confusing. There are simply too many vendors, and it is extremely difficult to select the right alternative, assuring proper bandwidth performance and connectivity.
- There are no planning and sizing tools and techniques in use. The result is that network planning is being done generally without assuring high performance at reasonable costs.
- Computer and office equipment are segmented by applications, such as personal computing, mainframe inquiry/response, and word processing.
- High overhead in communications is due to control characters for communicating in highly complex networking environments requiring bridges, routers, and gateways for various protocols.
- Standardization has not yet broken through to end-users.

2.2 EXPECTATIONS FOR THE NEXT 10 YEARS

To set an innovative pace and to improve the economy of scale of communications, the environmental conditions over the next 10 years have to be carefully evaluated and weighted for importance. The following likely environmental conditions may be considered: [GANT88A]

- The combined computing/communications industry will be reforming, causing a growing polarization among suppliers and a growing importance of communication managers.

- The number of end-users with heavy networking demand will be doubling within the next few years.
- The communication network will remain a multi-vendor, multi-tiered, and multi-media entity.
- Network control and management will be a matter of managing various subschemes (physical and logical) for supporting control and management.
- Backbone transmission will be an interchangeable commodity. Network access will vary from a commodity to a value-added item.
- Traffic will become increasingly digital and will significantly change in nature. The bandwidth demand will come not from an increase in real-time verbal communication between humans, but from add-on traffic types, including LANs supporting graphics (e.g., CAD, electronic publishing and factory automation, broadband information delivery, or catalog shopping and closed-circuit TV), store and forward voice services, telemarketing and information retrieval, and finally out-of-band signaling for network-management support.
- Variations between session duration and channel rates for different kinds of traffic will be enough to affect the resultant network architecture. In particular, users may assume:

 Transaction data processing and timesharing traffic will grow at much higher rates than the capacity of computer equipment.

 Voice-band data can be expected to grow a little slower than the rate for packet-switching or data communication expenditures.

 Voice telephony will grow proportionally by the number of handsets.

 High-speed data will increase, as a significant portion of processing takes place on-premises, and backbone networks are employed to carry interpremise communications using T1, T3, and probably ISDN.

 Broad-band information retrieval will grow as a result of packaging video and high-fidelity audio to homes and businesses. The growth rates will be highly dependent on service price, ubiquity, and innovation.

 Teleconferencing will grow constantly, and the growth rate will depend on acceptance, rather than on technology.

 Entertainment video is the question mark. When CATV-like programming or high-definition TV signals are accessible by homes and businesses, resource demand for networking facilities and equipment may go up substantially.

- Customer premise and nodal processor types will be of such varying characteristics (e.g., operating systems, contracts, data bases, access authorization) that a substantial part of network management will have to be devoted to keeping track of equipment, cabling environmental enclosures, and contracts.

- Management of networking resources will remain to some extent application dependent. Thus, the concept of a single, comprehensive corporate network is not realistic within the next 10 years.

In summary, the communication network of the enterprise a decade from now will likely be a multi-vendor, multi-device, mostly multi-application mosaic that sends traffic to and from numerous destinations under numerous forms of software and hardware control. The level of integration will depend on the environment of the enterprise, including the master architecture for voice and data.

2.3 GENERIC NETWORK ELEMENTS

Network elements may be subdivided into two major groups: equipment and facilities.

Equipment is defined for originating, relaying, and terminating information. Processing and storing information may be involved as well. Depending on the tasks of the equipment, servers and clients may further be distinguished.

A source node is a point (equipment) through which information enters the network. Examples are terminal devices, communication processors, and information and data base processors. A destination node is a point (equipment) to which information is delivered. Depending on the type of equipment acting as a destination node, the information may or may not leave the network and its control. Destination node examples are identical with those of source nodes.

Relay nodes are points through which information may pass en route from the source node to the destination node. Examples are communication processors, multiplexers, modems, channel and data service units, matrix switches, concentrators, bridges, routers, brouters, gateways, branch exchanges, channel banks, and so on.

Facilities are defined for physically connecting equipment and carrying information between equipment. Both analog and digital transmissions are expected to be supported.

Key network elements are grouped according to the geographical territory of their locations:

- CPE (customer premises equipment) defining the location within the customer's territory.
- LEC (local exchange carrier) defining the location within the territory of local exchange.
- IEX (inter-exchange carrier) or PTT (postal telephone and telegraph) defining the wide area, connecting many LECs and CPEs following the interexchange rules of the country or of the carriers.

In certain cases, it is difficult to allocate network elements to either of the areas uniquely because those elements act as the connecting or boundary device.

The following are typical CPE components.

Processors

Processing resources are not the primary targets of this book. They are interesting only insofar as communication-oriented activities are supported either in host processors—meaning information processing is accomplished at one side—or in host and satellite (distributed) processors—meaning information processing is accomplished at the point of origin or at the point of use. Virtually all mainframes marketed today include some kind of communication support. For the medium- and large-scale systems, this support generally takes the form of the communication-access method, a monitor residing in the mainframe and control software residing in the front-end processor. For smaller mainframes, internal provisions are included in the form of hard-wired adapters or microcoded options. The goal of the telecommunication-control software is to make programming for information exchanges between customer and communication systems resources as simple as for local-site applications.

Communication processors

A communication processor can provide different levels of processing and storing capacity for inbound and outbound information. Most of these processors include a processor with an instruction set designed and adapted for communication purposes. They may include auxiliary storage as well. Depending on the requirements, there are four typical implementation alternatives:

- Front-end processor for collecting, converting, and forwarding inbound messages for further processing in host computers.
- Concentrator for collecting data at remote locations and forwarding collected data via high-speed links to the host computer.
- Message switch for allocating transmission resources to addressed messages.
- Programmable terminal for ensuring the connectibility of various peripheral units.

Terminal control units

They are considered basically as send/receive data buffers for network access. In more advanced cases, an application program is placed between the user and the network, providing one or more of the following features: local format storage, backup operation, editing, validation, file storage and creation, support of nonstandard peripherals, and security filtering.

Personal systems or computers

For distributing computing intelligence, the personal system will play a key role in supporting users in various areas, such as dedicated calculations, source/destination device for advanced communication services supporting various communication forms, intelligent workstation interfacing other processors, word processor, report generator, graphics data processor, and an intelligent monitoring device. The ability to integrate various communication forms emphasizes the importance of these devices for designing highly economical LANs, MANs, and WANs in the future.

Terminal devices

Terminals being offered and used today fall into the following categories:

- **Typewriter terminals:** Include a keyboard and a printing device for simple tasks where the low speed is not a limiting factor.
- **CRT terminals:** Quiet, attractive, and easy to use. A large amount of information is fully displayed. The options with menus can improve overall efficiency.
- **Power entry terminals:** Used for collecting and entering a large amount of information within a short period of time.
- **Cluster terminals:** Controlled by a cluster controller. The entries and response for multiple terminals are buffered. Communicating resources may be used very economically this way.
- **Programmable terminals:** May reduce the information-transmission demand to a meaningful minimum. Editing can streamline the information format. Simple processing may be executed at the local site. Personal computers may be considered here.
- **Communicating word processors:** Can also be considered as customer terminal devices.
- **Special-purpose terminals:** Include optical-mark readers, voice-response units, portable terminals, and ordinary telephones of the touch-tone variety. Furthermore, terminals of integrated service digital networks (ISDN) may be listed here, enabling the customer to choose the desired communication form.

Modems

The modem is the most common and predominant network component. Its role in attaching end-user devices, either terminals or host processors, places the modem in almost every network installation. Within several configurations, modems and transmission media constitute the entire network.

Physical media visibility is provided almost exclusively through modems. Line outages, link retransmissions, and link utilizations are all parameters

gathered by the modem, which can be subsequently transferred to a management system.

In a fully digital environment, DSUs and CSUs will take the role of modems. They are responsible for encoding/decoding user data into bipolar form for transmission by high-speed links.

Channel Service Unit (CSU). CSUs perform several functions in provisioning a T-1 signal, such as signal enhancement and loop-testing. While they do not perform the synchronization function of the circuit, they keep track of the circuit's polarization/bipolarization. In this configuration, a CSU acts similarly to a repeater—a device that conditions, sharpens, and enhances the signal while providing testing and signal monitoring capabilities.

Data Service Unit (DSU). DSUs format the information by taking in the raw digital information and molding it into a D4-compatible signal. Most of these functions are now performed by the CSU, as discussed above. In fact, most CSU and DSU devices are marketed today as combined units.

Unfortunately, most data collected by modems, DSUs, and CSUs is difficult to integrate into vendor-provided management systems. The integration of modem, DSU, and CSU data into the mainstream network-management systems is critical to centralized network control. Statistical data collected for the network control function of network management must be integrated into the network-management data bases for control, administration, and analysis of the network.

Electronic matrix switches

The growth of the matrix switch industry is an indication of the importance placed on reliable management of corporate networks.

Matrix switches are designed to support data terminal equipment (DTE) connections to data circuit terminating equipment (DCE) using typically EIA RS-232-C and CCITT V.35 interfaces. With matrix switch and associated management systems, the following types of management functions can be performed:

- Error detection and recovery from front-end processor, modem, multiplexer, or communications line failures.
- Monitoring and testing of network component ports and communication lines with vendor-supplied diagnostic equipment.
- Balancing traffic loads to optimize network performance.

Matrix switches offer powerful tools for network management. However, users must be aware that most matrix switches include their own network-management systems. This restricts the integration of data between switches provided by different vendors. For example, most matrix switches support the

generation of trouble tickets upon the detection of network problems. However, these trouble tickets or associated change requests cannot be received and processed by network-management systems from other vendors.

Despite this limitation, matrix switches exhibit high utility. It is expected that as network-management architectures are opened, matrix switches will play an increasing role in physical network management.

Repeaters

Repeaters are hardware devices that extend the geographical coverage of a network by interconnecting two similar LANs, such as Ethernet or Token Ring. They operate at the physical layer of the OSI model. They simply repeat (amplify, reshape, retime) packets received from one LAN before sending them to the other. For example, the maximum length of an Ethernet segment is about 500 meters. However, repeaters can connect up to five segments for a maximum network distance of 2500 meters. Because of the built-in propagation delay limit of Ethernet, the end-to-end cable length cannot be more than 3000 meters. This plus their inability to do protocol conversion are some of the major disadvantages of repeaters.

Bridges

Bridges are intelligent passive devices that can connect similar and dissimilar LANs. Bridges are transparent to high-level protocols such as TCP/IP, XNS, or OSI. Since bridges interconnect LANs at the media access control sublayer of the data link layer of the OSI model, they are also referred to as MAC layer bridges. They filter and forward packets based on the MAC source and destination addresses of each packet. A bridge can be either local or remote.

A local bridge may interconnect two similar networks such as Ethernet or dissimilar networks such as Ethernet to broad band. A remote bridge interconnects local area networks using wide-area network transmission media. Remote bridges may use, for example, T-3, E1, and J1 lines to join two geographically separated networks.

Routers

Routers connect LANs that have common protocols at the network layer and above in the OSI model. They are therefore protocol sensitive and can, for example, connect two TCP/IP- or DECNet-based networks but not their combinations. Some commonly used network layer protocols are: ARPA, IP, XNS, DECNet, and ISO 8473. Routing schemes specified by these network layer protocols differ considerably from each other. A router can select one path among available ones based on many parameters, such as delay, path cost, or congestion at other routers.

Brouters

In order to combine the benefits of routers and bridges, some manufacturers offer a hybrid device with approximately the transmission speed of bridges and with the routing intelligence of routers. The ultimate decision for either of the components is given by performance indicators.

Gateways

Gateways perform protocol conversion at all seven layers of the OSI model. They can interconnect two LANs that have completely different architecture and protocols. For example, gateways can connect TCP/IP-, DECNET- or XNS-based LANs to X.25 or SNA. When a LAN is connected to a host via a gateway, two processes take place: one between the LAN and the gateway, and the other between the gateway and the host. The gateway acts as the protocol translator. Because of this complex process, gateways are generally slow and have limited performance.

Considering internetworking devices, there are two different observations:

1. The more sophisticated the device, the higher are the costs.
2. The higher the scope of functionality, the higher is the likelihood of processing delays.

The "sophistication" line starts with repeaters, is continued with bridges, brouters and routers, and ends with gateways.

Private branch exchanges

Private branch exchanges (PBXs) are not simple network components, but rather sophisticated digital switches that support both voice and data users. Currently, most corporate installations provide separate management organizations for the data network and the PBX (primarily voice) networks. Within this context there is very little service or functional integration. However, as voice and data communications merge, management of PBXs and other "voice" network systems will be fully integrated with the data systems management.

Currently, a small number of companies are using PBXs for both voice and data. Of this group, the majority use PBX switching facilities to switch lines between data communication devices. For example, a PBX is placed between a cluster controller and a front-end processor with a circuit that is dedicated to that configuration. This "nailed up" circuit provides a modem elimination function. Other organizations connect two local-area networks through PBX switches.

As the volume of outbound and inbound calls increases, other manual tasks become the targets of automation and are integrated into the PBX. Speed dialing, for example, allows the user to complete calls by dialing an

abbreviated number. Automatic call distribution allows sharing of incoming calls among a number of stations so that the calls can be served in the order of their arrival. Automated attendance is the capability of the system to answer incoming calls and prompt the caller to dial the appropriate extension or leave a voice message without using the operator.

Typical LEC components are:

Central office equipment

This is an alternative solution to on-premise PBXs. The central office (CO) takes over all switching responsibilities between the CPE and IEX usually using twisted-pair cables. Central offices are owned in most cases by the local telephone company.

Digital termination systems (DTS)

DTSs have received a lot of publicity, particularly in larger cities. DTSs are simply point-to-multipoint microwave. Standard configurations entail three or four back-to-back antennas, each serving one sector, transmitting and receiving messsages. Each message has an address, with customers picking up only messages addressed to them. DTS will deliver three kinds of services. First, it will be used to provide dedicated, full-time, private-line telecommunications services. Leased digital services will range from 2400 bits/s to T-1 (1.54 Mbits/s). Second, DTS will provide groups of 24 local voice trunk or access lines. Some corporations, governments, common carriers, and long-distance resellers have heavy voice-message traffic among multiple locations. These customers are either paying the Bell operating companies for those services now or are awaiting delivery of circuits. DTS is an economically attractive alternative that will be readily available in some locations. Third, DTS networks will also provide measured service. With measured service, a customer is charged only for actual network use. Measured service is valuable to customers who have heavy peak traffic but very little traffic at other times. Typical applications for measured high-speed service are computer backup, mass file transfer, remote laser printing, and high-speed facsimile.

Coaxial community antenna television (CATV)

The coaxial facilities of CATV companies pose a long-term alternative for bypassing in rural as well as in urban areas. CATV is widely distributed. Federal legislative efforts seem favorably inclined toward allowing CATV companies to provide most telecommunications services without regulation. CATV companies could conceivably sell their entertainment services to cover their principal costs and use incremental costs as a technique for gaining entry into communications. CATV does have some major hurdles to overcome first. There is no equipment today that economically puts two-way voice and data on CATV cable. Most CATV systems still use 12- and 24-channel, one-way-

only systems. However, a great deal of effort is going into equipment development. In summary, CATV represents one of the best long-term alternatives for large-scale bypass of local telephone networks.

Direct broadcast satellite (DBS)

There are two types of DBSs: one-way and two-way. Two-way systems are very expensive; a lot of traffic is needed to justify their use. As a result, two-way systems have not developed into a serious bypass alternative for any but the largest customers in large urban areas. A one-way system is aimed initially at the rural home television market, competing, ultimately, with standard and cable TV. Conceivably, in a small way, it could be a bypass option for such services as reservations and electronic mail.

Teleports

Teleports are the conglomerates of bypass. Currently, Merrill Lynch & Co., Inc., Western Union, and the New York Port Authority are operating a teleport on Staten Island to serve the New York City area. The center, which covers 200 acres, is served by 17 satellite dishes connected by high-speed fiber optics to customers in Manhattan, and there are both twisted-pair and coaxial-cable wiring in the buildings. The teleport in New York had a lot of publicity, but there are many others in various construction or planning stages, each slightly different. They include new, complex developers and reflect methods for bypassing using someone else's system rather than building their own.

Cellular radio

Cellular radio has received a lot of publicity. As a unit moves from one cell to another, it is automatically transferred to the closest antenna. At the computer-control center, the cellular network is connected to the direct-distance dialing (DDD) network or to another network. Cellular radio might be expected to quickly make local telephone plants and telephone obsolete. Everyone will carry a personal portable telephone, eliminating the need for a standard office or home telephone. However, if one examines the facts, it seems unlikely that this scenario will happen. Even the most optimistic studies do not show these costs dropping very drastically for at least 10 years. Realistically, cellular radio is not expected even to begin to replace standard telephones before the end of this century. However, cellular radio is important as a new service, offering opportunities for innovation in communications mobility.

Specialized mobile radio (SMR)

SMR is an inexpensive, easy-to-provide, mobile radio system. Unfortunately, it has many limitations that cellular radio does not. However, as a result of a recent Federal Communications Commission (FCC) decision, SMR

can be connected to the DDD network and is much less expensive than cellular radio. If the FCC continues to reduce SMR restrictions, SMR could become an effective competitor for low-cost mobile telephones.

Frequency-modulated (FM) subcarriers

Another interesting mobile bypass development involves FM subcarriers, officially called FM-SCA. Since 1983, FM radio stations have been able to utilize the unused portion of their assigned FM radio frequency, including leasing it to others. In summary, the network capacity planner is expected to evaluate new services continuously. Very frequently even the local phone company is willing to cooperate and to offer feasible value-added services.

Typical IEX components are:

Multiplexers

Network multiplexers represent the second most common network component. Their "partitioning" of common carrier circuits into lower frequency network lines provides user access into the host environment. Network configuration and transmission facility health are dependent upon integration of multiplexers into the network-management system.

Multiplexers may be divided into the following groups:

- Smart multiplexers
- Statistical multiplexers
- Time division multiplexers
- Frequency division multiplexers
- Channel banks
- T-multiplexers

A smart multiplexer processes and moves traffic in a fixed number of bits/character code set(s). That is, traffic entering the device from a terminal using an 8-bit-per-character code set remains in that code set during passage through the smart multiplexer. The traffic may be reformatted relative to block, buffer, or packet size for transmission on the next link, but the code set(s) remain constant.

A statistical multiplexer is capable of everything a smart multiplexer is, with one significant addition. The traffic flow anticipated is analyzed statistically to determine the frequency of occurrence of the various characters in the code set. From this, a statistically derived code-translation table is derived. The most frequently occurring characters are translated into 3- or 4-bit-per-character codes. The less frequently occurring characters are recoded (translated) into 5-, 6-, 7-, 8-, (or higher) bit-per-character codes, whereas the least frequently occurring characters become 13- or 14-bit-per-character codes.

Special-application-related data-compression techniques and their impacts are addressed in Chapter 9.

Traffic entering a statistical multiplexer from the source node (terminal, etc.) is translated from the fixed-bit-per-character code set into the statistically derived code set via the translation table and appropriate microprocessor logic. The translated traffic is repacked into blocks, packets, and so on, and prepared for transmission to the next node. A control block containing information to be used by the receiving device (another statistical multiplexer) in translating back to the original fixed code set is prepared and included with the transmission.

The receiving statistical multiplexer restores the traffic to its original code set for delivery to the next node (front-end communications processor, etc.). It is a logical extension of the software of communication processors to take on the statistical multiplexing function. In this manner, the cost of the second statistical multiplexer is eliminated. Addition of the statistical multiplexing function to communication processor software is justifiable when the software-development cost is recovered through the elimination of a sufficient number of statistical multiplexers. Smaller installations requiring a single (or relatively few) pair(s) of multiplexers do not produce the desired cost savings.

The primary advantage of a statistical multiplexer over a smart multiplexer is in its more efficient utilization of the available bandwidth of the multiplexed link. Since the more frequently occurring characters occupy only 3- or 4-bit positions, almost twice as many of them can be transmitted over a link during a given period of time than is possible in the fixed 8-bit-per-character mode.

The actual increase in effective bandwidth is a function of the type of traffic flowing and the closeness of fit to the frequency of occurrence indicated in the statistically derived code-translation table. Deviations from these frequencies occur across the multiple dimensions and across applications within a given dimension.

Further upgrades may include built-in modems, flexible configuration by customer, substantial growth in number of ports supported, downline loading of parameters, displaying interface signals and multiplexer parameter tables, message distributions to customers, and automated recovery after network breakdowns.

Due to the memory and buffering capabilities inherent in hybrid relay nodes, the time delay incurred is variable. Since most, if not all, smart and statistical multiplexers currently do not include auxiliary storage media (disks, drums), the queuing is limited to the single level. A model of a hybrid relay node must reflect the queuing problem if the delays are to be accurately evaluated. Should later versions of the hybrid relay nodes include auxiliary storage, the models must reflect this multi-level queuing problem.

The performance analyst should always compromise on saving information transmission resources and increasing customer-response time due to delays of transforming code sets. Decisions should be made on quantitative measures during peak-load off-peak time windows.

Channel banks and T-multiplexers

For interfacing equipment on customer premises to T1/T3 facilities, channel banks or T1/T3 multiplexers are usually used. A channel bank is part of a carrier multiplexing terminal that performs the first step of call handling. It multiplexes a group of channels into a higher frequency band at one end and demultiplexes the higher frequency band into individual channels at the other end. The distinction between channel banks and digital loop carrier systems is vague. Terms used for this type of equipment include channel bank, digital loop carrier, pair gain system, digital terminal, and multiplex terminal. The term channel bank is most often used loosely to designate equipment of these types.

The term T1/T3 multiplexer refers to a wide range of devices rather than to a specific product category. At the low end of the market are time division T1 multiplexers that handle voice, data, and video inputs in point-to-point applications only. At the high end are highly sophisticated T1 switching multiplexers, commonly called resource managers, that provide enhanced network control and more efficient bandwidth usage. These multiplexers are an actively participating segment of integrated network management.

Multiplexers, like modems, are typically locked out of vendor proprietary management systems. These management systems have not been designed to integrate the multiplexer information into real-time status or network control. Configuration data are typically gathered manually rather than transmitted through the network and automatically provided. Future multiplexers that reside within an open network management architecture will support network control and administration functions by automatically generating changes to transmission facilities that are faulty, and by providing real-time problem data to the NCC. Currently, multiplexers play only a limited role in the network-management scheme by being exclusively part of physical-level problem determination. Also, management of multiplexers, like modems, is performed by a separate network-management system, not integrated into the primary network-management system.

Fractional T1/T3 multiplexers show little differences. They must be able to provide a D4 framing format for the T1/T3 output. Most products offer this functionality, making the term "fractional" more a marketing term than an actual technical attribute.

Digital access and cross-connect systems

DACS (digital access and cross connect system) is a computerized facility allowing DS1 lines of 1.544 Mbps to be remapped electronically at the DSO level of 64 Kbps, meaning that DSO channels can be individually rerouted and reconfigured into different DS1 lines.

CPE is very often considered the local area that is fully controlled by customers. Most or even all equipment may be connected to each other within a limited geographical area by local area networks.

Local area networks (LANs) comprise a number of servers and clients

connected to each other within a defined geographical area. At the present time, there is no final determination as to the most promising local-networking method (e.g., digital exchange or broadband- and baseband-cable-based techniques). Local area networks are frequently classified by using one or more of the following criteria:

- **Networking scheme:** In broad-band networks, the cable's bandwidth is segmented (using frequency-division-multiplexing techniques) into multiple independent channels, which allows simultaneous transmission types (data, voice, or video); in baseband networks, only one signal is permitted on the channel at a time, but the signal generally travels so quickly that the channel can easily be shared by many devices. There is a trend of combining baseband and broadband networks. Baseband clusters will continue to exist, because many have been installed and new ones will continue to be installed, particularly to support smaller clusters not exceeding a total utilization level of 30% of the transmission medium. On the other hand, broad-band networks will grow to meet multi-mode, multi-channel requirements. In combination, broad-band backbones will serve local baseband clusters, which may offer flexibility toward traffic patterns, protocols, and access methods.
- **Physical transmission:** Transmission can be accomplished via shielded or unshielded twisted pair cable, coaxial cable, or fiber.
- **Protocols:** Local area network vendors can be grouped according to their present support and their expected short-range support. Vendors are increasingly supporting the seven layers of the OSI model. Based on the protocol for physical-level and link-level access, the packet-transfer protocol routes packets at the network level between separate link-level channels. The transport level supports two protocols [MOKH85]:
 Datagrams
 Stream protocol, supporting a virtual connection service with FDX, flow-controlled data streams
 In the session level, services are provided for session management, name management, datagram, and diagnostics and monitoring. The presentation and application layers are combined into the user-application layer, supporting electronic mail, file access, print service, terminal emulation, and distributed data-base access.
- **Topology:** The topology may be in the form of a star, bus, or a ring.
- **Access technique:** Three access techniques are used:
 Dedication (FDM, TDM, and SDM)
 Polling (hub, token, and roll call)
 Random (aloha: pure and slotted; or carrier-sense multiple access: pure or with collision detection)
- **Gateway:** They are classified in accordance with the layers they support while converting communication traffic. Gateway is the generic term also for repeaters, MAC-level bridges, bridges, and routers.

The management of local area networks (LANs) represents one of the biggest issues facing network management today. LANs from most of the independent vendors have developed as standalone systems. LANs provided by the major vendors do have some network-management capabilities, but so far IBM is the only vendor that has announced full integration with its centralized network-management system.

Most of today's LANs will collect status information and statistical data from each network device. The information exchange between manager and agent is via SNMP (Simple Network Management Protocol). But, the manager-level-processing of information still needs substantial improvements.

LEC is frequently considered as the MAN (Metropolitan Area Network) area. For not losing the high throughput capability of local area networks, users are requesting changes in the local exchange carrier's environment. Some of the alternatives have been covered previously.

The territory of IEX or PTT is considered by many customers as the wide area offering long-haul connection services to LANs, MANs, or the individual devices. Figure 2.1.1 gives an overview of the three principal areas covering CPEs, LECs, IEXs, PTT, or LANs, MANs, and WANs, respectively.

Elements outlined in section 2.3 are considered objects in the inventory control segment of configuration management covered in depth in Chapter 7.

2.4 CONNECTING NETWORK ELEMENTS AND TOPOLOGY

Topology refers to the way in which communication network elements are physically connected to each other. Network topologies may be characterized as follows:

Tree topology

Based on past teleprocessing services, the majority of present customers operate hierarchical tree topology. Level 1 may be the host and Level 2, the communication processors; Level 3 may include control units; and, finally, Level 4 constitutes the customer's terminals. The private branch exchange (PBX) and computerized branch exchange (CBX) alternatives are also based on the tree topology.

Bus topology

In internal computer architectures and in local area networks, the bus topology is most frequently implemented. This topology may be implemented with and without central controlling facilities. In case of device failures, operation may continue; but, when the link breaks down, the bus network is out of order as well. In order to improve overall reliability, multiple links are frequently implemented.

Ring or loop topology

Ring or loop topology is becoming very popular, using local area networks for store and forwarding, and for broadcasting information. Fundamentally, there are no significant differences between local and wide area applications. In order to improve overall reliability of the ring, vendors usually provide redundant links.

Star topology

There are many similarities between the star topology and the tree structure, the main difference being the lack of hierarchical levels. The single-center multidrop alternative has been most frequently used. This simple model may be augmented toward

- Multistar-multidrop
- Multicenter-multidrop
- Multicenter-multistar

topologies [SHAR82].

These alternatives play an important role in determining the scope of network-management responsibilities. The fully connected network topology provides a solution for very high availability but at unreasonable costs.

The connectivity matrix illustration is frequently used for describing communication networks. Figure 2.4.1 indicates four examples. The matrix also describes the direction of a connection (if this is not bidirectional, as shown by the arrow) by using a 1 entry in column A, row B or by using a zero entry in row A, column B. Connectivity is one of the key criteria in the communication-systems planning procedure (see Chapter 12).

Based on these physical connection alternatives, different logical connections maybe realized. There are far too many ways of classifying networks; this book tries to introduce four different alternatives that somehow consider present and next future status [KAUF89].

Terminal networks

These networks consist of a powerful mainframe controlling local and remote communication front-end processors. Those processors are connected to local or remote control units that usually serve unintelligent terminals or workstations. Peer-to-peer connections at low levels are frequently not supported. Besides physical connections (lines), both basic and value-added services may be utilized for connecting network elements (Figure 2.4.2).

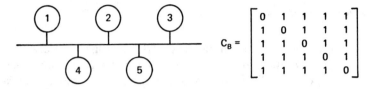

$$C_B = \begin{bmatrix} 0 & 1 & 1 & 1 & 1 \\ 1 & 0 & 1 & 1 & 1 \\ 1 & 1 & 0 & 1 & 1 \\ 1 & 1 & 1 & 0 & 1 \\ 1 & 1 & 1 & 1 & 0 \end{bmatrix}$$

(a) Bus Topology

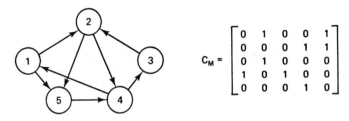

$$C_M = \begin{bmatrix} 0 & 1 & 0 & 0 & 1 \\ 0 & 0 & 0 & 1 & 1 \\ 0 & 1 & 0 & 0 & 0 \\ 1 & 0 & 1 & 0 & 0 \\ 0 & 0 & 0 & 1 & 0 \end{bmatrix}$$

(b) Mixed Topology

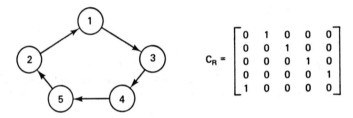

$$C_R = \begin{bmatrix} 0 & 1 & 0 & 0 & 0 \\ 0 & 0 & 1 & 0 & 0 \\ 0 & 0 & 0 & 1 & 0 \\ 0 & 0 & 0 & 0 & 1 \\ 1 & 0 & 0 & 0 & 0 \end{bmatrix}$$

(c) Ring Topology

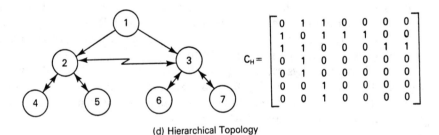

$$C_H = \begin{bmatrix} 0 & 1 & 1 & 0 & 0 & 0 & 0 \\ 1 & 0 & 1 & 1 & 1 & 0 & 0 \\ 1 & 1 & 0 & 0 & 0 & 1 & 1 \\ 0 & 1 & 0 & 0 & 0 & 0 & 0 \\ 0 & 1 & 0 & 0 & 0 & 0 & 0 \\ 0 & 0 & 1 & 0 & 0 & 0 & 0 \\ 0 & 0 & 1 & 0 & 0 & 0 & 0 \end{bmatrix}$$

(d) Hierarchical Topology

Figure 2.4.1 Network connectivity matrix.

Client-server networks

There are just two types of elements: Servers offering various kinds of services, such as processing, file management, printing, storing information, and so on, and workstations of clients that are generating requests toward the servers. Dedicated servers may take management responsibilities (Figure 2.4.3).

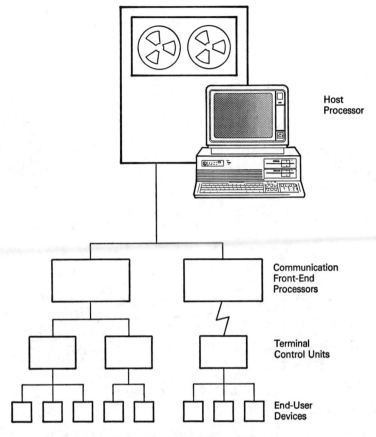

Host
Processor

Communication
Front-End
Processors

Terminal
Control Units

End-User
Devices

Figure 2.4.2 Terminal network.

Open networks

Assuming a number of elements offering service and even a greater number of elements requesting service, de facto and OSI-based architectures may help to logically connect all elements. In both cases, participating suppliers and users have to ensure efficient protocol conversion at network entry points. Within the open network, a variety of transmission services may be offered. Control and management functions are provided by the suppliers (Figure 2.4.4). Many users are connected to the open networks via terminal networks.

Distributed systems

As a result of networks and systems growing together, one may take advantage of using very different servers, multiple processors, a distributed operating system and distributed control and management modules, an arrangement recently termed "cooperative management" (Figure 2.4.5).

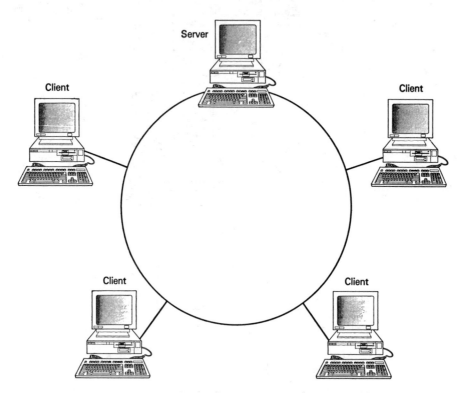

Figure 2.4.3 Client-server network.

Implementing and changing networks is an evolutionary process. "Strong" customers are very likely using all four types. Other users may start with the terminal network (e.g., SNA), and step by step replace the terminal clusters by local area networks and thus migrate to a mixture of terminal network with client-server networks (e.g., Ethernet or Token Ring).

Participating in electronic mail or electronic data interchange may require the use of an "open" network offering those services (e.g., SNA with Token Ring supporting X.400 E-Mail). Finally, for performance or for price reasons the central computing facility may be replaced by a distributed solution. The ultimate goal of the evolutionary process is enterprise networking.

The basic concept of enterprise networking is to move digitalized information from everywhere to anywhere without the intermediate step of converting it to human-readable form. By eliminating unnecessary conversions, the enterprise can get the maximum benefits from what computers and communication facilities do much better than humans—access, process, and move information—leaving humans more time to do what they do best: make decisions and exercise their creativity.

The price/performance ratio of computing and of digital transmission has improved dramatically over the last few years. In order to get the most out of investments, many companies are in the process of combining their comput-

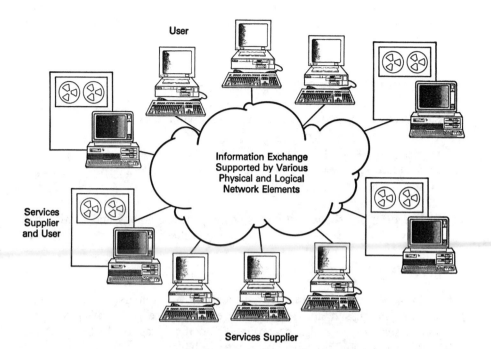

User

Information Exchange
Supported by Various
Physical and Logical
Network Elements

Services
Supplier
and User

Services Supplier

Figure 2.4.4 Open network.

Network and processors may be considered as one distributed system
that is completely transparent to users.

Figure 2.4.5 Distributed systems.

ing and communication facilities. In most cases, networks become the center
and computers the periphery.

2.5 SERVICES OFFERED BY CARRIERS

Basically, three different levels of services are offered by carriers:

- Transport services by leasing communication facilities
- Standard services
- Value-added services

The offerings show continuous changes of technology and tariffs. It is
extremely difficult to give a valid long-range evaluation.

Transport Services

In this service class, facilities are leased by customers. In certain cases
cables are purchased and not leased (e.g., in case of premises wiring).
Switched services may also be grouped into this category. In terms of the
physical media, the following choices are available:

Physically, the links can be installed using totally different techniques.
The usual classification groups are wired (guided) and wireless communica-
tion media [CHOU83].

Communication lines refer to the set of coaxial cables and wire pairs that
have historically been the standard method for transmitting information. Us-
ing the present analog mode of operation, the Shanon [MART72] formula
expresses the throughput (TP) for ideal modulations:

$$TP = \text{Bandwidth} \times \log_2 \left(1 + \frac{\text{signal}}{\text{noise}} \right) \qquad (2.1)$$

Present physical applications may reach 30% of theoretical capacity only
[MART72]. Sometimes it is more economical to employ a large bandwidth
than to increase the signal power. In using wire pairs, the following impair-
ments should be carefully considered:

- Attenuation at baseband frequencies
- Interference and noise
- Crosstalk and echo
- Environmental factors

Waveguides support and guide the transmission of radio-frequency
waves. Due to much lower attenuation—as compared with coaxial cables—
they are commonly used as connections between antennas and transmitters or
receivers.

Basically, there are three areas in which, due to low-loss, high-bandwidth properties, coaxial cables are widely used [CHOU83]:

- Telephone transmission
- Short-run system interconnects
- Television distribution

In the case of satellite communications, a number of earth stations distributed over a large geographical area share the capacity of satellite channels offered by commercial organizations. Transmission via satellite channels is effective not only for data but also for voice and teleconferencing. This alternative to terrestrial techniques has unique characteristics that provide the most cost-effective solution to the following communications needs:

- Traffic between few nodes over a great distance
- Overcoming natural barriers, such as oceans, jungles, or mountains
- High availability
- Fluctuating traffic levels between nodes (with a reasonably constant summary-type node)
- High speed for transmitting mass information
- Point-to-multipoint distribution

However, the issues of stability and propagation delay still need to be addressed. This technique does not seem to provide the right trade-off for interactive-type applications, for instance, due to the range of expected propagation delay. In practice, delays of up to 1 s are reported.

Light-wave communication involves using light as an information carrier. This concept is based on fiber-optic cables (made of tiny strands of glass) and has received new impetus due to successful demonstration of practical systems in several countries. Included in the demonstration were strong, low-loss fiber-optic cables, several splicing techniques, and solid-state light generators and detectors.

Fiber-optic cables (light guides) directly replace conventional coaxial cables and wire pairs. The glass-based transmission facilities occupy far less physical volume for an equivalent transmission capability, which is a major advantage in crowded underground ducts. In addition, such cables can be manufactured for far less, and installation and maintenance costs are lower. Coupling all these advantages with the reduced use of a critical resource (i.e., copper), a strong impetus for rapid development of light-wave communications can be seen. In particular, high bandwidth and extremely low attenuation can be realized.

In summary, the principal benefits of fiber-optic cables are as follows [CHOU83]:

- Small size
- Light weight
- Very wide bandwidth
- Low cost potential
- Immunity against interference and noise
- Complete electrical isolation
- Greater repeater spacing
- Low crosstalk
- No spark and fire hazard
- Very high security

However, factors such as ease of installation, fiber degradation, improving coupling, and interfacing need further research.

For packet radio, the common radio channels may be used. The geographical area is limited in this case. The propagation delay is very low, but there are problems to be solved for routing, path hunting, and managing this kind of network. In particular, multidrop communication is not yet solved [KLEI82].

Microwave transmission may be used for a limited geographical area. The general idea is to direct electromagnetic waves for bridging certain distances not achievable by other techniques. The higher the frequency, the better the quality of transmission. In particular, it is important to place sender, receiver, and relay stations at high altitudes to ensure transmission without natural barriers. In the carrier frequency ranges of 3 MHz and 30 GHz, transmission is hardly disturbed. In terms of quality, microwaves may be compared with wire-based transmission techniques.

Line (circuit) switching offers an alternative between value-added services and leasing communication facilities. In such cases, some features (e.g., in terms of quality assurance) are taken care of by the carriers. All other features, such as network management and administration, are becoming the customer's responsibility.

After digitalization of communication links, the following significant benefits are expected:

- Potential for any mix of video, data, voice, word, and image is feasible.
- The opportunity exists to compress bit sequences.
- Immunity against disturbances due to broader error tolerance (yes/no) and error-correction features is possible.
- Easy encryption for security can be done.
- Mass-storage devices are available.
- Transmission techniques via time-division multiplexing and inexpensive digital chips are very economical.
- Economic use of the packet-switching technique is possible.

T1 facilities are high-speed digital trunk circuits and associated hardware for transmitting voice, data, and video. The use of 56 kbit/s for each digitalized voice channel facilitates the integration with many digital PBXs on the market today [DATA86]. Without data compression, a T1 facility can transmit up to 24 voice channels, providing a substantial utilization improvement over conventional two-wire pairs. The speed ranges are defined in accordance with channel banks, considering DS1 (Digital Signal) with 1.544 Mbps as the T1 basis. Current levels offer up to 168 times of T1 equivalents. T1 has grown from internal telephone company technique into a generalized network resource. The most important applications include [DATA86]:

- Telephone-related applications
 Analog-switched network services
 Tie trunk services
 Remote equipment groups
 Proprietary PBX-to-PBX transmission services with
 ISDN-like interfaces
 PBX-to-Computer Services
- Data communication applications by offering specialized multiplexing equipment for providing RS-232, V.35, and RS-449 interfaces from subchannels of the T1
- Video applications
- Integrated voice and data, with video a significantly growing trend

T1 is used in many cases just as a generic term for high bandwidth transmissions. Certain applications will, however, require even more bandwidth in the future. Higher rates are available with

- T2 (DS 2) with 6.312 Mbps for 96 channels
- T3 (DS 3) with 44.736 Mbps for 672 channels
- T4 (DS 4) with 274.176 Mbps for 4,032 channels

However, T1 is not the standard everywhere. Many countries prefer E1 (or J1 in Japan) on the basis of 2048 Mbps. Both systems are bipolar, allowing clock information to be embedded in the data stream. From the network management perspective the supervision of converting devices is important.

Organizations wishing to communicate between E1 territories and T1 territories are therefore faced with a seemingly enormous technical task. The public exchanges, PABXs, data communications equipment, and transmission line plant of the two territories will generally only support one standard [JORD88].

A number of devices are available which can perform conversion between E1 and T1. Traditionally, this has been performed by dedicated transcoders. These convert directly between a single T1 line and a single E1 line. Signaling will often be selectable per channel, allowing for the simultaneous support of

both voice and data on different channels. There are, however, a number of limitations. The most obvious limitation is that, as the T1 line supports 24 × 64-kbps channels while the E1 line supports 30 or 31 × 64-kbps channels, capacity on the E1 side is wasted. In addition, there may be problems supporting channels greater than 64 kbps and guaranteeing one's density on the T1 side. The unit also represents an additional discrete network element, and thus affects the control and management strategy for the network.

Another class of device capable of converting between E1 and T1 is the digital automatic cross connect system (DACS). These devices have been developed to switch timeslots between primary trunks. Initially, they were dedicated to either T1 or E1 working, but hybrid DACS have recently become available which support both standards (Figure 2.5.1).

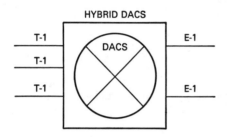

Figure 2.5.1 DACS connecting T1s and E1s.

Supporting tens, perhaps even hundreds, of trunks, these devices overcome many of the disadvantages of the single link transcoder. Timeslots from several T1 lines may be mapped onto a number of E1 lines, ensuring full use on the E1 side. Channels above 64 kbps are generally supported, and control of one unit will normally be easier than controlling a large number of discrete devices. However, these systems are large and complex. Although suitable for major international gateways, they do not provide the smaller user with a viable solution.

The other class of device capable of supporting both E1 and T1 is the networking multiplexer. Developed principally for business communications networking, this versatile class of device has also found a home in areas of the carrier world, especially in international applications. Full conversion is provided between E1 and T1 standards. Proprietary framing is generally used on the trunk side allowing for superior bandwidth utilization, including the maintenance of one's density and the support of channels of all speeds. It also allows for enhanced control by the provision of robust supervisory communication between the multiplexers.

Standard services

Standard communication services offered by public and private companies may be grouped in accordance with the four fundamental communication forms of voice, data, word, and image. However, it is becoming increasingly

difficult to make a clear-cut separation because of integrated offerings. The most frequently used alternatives are summarized as follows.

Telex is well understood and also widely used as a transmission service. Particular interest should be paid to establishing international connections.

Teletex is a relatively new communications service based on digital techniques. Due to lack of support in many countries, teletex has not developed into a worldwide standard service yet.

Telefax solves problems with intelligent copying, which involves a combination of data and image. The next enhancement will use phone lines as the transmission medium. At the present time, only point-to-point connections are established. The relay nodes can be provided to accept, store, and transfer the image as specified by the source. Even delayed delivery and copies to multiple locations are feasible. In addition, speed and format conversion can be supported if transfer is requested between dissimilar facsimile nodes.

Electronic mail is a generic concept that may be implemented by adding a communications capability to word processing terminals or by adding a software package on a mainframe/minicomputer-based communications network. Communicating copiers (copiers that receive data over a communications line) have evolved from high-speed, nonimpact printers. Using electronic mail, messages are usually stored within the system to be available to destination nodes on a demand-access basis. The principal functions include creating mail, delivering mail, and reading mail.

Voice mail is the audio equivalent of electronic mail. Unlike electronic mail, voice mail uses a familiar instrument—the telephone—as a terminal. Hence, the executive user is more likely actually to use it, since it does not require typing. With a voice mail system, the user can receive messages, transfer them to someone else's voice mail box, and originate messages. In the originating mode, the user can instruct the voice mail system to deliver the message to a specific party at a predetermined time and location. The system can also be instructed to deliver a single message to many persons simultaneously or at predetermined times. Systems may be installed in-house as part of the company's PBX, or a company may choose to lease facilities on a shared basis from a voice mail service center. Considerable benefits are [LUDL84]:

- Expanded communication accessibility
- Location-independent use
- Avoidance of telephone tags
- Reliability of delivery and confirmation to sender
- Opportunity of group communication
- Use of a familiar existing device instead of additional equipment
- Better management of individual's time
- Opportunity of message broadcasting
- Reduction of number of calls

- Reduction of call's duration
- Savings on paperwork

Teleconferencing is a meeting between two or more individuals or groups who are located at different physical sites. Teleconferencing can range in sophistication from simple audio communication via speakerphone to bidirectional full-motion video with automatic speaker-driven television cameras. The justification for teleconferencing involves saving travel and living expenses, in addition to saving time. It has been proven effective for certain types of meetings, such as technical meetings involving many persons and requiring information not foreseen in advance.

Videotex (*viewdata*) tries to bridge the gap between image, data, and word. The services offered are still confusing, depending on national resources. Most frequently, TV sets are used to display information. The local intelligence of sets is augmented by special-purpose adapters, which offer entry capabilities as well. Phone lines are used for transmission.

The following are the most important properties of videotex:

- Information units (pages) are stored in a data base.
- Each information page can include 24×40 color characters (word, data, and simple graphics).
- Authorized decentralized customers may retrieve these information units. They are led by the system to the information required. This method is self-explanatory.
- Content and structure of these information units are defined by information suppliers. Information may be entered via supplier's terminals or by converting already-stored information. Regular updates are supported as well. Information may be entered from any place that is linked to the viewdata data base.
- Data transmission is accomplished either by phone lines or two-way broad-band cables. Customer terminals are customized television sets.
- Customers of videotex may send messages to each other.

The resource demand is very difficult to determine, because the customer's information demand is hard to estimate in the private area. In many countries, this service is provided, supported, and controlled by the PTTs. Similar characteristics to videotex can be observed using videotext applications. The only difference is the use of TV cables for transmission instead of viewdata phone lines.

Electronic Data Interchange (EDI) is the computer-to-computer exchange of business information between business parties in a structured format. EDI helps to replace paper documents with communication offering increasing efficiency. Additional benefits include the elimination of redundant business procedures associated with paper-based systems; reduction of potential for errors; acceleration of doing business; and support of increased auto-

mation by increasing EDI with electronic funds transfer, bar code printing, and data-base applications.

Value-added networking services

The capacity planner may follow the guidelines for considering value-added services. In such cases, the customer may benefit in many ways:

- The carrier is able to provide load balancing features, which are a rare commodity in private networks.
- The complexity of communication network development can be reduced because just the interfaces to the value-added service—not the nodes or the links—must be configured.
- Efficient sharing of communication bandwidths among large numbers of subscribers is possible, which typically allows between 10 and 15 times as many subscribers to be supported on the same physical facilities, compared with conventional dedicated or dial-up arrangements.
- There is an improvement in error rates as a result of more investment in error-recovery and failure-prevention techniques.
- An improvement in flexibility occurs because multiple paths are available for alternate routes in case of subnetwork outages.
- Costs are reduced, particularly in case of occasional traffic.

Packet-switched networks permit the transfer of information between two subscribers (users) by routing addressed packets of information through the network. Both the links and the network nodes are completely time-shared among all the users. Unlike other networks, each packet-switching node implements the store-and-forward technique for switching each packet. All packets are switched according to the first-in first-out scheme, unless packet priorities are employed.

Future applications will require hybrid packet/circuit-switching scenarios, most likely supported by ISDN. It is assumed that the fixed bandwidth assignment of ISDN will give way to more flexible solutions. Performance improvement is imperative with packet-switching. New switching techniques, called "fast-packet" engines, are already being developed, and they are expected to support a 150 Mbps to 160 Mbps bandwidth. It is believed that Queued Packet Synchronous Exchange (QPSX) represents a true performance breakthrough. Based on distributed scheduling and separate channels for data and control information, it is a complete departure from present systems.

Prototypes of packet switches based on asynchronous transfer mode (ATM), or so-called fast-packet operation have already been demonstrated. These perform almost no software-based processing and instead perform packet-manipulation functions based on silicon-embedded logic, which is much faster. Throughput rates up to 1 million 48-byte cells per second is the

target. This technology is the basis for the switched multi-megabits/s data services to be applied for metropolitan area networks, mainly as a network facility for linking multi-megabits/s LANs.

On the way to fast-packet switching, the frame relay technique will give a significantly higher throughput rate—10,000 to 100,000 LAPD-based frames per second—by minimizing packet layer processing. Frame relay does not request the change of present packet-processing hardware.

Fast-packet technology will increase transmission speed up to 100 times more than offered by the usual OSI-X.25 standards. This high throughput requires more sophisticated network management. One physical connection of many logical connections makes it more difficult to automate the reconfiguration processes in case of component breakdowns. A richer set of indicators is expected for supervising the fast-packet nodes, but no fundamental changes are expected at the network-management systems level.

Message-switching (MS) networks receive the entire message and store it in secondary storage. When the output link is available, these networks transmit the message to the various subscribers. Although there may be several variations in the way a message is received in the form of segments, most MS systems handle messages internally in the form of fixed-length segments, or cells, to maximize the utilization of expensive storage resources. An MS system usually provides long-term storage on a secondary storage medium for each message, even after it has been delivered to all the destination subscribers. This capability allows quick retrieval of a message in case any questions arise regarding the validity of the message reception at a later date. Most message-switching systems also provide a permanent record of traffic handled in the form of a magnetic-tape journal or log.

The major customer facilities offered by MS systems are complete end-to-end message assurance, extremely good utilization of expensive user links through the use of long-term queuing offering within the MS node, and long-term protected storage. Designing such a system is not easy. New data structures must be cleared to achieve an efficient use of core and disk storage. A real-time operating system must be developed for better CPU utilization.

In terms of the future, MS will tend to become just another facility within a public data network. When the office of tomorrow becomes a reality, MS is bound to play an even greater role in distributing a large amount of interoffice memos and mail and storing and retrieving a large amount of word processing data for later retrieval or printouts. In many countries, teletex will offer similar services.

Integrated Services Digital Networks (ISDN) will try to bring much more visibility into the services area. ISDN may be considered a solution for all three previously introduced alternatives. ISDN enables the integration of communication forms. In the wide area, there is no difference among networks, because mixed transmission is accomplished via 64-kbit/s channels. Simultaneously, multifunctional customer terminals—for instance, phone, telex, and viewdata—are being developed and implemented. ISDN can be characterized by the following features:

- Availability of 64-kbit/s channels for fast and high-quality transmission for voice, word, image, telemetry, slow-motion picture, and remote control
- Channel structure of customer interfaces in accordance with CCITT recommendation: B (64 kbit/s) + B (64 kbit/s) + D (16 kbit/s, later 64 kbit/s)—up to 23 B channels may be integrated building 384 kbit/s H-channels
- High-speed transmission for voice-related services (such as videotex, image)
- Full television resolution (frozen picture) with picture construction within 10–15 s and voice output for explanations
- More economical word and data communication via 64-kbit/s channels charged to voice tariffs
- Resource sharing by multiple services
- One or two channels plus one word and data channels over the same customer link (one connection, one call number)
- Multiple use via integration (mixed and multiple communication, multipurpose customer devices); in many office application areas, simultaneous use of voice and word processing is required. However, using different customer devices and different networks, asynchronous traffic is rarely achievable.

Figure 2.5.2 shows an example for allocating B and D channels.

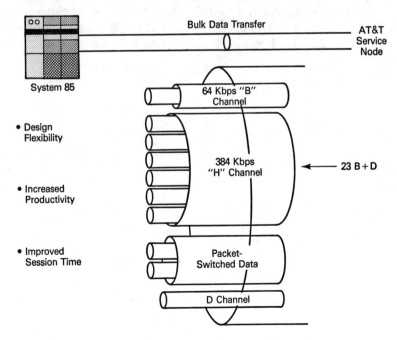

Figure 2.5.2 ISDN data networking.

Broad-band systems will be based definitely on fiber. The transmission rates are of a magnitude greater than copper-based systems. Recent developments in fiber, coupled with VLSI technology and new software systems, now mean that transmission rates of up to 2.4 Gbps can be achieved. The theoretical bandwidth of a single-mode fiber is 20,000 GHz. Fiber, therefore, has the potential to meet all of the possible communication demands of the future. SONET will help standardize these high throughput rates.

2.6 BANDWIDTH MANAGEMENT

The concept of bandwidth management consists of balancing the spending on transport facilities and on equipment, that is, to optimize the expenses caused by both classes of communication components. Figure 2.6.1 shows the optimization by highlighting three typical areas:

1. Intelligence in the network is not sufficient. The consequence is that too much money is spent on transport due to underutilized facilities.
2. A well-balanced solution with an adequate number and intelligence of nodes, resulting in optimal expenditures for transport.
3. Too much intelligence and/or too many nodes implemented resulting in optimal (minimal) costs for transport but very high equipment costs.

Aside from selling bandwidth, suppliers are getting more flexible and more cooperative to help optimize the customer's communications environment. However, the interests of IEX and LEC suppliers are contradictory. The interests of IEX suppliers may be summarized as follows:

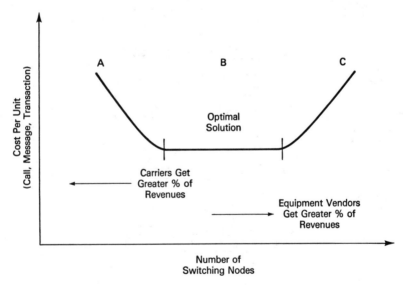

Figure 2.6.1 Concept of bandwidth management.

- Least expensive transport from customer premises to the inter-exchange network
- Use of high-capacity digital bandwidth for this transport wherever there is enough traffic volume
- Intelligence of the network is realized by CO switches and common-channel signaling
- Routing and network management by the carrier
- High dependency on carrier
- Value-added services

Figure 2.6.2 shows a simple example target architecture for this case.

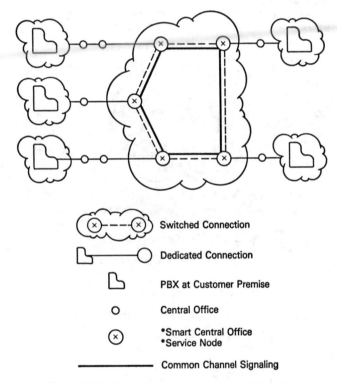

Switched Connection

Dedicated Connection

PBX at Customer Premise

Central Office

*Smart Central Office
*Service Node

Common Channel Signaling

Figure 2.6.2 Networking strategy seen by IEX carriers.

The interests of LEC suppliers lie on the opposite side (Figure 2.6.3):

- Usage rated, switched services within the Local Exchange Carrier's territory
- Least expensive transport between LECs
- Visual networking including bandwidth allocation within the LEC
- Network management responsibility most likely remains with customers

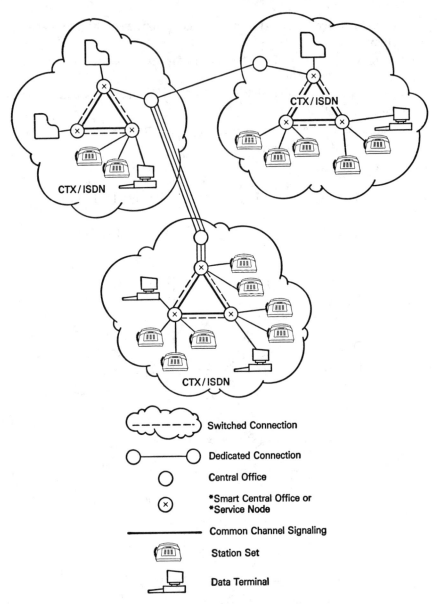

Figure 2.6.3 Networking strategy seen by LEC suppliers.

Bandwidth management has to guarantee adequate economy and high flexibility independent of the actual implementation. Dynamic bandwidth management means the opportunity of changing and reassigning bandwidth depending on time of day and on application portfolios. Multiplexer devices are intelligent enough to support customers with this demand. Bandwidth management features are summarized in Table 2.6.1.

Leading suppliers are going one step further and offering visibility to

TABLE 2.6.1: Bandwidth Management Features.

- Software programmable
- Configurations supported (point-to-point, multi-point, drop/insert, bypass, tandem switching)
- Network parameter configuration from a central location and from any node
- Primary/alternate route selection
- Downline/upline loading to/from any multiplexer
- Redundant power and logic for supporting failsafe operations
- Password security
- Channel priorization
- Compatibility with channel banks
- Diagnostics (tests of internal circuitry of incoming and outgoing channels and trunks; remote lookback tests, self-tests, local/remote loopback tests)
- Subrate and superrate bandwidth allocation
- Dynamic bandwidth allocation to voice, data, video, image
- Voice compression
- Distributed intelligence
- Network event recording, interpretation, display, and correlation
- Compatibility certification with industry and international standards
- Modularity and expandability
- Internal network digital cross-connect capability

users by providing a window into the network. By properly partitioning the access authorization, security violations are very rare. This new type of networking principle is called virtual networking; sometimes it is called software defined networking. Sharing network-management responsibility with users, suppliers are offering dynamic flexibility by so-called network-management services tools. AT&T and MCI are leaders in these services.

2.7 DRIVING FORCES FOR STANDARDIZATION

Enterprisewide networking obviously requires that each computer-based device in the enterprise be able to communicate with all the others. That is not an easy requirement for most organizations to meet. The explosive demand for computers and other microprocessor-based equipment during the last two decades has been satisfied by hundreds of high-tech suppliers. Today, most large organizations encompass computer equipment from dozens of vendors. Without question, multi-vendor is an established fact of modern organizational life. Today most organizations, or at least functional units within the organizations, rely on a dominant computer supplier to address primarily automation requirements. But networks are becoming increasingly complex in size and functionality and are reaching out to embrace a greater diversity of computerized equipment—from the office to the shop floor and beyond.

Before all these hundreds, thousands, even millions of computers and

other smart devices can be tied into the enterprisewide mega networks, they need to be able to exchange data as easily and efficiently as they process and store it—a capability the industry calls interoperability. And multi-vendor interoperability is still a long way off. The solution is vital to making global enterprisewide networks a reality.

Finding that solution is exceptionally complex and time-consuming—requiring the active participation of vendors, users, government, and standards bodies. With the potential rewards of enterprise networking so tantalizing, the process may seem too slow. But viewed in its proper historical perspective, it is far more important that the job be done right the first time; a rush to deploy inadequately coordinated standards could well result in a wide range of independently generated improvements. Nevertheless, while largely out of public view, the standards movement has achieved powerful momentum and a good deal of tangible progress.

The origin of the incompatibility problem lies in the fact that vendors generally developed their own communications systems and architectures to provide interoperability among their own devices. Unlike the regulated monopolies that brought the world a telephone system that provides universal access, the highly competitive, unregulated computer industry evolved without any great compulsion to ensure communications with equipment close to its own network specification.

What was needed was a neutral, open network—a common interface that could carry transmissions from any computer to any computer, no matter who manufactured the computers plugged into it, the way the telephone system carries voice transmission, no matter what brand of phone is being used. What was needed was a data communication standard.

Data communication standards can improve the efficiency and reduce the cost of linking computers and other digital equipment. Both ISO and CCITT were already trying to define standards for the data communications and telecommunications industries, but neither could devise a single standard and compel universal compliance with it. Consensus was required. What finally emerged from the efforts of these and other standards-setting bodies was not a single standard, but the Open Systems Interconnection (OSI) Reference Model (Figure 2.7.1), a framework that could accommodate many standard protocols and combinations of protocols. Table 2.7.1 summarizes the responsibilities and functions of each layer.

The benefits OSI standards will bring are many and substantial. OSI provides a single, consistent set of standards leading to interoperable multi-vendor computing and communication systems. The principal productivity gains are:

- Information will only need to be entered in the system once; any other device on the network can then access, amend, or update the information. Every device on the network can thus have access to the most current information. This eliminates the need to manually update sev-

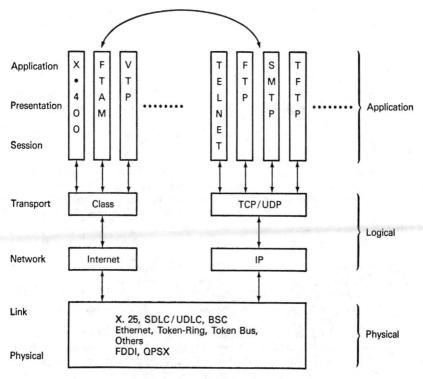

Figure 2.7.1 OSI and TCP/IP.

eral data bases every time a correction is made to one. It eliminates the mistakes that result when those multiple updates are not made. It saves the time and money those updates—and those mistakes—can cost.

- Users will spend a lot less on network gateways and bridges, improvising connections between incompatible devices and concentrating on ways to make more productive use of the equipment and applications they buy or develop and implement. In time, they will see the disappearance of at least a good deal of conversion solutions they have to use and maintain.

- OSI will change the way businesses operate in the 1990s, allowing them to achieve the integration of various departments and to improve customer and supplier relationships. The integration of data processing and communications that OSI represents will permit cost-effective information interchange to support both new and existing business applications.

- Other OSI links promise to maximize the potential of joint-partnering ventures in research and development, manufacturing and marketing, and to smooth the integration of merged companies' operations.

- OSI will facilitate the way for organizations to take advantage of ISDN, the enhanced public network whose introduction has already begun in some parts of the world, and will begin in the United States by the end of

TABLE 2.7.1: Responsibilities and Functions of OSI Layers.

Layer 1:
- Raw bit transfer
- Allocation of pins
- Establishing connections
- Bit error control

Layer 2:
- Data-link connection activation and deactivation (These functions include the use of physical multi-point facilities to support connections between peer network layer functions.)
- Mapping data units provided from the network layer into data-link protocol units for transmission
- Multiplexing of one data-link connection onto several physical connections
- Delimiting of data-link protocol units for transmission
- Error detection, recovery, and notification
- Identification and parameter exchange with peer data-link parties
- Adaption of speed between sender and receiver

Layer 3:
- Network addressing and end point identification
- Multiplexing network connections onto data-link connections provided by the next lower level
- Segmenting and/or blocking to facilitate data transfer
- Service selection when different services are available
- Selection of service quality based on parameters such as residual errors, service availability, reliability, throughput, transit delay, and connection-establishment delay
- Error detection and recovery to support desired quality of service
- Error notification to higher levels when service quality cannot be maintained
- Sequenced delivery of data if available from a particular implementation
- Flow control
- Expedited data transfer as an optional service
- Connection reset with loss of enroute data and notification to using parties
- Termination services when requested by a using party
- Congestion control
- Providing billing information

Layer 4:
1. Establishment phase
 - Selection of network service as a function of parameters such as throughput, transit delay, set-up delay, and error characteristics
 - Management of transport connection to lower level connections
 - Establishment of appropriate data unit size
 - Selection of functions used during data transfer
 - Transport of data from higher layers
2. Data transfer phase
 - Blocking
 - Concatenation
 - Segmenting
 - Multiplexing of connections provided by lower levels
 - Flow control in a session-oriented, end-to-end sense
 - Maintenance of the identity of data units received from the session layer
 - Maintenance of connection identity between the two transport functions acting on behalf of the parties of the conversation
 - Error detection for lost, damaged, duplicated, misordered, or misdelivered data units
 - Error recovery to address problems detected in this layer or signaled from lower layers

- Transport of expedited data that flows outside normal flow control mechanisms
3. Termination phase
 - Notification of termination reason
 - Identification of connection terminated
 - Optional information as required

Layer 5:
- Session-connection establishment
- Session-connection release
- Normal data exchange
- Expedited data exchange
- Quarantine service (the ability of a sender to control delivery at a receiver)
- Interaction management (two-way alternate and two-way simultaneous transmission control)
- Exception reporting
- Mechanism for session-connection synchronization
- Management of the session
- Address translation

Layer 6:
- Session initiation and termination requests
- Negotiation and renegotiation of presentation image
- Data transformation
- Data formatting
- Syntax selection
- Library routine provision
- Encryption to ensure security

Layer 7:
- Identification of intended communications partners and their availability and authenticity
- Establishment of authority to communicate
- Agreement on required privacy mechanisms
- Determination of cost allocation methodology
- Determination of resource adequacy to provide an acceptable quality of service
- Synchronization of cooperating applications
- Selection of dialog discipline
- Establishment of error recovery responsibility
- Agreement on data validity commitment
- Identification of data syntax constraints
- Information transfer

this decade. OSI gateways will efficiently connect private networks to this powerful public network.

- OSI gateways will also be phased in to connect existing proprietary architectures, both to ISDN and to other networks. Despite OSI's obvious benefits, users are not likely to discard an existing non-OSI network in which they have made a substantial investment and for which they have developed important applications.

- OSI will give freedom to users to select any vendors' equipment and systems. This will make for a more competitive marketplace, one that differentiates on the basis of quality and performance—not connectivity. This much larger market will also offer tremendous growth opportunities for a wide range of suppliers.

At the top of the OSI model are the application, presentation, and session layers. Together, they are responsible for turning conditioned, formatted data into a stream that can travel on a generic network. The bottom layers—transport, network, data link, and physical—transfer traffic effectively and efficiently to the destinations. The same seven layers operate at the receiving end, in the opposite order, to condition and format the data stream for storage and processing at another device.

Proprietary architectures, such as SNA, DNA, DCA, DSA, and so on, are in use and competing with OSI (Figure 2.7.2). In order to persuade customers about the long-range applicability of their products, each of the manufacturers offers gateways into OSI. The new versions and releases come

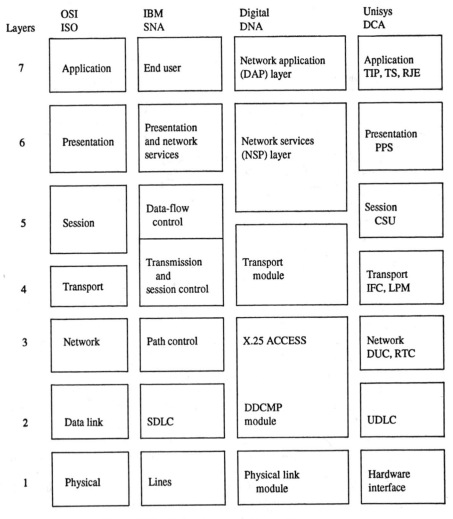

Layers	OSI ISO	IBM SNA	Digital DNA	Unisys DCA
7	Application	End user	Network application (DAP) layer	Application TIP, TS, RJE
6	Presentation	Presentation and network services	Network services (NSP) layer	Presentation PPS
5	Session	Data-flow control		Session CSU
4	Transport	Transmission and session control	Transport module	Transport IFC, LPM
3	Network	Path control	X.25 ACCESS	Network DUC, RTC
2	Data link	SDLC	DDCMP module	UDLC
1	Physical	Lines	Physical link module	Hardware interface

Figure 2.7.2 Comparing networking architectures.

closer to OSI and it may be assumed that they will coexist for many more years. After careful evaluation of the key functions supported by the de facto architectures, the main differences fall into three categories (TERP87A);

- The functions allocated to an OSI layer may differ from those allocated to the equivalent layers of de facto architectures.
- The interpretations of a particular function may not be identical.
- Implementation considerations may cause a particular function to be placed outside the layer structure.

The Defense Department's Transmission Control Protocol/Internet Protocol (TCP/IP) has complicated the issue somewhat. Some users have seen TCP/IP as an interim "de facto standard" that can be adopted until the OSI Layers 4 and 5 standards win final acceptance. Figure 2.7.1 shows the layer of the TCP/IP de facto standard. Table 2.7.2 displays the responsibilities and functions of layers supported by TCP/IP.

With international standardization coming in the foreseeable future, adopting the TCP/IP protocols may be counterproductive. These protocols are limited when compared with the OSI family of standards. In addition, the Defense Department has made a commitment to migrate from TCP/IP to OSI standards over the next several years.

The most pressing concern was for managing network layer gateways (routers) in the Internet. An approach was taken to satisfy the immediate requirements with an interim Simple Network Management Protocol (SNMP), with the long-term solution using the OSI management framework and protocols. The latter approach is referred to as CMIP over TCP (CMOT). Both protocols work with the same core Management Information Base (MIB) defined for the TCP/IP Internet. Recent MIB expansions are, however, resulting in SNMP-specific management information.

Having started later than the MAP/TOP effort, the TCP/IP community was able to use DIS and IS ISO network-management standards for their long-term approach. They developed standards and specifications for the layer management information associated with the TCP/IP, non-ISO protocol layers.

Both TCP/IP-based and ISO-based components will coexist in networks for at least the next decade. During this transition period, when both ISO network nodes and TCP network nodes coexist, a common set of CMIS communication services will be provided. For ISO nodes, CMIS services will be provided by CMIP over the entire seven-layer protocol stack. For TCP/IP nodes, a subset of CMIS services will be provided by SNMP for the short term, and for the long term, full CMIS services will be provided by CMIP over TCP/UDP transport layer protocols [DANM90A].

Government agencies have joined the standards implementation effort. In the United States, government agencies are insisting on OSI specifications from contractors under the Government OSI Profile (GOSIP). Since GOSIP

TABLE 2.7.2: Responsibilities and Functions of Major TCP/IP Layers [DANM90E].

TCP/IP is almost always referred to in just that unified form, but, in fact, each element (TCP and IP) is a unique, functional layer of protocol:

- **Transmission Control Protocol (TCP)** provides traditional circuit-oriented communications services for programs (or users, through programs), including end-to-end flow control, error control, connection setup, and status exchange. The TCP, in other words, provides the kind of communications that programs and users are accustomed to having. Without it, programs could not be assured of send/receive order, correctness, and so on.
- **Internet Protocol (IP)** provides a datagram-oriented gateway service between subnetworks, so that hosts (presumably using TCP) can access other hosts. IP does not enhance the reliability or exactitude of the datagrams—it only lets them be bridged from one subnetwork to another.

Transmission Control Protocol

TCP is essentially a Level 4 function—Transport Layer—and provides for the following functions:

1. Data transfer support, simulating a virtual circuit connecting the called and calling user, regardless of the lower level delivery system. (IP, in fact, is a datagram service.)
2. Error checking, including the detecting of lost information elements, duplicate information elements, and out-of-sequence information elements.
3. Flow control, to prevent the "swamping" of one user by another faster or more powerful user.
4. Status and synchronization control, including the ability to set up and break connections, to mark significant points in the dialog, and so on. This includes the ability to signal an unusual event (interrupt).

The data flow for TCP is unusual with respect to other protocols in that it provides only one type of *Transport Data Unit* (*TPDU*). The TCP header is 20 to 24 bytes in length— long by any protocol standard.

Internet Protocol

IP is a Level 3, or Network Layer, function in the ISO parlance. Such a layer is normally responsible for routing and delivery. In a multisubnet environment, an internet protocol is responsible for the following general communications areas:

1. Name control and translation. Members of subnetworks may not have the same naming conventions, and there may not be common naming control. IP assumes a catenet-wide naming convention generated by combining a network ID assigned by the network administrator and a local host address.
2. Status translation and communications. The result of internet operations must be communicated to the local user in a form that user can understand. In addition, the operations which that user performs must return status conditions to alert the user to problems. IP provides four types of status messages: destination unreachable/invalid, timeout, parameter error, and redirect requested. The first three are largely self-explanatory; the last means that another gateway has a shorter route to the destination.
3. Routing. IP provides for the exchange of Gateway-Gateway Protocol (GGP) messages to determine the status of gateways and their related hosts. GGPs can also be used to verify the operability of each interface: "probes" are sent to interfaces, and failure to return several successive probes causes the interface to be marked down.
4. Management. IP provides a vehicle for operation center management of the internet environment, a vehicle which provides for control and information gathering.

The IP appends an additional header on the TCP information element. This header is a minimum of 20 bytes and may be 24 or more. Source and destination address are made up of a one-byte network ID and a three-byte host ID. The definition of subaddresses within a host is the responsibility of the TCP layer.

encompasses tens of billions of dollars worth of computer and communication systems purchases a year, that is a powerful user voice.

The GOSIP specifications directly point to implementation agreements decided upon in the series of ongoing National Institute of Standards and Technology (NIST) Workshops for the Implementators of Open Systems Interconnection [HUNT89].

The activities to formulate network management implementation agreements at the NIST workshop have recently started. The Network Management Special Interest Group (NMSIG) is spearheading the development of GOSIP network-management implementation agreements over the next several years. Ongoing implementation agreements have existed since March 1989 for 16 of ISO's OSI management standards. These agreements, updated quarterly, are based on the most recent ISO, ISDN, and telephone network-management standards. They are expected to be published as a Federal Information Processing Standard (FIPS), to be utilized in part by GOSIP. Final implementation agreements corresponding to a full complement of ISO network management ISs and DISs will follow as the various ISO network management standards are finalized. It is anticipated that interoperability tests and demonstrations of separately developed implementations of the SIG's agreements will occur during the early 1990s. NIST is now formulating a multiorganization program to foster advanced research and interoperability testing on NMSIG agreements.

The ultimate benefit of the NIST network management implementors' agreements is that conformance tests will be developed for these agreements by the Corporation for Open Systems (COS). COS was created in 1985 primarily by a consortium of OSI vendors. Its charter focuses on the development and conducting of conformance tests to certify that implementation of OSI protocols conforms to the applicable OSI standards and specifications. COS has recently created a Network Management SubCommittee (NMSC) to accomplish COS's mission for network management conformance tests. A close collaborative working relationship exists with the NIST network management SIG. NMSC and NIST NMSIG are jointly considering conformance testing philosophies. The SIG is developing conformance testing guidelines. The COS NMSC will begin developing their conformance test tools according to these guidelines once the corresponding NIST network management SIG implementation agreements are based on OSI standards at the DIS level.

The government is not only the only user that has gotten into the standards act. Other network users have joined together, most notably in the GM-led MAP/TOP Users Group. In recognition of their constituency's immediate user needs for nonproprietary remote management capabilities in a multivendor networking environment, MAP/TOP, representing hundreds of vendor and user organizations, recently completed development of its version 3.0 network-management specifications.

MAP/TOP envisions networks (primarily LANs) with heterogeneous nodes, some of which have the entire seven-layer ISO communication protocol stack implemented, while others contain only partial protocol stacks (e.g.,

link and physical layer protocols only). Since the ISO network-management standards implicitly assume all network nodes being managed contain the full seven-layer protocol stack, the MAP/TOP network-management conceptual framework goes beyond the ISO network-management reference model. Accordingly, the management decision-making processes within the MAP/TOP manager(s) communicates with its (their) management agents in the MAP/TOP network nodes in different ways, depending on whether the network-management agents reside in a full or partial stack node. In all cases, these processes use the network-management communication services/protocol (CMIS/CMIP) defined in the ISO DP. In managing full stack nodes, the CMIP uses the services of the entire seven layers of underlying communication protocols. In managing partial stack nodes, CMIP's communication service needs are mapped onto the services provided by the LLC protocol. Conceptually, this mapping is provided by a "thin protocol stack" between CMIP and LLC. This thin stack provides extremely little, if not null, communication capabilities corresponding to the missing intervening layers.

Where ISO network management standards existed, such as CMIS/CMIP, the MAP/TOP network-management specifications stated the required standards' options that are mandatory for the networking products to be procured by these specifications. Where ISO standards did not yet exist, such as in defining the layer management information and defining its structure, MAP/TOP developed its own standards. In some cases, such as the management information associated with upper layer protocols, the MAP/TOP "standards" work preceded any ISO work. In other cases, such as the network and transport layer management information, the MAP/TOP and ISO work proceeded cooperatively and in parallel, and it is extremely likely that major portions of the MAP/TOP standards will become ISO standards. They have also joined with vendors creating the Corporation for Open Systems—like MAP/TOP, an important force for developing OSI functional specifications. Both MAP/TOP and COS have developed international ties and inspired similar organizations in Europe and Japan.

The basis of MAP is the broad-band Token-Bus-LAN technology (IEEE 802.4). The higher layers are completely independent from the LAN technology selected.

The standardization process altogether shows satisfactory progress at lower layers. Besides working standards at the physical, data link, and network layers of WANs, lower layers have been successfully standardized for MANs and LANs. In particular, the physical and logical link control layers have been standardized as shown in Figure 2.7.3. Also the interfaces to higher layers have been defined. The coexistence of OSI and IEEE 802.X recommendations are displayed in Figure 2.7.4.

Most changes are expected in the MAN-area combined with the progress of fiber applicability. FDDI (fiber distributed data interface) for hybrid services (voice and data) recommended a standard at the 100 Mbps level. FDDI supports either synchronous traffic class and/or asynchronous traffic class by dynamically changing the bandwidth between both. Based on a differ-

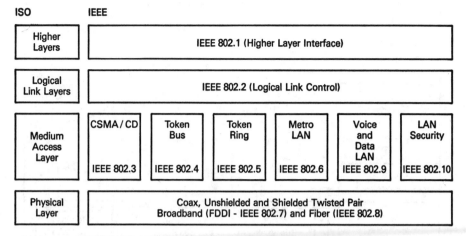

ISO	IEEE					
Higher Layers	IEEE 802.1 (Higher Layer Interface)					
Logical Link Layers	IEEE 802.2 (Logical Link Control)					
Medium Access Layer	CSMA / CD IEEE 802.3	Token Bus IEEE 802.4	Token Ring IEEE 802.5	Metro LAN IEEE 802.6	Voice and Data LAN IEEE 802.9	LAN Security IEEE 802.10
Physical Layer	Coax, Unshielded and Shielded Twisted Pair Broadband (FDDI - IEEE 802.7) and Fiber (IEEE 802.8)					

Figure 2.7.3 Recommendations of IEEE 802 standards for LANs.

ent architecture, DQDB (Distributed queue dual bus) or with the other name, QPSX (queued packet and synchronous switch) are competing for the IEEE 802.6 standard at the 150 Mbps level.

For supporting high-speed computer-to-computer communication applications, even higher bandwidths are required. The evolving HPPI standard (High Performance Parallel Interface) will specify data rates at 800 Mbit/s and 1.6 Gbit/s to allow communications at speed beyond these of FDDI and QPSX.

In order to unify and multiplex all existing throughput rates into one architecture, SONET (synchronous optical NETwork) is under consideration. The fundamental building block of the SONET standard is the Synchronous Transport Signal Level 1 (STS-1). The STS-1 has a synchronous frame structure and a bit rate of 51.8 Mbit/s. Individual DS1s can be defined and extracted within this frame. The bulk of this frame is made up of the SONET payload envelope around 45 Mbit/s. This traffic rate increase over fiber is due to the support of wave-division multiplexing (WDM). WDM permits the use of different data channels over the same cable.

Not only the data communication or hybrid communication receives support from standards. In the voice environment one can recognize the trend of grouping functions in terms of layers similar to OSI. Strictly speaking, for voice support layer 1 for physical connection and layer 7 for some telemanagement applications are used. Layers 2 through 6 are usually empty. Performance improvement drives the need for a more powerful common channel signaling recommendation. Signaling system number 7 is conceived as a separate signaling network with seven layers available. The bottom three layers are collectively referred to as the message transfer part (MTP). MTP provides a packet-switched network comparable with X.25. However, the addressing capability is sufficient for addressing switches, but not for processes or users at the switch. The higher layers are expected to be used for

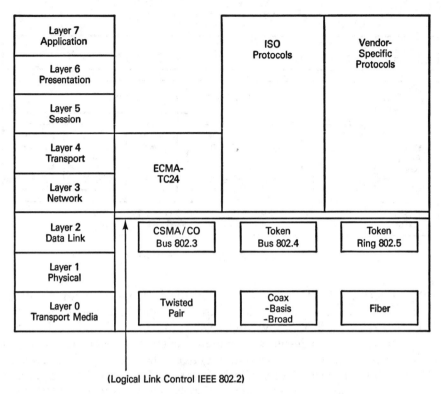

Layer 7 Application		ISO Protocols	Vendor- Specific Protocols
Layer 6 Presentation			
Layer 5 Session			
Layer 4 Transport	ECMA- TC24		
Layer 3 Network			
Layer 2 Data Link	CSMA/CO Bus 802.3	Token Bus 802.4	Token Ring 802.5
Layer 1 Physical			
Layer 0 Transport Media	Twisted Pair	Coax -Basis -Broad	Fiber

(Logical Link Control IEEE 802.2)

Figure 2.7.4 Recommendations of IEEE 802.X for OSI.

functions other than circuit-related signaling. Typical application kernels are TCAP (transaction capabilities application part) and ISUP (ISDN user part). The first is an umbrella product for voice-related applications (camp-on, call-forwarding, call gapping, virtual private network management). The second provides an interface to ISDN connections.

2.8 SUMMARY

All components of the network, such as communication facilities and equipment, may become bottlenecks during operation. Proactive performance analysis may help in avoiding them prior to and during operation. But no favorable results can be accomplished without quantitatively evaluating the performance indicators, such as reliability, delay, throughput characteristics, utilization ceiling, congestion criteria, and mean time between failures. The following chapters deal with how information about networking components can be extracted and processed, and how future performance can be predicted. In this chapter, all relevant network components have been introduced which have to be managed. The same components will be considered as information sources in the following chapters.

For standardizing networks, the multilayered architecture of OSI has been introduced as the common dominator for many current proprietary architectures. One of the leading de facto networking standards, called TCP/IP, has been introduced as well. Both have to be considered beside special WAN, MAN, and LAN architectures while building an enterprise network.

In the following chapters, services of proprietary and standards-based architectures will be used to build the optimal network-management architecture.

<div align="right">**3**</div>

Generic Architecture
of a Network-Management Product

Based on requirements and needs for network management from Chapter 1, and existing and near-future networking, the objective of this chapter is to address a generic architecture of a product and to compare present architectures with it. Present architectures include proprietary solutions from IBM, Xerox, Systems Center, Timeplex, Codex, Novell, Ungermann-Bass, Tandem, Siemens, Banyan, Bull, 3Com, Proteon, Sun, and OSI-based solutions from AT&T, DEC, and Hewlett-Packard. Also users' solutions are briefly discussed. In-depth discussion of each of the solutions will follow in subsequent chapters.

3.1 GENERIC NETWORK-MANAGEMENT PRODUCT ARCHITECTURE

This architecture model will identify the principal architectural components and their interactions, and in doing so, will facilitate a practical implementation in an evolutionary modular fashion.

The following architectural components are included (Figure 3.1.1) [FELD89]:

- Unified user interface
- Presentation services

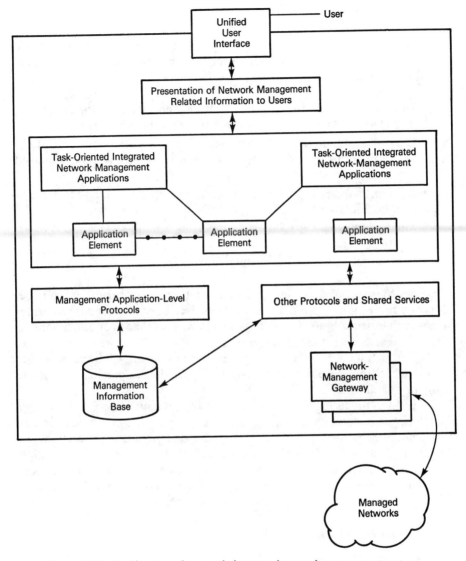

Figure 3.1.1 Architecture of a generic integrated network-management system.

- Network-management application elements
- Management application level protocols
- A set of communications protocols and shared services
- Data repository
- Network-management gateways for various native network-management systems

Unified user interface (UUI)

UUI is the functional means through which interaction between the system and its users takes place. This interface possesses the following properties [FELD89A]:

- Single focal point through which management of any of the underlying managed network domains and its objects can be achieved
- Generic symbolic (i.e., graphic) and textual notations of managed objects and of management data and controls associated with the managed objects
- Built-in zooming capability for examining network conditions in a systematic, hierarchical way
- Multi-windowing capability for supporting a multi-tasking mode of users' activities
- Built-in help/advisory (i.e., expert) function

Together these properties constitute what can be referred to as user interface. It is of utmost importance that the user interface be consistent across various managed network domains and functional areas so that operator training is minimized and ease of use is maximized.

Through the UUI, the heterogeneous environment will be presented to and managed by the operator generically to the degree possible and practically justifiable.

Even in the face of increased automation, there will be a role for human involvement in network management. Specifying required elements of a network design, choosing among alternative designs, monitoring operations and observing events that do not themselves indicate failures, analyzing relationships between network events, and diagnosing complex failures are all activities that can be expected to retain a large measure of human involvement, and they generate requirements for effective interfaces.

Presentation services

In order to achieve the single-image capability of the integrated solution, its integrated network management applications shall apply industrywide adopted conventions on the semantics and syntax of the user-oriented network-management information. This information will be exchanged between the user interface function and the integrated network-management application function so that generic visual (and potentially audio) constructs can be conveyed to and obtained from users.

Most large systems require some sort of management, but there are a number of characteristics that make network management particularly difficult. These characteristics cannot be ignored when management interfaces and data representations for network-management information are designed.

Network operation is tied to network structures, and events within a network occur in the context of this structure. If a network representation does not reflect this structure or fails to allow the context to be noted and even reconstructed, then systems built upon that representation will lack information critical for understanding network operations.

Although the complexity of networks is constantly being cited, it is not just a phrase to point out that modern telecommunications networks are among the largest and most sophisticated systems that have been created. Furthermore, the physical distances which can exist in a network limit the possibility of maintaining a truly current representation of the state of that network.

Network user interfaces and network data representations must provide the tools to organize this complexity and provide network managers with insight into the operation of their networks.

An ideal network interface or presentation system is centered around graphical network images. Use of other modes of display such as business graphics and text windows are aimed to augment the network pictures, and to reflect the results of various requests for information.

Building such an interface around network pictures makes it necessary that the appropriate pictures be generated automatically, and in response to the specific requirements of a user. It is not reasonable in a large network to try to predefine all of the combinations of items one might want to portray on a screen, nor all the possible arrangements of those items that might be meaningful.

In order to build a platform that can be used with a range of networks, it will have to be loosely coupled with its data sources, allowing data processing required to satisfy a particular request to be performed on a separate processor, or even on multiple processors.

Two examples are shown for presentation services: the first (Figure 3.1.2) [DANM89G] presents the capability of simultaneously displaying results from alarms management, tests, problem tracking, configuration overview, and

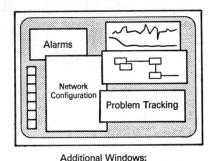

Additional Windows:
System Surveillance
Test Results
Problem Tracking
Network Configuration
Special Function Menus

Figure 3.1.2 Multi-window environment.

from special functions means; the second (Figure 3.1.3) [DANM89G] demonstrates the well-balanced layout between graphics and text.

Network-management application elements

The integrated management applications provide the value-added management functions that may be accessed via the unified user interface. These management functions will behave similarly when used for various network domains, although there may be differences between classes of networks (e.g., between LANs and T1/T3 multiplexer-based backbone networks).

Integrated network-management applications are contrasted with native network-management applications of vendor-specific network-management systems and/or managed objects. Integrated network-management applications provide network-management functions directly, and provide access to native network-management applications. For example, software loading of a device may be done directly by integrated network-management applications, or by a native network-management application at the request of an integrated network-management application.

Regardless of where a function is performed, the interface to the operator shall remain consistent and generic. Thus, the varying levels of functions provided by native network-management systems can be made consistent throughout the system.

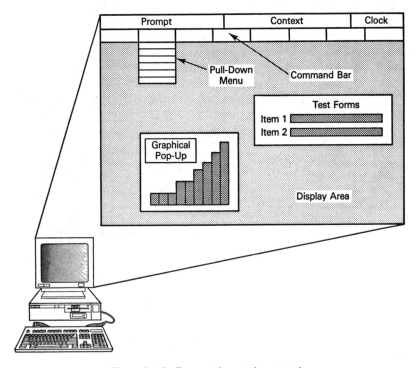

Figure 3.1.3 Presentation service example.

To develop and utilize generic applications in a modular fashion, the functional space can be segmented into task-oriented integrated network-management applications, based on classification of user activities. Integrated network-management applications may share a set of discrete elements defined in the context of several major functional areas (e.g., based on OSI management standard in terms of common management information service elements).

Task orientation means that not only single functional areas within fault, configuration, performance, security, accounting, and planning management, but also tasks across those functional areas are supported. Examples are trouble-tracking, alarms management, security surveillance, change management, and network design.

Each element represents the lowest level (i.e., indivisible) architectural application module and is defined in terms of management application services which it provides. Examples show the common management information service elements.

These services are not defined to be a set of services as seen by the integrated network-management system user. Rather, they are services provided within the integrated network-management system to support open cooperative processing environments by a number of application elements, as well as to support interaction of integrated network-management system elements into task-oriented management applications. Thus, the functional area services are used internally among integrated management application elements, while the integrated network-management system user sees only the results of these services as provided by the task-oriented management applications.

In order to deal with highly complex, dynamically changing, and relatively uncertain behavior of modern network environments, the task-oriented applications are envisioned to include expert system components in addition to conventional procedure-based software nodules.

The expert system components will provide for the following features [FELD89A]:

- Capture the knowledge of network-management experts and represent it explicitly in the form of network-management rules (i.e., domain knowledge base)
- Separate the network-management information (i.e., facts about network behavior and anatomy) from program control structure (represented by a shared logic, commonly called inference engine)
- Account for qualitative network characteristics along with quantitative ones
- Introduce limited learning capability through discovery of "new" facts and automatically create new rules

These features will produce two major benefits:

- Facilitate an iterative, incremental upgrading of the network-management knowledge base both by the users and by the system itself. This

will augment the system's intelligence and reduce the skill requirements to manage networks.

- Allow for modular architecture of the application space and its effective modification.

Repository of generic management data—concept of a generic managed object

The unified user interface and integrated network-management applications are based on providing a unified and generic view of heterogeneous networks [FELD89A].

The key to this approach is to define a broad set of generic management information items for describing managed objects and their relations. Managed objects (MO) are individual manageable components of a network. Management applications can access and act upon managed objects within a network. Applications can also represent managed objects within the application for the purpose of performing management functions (e.g., to prepare a configuration or record a fault). The offered architectural model makes use of two distinguished concepts—real managed object and generic managed object.

A real managed object (RMO) [FELD89A] is simply an actual managed object within a vendor-specific (native) network. Real managed objects are various software and hardware components of a network, such as facilities and equipment. Their actual manifestation in a network will be unique to the native network implementation. This object can represent either a real open system or a component of a real open system and can be viewed as consisting of OSI resources (generic by definition) and of vendor-specific real resources (e.g., CPU, memory blocks, I/O devices, ports, and so on). RMOs can be described for the purpose of management in terms of their vendor-specific anatomy (i.e., configuration), behavior (e.g., status, events, and so on), and controls. Integrated management applications ultimately can access and act upon real managed objects. However, because these applications deal only with generic management information items, they cannot access RMOs directly. These must be accessed via a network-management gateway, and a generic representation must be used for the RMO.

Generic managed objects (GMO) are the generic representations of RMOs. Essentially, they are the information "view" an integrated management application has of a real management object. This object can be viewed as consisting of OSI resources (generic by definition) and of generic real resources (GRR) (generic memory blocks, generic I/O devices, and so on). Generic managed objects are specified in terms of generic management information items describing their generic anatomy, behavior, and controls.

Management information base then can be viewed as a conceptual repository of those generic management information items, subsets of which describe generic managed objects plus those generic management information items that reflect the peculiar needs of the integrated network-management

applications themselves (e.g., attributes of a trouble ticket in a fault management application).

In summary, GMOs are components of the management information base and will be used as the basis of the design for applications, and will provide a consistent and unified approach to representing the real objects managed by the system.

Management application level protocols and shared communication services

One of the key architectural requirements to any practical integrated offering is the provision of a flexible and open distributed organization of the integrated management application.

Flexibility of a distributed organization of integrated network management applications refers to:

- The ability of grouping integrated network-management application elements and generic management information items into applications sets, called network managers (or simply integrated network managers) and management data sets, called MIB partitions, respectively.
- Nonrestrictive assignment of integrated network managers and/or MIB partitions to different and often geographically dispersed computerized systems (e.g., open-end system), from which they can be delivered.
- Most important, performance of the integrated management functions in a cooperative processing mode through the use of management application-level protocols.

Openness of a distributed organization of applications refers to the interoperability of offerings from various vendors. This interoperability is being achieved through the use of industrywide, standard network-management protocols (at both the application level and the supporting communications levels). International standardization organizations are currently intensively developing initial sets of such application-level protocols.

It is of utmost importance to notice that in order to achieve any meaningful level of commercially viable management-level protocols, a minimum set of generic managed objects shall be developed to represent the corresponding real managed objects. This shall be coupled with a critical set of management services.

In this respect the emerging OSI standards on the common information management protocol represent a first important and necessary step. At the same time, without available standards on generic management information items, even limited to OSI resources, the CMIP protocol by itself does not represent a sufficient foundation for building truly open integrated network-management systems.

In addition to management application-level protocols, the architectural

model envisions a range of shared services and communications protocols in support of distributed open integrated network-management systems (e.g., OSI communications protocols and services, security, directory, remote operation, file transfer accesses and modification, application level protocols, and services, to mention a few).

Network management gateway—relation of generic to real objects

As just described, the use of generic constructs by integrated applications insulates them and the network operator from the unique aspects of each native network. However, a facility is needed to access each native network and to translate (mediate) between the generic constructs and the native constructs of each network.

As shown in Figure 3.1.4, the proposed generic architecture addresses this need by providing a network-management gateway for each native network. The gateways are expected to support both mainstream- and sidestream-based native network-management solutions. Integrated management applications interact with the gateway using a stable set of generic services and protocols. The gateway in turn interacts with the native network objects and management system(s) using native (i.e., vendor-specific) physical and logical interfaces.

The nucleus of the network-management gateway is the mapping between generic management information items used by applications and the equivalent ones of the native network. It is important to notice two basic types of mapping that are performed by the network-management gateway:

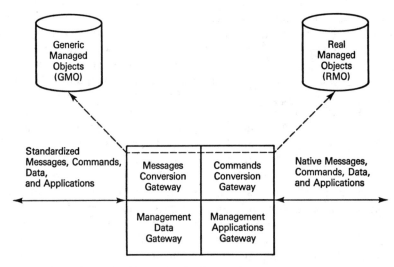

Figure 3.1.4 Architectural role of network-management gateways.

- Mapping between management data, in essence, establishing a relation (i.e., synchronizing) between a real managed object and its generic information image (i.e., generic managed object),
- Mapping between management applications (i.e., generic and native), in essence emulating integrated network-management application elements and then employing application-level protocols for interaction between application elements of the integrated network-management system and emulated application elements of the native network-management system.

Segmentation of an integrated network-management system

The distributed capabilities of the generic solution outlined in the previous section will provide for flexible segmentation into various domains based on specific user needs. Each integrated network manager will be responsible for an assigned subset of managed objects and functional capabilities. Where the user network environment represents a strategic business or mission asset, special survivability requirements will dictate both standby configurations and multiple alternative connectivity paths available for communication among numerous integrated network managers, and between the managers and critical managed objects.

In summary, the architectural model outlines the major architectural components and their interactions. It offers a modular approach to building commercially viable integrated network-management systems and their components by multiple vendors.

When the processing needs are high, multiple processors may be connected by a LAN to each other. Figure 3.1.5 shows this architecture [SALA89] with separating data collection, user presentation, data-base processing, and I/O engines. Each of the engines could be sized to the application requirements or added to the network as network-management requirements change.

The generic architecture exhibits the following features and benefits:

- Accommodates incremental expansion by means of gradual introduction of new generic managed objects and integrated management function elements coupled with the growth of the number of network-management gateways to native networks and management systems.
- Calls for integration of discrete network-management application elements into user-task-oriented management applications. This application level of integration can be significantly advanced by combining expert rules with the generic management information items reflecting the real network environment.
- Based on standard network-management application level protocols along with a range of standard communications support-level services

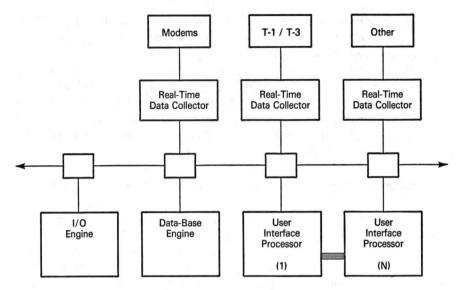

Figure 3.1.5 Multiprocessor system connected by a LAN.

and protocols. This facilitates introduction of flexibly segmented and openly distributed integrated network-management systems.

- Introduces the concept of a generic managed object as the methodological means for achieving integration at a data level and thereby facilitating integration at application procedure and application protocol levels.
- Identifies key properties of a unified user interface which will ultimately convey all benefits of network-management integration to the user.

The next sections of the chapter will contrast approaches from proprietary, de facto, and OSI standards in terms of the generic network-management product architecture. In all cases, solutions may be grouped in terms of "space" of network-management, meaning WANs, MANs, and LANs related instruments.

3.2 PROPRIETARY AND DE FACTO ARCHITECTURES

This part of the book gives an architecture-related overview of solutions. Most of them are supported by products, which will be addressed in subsequent chapters. Depending on the number of customers utilizing a certain proprietary architecture, it may become a so-called de facto standard, such as ONA from IBM or SNMP from the TCP/IP origin.

3.2.1 IBM Network-Management Architecture

Open network management (ONA) is intended as a framework for the development of IBM management products, which are aimed at managing large SNA networks. Through published interfaces and message formats, IBM is also inviting other vendors to implement compatibility with this architecture, in much the same way that most vendors implement at least limited SNA compatibility. Figure 3.2.1 summarizes the architecture. Under this framework, there are three major kinds of elements that perform management functions [HERM89A]:

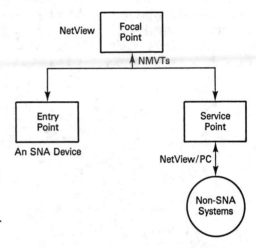

Figure 3.2.1 IBM's open network-management architecture.

- Focal points, which provide centralized network-management support. Focal points support the needs of human and programmed operators and provide a central point for collecting, analyzing, and storing network and system management data. The NetView family of products constitute IBM's strategic focal point products.
- Entry points, which are SNA devices that are capable of implementing the management services architecture for themselves and other attached products. Most IBM data network products are capable of functioning as entry points.
- Service points, which provide measurement support for themselves and attached devices and networks that are not capable of being entry points.

 The service point is capable of sending network-management data about non-SNA systems to a focal point, and it is capable of receiving commands from a focal point to be executed on the non-SNA systems. The service point is thus a network-management gateway, translating between the SNA formats and those of non-SNA devices. NetView/PC

is IBM's major service point product, although other management packages may contain embedded service points.

IBM has classified these announcements as a major strategic initiative. They do indeed set a direction for IBM. They first and foremost establish the S/370 mainframe as the focus of management capabilities within the IBM product line. However, these announcements also established IBM's intention to use the focal point to manage all the information resources of the enterprise, even those from other vendors, through the agency of the service point. These announcements preempted other vendors and gave IBM a major marketing lead for about a year and a half. But other vendors are now actively competing with IBM for control of the enterprisewide focal point.

In the early 1990s, IBM informally showed an expanded version of their open management architecture, as shown in Figure 3.2.2. It adds the following architectural elements:

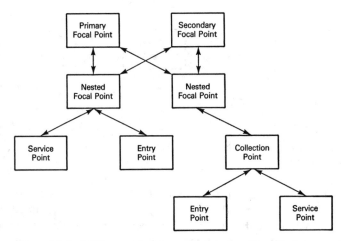

Figure 3.2.2 IBM's extended network-management architecture.

- Secondary focal points, which are redundant focal points that can take over in case the primary focal point fails. Reacting to the need for high availability of the focal point, IBM will be providing increased support for multiple focal points which are able to back each other up.
- Nested focal points, which provide distributed management support for segments of large networks, while still forwarding critical information up to more global focal points.
- Collection points, which provide a network-management relay function from a self-contained SNA subnetwork to a standard focal point. It would appear that the AS/400 or System 88 will act as a collection point for IBM peer-to-peer networks of midrange systems.

The direction is clear with these architectural extensions: IBM is developing the capability for a more distributed approach to network and system

management that allows many different IBM network management systems to work together to deliver enterprisewide management.

SystemView is considered a framework for gradually integrating systems and network management. SystemView is a subset of IBM's SAA (System Application Architecture) and offers another layer of integration. The product outlines end-user, data, and application dimensions that address many of NetView's existing problems. In summary, SystemView offers a user interface, common object-oriented repository, and shared application. The repository is based on the OSI structure of MIB and on SAA's SQL (Structured Query Language) interface. This direction improves the integration of fragmented data files of NetView's subsystems.

Focal point NetView may be replaced by the competitive product, Net/Master. But this replacement does not mean any changes to the architecture.

In the LAN area, IBM's choice is Token Ring. Token Ring-based LANs are connected to ONA by a service point. With regard to software, the LAN manager emulates the functions of the service point. In special PC networks, the LAN manager is connected to NETBIOS which is implemented for the session, transport, and network layers networks. Network-management functions are expected to be implemented in higher layers, such as the layers for presentation and application services.

3.2.2 An Overview of Simple Network Management Protocol (SNMP)

Simple Network Management Protocol (SNMP) originated in the Internet community as a means for managing TCP/IP networks and Ethernet networks. During 1989, SNMP's appeal broadened rapidly beyond Internet, attracting waves of users searching for a proven, available method of monitoring multi-vendor networks. SNMP's monitoring and control transactions are actually completely independent of TCP/IP—SNMP only requires the datagram transport mechanism to operate. It can therefore be implemented over any network media or protocol suite, including OSI.

SNMP operates on three basic concepts: manager, agent, and the management information base (MIB) (see Figure 3.2.3) [DANM90A].

An agent is a software program housed within a managed network device (such as a host, gateway, or terminal server). An agent stores management data and responds to the manager's requests for this data.

A manager is a software program housed within a Network Management Station. The manager has the ability to query agents using various SNMP commands.

The management information base (MIB) is a virtual data base of managed objects, accessible to an agent and manipulated via SNMP to achieve network management.

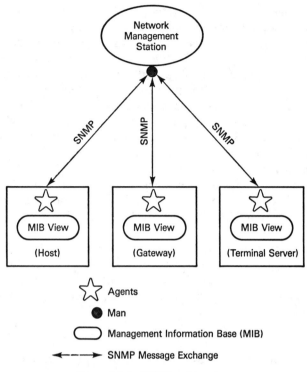

Figure 3.2.3 SNMP architecture.

Agent responsibilities

Each agent possesses its own MIB view, which includes the Internet standard MIB and, typically, other extensions. The agent's MIB does not have to implement every group of defined variables in MIB specification, however. This means, for example, that gateways need not support objects applicable only to hosts, and vice versa. This eliminates unnecessary overhead, facilitating SNMP implementation in smaller LAN components that have little excess capacity for bearing overhead. An agent performs two basic functions:

- Inspects variables in its MIB
- Alters variables in its MIB

Inspecting variables usually means examining the values of counters, thresholds, states, and other parameters.

Altering variables may mean resetting these counters, thresholds, and so on. It is possible to actually reboot a node, for example, by setting a variable.

Manager responsibilities

Managers execute network manager station (NMS) applications, and often provide a graphical user interface that depicts a network map of agents. Typically, the manager also archives MIB data for trend analysis.

The MIB

The MIB conforms to the Structure of Management Information (SMI) for TCP/IP-based internets. This SMI, in turn, is modeled after OSI's SMI. While the SMI is equivalent for both SNMP and OSI environments, the actual objects defined in the MIB are different.

SMI conformance is important, since it means that the MIB is capable of functioning in both current and future SNMP environments. In fact, the Internet SMI and the MIB are completely independent of any specific network-management protocol, including SNMP.

The SNMP-MIB repository is devided into four areas:

- Systems attributes
- Private attributes
- Experimental attributes
- Directory attributes

All documentation is written in ASN.1 (Abstract Syntax Notation One). ASN.1 is no replacement for other programming languages, but offers many benefits, such as flexibility, definition of new structures, and writing new macros. The clear structure and ease of specification help to consider ASN.1 to become the common denominator of SNMP-documentations.

MIB I includes a limited list of objects only. They are dealing with IP internetworking routing variables. MIB II, currently under consideration, extends the capabilities to a variety of media types and network devices, not limited by the "territory of TCP/IP." There are many attempts to improve the performance of MIB-accesses. A query-language interface seems to offer a number of new capabilities in offering a relational mask, and fast access [DANM91A].

IBM's version of Unix, called AIX, offers an optional network management module known as AIX Network Management/6000 with the support of SNMP. The application includes an SNMP manager with an X-Windows implementation, real-time, color graphics interface, and network topology display. The package includes an SNMP agent and MIP I. The product provides interfaces to NetView for remote log-on, monitoring, and software and file distribution. In addition, a communication module is required for translating AIX alerts to NMVT. The central SNMP manager, installed next to Netview, is expected to poll all SNMP agents distributed throughout the network.

To carry out these duties, SNMP specifies five types of commands or verbs, called Protocol Data Units (PDUs): GetRequest, GetNextRequest, SetRequest, GetResponse, and Trap.

GetRequest, GetNextRequest, and GetResponse

An agent will inspect the value of MIB variables after receiving either a GetRequest or GetNextRequest command (PDU) from a manager. The agent then sends back the data it gathers with a GetResponse verb.

SetRequest

The agent will alter MIB variables after receiving a SetRequest command. Using SetRequest, an NMS could instruct an agent to modify an IP route, for example. SetRequest is potentially a powerful command and, if used improperly, could corrupt configuration parameters and seriously impair network service. Due to SNMP's lack of inherent security measures, some component vendors have not implemented or enabled SetRequest within their SNMP agent implementations. Many vendors are working to enhance security features within their products.

Traps

Trap is a special unsolicited command type that agents send to a manager after sensing a prespecified condition, such as ColdStart, WarmStart, LinkDown, LinkUp, AuthenticationFailure, EGPneighborLoss, or other enterprise-specific events. Traps are used to guide the timing and focus of polling, which SNMP employs to monitor the network's state.

Transport mechanisms

As mentioned previously, managers and agents exchange commands in the form of messages. There are currently two standard SNMP transport mechanisms: Unreliable Datagram Protocol (UDP) and Ethernet frames.

SNMP proxy agents

Proxy agent software permits an SNMP manager to monitor and control network elements that are otherwise not addressable using SNMP. For example, a vendor wishes to migrate its network-management scheme to SNMP, but has devices on the network that use a proprietary network management scheme. An SNMP proxy can manage those devices in their native mode The SNMP proxy acts as a protocol converter to, in essence, translate the SNMP manager's commands into the proprietary scheme. This strategy facilitates

migration from the current proprietary environment, which is prevalent today, to the open SNMP environment (see Figure 3.2.4).

Proxy agents are well suited for vendors with an existing base of non-SNMP devices communicating efficiently under a proprietary scheme. By using a proxy agent, the vendor can reduce the investment risk of putting SNMP equipment into the field.

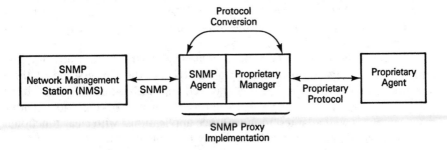

SNMP proxies help a vendor migrate a proprietary network-management scheme into the SNMP environment.

Figure 3.2.4 SNMP proxy implementation.

In summary, SNMP's major advantages are:

- Its simplicity eases vendor implementation effort
- It requires less memory and fewer CPU cycles than CMIP
- It has been used and tested on the Internet
- SNMP products are available now, and affordable

SNMP has several disadvantages, including:

- Weak security features
- Lack of global vision
- Problems with the Trap command

3.2.3 Network-Management Architectures from Network Element Management System's Providers

It is very difficult to differentiate between products and architectures. Most frequently, manufacturers try to sell the products under the umbrella of an architecture. Chapter 13 will deal in great depth with products.

Representing a wide range of products, Systems Connectivity Architecture (SCA) from Timeplex may be mentioned. SCA defines the rules for integration of voice, data, and image processing systems over hybrid networks and

for managing hybrid networking components. SCA clearly defines the interfaces to the OSI reference model, to ISDN, and to other de facto standards.

Unisys Network Management System (UNMS) is tightly coupled with UNMA from AT&T. Unisys does not provide an architecture for network management on its own, but connects essential parts of existing and future products from the DCA and BNA networks, from Timeplex's TimeView, and from Convergent Technologies under the UNMA umbrella. At the peer-to-peer level, UNMS is intended to talk to SNA network managers, such as NetView and Net/Master, using the SMA (SMA Management Application) component from AT&T.

Many early solutions have been influenced by the Xerox Network System (XNS). Many companies have used XNS as the cornerstone of their network product offerings. The XNS layered approach is known to have been part of the OSI models. The XNS approach to networking and network management is well adapted to most office applications, with clear functional layers, clearly defined protocols, and easy-to-implement features. Due to its robustness and simplicity, it became one of the favorite LAN architectures.

The other example is Novell with the LAN operating system called NetWare. Novell offers NetWare care for fault and performance monitoring of physical and data-link layers, and there are accounting and security features in its operating system. However, the present software architecture does not include a special extension toward dedicated network management.

Novell has been forthcoming concerning specifics of its approach to LAN management. Recent statements on OSI indicate long-term commitment to OSI network-management standards, CMIS, and CMIP. Their stated goal is to create standards-based management tools that will work with any OSI-compliant system. Initially, CMIP and CMIS will run over Novell's IPX transport protocols. Once Novell's multiprotocol architecture is fully implemented, CMIP and CMIS will run over the OSI transports and any other NetWare supported transport protocol, such as TCP/IP, SNA, and X.25, in addition to its proprietary IPX and Sequenced Packet Exchange (SPX) protocols. Novell's Network Management Server will communicate using CMIP with both NetWare servers and with OSI-compatible hosts running network-management systems that are CMIP/CMIS compliant. Novell is exploring links with integrated management systems from Hewlett-Packard, IBM, AT&T, and DEC.

Ungermann-Bass has recently enhanced its core network-management system (NMS) and launched a new line of intelligent bridges that link with wide area networks. Integration with the parent company's network-management architectures is expected soon.

Tandem computers has enhanced its Distributed Systems Management (DSM) architecture by offering more sophisticated problem management, monitoring, performance analysis, and windowing capabilities to DSM. DSM will connect to NetView and Net/Master on the SNA side, and also provide links to OSI-based network management. The ultimate goal may be the replacement of the network-management platform by a fault-tolerant Tandem

solution. If so, Tandem, with its architecture, is in the network-management integrator market.

DSM has six main components:

- Systems Programmatic Interfaces (SPI) provides gateways and conversion services to third parties.
- Event Management Service (EMS) administers and distributes events generated anywhere in the network to any destination node.
- Viewpoint serves as the presentation platform based on Tandem's proprietary command language.
- Measure enabling operators examine the use of the system components.
- Network Statistics Systems (NSS) is designed to give an overview of the whole of the distributed system.
- Distributed Name Service (DSS) maintains the different names to one another.

Siemens' strategy is twofold: management of HICOM networks and management of data networks. The management of a HICOM network is focused around the HICOM administration and data server (ADS). ADS is generated as a UNIX-based integrated server which may be accessed from Network Control Centers. Functions such as general administration, report handling, site management, and operational control are supported. The data network is managed centrally via PDN, which runs in front-end processors, supporting administration (ACUT), host event correlation (NTAC), remote diagnosis (RDE), and performance measurement (TRASOM).

Bull's network-management architecture tries to integrate the three principal segments of DSA (Distributed Systems Architecture) users. The architecture's ultimate goal is the migration to a OSI-based network-management solution. It has not yet decided which other architectures and products are going to be supported.

As a supplier, Bull views the role of network management as essentially being responsible for two tasks:

- Making sure the network is not a bottleneck to customers' growth
- Making sure the network provides the level of service customers require to do their business

Network management is seen as much more than just providing tools. It has a high service component in terms of aiding customers to determine the role of networking in their companies, to optimize the use of this resource, and to personalize the management of the network.

Bull's network-management products are supplied within this context. Network management forms an integral part of purchasing a network from Bull. It begins with network planning and design, includes tools designed to

support day-to-day network management, and continues with after-sales support and maintenance.

Bull also works closely with third-party companies in order to be able to extend the range of products and services available to its customers.

3Com's Open Management Architecture (OMA) is going to support multiple protocols and links to various enterprise network-management solutions. In general, 3Com's strategic direction includes integrating its personal computer work group with multi-vendor, enterprisewide networks using CMOT (CMIS/CMIP over TCP/IP) [HERM89C]. 3Com is a strong supporter of standards. 3Com's OMA is a set of design specifications that range from transport layer protocols to end-user interfaces. An initial implementation is likely to support a diverse set of functions, including configuration management, performance management, fault monitoring, accounting, and security with particular emphasis on fault detection, isolation, and correction. Management will be permitted across geographically dispersed LANs connected with repeaters, bridges, routers, and gateways from 3Com or other vendors supporting standard network-management access protocols.

The Open Management Architecture describes two aspects of management information: (1) the OSI structure of management information (SMI) and (2) the management information base (MIB). The architecture for SMI employs object-oriented techniques and abstracts management information into a collection of managed objects. The OMA MIB is a composite of several standards-defined MIBs and 3Com's own proprietary extensions particular to 3Com products; it simultaneously supports each MIB. The manager data base contains all configuration, performance, and audit data. The architecture distinguishes between the MIB and the manager data base. The MIB contains all the management data for all the managed systems comprising the network. That manager data base is a specific physical storage of a subset of instances of the MIB objects as needed for management functions. Some management functions require caching of MIB information in the data base while other functions dynamically access MIB objects on demand over the network. Initial releases will support ISAM, SQL, and sequential access. Longer term object-oriented data bases will also be integrated [HERM89C].

In view of multi-vendor networks, 3Com has designed OMA to provide network-management gateways to other popular network-management systems. OMA particularly focuses on IBM's NetView, DEC's Enterprise Management Architecture (EMA), AT&T's UNMA, and HP's Open View. The IBM NetView connection will be made through the 3Com Maxess product acting as a service point in the NetView scheme. OMA will support alert forwarding and NetView command processing. The DEC connection will be through EMA's support of standards in the access modules of the architecture. AT&T's UNMA connection is to be integrated as an element network-management system communicating with the central control station through the CMIP-based network-management protocol (NMP). Compatibility with OpenView is designed into OMA as part of a technology partnership with HP [HERM89C].

Banyan's Network Management software option is a real-time network monitor that enables administrators to examine the performance of all network components including LAN/WAN connections, system configuration, VINES software services server disk, and network routing. It provides diagnostic, performance, and utilization statistics from any network PC or server console [HERM89C].

Proteon provides simple but effective tools for the management of its LANs and of multi-vendor, multi-protocol internets. These tools address the management of the physical rather than of logical networks. Proteon offers network-management packages, TokenView for LANs and OverView for internets. At present, these systems do not interoperate. Currently based on SNMP, OverView is designed to allow future support for CMOT (CMIS/CMIP on TCP). Their internetworking router products support SNMP and they can migrate to CMOT if the market demands it.

According to Proteon, they continue to evaluate their network-management strategy. Possible future directions include porting OverView to a Unix environment and/or distributing the current OverView functionality over multiple machines in order to avoid a single point of failure in the management system. Since they are primarily a networking and router vendor, they are also considering partnering with a management platform vendor such as Sun and placing less emphasis on OverView [HERM89C].

Based on distributed computing architectures and protocols, Sun has created a set of tools to manage elements of a network rather than an enterprisewide network. Sun has implemented a platform-based approach in which the platform is a Unix workstation with SunNet Manager software that monitors and controls devices and processes on TCP/IP and DECNet over Ethernet networks with future support for managing FDDI networks announced. SunNet includes development tools so that third parties can create interfaces to devices and networks not supported by Sun and so that users can create customized reports and network-management applications. SunNet Manager manages TCP/IP and DECNet networks. Through network windowing and terminal emulation products, SunNet Manager also provides integration with systems such as IBM NetView and AT&T Accumaster Integrator, allowing them to be run from the same screen [HERM89C].

Codex has successfully implemented network-management systems for many years. It is a typical provider of network element management systems for modems and multiplexers. In the short term, Codex develops and improves its network-management systems for its own products. In the medium term, the company wants to incorporate products from third-party-product suppliers. In the longer term, it is looking toward turnkey integrated network-management systems embracing all network elements in a client's network. Codex is committed to OSI standards and to the support of leading network-management solutions such as NetView, EMA, and most likely Accumaster.

In summary, the proprietary and de facto standards may be characterized as follows:

- Dominance of IBM in the WAN network-management area; almost all other architectures are seeking connections to ONA by the service point or by reverse-engineering entry point internal SNA information flows.
- The LAN management market is completely distributed by networking architectures, such as Token Ring, Token Bus, or Ethernet; by network operating systems; and by network-management support techniques. Almost all manufacturers support TCP/IP and architect SNMP (Simple Network Management Protocol), but also promise CMOT (Common Management Information Services from OSI on TCP/IP).
- There are no special network-management architectures designed and implemented for MANs.

3.3 ISO-BASED NETWORK-MANAGEMENT ARCHITECTURES

Based on the seven-layer model (see Chapter 2), network-management-related applications are also supported. Applications are implemented in layer 7. Layers 1 through 6 contribute to network management by offering the standard services to carry network-management-related information. Systems management application entities (SMAE) have three key components—so-called application service elements—which are vital to network management [MCCA89]:

- ACSE (association control service elements) is responsible for an association establishment and a release establishment for an application association.
- ROSE (remote operation service elements) is responsible for connection establishment and release.
- CMISE (common management information service elements) is responsible for the logical part of communicating network-management information.

The service elements of CMISE are:

The M-INITIALISE service is used by a CMISE service user, such as a managing process, to establish an association with a peer CMISE service user, such as a managed process. The M-INITIALISE service forms the first phase of an instance of management information service activity. It is only used to create an association and may not be issued on an established association. It is defined as a confirmed service (e.g., meaning that the target CMISE acknowledges the initiating CMISE that the service has been provided). It is routed to ACSE to establish an association with a peer CMISE service user.

The M-TERMINATE service is used by a CMISE service user to cause a normal release of an association with a peer CMISE service user. It is defined as a confirmed service. It is routed to ASCE to cause a normal release of an association with a peer CMISE service user.

The M-ABORT service is used by a CMISE service user to cause an

abrupt release of an association with a peer CMISE service user. It is defined as a nonconfirmed service. It is routed to ACSE to cause an abort release of an association with a peer CMISE service user.

The M-EVENT-REPORT service is used by a CMISE service user to report an event associated with management information to a peer CMISE service user. It is defined as either a confirmed or a nonconfirmed service.

The M-GET service is used by a CMISE service user to retrieve management information values from a peer CMISE service user. It is defined as a confirmed service.

The M-SET service is used by an invoking CMISE service user to request the modification of management information values by a peer CMISE service user. It is defined as a confirmed and a nonconfirmed service.

The M-ACTION service is used by a CMISE service user to request a peer CMISE service user to perform an action on a managed object. It is defined as a confirmed and a nonconfirmed service.

The M-CREATE service is used by an invoking CMISE service user to request a peer CMISE service user to create a representation of a new managed object instance, complete with its identification and the values of its associated management information, and simultaneously to register its identification. It is defined as a confirmed service.

The M-DELETE service is used by an invoking CMISE service user to request a peer CMISE service user to delete a representation of a managed object instance, and to de-register its identification. It is defined as a confirmed service.

Two additional services are anticipated to become a part of this set of services. These services are M-CANCELGET and M-ADD/REMOVE.

Using these service elements, a variety of system management functions (SMF) can be supported (Figure 3.3.1) [COLL 89]. SMFs carry out the management processes, or activities, specified by the various Specific Management Functional Areas (SMFA). It is clearly specified which of the SMFs are used by the various SMFAs. For example, a state management SMF is used by the fault management and configuration management SMFAs.

Currently, seven SMFs are defined in the SMF document (see Figure 3.3.1). They are:

Object management. This uses OSI services, such as those specified in the Common Management Information Services (CMIS) standard, to perform actions on managed objects. These actions include creating, deleting, and renaming managed objects. For example, the management function Object Management may invoke the CMIS service M-DELETE to delete a managed object from an open system.

Within the Object Management definitions, services are specified that allow reports about Object Management activities to be communicated to other open systems. For example, an attribute change event report service can be used to send an event report to another open system if an object's attributes change.

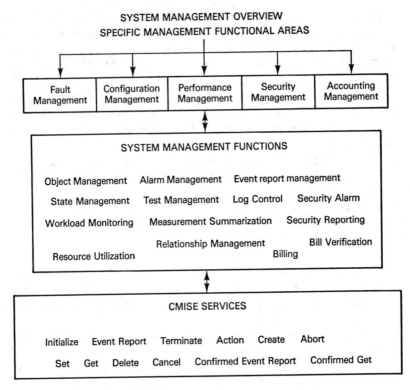

| Fault Management | Configuration Management | Performance Management | Security Management | Accounting Management |

SYSTEM MANAGEMENT FUNCTIONS

Object Management Alarm Management Event report management

State Management Test Management Log Control Security Alarm

Workload Monitoring Measurement Summarization Security Reporting

Relationship Management Bill Verification

Resource Utilization Billing

CMISE SERVICES

Initialize Event Report Terminate Action Create Abort

Set Get Delete Cancel Confirmed Event Report Confirmed Get

Figure 3.3.1 System management overview.

State management. This describes services that allow the OSI Management user to monitor the past state of managed objects and receive notices, or alarms, in response to changes in the state of managed objects.

The State Reading service uses the M-GET service of CMIS to retrieve information from managed objects. For example, M-GET may be used to retrieve an indication of whether a managed object is accessible by the management system.

The State Change Reporting service calls on the attribute change event report service of Object Management to notify users of changes in either the administrative or operational state of managed objects.

Relationship management. This describes services that create, delete, change, and report relationships among managed objects. Relationships among managed objects is a complicated issue.

In general, a relationship is a set of rules that describes how the operation of one managed object affects the operation of another managed object within an open system.

For example, two managed objects in an open system may have a relationship in which one is activated in the event that the other fails as a result of a fault management diagnostic.

Error reporting and information retrieval. This allows various types of information to be reported and retrieved through the open system.

Descriptions of error types, probable causes, and measures of severity are specified. This type of functionality will be essential in integrated network-management scenarios where users have more than one network in place. For example, a single network-management system's ability to access information about errors occurring in two open systems could be important in situations where a relationship exists between the two open systems.

Types of errors defined by this SMF are: communications failure, quality of service failure, processing failure, environment failure, and equipment failure. Error reporting services for each type of error are defined in this SMF.

Probable cause information provided by this SMF would indicate the problem that results in an error.

For example, in the case of a communications failure, a probable cause might be a call establishment error.

Five severity parameters are defined: indeterminate, critical, major, minor, and warning. In a network-management application of this SMF, the ability to categorize alarms by severity helps the network manager decide quickly which alarms must be responded to immediately and which ones can wait.

This SMF uses the CMIS service M-GET to perform information retrieval.

Management service control. This describes services that allow the management system user to determine which event reports are to be sent where.

For example, this SMF could play a key role in network-management systems scenarios by allowing the network manager to specify which information can be exchanged between Manager Processes and Agent Processes. Consider a scenario in which a user has one Manager Process that centralizes management of multiple separate Agent Processes.

As Figure 3.3.1 illustrates, the Management Service Control functions will allow the user to choose which types of event reports will be exchanged between the Manager Process and the individual Agent Process.

Confidence and diagnostic testing. This allows tests to be performed on managed objects. The purpose of such tests is to allow the management system to determine the quality of services and to assist in the diagnosis of faults within the open system. For example, this SMF might be used to initiate bit error rate tests on remote modems.

Log control. This service allows users to choose which event reports the system will log. The log control function also enables an external managing system user to change the criteria used for logging event reports.

The application of the log control function in a network management scenario is very important. The network manager wants the ability to specify which events should be logged, but the ability to add or delete event reports to

be logged is also very important. For example, the user may want to log only critical event reports, but at a later date, perhaps the need to track all reports on a historical basis will become important.

The implementation targets are SMFAs (Specific Management Function Areas) which represent the principal network-management applications, including configuration, fault, performance, security, and accounting management (see Figure 3.3.1). Figure 3.3.2 shows an example for fault management which includes two systems management functions and three different service elements for managing objects.

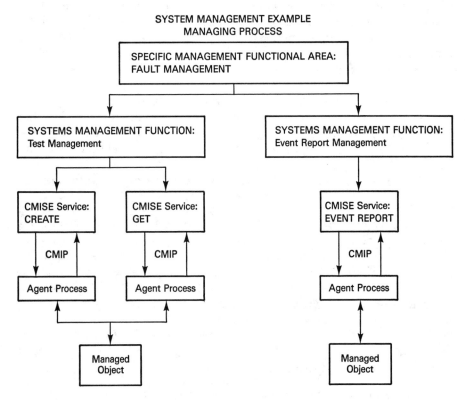

Figure 3.3.2 Fault management example.

OSI includes the concept of managed objects. It specifies their attributes, operations that may be performed upon them, and the notification that may issue. The set of managed objects in a system, together with their attributes, constitute that system's Management Information Base (MIB). The Structure of Management Information (SMI) defines—in addition to MIB— the logical structure of OSI management information. Both MIB and SMI are subject to special customization by manufacturers and users.

The recommendations are interpreted by the major players and are implemented in a slightly different way. Three architecture examples will be covered in the next part of this chapter.

3.3.1 AT&T's Network-Management Architecture

UNMA (Unified Network Management Architecture) is a general, OSI-based, multiple management system architecture [GILB88]. It fits well with AT&T's product direction, which is also based on ISO and CCITT open protocols. One of the most distinctive aspects of AT&T's approach is the fact that it is not tied to a particular network technology, but is intended to serve as an all encompassing design for managing any type of network. It will cover networks of all types including voice and data, public and private, wide area and local area, AT&T and non-AT&T. Based on vendor-independent interfaces defined by ISO, it provides a way of tying together network-management systems from a variety of suppliers. UNMA will also guide the development of AT&T's future products for integrated management of diverse products and services.

UNMA describes a three-tier architecture (see Figure 3.3.3). The lowest tier comprises network elements, which are the logical and physical components which comprise the network(s) being managed. Network elements exist in three domains:

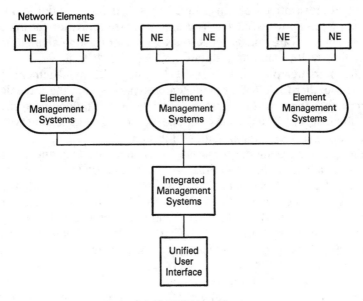

Figure 3.3.3 UNMA architecture.

- Customer premises, which includes PBXs, computer systems, workstations and PCs, LANs, premises wiring, modems, multiplexers, DSUs, bandwidth managers, packet switches, and the like. AT&T seems to be focusing on management of premises equipment with UNMA.
- Local exchange carrier (LEC) networks, which provide intra-LATA communications services, including switched and private line services for both voice and data. Although AT&T always talks about intra-

LATA elements being part of UNMA, there is little indication that any of the BOCs want to play along with AT&T.

- Inter-exchange carrier (IEX) networks, which provide long-distance, inter-LATA communications services, including switched and private line services for voice and/or data. AT&T, of course, is the major IEX on which UNMA is focused. By providing management of public network services to customers through UNMA, AT&T is hoping to improve the appeal of its services and make them more dynamic and responsive to customer needs.

The second tier of UNMA are the element management systems (EMS), which administer and manage network elements. EMSs can be located on customer's premises, at a LEC central office, or at an IEX central office. They might be located at a third-party site. Element management systems are specialized to the needs of specific kinds of equipment and form a set of modular components for meeting the management requirements of different network environments. The EMS tier is necessary since network equipment exists in different administrative domains (e.g., LECs vs IEXs). In addition, the concept of an EMS allows AT&T to preserve its current investment in network-management software and systems. AT&T's major existing element management systems will be summarized later in Chapters 7 and 8.

The third tier of UNMA consists of integrated management systems, which tie together the element management systems from the three domains. This tier concentrates on integrated applications and unified user interfaces. Although most AT&T diagrams show one integrated management system, the architecture is very general and allows for many.

Element management systems and integrated management systems communicate with and among each other using a standard management protocol, which AT&T calls the Network Management Protocol (NMP). Element management systems communicate with network elements using whatever protocols are best suited to the task. NMP is based on the ISO Common Management Information Protocol (CMIP). NMP is really the means for integration in the architecture and the vehicle for tying in management systems from other vendors.

Although this general architectural definition explains the purpose and goals of UNMA, it does not really provide much detail. The detail is coming from the specification of NMP, on which four technical references have so far been published by AT&T. The most important of these is the Data Modeling and Naming Framework specification. This document models various aspects of both the communications management network and the communications network that is managed. The models collectively define a management model for UNMA and NMP. These models are based on emerging CCITT/ISO concepts of object-oriented data models and are similar to the methods used in defining the OSI Directory Service in the X.500 standards.

AT&T has defined two basic models, which will guide the development

of NMP and the implementation of products which will operate under UNMA:

- The organizational model, which describes the ways in which network management can be distributed administratively across management domains and across management systems within a domain.
- The information model, which provides guidelines for defining managed objects in the communications network and their respective interrelationships, classes, attributes, methods, and names. It is the most concrete published example of how OSI management concepts might be put into practice.

One thing is immediately clear upon examining the definition of these models: AT&T is defining a multiple management system architecture, in which an essentially unlimited number of administratively separate management systems can cooperate to perform useful network-management functions. This is evident from the definition of a management network, which is distinct from the network(s) being managed. In contrast to this architecture, the following sections concentrate on platforms that give users the opportunity to write and exchange applications among each other.

3.3.2 DEC's Network-Management Architecture

Enterprise Management Architecture (EMA) from DEC incorporates a number of design goals and principles. Its primary function is to provide integrated network management—a consistent user interface, a common information repository, and integrated access to management functions and managed devices. Four distinguishing EMA characteristics in particular directly address current market needs: applicability for distributed environments, open interfaces, third-party support, and OSI compliance via a migration path [DANM89H].

The structure of EMA is simple yet flexible enough to be implemented in numerous ways. EMA is composed of several basic pieces that do not have to reside in one location. This flexibility is a major advantage, since it is adaptable to the distributing computing environment which, due to the LAN and PCs technology, is on the rise in more and more enterprise networks.

EMA employs a director-entity model to describe the relationship between the networking elements being managed (entities) and the systems managing them (directors). The entity is actually composed of two parts—the managed object (multiplexer, modem, line, control unit, and so on) and its agent (the management software). This software acts as a conduit for management operations, such as events and directives, and may also provide a degree of management capability for the entity. The director is a software system that acts as an interface between the user and the managed network devices and systems. It is made up of five parts (Figure 3.3.4):

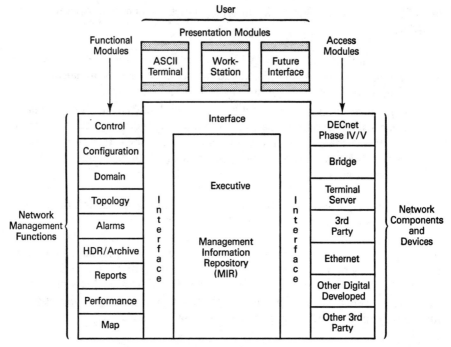

The structure of Digital's Enterprise Management Architecture (EMA) supports plug-in modules (Access Modules, Presentation Modules, and Functional Modules) that may be developed by Digital, third-party vendors, or by users themselves. At the heart of EMA's Executive control program is the Management Information Repository (MIR), an object-oriented database.

Figure 3.3.4 Architecture of EMA.

- The Executive is a master control program for coordinating all activities within the director.
- The Management Information Repository (MIR) is an object-oriented configuration data base for information about devices and management activities.
- The Presentation Modules create the user interface for EMA directors. These modules can be written to support a specific console or presentation format or to interface with non-EMA applications.
- The Access Modules communicate directly with typical network components, such as multiplexer, PBXs, modems, DSUs/CSUs, LANs, and nonnetwork components, such as systems, applications, and data bases. To accomplish this, various protocols will be offered.
- The Functional Modules provide configuration, fault, performance, accounting, and security management services. Functional modules can be developed by Digital or by third parties wishing to build on the EMA platform.

Network-management solutions are grouped into domains. Domains are defined as user-defined spheres of management interest and control, adding another dimension of architecture flexibility. Domain may be defined according to functions, organizations, technology, geography, or a combination of all of these. Domains may be nested, overlapped, shared, or clearly fragmented. It is assumed that EMA will first be populated by existing DEC products in the WAN area, such as the NMCC/DECNetMon, Netpath, Netresponse, Netava, and NIWatch; and in the LAN area, such as Ethernim, LAN Traffic Monitor, Terminal Server Manager, Remote System Manager, Remote Bridge Management Software, PBX/Facilities Manager, and Cable Facilities Manager.

3.3.3 Hewlett-Packard's Network-Management Architecture

HP's OpenView offers a comprehensive network-management solution for managing local and wide area multi-vendor networks. The product is based on an OSI platform and integrates existing wide area HP AdvanceNet network management, and LAN-based performance management products.

The center of OpenView is HP OpenWindows, a graphical user interface running on the HP Vectra PC. For third-party integration, HP offers a developer's kit.

HP approaches the management of multi-protocol, multi-vendor LANs with a distributed architecture. In their view, a single enterprisewide management system is impractical today given the lack of universally accepted standards and the complexity of networks. Thus, a distributed architecture allows for the management of a diverse set of networks and network elements.

Initial OpenView offering builds on HP's extensive experience with network diagnostic and monitoring equipment, network interfaces and routing devices, workstations, PC LANs, and network-management services. HP's OpenView offerings focus on seven areas: fault management or problem isolation, accounting management, security management, configuration and change management, performance management, inventory management, and system management.

At present, OpenView focuses on management of HP systems and networks with current or future interfaces to equipment and systems from other vendors. Although not yet a true multi-vendor management offering, OpenView is well-positioned if HP decides to create the interfaces to other vendors' equipment and systems, a task currently left to third parties.

Along with Sun and Digital, HP's strategy is to provide a framework for the management of its own systems based on creating a Network Management Station—PC based rather than Unix based. Whether they can convince others to follow their lead given their current offerings remains to be seen.

SNA Link and other IBM connectivity products send appropriate alerts

and alarms back to NetView. HP has announced future direction to have OpenView exchange information with NetView.

Announcements of new network-management products are expected in the early nineties. These are likely to include a Unix-based system and support for SNMP [HERM89C].

3.4 NETWORK-MANAGEMENT ARCHITECTURES FROM USERS

Powerful and impatient users are tempted to define and build their own network-management architectures. In this process, they take advantage of existing modules and protocols from both the proprietary and OSI environments. After successful implementation in their own environment, commercial use is likely. Major players in this category may be Nynex, BBN, Ameritech, British Telecom, USWest, Boeing, McDonnell Douglas, and American Express. Regional phone companies also may play an important role due to the excellent prerequisites of offering integrated data/voice solutions.

In many cases, however, the solutions show a tailored integration of products rather than a well-designed architecture.

3.5 COOPERATIVE SOLUTIONS

It is expected that for a long period of time heterogeneous solutions will dominate the network-management marketplace. Cooperative management will ensure the export and import of network-management-related information among network-management entities.

Three gateway solutions are addressed as examples:

- IBM's OSI/CS (Figure 3.5.1), which offers management services to OSI networks and to network management. It offers solutions that use CMISE. This gateway offers a host-based protocol conversion into an internal ONA format. The gateway represents a hierarchical solution.
- SMA (SNA Management Architecture) (Figure 3.5.2) from AT&T uses a software extractor in SSCP processors. The extractor converts ONA protocols into NMP and transfers it to UNMA processors, enabling UNMA products to have expert-like correlation of logical and physical network elements in real time. This solution is closer to a peer-to-peer architecture, but presently SNA sessions are exporting and importing information. An extension to LU6.2 is very likely by adapting the distributed Net/Master concept from systems center.
- IBM's TCP/IP network-management solution represents the use of SNMP agents for collecting network-management-related information

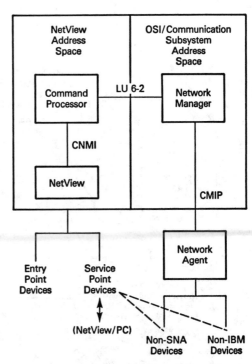

Figure 3.5.1 OSI integration into IBM network management.

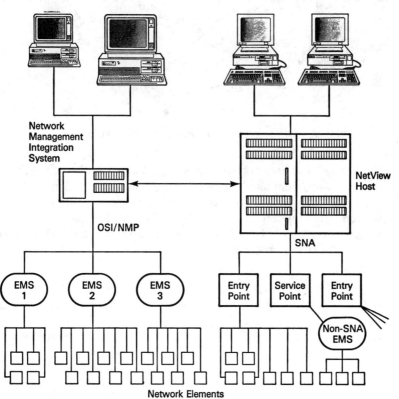

Figure 3.5.2 SNA management architecture.

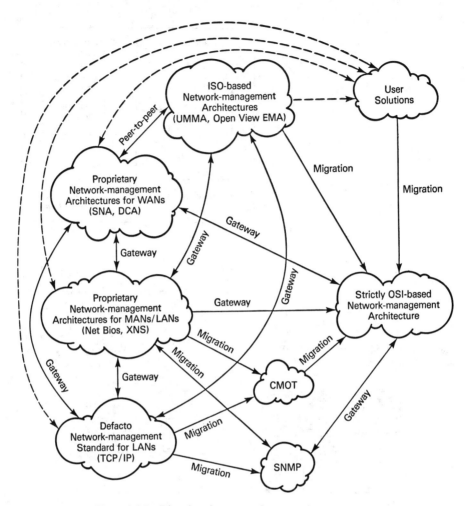

Figure 3.5.3 Directions in cooperative network management.

anywhere in the network. SNMP is implemented in the new AIX components. Also commands may be interpreted by the agents. The following SNMP commands are in use: GetRequest, GetNextRequest, SetRequest, GetResponse, and Trap. The SNMP query engine software will run under NetView. The query engine is the actual gateway between NetView processes and the agents.

In other cases, bilateral gateways help to integrate network-management architectures (e.g., Interlink gateways) residing in SSCP processors and emulating DNA and offering solutions to its management.

Manufacturers of MAN and LAN architectures are momentarily uncertain about the directions in standardization. In almost all cases, they offer

support to both SNMP and CMOT. CMOT will migrate to OSI; SNMP will very likely use a gateway for information export/import with OSI.

For summarizing potential moves, Figure 3.5.3 shows the present situation and where gateways are used for information conversion. Also migration paths are identified, but no timeframes are set yet. Network management will remain heterogeneous and multi-vendor for the next few years.

<div align="right">

4

</div>

Information Extraction
and Collection Instruments

Availability of information at the right time and place is the basis of successful fault, security, and performance management. Consolidated information in near real time is the basis for configuration accounting and planning management.

This chapter will introduce the most important monitoring devices in the category of physical and logical network management. Monitoring options supporting network-management services are also discussed. The major emphasis is on generic solutions and principles; product examples are given, but extensive listings of products are avoided. Table 4.0.1 shows the instrument categories characterized by complexity, costs, overhead, accuracy, and human resources demand.

In reference to Figure 1.4.2, extraction and collection instruments reside in or around network elements, and are controlled by network element management systems or directly by network-management integrators. In certain cases, the demarcation line between a managed object and a management entity is very difficult to recognize. Standardization of monitoring and performance management will soon improve this situation.

4.1 MONITORING PRINCIPLES

The ultimate goal is to extract, interpret, and compress data near its origin and transfer it to the management entity. Integrating monitoring data from different components can be simplified if data are converted to a common

TABLE 4.0.1: Categorization of Information Extraction Instruments.

Instruments	Complexity	Cost	Accuracy	Human Resources	Overhead
Accounting packages	low	low	fair	low	low
Special-purpose response-time monitors	low	low	good	medium	low
Modem, CDU/CSU monitors	low	low	good	low	low
Line monitors	low	variable	high	high	low
Switch monitors	medium	medium	high	medium	low
Multiplexer monitors	medium	medium	high	medium	low
LAN monitors	low	low	high	medium	medium
PBX monitors	medium	medium	high	medium	low
Network monitors	medium	high	high	medium	low
Software monitors	high	variable	variable	medium	medium
Security monitors	medium	medium	good	medium	low
Application monitors	high	variable	variable	medium	medium
Hardware monitors	high	high	high	high	low
Expert systems	high	high	variable	high	medium

format. Different types of status changes may be represented in binary values, as shown in Figure 4.1.1. The four different status changes may be interpreted as follows [FRIE89]:

1. Shows a simple failure that can be readily mapped into an up or down condition.
2. Shows a failure that is defined as an event that recurs too frequently. Although this failure type is more complex, it too can be mapped into a binary variable: periods of failure and nonfailure.
3. Shows the detection of a single event that does not result in an ongoing failure, but that is sufficiently unusual to warrant operator attention. The first occurrence of this event triggers an "alarm condition," which is active until the event is investigated and cleared.
4. Shows a threshold failure. When the threshold is exceeded, a failure condition exists. When the measured value dips below the threshold, the failure is "cleared."

Status information on individual components will be represented in Figure 4.1.2. The network status representation may be maintained either in the network element management systems or in the integrator. All related further processes, such as event rectification, alarm management, and problem diagnosis, are addressed in Chapter 8.

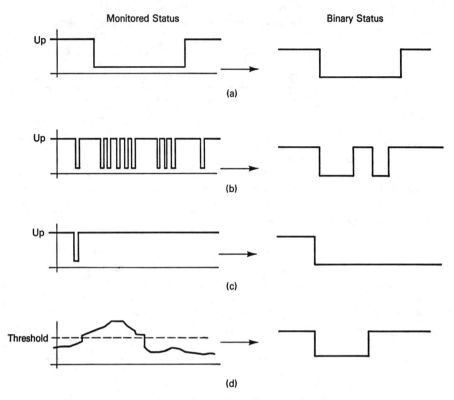

Figure 4.1.1 Representation of monitored status.

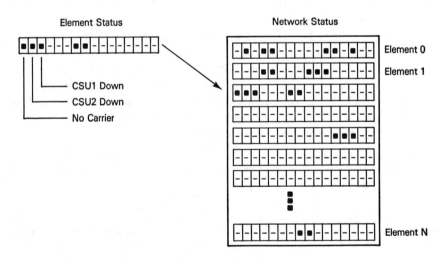

Figure 4.1.2 Representation of network status.

4.2. INSTRUMENTS SUPPORTING PHYSICAL NETWORK MANAGEMENT

This section summarizes instruments using communication interfaces, ports, special channels, device-internal interfaces, and in special cases software elements reporting on physical status. In general, the following functions have to be provided [FROS83]:

- Automatic and remote testing and monitoring of the system. The intent is to avoid the need for service personnel.
- Restoring and/or reconfiguring the system upon failure in real time.
- Providing network performance statistics on network components and all networks for facilitating planning and management.

4.2.1 Line Monitors or Datascopes

The first category, technical control of network components, is covered mostly by line monitors, which are probably the simplest form of testing equipment that can be arranged to provide network information from a remote site to a central site. Line monitors monitor and analyze the data passing through the data communications network and display the information on a screen or, alternatively, store the data for later analysis on an attached recording device or at the central site. The more sophisticated data line monitors today also incorporate simulator and protocol-analyzer functions.

This category of tools may be considered to be generic due to the fact that these instruments may also support other areas such as LAN monitoring, T1/T3 monitoring, and ISDN tests.

There is a large variety of equipment supplied by many vendors in today's marketplace. These tools usually can be put into two categories: those that are used to test the line side of a modem (known as the analog interface) and those that are used to test the data equipment side of the modem (normally called the digital interface).

Analog tools and measurements

Hardware tools that attach to the analog, or line, interface of the modem are considered first. The analog patch panel provides a connection point between the modems and the telephone lines, allowing patching and monitoring of the two- or four-wire line attached to the modem. The audio panel on the analog patch panel contains a speaker and amplifier that can be attached at the analog interface to the telephone line. The listener uses this panel to make subjective decisions. Through practice and training, the listener can recognize many line impairments, listen to polling rates, and hear terminal and system responses.

The decibel (dB) meter measures the transmit and receive audio levels on the line. It can be attached to the line by using the analog patch panel. The audio levels are set by the common carrier according to the conditioning parameters for a line and are adjusted by the carrier.

The line-quality monitor measures line impairments such as attenuation phase jitter, amplitude jitter, frequency jitter, gain hits, noise, line errors (amplitude and phase jumps, short interruptions), and frequency distortion. Measurements of these impairments are very useful in determining line condition and can give indications of a line failure. (These tools may be restricted in some countries: therefore, the common carrier or Post Telephone and Telegraph Association (PTT) should be consulted for country regulations and restrictions.)

The analog test set can test communication lines for various parameters. It usually tests most of the transmission parameters specified by common-carrier tariffs for the type of conditioning on the communication equipment and provides an effective way to gather data.

Digital tools and measurements

The process of digitization is supported by a number of public and even private carriers. In most cases, the pulse-code modulation is used for transmission purposes. In addition to measurements similar to those of the analog circuits, such as signal attenuation, noise, and distortion, measurements for code control and for bit-error rate are required.

The digital category of technical control of network components is covered mostly by line monitors (Figure 4.2.1). A data line monitor is a diagnostic test equipment used for monitoring and analyzing the data passing through

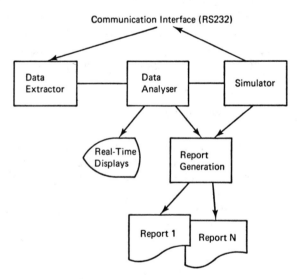

Figure 4.2.1 Line-monitors architecture.

a data communication network. It speeds the isolation and diagnosis of network problems by displaying the data and control characters that flow through the network. The unit displays all the information of the data communications line in both directions. It highlights the control characters on the line, which are normally not available to the user, and turns on various signal lights when certain events are detected that are crucial to the transmission and reception of information signals [FROS83].

Monitors may be provided as portable equipment, which may be carried by field personnel to a network connection point to survey the data through that point, or they may be permanently connected to a number of network interfaces as part of a technical control system. When permanently connected, a dedicated circuit is generally used by the centralized monitor selector to activate the remote monitoring devices. On the other hand, portable monitors may also be connected to the central site via dial-up lines.

Measurements criteria include

- Display of interface signals
- Measuring the IN and OUT status
- Determining and diagnosing short interruptions
- Serving as a patching unit for any of the interface signals

The early monitors performed only passive monitoring functions, sitting at the network connection point, indiscriminately trapping data. These early monitors were sufficient to meet the simple needs of the relatively small and unsophisticated networks of the time.

At this stage, the two most important measurements include the determination of bit- and block-error rates (BER and BLER) by counting erroneous bits and time intervals and considering the line speed. In addition, timing tests, including timeouts and jitter, are becoming increasingly important.

As the networks grew in complexity and sophistication, these line monitors evolved to meet the new demands and to include simulation functions. With these monitor simulator units, customers can not only monitor data traffic but can also simulate various network components, such as modems, terminals, and CPUs to perform interactive tests in a variety of simulated operating environments. Communication protocols and codes can also be tested, so these monitor simulators are often called protocol analyzers [FROS83].

In the monitoring mode, the unit does not become actively involved in the data transmission function or inhibit transmission. It simply monitors the interface between the DTE and the DCE equipment, counting and recording standard transmission problems. Load and traffic patterns and a variety of network performance parameters are monitored. Statistics such as block counts, block lengths, retransmissions, character counts, protocol delays, and errors are captured. These statistics can be displayed on a CRT or some other output device. If a CRT is used, there is generally a command, which can be

executed by the operator, that "freezes" the display to make more detailed examination possible. Some monitors also accommodate a peripheral tape unit to store monitored data for later examination. Alternatively, the data can be relayed to a central location for analysis. The remote equipment can also be configured to alert the central location of previously defined major and minor alarm conditions occurring in the remote or field data communications equipment. These monitors can also be used to trap, retain, and count the number of times a specific control character is seen. For example, the monitoring equipment can be set to recognize and note a particular character which, in a given application, is associated with a polling cycle. By trapping this character, the monitoring equipment enables the progress of a sequential polling routine to be checked from a central test site [FROS83].

In the simulation mode, the unit becomes actively involved in the operation of the CPU, communication facilities, or terminals, instead of just observing the data flow. To do this, the connection between the DTE and the DCE equipment of one end of a communication link is broken and the unit is connected between the two pieces of equipment via the RS-232C (V.24/X.21) interfaces. To perform the network testing, the simulator adopts the role of one of the other components in the link, emulating a modem, a terminal, or a CPU. It then transmits data to the network elements being tested and receives data back from those devices. By checking the validity of the responses from the devices, any error in the devices can be detected [FROS83].

The data generated by the simulator for testing may include a standard message, such as a certain sentence, or a set of protocols that are standard for the network, or a random or pseudorandom test pattern. For example, in an SDLC environment, unique "frames" may be sent in the standard reference, which is composed of flag, address, and control characters; data characters (variable length); a frame-check-sequence character pair; and a final flag character.

Today monitors are required to support higher data speeds of modern networks made possible by satellite and other wideband network services.

State-of-the-art datascopes are usually able to monitor and test up to layer 3 of the OSI reference model (see Chapter 2 for definitions and details). Furthermore, due to the capability of analyzing any kind of data streams, these instruments may be utilized as dedicated devices for measuring T1/T3, ISDN, and also local area networks. Table 4.2.1 summarizes the most important criteria for selecting datascopes.

4.2.2 Modem Control Systems

The second category is commonly called modem or network technical control systems. Network technical control systems include manual technical control systems and automated network technical control systems as well as more sophisticated combinations of these systems. The network technical control systems are supplied by traditional suppliers of patching, switching,

TABLE 4.2.1: Selection Criteria for Datascopes and Technical Control Systems.

Generic Criteria
Availability of user program-supported data analysis
Simulation capabilities
Extendability
Data security
On-line analysis capabilities
Off-line analysis capabilities
Portability
Maintenance
Documentation
Printer quality
Replay capabilities
Ease of use
Company reputation
Interfaces supported
Warranty period
Price

Specific Criteria
Support of synchronous and asynchronous protocols
Storage capabilities including capture buffer size
External clock rate
Protocols monitored
BCC (binary control characters) test availability
Display formats (ASCII, EBCDIC, HEX), and graphics
Throughput capabilities
Time measurability
ISO transmission-hierarchy levels supported
Triggering for event, time, breakdown, error code
Measurability of the HDX and FDX environments
Separation of send and received data
V.24 or RS-232 interface signals to be controlled
X.21 interface signals to be controlled
Controllability of packet-level events
Computing power of hardware
511 and/or 2047 tests
Data buffer size
Peripheral ports available
Power supply
Remote communications supported
Support of traps
Support of network performance analysis

and modem equipment. These systems offer access to remote sites via leased lines or dial-up lines or through the use of a secondary channel. Network technical control systems offer centralized testing and control by integrating the supplier's data line monitors with the accompanying line of patching and switching equipment that is rack-mounted at the central site. Furthermore,

the technical control system monitors, tests, and restores the network upon failure. Through the development of the secondary channel of the modem, in-service monitoring is possible, and tests at a remote site can be performed from the central site without the need for any manual intervention at the remote site. Modem loopbacks, bit-error rate tests, and often line parameters, such as receive-signal level, phase jitter, and signal-to-noise ratio, are measured from the central site.

More sophisticated devices maintain data bases as well. The data base stored in the microcomputer also includes inventory information, which is useful for asset and cost control, as well as vendor information. Because the network-management module is software based, it is extremely versatile. A variety of application packages can be provided, such as a trouble-ticket management system. Flexible report writers are also available so that reports and analyses on network performance statistics can be generated in a customized format for management. The historical reporting capability provided by the network-management module permits trend analysis and enables the data communication manager to plan and achieve a more cost-effective utilization of the network. But the increasing availability of end-to-end digital communication may soon affect the applicability of modems as an information source. In certain environments, similar capabilities will be provided for DSUs and CSUs. Network technical control systems include a wide range of alternatives. Manual systems based on patching or switching and automated systems based on modems are widely implemented.

The patching and switching equipment is integrated with diagnostic equipment such as data line monitors which can be switched into the network for testing purposes. The definition of network technical control systems includes manual technical control systems as well as the newer, more sophisticated versions from the same suppliers, which provide automatic or semiautomatic remote switching and monitoring capabilities. Access to remote sites from the central site is achieved in the network technical control systems through dial-up or leased lines. The network technical control systems here do not make use of a secondary channel for control signaling, in contrast to the network-management and network-control systems. Network technical control systems do not offer facilities that are as powerful or as sophisticated as those provided by the latter systems, such as continuous nonintrusive monitoring of entire multi-tiered networks; however, network technical control systems are cheaper and service the simpler needs of the small networks in the marketplace.

Patching equipment forms the basis of a network technical control system by providing the following functions [FROS83]:

- Fall back to standby or spare facilities in the event of a failure.
- Test and monitor the network by switching diagnostic equipment into the required circuits.
- Reconfigure the network to isolate a fault or when the network changes in design or expands.

The simplest, oldest, and most basic form of patching equipment is the plug-and-jack panel, which resembles the telephone switchboard, where lines and equipment can be tested through the positioning of patch cords. By using plug-in cables, the technician can manually plug into a particular line and monitor its operation without interrupting the data going through it. In the same manner, a faulty line can be bypassed to another line until the faulty line is restored. This process is, of course, limited by the number of access ports available on the patch panel and the degree to which redundant lines have been incorporated into the data communication scheme.

Switching equipment performs the same functions as the patch panels but does so through the use of a switch rather than a patch cord and tends to be electronic rather than manual. In addition, remote switching can be performed under control from a central site, and switched equipment permits secondary fallback equipment to be switched on-line immediately in the event of failure in the primary equipment. Patch-switch ports need to be planned to be treated as part of the data base for the network component's inventory. In addition, procedures also need to be written ahead of time that document how an operator can switch in backup equipment.

Typically, a network control system employs a master controller at the central site, which communicates with a special electronics module added to each modem in the network. Figure 4.2.2 shows configuration of a typical network-control system. This module is responsible for gathering status and operational data from its associated modems and responding to commands from the controller. Communications take place over the regular data network but in a low-speed band, separate from the main channel, called the out-of-band secondary test channel. Diagnostic and control commands and responses can therefore flow between the controller and the remote modules without interrupting regular network operations. At the central site, a CRT terminal alerts the operator to network problems and provides the means for diagnosing a problem, isolating the faulty unit, and restoring network operation while the failed element is being repaired or replaced.

The three basic elements in the design of a network-control system are [FROS83], [TERP85A]:

- The secondary test channel
- The remote-addressable test module
- The central control

The secondary test channel

The secondary test channel is an independent low-speed channel that utilizes unused frequency bandwidths on leased telephone lines. Figure 4.2.3 shows the typical bandwidth and position of the test channel next to the main data channel on a conventional leased line.

As Figure 4.2.3 shows, the main data channel is concentrated within a

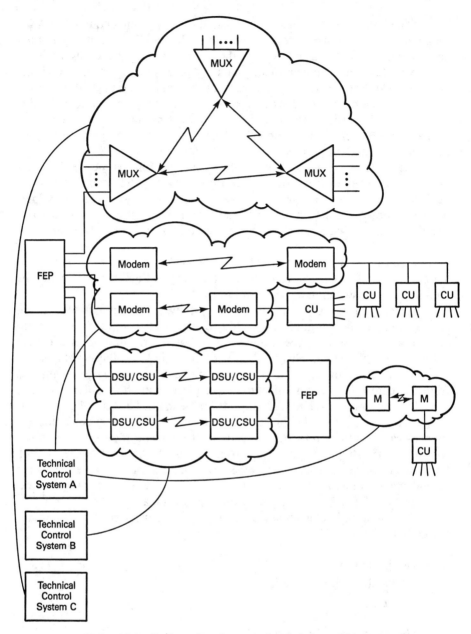

Figure 4.2.2 Configuration of a network technical control system.

narrow portion of the total available bandwidth, which spreads from 300 Hz to 3000 Hz, and is centered at 1800 Hz. As a result, the unused frequencies beyond the spread of the main data channel can be utilized for low-speed signaling for diagnostics and testing.

Using the low-speed (75 bits/s to 150 bits/s) test channel, which is

Information Extraction and Collection Instruments Chap. 4

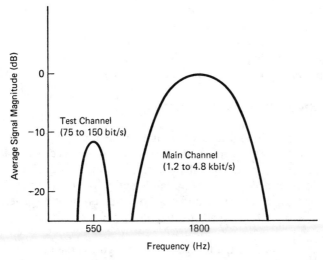

Figure 4.2.3 Secondary channel applicability.

frequency-division multiplexed onto the same circuit as the user's data circuit, an entire subnetwork can be created, which operates over the same transmission facilities as the main channel application. This test-channel subnetwork has exactly the same configuration—however complicated—as the main network, whether point-to-point, multi-point, or multi-tiered, but is invisible to the customer's operational main-channel network.

Prior to the decision on the secondary channel configuration, it is useful to look at circuits supported for secondary channels by RS-232 (V.24) or RS-449. Suppliers claim that the test channel is generally more reliable than the main channel because of its smaller bandwidths and much lower data rates. Thus, even when the main channel has deteriorated considerably, the test channel can still often function properly. This is useful, since it is on such occasions that the diagnostic capability becomes crucial. Diagnostics of deteriorating lines can enable suitable preventative action to be taken before the line goes down completely (see Chapters 8 and 9).

There is an interesting hybrid solution. The secondary channel is used for diagnostic and control commands and responses only, and the main channel is used during off shifts for transmitting bulk data previously stored with extensive network-management-related information. But there are certain digital offerings (e.g., satellite transmission) where side channels are not available at all.

The secondary test channel technique requires users to employ additional devices to support the transmission of modem net management data through the digital portion of their nets. That is because when an analog line is digitized, the net management data will be merged with the regular data flow in an incomprehensive pattern, if it gets digitized at all. One way of accommodating secondary channel data is to use a multiplexer to accept net management data from a number of modems and multiplex it over its own channel on

the digital link. The other way is to use the inbound technique for time multiplexing user and modem management data over the same channel. However, the use of the secondary channel allows use of data encryption in the main channel. Normally, using time divisions multiplexing, management data would also be encrypted and would become useless for control purposes.

The remote-addressable test module

The remote-addressable test module is an electronic module that is added or integrated into every modem. The test modules communicate over the secondary test channel. A test module recognizes its own address when instructed and then accepts the commands and performs the required functions. It has sufficient access to and control of external and (generally) also internal modem signals to perform diagnostics, tests, and remedial control functions.

There are fundamental alternatives to configuring the modems for use as an information-collection source. In the usual case, circuit cards are used, which are plugged into the supplier's modems for capturing operation-relevant information. It is an inexpensive way of augmenting modem capabilities. It is the most meaningful alternative, when only one supplier's modems are installed.

For the multinational heterogenous environment, a completely independent test unit with a separate power supply is more advantageous. This test unit electrically surrounds the modem to provide surveillance and control of its condition and operational status.

This wraparound approach has an advantage: Tests and loops are performed at the equipment interface, which is the interconnection point to the terminal equipment and the telephone line. If a failure is detected, the test unit automatically bypasses itself, directly connecting the modem to the line and to the terminal equipment. Monitor and test facilities are lost, but normal data traffic is not disrupted. The advantage of using this wraparound approach is that the test unit is compatible with all types of modems from different suppliers. The disadvantage is that the units (and power supply) are more expensive than the modem-dependent plug-in cards used by other suppliers.

The central control

The central control incorporates intelligence at the central site, which controls the entire test-channel subnetwork, communicating with each test module over the test channel. The network-control console forms the interface between the central-site operator and the network-control system. Today's systems are microprocessor-based and highly automated, and the operator interface is designed to be as user-friendly as possible.

For storing data, multiple floppy-disk drives are utilized. Three drives are usually provided: one for the system programs, one for the configuration file, and the third for other data, such as trouble tickets. Through a CRT

terminal, the operational controller can establish system parameters, monitor system functionality and performance, and change configuration in the event of an outage or of anomalies.

The network-control system usually provides three operational modes [FROS83]:

- The *automatic monitoring* mode, which continuously monitors every line and drop in the network while normal data communications continue.
- The *manual diagnostic mode,* which provides additional specialized testing of faults without affecting the remainder of the system.
- The *automatic preventive maintenance mode,* which automatically tests the complete system at programmed times during off hours.

Most of the time, the network-control system operates in an automatic monitoring mode, where the controller polls each modem in turn, alerting the operator when any condition exceeds preset threshold limits. Diagnostic tests can then be run to identify the nature of the problem, and corrective action, such as initiating dial backup, switching to a hot standby modem, or disabling a "streaming" modem [FROS83], can be taken.

These same systems, while emphasizing powerful centralized control strengths, are characterized by an inability to manage and organize the data they generate. Their weaknesses can be summarized by these four points:

1. Storage capacity is limited and volatile. Only minimal memory is available for the data base and related configuration data.

2. Access by the data communications operator is limited because only printouts of specific files and alarm reports are available. These are generated in bulk and are not organized or accessible by field key or sorted by fault type. These reports are printouts of all day-by-day fault reports.

3. Operator analysis is nonexistent. Large amounts of alarm data are generated by the network. However, only manual and time-consuming effort by the network operator can determine performance trends or network degradation.

4. No executive summaries are produced. Management cannot compare last week's or last month's data on a given site with the current data. Also lacking are summaries of fault times and performance of the entire network over selected times.

The major suppliers of network-control systems have recently incorporated four major network-management functions in their newest systems alongside the network-control functions. These systems offer network management through the use of a microcomputer-based data-base management system that stores information about the network. In response to user inquiries, the data-base management system can recall the relevant information

and display it on a screen or produce it as hard copy. It can also generate statistics from the stored information and product trend analysis and customized reports.

4.2.3 CSU/DSU Monitoring and Control

A major component in point-to-point and backbone network monitoring and control, the CSU is a protective interface designed to connect customer premises data equipment to a carrier's digital transmission line, either a Digital Data Service (DDS) facility or a DS1/T1 facility. To facilitate network monitoring, control, and fault isolation, additional built-in CSU features provide for test and monitoring access of the signals sent and received by the DTE.

CSUs provide extensive on-site diagnostics in the form of jacks, LED displays, and loopback switches. CSUs facilitate testing both the span lines and customer-premise (CPE) equipment. The latest CSU hardware allows test and monitoring functions that can be integrated with centralized diagnostic systems [JORD88].

The CSU may employ inband and out-of-band signals at the network interface to allow maintenance personnel to conduct span diagnostics locally or from a remote location. The front panel also generally provides diagnostic LEDs to display minor alarm conditions such as excessive jitter, excessive Alternate Mark Inversion (AMI) or Bipolar 8th Zero Substitution (B8ZS-coding) violations, all-ones signal detection at the network interface or CPE, and loopback status. The front panel may also provide test jacks to access, monitor, and test the CPE and the span line. These jacks are useful in facilitating test operations for quick diagnosis of communications problems. Typical signal access points on the CSU include:

- Line in, breaking facing network interface receiver
- Line out, breaking facing network interface transmitter
- Equipment in, breaking facing CPE receiver
- Equipment out, breaking facing CPE transmitter

These tests affect service by disrupting normal communications.

Other signal taps can be done while the facility is in normal operation. Jacks corresponding to these tests are:

- Line monitor, nonbreaking facing network interface receiver
- Equipment monitor, nonbreaking facing CPE equipment

Loopback tests are set locally using switch activation. Digital-code (DC) activated signals facilitate loopbacks at remote CSUs.

The ability to perform local and remote loopbacks is important, as is the ability to test and monitor the signal in both transmission directions.

Many CSUs can also generate alarms based on selectable thresholds (for example, loss of line signal for more than 100 milliseconds). This saves time and money, as it avoids the need to connect external test equipment. Some typical parameters used include:

- Signal level
- All-ones conditions
- Loss of synchronism
- Framing error rate
- Bipolar violation rate
- Jitter
- Bit-error rate
- Errored-seconds rate

Many CSUs offer signal monitoring using LED indicators, built-in loopback controls, and test signals, as well as remote control over some of these functions. Only a few CSUs, however, provide integrated centralized network control or sophisticated performance monitoring.

A new generation of intelligent CSUs may reach the market soon. These CSUs incorporate sophisticated performance monitoring capabilities, with increased diagnostic functions, and supervisory ports for communicating with the user's network-management center. In this regard, CSUs have followed an evolution path similar to that of analog modems. Intelligent modems now incorporate monitoring and diagnostic capabilities by using a secondary auxiliary channel. The nondisruptive centralized control features in second-generation CSU equipment are similarly based on the maintenance channels provided by the ESF line format.

In the early 1980s, the Extended Superframe Format (ESF), a new framing format, was introduced by AT&T for DS1/T1 lines. ESF enhances the ability to monitor and control the network.

ESF defines 24 frames in its superframe, but only six bits in its framing pattern. Thus, 6000 bps of channel may be utilized for other purposes. The allocation of 8000 bps is the following:

- 2000 bps for framing
- 2000 bps for error and performance determination
- 4000 bps for telemetry and facility management and reconfiguration

Those signals/bits are utilized by the majority of vendors offering built-in or external monitoring services.

CSU- and DSU-monitoring instruments contribute to proprietary element management systems by generating status information and in most cases also alarms. Typical indicators include (RUX90): out of frame, loss of signal, alarm indication signal, yellow alarm, and excessive error rate. Intelligent

CSUs and DSUs can work in conjunction with software management tools to provide a comprehensive look at all types of equipment, such as multiplexers, PBXs, bridges, and routers. Connections to integrators supporting two-way communications are provided as well.

4.2.4 Monitoring T1-Multiplexers and Channel Banks

Basic T1 multiplexer network-management functions include circuit provisioning, fault diagnosis, alarm reporting, and production of management reports. Management can be done at the port, node, network, or end-to-end level, as shown in Figure 4.2.4 [DANM87A].

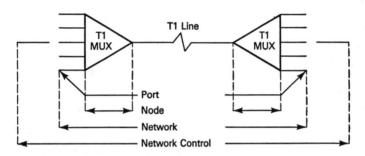

Figure 4.2.4 Control areas in T1 multiplexers.

Port Level. The port-level management function provides control and monitoring of the multiplexer interface to the DTE. This interface should be flexible and support test capabilities. Typical requirements include:

- Collecting performance measurements (for example, BERT, levels, lead status)
- Providing accounting reports that highlight port usage statistics
- Software control, which avoids the necessity of removing the line card and dealing with DIP switches
- Loopback testing capabilities

Node Level. The node-level management function provides control and monitoring of the node itself (the multiplexer) and of the telecommunications link. Hence, it provides the connection between the physical access port (typically an EIA-based facility) and the DS1 bandwidth. High bandwidth availability is critical; therefore, the network-management system should provide a mechanism for handling dynamic bandwidth allocation. Other NMS requirements at the node include a user-friendly interface, self-test capabilities, and redundancy of key components. The node should support a local network-control console and provide alarm and usage reports.

Network Level. The network-level management function provides control and monitoring at the application layer. It is responsible for application availability and quality of service.

Network-level management functions must support multiple carriers. In addition, users require easy circuit provisioning and rapid circuit restoral in case of failure. A number of high-end multiplexers provide automatic route generation; restoral time can range from 2 seconds for packet-driven multiplexers to 40 seconds or more for circuit-based multiplexers. Parameter routing, which involves sending parameters to remote locations, is also very important.

Network-Control Level. The network-control-level management function tracks all network components, typically provided through a relational data base and a full-fledged report generator. The data base must be capable of supporting complex topologies involving thousands of network components. Additionally, the data base must track multiple component types (hardware, software, etc.) as well as the relationships between network components, including physical, logical, procedural, and organizational relationships.

Advanced PBXs and T1 multiplexers incorporate many monitoring functions. Less functional multiplexers and channel banks require external systems and equipment. Monitoring equipment may be categorized as follows:

- Analog testing equipment
- Interface/access equipment
- Datascopes and recorders
- Error-rate measurement devices
- Protocol analyzers

T1 monitoring and testing includes both analog and digital, and both voice- and data-oriented measurements.

Voice-oriented analog testing generally relates to levels, bipolar violations, and so on. Voice-oriented digital testing generally involves clocking/synchronism, signaling bits, VF drop/insert, errored-seconds, and so on. The basic need of most voice-testing personnel is the ability to access one or more channels without interrupting service; other needs include monitoring for loss of frame or loss of loop and the ability to signal or simulate signaling functions. Analog impairments include voice, attenuation, distortion, envelope delay distortion, frequency interference, and dropouts.

For years, telcos have performed this type of testing to manage the plant. Data-oriented testing follows the same principles, except that the drop/insert of 64 Kbps subchannels is not a major concern; the aggregate nature of the DS1 signal and the ones-density issues are more prevalent.

In-service monitoring can be used to test facilities periodically so that degraded conditions can be identified before they affect service. When traffic-carrying circuits cannot be disturbed, in-service monitoring is desirable. In some cases, the traffic could be rerouted to perform out-of-service testing, but

the cost involved in this action (either in transmission or labor charges) may be prohibitive. In-service monitoring can also precede out-of-service testing, since localizing potential problems with passive monitoring may reduce the out-of-service repair interval.

In-service testing can be divided in two classes: (1) those measurements that apply to the DS1 signal proper; (2) measurements applying to the content of the information carried on the DS1 facility. The former includes coding violation analysis, excess zeros detection, signal frequency determination, signal level, all-ones condition, and time jitter analysis. The latter includes framing error analysis, cyclic redundancy check analysis, and yellow alarm detection. Service-disruptive monitoring concentrates on bit/block error-rate measurements.

There are many similarities between measurements on channel banks and interchannel bank links. Typical measurements with auxiliary equipment include the following [DANM87B]:

- Error rate and framing loss determination
- VF output and A and B signaling bit display for any particular channel
- Detection of conventional DS1 superframe formats or ESF formats constructed by the channel bank
- Determination of clock frequency
- Determination of bipolar eighth zero substitution (B8ZS) for the DS1 signal output by the channel bank
- DSO signal out with bit and byte clock signals for any specified channel in DDS applications

Additional features that are now beginning to become available on DS1 test equipment are [DANM87B]:

- Access to DS1C, either as an aggregate or to examine each individual DS1 stream
- VF output and A, B, C, and D signaling bit display for any particular channel of a DS1 link operating under the ESF format
- CRC-6 error results for a DS1 link operating under the ESF format
- Simultaneous display of A, B, C, and D signaling bit for all 24 channels of the channel bank operating in the ESF mode.

Some simple tests on DS1 outputs of a channel bank are insertion of a digitized VF channel on a specified slot while all other 23 slots are unaffected and insertion of A-type and B-type signaling bits.

Traditional bit error rate (BER) tests, which require injection of a defined pseudorandom pattern into either one channel or the entire facility, do not work too well because of bit-robbing procedures used in T-carrier framing and signaling. On the other hand, a count of errors observed in the framing

word (which is a specific bit pattern) will provide a reasonable approximation (at times even an exact count) of the BER.

4.2.5 PBX and Centrex Monitoring

Today's PBXs combine stored program control, advanced processing power, large-scale circuit integration, and high-capacity memory to support an incredible number of features. Although more compact and sophisticated in design, they provide the same basic functionality as the first generation of switchboards. The difference is in the process of receiving call requests, setting up the connections, and tearing down the paths upon call completion— they are entirely automated, which means that more calls can be handled in less time. Monitoring functions usually fall within the responsibilities of PBX administrators.

The PBX system administrator's job is very much like that of a computer center operator's: management, control, and diagnosis of the PBX and its network of attached devices. This includes the following:

- Making changes to the system data base to add or update station information, users, and classes of service.
- Requesting statistics and status reports.
- Ordering diagnostic tests and analyzing the results.

Permission classes and multi-level passwords are typically used to limit administrative access. Operating a PBX is similar to operating a computer, the difference being that the PBX's application is narrow in scope. The application of maintenance and programming (MAP) output channels, however, has steadily evolved toward more comprehensive applications. A circuit assurance system interfaces to a PBX MAP port, for example, on which the PBX can be used to monitor the performance of all lines in the system, providing comprehensive line outage and trouble reports. A number of systems use MAP channels to support more comprehensive traffic reporting both in real time and historically to develop trend information. The MAP channel can also provide an interface to more sophisticated network-management systems, which can control an entire voice/data network. Network-management systems—such as Systems Center's NetMaster, IBM's NetView, and AT&T's Accumaster serve as information collectors that act on alarm conditions and monitor the progress of the user's entire network.

In this regard, there has been a more proactive application of PBX MAP channels in recent years than was true in the past.

After AT&T divested the Bell Operating Companies (BOCs), it was up to them to revitalize their Centrex offerings. After adding more features, the telephone companies began to address the area most criticized by prospective customers—lack of management and control.

In addition to obtaining call detail in a virtual real-time basis (instead of waiting for billing tapes), users can now control which numbers, features, services, and billing codes are assigned to each line via an on-premises terminal and interactive software program. Instead of waiting for changes to be implemented in a matter of days or weeks, they can be implemented in a matter of minutes. Even adding or deleting lines falls under the automated management capabilities of Centrex.

Not only can the network manager review the status of the current Centrex configuration, but plan ahead to meet future demands by determining the effective dates of the changes. All such configuration information is stored at a management system located at a central location in the telephone company's serving area. Individual Centrex exchanges poll the system for any customer changes, which are then loaded in the master data base. This causes internal telephone company records to be automatically updated. Monitoring, managing the switching devices, consolidating monitored data, and connection to integrators are similar for PBXs and Centrex.

4.2.6 Network Monitors

The purpose of network monitors is to continuously measure and analyze the most important control parameters in a network. Network monitors can simultaneously collect performance-related data on over a thousand lines and many thousands of terminals. As data collection interfaces, the RS-232, V.24, X.21, RS-449, and V.35 are most commonly used.

Figure 4.2.5 shows a general architecture of a network monitor. The CPU controls all measurement and reporting functions. The addressable modules are responsible for gathering information on the digital interface. Communication may take place over a regular data network or via switching services. At the central site, powerful alerting features facilitate the work of the help desk by indicating problems and their possible causes. Thus, the time window between occurrence of problems and their resolution can be reduced significantly.

The modules for data collection are microcomputers that include all the elements of any computer system, namely, control logic, internal memory, and capability. The function of the data collection module is to monitor multiple communication lines for the purpose of determining the status of the system by interpreting the traffic. The number of lines for simultaneous monitoring is determined by the bandwidth of the modules. The programs for traffic interpretation are stored in PROMs. These programs are protocol-dependent. Configurations of the future must provide measurement capabilities for asynchronous, character, and bit-oriented protocols and, even more importantly, for packet-level protocols. At the packet level, events of significance include call clearing, reset, and restart packets. The data collection modules are usually attached to the CPU by asynchronous communication ports. To perform the data gathering function, these modules recognize events

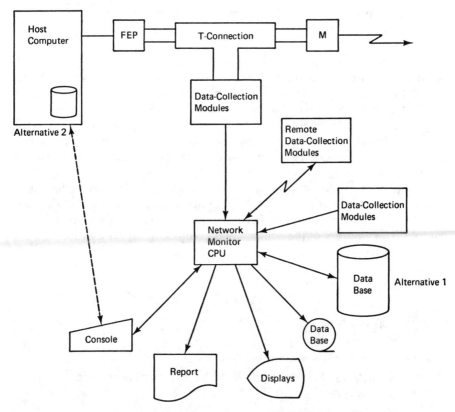

Figure 4.2.5 Network monitoring architecture.

significant to the status and performance of a communication line. Once events of importance have occurred, status or alert messages are prepared and buffered for transmission to the CPU. State-of-the-art modules are equipped with 32 ports, and multiple protocols can be accommodated within the same information capturing module.

The throughput rate of information-collection modules is particularly important in measuring trunk networks. They connect hosts at local and remote sites and multiple-communication controllers. Due to complex logical structures, the interaction among these components dramatically increases the types of problems and the degree of impact each has on unrelated local (boundary) and remote components. Information-collection modules may be attached anywhere to the digital interface. Depending on the network topology, remote collection may be required. Typical cases include:

- Collecting traffic-related figures for terminal-to-terminal traffic without involving front-end processors.
- Using remote front-end processors and trunk lines between local and remote sites.

- Collecting information in the remote (e.g., office) area, but still not sacrificing central control.

Communication with the CPU is asynchronous, using the productive networks channels, secondary channels, or circuit-switching services. In certain network architectures, the front-end processor may be addressed for transmitting the network-management-related information.

In addition, the remote information-capturing module may be extended to include testing, resetting, measurement, and status-display functions. The scale of functions supported depends on the intelligence of the microcomputer under consideration.

The CPU of the network monitor controls the operation of the entire system, including multiple data-collecting devices and multiple I/O devices.

State-of-the-art monitors offer more than just a centrally located system console. The majority of the equipment accommodates a workstation, including, among other features:

- Menu-driven techniques
- Function keys
- Word processing
- Zooming capabilities
- Graphic reporting capabilities
- Application-development interfaces for high-level languages
- Help facilities
- Windowing techniques
- Screen dump
- Modeling features
- High resolution display units
- Electronic mail

In order to define the most meaningful thresholds optimizing and redesigning networks, historical data should be available. The data stored in a performance data base can thus be interrogated and processed at will. Contents of the network performance data base may include service-oriented measures such as availability, response time and accuracy, and efficiency-related measures such as throughput and resource utilization.

Depending on the product under investigation, these parameters can be collected, analyzed, and compressed at different detail levels, such as last-minute, today, previous day, weekly, or yearly summaries.

Usually, there is a separately maintained data base indicating the nucleus of a sidestream concept. Contents of the data base do not usually include inventory-, vendor-, and trouble-oriented data. In most advanced versions, however, these data should be integrated as well. The data-base size depends on the number of network elements, including all types of source, destination,

and relay nodes, and links under control. In most cases, a few days' data are on-line, and the remaining part will be maintained on tape drives for further analysis. Usually hourly averages are maintained.

Other approaches use the data-base or data-storage capabilities of the mainframe computer. The information captured is transmitted via the front-end and channeled to the mainframe's data base. Thus, correlation with other information can easily be accomplished. Technically, similar procedures may be used for any data-base options out of the scope of the network monitors. In addition, saving I/O devices may reduce the overall installation costs. But, in the case of front-end and/or mainframe outages, the monitor cannot transmit information. Depending on the duration of the outage, information may even be lost as a result of the limited on-line storage capabilities of the monitor.

Depending on the product under consideration, different performance indicators are supported. The decision for a certain indicator should be made in the early design stages because the programmers of the data-capturing modules must be aware of the method for processing the data collected at the digital interface. An average measurement program should include at least the following indicators:

Service parameters
 Availability
 Overall network availability
 Line availability
 Customer's level availability
 Response time
 Network delay
 Host delay
 Average ⎫
 Maximal ⎬ Response time
 Minimal ⎭
 Alternatives at the customer's level
 Up to the first character
 Up to complete information arrival
 Up to terminal unlocking
 Modem turnaround
 Poll-list wrap time
 Accuracy and integrity
 Number of troubles by network elements
 Hit list for most frequent troubles
 Number of messages lost
 Number of messages duplicated
 Number of messages arrived but not delivered
 Number of NAKS
 Number of retransmissions
 Number of timeouts
 Number of incomplete transmissions

Efficiency parameters
 Throughput
 Transmit
 Number of transactions
 Number of messages
 Number of characters
 Longest message
 Average message length
 Number of packets (X.25)
 Receive
 Number of transactions
 Number of messages
 Number of characters
 Longest message
 Average message length
 Number of packets (X.25)
 Polling
 Number of positive and negative polls
 Polling delay
 Utilization
 Communication controller
 Cluster controller
 Terminal device
 Link idle
 Link utilization
 Software utilization
 Contention

In both groups of parameters, over-threshold counts may be reported.

In monitoring trunk networks, the grouping of performance indicators may be slightly different. Service and efficiency indicators are grouped in addition to those of boundary networks by transmission groups and trunks. Furthermore, application allocation to hosts may also be monitored and reported.

In monitoring X.25-type networks, the monitoring strategy is slightly different from private networks. Implementing both local and remote monitoring capabilities, derived indicators report only about the value-added segment of the network. Derived service and efficiency indicators help in negotiating performance with the Value-Added Network (VAN) supplier.

The alerting devices associated with a network monitor usually include a large-screen high-resolution color graphics display used to communicate to network administrators; a large-screen video-projection system used in large control centers, where network performance must be visible to more than one administrator; and printers for preparing system-alert messages and printed reports. Functional and performance thresholds can be programmed by the user. Alerts can also be acoustically supported.

The preprogramming of thresholds should be carefully accomplished. Too-rigid thresholds and frequent display of exceptions may lead to overreactions on behalf of the network operational control. However, infrequent checkpoints can cause serious impact in maintaining the proper service level. It is recommended that one starts with longer resolution rates and changes to shorter ones when required. In addition, at least first-level problem determination is expected. Besides problem location, at least the most probable cause and recommended actions may significantly facilitate second- and third-level problem determination. Occasionally audible alarms are provided as well.

As with multiple-level alarming, information can be displayed and/or printed for multiple hierarchical levels of the communication network. Any combination of the performance indicators can be processed and reported on. Multiple-level status information is required for simplicity and clarity. In addition, any detail required should be accessible as well. The report generation can be achieved with current data or via the data base, including historical data as well.

Present capabilities of mini- and microcomputers are almost unlimited. Usually, data of the performance data base are further processed, analyzed, interpreted, and reported using statistical and graphic software features. Trend analysis can be used to track potential problems in the network configuration, suggesting the right places for reconfiguration. Statistical analysis using correlation techniques explores the dependency of the service parameters on the resource utilization.

Network monitors usually analyze everything in correspondence with physical addresses. But many customers want to get information clustered by applications using, eventually, the same physical address. By means of additional storage spaces in the data base and decoding additional fields in protocol headers and trailers, the problem of application switching can be reasonably solved.

Not everything can be preprogrammed by the vendor. Tailored applications are still sometimes necessary. Integrated software packages providing high-level, menu-driven access to data bases, statistical modules, graphic features, and report generators are still required. High-level compilers, which may be installed on any workstation, are expected as well. For tailoring purposes, the source code is expected to be made available.

Real-time actions are based on the performance data collected and reduced. Any inaccuracy can thus cause a severe impact on the overall performance. The accuracy criteria are dominant in defining the sampling rate of measurement tools. High accuracy should be offered at all load levels. Furthermore, the monitors should work in a noninterfering fail-safe manner and should not impact the communication network operation at all.

In order to avoid cumbersome programming and modification procedures on remote-addressable information-capturing modules, new program versions should be distributed under central site control. In order not to

impair productive work, distribution should be carefully scheduled for high- or off-loaded periods.

In a complex communication network, configuration changes are frequent. Many on-line displaying features, however, are designed and implemented in accordance with the actual configuration. It is expected that any change in the configuration automatically updates—via catalogued procedures—all displays that are impacted.

Table 4.2.2 summarizes the principal criteria for comparing and selecting products. Manufacturers of network monitors are looking for other products in combination with network monitors or for strategic partnerships. Usually, the vendors are selling network monitors in addition to electronic matrix switching (e.g., Dataswitch, Dynatech) and offering a semiautomated measurement architecture on a rotational basis.

TABLE 4.2.2: Selection Criteria for Network Monitors.

Capacity of addressable information-capturing units
Flexibility toward selecting the location of the digital interface for information collection
Availability of a central-control facility
Protocols supported
Data-base management support
Trouble-ticketing support
Performance indicators supported
Availability of multiple-levels alarming
Availability of multiple-levels report generation
Support of trend and performance analysis
Message broadcasting
Support of driver functions
Availability of modeling functions
Support of application monitoring
Programmability
User interface
Expandability
Accuracy
Downline loading of systems software
Flexibility toward configuration changes
Correction of errors

The matrix switches themselves may be considered another information source providing data on the principal status on three network elements:

- Connection between the switch and the communication controller
- Connection between the modem/CSU/DSU and the switch
- Switch

This information will help the Network Element Management Systems and Integrators to consolidate status information of physical components of the network.

4.2.7 Hardware Monitors

Hardware monitoring is based on the fact that the majority of performance characteristics of computer systems can be measured by detecting signal-voltage transitions in the circuitry of the hardware. Using these devices, any hardware of any manufacturer can be measured, including central system hardware, lines, concentrators, storage devices, front-end processors, and mini- and microcomputers. The signals captured are logically combined, and using counting, storing, and mapping techniques, are compressed. The results are sequentially stored or included in a performance data base. These data are processed either by the hardware monitor or by the host and are displayed in various reports.

For supporting measurement data processing, the majority of state-of-the-art hardware monitors are equipped by minicomputers. In addition, direct-access data bases and powerful report-generation software are available. The term measurement system seems to be more suitable for such devices.

Fundamentally, two measurement alternatives can be distinguished [FERR83]:

- Eventing (accumulation of the number of occurrences of a specific event).
- Timing (timing the duration of a specific signal by accumulating fixed frequency clock pulses from the start of the signal to the stop of the signal).

Direct contacts between the component to be measured and the monitor are accomplished by electronically isolated monitoring sensors. These sensors are able to detect all kinds of signals in the host computer and to communicate with other parts of the monitor. More precisely, their major function is to sense a voltage differential at the probe point, amplify the detected signal, and transmit it back to the monitor for further processing, using a built-in miniature amplifier if required.

For facilitating the attachment, a few manufacturers provide a standard measurement interface. In such cases, internal addresses are no longer required; however, not all signals that may be eventually requested are available for the customer.

For meaningful real-time data-reduction measurement, processors such as special-purpose counters and timers may be used. The collected data, however, are connected first to hardwired or microcoded logical units on the patch panel executing the counting, storing, and mapping functions.

State-of-the-art hardware monitors are equipped with a powerful data base option using a direct-access retrieval technique. Using such an option, the data base should be defined prior to starting measurements.

State-of-the-art monitors may be implemented for filtering data prior to transmission to data base or to generating reports. Measurement results can

be displayed for supporting operational management, or reports can be generated for supporting performance analysis and capacity planning.

4.2.8 Value-Added Features of Physical Network Management

Network Element Management Systems presently offer more than just collecting, processing, and displaying information. In addition, they use the information to control the elements connected and maintain the information in various files or even data bases. This data base may then be used for trending and generating reports. Important value-added features are concentrated around the next four areas:

Network data-base management

Network data-base management is provided by the system supporting a data base on the network configuration and equipment. Contents of the network data base may include the geographical locations of equipment, serial numbers, local personnel, local telephone numbers, and telephone numbers for service calls. The network inventory is kept up to date by the network operator using the data-base management system (DBMS) software in the microcomputer. This network inventory is useful for asset and cost control and also to enable the location of any component of the teleprocessing network immediately when required. Such a situation may arise when spare equipment is needed for restorative purposes, for example. Network data-base management is provided by most of the systems available today.

Network-maintenance management

Network-maintenance management is provided to aid the manager in the supervision and control of the day-to-day maintenance activities of the network. This involves a trouble-ticket tracking system, which is basically a software application package for automated problem reporting and tracking. When a problem occurs, the control system automatically opens, time-stamps, and sequentially numbers a trouble ticket and displays the opened form on the management terminal [ROBB80]. As the operator identifies the fault location, all pertinent site information is automatically copied into the trouble-ticket file and displayed on the screen. From this information, the operator can read phone numbers to call the vendor for service. At the same time, the trouble-shooting features precisely pinpoint and define the fault for the responsible vendor so that he or she will have an exact understanding of the problem and the replacement parts needed to restore network operation. Should the problem remain unsolved past an operator-set time limit, a re-

minder alarm is sounded. When the problem is solved, the operator closes the relevant ticket through a command at the keyboard, and the closed ticket is stored on-line for future reference, such as analysis of problem trends, tabulation of customer-operator errors requiring better education and documentation, and compilation of vendor statistics.

Through the on-line trouble tickets, the person at the help desk can answer user queries immediately. The operator can also have a complete overview of all the network trouble tickets. Any individual ticket, vendor, or site can be displayed. All trouble tickets current and past are available on-line for review and inclusion in summary reports. Sites with an unusually high number of trouble tickets or long repair times can be pinpointed, and vendor-response times can also be tracked accurately.

Trend and performance analysis

Historical reporting capabilities permit trend and performance analysis of the network. The statistics that are gathered by the network-control system during monitoring and testing of the network are automatically recorded in the data base of the network-management system. Such records may include the site address, the test time, the type of test, and the test result. Similarly, if there is an added facility in the system for measuring system performance parameters such as response time, poll-to-poll times, and link utilization, these system performance statistics are also recorded.

Using programs present in the network-management module, the network manager can then perform trend and statistical analysis on the performance data. Trend analysis of data content parameters can be used to track potential problems in the software or in the network configuration. By analyzing response times, for example, the network manager may be able to predict when and where certain network components should be replaced, added, or removed.

Report generation

Report-generation facilities are provided in all the systems to enable the user to produce reports from the information in the data base. The report generator allows the user to customize the reports generated according to his or her requirements. In addition to the many listing facilities available, the report generator can also be used to calculate certain statistics derived from collections of records such as record counts, maximum and minimum field values, differences, averages, and variances. Sorting can be performed and exception reports produced. For example, a very useful exception report that can be produced by the report generator is one showing only the failed tests, where the results have exceeded the customer-selected thresholds. Color and graphic presentation of reports is also supplied in some systems. More details about data basing and reporting are discussed in Chapter 5.

4.3 INSTRUMENTS SUPPORTING LOGICAL NETWORK MANAGEMENT

This section focuses on instruments that use software modules in processors, any kind of nodes, servers, bridges, routers, and gateways with reports on logical status. Applications monitoring instruments are also included.

Network performance can be influenced to a great extent by node and mainframe processing. The principal areas are controlled by the operating systems, including queuing control, resource management, scheduling, and priority control, and by application subsystems, including data-base management and program-execution management. Thus, the service level to the customer can be influenced as well. Depending on the environment, the node delays can determine up to 70% or 80% of the customer-response time. For analyzing and evaluating the performance, software monitors are of great assistance. They are not intended to be used continuously for avoiding unnecessary overhead but rather to be used as part of the overall communication software. Performance investigation can shed light on areas not to be covered by any other instruments. In other cases, software-based monitors are continuously used for reporting status.

Software monitors constitute a class of programs for measuring hardware, system, and application software. They are resident in storage and can be activated or deactivated by the user. The activation can be triggered by events or by a timer, which causes an interrupt. (An event is any change of the system's state, such as start or completion of I/O operation, transition of the CPU from busy to idle or from idle to busy, or initiation and termination of programs.) Events can be twofold. When they are associated with a program's function, they are known as *software events;* when signals change in the circuits, they are known as *hardware events.* Hardware events can usually be detected by software because of some modifications elsewhere in the software.

The data collected by sampling or eventing are reduced, processed, and reported. State-of-the-art software monitors maintain measurement data files or even data bases, which can be accessed at any time. Furthermore, thresholds may be defined, and thus exceptions, alarms, and/or reports can be generated automatically. Frequently, the monitors offer capabilities for accessing system-status information in on-line real time. Using these options, system operating can efficiently control the principal system resources.

State-of-the-art monitors may be implemented not only for collecting data on performance but also for controlling the operating system's resource-allocation strategy. Many times, the software monitor is able to interpret the measurement results and indicate the causes of bottlenecks. Measurement results can be displayed for supporting operational management, or reports can be generated for supporting performance analysis and capacity planning. Typical measurement results include the following:

System Profile. Very helpful for evaluating overall system performance. In most cases, CPU- and I/O-related parameters are included. Overlapped status, however, cannot be reported with the required accuracy. All

information of a system profile can be generated as a function of application—a great advantage over hardware monitors.

Memory Utilization. Provides information regarding usage of address space by applications, which help to distribute resident programs more effectively.

Data Layout. Provides information about physical placement of data which may cause extremely large numbers of arm movement. By analyzing the results, significant improvements may be achieved.

Utilization of Logical Channels. Provides basic information for improving segments of all I/O configurations.

Queue-Length Distribution. May be used to fine tune the operating system when critical resources and excessive queue lengths are discovered.

Application Program Mapping. Gives important guidelines for optimizing application programs. The software monitors insert counters and give information concerning the program performance during execution:

- Frequency of execution of particular statements.
- Estimated total execution time per statement.
- Total number of "true" paths in IF statements.
- Sum of estimated execution time and its distribution per module.

Some of the software monitors may be considered complete network element management systems serving the logical segment of network management.

4.3.1 Accounting Packages

The majority of widely used systems are equipped with software monitors, but almost all at least have accounting packages. The vendors are the mainframe manufacturers or independent software companies. Those packages deliver the basic data for resource consumption by certain application areas. The most widely used communication-oriented indicator is the byte count for data communication.

In the voice area, data collection is at the PBX or Centrex level. After primitive local processing, the voice-accounting records are transferred to more powerful processors. Telemanagement examples will be shown in Chapters 5 and 11.

4.3.2 Application Monitors

Besides collecting information for performance improvements, application monitors help to give status on application subsystems, partitions, or on the applications themselves. This is an important segment of information for

end-to-end network management. These monitors are also used for real-time control of resource consumption. This is a very promising area for implementing expert systems. Display features are usually combined with access monitors.

4.3.3 Communication Monitors

This category is very close to software monitors; the only difference is the selected information extraction and collection on communication-related activities in any equipment constituting the network. The information flow to and from the control instance is inband and regulated by the rules of the architecture under consideration. Each architecture has specific rules to collect, compress, consolidate, and transfer data, collected by built-in monitoring capabilities. Due to the popularity of SNA, most examples in this section will use the SNA architecture and various subsystems of NetView. Other architectures offer different features, but basically the differences are less than expected. NetView and Net/Master give classical examples of the hierarchy of elements, and those elements' management and integration. Elements are grouped in both cases by entry and service points. They are controlled and managed by specific subsystems, like the control facility, hardware monitor, network error warning system, network tracking system, and so on, and those subsystems are finally brought under the umbrella of NetView and Net/Master. The major emphasis here is on the status monitoring capabilities. Other subsystems will be addressed in Chapters 8, 9, and 13.

SNA tools

The virtual telecommunication access method (VTAM) has its own command language and operator functions that allow commands and messages to be issued and received via the system console. In the past, the sharing of the system console for VTAM and operating system messages created operational problems for IBM customers with large networks. To alleviate this problem and to separate network messages from host-system messages, an interface called the programmed operator interface (POI) was made available in VTAM.

The network communication-control facility of NetView [IBM81A] is the current IBM product that uses the POI. With this interface, terminals defined to the control facility can issue any command to VTAM that can be issued from the system console. The terminal can also receive messages from VTAM and output them to the NetView terminal. In addition, the control facility uses the communication network-management interface (CNMI) provided by the SSCP.

The control facility or REXX-programs allow grouping of individual commands into lists, called CLISTs, that can be invoked with one short command. The control facility provides program-based services for user or IBM-

written applications. These services can be used for communication network-management applications or to tailor operator control functions.

In multiple-system networks (MSNF), the control facility provides for communication across domain boundaries. Coordination and control of the network can be assigned to control facility operators in any or all of the domains in the network. The control facility may become the central point for analyzing and filtering all SNA-related messages (see Chapter 8).

The VSE/OCCF (operator communication-control facility) [IBM82D] extends the control capability of the control facility for the inclusion of DOS/VSE control, operated at remote locations. MVS/OCCF allows one or more remote MVS systems to be operated from a host MVS system. It resides in the remote systems and optionally in the host. ROCF resides in the remote facility.

Network operational control is frequently overloaded by supervising various applications (IMS, CICS), various systems (MVS, VM, OS/2) and network-related information (NETVIEW, NCCF, NPDA, VNCA, NLDM). Until recently, for each area indicated, different display devices were required for continuous control. To address the access-to requirement, NetView access services connect to a variety of display-oriented network-management tools that reside in a variety of software bases. It ensures that messages are not lost while the screen is dedicated to a specific application. Both solicited and unsolicited communication are supported, and a correlation of requests to replies is provided [SULL83]. The NetView hardware monitor [IBM81B] assists network operators in performing network-problem determination by collecting and interpreting records of errors detected within a network and by recommending a possible resolution. The hardware monitor is a command processor with access to the accumulated error-data and statistics-data base. These data are presented as follows:

1. Error counts associated with communication controllers, channels, modems, terminals, links, and third-party components.

2. Specific data, an error description, and a probable cause associated with each class of errors collected. Recommended actions to resolve the displayed errors are provided.

The Network Management Vector Table (NMVT) is the vehicle for carrying solicited and unsolicited messages between the hardware monitor and SNA, non-SNA, and non-IBM devices supported by entry and/or service points of the Open Network Management architecture of IBM.

The hardware monitor provides error description and probable-cause statements on displays to the network operator. The error descriptions and probable-cause statements are derived from an analysis of network error data stored in the hardware monitor data base. The problem-cause definition identifies the most likely network component or group of components that caused a failure of hardware or software.

The hardware monitor allows the network operator to receive advanced

warning when a communication-controller data link connecting a specific station exceeds an error-threshold rate on the link. The operator is alerted if the ratio between traffic and temporary station errors exceeds thresholds, specified by the user, on a line basis. The alerts are designed to flow unsolicited from the network elements using NMVTs.

The alert originator communicates the alert to the alert processor, which forwards it to the alert manager. The originator and processor may be combined in the same network resource. The manager may or may not coreside with the alert processor. Besides physically oriented alerts (e.g., stations, lines, etc.), application alerts generated by customer-specified error-performance limits being exceeded are also included.

Figure 4.3.1 shows the filtering characteristics of the hardware monitor. Via the event-statistical recording filter, irrelevant events grouped by unit name and type can be suppressed. The alert-generating filter enables operators to classify certain types for alarming. These are stored in a separate part of the hardware monitor data base, accessible for operational control at any time. The network operator viewing filter enables network management to set up authority levels for operational control. Finally, the hardware monitor customer viewing filter assists operational control to customize the filtering characteristics for the specific tasks under consideration.

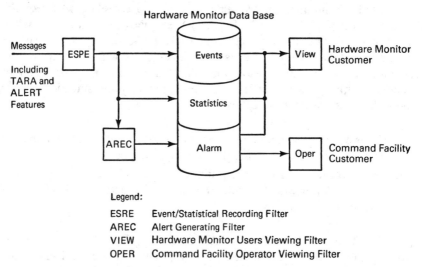

Figure 4.3.1 Filtering features of NetView Hardware Monitor.

The hardware monitor provides a data base for further processing by other tools, such as, SMF, Info/System, Capacity Management Facility Performance Data Base (CMF/PDB), Statistical Analysis System (SAS), or MICS. The data copied onto performance data bases are very valuable in supporting diagnosis in on-line or off-line modes.

Until recently, the stations attached to a controller were not explicitly known to the SSCP. For satisfying the downstream requirement for sub-

networks, a threshold analysis and remote access (TARA) [SULL83] program was developed as an additional hardware monitor feature. Information may be solicited by the operator but more frequently is driven by automated procedures. This information can be centrally displayed in a hierarchical form, consistent with the hardware monitor. Interfaces for management reporting via Service Level Reporter (SLR) and Info/System are supported as well. Recently MICS offered hardware monitor interface as well.

SLR is considerably extended by offering network-related reports for service-level supervision, availability, performance, capacity planning, efficiency of operations, problem and change management, and also for basic-level network accounting.

Net/Master's Network Error Warning System (NEWS) exchanges information with VTAM's Communication Network Management (CNM) interface. CNM passes to Net/Master all of the management data from the SNA Entry Points and Service Points (including information from systems attached components through NetView/PC), which is filtered, stored, and displayed as required. The filtration and retention of information is controlled by origin and content, and is easily modified without requiring a restart of Net/Master. The CNM interface also provides the gateway for Net/Master's Service Point Command Services (SPCS), which allows Net/Master to control NetView/PC applications and systems such as IBM's Lan Network Manager. The interpretation of all device-dependent and Generic Alert data is not built into the NEWS code but is held on a dictionary file. This allows data for new equipment, connected either directly to the SNA network or managed via NetView/PC, to be added quickly and simply. There is no strategic motivation for Net/Master to support only IBM equipment, and NEWS comes supplied with device support for both IBM and non-IBM hardware and software. The dictionary file is designed to have site-specific problem resolution data added by the people who actually use the product, with a mechanism to merge this user information with the updated base data supplied whenever new releases are installed or new device support is added by Systems Center.

Filtered Alert information is presented to users via a dynamically updated selection screen. This service provides multiple users with information regarding who is working on each incident, eliminating the situation where several people take conflicting actions to resolve a problem. The format and content of the information shown when a selection is made is dependent on the dictionary, but typically consists of several pages of diagnostic and recovery information.

NetView session monitor [IBM82A] was designed in response to logical problem-determination requirements. It is an application under the control facility for collecting SNA session-related information, correlating data related to SNA sessions between network-addressable units, and displaying relevant information at a network operator station. The intent is to establish session awareness and provide session trace capability. By collecting relevant activities in progress at and just prior to failure, central problem determination can be significantly facilitated.

The principal session monitor features are (Figure 4.3.2):

- The session monitor is an on-line, interactive software monitor that extracts information from the telecommunication access methods (e.g., VTAM or TCAM) and from the network-control program in single and multiple domains.
- Data are displayed in full-screen mode, utilizing color support.
- It provides useful data (SNA protocol, data-flow, Path Information Units (PIUs) and selected NCP control information) when network problems (e.g., "hung" sessions and stopped applications) occur that otherwise might not produce problem-related information about physical networking resources.
- The operator can select the session(s) to be traced prior to and during the sessions.
- Active session data are maintained in virtual storage. When the session is terminated, the data are transferred to a VSAM data base for further processing and later reference for accounting, problem determination, availability reporting, and capacity planning.
- The session monitor provides information for local or remote resources in the same domain or in cross-domain sessions.
- Reduction or elimination of the need to recreate software problems or to run dedicated traces because of the ability to collect and store relevant SNA information in progress and prior to a failure.
- Support for the response time monitor (RTM).

Information collected by the session monitor may be further processed and reported by SLR, SAS, or MICS.

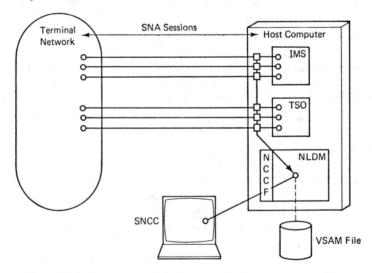

Figure 4.3.2 Measurement interfaces provided by the session monitor.

Advanced Network Management (ANM) of Net/Master receives VTAM data on the logical network through the optional Network Tracking System (NTS). This displays session routing, trace data, accounting, and virtual and explicit route performance. It provides performance and problem determination information related to VTAM application sessions rather than physical devices.

NTS is designed for efficient operation in single- or multi-domain networks and SNI configurations. For complex environments, NTS systems exchange information with each other to complete their view of resources in the network. This is achieved without explicit commands or lengthy definitions.

NTS's presentation services form a major part of its facilities. Color and graphics are used to provide a pictorial display of session and resource configurations, trace data are analyzed and presented in English, and resource utilization and throughput data are shown as block graphs. The information presented is optionally written to SMF, in a format compatible with analysis and billing products such as MICS-SNA, and may also be used in installation-written NCL (Network Control Language) routines.

Problems with network hardware, while costly, can usually be resolved in a straightforward manner. NTS speeds the resolution of the less tangible gremlins that bedevil the logical network, and does so without crippling the machines on which it is running. It also provides a means of charging individual users (isolated in cooperation with Net/Master's Access Services component) for their usage of network resources and of measuring the usage and performance of individual network elements.

DNA tools

DECnet has been notable for the number of management functions that are not separate products but come with the DECnet license. As DEC's OSI integration plan unfolds, present users will see some new terms for them, but major functions will not change. NCP (Network Control Program) in DECnet is the network manager's interface to the network. In management, it is used to communicate with Network Management Listener (NML) modules in other systems on the network at various layers of the DECnet architecture via the Network Information Control Exchange (NICE) protocol. In OSI, NICE will be replaced by CMIP, and NCP by NCL (Network Control Language). The Event Logger is an application program that uses processors at lower network layers to record events such as the occurrence of a line going down. The Maintenance Operations Protocol in DECnet uses NCP at the data-link level to allow downloading and up-line dumping when other layers are not available in a node that is not fully operational. The instruments will be subdivided into tools supporting the wide area or supporting the local area.

Wide area tools. The Network Management Control Center/DECnet Monitor is a tool that builds a data base created from network polling via NCP commands and allows the network manager to graphically display the informa-

tion in various forms for purposes of monitoring and planning changes. The three principal tasks are:

- **Data collection:** By polling selected network nodes at user-specified intervals, an on-line data base is updated by status and utilization-related information.
- **Data presentation:** On-line data are presented in various formated screen displays. At specific intervals, on-line data are written to history files, which can be viewed in report form.
- **Data reporting:** Network-management reports can be generated from summary files, which are a compilation of the data contained in various history files.

In addition to the NMCC/DECnet monitor, components of the Assets Toolshed programs are included in the tool's offerings. Those components are: Netpath, Netresponse, NIWatch, and Netaval.

Local area tools. NMCC/VAX Ethernim runs as layered software on VMS, and is the Ethernet counterpart to NMCC/DECnet monitor, working in conjunction with it to signal which DECnet nodes are on an Ethernet LAN so that a communication path can be tested and faults isolated. When Ethernim detects new nodes, it automatically adds to the network topology, which can then be displayed by the DECnet monitor, and creates a database entry for network-management areas. The most important ones are: Remote Bridge Management Software, LAN Traffic Monitor, Terminal Server Manager, Remote System Manager, PBX/Facilities Manager, and Cable Facilities Manager.

Besides tools, DEC is offering network-management services. The services are based on the experiences DEC has collected over the years with proprietary products and the knowledge base of many service providers, such as Telesis-Pactel (now owned by IBM).

DEC is very much interested in maintaining all network-management information in a proprietary relational data base. The product does exist and the population is scheduled in increments.

Other architectures

Bull's network management is done by a set of components and utilities, known collectively as Distributed Systems Administrations and Control (DSAC), built into the DSA architecture for controlling, monitoring, and testing the network.

DSAC is made up of a number of different components. Within each node of a DSA network there is a Node Administrator application (NAD). The NAD monitors the events on a node. Events are transmitted to three further components. These are:

- Network Operator Interface (NOI). The NAD transmits significant events to the NOI. In addition the NOI issues commands for the NAD to execute.
- Administrative Storage Facility (ASF), which collates history reports on a disk file.
- Administrative Utility Programs (AUT), which receive events reports for handling by individual applications built using the Administrative Utility Programmatic Interface (AUPI). AUPI provides access to network logs (ASF) for building billing, statistical, and other individual applications. Network management can be personalized and extended using AUPI for direct access to the NADs, for example, for the development of automated actions and command sequences in response to specific network events. It also supports a number of standard utilities supplied by Bull and third parties, for example, STATDSA from Unilog.

Network Event Monitor (NEM) has recently been implemented for supporting real-time displays on faults and performance degradations including symptoms, probable cause, and corrective actions. The alarm indication of present solution is comparable to IBM's NMVTs and OSI's CMIPs.

One of the network-management utilities supplied by Bull is VIDSA. It is used for real-time network supervison and monitoring. It provides a real-time display of the topology of the network together with activity on physical lines and logical connectors.

An optional addition for network management supplied by Bull is a user-friendly interface implemented on a Bull Micral microcomputer using MS-DOS and Windows. The Windows allow activities, such as receiving messages and sending commands, to be carried out simultaneously. This interface also has a menu function for building network management and control commands. A help function lists the meaning of DSA error messages.

In Unisys environments, consisting of BNA and CNA architectures, data extraction devices are rare. The user has to rely on built-in capabilities such as Cenlog in Telcon. The raw information may then be processed and presented by third-party instruments (e.g., Tristar's reporting packages).

TNAS (Telecommunication Networks Application System) is a transaction-processing application in conversational mode with the terminal of network management. Each screen provides dialogue options that allow forward and backward steps, using help menus, and the terminate option. Using TIPX, the utilization indicators of TNAS can easily be recorded and reported.

TNAS supports four groups of application areas:

- **TNAS base:** Accommodates the basic software, together with the data base. The key features of the basic software provide the customer interface by menu-driven dialogues and a security filter and define the span of control related to geographical areas of the network. The data base

supports segments for the network configuration, error events recorded by the communication software, statistics, and historical events.

- **TNAS inventory:** Provides management and administrative visibility to the usage of equipment and applications in the network. Data records are provided for organizational units, terminals, Telcon, and customer-defined equipment types and host applications. Data include, among others, equipment type, codes and serial numbers, locations, service responsibility of vendors, and updates. Extensions toward availability-oriented information are possible.

- **TNAS alarm:** Provides for the on-line display and processing of Telcon-generated error-event messages. The log records are sent to the host via TIP transaction inputs. On-line displays of incoming events are supported according to customer-defined filtering criteria. Furthermore, recommended actions for problems as well as the recording of operator's comments and estimated time to repair are provided. Insertion of operator-defined events in the data base is allowed. Archive and purge options are included as well.

- **TNAS statistics:** Collected by Telcon, periodically logged, and sent as TIP transactions to the host. Traffic statistics are collected for terminals, drops, lines, trunks, and channels. I/O messages and characters are counted and analyzed. Performance-related indicators are not supported at this point in time.

TNAS is comparable with other modules of communication software provided by other manufacturers. TNAS is strong on intelligent error diagnosis and traffic-oriented evaluations, but there are no alternatives for collecting and processing performance-related information such as response time at the customer level.

The basis of Siemens' network-administration software is the program system for data communications and network control (PDN). PDN provides administration-oriented data via traces, error messages, and utilization profiles. These data are buffered for a certain period of time in internal tables. Data collection means to extract this data and to process it in communications and/or mainframe processors.

PDN extracts measurement data from the following components:

- Line ports
- Transport control
- Path control
- Application programs

Information flows from the PDN tables via the mainframe or communications processor to the administrator. Via the Transdata Diagnostics Aids (TDA), the user can start a dialogue with the data stored in the mainframe

files. This interactive feature is comparable with the hardware monitor of NetView.

TDA is very strong in terms of detecting and diagnosing errors. This product is fairly good for recording line statistics but is poor for providing any information on performance-related measures. Using Transdata Software Monitor (TRASOM) provides additional resource-utilization data, at least for links and for a certain group of communication processors.

4.3.4 Security Monitors

Security monitors are event-driven solutions, which continuously supervise the principal security indicators. Most likely, the requirement everywhere for sensors must be a multi-media-monitoring hierarchy. Basically, sensors have to be planned and implemented for the following:

- End-user device level
- Transmission media level
- Processor level, including the system's software, data bases, and applications

The basic structure of this type of monitor does not differ from that used for general-purpose monitoring. The following fruitful combination is becoming very popular with users: access management and security monitoring combined in one unit at the host applications processing level. Access management helps to faciliate production work at the end-user level by offering an easy way of changing access to applications and system modules. At the same time of access request, the authorization may be monitored as well. Most access management solutions, such as Supersession (Candle), Teleview (Pansophic), TPX (Legent), Multiple Access Unit (Systems Center), and CA-WMAN (CA) are offering security monitoring on their own, or an interface to other leading security management software.

4.4 LOCAL AREA NETWORK MONITORING

Historically, LAN systems suppliers did not recognize monitoring as a major requirement. Manufacturers have concentrated on connectivity and resource sharing. These two principal driving sources have accelerated the growth of complex, multi-vendor, and multi-media systems without regard to their controllability and measurability.

LANs may be seen as distributed switches, and their management is also a highly distributed problem. Particular problems may be summarized as follows [TERP91B] and [HERM89C]:

- **Large number of components:** This includes workstations, PCs, station adapters, servers, repeaters, bridges, routers, gateways, modems, DSUs, multiplexers, wiring concentrators (that allow for LAN cable fault isolation and bypass of failures), and dedicated measurement devices that may listen to everything on the LAN.

- **Status monitoring:** This works differently for LANs than for WANs. The passive nature of LAN connections for most devices means that if a device fails, other devices do not automatically notice it. For the most part, LAN devices do not keep track of their neighbor on a multicast LAN. Since a failed device cannot generally be counted on to let the user know that it is broken, there is often no way for a network-management system on a LAN to be told of a broken component.

 This leads to a requirement for the LAN manager to actively poll the key components on the LAN. But the large number of devices on the LAN means that polling is a nontrivial task. It can take many minutes to poll all the devices on a large extended LAN or internet and this can mean that a significant time lag occurs from when a failure occurs until when operators are notified of the failure.

- **Overhead of supervision:** In order to deal with the problem of having so many components to manage, especially since a polled approach to monitoring is necessary, most LAN management approaches have stressed a decentralized strategy. In many cases, each campus of LANs will be managed independently, with some centralized aggregation of status and statistics.

 Decentralized approaches to LAN management have also been prevalent because most LANs have been standalone until recently. LANs have been bought at the workgroup or departmental level and have often been managed at that level. For these reasons, low-cost, easy-to-use tools for managing a single site's LANs have been the priority items in the development of first-generation LAN management.

- **Broadcast nature of LAN operations:** This item is particularly interesting. The broadcast nature of LANs makes it possible in theory for any station to record everything that occurs on the LANs, including traffic statistics, errors, and performance parameters. In some cases, vendor products such as bridges and routers have been instrumented to do such recording.

 However, the speed of most LANs makes such recording a heavy CPU requirement, and turning on this type of measurement seriously degrades the performance of the bridge or router. Thus, it is often better to dedicate a device to this measurement function.

- **Diversity of technologies:** LANs present one of the most challenging management problems due to their extreme diversity in technologies, protocols, and vendors. Since their introduction into the enterprise has generally been a grass roots affair, most organizations now find themselves with one each of Token Ring, Ethernet, and LocalTalk. These LANs run

mixtures of TCP/IP, DECnet, SNA, XNS, NetWare, NETBIOS, and VINES. They use a variety of management protocols including SNMP, CMOT, CMIP, 802.1, NETBIOS, SNA, NMVTs, and network operating system protocols found in LAN Manager or NetWare.

- **Lack of standards:** Given a lack of standards for network management, the first generation of LAN management tools has also been characterized by proprietary protocols for interaction between a component and its manager. Often these proprietary protocols were very low level in nature and were not able to cross bridge or router boundaries. This further reinforced the decentralized approach to LAN management.

 An even more fundamental problem with the first generation of LAN management capabilities has been the incomplete instrumentation of LAN components. Not all components on the LAN are manageable. Some are only manageable through accessing a local administrative terminal port. Like most network technologies, network management has been an afterthought for LANs. It was not the differentiator that decided winners from losers in the marketplace and, hence, got little attention. Performance has generally been the major market share determiner in the LAN market.

- **Mixture of networks and systems management:** Lastly, LAN management is a complex mixture of network and system management. On today's LANs, high-powered servers and desktop devices are replacing minicomputers running multi-user operating systems. But there is still a requirement for the system administration functions that used to be performed using the minicomputer operating system. When users and vendors talk about LAN management, they often mean server management functions such as maintaining user accounts and tracking utilization of disk space on servers.

Most existing tools are aimed at fault isolation and network performance. LAN monitoring is supported by three types of instruments:

- Protocol analyzers (similar to those mentioned in section 4.2) help to analyze data packets, examine node interactions, and track network traffic. These data help to identify bottlenecks. Information about traffic patterns can help to solve hardware-related problems, such as transport delay and slow response time for particular users. High-end products offer rich functionality by combining powerful hardware and software.

- Software-only diagnostic tools or programs are available that provide some of the functionality of the hardware-based protocol analyzers, at a much lower price.

- Time-domain reflectometers use bursts of electromagnetic energy to isolate cable faults. They are simple to operate and offer fair accuracy at moderate prices.

LAN monitoring is an evolving area with far too many fragmented monitoring devices. In summary, data are available, but solutions are not yet available for converting the rich data volumes into successful LAN management strategies.

4.5 INFORMATION EXTRACTION USING NETWORK-MANAGEMENT SERVICES

The use of networking standard and special services is constantly growing due to the value-added characteristics, to more honest information exchange between suppliers and users, and to expected data savings. The suppliers are monitoring and partially managing their own networks with the instruments introduced earlier in this chapter. The question is what portion of the very rich information about internal network status, events, alarms, and traffic is going to be shared with users. The network elements are on the territory of the suppliers and are supervised and managed by suppliers' monitors, and/or by network element management systems. Certain data bases of those systems may be offered for access by users and incorporation of the exported information into the proprietary monitoring architecture of the user. In order to explain how this information export may work, three examples are shown briefly for the T1/T3-multiplexing area, for ISDN, and for packet-switching networks.

T1/T3 multiplexing area [RUX90]

In order to quickly sectionalize a problem on a DS1 circuit running through several carriers' facilities in tandem, the carriers must be capable of reading the CSU registers to check the facility between the points-of-presence. Counters, accumulators, and registers are built into the CSU to take the ESF CRC-6 and framing information and provide the following 15-minute and 24-hour performance information [DANM87A]:

- ES (errored seconds): Number of second-long time intervals with one or more ESF errors
- SES (severely errored seconds): Number of time intervals with more than 320 ESF errors events or out of frame (OOF) events in one second
- FS (failed seconds): Number of time intervals with greater than 10 consecutive SES.

AT&T has installed Line Monitoring Units (LMUs) at the point-of-presence where the T1 circuits joins its facilities. It also can add an LMU at any critical facility transfer location, to monitor the performance through its system. It can remotely loop back the CSUs and the LMUs in either direction to sectionalize a problem, as shown in Figure 4.5.1.

While this approach is a step forward in monitoring and control, it still has limitations. The LMUs have only one set of registers, which record errored seconds in 96 15-minute registers (covering 24 hours). These registers

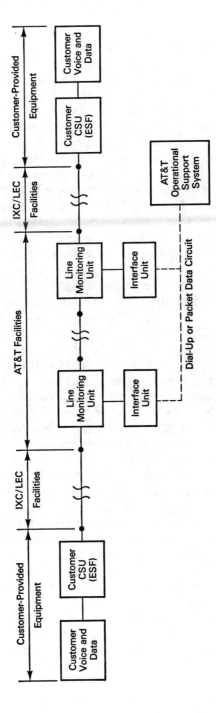

Figure 4.5.1 Deployment of line monitoring units for T1 systems.

can only be reset by the carrier (not the customer) via a dedicated or dial-up facility to each LMU. The LMUs can send an alarm to the central monitoring location when errors exceed a preset threshold. The carrier and customer registers in the two terminating CSUs can also be read by the carrier via the ESF data link. The data link is queried by a maintenance center to retrieve the information from the CSUs and the LMUs. It is also used to reset the counters, accumulators, and registers and to activate or deactivate a built-in, out-of-service data loopback testing system in the CSUs and LMUs. Messages are sent over the data link using a simplified X.25 packet proprietary (but publicly available) protocol called Telemetry Asynchronous Block Serial (TABS).

Some controversy exists as to what performance information the customer should receive and whether the customer should be allowed to read the intermediate LMUs. At the moment, customers can read the registers in their own CSU and perhaps the far-end CSU if the circuit is end-to-end transparent to the ESF signal. Customers cannot read the registers in the intermediate LMUs, nor can they control the loopback to sectionalize a problem.

AT&T's provision of ESF performance monitoring forced MCI to move rapidly to introduce ESF itself. MCI is implementing ESF performance monitoring on its DDS circuits, using a custom-designed system. US Sprint is also introducing ESF and ESF performance monitoring features.

ISDN area [RUX90]

Network-monitoring capabilities are critical to ISDN as well. There are three levels of monitoring and management that users need and ISDN suppliers must provide: receiving alarms; controlling, altering, and reconfiguring private network resources; and using private network-management systems to control the configuration of publicly provided ISDN services.

One of the important questions now on the standards bodies' agenda is whether the ISDN will adopt the OSI Common Management Information Protocol (CMIP) or adopt something under the ISDN message set umbrella. It is generally accepted that the D-channel will be the mechanism for the management of narrow-band ISDN lines.

ISDN network management is divided into two topological areas: managing CPE and managing the network. Common Channel Signaling System 7 (SS7) is regarded as the vehicle for managing the network: SS7 provided node-to-node control, and it will enable ISDN switches to communicate with each other. The network can also assist the CPE in its customer-oriented network-management task.

There are between 50 and 100 features a user might want to control and monitor with analog Centrex. With ISDN, that number could double. The ISDN user will be dealing with channels that can be allocated dynamically. Both AT&T and Northern Telecom are in the process of deploying ISDN network-management capabilities into Centrex. AT&T named its product NetPartner; Northern named its system Business Network Management (BNM). These products are now in development and are being tested at customer sites.

Packet-switching area

Packet-switching networks usually have advanced monitoring and management capabilities. Data capturing is usually at the switching nodes level; PADs may also be involved in monitoring. Information export may include:

- Selected events on physical and logical components
- Selected alarms on physical and logical components
- Availability indicators
- Congestion in certain geographical areas
- Lost/duplicated packages
- Internal packet travel times

This information is then incorporated into the monitoring architecture of the user.

4.6 TRENDS WITH INFORMATION EXTRACTION INSTRUMENTS

Extraction instruments will play a key role in supporting network management. Single, isolated products and solutions will most likely be replaced by network element management systems, which supervise and coordinate a homogeneous group of built-in or auxiliary measurement devices.

Those groups include modems, CSU/DSUs, switches, multiplexers, LAN-monitors, PBXs, network monitors, and datascopes. These components are equally important to the physical health of a network. Hardware monitors are expected to be completely phased out. Sensors in the communication architecture will not lose importance for collecting status information on the logical level. Standards will help to find the places of sensors and of applications.

Both physical and logical management may have first separated integrators of network element management systems. The integrators will communicate with each other, most likely using OSI-based standards.

Expert systems will play a very important role in the monitoring field, but in close combination with monitoring devices [DAM90C]. Targeted functions are: event interpretation, grouping related alerts, consolidating alarms, and correlation. Probable cause and recommended actions may also be included for speeding up problem determination. By doing so, important instrumentation breakthroughs may soon occur in the area of fault management. Despite the availability of advanced AI tools, the technology still needs refinement, customization, and time. Actual field results with prototypes are not yet satisfactory.

LAN monitoring will show the highest growth rates in number of available measurement devices and of implementations. A lot of work is predicted

in the areas of event filtering, interpretation, and consolidation. New LAN-related network element management systems are urgently needed.

The relationship between suppliers and users will further improve. Most likely, advanced electronic data interchange technology will be used for exporting information into the user's monitoring architecture.

5

Systems
for Information Compression,
Processing, and Data Basing

Network elements, network element management systems, and integrator products work with a large amount of data generated in most cases in or by network elements. This chapter will introduce the most important topics of compressing, processing, and data-basing information. Physically, the data base may be attached to network element management systems or integrators, or may be operated as independent products. The major emphasis is on generic solutions and principles; product examples are given, but extensive listings of products are avoided. Table 5.0.1 shows the instrument categories characterized by complexity, costs, overhead, accuracy, risks, and human resources demand.

After a brief overview of techniques referenced in Table 5.0.1, a generic architecture of a network-management data base is addressed. More specific discussions address the configuration, performance, and telemanagement aspects of the data base. Chapter 7 will introduce solutions based on various data-base concepts including hierarchical, relational, and object-oriented techniques.

5.1 OVERVIEW OF SOLUTIONS

Some products improve only the readability of accounting information by generating new reports and by choosing other presentation forms; these can be either software- or hardware-based. Reduction software or data bases provided by monitor vendors may be used and eventually augmented for analysis

TABLE 5.0.1: Information Compression and Processing Tools Overview.

Instruments	Complexity	Risks	Costs	Demand		
				Accuracy	Human Resources	Overhead
Extended accounting packages	low	low	low	low	low	low
Special-purpose monitoring software	low	high	low	fair	low	low
Administration tools	low	low	variable	fair	medium	fair
Information data base	low	high	low	high	high	high
Statistical packages	low	low	low	fair	variable	variable
Codasyl-type data bases	medium	medium	medium	high	variable	high
Relational data bases	medium	low	variable	fair	variable	medium
Object-oriented data bases	high	medium	high	high	high	medium
Service-level evaluation tools	high	low	medium	fair	high	high
General-purpose data bases	high	low	variable	fair	high	high
Expert systems	high	high	high	fair	high	high

purposes. They are implemented and seem to be a promising and economic alternative. For the data base, a powerful language or menu-driven feature, or both, may be required, depending on the experience of the customer.

To keep track of all network inventory, vendor information, and trouble tickets, special-purpose administration-oriented tools may be implemented. These are mostly limited to administration, but, using this administration nucleus, other types of data may be integrated very economically. Many vendors typically use an information data base for distributing up-to-date system and network software releases. This widely used data base may be augmented by automatically integrating network performance-related data. Management facilities and powerful graphical support may be provided as well.

Statistically oriented packages may be used when the customer is ready to invest time and provide human resources. These packages are state of the art, providing powerful data reduction, report generation, and graphic capabilities. But the customer interface and multiple monitor's input-data integration usually are solved by the customer. SAS [SAS80] is a good example of this kind of product.

Codasyl-type data bases are expected to be available soon and will fully support network-performance management. Typically, the resource demand is reasonable, and all principal areas can be supported. At most, tuning oriented data should be restored from tapes because the adequate time resolution of the data base usually does not support detailed-level information segments. But,·in this respect, some flexibility is expected by the customer community. Special data bases on relational basis or using object-oriented storage architecture become increasingly important. Both areas are supported by artificial intelligence techniques. Large mainframe vendors usually provide monitor and data-reduction tools for supporting service-level evaluation and control.

The products involved are able to integrate multiple-monitor input, to analyze data, and to report on preselected performance indicators. The problems include limited flexibility, resource demand for storage and processing, and the inability of integrating additional information sources. Mainframe manufacturers are expected to improve this type of product line for increasing customer confidence in monitoring and analyzing capabilities of the manufacturers. Furthermore, using a unique, service-oriented data base, supported and maintained by the mainframe manufacturer, the transparency required for future upgrading can easily be guaranteed.

There is at least one product for providing a large-scale data base for the MVS-oriented user. A number of information areas, multiple time evaluation alternatives, and multiple-input sources are supported. Furthermore, a structured analysis facility is provided for meeting customers' on-demand information needs. Besides various benefits, the resource demand for on-line access and the nightly update runs could become a serious bottleneck.

In terms of report generation, both display and hard-copy features should be considered. Principal criteria include [BIAR83]:

- Accessibility of all data elements
- Default formating
- Graphical support
- Flexible report design
- Usability of personal computers for accessing data-base segments

Voice-related data today constitute a completely separate data-basing entity. Data are collected in PBXs or central offices, but are not necessarily processed efficiently. Leading manufacturers with integration in mind—e.g., AT&T, IBM, and DEC—are expected to offer solutions based on Station Message Detail Records (SMDR).

5.2 GENERIC NETWORK-MANAGEMENT DATA-BASE ARCHITECTURE

The fundamental structure is shown in Figure 5.2.1. Information sources include modem, data and channel service units, multiplexer, and network monitors, electronic switches, features of the communication software, software monitors, PBXs, central offices, LAN monitors, and special-purpose measurement devices. For the sake of validity, at least two independent information sources should be used when possible and feasible. Thus, validity checks can be accomplished by the information translator prior to being accepted for the data base. In addition, special manual inputs (e.g.,

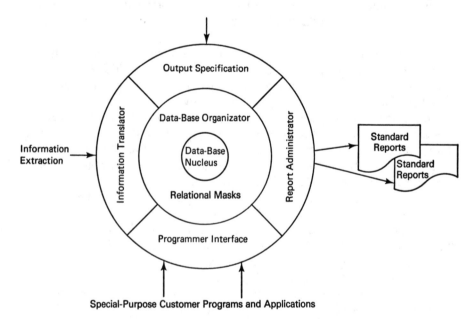

Figure 5.2.1 Generic network-management data-base architecture.

configuration and topology data, accounting guidelines, trouble tickets, various thresholds for alarming on functionality, performance, and security, or change requests) can be accepted.

Arriving information is converted into the data-base internal format by the information translator. There is always a trade-off when defining the proper data-base structure. On one side, there are the requirements for total flexibility; on the other side, however, performance criteria should be taken into account. For analyzing information requirements, data elements can be organized into network structure, but several groups of data frequently demanded together can also be structured in a hierarchical way. Recent evaluations show the applicability of relational and object-oriented storage of information. In particular, the object-oriented organizational form is preferenced by artificial intelligence, promising outstanding user interfaces by high performance.

Internal data conversion and data preprocessing is accomplished by the data-base organizer. Using the network-management data base, user requirements have to be met. The report administrator is responsible for report generation in various areas such as configuration, performance, and telemanagement. The different parameters, such as frequency, threshold values, time of generation, output form, and so on, can be defined by using several input features. In order not to impair overall data-base flexibility, data should be processed only when required.

The processing includes complete arithmetic and logic functions on data items, conditional and unconditional branching, editing, data conversion, change of sequence of computations, mathematical functions, update, sort, merge, match, and word manipulations. As emphasized previously, the system operates using the reporting-by-exception technique. Thus, the administrator is activated in most cases in the interactive way or by predefined states. In order to reduce specification efforts, frequently required procedures can be catalogued. But this option should not impair information access (first of all special-inquiry requirements) in any way. SQL (Structured Query Language) is widely accepted as a de facto query language standard.

In addition to routine outputs, detailed processing is very often required. In some cases, one may be interested in statistical evaluation of correlation between resource utilization and workload components. For such purposes, application programs are designed that use data-base components as their own parts. This feature is accomplished by the programmer interface.

In addition, parts of the data base can be compressed and dumped onto a temporary display data base. This data base can be physically located on a personal computer as well.

Depending on the installation's conventions, the processing schedules should be decided upon. Currently, the majority of performance and accounting-related information is provided via daily tapes, mostly SMF types for the IBM environment. Other sources are usually converted onto SMF format first. In the future, on-line interfaces from information-extraction instruments are expected as well. Administration-related data are usually

entered in dialog. Automated procedures will also be supported soon (e.g., copying NetView screens into certain segments of the data base).

The maintenance of the data base must not be underestimated. Key success factors include [TERP83C]:

- Determination of updates and compression intervals
- Allocation of responsibilities within the organization
- Determination of the number of data-base generations for recovery purposes
- Preparation of procedures for data-base crashes
- Working out update sequences and schedules
- Controlling missing-data intervals
- Defining access authorization

Network-management data bases should be evaluated using the following criteria:

1. **Information sources.** How many and what kind of information sources, such as software, network, modem, data and channel service units, multiplexers, PBXs, switches, LANs, and application and hardware monitors, can be understood. The more sources that can be integrated, the better are the chances for correlative analysis and reporting. Also included are specific validation and context checks.

2. **Data volumes.** Efficient processing of large amounts of data may be required for updates from multiple sources within given time intervals.

3. **Level of detail.** The capability of maintaining data at various levels of detail serves management as well as analysis. Usually, the level of detail is controlled by time.

4. **Update procedures.** The amounts of time and resources required for updates. In addition, requirement for automated updates may be included.

5. **Internal processing features.** Summarize requirements toward reduction, sort, selection, and creation of derived data elements. Access, availability, and performance issues are addressed here.

6. **Hardware/software dependency.** Answers whether the data base is dependent on hardware or software features of mainframe and/or monitor vendor.

7. **Flexibility.** Demand for adopting additional information sources and additional information segments, such as administration from the same or other vendors. It is a property of flexibility and expandability of the network-management data base in dynamically changing networking environments.

8. **Relational capabilities.** Important for accelerating retrieval procedures during analysis and reporting, and more importantly during real-time conditions.

9. **Query language.** Powerful data-base query requires a user-friendly language for the experienced user. In addition, menu-driven query may be provided for the occasional user. SQL (Structured Query Language) capabilities have to be supported as well.

10. **Availability of usual data-base management features.** They include help, backup, recovery, data dictionary, data integrity, recoverability, and multiple-level data security.

11. **Statistical analysis of data.** Includes
 Standard features such as regression, correlation, time series, and regression
 Special statistical features
 Ease of use
 Usability for all data elements stored

12. **Reporting and analytical capabilities.** Include
 Ease of use
 On-line and batch
 Use of high-level languages
 Multiple functions
 Access over several fields
 Default formating
 Easily understandable display graphics
 Screen display or hard copy
 Screen-development system
 Screen-zooming

13. **Interface for modeling.** Actual and historical performance data should serve as input for models (see Chapter 6 for further details). This criterion evaluates whether special interfaces and/or even a special model data base are supported.

14. **Data dictionary.** Short description of all data items included into the data base.

15. **Documentation.** Includes the actuality and update of the documentation.

16. **Implementation.** Includes the training and support prior to, during, and after implementation on behalf of the vendor.

The present status of data basing networks-related data shows too many fragmented files and solutions that are not synchronized with each other. Figure 5.2.2 shows an example with a large number of different files addressing various areas. The next segments of this chapter try to group these fragmented files into three areas:

- Configurations and inventory-related data
- Performance-related data
- Telemanagement-related data

Products and solutions are addressed in more detail in Chapters 7, 8, 9, and 11.

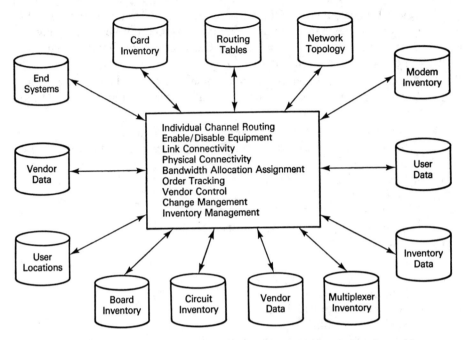

Figure 5.2.2 Typical file structure of today's network-management environment.

5.3 CONFIGURATION AND INVENTORY-RELATED DATA SEGMENTS

This segment of the data base is expected to show three different areas:

- Static or inventory part containing all relevant information on network elements categorized by equipment (nodes), links (facilities), and services. Entry examples are:
 Nodes (equipment)
 Classification (source, destination, relay, LAN)
 Identification (code, model, location)
 Application support
 Reliability (trouble reports, MTBF, MTTR)
 Throughput
 Software implemented
 Compression software implemented
 Connectivity
 Maintenance
 Recovery rules
 Auditability
 Links (facilities)
 Architecture and topology for network and/or for subnetworks

Source/destination connections
Speed
Procedure (character, bit, or asynchronous)
Modus (simplex, half-, or full-duplex)
Links identification and performance indicators
 Communication line
 Microwave
 Lightwave
 Satellite
 Circuits (physical connections specified by the connectivity constitute logical circuits between applications and end-user nodes)
Maintenance
Recovery rules
Auditability
Networking services
Value-added service identification and performance
 Packet switching
 Line switching
 Message switching
 Electronic mail
 Teleconferencing
 Voice mail
 Videotex
 ISDN
Virtual and software-defined networks
Vendor (name, address, telephone, responsibility, contracts)

All entries include inventory status, such as operational, ordered, and change logs, sorted by the inventory identification.

Software classification used for describing both application and system software related characteristics. They include the following items:
 Inventory of installed and in-process software (ID, name, status)
 Supplier
 Ownership
 Security (access and physical)
 Recovery rules
 Auditability
 Connectivity requirements
 Maintenance requirements
Customer information describes vital customer-related data such as addresses, telephone numbers, and application-access authorization service requirements.
Both open and closed *trouble tickets* should become part of the data base. In addition, compressed versions of closed trouble tickets can be included. They are interrogated by operational control during problem determination. Status and resolution of open tickets are usually interro-

gated by network administration. Usual information includes problem definition, impacts, status, severity, responsibility, maintenance, and tuning requests.

Ordering and billing information can be included optionally. Such information may be correlated with inventory status, financial data, and accounting information.

Security logs may be included optionally for interrogating and further processing security violations, evaluating unusual occurrences, improving the security plan, and triggering alarms by certain types of violations.

- Connectivity information for supporting physical and logical network management indicating

 physical connections between components (hierarchical and also peer-to-peer)

 logical connections between components indicating paths for end-to-end and application-to-application

- Dynamic or status indicators in part containing the actual status for key indicators such as in-service, out-of-service, operational, inactive, pending, or status information not available.

This section shows links to performance-related data and has a direct connection to the monitoring devices introduced in Chapter 4.

Figure 5.3.1 shows an example of how this segment of the data base may look using an object-oriented representation technique. In addition, a data dictionary segment is included almost automatically. All products provide some form of a dictionary. The OSI/Network Management Forum is periodically publishing recommendations for managed objects and for their attributes.

5.4 DATA SEGMENTS FOR DATA-COMMUNICATIONS PERFORMANCE

Traditionally, monitors have transferred data into performance data bases which serve as central repositories for statistics and reporting. The first performance data bases were very much processor-oriented. The migration to a more general solution incorporating networks has been slow.

This segment of the data base is expected to include the following data items:

- The *data dictionary* provides an overview about all information stored in the network-management data base. The amount of information stored may be customized.

- *Identification fields* are used for unique classification of all information stored. They may be categorized by application groups:

```
(DEF–CONFIG-FLAVOR application
        ( (APPL_NO  1  4  :INTEGER)
          (IDENT  5  12  :SYMBOL)
          (HOSTS)
         ;; monitored variables
          (VTAM_UNAVAILABLE)
          (NO_TRAFFIC)
          (UNAVAILABLE))
        (basic-net-object)
      : accessor-prefix "APP_")

(DEF–CONFIG-FLAVOR control_unit
        ( (LINE_ID_NO  1  12  :INTEGER)
          (CU_ADDR  13  14  :HEX-INTEGER)
          (DEVICE_ADDR  15  16  :HEX-INTEGER)
          (ALTERNATE_ID  17  22  :INTEGER)
          (V  23  24  :INTEGER)
          (H  25  26  :INTEGER)
          (THRESHOLD_TABLE  27  29  :INTEGER)
          (TYPE  30  30  :CHAR)
          (REC_TYPE  44  44  :CHAR)
          (MODEM)
          (DEVICE_LIST)
         ;;; monitored variables
          (ERROR)
          .UNAVAILABLE)
          (RESPONSE_TIME)
          (NETWORK_TIME)
          (HOST_TIME)
          (TIMEOUT)
          (POLL_LATENCY))
        (basic-net-object)
      : accessor-prefix "CU_")

(DEF–CONFIG-FLAVOR device
        ( (LINE_ID_NO  1  12  :INTEGER)
          (CONTROL_UNIT_ADDR  13  14  :HEX-INTEGER)
          (DEVICE_ADDR  15  16  :HEX-INTEGER)
          (ALTERNATE_ID  17  22  :INTEGER)
          (V  23  24  :INTEGER)
          (H  25  26  :INTEGER)
          (THRESHOLD_TABLE  27  29  :INTEGER)
          (TYPE  30  30  :CHAR)
          (REC_TYPE  44  44  :CHAR)
          (CU)
         ;;; monitored variables
          (ERROR)
          (UNAVAILABLE)
          (RESPONSE_TIME))
        (basic-net-object)
      : accessor-prefix "DEV_")
```

Figure 5.3.1 Configuration data-base segments using LISP and PROLOG in combination.

Batch: Job name
 Accounting fields
 Job class
 RJE station identification
 Programmer name

Time sharing:	User identification
	Accounting fields
Data base:	User identification
	Transaction codes
	Terminal identification
TP-monitor:	User identification
	Transaction codes
	Terminal identification

- *General workload and traffic volumes* indicate quantities at a global level for a certain period of time. They usually include
 Link level (transactions, messages)
 IN
 OUT
 Byte count
 Network level
 Null-header packets
 Non-null-header packets
 Byte count
 Transport level
 Number of connections (in, out)
 Number of requests
 Number of expedited transactions or messages (in, out)
 Byte count
 Session level
 Number of accepted connections
 Number of rejected connections
 Byte count
 Application level (node oriented)
 Number of jobs, transactions, messages
 Number of net and control characters
 Further processing the indicators for averaging, calculating peak-average ratios, and percentiles is usually supported.

- *Resource utilization measures* indicate actual and average utilization profiles for a certain period of time. Profiles usually included are
 Nodes
 Processing unit
 Busy
 Problem
 Supervisor
 Wait
 Protection key
 Memory
 I/O area
 Channel busy

Byte count
Controller busy
Device busy
Contention
Links
Busy/wait
Bytes transferred
Bytes received
Retransmission
Timeout
Overlapping
Processors and I/O
Processors and communication
Wait for I/O
Wait for communication

- *Service-level measures* give an overview of the service provided, most frequently offering comparison for the actual level with planned level over predefined time windows. Indicators included are
Availability
Hardware level
System level
Application level
Session level
Transport level
Network level
Link level
Physical level
Customer level
Response time
Node delay
Link delay
User think time
Response-time distribution by
User
Workstation
Cluster
Line
Communication controller
Node
Application
Accuracy and integrity
Application
Transfer
Session
Connection

Network
Link

- *Application unit measures* classify the principal workload clusters for workload characterization and representation. There are numerous alternatives, but the most frequently used include

 Production (data base, transaction, monitor, infocenter, batch)
 Test (data base, transaction, monitor, infocenter, batch, program development)
 Systems support (housekeeping, utilities)

- *Natural forecast units* (NFUs) are relevant for predicting the future resource demand and transaction-arrival rates as a function of business-related forecasts. NFUs could be the number of checks, number of passengers, number of reservations, number of tires manufactured, number of inquiries, or number of reports generated, depending on the industry and the size of the organization. Very frequently, multiple NFUs should be considered until the most important ones can be determined by means of a dependency analysis.

The performance segment is expected to interact with the dynamic indicators of the configuration segment by updating those indicators periodically or by event. SNMP gives a good example for these updates; details are covered in Chapters 3 and 13. In addition, a data dictionary segment is expected to be included. Most products provide this feature.

5.5 DATA SEGMENTS FOR VOICE COMMUNICATIONS PERFORMANCE AND ACCOUNTING

The voice environment is still considered a separate entity within most companies. Voice accounting is a well-established discipline offering different levels of detail and accuracy. The source of resource usage information is the PBX or the Centrex service.

Data collected—usually by station message detail recorders (SMDR) are reformatted, stored, and forwarded to the processing center or to the service bureau, if the third-party selection has been made.

The process is shown in Figure 5.5.1, indicating both the collection and processing phases. Physically, the processing may take place in mainframes or in microcomputers. Trade-offs for the processing solution are addressed in greater depth in Chapter 11.

Through adequate support of the data-base segment, the timeliness of information about calls and traffic profiles can be significantly improved. The present support is batch-oriented, and management is confronted with partially or completely obsolete data.

Alternatively, one has to look for an intelligent SMDR that will process call records from virtually any PBX into a common format. Although they

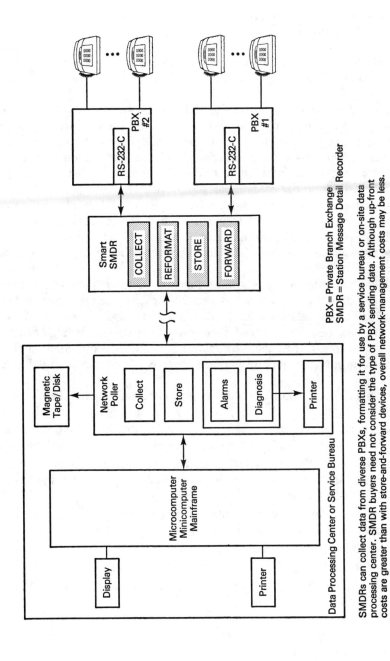

Figure 5.5.1 Processing SMDRs from various PBXs.

PBX = Private Branch Exchange
SMDR = Station Message Detail Recorder

SMDRs can collect data from diverse PBXs, formatting it for use by a service bureau or on-site data processing center. SMDR buyers need not consider the type of PBX sending data. Although up-front costs are greater than with store-and-forward devices, overall network-management costs may be less.

cost more, these smart devices make data collection and report processing much easier, and they provide flexibility in choosing additional PBXs for network expansion. They can be purchased without regard for PBX type (see Figure 5.5.1) [DANM89E]. An additional benefit is that a single device can accept data from multiple PBXs simultaneously.

If saving money on gear is an objective, the user may consider a service bureau that will poll inexpensive store-and-forward data collectors and assemble the diverse call record data in a common format for call costing and report processing.

In addition to eliminating the risk, labor-intensiveness, and cost of magnetic tape delivery, the polling process can enhance data integrity by auditing the data from the point of origin to the point of delivery. Blocks of data are sequentially numbered at the point of origin and are "checkpointed" as they are teleprocessed to the destination polling equipment. In this cyclic redundancy check, the number of data blocks is verified by both the sending and receiving units. Sometimes the ACK/NAK (acknowledgment/negative acknowledgment) process is used to confirm the receipt of data. In the event that incomplete or damaged data arrives at the network poller, repolls are initiated automatically until all data blocks are accounted for and arrive at the destination error-free.

Polling provides a degree of flexibility to data collection in that the process may be initiated as demand warrants or according to a routine late-night schedule that takes advantage of lower transmission costs. And most pollers are designed for unattended operations. If users have high call volume and plan to use their microcomputers in a multi-tasking mode, polling must be done more frequently because there is less memory available for storage.

But even the selection of polling equipment requires careful evaluation:

- In the event of a power outage, will the poller turn off and stay off, or will it restart automatically and initiate a repoll when the power resumes?
- If there are different SMDR types on a multi-node network, will the poller adjust automatically to the error-checking protocol of the SMDR device being polled?
- Does the poller have enough intelligence to switch lines automatically or to hang up and dial again when it encounters poor line quality?
- Does the poller allow remote activation for polling on demand?
- Does the poller furnish a complete report of its activities?
- Does it have the capability to perform remote diagnostics on PBXs as well as on the SMDR devices?

Answers to these questions are critical to the long-term reliability of data collection and, ultimately, to the viability of in-house report processing on multi-node networks. When these questions are applied to most

microcomputer-based pollers, there may be trade-offs between reliability and convenience and low cost.

Alternatively, one has to look for an intelligent SMDR that will process call records from virtually any PBX into a common format.

This segment of the data base is expected to include the following data items:

- Basic details of cells
 Extension number originating the call
 Time of call origination
 Date of the call
 Number that was dialed
 How long the call lasted
 Outside line that was used to complete the call
 Special comments
- Tariffs
 Geographic locations
 Distance from main office
 Time zones (day/week)
 Volume discounts
 Packet price
 Area codes
 Range of extension for voice, document transfer, mail
 Identification of data-oriented devices
 Special comments
- Traffic engineering
 Activity by service (WATS, non-WATS, DDS, V-NET)
 Busy hour profile
 Errors
 Congestions
 Number of rejected calls
 Utilization of switches
 Number of reroutings
- User profile
 Location
 Access profile by service
 History of traffic volume

There are several links to other segments of the network-management data base. Tariffs have pointers to configuration segments, traffic has pointers to the performance segment, and user profiles to both. Basic call details are unique to the telemanagement segment.

In addition, a data dictionary segment is expected to be included. Most telemanagement products provide this feature.

5.6 TRENDS WITH DATA BASING AND RELATED INSTRUMENTS

Data-basing solutions will play a significant role in supporting network‑management applications. Single, fragmented products and files are expected to be replaced by an integrated data base with three major segments addressing configuration, performance, and telemanagement.

Due to the required higher flexibility, hierarchical data-base structures are likely to be replaced by relational or object-oriented techniques. The ultimate solution could be implemented in two different ways:

- Purchasing a data-base product and populating it with existing data; in addition, front-end programs and reporting programs have to be designed, developed, and implemented by users.
- Purchasing a special-purpose product supporting the data base, the front-end programs, and report generation; in this case, the customization effort has to be evaluated against the higher purchase price.

This decision will be heavily impacted by the repository offerings of the major network-management product players, including IBM, DEC, and AT&T. The migration to a single product or integrated solution may lead to a so-called directory service on the basis of X.500.

How the data base is physically implemented may be different depending on the users' environment and installed products. The data base and related products may be attached to the integrator, or to network element management systems, or to both.

Applicability of expert systems are predicted for the following areas:

- Interpreting, combining, and filtering arriving information prior to data basing
- Evaluating performance logs for highlighting bottlenecks
- Evaluating traffic logs for improving routing and switching
- Recognizing trends in resource utilization helping in quantifying capacity planning

More details on the use of expert systems may be found in the following chapters.

6

Systems
for Performance Prediction

The future level of service toward end-users depends to a large extent on the quality of performance prediction. Based on workload and call estimates, growth rates, geographical locations, network facilities, and equipment, performance prediction packages help to quantify future service level and resource utilization. In most cases, they help to answer "what-if" questions in terms of the majority of indicators impacting service level and resource utilization.

The major emphasis is on generic solutions and principles; product examples are given, but extensive listings of products are avoided. Table 6.0.1 shows the instrument categories characterized by complexity, cost, speed, risk, and human resources demand.

In particular, statistical techniques, applied queuing, Erlang-B simulation, benchmarking, and remote terminal emulation are addressed in some detail. More specific product examples are given in Chapter 12.

6.1 RULES OF THUMB AND STATISTICAL TECHNIQUES

Rules of thumb are sets of general guidelines of system performance based on observation experience or knowledge of system internals and may help to avoid serious misplanning for the future. Individual experiences based on historical data are considered in a documented or undocumented manner. Rules of thumb frequently solve problems without interpreting and technically justifying the solution recommended. In many cases, statistical tech-

TABLE 6.0.1: Performance Prediction Tools Overview.

Instruments	Demands				
	Complexity	Speed	Costs	Risks	Human Resources
Rules of thumb	low	high	low	high	low
Financial analysis tools	low	high	variable	medium	medium
Regression and correlation tools	variable	low	variable	high	high
Time series analysis	variable	medium	variable	high	high
Operational analysis	medium	high	medium	low	variable
Erlang-B technique	low	high	low	low	variable
Decision support systems	medium	high	variable	medium	medium
Expert systems (in combination with other instruments)	high	high	high	low	high
Simulators	high	medium	high	medium	high
Benchmarks	high	low	medium	low	high
Terminal emulation	high	low	high	low	high

niques are used for performance forecasting. (Forecasting means assuming that some basic pattern exists in historical values that provide relationships between two or more variables and can, via statistical treatment, provide a basis for predicting future performance.) Three techniques have been successfully implemented:

Correlation analysis: Indicates the strength of the relationship between two variables.

Regression analysis: Defines an equation between two variables and thus requires estimation of future values of independent variables. Linear, multiple-linear, stepwise, and nonlinear regression are most widely used.

Time-series analysis: Investigates the behavior of certain variables over time and isolates cyclic, seasonal, trend, and random behavior. The following types are most frequently used:
Naive methods forecast based on the most recently observed value.
Moving average removes randomness by averaging past values.
Exponential smoothing removes averages and weights most prevalent values.
Decomposition isolates cyclic, seasonal, trend, and random characteristics.

Table 6.1.1 gives a short overview on the advantages and disadvantages of statistical techniques.

TABLE 6.1.1: Evaluation of Statistical Techniques.

Method	Advantages	Disadvantages
Naive	Very simple	Usually inaccurate
Moving average	Simple: better than naive	Does not distinguish subparts of underlying pattern
Exponential smoothing	Good potential accuracy for short-term forecasts	Does not distinguish subparts of underlying pattern
Decomposition	Easily understood; useful information on subpatterns	No statistical test of significance or confidence intervals—subpatterns may not be clearly separable
Linear regression	Simple to calculate; fairly accurate for short-range trending	Does not distinguish subparts of underlying pattern
Multiple regression	Statistical test of significance and confidence intervals	Hard to identify variables and relate to workloads

6.2 OPERATIONAL ANALYSIS

When interpretation of the predicted performance is also required, the technique of operational analysis may be used. (Operational analysis means the use of applied queuing theory for the purpose of computer-system and, recently, network modeling.) The person may achieve reasonable accuracy (over 90%), can easily answer "what-if" questions, and can evaluate a fairly large number of planning alternatives within a short period of time. More important, the critical operating areas can easily be highlighted. Figure 6.2.1 compares results accomplished by linear regression and by operational analysis. For the planner, the latest figures are more valuable because they give a better indication of the service sensitivity for the range of utilization under consideration.

Models are no replacement for the real network, but, using meaningful simplification, they contribute to the following:

* Gaining a better understanding of complex communication networks
* Providing an easy evaluation of service level as function of utilization indicators
* Determining the stress point of a certain configuration
* Minimizing the time required for approximate problem solving
* Providing feasible alternatives as a basis for decision making

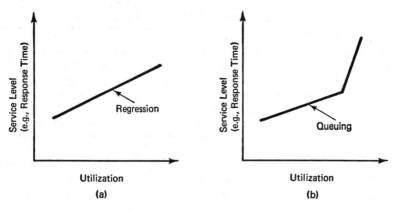

Figure 6.2.1 Comparison of linear and operational analysis.

- Evaluating the sensitivity of solutions against a fairly large number of impacting parameters

Basically, the processor and I/O subsystems are modeled for various workload clusters. The level of detail incorporated in an analytical model can be readily adjusted to reflect the nature of the questions being studied and the accuracy of the data available to the analyst. That is, simple questions can be answered on the basis of simple input parameters, and additional information can subsequently be provided to obtain answers to more detailed questions. The models are unique in their ability to adapt the level of detail to the question at hand and to extract the maximum amount of useful information from each set of input data. Moreover, the analyst who is familiar with the basic terms and concepts of computer performance evaluation requires little special training in order to use the package. The internal algorithms and procedures used are usually insulated from the customer to the maximum extent possible. Reports generated by the modeling software are easy to understand and apply.

Figure 6.2.2 shows the basic flow of the modeling process. The input parameters include configuration- and workload-oriented information. Usually, input parameters characterize information on a per-workload basis. For each workload being modeled, there are two sets of parameters that need to be captured: the workload descriptor data and the workload service requirements. The workload descriptor data characterize pertinent information concerning the system's view of the workload (e.g., arrival process, multiprogramming level, and relative CPU-dispatching priority). The workload service requirements capture each workload's resource-consumption profile (e.g., CPU, I/O, and communication activity). Usually, these indicators are automatically generated by the front-end processors of the models. Otherwise, these indicators must be hand calculated, a process that generally requires suitable software monitor output.

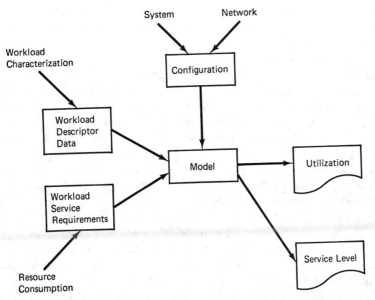

Figure 6.2.2 Overview of the modeling process.

Fundamentally, there are three workload types supported by data-oriented analytical models:

- Time-sharing
- Transaction processing
- Batch

Timesharing workloads are associated with sets of terminals. The customers at the terminals are assumed to generate transactions that arrive at the system and undergo processing. When a transaction has been completed, a response is printed on the customer's terminal. The customer then generates a new transaction and the cycle repeats. In the case of timesharing workloads, the analyst specifies the number of terminals and the average think time (e.g., the average time between the system's response to a given transaction). The principal performance factors calculated for these workloads are the response time per transaction and the throughput rate in transactions per hour.

Transaction-processing workloads are similar to interactive workloads in that the external load is assumed to be generated by customers at terminals. However, instead of specifying the external load in terms of number of terminals and think time, the analyst simply specifies a total arrival rate in transactions per hour.

Since the arrival is specified as an input parameter and since throughput is equal to arrival rate as long as system capacity is not exceeded, the most important performance value computed for transaction-processing workloads

is the response time. The models usually also calculate the maximum attainable throughput rate for a transaction-processing workload in cases when the system capacity is exceeded.

The third generic workload type characterized is the backlog-processing workload. In the case of backlog-processing workloads, analysts are usually most interested in system performance during time periods when the input queues are backlogged (i.e., when there is always at least one job waiting to be loaded into main memory). The models enable that analyst to specify batch workloads that have this backlog property. The closed loop indicates that in a backlog situation new jobs are loaded into main memory whenever an active job completes and memory space becomes available. This is precisely what happens in real backlog situations. Both throughput and response time (turn-around time) are computed for these workloads.

A workload is defined as a distinct class of demand for systems resources. Further, any level of refinement in a workload's definition is possible. Each IMS transaction type, for example, may be viewed as a distinct workload, if desired. In order to prevent one or two workloads from monopolizing main memory in an uncontrolled manner, the domain component may be used [BGSS83A]. In the model, each workload is assigned to a single domain, which may be unique or may be shared by other workloads. Each domain is associated with parameters that control the entry of individual transactions into the multiprogramming mix. Thus, the memory queue actually represents a set of queues, one corresponding to each domain. The models treat the queues separately and compute performance values for each one individually.

Besides evaluating present configurations with various workload types, future configurations and projected workloads of not-yet-existing applications can be modeled and evaluated as well.

All modeling tools provide evaluation software as well. The principal results include:

- Service-level reports for the mainframe in the form of response-time summaries, and statistical and graphical illustrations.
- Utilization reports for all key resources under consideration in the form of summary reports, consumption by workload clusters, and overlap profiles.

Another class of models attempts to consider networking requirements and topological prerequisites for the application classes introduced previously. Performance is usually addressed by evaluating the response time and availability of network facilities. Other types of models offer least-cost solutions for the current or future topologies, disregarding performance expectations. The best results can be accomplished when both types of models are used in combination. Network-related models have to address—besides considering the physical characteristics of facilities—the parameters of the network architectures which have to be properly set in network nodes.

For sizing communication resources (facilities, lines), alternatives of the following very basic equation are used:

$$RT = ST + \frac{ST \times UT}{2(1 - UT)} \qquad (6.1)$$

where
RT = Response Time
ST = Service Time
UT = Utilization of the resource

Modeling instruments use sophisticated versions of this equation by extending it with parameters of the facility and of the communication architecture. The curve B in Figure 6.2.1 actually displays this equation, characterized by $RT = ST$ at low resource utilization and by exponential growth of RT by $UT \approx 100\%$.

When selecting models, the following criteria have to be considered:

1. **Accuracy.** Modeling tools are expected to provide not more than $\pm 10\%$ inaccuracy during the model-verification process. During verification, modeling results are compared with measurement data.

2. **Scope of the model.** Scope determines whether the model supports nodes, links, or both. Voice, data, and voice/data models are differentiated as well. The best results are expected from an integrated model.

3. **Input-data handling.** The system needs to decide about the completeness of input data, including workload, configuration, and resource-demand-related information. In addition, the ability to automate the input data generation using network-management data bases is included.

4. **Modeling results.** Results include resource-utilization figures, service-level indicators at different levels of detail, and tariffs for the link models.

5. **What-if analysis.** Interactive capabilities for answering what-if questions in terms of existing and future workload, existing and future networking locations, estimated utilization levels, expected service level, and sensitivity toward new technology must be available.

6. **Reporting features.** The kind of reports generated and how they are presented are included. In addition, interfaces to statistical-analysis packages and to financial and other decision-support systems should be considered.

7. **Model calibration.** Requirements in terms of time and resources for validation and verification of the baseline models are summarized. Automated techniques such as expert systems should be weighted high.

8. **User interface.** This interface includes subcriteria such as:
 Requiring no special knowledge of how to operate a computer or a communication network
 Ease of use by providing menu and help facilities
 Readability of recommendations

Requiring no long training

Implementation on personal computers when required

9. **Resource demand.** Processing, storage, and model-update demand are expressed in resources and human resources.

10. **Maximum capacity.** The planner needs to know how many nodes and links the model is able to consider. The throughput rates of each individual resource are also very important.

6.3 ANALYTIC METHODS FOR VOICE CHANNELS

One simple analysis technique is the use of Erlang as an indicator of the load on communication channels. This technique tries to quantify the relationship between resource demand, probability of blocked requests, and the number of communication channels needed for a predefined grade of service. In most cases, the sizing is accomplished for the peak hour. The calculation steps are as follows:

- Determining the total number of calls (or circuit-switching engagements of data) over an observation period.
- Computing the peak load by adding 50% load to the average hourly load.
- Determining the typical call durations (or circuit-engagement type) by application areas.
- Dividing the total by 3600 will give the "so-called" offered load for the peak hour in Erlang.
- Defining the percentage of blocking not impacting the targeted grade of service.
- Using tables, probably based on Poisson-distribution for determining the number of communication facilities.

Figure 6.3.1 [HOWA90] shows an example of such tables. The table displays the number of channels required as a function of offered load in Erlangs. The parameter in the table is the blocking probability.

6.4 SIMULATION

Simulation is a powerful technique that uses a model instead of a real system for performance prediction. Present complex systems should be carefully analyzed before modeling to achieve adequate accuracy with reasonable simulation costs. Simulation packages can be successfully used, when accurate workload estimates and hardware or software specifications can be provided. Instead of operational analysis or queuing, simulation techniques can be implemented for forecasting purposes as well. In addition, everything in terms of customer

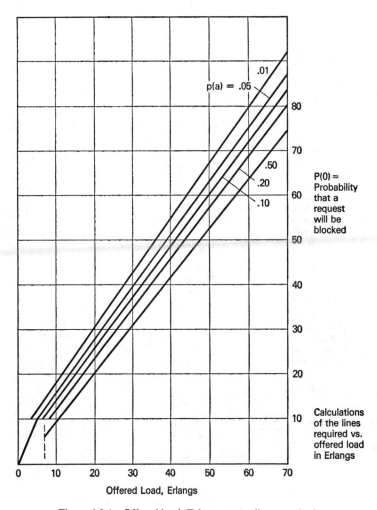

Figure 6.3.1 Offered load, Erlangs versus lines required.

interfaces and reporting features is valid in using simulation experiments. Simulation models are very sensitive toward input specification of

- Workload description
- Network configuration
- Software environments

Any incompleteness in these data may lead to inaccurate results. The simulation procedure may be characterized as follows, using Figure 6.4.1.

After calibrating the baseline model, either the workload or the configuration (or both) can be changed. After each iteration step, the intermediate results can be evaluated on-line or off-line. Furthermore, the decision can be made to continue or to terminate the experiment. The major advantage is that

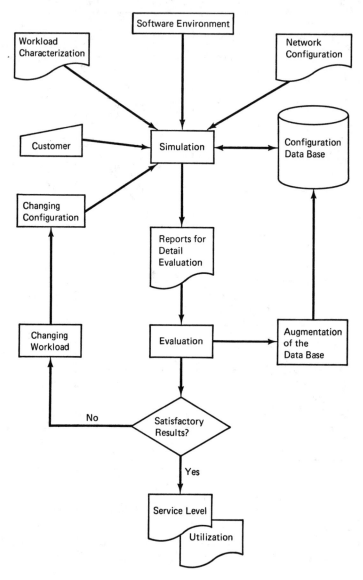

Figure 6.4.1 Simulation flowchart.

simulation may be used without an actual operational network. On the other hand, problems may occur regarding the following items:

- Implicit and explicit assumptions must be accepted.
- Structure for network and its software is inflexible.
- The level of detail may not be consistent with purpose.
- Run times (e.g., 10,000 arrivals and departures) may involve up to 400,000 instructions).

- Maintenance may be difficult.
- Costs may be high.

Almost all vendors of network architectures, such as SNA, CNA, and DCA, use house internal-simulation packages. They are usually neither available nor visible to their customers.

6.5 BENCHMARKING AND REMOTE TERMINAL EMULATION

Benchmarking is a method by which a customer collects a representative set of an installation's workload and runs it in some predefined sequence on real existing or alternative hardware. Using the real workload, or at least part of it, helps accomplish more realistic results. However, the customer should weigh the factors that may influence the decision for or against benchmarking:

- Networks, nodes, and links cannot be evaluated.
- An accurate level of workload representation must be determined.
- Operating influences must be excluded.
- Measurements and reporting procedures must be specified prior to benchmarking.
- Hardware, operating system, and utilities must be specified accurately prior to benchmarking.

Remote terminal emulation means the use of an external, independent load driver connected to the system under test via standard communication facilities; this method generates messages and transactions according to a set of scripts based on the installation's on-line workload. It is at the customer's disposal to decide about the communication network to be included. This technique is very advantageous for stress-testing prototypes of systems and networks for large applications.

Analytical modeling and simulation may help in designing networks and evaluating future service levels and resource utilization. These models can be verified for the present workload conditions only. However, verification for projected workload remains a serious problem to be considered. The customer needs tools and techniques for testing the network or parts of it during operation.

6.5.1 Methodology of Testing Networks

There are several alternatives for testing communication networks [FIBS78]:

- **Test drivers.** As an alternative to the measurement of uncontrolled usage, customers at terminals may be employed to generate workload. However, since a terminal operator's performance is unrepeatable and error-prone and introduces undesirable variability into the time spent in the user state, operators should not be employed for this purpose unless other, more desirable alternatives are neither feasible nor available.
- **Automatic send-receive (ASR) terminals.** Instead of employing customers alone, ASR terminals can be used for representing customer workload. This technique is very attractive and relatively simple. The terminal is operated with the stored input and produces communications traffic equivalent to that which would have been produced by a user.
- **Driver-monitor combination.** Some of the limitations on the use of ASR terminals may be eliminated by the use of intelligent terminals. Although theoretically attractive, this approach has not been widely used. The remote-terminal emulator discussed shortly embodies this concept. Although the use of a driver internal to a computer is not recommended for evaluation and selection of network service provided in part by that computer, it may be useful for such purposes as the following:

 Comparison to determine if the computer system is completely homogeneous in hardware and software

 Testing for compliance with standards (such as language and communications protocol)

 Tuning of the computer

 Detecting the effect of change in host hardware, software, or utilization

 The use of an internal driver is less expensive and complicated than that of an external driver, since only one computer is required. When an external computer is used to provide the workload on an interactive computer-network service, the computer performing the testing is known as an RTE.
- **Remote-terminal emulator (RTE).** The RTE and the entire network being tested is the system under test (SUT). The capacity of RTEs can range from one terminal to the maximum number the service can support. An RTE may be an appropriate test tool when there is a specified number of access ports that the service must provide.

Figure 6.5.1 summarizes all possible locations of the emulators. The principal alternatives are as follows:

1. The driver is located in the host (the majority of these are software-based).
2. The driver is implemented in the front-end processor.
3. The driver is implemented in one or more concentrators in the form of a message generator.
4. The driver is located in a microprocessor, attached to the digital interface.
5. The driver is part of a remote job-entry station.

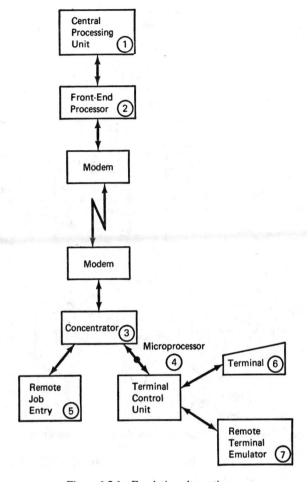

Figure 6.5.1 Emulation alternatives.

6. The driver runs in terminals and can be automatically, semiautomatically, or manually initiated.
7. The driver is implemented in a neutral independent processor with the capability of emulating the whole network or parts of it.

There is no doubt that remote-terminal emulation, implemented in the host or as an independent processor, is going to become the key technique for at least large networks.

6.5.2 Principal Modules

The general architecture of RTEs is shown in Figure 6.5.2. This figure indicates a complete experiment, involving all relevant components of the communication network. In many experiments using software drivers, only

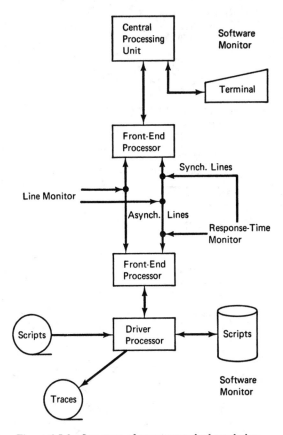

Figure 6.5.2 Structure of remote terminal emulation.

segments of the network are tested. Particular interest should be paid to the instrumentation at various levels:

- System under test, where the application runs.
- Visibility at the line level using line monitors.
- Observing overall network service level and traffic indicators anywhere on the digital interface via response time or network monitors.
- Using driver features for tracing the response time, traffic, and application accuracy at the driver level.

The RTE usually consists of the following main modules:

- Script generation
- Scenario control
- Configuration description
- File handling

- Hardware interface
- Instrumentation
- Evaluation

The flow of information is shown in Figure 6.5.3.

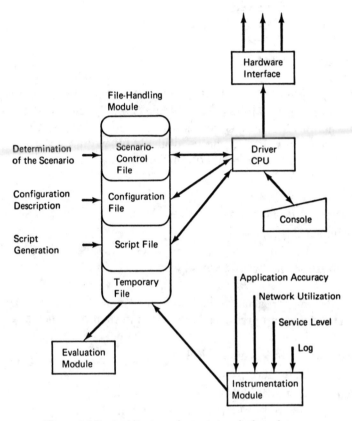

Figure 6.5.3 Architecture of remote terminal emulators.

The major responsibilities of the modules can be summarized in the following way.

Script generation

The general idea is to use the productive type of work like benchmarks do. Scripts can be manually compiled or automatically generated. For large emulation runs, the second alternative is highly recommended. The productive runs can be logged, and crucial parts of them can be edited for emulation experiments. Scripts can be prepared for both stress and acceptance testing. Depending on the purpose, all or parts of the following information may be included:

- Application identification
- Sequence of transaction
- Request for customer entries
- File identification
- Expected system or application responses
- Expected service level
- Length of I/O messages

Scenario control

The emulation assists in testing live environments. In order to do so, the sequence of transaction initiation should be carefully scheduled if stress testing is the major objective. Otherwise, all sequences are feasible. Usually, a special-purpose programming aid is available for writing scenarios. At least the following information should be embedded:

- Frequency of activation
- Think-time distribution
- Dependencies

Configuration description

In order to approach live conditions, the emulated load should be shared among networking resources. The following information is included:

- Number of physical and logical lines
- Line discipline and speed
- Number of emulated terminals
- Identification of the interface to the networks (e.g., front-end processor)
- Protocols supported

The description is usually edited by the standard operating-systems feature.

File handling

Depending on the nature of the driver, there are different alternatives for practical solutions. If software drivers are implemented, file handling is a standard feature. In the opposite case, special unsophisticated routines are expected to be implemented.

Hardware interface

This module, with its parts, is responsible for sending and receiving emulated transactions and their responses. This interface is usually directly connected to the front-end processor on the driver end. Channel attachment is frequently implemented. The software support is similar to telecommunication-access methods of the mainframes.

Instrumentation

As stated earlier, measurements are accomplished at many locations of the communication networks and the driver. Using a temporary file (see Figure 6.5.3), run information and measurement results are stored for further analysis. The instrumentation should be adapted as a function of the tool availability. But using the emulator's features is a must.

Evaluation

For supporting the network-capacity planner, powerful reporting software is required. The log file should be evaluated at different levels of detail. The temporary emulation file may be interrogated by

- Time window
- Transaction identification
- Terminal identification
- Expected ranges of service levels
- Error-bit lists
- Traffic profiles

A powerful reporting software is expected to provide information on

- Number of emulated transactions
- Number of repetitions owing to erroneous response
- Byte transfer (sent and received)
- Transaction profile
 Number of entries
 Number of errors
 Response time (maximal, minimal, average)
- Terminal profile
 Number of entries
 Number of timeouts
 Protocol errors

Number of false responses
Response time (maximal, minimal, average)
- Line summary
Number of timeouts
Number of fatal errors
Protocol errors
Number of false responses

Usually just a few standard reports are provided. But, on the other hand, the customer may design and generate a large number of ad hoc reports.

The practical implementation of the modules depends on the basic architecture of the emulation.

The execution of the emulation is most frequently automated. The catalogued procedure can be automated after entering the parameters for

- Number of iteration steps
- Number of transactions to be emulated
- Duration limits
- Thresholds for tolerable and intolerable errors
- Options for supervising the run

Relevant messages, programmed in the scenario, are displayed on the operator's console device. Inquiries about the emulation status can be obtained any time by authorized personnel. Regarding run times, there are different reports; for example, emulating 200 terminals with reasonable representation takes around 30 to 40 minutes.

Remote terminal emulation can be supported by software devices (e.g., TPNS from IBM, SURF from Amdahl, CS 1100 from Unisys) or by hardware drivers (e.g., PACE from Computer Sciences Corporation, RTLE from TITN).

6.6 USE OF ARTIFICIAL INTELLIGENCE

An *expert system* is a computer program that has incorporated knowledge of a specific area of expertise, which it uses to solve problems at a high level of performance, similar to a human expert. The ultimate performance depends on the knowledge base and on combining principles.

For solving complex problems, the number of possible alternatives—using conventional software—is very large. Expert systems accumulate a base of necessary facts and inference rules. By applying the inference rules to the facts to develop new facts, or chaining them together, expert systems generate the necessary pieces of the system.

Expert systems are designed by a knowledge engineer, who is responsi-

ble for converting the rules of problem solving for the domain expert, who is an expert in the field in which the expert system is implemented.

The architecture of expert systems involves four basic components (Figure 6.6.1) [TERP86A]:

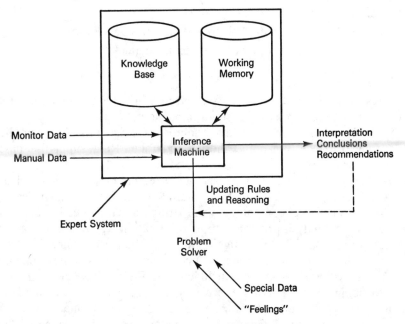

Figure 6.6.1 Expert systems architecture.

- A knowledge base, which is problem-specific and contains knowledge structures and production rules. It is created by the domain expert.
- An inference engine, which is problem-independent. It is specific to the knowledge structures and is built by the knowledge engineer.
- A working memory, which keeps track of all data presented and the conclusions deduced in dealing with the particular problem.
- A user interface, which is designed to allow natural dialogues.

Production rules are a popular way of representing knowledge. They are generally of the form *if* "conditions," *then* "actions." If all the conditions are true according to the current state of the working memory, the actions are taken. There are two fundamental directions of inference that control how the production steps are chained together. Using forward chaining, the productions start with the available data and move forward from condition to action. This allows for data- or event-driven reasoning. Backward chaining starts with a hypothesis and moves backward to find productions that satisfy the antecedent of the goal.

There are, however, limitations for designing expert systems. The design may be justified where:

- Human expertise is rare
- It is difficult to educate new experts
- There is a demand for this expertise
- The problem can be well defined and must have a solution
- Problems are complex and not easy to solve quickly
- Mistakes are costly

In this respect, the operational control and network capacity-planning areas are the prime targets for expert systems implementation.

There is an urgent need to provide solutions for sizing LANs and predicting their performance. For both Ethernet and Token Ring, simulation-based solutions seem to arrive first.

As a useful extension, a financial analysis feature may assist in purchase-lease analysis, cost-benefit evaluation, and budgeting functions. This can be done thanks to personal computers by preparing standard spreadsheets, forecasting, and cost-analysis programs. Input information is provided partially by the customer and partially by certain segments of the performance data base.

In addition, for facilitating objective nonbiased decision making, decision-support systems may be included [BIAR83]. These allow the customer to define decision criteria, weights, factors, and decision methods. Decision support can help in finding an answer based on information from the performance data base or defined by the network capacity planner. When heuristic decison making is expected to be involved, artificial intelligence or expert systems may be implemented.

6.7 SUMMARY AND TRENDS

Performance and cost prediction systems help network design and capacity planning to predict the future behavior of communication networks and their components. At the moment there are far too many fragmented solutions, each of them addressing particular problems, such as performance, or cost, or nodes (equipment), or links (facilities). Integration is absolutely necessary, but it will most likely come first from users and not vendors. In the second step, due to shareable resources, such as T-links, MANs, and LANs, integration over data and voice models is expected. Chapter 12 will demonstrate that the use of prediction models is just one part of the network design and capacity planning process. Modeling devices are operated usually independently from network-management integrators and network element management systems.

7

Configuration Management

Configuration management is a set of middle- and long-range activities for controlling physical, electrical, and logical inventories; maintaining vendor files and trouble tickets; supporting provisioning and order processing; defining and supervising service-level agreements; managing changes; and distributing software.

7.1 INTRODUCTION, STATUS, AND OBJECTIVES

The principal objectives of this chapter are:

- To discuss the major functions of configuration management as a process
- To define the interrelationship of the functions
- To determine information export and import with other network-management subsystems and functions
- To find the most promising instruments supporting configuration management activities
- To summarize the implementation considerations, including the human resources demand for supporting configuration management
- To construct a responsibilities/skills matrix to help staffing configuration management functions

In addition to the issues we are facing today, as detailed in Chapter 1, more specific problems are seen in the configuration management area that may be characterized as follows:

- It is extremely difficult to synchronize the updates of fragmented data bases and files. Sometimes, larger corporations have to deal with 25 to 40 different files and data bases serving various areas, such as purchase, vendor management, trouble ticketing, planning, telemanagement, and so on.
- It is very difficult if not impossible to reduce the redundancy of data elements in different data bases and files without taking a serious step toward integration.
- Because of missing integrated addressing and naming, there are too many views of the network; the problem of how to generate the configurations for the physical, electrical, and logical networks, and network-management products is unsolved. Network element management systems are good examples of partitioned views.
- Voice and data network elements are usually in separate databases, which makes it difficult to control inventory of shared resources.
- Solutions for asset management are very rare.
- There are too many products competing for the configuration data base, including general- and special-purpose solutions in the area of relational and object-oriented techniques.
- Experiences are missing for selecting the right language, product, and implementation strategy. In addition, guidelines are missing for how to size data bases.

In summary, sectionalization by vendors, components and by geographical areas seems to be the principal burden of integrating configuration views.

There is a trend to sectionalize customer networks for improving quality of service, clearly allocating responsibilities, improving instrumentation, and reducing operating costs. The example (Figure 7.1.1) illustrates this trend by introducing different network sections:

- Central data-processing centers, including host computers, front-end processors, local area networks, and private branch exchanges.
- Networks, including modems, circuits, DSUs, and CSUs, and multiplexers for supporting connections and transfer functions.
- Remote data-processing centers, including host computers, front-end processors, local area networks, and private branch exchanges.
- User networks, including remote front-end processors, local area networks which connect PCs and any type of servers, minicomputers, and private branch exchanges.

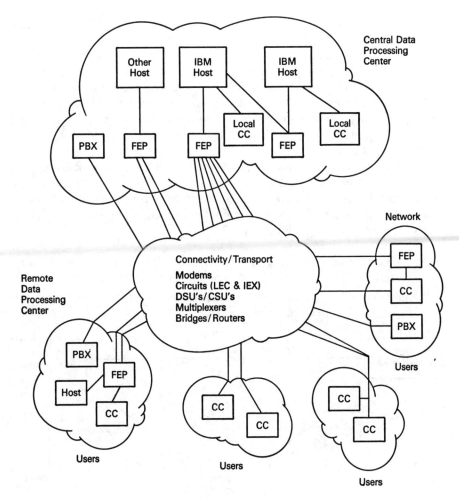

Figure 7.1.1 Sectionalization of customer's networks.

These sections may be considered separate configuration and management domains. However, integrated and centralized network management is still the ultimate goal.

Manufacturers of network-management instruments may be categorized by how many network sections they are able to serve.

7.2 PROCESSES AND PROCEDURES OF CONFIGURATION MANAGEMENT

Configuration management is considered the central process of network management. All other areas, such as fault, performance, security, and accounting

management are supported by configuration details from configuration management. Figure 7.2.1 illustrates this exchange of information.

In this figure, data bases, data-base segments, and files are not identified individually. Within the configuration management subsystem, however, data are segmented for serving various functions, such as inventory control, topology service, service-level agreements, provisioning, order processing, change and asset control vendor management, and directory services. Figure 7.2.2 shows the high level of interactivity between the data base and configuration management functions.

Attributes of objects may be used by different functions concurrently. In order to avoid synchronization problems, it is recommended to reduce the redundancy by using advanced relational and/or object-oriented techniques. This is the ultimate goal, which can only be reached in multiple steps. These steps are identified as follows (Figure 7.2.3):

1. **Define inventory entries.** Data elements to be maintained in the integrated level; it is predicted not to be higher than 15% to 20%.
2. **Select records.** Quantification of data fields and/or tables to be included into the integrated data base.

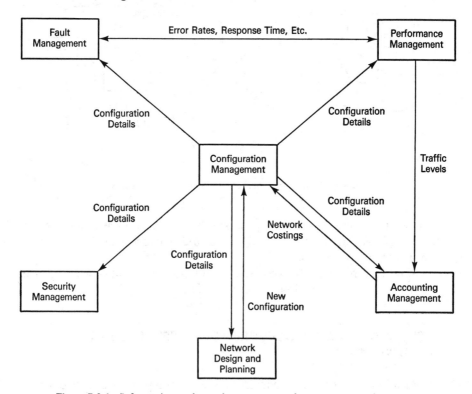

Figure 7.2.1 Information exchange between network-management subsystems.

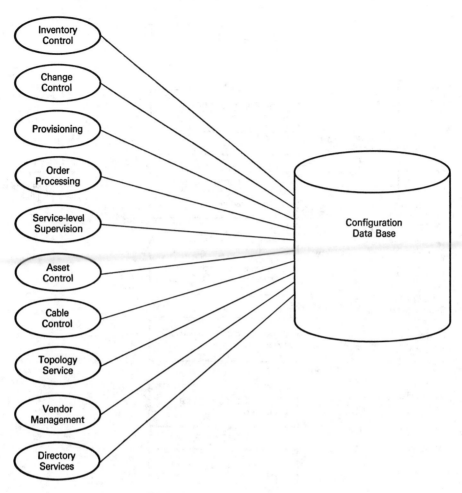

Figure 7.2.2 Configuration data base serving multiple functions.

3. **Analyze existing data bases and files.** Analysis of existing configuration data at network element management level. All existing configuration files and data bases are analyzed for the requirements of being included into the integrated data base.

4. **Elimination of redundancy.** In order to improve efficiency and upload and download resource demand, redundant elements have to be eliminated from element management configuration data bases prior to upload.

5. **Develop upload programs.** Assuming electronic readability of files and data bases, programs are designed for scanning, interpreting, and converting data fields for upload.

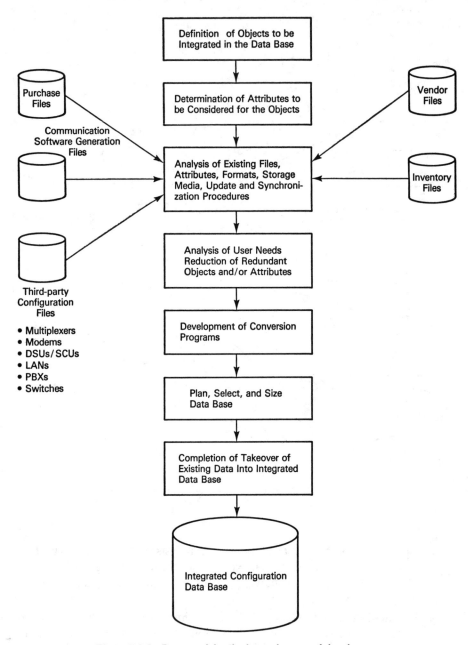

Figure 7.2.3 Process of developing an integrated data base.

6. Execute upload, sort, merge, and delete. Using the upload programs, the conversion process is executed and configuration data are uploaded to the integration level.

This process is expected to be a one-line activity.

Based on this integrated data base, configuration management functions may be more efficiently supported. In order to successfully support configuration management, the following information is necessary:

- Primary demand
 Actual configuration
 Attributes of network elements
 Generated configuration that may contain more components than the actual one
 Status indicators of network elements
 Vendor data
 Change requests and records
 Order data
 Actual inventory
 Status of service-level indicators
- Secondary demand
 Traffic volumes
 More detailed data on indicators
 Performance indicators of network elements

7.3 CONFIGURATION MANAGEMENT FUNCTIONS

Configuration functions have been identified in the introductory part of this chapter. After having defined the functions, typical processes, structures, and architectures, practical examples are now given for better understanding of how the functions work and how they are interrelated.

7.3.1 Inventory Management

Inventory management is an automated inventory that provides an on-line record of the currently installed components base and their spares. The inventory items include equipment (modems, data and channel service units, switches, mainframes, mini- and microcomputers, control units, concentrators, key equipment, front- and back-end processors), facilities (trunks, tie lines), cross-connect, circuits (individual circuits, groups, and multi-point), networks, services offered, customers, provider, vendor, location, and contact.

Linked but not yet necessarily integrated are inventory items of local area networks. Identification of associations is also frequently part of the inventory data base. State-of-the-art communication networks usually contain many thousands of components—in other words, managed objects. Neither other network management subsystems nor other configuration management functions can operate successfully without efficient inventory management. As recommended in Chapter 5, the inventory segment of the general-purpose

network-management data base has to deal with attributes, connectivity, and status.

Table 7.3.1 shows examples for certain managed objects, indicating the generic definition and the most frequently used attributes. This example details

- Equipment
- Facility
- Circuit
- Application and system software
- Service
- Contact (vendors)
- Location

The OSI/Network Management Forum publishes periodical updates to recommended objects and attributes [DSIN90C]. In official documents, the ASN.1 description technique is used for details of attributes which are subdivided into three major areas:

- Attributes must contain
- Attributes may contain
- Operations, create, and delete notifications

Optionally, the contact may be expanded into a vendor segment, identifying the vendor, vendor alias, customer, provider, network, and so on. The grouping of information allows the quick retrieval of the following for vendor and vendor equipment:

- All equipment of a certain vendor
- Performance statistics for certain equipment of the vendor
- Contract-expiration schedule
- On-line invoice-verification screen
- Maintenance requirements for certain equipment classes
- Access for vendor-related data to network operational control for troubleshooting
- Service statistics, including

 Number of outages
 Response for repair
 Repair-time distribution
 MTBF, MTTR, and MTOR (see Chapter 9 for details of calculation)

 A well-maintained vendor file helps to

- Better prepare vendor negotiations
- Cut costs by excluding overpayments

Class Name: Equipment

Class Definition: A physical unit. Equipment may be nested within equipment, thereby creating a parent/child relationship. A facility is supported by equipment at each end. Equipment may also connect or terminate circuits.

Equipment includes telecommunication systems that provide a service to an end-user, the management systems that are used to manage such systems, and the end-user hosts and terminals. Equipment also includes physical units of functionality within these systems (e.g., CPU).

Data Elements:

Equipment type
Equipment ID
Equipment alias
Equipment status
Equipment release
Parent equipment ID
Child equipment IDs
Location ID
Network IDs
Customer IDs
Provider IDs
Service IDs
Vendor IDs
EMS IDs (= equipment IDs)
Contact IDs
Effective time

Class Name: Facility

Class Definition: A physical connection between equipment in two different equipments without any intervening equipment. A facility is geographically distributed functionality and excludes the equipment within the associated equipments. The function of a facility is to support the transport of circuits (0 or more).

Data Elements:

Facility type
Facility ID
Facility alias
Facility status
Endpoints (= 1 or if known 2 Equipment IDs)
Network IDs
Vendor ID
Effective time
EMS IDs
Contact IDs

Class Name: Service

Class Definition: An offering from a single provider which supplies a specific network functionality to one or more customers.

Data Elements:

Service type
Service ID
Service alias
Provider ID
Contact ID

Class Name: Circuit

Class Definition: A logical point-to-point connection between two end equipments which traverses one or more facilities and possibly one or more intermediate pieces of equipment. Circuits may be simple or complex. A simple circuit is supported by two end pieces of equipment and an interconnecting facility. A complex circuit is supported as well by intermediate equipments and additional facilities. In general, a complex circuit consists of an ordered sequence of (1) less complex circuits of the same bandwidth and (2) associated cross-connects within any intermediate equipments.

A parent/child relationship may also exist between circuits in that a circuit may share the bandwidth of another circuit.

Data Elements:

Circuit type
Circuit ID
Circuit status
Circuit alias
Circuit bandwidth
Endpoints (= 2 Equipment IDs)
Facility IDs (1 or more)
Parent circuit ID
Child circuit IDs
Component circuit IDs (for complex circuits)
Cross-connect IDs (for complex circuits)
Circuit group ID
Network ID
Customer ID
Provider ID
Service IDs
Effective time
EMS IDs
Contact IDs

Class Name: Application and system software

Class Definition: Program having responsibility for executing applications and systems-related tasks.

Data Elements:

Software type
Software ID
Versions and level
Options
Fixes
Warranty information
Date installed/removed

Class Name: Location

Class Definition: A place occupied by one or more managed objects or persons associated with object management.

Data Elements:

Location type
Location ID
Location alias
Customer ID
Provider ID
Parent location ID

Child location ID
Location level
Location details
Geographic coordinates type
Geographic coordinates
Contact IDs

Class Name: Contact

Class Definition: A person having responsibility for a specific location, function, or network object

Data Elements:

Contact type
Contact ID
Contact alias
Contact details
Location ID

- Reduce clerical costs
- Improve contract control
- Facilitate budget preparations
- Make equipment and vendor selection objective

Figure 7.3.1 shows where users usually start with building an integrated configuration data base. The situation may be summarized as follows:

- Fragmentation by logical, electrical, and physical components supporting certain networking views only. Logical partitioning is well understood due to the support of network architectures.

 Electrical and physical partitioning are not yet fully in operation. In most cases, the users have to deal with a large number of files that have been growing, unchecked, over time. Usually there is no synchronization between the individual files.
- Contradictions in addressing and naming cause serious problems during troubleshooting, change management, and capacity planning. Usually, components are seen and identified differently by various measurement and management instruments.
- Redundancy is caused by storing the same or similar information in different data bases or files. Considerable amounts of storage places and processing time are saved after integration occurs.
- Lack of synchronization may cause severe problems due to the different upgrade level of the data bases.

As emphasized earlier, target status is an integrated relational data base supporting OSI naming and addressing conventions.

An integrated data base may be considered a source for generating all

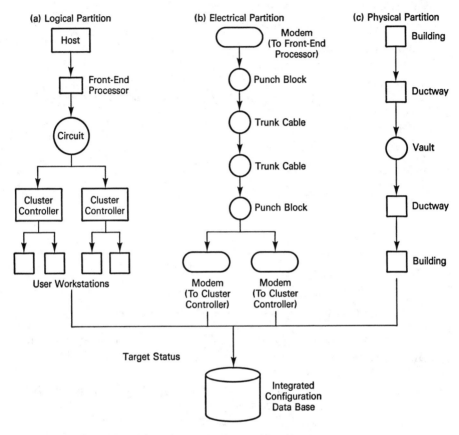

Figure 7.3.1 Segmented data bases.

configuration views applied by various software and hardware products. If properly implemented, the following benefits are recognizable:

- Less redundancy
- Synchronized change management
- Unique names and addresses
- More efficient troubleshooting
- Easier capacity and contingency planning

International standards committees have been trying to make progress in this area. The managed objects are managed using four major indicators:

Existence—A managed object *exists* if it has an object identifier and an associated set of management information that is accessible through OSI Management services.

Managed objects can be created or deleted. To create a managed object, the user places into the MIB the object's identifier and a set of information appropriate to the object's class.

Attributes—These describe properties of the object, such as operational characteristics. An attribute has an ID and a value. During the object's existence, only the values can be changed—the attributes themselves cannot be created or deleted.

State—This represents the instantaneous condition of the object's availability and operability. For example, a multiplexer's state may be represented as 11, meaning available and operable. Conversely, state 10 may indicate available, but inoperable.

Relationships—These define the interdependence between the managed object in question and other managed objects. For example, a relationship exists between an OSI terminal and the OSI packet switch that provides protocol processing and routing for that terminal.

MIB (management information base) is the carrier of all types of entries, but is not and will not be defined physically or logically by OSI. The MIB concept is actively used by products managing local area networks on the basis of SNMP (Simple Network Management Protocol) [DANM90A]. CMIP-based MIB updates are available from the OSI Network Management Forum.

SMI (structure of management information) may be helpful in planning and implementing information bases despite its very abstract nature.

The SMI standard defines the logical structure of OSI management information, which includes any information that may be the subject of OSI management communications. This information is structured in terms of managed objects, their attributes, the operations performed on them, and the notifications that objects may issue. The SMI standard defines managed object concepts within the OSI information model and sets out the principles for naming the managed objects and their attributes. Objects must be named in order to be identified in OSI management protocols.

The SMI standard also defines a number of subobject types and attribute types that are, in principle, applicable to all classes of managed objects. These definitions include the common semantics of the object/attribute types, the operations performed upon them, and the notifications they issue. The definitions also cover the relationships that may hold between the various types.

7.3.2 Network Topology Service

Network topology service is supported by the data base of current and historical network configurations. Layered configuration displays of the physical, logical, and electrical layout of the network and its components have to be supported individually or in an integrated manner. In other words, both dynamic and static configuration data may be requested by the various network-management functions.

Figure 7.3.2 illustrates the mixture of both types: dynamic data drive

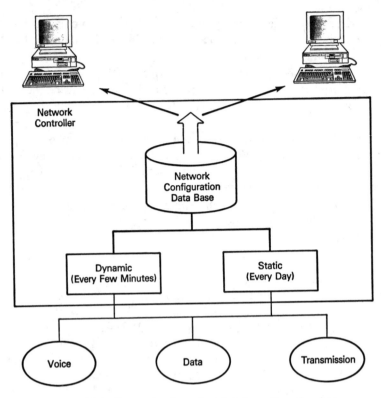

Figure 7.3.2 Integrating dynamic and static configuration data.

fault management-oriented displays for supporting event filtering, management, consolidation, and correlation of alarms, trouble ticketing, and problem resolution; static data in most cases handles reporting and statistics. Static data refers to network configuration information such as the existence of certain elements in a particular location or the number of circuits in a circuit group. This information is changing as a result of service order processing or of change management.

Figure 7.3.3 shows the integrated view using entries from both physical and logical status indicators; in most cases this screen or similar ones are the practical interfaces between fault and configuration management.

In order to support selected functions of configuration management such as inventory control, change management, provisioning, and fault management, such as troubleshooting, workarounds, and problem diagnosis, the configuration data base has to offer multi-layer display capabilities. Recommended layers are (Figure 7.3.4):

- **Network:** Displaying all the network, indicating problems by color changes
- **Region:** Displaying the more detailed configuration of a region experiencing problems

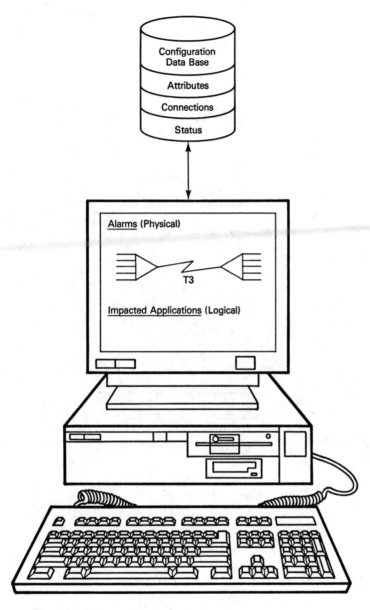

Figure 7.3.3 Integrating physical and logical views of the network.

- **Elements:** Displaying in-depth information on the element with problems; the level of detail may include any single item, used in the inventory data base of the element (see Table 7.3.1 for examples).

Not everyone has a ready-to-use product for offering topology services. Frequently, users are expected to design and implement home-grown solutions. For such cases, the process may have the following principal elements:

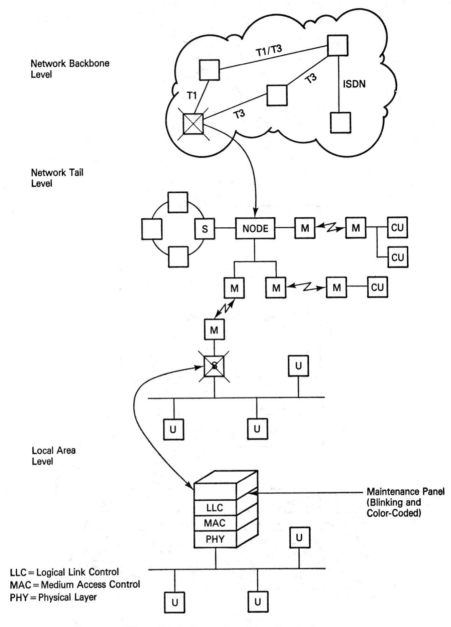

Network Backbone
Level

Network Tail
Level

Local Area
Level

Maintenance Panel
(Blinking and
Color-Coded)

LLC = Logical Link Control
MAC = Medium Access Control
PHY = Physical Layer

Figure 7.3.4 Layered configuration display.

- Identification of information sources, because both software- and hardware-based instruments have to be considered. In many cases, network element management systems and/or monitors provide the requested information.

- Design criteria may include layout, window allocation, zooming, use of functional keys, colors, alert status differentiation, screen-refreshing rates, message recycling.
- A decision must be made determining which information source (if any) is meeting the most design criteria. If the answer is "yes," displays are expected to be designed around this particular tool.
- In case of a "no" answer, information from various sources has to be processed, reformated first, and then integrated with other information sources.
- Hierarchical levels help operators to quickly recognize problems. At the same time, however, operators must not be overloaded by too many details. Alternatives for the entry display screens are:
 by communication forms (voice, data, video, word, image)
 by application groups
 by data centers
 by backbone and boundary network
 by WAN, MAN, and LAN
- Implementation includes testing the solution selected and functioning the parameters, such as colors, screen-refreshing rates, zooming speed, and allocation of windows.

Figure 7.3.5 shows the flowchart of the design and implementation process. In addition to managers and administrators, support desk personnel, network operators, and technical support are also primary users of the multiple-layered configuration displays. Present platforms allow more graphics, colors, zooming, and windowing.

The documentation of the generated network is frequently the most promising entry for the topology service. For the SNA-world, two products: SNA*DOC from International Business Link and NET*EDIT from Systems Center are important.

Topology services are also important with local area networks. Promising results are available in the TCP/IP environments when using SNMP. Actual configuration and element status are stored in the MIB, which drives the configuration display application, as shown in Figure 7.3.6.

Network topology services are extremely important for suppliers of value-added and packet-switching networks. In combination with fault management functions, network displays help to recognize functional and performance bottlenecks in real time. Reactive and proactive actions help to restore the expected high level of service toward customers. The network control centers of these suppliers are expected to be much better equipped than those of private enterprises.

Particular emphasis is usually placed on virtual circuits, PADs, and any other key nodes converting native protocols into the proprietary or standard protocol format of the supplier. Breakdowns or even slowdowns may have a

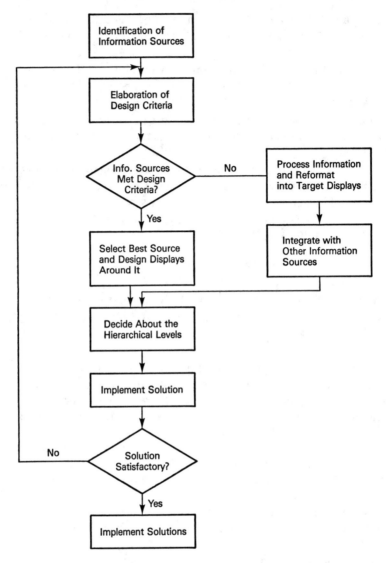

Figure 7.3.5 Process of designing network configuration displays.

catastrophic impact on the overall service level, which may risk the suppliers' business with their clients. In addition to displaying the status of primary routes, alternate routes also have to be indicated and specified in the event of facility failure.

Equally important are displays of interconnected LANs using bridges, routers, brouters, and gateways as information sources for driving the topology service. Early warnings on status may help to identify problems even beyond the demarcation line between service provider and user just in time to indicate the probable cause and recommended actions to the user administrator.

SNMP Configuration Management

SNMP supports configuration management via the SET command. This figure displays a sample configuration screen within a 10-node subnetwork. (Source: SNMP Research.)

(DANMGDA)

Figure 7.3.6 SNMP configuration management.

7.3.3 Service-Level Agreements

The indicators on the present service level are summarized—using the network-management data base—for further assessment by reporting options. Network administration is expected to evaluate service levels over a long period of time. If the actual status matches the planned figures, network administration issues a status report on present status, stating that neither tuning nor renegotiating of the service level is required.

Service-level management involves an application of a standard methodology to ensure that commitments for customer service levels are consistently met. The effect is increased planning and decreased crisis management. An SLA is, most simply, a formal written contract. Simple or elaborate, service-level agreements contain the following elements [WITZ83]:

- Identification of the contracting parties
- A description of the work to be processed, including type, volume, mix, and time of arrival
- The service levels to be provided, including response time, turnaround time, deadlines, accuracy, and availability
- A performance-reporting procedure with frequency and types of reports to be provided to users and data-center management specified
- Penalties for noncompliance
- Provisions for modifying the agreement
- An expiration date

In addition, if the network management center uses a charge-back system, the rates for each service provided must be stated, along with a description of each service. The elements of an SLA are examined next.

Identification of the contracting parties

The SLA begins by identifying the parties involved, that is, the network center and the department or organizational entity, which will be presented work for service. In establishing an SLA, the customer is made as responsible as the network center for ensuring that a production system runs properly. Since the network center should be promoting business goals, the service levels described in each SLA should support those goals. In order to ensure that business priorities are reflected in SLA, a representative of management who is familiar with the company business plan should review and sign off on SLAs, thus approving the classification scheme used to assign service levels.

Workload description

The customer supplies his or her best estimates of the expected volume of activity associated with each application. Will inquiries follow the typical midmorning and midafternoon peaks? Will volume vary by day of the week,

day of the month, season? The systems staff may wish to specify different service levels for peak and nonpeak periods or for lower priority work under certain circumstances; for example, if capacity is adequate to handle normal peaks but not unusual peak periods, it may make sense to plan to change priorities for some applications.

The other critical aspect of the workload description is the size of the job (e.g., the number of sales listed on that daily sales report). While the systems staff, because they have technical backgrounds, may be more interested in calculating CPU service units associated with this report, the customer can, however, distinguish between complex inquiries (list customers in a certain city with annual purchases greater than X) from the simple (locate company XYZ to determine the name of the purchasing agent) and from the trivial (change a customer's telephone number).

Service levels

The areas of service that matter most to users are responsiveness, accuracy, and availability. All time measures should be reported and discussed in customer-perceived terms. This means that response time should not be the internal response time provided by mainframe software tools but the time for the response to return to the terminal. The customer cares little whether the cause of poor response is due to mismanagement of network performance, improperly allocated main storage, or hardware problems. It is critical to define when a job or transaction is complete. Does it occur when it is enqueued to the printer, printed, burst, or delivered? Since it may take hours for manual distribution, the user must agree to a mutually accepted definition of "complete." The agreement might state that reports will be "available" (burst and sorted into the appropriate output bin) by or within a certain time.

For on-line work, internal response time will be the only readily obtainable response-time measure if a network monitor is not available. In general, internal measures are not a suitable proxy for external response time unless network time is consistently small (see Chapter 9 for a more detailed discussion). In that instance, it will be necessary to take measurements from time to time to verify user perceptions. The main points to remember are that one should commit only to service that can be measured and one should make sure the customer understands and agrees to the measures that will be used.

Responsiveness varies by need and purposes. On-line work is measured by response time, usually in seconds. The key to constructing an achievable response-time objective is to build in a margin of safety. For example, if the systems staff knows that on-line inquiries by the sales department average 2 s each, they should not succumb to the temptation to commit to 2 s or even 3. A few wildly high values could skew the average for the reporting period above the acceptable level. Instead, they should specify an average response range and the percentage of time that average will be met. They might write "on-line inquiries will, on average, be processed in between 1 and 3 s 95% of the

time." Of course, they need also to allow for short-term growth and unexpected problems by adding a cushion around the current 2-s average.

Turnaround time refers to the length of time it takes to complete a job after the job is input to the system. As with response time, service objectives should be expressed in averages to be met a certain percentage of the time. A *deadline* is the time by which the report must be available to the user. Not only the finished deadline but the time by which the user must submit data or the job itself must be specified. *Availability* refers to the proportion of time the network management center's services can be used. In most instances, this measure is meaningful only for on-line work but is a critical issue if the customer is being charged for use of equipment on a monthly basis. Both scheduled and unscheduled downtime should be reported.

For monitoring and control of medium-term availability, the availability control chart may be used. Typically, the control band spans three standard deviations above and below the mean, or expected, value of availability [AXEL83]. In Figure 7.3.7, the expected and upper-level availability are horizontal lines that may be valid over middle term only. In the figure it may be observed that the fourth observation pumps outside the upper limit, indicating an availability problem. However, investigation shows a random environmental effect as a result. After the environmental conditions return to normal, the availability moves back inside the control range. Several observations show the upper limit is violated again later; it is discovered that the increased nonavailability is due to component overload in the network. After proper load balancing, the availability returns to normal again.

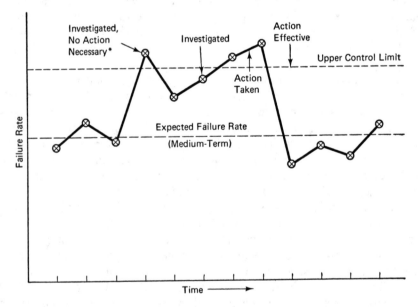

*High Failure Rate Due to Unusually High Transaction Volume

Figure 7.3.7 Quality control chart.

Accuracy, also expressed as a percentage, refers to the number of jobs run without errors. Errors include mounting the wrong tape, printing on incorrect forms, retransmission reruns, and so on. If a check-back system is in place, financial incentives for improving data center accuracy can easily be developed. Information transmission accuracy is becoming an essential part of overall accuracy.

Performance reporting

The performance report compares planned and actual workload characteristics and service levels obtained during the reporting period. By comparing both workload and service, it becomes easy to determine if missed service levels were due to excess work or inadequate performance on the part of the data center. Furthermore, consistently large variances on either the workload or service areas indicate that the SLA itself may need revision.

The performance reports should be regular (monthly, weekly, etc.), and copies should go to the customer department, network-center management, and capacity-planning staff. The reports should come from the network-center management, which has responsibility for all the functions (network performance, systems software, data-base management, etc.) that affect response time. The key to effective reports is simplicity. Performance reports provide an opportunity for identifying impending problems and proposing solutions in advance. They are a key tool for avoiding crisis management, or the "fire-fighting syndrome," by planning and control. Sample genenic reports are given in Chapter 9. Not only is a high level of service required, but documentation on this level of service on a factual basis must also be given.

Penalties

If a charge-back system is in place, creating penalties for noncompliance is relatively simple. If the customer's work exceeds the level described in the agreement, then surcharges can be assessed. The network center can be penalized by having to pay the customer a fixed amount for unscheduled down times or by charging lower rates for service that is poorer than specified in the SLA. Without a charge-back mechanism the quantification of the agreement is much harder. Network and data-center staff can be made to work overtime to correct mistakes that jeopardize commitments; however, customers have little intrinsic motivation to abide by the agreement without financial incentives. Penalties alone may have little impact, since the extent to which both the customer and the network center staff take seriously the commitments described in the SLA is a reflection of the importance of SLAs to senior management. The ultimate penalty to both parties, of course, is service degradation.

Provisions for modification

Somewhere in the agreement, preferably in the front, the provisions for modifying the agreement should appear. Basically, the provisions should allow for either the customer or the network center to reopen negotiations and

for management approval if the priority of the work is to be changed. Generally, changes should be made only after an analysis has demonstrated that the problem is not an aberration. Trial agreements for new services could be a meaningful approach.

Expiration date

The agreement should be written as ending after a certain period of time, such as a year, or by the end of the fiscal or planning year. Alternatively, all SLAs might be scheduled for revision after expected changes to hardware, network, or software. Above all, no one should be under the impression that the SLA is a commitment for eternity despite changes in the business or processing environment. Table 7.3.2 summarizes the consequences for the alternatives of different service-level agreements. Figure 7.3.8 displays the results by using the response time $= f$ (utilization) curve for the three policies identified by 1, 2, and 3.

TABLE 7.3.2: Consequences of Different Service-Level Agreements.

| | Management Criteria | | |
Policies	Level of Service	Resource Cost	User Cost
1	User requirements will always be met.	High—substantial excess capacity	None—service levels always met
2	Service will be degraded at highest volume periods.	Moderate—some excess capacity	Moderate—loss of business during peak periods
3	Service will be degraded during all peak periods.	Lowest—little or no excess capacity	High—unhappy customers

7.3.4 Designing, Implementing, and Processing Trouble Tickets

The importance of trouble tickets for tracking vendors' performance, for controlling the trouble resolution process, and for using them as input for the knowledge base of expert systems is obvious. But, with regard to supervising service-level agreements, trouble tickets may deliver the most valuable input for availability calculations.

For preventing future network outages, reports on causes of any breakdowns are vital. Network administration is responsible for

- Designing the layout of tickets
- Determining procedures for entering and closing trouble tickets

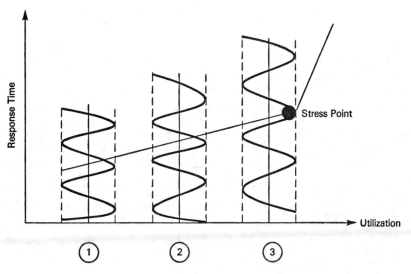

Figure 7.3.8 Consequences of different service-level agreements.

- Linking trouble tickets
- Processing and evalution of trouble tickets
- Tracking of unsolved problems

Figure 7.3.9 introduces a form applicable in almost every environment. It includes identifiers such as date, site, network, problem, technician; contacting information, such as vendor, contacting person, address, and phone; time definition for occurrence, notification, response, recall, and clearing; problem description, such as component status, problem status, priority, responsibility, detailed description, escalation, and reason for outage. Finally, total outage time and preventive-maintenance data are included. This form may then be used as a formated screen for the help desk.

Depending on the operational environment, entering procedures are designed primarily for the help desk. The event for entering may be triggered by any customer calls or exceptional-status reports. Closing tickets is possible after the restoration of normal networking conditions. This process can be illustrated by the joint use of Info/System [IBM81E] and NetView [IBM81B]. Time stamps are usually kept to determine the outage time due to problems. Segments may include:

- Time reported, T_0
- Time received by the responsible group, T_1
- Time network service restored, T_2
- Time vendor notified, T_3
- Time vendor responded, T_4
- Time vendor restored, T_5

Date/Time TO =	Site		Tech Name	• Severity • Responsible • Received
Network ID	Line ID		Terminal ID	
Vendor	Contact Name		Contact Phone	
GMT Notification T3 =	GMT Response T4 =	GMT RE-Call T6 =	GMT Cleared T5 =	
Problem Description "Device ID • • • "				
Escalation: Yes/No				
Action Taken-Service Restored: T2 =				
Progress				
Reason for Outage		Comments		
Total Outage Time		PM Data		

PM = Preventive Maintenance
GMT = Greenwich Mean Time

Figure 7.3.9 Sample trouble ticket.

Using these time stamps, statistics may be calculated for

- Total vendor time $(T_5 - T_3)$
- Total user nonavailability $(T_2 - T_0)$
- Total service outage $(T_5 - T_0)$

Network administration is in charge of further processing and evaluation of trouble tickets for completed problems. The processing could be accomplished by

- Responsibility area
- Vendors
- Components
- Call analysis (Figure 7.3.10)
- Response performance by the vendors and/or by a responsible group
- Elapsed time or its component
- Incidents
- Outage resolutions

Usually, multiple-level trouble tickets are implemented. The levels may completely or partially correspond to the problem determination levels. The first entries are completed by the customer support desk; these may include the

RUN DATE 10/01/90

RESPONSIBILITY CALL ANALYSIS
FROM 09/01/90 TO 09/14/90

```
*****************************************************************************
RESP NAME & ADDRESS              NUMBER  PERCENT              NUMBER  PERCENT
*****************************************************************************

200  AMDS CUSTOMER SERVICES      NEW *************   10   34.4   COMPLETED          4    13.7
     OAKRIDGE RD. BLDG. 13           *************                OPEN               4    13.7
                                 OLD *************    3   10.3   CANCELLED          2     6.8
     ORLANDO        FL           TRANSFERRED IN      16   55.1   TRANSFERRED OUT   19    65.5
                                                    ------ ------                 ------ ------
                                 TOTAL               29    4.4   TOTAL             29     4.4
                                                    ====== ======                 ====== ======
                                 DUPLICATES           0    0.0   INCOMPLETED        6    20.6

*****************************************************************************

2000 AEROSPACE CUSTOMER SERVICE  NEW ************    12   50.0   COMPLETED         13    54.1
     MAIN PLANT                      ************                OPEN               5    20.8
     2ND FLOOR                   OLD ************     5   20.8   CANCELLED          2     8.3
     ORLANDO        FL           TRANSFERRED IN       7   29.1   TRANSFERRED OUT    4    16.6
                                                    ------ ------                 ------ ------
                                 TOTAL               24    3.6   TOTAL             24     3.6
                                                    ====== ======                 ====== ======
                                 DUPLICATES           0    0.0   INCOMPLETED       18    75.0

*****************************************************************************
```

Figure 7.3.10 Call analysis.

use of information from the user calls and from information-extraction devices, such as network monitors and communication software features. At least, the problem point of outage can be determined at this level. Operational control is expected to enter a brief summary of symptoms as well.

The priorities of problem solution by the responsibility group depend on the estimated impact of a certain problem in terms of end users affected by the problem. Priorities may be set by availability levels such as

- Application breakdown
- Source- or destination-node breakdown
- Primary-end communication problem
- Secondary-end communication problem
- Single-component problem

Depending on the nature of the problem, the customer support desk should forward the first-level trouble tickets to responsible groups in operating (second-level) or to technical maintenance (third-level). Prior to sending the trouble tickets, the links to existing first-level trouble tickets are checked. If they match, that is, within 2 up to 8 hours, no new tickets are opened, but problem weight is increased. Artificial intelligence (AI) may considerably increase efficiency and speed by search for matches. New AI processors are able to use the symptoms segment for matches. Once opened, trouble tickets may be accessed until closing by authorized network-management personnel. Trouble tickets become part of network-management data bases.

Not all problems can be resolved within the time limit requested. Tracking of unsolved problems contributes to better problem and vendor management. Figure 7.3.11 shows a sample of pending problems. Network administration may consider several alternatives in such situations:

- Informing users and requesters
- Changing problem weights
- Increase of problem priority
- Alerting management groups in charge
- A combination of all of these solutions

The following may work as alerting parameters [TERP87A]:

- **Chronological:** Alarms can be accessed within a selected time window. Events may be sorted by date and time, so that each of them has a separate printout.
- **Site basis:** All alarms should be accessible by individual networking site, sorted by name.
- **Problem (trouble) type:** Alarms should be accessed based on preselected type. For a certain type, historical records can be provided. Thus, particular trouble events may be tracked over time.

UP 45771218

統　一　發　票（二聯式）（省）

中　華　民　國 83 年 3 月 11 日

品名	數量	單價	金額	備註
	2件		1187	

買受人：
地址：　　縣市　　鄉鎮市區　　街路　　巷　　弄　　號　　樓　　室

第二聯 收執聯

總計新臺幣（中文大寫）　仟　佰　拾　萬　仟　佰　拾　元
計 1187元

總　　計 1187元

稅　別	應稅	零稅率	免稅
	✓		

營業人蓋用統一發票專用章

信普視文化企業有限公司
統一編號 84388218
新竹市
TEL:712349
楊
經水里學府路 327 號 1F

統一發票給獎辦法摘要

一、統一發票中獎號碼，每逢單月之二十五日開出，於（二十六）日刊登新副紙公告臺灣全國之中獎週知。

二、中獎人應於開獎後第十日起三個月內，憑中獎之統一發票收執聯，向左列全國金融機構洽領，逾期不行補發：

（一）特獎、雙頭獎、頭獎、二獎及三獎為合作金庫總部（臺北市昆明街77號五樓）及高雄支庫（高雄市六合路99號）及臺灣省各縣市政府所在地之支庫。

（二）四獎、六獎為各地合作金庫、臺灣銀行、臺灣土地銀行、第一銀行、華南銀行、彰化銀行、臺灣中小企業銀行、臺北市銀行及高雄市銀行。

三、前項各獎中獎金額及其他有關給獎事項，依統一發票給獎辦法之規定辦理。

領 獎 收 據		
貼 用 印 花	新臺幣	元正
	中獎人	簽章
	國民身分證統一編號	
戶籍地址		
	電話聯絡	

MAN LIST 412 PENDING PROBLEMS (BY LOCATION & SYSTEM) CSCALIF PAGE
TRIBUTE TO DP MANAGER SYSB PROCESSED 11/05/89 4:04

E	UNIT	VENDOR	LOGICAL NAME	PROBLEM DATE & ID	CONTRDL NUMBER	CATEGORY	RESP AREA	STAT	EVENT	INITS	DATE	TIME	ELAP:
3	00002	IBM	PRINTER2	7/04/89 0004	00000004	XX	IBM	DW	PROBLEM OCCURED	CSI	7/04/89	9:00	0.
									VENDOR INFORMED	CSI	7/04/89	9:10	0.
									ENGINEER ARRIVED	CSI	7/04/89	9:18	0.
									SPECIALIST ARR.				

PRINTER LOSES ALIGNMENT
OPERATOR CANNOT KEEP FORMS ALIGNED

******************** 1 PROBLEMS PENDING FOR TYPE 1403

E	UNIT	VENDOR	LOGICAL NAME	PROBLEM DATE & ID	CONTRDL NUMBER	CATEGORY	RESP AREA	STAT	EVENT	INITS	DATE	TIME	ELAP:
9	00001	IBM		9/04/89 0002	53279001	XX	IBM	DW	PROBLEM OCCURED	DT	3/01/89	9:11	0.
									VENDOR INFORMED	DT	3/01/89	9:15	
									ENGINEER ARRIVED				
									SPECIALIST ARR.				

TERMINAL DISPLAY REMAINED BLANK
OPERATOR CANNOT KEEP FORMS ALIGNED

E	UNIT	VENDOR	LOGICAL NAME	PROBLEM DATE & ID	CONTRDL NUMBER	CATEGORY	RESP AREA	STAT	EVENT	INITS	DATE	TIME	ELAP:
9	00001	IBM		4/04/89 0003	33279002	XX	IBM	DW	PROBLEM OCCURRED	DT	3/06/89	15:12	2.
									VENDOR INFORMED	DT	3/06/89	15:10	17.
									ENGINEER ARRIVED	DT	3/07/89	9:00	
									SPECIALIST ARR.				

GHOSTS ON SCREEN: COLOURS BLURRING
OPERATOR CANNOT KEEP FORMS ALIGNED

E	UNIT	VENDOR	LOGICAL NAME	PROBLEM DATE & ID	CONTRDL NUMBER	CATEGORY	RESP AREA	STAT	EVENT	INITS	DATE	TIME	ELAP:
9	00003	IBM		4/04/89 0004	33279804	XX	IBM	DW	PROBLEM OCCURED	DAT	3/10/89	15:25	0.
									VENDOR INFORMED	DAT	3/10/89	15:45	
									ENGINEER ARRIVED				
									SPECIALIST ARR.				

COLOURS OUT OF ALIGNMENT: GREEN
SHOWING AS YELLOW-BLUE

******************** 3 PROBLEMS PENDING FOR TYPE 3279
******************** 4 PROBLEMS PENDING FOR SYSTEM SYSB
******************** 11 PROBLEMS PENDING FOR LOCATION CSCALIF

MAL TERMINATION OF NETMAN REPORT 412

Figure 7.3.11 Pending problems.

The results of problem completion can further be analyzed and stored in related files, such as inventory and vendor files. Furthermore, network administration is responsible for working out procedures for using completed trouble tickets as an entry for the experience file, heavily used by the network operational control. During this procedure, trouble tickets may be compressed by means of artificial intelligence twofold:

- By symptoms, which are identical or sufficiently close to each other
- By reasons for outage, indicating all conditions that have led to the final conclusion

Using various segments of the network-management data base, a large number of cross references are possible. Trouble tickets, completed from inventory information for a certain site, may be used for exception reports.

Fundamentally, trouble diagnosing and reporting can be centralized, decentralized, or implemented in combination. If centralized, the central-site personnel are responsible for

- Receiving all trouble reports
- Coordinating isolation and restoral
- Providing trouble-cleared notification
- Carrying out restart procedures

If decentralized, the remote site personnel

- Accept and handle trouble reports
- Initiate restoring procedures in calling vendors and changing to spare equipment
- Keep records of site activity
- Notify central site of restoral

For optimization benefits, both alternatives should be combined in a straight-forward manner:

- Remote site personnel provide first-level diagnostics.
- Central site personnel provide higher-level diagnostics if not isolated and repaired after first level.
- Remotes site personnel may assist or may not assist following escalation.

In addition, maintenance and trouble logs can be established manually or via automation. These provide a running history of network-component performance. They are valuable as support information when dealing with vendors or suppliers for the purpose of obtaining better service, evaluating future purchases or rebates for outages. The recorded data will be used by the

problem coordinator for problem tracking and control. Summary type reports help to determine

- Customer help desk effectiveness
- Applicability of problem-determination procedures
- Customer education requirements
- Resource requirements

In addition, in-detail evaluations can be made. Some of the examples are the following:

- Call volume
- Percent of first-, second-, and third-level problem determination
- Percent of problem assigned properly the first time to the responsible group
- Time duration for problem solving
- Customer hold time

Products in this area should enable the problem coordinator to

- Identify customers having the most problems
- Highlight problem recurrence
- Ensure efficient middle-range problem resolution
- Prevent future problems
- Provide notification when problem escalation is needed
- Determine incorrectly assigned problems
- Improve timely resolution of all problems

7.3.5 Order Processing and Provisioning

Order processing supports the installation of new equipment and facilities, prepares and tracks service orders, provides access to vendor ordering systems, and updates inventory and configuration data bases when installations are completed.

A simple typical workflow process is shown in Figure 7.3.12. The flowchart emphasizes the single point of contact for handling all add, move, change, and delete requests. Table 7.3.3 illustrates the information demand for a typical station/trunk order processing example. Order processing is sometimes called resource provisioning.

Provisioning supports the movement of network components, updates inventory, and provides activation of nonscheduled and scheduled changes. It also prepares and tracks work orders for moves, adds, and changes.

The other provisioning technique is called service provisioning, which

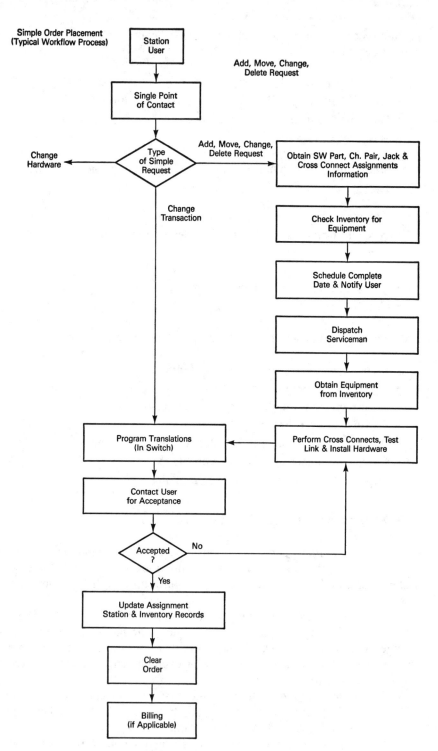

Figure 7.3.12 Example for simple order placement.

TABLE 7.3.3: Information Demand of Order Processing: Order Data for Station/Trunk Administration

- Time and data service order was submitted
- Service order number
- User phone number
- Point of contact and telephone number
- Work description (includes specific data such as class of service, equipment assigned)
- Requested completion date
- Status of service order (completion status)
- Actual completion date, time, and technician's name
- Costs associated with the service order (length of time to complete work)
- Identification of circuit and/or station line
- Building and room number
- Ordering priority
- Name, payroll number, title, and telephone number of authorizing manager
- Cable pair number
- ELL
- Station number assignment (if new user)
- Old station number (if number change only)

provides services supported by the network to customers. Processing the service order involves distributing it to all relevant organizations. If the order involves two or more organizational entities, such as an exchange carrier and an inter-exchange carrier, then performance requirements for each piece must be specified.

When a service order is received and verified, a functional-level design is determined to provide the requested service. This would be an identification of the transmission facilities and the functions needed at facility interfaces to provide the service. The network resources (i.e., the transmission facilities and equipment) will then be assigned to implement the service-providing architecture. The next activity involves any work required to install the designed circuit. The installed circuit is then tested to ensure that it meets performance objectives. Relevant data bases, such as equipment and facility inventory data bases and circuit layout data bases, must then be updated. Finally, the billing process must be initiated—for example, proper data must be sent to the accounting systems for preparation of customer bills based on usage (time or message unit transport); see Chapter 10 for accounting details.

With the advent of intelligent network elements (INE) with the attributes of software configurability, capable of storing data and being remotely controllable, service provisioning can be significantly improved [MALE88].

Figure 7.3.13 shows the service provisioning environment in an INE-based network. Each INE has a data base containing its own configuration data. The remaining data needed for service provisioning (e.g., customer data) could be stored at INEs or at the work center from which provisioning takes place. The division of data between INE data bases and the work center

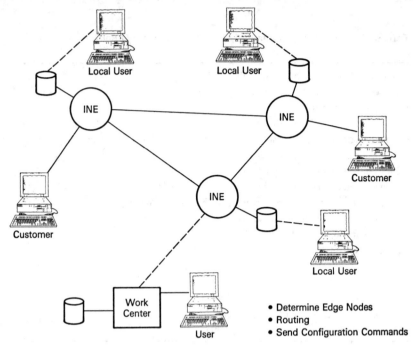

INE = Intelligent Network Element

Figure 7.3.13 Service provisioning overview.

data base is an issue that needs to be worked out based on the network architecture and economic considerations.

The local user at each INE needs to have access to an INE data base (e.g., for resource provisioning purposes). The user at the work center in this chart indicates the person performing the service provisioning. This raises the possibility of contention between the work center user and a local user to access an INE data base—an issue to be handled by the data base management system.

In this environment, service provisioning activities include determining the edge nodes involved in the circuit, determining a route in the network between the edge nodes that meets end-to-end performance objectives, and sending configuration commands to the INEs.

Order processing and service provisioning will more heavily use EDI (electronic data interchange) in future applications.

7.3.6 Change Management

When dealing with networks with many thousands of components, the question is not whether to make changes but rather how to manage changes. Network administration is the only place in the network-management organization responsible for

- Planning
- Approval
- Execution
- Documentation of changes

For scheduling and evaluating changes shown in Figure 7.3.14 the following information is needed by network administration:

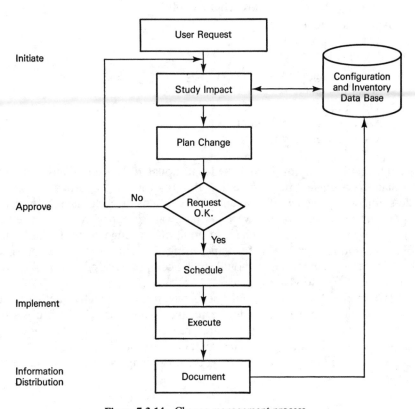

Figure 7.3.14 Change management process.

Change coordinator segment
 Identification of the change
 Change number
 Date of request
Requester segment
 Requester name and affiliation
 Location
 Change description
 Network components involved by inventory identification

Network components affected by change
 minor impact = change nondisruptive
 regular impact = change may be disruptive
 major impact = change disruptive
Due date
Priority
Reason for change
Personnel involved in executing the change
Fallback procedure when change fails

Approval segment
 Date of approval
 Signature

Evaluation segment
 Result of change
 Downtime due to change
 Date of actual implementation
 Cancellation or postponement

Usually, this information is provided and updated by using dialog-oriented automated systems. After evaluating this information, approval is issued, unless objections are stated. The approval contains the accurate schedule and responsibilities (e.g., for software or hardware groups). More frequently, single changes may invoke a chain of additional change requests. CPM and PERT techniques are useful for supervising the change procedures. After execution, the documentation should still be completed. Updates are required for the inventory and vendor files.

An emergency change would occur when the productive network was down and a change was made for restoring the network. In such cases the trouble-ticket information or cross-reference should be written onto the change format. The most promising method is to use interactive facilities for completing the administrative jobs involved. A change management data base may help to

- Get up-to-date information on present status
- Summarize change events by
 User group or category
 Components
 Date
 Priority
 Responsibility
- Display components affected by changes
- Display consequences of altering schedules

The change management functions should be automated as far as possible. Change requests forwarded to change management are used to open a

change-request record. This record—interactively accessible—can then be used to document the flow of the change through its life cycle. The close connection to the inventory data base is obvious.

Usually, batch reports are available as well:

- Approval report
- Change summary (Figure 7.3.15)
- Components affected by changes (Figure 7.3.16)
- Weekly schedules

```
format: change.hardware        select option          scroll: half

Change No: 801__ Tasks: 0_ Page 1_ of 1_ Entered: 09/13/86 By: nbn___
Category: hardware_____  Status: INITIAL_____ Approval: PENDING_
Change Description: install more DASD_____
Requested By: naomi_____ Dept: opns__ Phone: 3923___ Date: 9/13/86
Assigned  To: mike_____ Dept: ssu___ Phone: 3937___ Date: 9/13/86
Coordinator : chgcoord_____ Dept: tsu___ Phone: 3233___ Date: 9/13/86
Planned Start: 09/13/86____ System: ALLSYS___ Key item Affected: DASD___
Planned   End: 09/15/86____ Reason: ran out____ Associated C/R: _____
Est. Duration: 2____ Current Phase: _____ Risk Assessment: ____
Location Code: dp100_____ IPL Required: y IPL Type: ____ Priority: _

Device: a7866_____   Install or Remove: install    Upgrade: no_
Move -- From loading dock__   To computer_____ Must be Offline: yes
Maintenance Level: _____  Level of Microcode: _____

Description
installing more DASD because ran out of space._____
_____
_____
_____
_____

Backout Procedure
_____
_____
_____

Justification
ran out of disk space._____
_____
_____
_____

    approvals required  approval      date      reviewer class
       GTFOPS__                                    ssu____
       CHGCOORD                 _____    _____   tsu____
       QAG_____                 _____    _____   opns____
       _____                  _____    _____   dsu____
       _____                  _____    _____   ssu2____

  1=dupl f2=open f3=end f6=info f8=find f9=fill 10=open tasks
```

Figure 7.3.15 Change summary.

Cable management must not be underestimated as part of change management. Usually, cables are marked at both ends with standard identification, such as interface type, location, connection port, network, and so on. Cost

```
NETMAN LIST 702 COMPONENTS AFFECTED BY CHANGES
DISTRIBUTE TO DP MANAGER                                              PROCESSED   3/07/90  PAGE  1
                                                                                          9:20 AM

PRIMARY COMPONENT ID          CHANGES AFFECTING COMPONENT
LOC      SYS  TYPE     UNIT   CHANGE    TASK      DUE DATE   DESCRIPTION                         START DT   STAT  RESPONSIBLE  PRIO

CSCALIF  SYSA V/6      00001  CHG00001  TSK00002  5/03/89    ADD TEST RJE G SRJE IDS TO JES      2/23/89    APPR  MAN          0
                              C001087             1/01/89    IMPLEMENT SNA/VTAM                  1/12/89    REQ   MAN          0
                              C001087   TSK00002  1/29/89    BRING UP LOCAL OPS UNDER VTAM       12/01/89   INST  MAN          0

CSCALIF  SYSA 3420-2   00001  CHG00007            9/30/89    DEVELOP NEW PAYROLL SYSTEM          1/01/89    INIT  DAT          0

CSCALIF  SYSA 3705     00001  CHG00006            8/31/89    INVESTIGATE POWER MAINTENANCE SYSTEM 5/31/89   REQ   JAS          0
                              C001087             1/01/89    IMPLEMENT SNA/VTAM                  1/12/89    REQ   MAN          0
                              C001087   TSK00001  12/15/89   NEVADA LINE AS FULL SNA             12/01/89   INST  MAN          0

CSCALIF  SYSB CICS/VS  00001  C001087   TSK00005  4/02/89    CICST ID 1.5 AND VTAM              12/01/89   REQ   MAN <IO      0
                              C001087   TSK00006  4/09/89    CICSB ID 1.5 AND VTAM              12/01/89   REQ   MAN <IO      0
                              C001087   TSK00007  4/16/89    CICSA TO 1.5 AND VTAM              12/01/89   REQ   MAN <IO      0

CSCALIF  SYSB 4341     00001  C001087             1/01/99    IMPLEMENT SNA/VTAM                  1/12/89    REQ   MAN          0

CSNEVADA SYSA 3276     00001  CHG00001            5/01/89    PROVIDE MULTIPLE DIAL-UP TEST       2/23/89    INIT  DXH          0
                              CHG00001  TSK00003  5/03/89    TEST 3270 DIAL UP                   2/23/89    APPR  MAN          0
                              C001087   TSK00001  12/15/89   NEVADA LINE AS FULL SNA             12/01/89   INST  MAN          0

NORMAL TERMINATION OF NETMAN REPORT 702
```

Figure 7.3.16 Components impacted by changes.

effectiveness may be improved by installing cable patch panels, allowing quick changes by not losing visibility. All changes in cabling must be documented following internal change management procedures.

While the technology associated with cable management systems is generally mature, the following factors will influence their development over the next several years [ROTH91]:

1. New developments in the LAN and PBX/ISDN market will generate a variety of new requirements for cable management systems.
2. The imminent adoption of the EIA/TIA-568 Intrabuilding Wiring Specification will provide a standard foundation for developing new systems. It is important to recognize that these systems will be required to accommodate prestandard installations as well.
3. Advances in relational data-base architectures, including LAN server capabilities, will enable global transparent access to cable management data bases.
4. Integration of cable management software with the Simple Network Management Protocol (SNMP) will enhance users' ability to perform remote diagnostic network tests. It is likely that a time domain reflectometer (TDR) value (distance) will be used to identify and display fault locations on a CAD screen. Future cable management workstations may integrate TDR components within the cable management workstation, thus completely automating this procedure.
5. The development of expert system modules capable of performing routine diagnostics is highly probable with the next generation of cable management systems.

After successful implementation of change management procedures, network administration benefits in many ways:

- Reduced overruns of schedules
- Coordinated change implementation
- Improved problem solution cycles
- Better end-user service

Products under consideration for the change management area should have the capability to

- Standardize the process
- Provide approver and reviewer features
- Maintain change history
- Change using on-line techniques
- Interface to inventory and trouble-ticket management

- Provide exception notification
- Provide a variety of reports

In particular, for change impact analysis and for emergency changes, artificial intelligence may be implemented. Object-oriented or relational storage structure of the inventory data base enables network administration to make rapid evaluations, even during change management meetings.

7.3.7 Directory Services

This function is intended to provide a more or less temporary solution for accessing and updating configuration management related information stored in various systems, data bases, and files. These systems could be network elements or network element management systems which maintain data about specific network elements they control and manage, or applications that run on a variety of processor and operating systems. Although applications do not control or manage network elements directly, they play an integral part in managing information about these elements.

The directory service is needed to maintain a centralized logical view of the data stored in the attached network management systems. The data would actually physically reside in many of these different systems. Applications could then be written without regard to a specific DBMS. Data-base calls would simply be made to the directory in a standard format. The directory would then forward the data request to the appropriate system for processing. Each remote system participating with the directory would have to translate the data request into the correct data-base call for its particular DBMS and its schema. For example, the addition of a performance management application to the integrated network-management system would require interfaces to multiple systems. Some customers may use NetAlert from Boole to gather network-related performance data. Other customers may have Legent's NetSpy product to perform the same function for the SNA environment. These systems can build an interface to the integrated network management system allowing the sending of performance threshold alarms. However, the large volumes of performance data generated will not be sent, but accessed when needed by the performance application. The directory service will offer a standard way to access this data from each performance monitor.

Another illustration of a need for this type of architecture is with interfaces to other customer applications, such as inventory and change management.

Many large customers have inventory systems that support the administration of the network elements comprising their corporate networks. There are more than 100 different inventory systems on the market that store data in a multitude of relational and proprietary data-base management systems.

These inventory systems are usually mainframe based since they must support upwards of a 100 simultaneous users. The integrated network-management system cannot support this type of application, nor can customers be expected to replace their investments in those systems if it did. They would, however, like the ability for the integrated network management system to pass configuration information obtained from other network element management systems directly to their inventory systems in real time. This way configuration changes would only have to be made to one system accessing the directory, and the update could be propagated to all other systems requiring the data.

The directory service should also support the concept of multiple directories in a shared environment. This would allow for another copy of the directory to be running on mainframes. These shared directories could communicate any directory changes with each other. The shared directory concept would allow customers to write and use integrated network-management applications without affecting the performance of the integrated network-management system.

An example of this would be a user-written program to access the performance data base to obtain a listing of all the terminals in his or her network that had less than 10% utilization for the last 30 days. The same program could then extract location and contact information from the inventory data base. This may allow the user to reallocate these underutilized corporate assets. By accessing a copy of the directory on a mainframe, this program can obtain all the information it needs without adding any processing constraints to the processor of the integrated network-management system.

The directory service should provide reasonable response times to the user when accessing data. Access to the directory and forwarding of the request to the appropriate system should not add significantly to the response time. The response time currently provided by accessing any system directly should only slightly increase when accessed through the directory.

The directory service should manage updates to multiple systems. If an update requires records stored in several systems to be updated, some type of integrity locking must be performed on those records in each system. These locks should not be released until confirmation of a successful update has been returned from each system or some time limit threshold has been exceeded. If a successful acknowledgment is received from each system participating in the update, the locks should be released. Otherwise, the update should be aborted and backed out from each of the systems participating in the update.

The directory service is expected to incorporate a security scheme. It should be able to let customers define which terminals, user IDs, and applications can have access to different types of data. It should further define what type of access they can have, that is, read, update, add, and delete.

The directory service is most likely going to implement the emerging OSI standards for Directory Services (X.500). Although these standards are not yet agreed upon, users should be aware of their progress in this area. They

are currently working to see how the directory services attributes can be used to support distributed data-base access.

Data base import/export features have to be defined very clearly to avoid blocking and performance bottleneck while the features are in use. The data base import/export feature is intended to allow customers to load and extract data from the data base of the integrated network-management system. This feature should be designed to allow customers flexibility in determining which fields they want to load and extract.

Import. Many users have information about their network elements stored in a variety of inventory and DBMs. Much of this information makes up the optional fields and attributes in the configuration message set and configuration data base. This information, such as user or vendor contact and location, has already been input into other systems and they do not want to enter it again on the integrator.

These customers could write an extract or unload program against these data bases to create a file with the information needed to populate these fields in the data base of the integrated network-management product. This file should then be sent to the integrated network-management product with some type of file transfer program. They should then be able to load the file into the data base using some type of load program or utility.

Export. Users may have be interested in the ability to extract fault and configuration information from the data base of the integrated network-management system. This information can then be transmitted to their host processor for input into an inventory system or problem tracking and availability systems.

These users should have access to an internally developed user interface to unload and extract the tables, records, and fields they need into a file. Again, this file would need to be transmitted to a host processor where additional customer-written programs could process the data into new files for loading into these other systems.

The integrated network-management system should also keep a log of any changes made to the configuration data base. This would further allow customers to extract information on changes made to the configuration data base. This change log should keep track of changes for a user-definable time frame, for example, 24 hours, 3 days, 1 week. Figure 7.3.17 shows an example of exporting and importing information from/to various data bases and files.

7.4 INSTRUMENTATION OF CONFIGURATION MANAGEMENT

There is a wide range of instruments supporting single or more complex configuration management functions. The selection and allocation of instru-

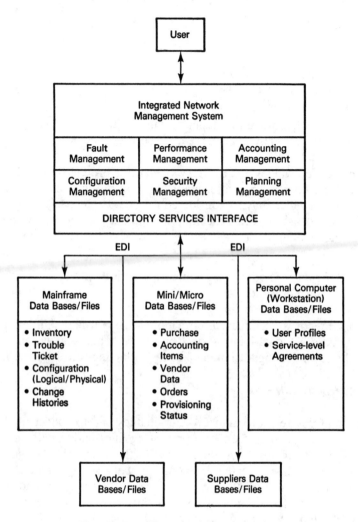

Figure 7.3.17 Example of directory service.

ments to functions is, however, more difficult than in other network-management subsystems. The reasons are many

- There are relatively few products that may be used without substantial customization.
- There are many general-purpose data-base products that are basically applicable for configuration management support, but the customization support may become very high.
- There are very few guidelines for comparing products or data bases.

- Configuration management activities and functions are very complex, and it is very difficult to serve all of them by one single integrated data base.
- Nobody starts from scratch; that means that the instruments under consideration have to at least be able to export/import information with existing solutions.
- It must be determined what performance criteria are realistic, and when dedicated data-base machines can be cost justified.

This section will give an overview on existing products for each category introduced previously. The major emphasis is on product selection and comparison criteria which may be considered as generic. References and description of products are kept to a meaningful minimum. However, examples are given for the leading products.

7.4.1 Special Products Supporting Configuration Management

This category of products offers a more or less turnkey solution. In many cases, the core is a data-base product or a file management system. In most cases, all relevant configuration management functions are supported.

Info/System (IBM)

The Info/System Program Product enables one to collect, update, retrieve, display, and report on data-processing information with the goal of improving the delivery of system services to the user. Installations can use Info/System to track and review problems, to plan and coordinate changes, to maintain an inventory of all system and network resources, and to access directly current information on MVS- and network-related objects.

Info/System provides an interface to the Alert Dynamic Screens of the NetView-Hardware monitor (Figure 7.4.1). This interface enables users to transfer problem data collected by NetView to the Info/System. Table 7.4.1 shows the information fields that are transmitted to the Info/System. Multiple sources of information are expected to be included as well. Additional sources must include service and resource-related figures, collected by NPM (NetView Performance Monitor) and/or by independent extraction devices. Furthermore, interfaces are expected toward the DB2-based repository, GDDM/PGF, SLR (Service Level Reporter), and SAS (Statistical Analysis System).

NetView/Asset Management allows operators to gather inventory data (such as device model numbers, etc.) from network components. NetView Asset Management offers some relief for users trying to control physical network assets, such as modems, micro- and minicomputers, communication controllers, switches, and multiplexers. For example, NetView/Asset can auto-

HARDWARE MONITOR
ALERTS DYNAMIC

COMMAND=NPDA ALD (OR SELECTION FROM NPDA MAIN MENU)

```
N E T V I E W                                    OPERA           07/29/87    13:18:56
NPDA-30A                          *      ALERTS-DYNAMIC *
DOMAIN: HOST1

DATE/TIME    TYPE    RESNAME      ALERT DESCRIPTION:  PROBABLE CAUSE
07/29  16:11 CTRL    P1262        FORMAT EXCEPTION: DEVICE
07/29  15:42 CTRL    T14C3TO5     ERROR TO TRAFFIC RATIO EXCEEDED:   COMMUNICATIONS
07/29  15:34 CTRL    T14C3TO5     ERROR TO TRAFFIC RATIO EXCEEDED:   COMMUNICATIONS
07/29  15:30 CTRL    T14C3TO5     ERROR TO TRAFFIC RATIO EXCEEDED:   COMMUNICATIONS
07/29  15:09 CTRL    P15C7        PARTIAL OR NEGATIVE ACK.:  DEVICE/COMMUNICATIONS
07/29  14:52 COMC    NCP42        OVERRUN:  COMMUNICATION CRTL/CTRL PROGRAM
07/29  14:17 CTRL    P24C9        ERROR TO TRAFFIC RATIO EXCEEDED:   COMMUNICATIONS
07/29  12:03 LINE    LN22         MODEM ERROR:  LOCAL MODEM OFF/LOCAL MODEM
07/29  10:42 CTRL    P2C4         TIMEOUT:  DEVICE OFF/REMOTE MODEM OFF/COMM
07/29  10:40 CTRL    12C2         PARTIAL OR NEGATIVE ACK.:  DEVICE/COMMUNICATIONS
07/29  09:44 CTRL    LN21         POOR LINE QUALITY: LINE
07/29  09:26 CTRL    P24C2        NEG SNA RESP: HOST PGM/HOST COMMUN PGM/DEVICE
07/29  08:44 LINE    LN24         MODEM CHECK:  LOCAL MODEM-LSL1 OFF/LOCAL MODEM
07/29  08:11 TERM*   P24C1        POWER OFF/INVALID ADDRESS:  DEVICE
```

DEPRESS ENTER KEY TO VIEW ALERTS-STATIC

???
CMD = = = >

- SCREEN DYNAMICALLY UPDATED
- LAST ALERT ON TOP
- AUDIBLE ALARM SUPPORTED
- ALERTS ARE THE EVENTS THAT PASSED FILTER
- ALL MANAGED DEVICES MIXED TOGETHER

Figure 7.4.1 Alert dynamic screen of the NetView hardware monitor.

TABLE 7.4.1: Import of NetView Information to Info/System.

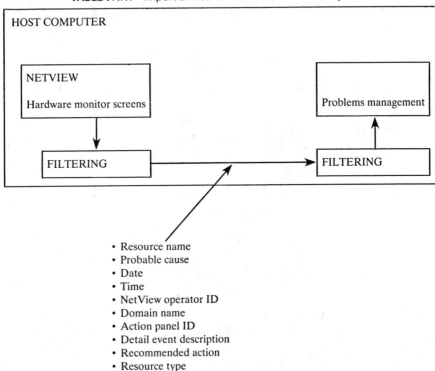

matically gather information such as model numbers and serial numbers from late-model IBM devices such as modems and communications controllers.

With higher NetView releases, controlling software inventory and changes, such as upgrades, comes under the province of NetView Distribution Manager. NDM also supports host-to-host communications.

The Problem Management Productivity Series software products also include a help desk tool that assists with facilities management. This tool frees operators from the burden of repeatedly entering data into the Info/Manager each time they receive a trouble call. The product provides valuable services but does not surpass competitive products.

NETMAN (Computer Associates)

NETMAN collects, revises, and inquires about the operational and relational characteristics of all physical hardware and software components in the data-processing-data-communications environment. It is an on-line management tool for data network management. It maintains complete information (configuration, financial and problem) in a single data base. It saves personnel time, prevents inappropriate payments, monitors contracts, reports all problems, plans for change, and produces budget input.

The data base covers the principal activities for the network administrator. NETMAN could serve as the nucleus of a comprehensive performance data base; however, efforts for extensions must not be underestimated.

Through on-line, integrated functions, the majority of network management problems can be solved. Virtually all mainframe-centered events can be recorded, tracked, and managed. Typical uses include:

- **Problem management:** Tracking problems from initial discovery through final resolution.
- **Customer-service response:** Coordinating support for data-processing customers to ensure timely response and good-quality service.
- **Inventory control:** Managing all components of physical inventories (hardware, software, furniture, and so on) to facilitate rapid problem resolution and coordinate maintenance efforts.
- **Project management:** Monitoring planned changes to ensure orderly completion of all tasks.

All types of events and the actions they trigger are drawn together within a single system. Integrated functions and shared data give a complete picture of each event and its impact. Managers have available the information needed to plan, direct, coordinate, analyze, and control the activities that contribute to the success of operating and administering the communication network.

Using the additional CRISS feature [MCCU82], the customer support desk activities can be automated to a great extent. But the product is heavily administration-oriented rather than network-performance-oriented.

Peregrine Network Management System (Peregrine, Inc.)

PNMS III [PERE86] is capable of addressing problem, information, inventory, change, financial, and configuration management. Not only the networking, but the data-processing environment may also be covered. Special emphasis is on problem management, including opening, updating, and closing a problem. At first, problems should be categorized. Information collection during opening and updating problems is by categories. After opening problems, responsibility groups track the problems to ensure rapid solution. Alert intervals are expected to be defined by the customer. The definitions usually correspond with the categories. Alerts—at multiple stages—notify management and assignment groups failure to meet problem resolution deadlines.

The modules are written in Peregrine's fourth-generation language, called Application Generator. This language offers the flexibility of changing and customizing applications. Near future applications will include support for internal order processing, performance modeling, NetView connections with an expert system for filtering and correlating information prior to transferring it to PNMS-III, LU 6.2 interface to exchange information with external applications, and also voice-related applications.

The Network Automated Problem Application (NAPA) from Peregrine Systems, Inc. is a series of software modules for filtering NetView-Hardware-Monitor alerts and status information. Properly used, this application helps to limit the number of trouble tickets to be open for networking alerts. NAPA works like an expert, and tries to identify related messages. NAPA supports four major applications, with network alerts, job dealing, general problems, and automatic routing. The application may be considered generic, insofar as other sources are going to be supported for the PNMS-family of administration products.

Telemanagement Information System (TMIS) (Telwatch)

The Telemanagement Information System (TMIS) offers assistance in the following areas:

- Network control for monitoring network devices and circuits, activating workarounds for problems, and assigning repairs to technicians.
- Call accounting for SMDR processing from single or multiple PBXs for station activity, project code, authorization code, exception, and multi-level summary reporting.
- Resale accounting for billing and accounts receivables for shared-tenant services, hospitals, and universities.
- Traffic analysis for precise costing, analysis, and optimization for single- or multiple-site networks.
- Inventory for managing the acquisition and use of equipment, PBXs, cable circuits, network circuits, and features.
- Service orders for generating, tracking, and analyzing trends in work orders to add, move, change, or remove.
- Trouble tickets for recording, prioritizing, tracking, and analyzing trends in problems and repairs.
- Inventory and service cost allocation/customer charges for equipment, circuits, features, and one-time services at user-defined multiple rates.

 The cost allocation version may be combined with call accounting for internal allocation of all telecommunications charges in a single report.

 The customer charges (billing) version may be combined with the resale accounting for external billing of all telecommunications charges in a single report.

- Bill reconciliation for checking vendor bills to detect and correct over-charges (requires some customization for each installation).
- Electronic directory for on-line directory assistance from multiple terminals for personnel and organizational entities including classified centers (yellow pages).
- Printed directory for alphabetical white pages and classified yellow pages by name, station, and so on.

TMIS uses sophisticated report generators, which give users the opportunity of custom designing content and format of any of the reports.

TMIS runs on UNIX^m-based processors to offer security, multi-user and multi-tasking processing, and the greatest flexibility in hardware and operations.

TMIS uses a relational data base so a single data entry automatically updates the entire system.

It is obvious that TMIS addresses multiple network-management functions for various communication forms.

Integrated Communications Environment (ICE) from AUXCO

AUXCO's private network system—Integrated Communications Environment with nine major modules (ICE-9)—serves the market with a completely integrated solution to an organization's private network-management needs.

Over the last several years, AUXCO has been successful in the marketing and support of LUCAS, AUXCO's Line Utilization and Cable Assignment System. This system, accepted worldwide, provides for most of the functions required in a private network administration system. The ICE-9 design draws on AUXCO's experience with the LUCAS software. LUCAS has served as a functional specifications baseline for the ICE-9 facilities assignment processing. AUXCO has acquired many years of experience with LUCAS and did not have to "reinvent the wheel" during the design of ICE-9.

ICE-9 incorporates functions of the LUCAS package to provide facilities assignment. Automatic facilities assignment is needed to speed the service order process and ensure the accuracy of inventory records. Systems without automatic assignment require double posting of information to manual forms and electronic systems. ICE-9 will be one of the few packages to address this area. Other packages omit this feature due to a lack of knowledge required for developing it. AUXCO possesses this knowledge, and was able to utilize it to provide a truly integrated system.

The marketplace is also asking for low-cost departmental systems, rather than mainframe solutions. AUXCO has addressed this need by developing ICE-9 on a Unix-based departmental processor.

The initial release of ICE-9 addresses each functional area expected in an integrated private network system. Future releases of the system will provide enhancements to create a more comprehensive system for larger organizations.

The system contains the following major functions:

1. Service-order processing
2. Trouble-ticket processing
3. Directory assistance and publishing
4. Equipment inventory
5. Employee administration

6. Switch administration
7. Frame administration
8. Cable and wire inventory
9. Billing

It is obvious with ICE-9 that multiple network-management functions for various communication forms such as voice and data may be supported.

Info/Master (Systems Center)

Info/Master is part of the Net/Master product family, offering help to network administrators in the areas of configuration, change, and problem management. The product is VSAM-based and is used in most cases in batch. The product is powerful with trouble tickets, which are automatically opened by NEWS and further processed by Info/Master. Users benefit in particular from the integrity of all three products, Net/-, Sys/-, and Info/Master.

In order to facilitate the comparison of various products and to select the right product, Table 7.4.2 summarizes the most important criteria. These criteria have been grouped by support of network-management functions, such as inventory, configuration, problem, change, and financial management, and by feature, including security, utilities, help, documentation, graphics, mailing, user interface, installation, and training.

7.4.2 General-Purpose Data Bases

These products have been designed and implemented for a wide range of applications. The products may be grouped as follows:

- Hierarchical data bases for large and very large applications. This group includes IMS (IBM), IDMS (CA), and ADABAS (Software AG).
- Relational data bases for various sizes of applications. This group includes DB2 (IBM), Informix (Relational Database Systems), Oracle (Oracle Corp.), Sybase (Sybase, Inc.), Ingres (Relational Technology), Unify (Unify Corporation), Access (Unify Corp.), Ingres (Relational Technology Inc.), Supra (Cincom), SQL/DS (Data General), and RDB (Digital). For relatively small applications. dBase III and dBase IV may also be considered and implemented. In most cases, compatibility with Unix is requested.
- Object-oriented data bases for various sizes of applications. In particular, applications in artificial intelligence have driven the progress of this technique. Solutions are expected from manufacturers of expert systems—for example, Symbolics with object-oriented structures of network elements and facts using generic and specific FLAVORS.

TABLE 7.4.2: Selection Criteria for Inventory Management Products.

1. Support of network-management functions

 Inventory and configuration management
 - What components are included
 - Links between entries
 - Auto-fill of fields
 - Reporting

 Problem management
 - Categories
 - Assignment groups
 - Alerts
 - Indicators
 - Links to inventory entries
 - Linking trouble tickets
 - Reporting

 Change management
 - Categories
 - Approvals
 - Change tasks
 - Impact analysis
 - Reporting

 Financial management
 - Financial inventory
 - Contract details
 - Budget and forecasting
 - Invoice reconciliation
 - Reports

2. Features

 Installation duration

 Training requirements

 Terminal access method

 Use of function keys

 Menu/command system
 - Support of experienced users
 - Support of novice users

 Editor and screen painter
 - Level of editing
 - Field attributes
 - Data dictionary creation

 Data dictionary utility
 - Data types
 - Structures
 - Nesting

 Data-base utility
 - Ad-hoc search
 - Query by Example
 - Structured Query Language
 - Mass updates
 - Export/import

 Report writer capabilities
 - Content
 - Periodicity
 - Level of details
 - Presentation form

 Electronic mail
 - Send mail to groups of users
 - Schedule mail
 - Broadcasting
 - Remainder service

 Logging
 - Message log
 - Event log

 Security
 - Levels
 - Change procedures
 - Passwords
 - Authentication

 Documentation

 Help facilities
 - User-defined helps
 - Screen help on-line
 - Tutorials

 Automation capabilities

In many cases, the volume of data to be stored and administered by the data base calls for special solutions with data-base machines. In such cases, not only the software, but also the hardware will be concentrated in a powerful input/output processing unit offering high-speed parallel processing. The first experiments with those machines (e.g. Teradata) show encouraging results. In particular, relational data bases need fast processors for ensuring adequate performance of the network-management system.

Recent surveys show that an integrated configuration data base, serving

multiple users, may require substantial resources; one single network element of this data base may require as much as 2 KB to 8 KB of storage place.

Table 7.4.3 summarizes the most important criteria for comparing the performance of relational data-base products.

TABLE 7.4.3: Evaluation of Functionality and Performance of Relational Data Bases.

Functionality

1. Components
 (Query language, report writer, editor, user interface)
2. System architecture
3. Indexing techniques
4. Data entry and data retrieval
5. Data-base maintenance; availability and recovery from crashes, support of standard and extended SQL
6. Host language interfaces
7. Multi-level security features
8. Availability of performance and system monitors
9. Data-base integrity and recovery
10. Availability of auditing functions
11. Documentation
12. Availability of end-user tools (programming languages)
13. Vendor support

Performance

1. Single user tests
 (Retrieving/selecting several records, joining tables, projection queries, aggregate functions, appending/deleting/modifying one record)
2. Multi-user tests
 (Retrieve script, update script, mixed script)
3. Gaedes test
 (Series of common UNIX commands, such as cat, is, cd, ed)
4. Performance in processing live on-line transactions

7.4.3 Computerized Cable Management

During the last few years a number of computerized cable management (CMS) products have become available to better manage telecom equipment and the physical plant. Because of overcrowded conduits, lack of standard cabling of data-processing equipment, and excessive changes, customers have started to request mass installation of standard media. Standard media are expected to support both voice and data communications. The use of standard media has to be combined with a powerful documentation and reporting system. Basically, there are three choices for improving cable management:

- Use a product that fits into the environment without any serious adaption needs.
- Abandon the company's own strategy and outsource cable management to vendors.
- Design, develop, and implement a system.

When evaluating CMS systems, there are several features that are essential. Unfortunately, however, they are often overlooked by vendors who emphasize fancier, less useful features.

The ability to track cables and cable pairs end-to-end. This is the most basic capability of a good CMS. The system should be able to display cable records from their originating PBX or computer port through several levels of patching and cross-connect hardware and finally to the end-user's desk. The system should explicitly display information including individual cable numbers, locations of cable terminations on main and intermediate distribution frames, and cross-connects between lateral and riser cables. The system should also be able to relate this information to user and department names or room and telephone extension numbers.

This capability enables a system administrator to quickly identify available riser pairs, spare station cables, and available equipment ports. Moves, changes, and troubleshooting can be accomplished faster if this information is accurate.

Capability to automatically generate information such as cable numbers, terminations, and cross-connects. This feature is overlooked in most CMSs, which require the user to manually enter these data for each individual cable run. In a small installation, this is not a major data entry problem, but it is not practical for large organizations with a lot of move and change activity or when purchasing a CMS in anticipation of managing a new installation.

If the CMS can generate detailed cable information automatically, it can be used to guide installers during the placement of new cables. With this feature, the user can actually begin to manage the cable plant as it is being built.

If purchasing a system to manage an existing plant, however, this feature will be of little use initially. The user will still probably have to go through the exercise of data entry. In the long run, however, it will save time and aggravation when installing new cables.

It is important that the format is compatible with other existing formats in the cable management area. Typically these systems tie the user into a particular numbering or termination scheme, generally the way the telephone company did it in the past. Typical products' characteristics are [NUCI89]:

Manage the attached equipment, as well as the cable plant itself. The system chosen should enable the user to have records of all telecom equip-

ment (both in-use and spare), including active and available equipment ports, location and status of end-user equipment such as telephones, terminals, and modems, as well as pending equipment orders.

Generate customized management reports. Hard copy reports should be available from the CMS detailing particular aspects of the telecom system. These include cable placement schedules showing the locations of individual cables; riser cross-connect reports showing pair availability; work orders for adds, moves, and changes; and other management reports.

Most CMSs have some report-generating capability, since it is inherent in all DBMS packages.

The ability to manage a wide variety of media. This important CMS feature is too often overlooked during product evaluation. It gives the user the ability to manage different types of media, including associated equipment, termination, and cross-connect hardware.

Almost all users have, and will continue to have, multiple types of media installed in their facilities. It would be counterproductive to buy one CMS for managing UTP (unshielded twisted pair) and a separate system or systems to manage the other media. The CMS chosen today must be flexible enough to support media that the user may install tomorrow.

The ability to manage the facility as well as the cable. The need for this capability is directly attributable to the market movement toward decentralized systems. The distance limitations of LANs and other distributed systems require up-to-date records of telecommunications closet sizes and locations; the sizes, lengths, and quantity of conduits and cable trays between equipment rooms; and the available riser space.

Most computerized cable management systems do not adequately provide this information, and some vendors have ignored this requirement altogether. There are several vendors who have tried to address this issue by integrating CADD packages with the CMS. However, most of the CADD-based CMS packages either do not take full advantage of CADD technology's considerable power or are not fully integrated with the CMS's DBMS.

Most of these packages simply identify the telecommunications cables, pathways and spaces, and their relationships to other building systems, by graphically overlaying them onto a digitized architectural rendering of the facility. While maintaining these accurate "as-built" drawings is important, it is often not important enough to justify the sizable investment required. This is especially true if the architectural records are not already available on CADD, in which case it is often easier to maintain the information drawings manually.

CADD becomes useful when it is fully integrated with the CMS's DBMS. The integration makes it possible to automatically update a cable data base when additions or deletions are made to a drawing. This feature is useful

when many changes are being made or new cables are being installed. As product examples, the COMMAND Cable Management System from Isicad, CRIMP from Cableship, Planet from Network and Communication Technology, LAN Mapper from Vycor, Cableware from Comcorps, and the Communication Resource Management System from Chi/Cor may be mentioned.

Cable management systems reside on a variety of hardware platforms. For the most part these are standalone PCs; however, they may be "networked" so as to enable distribution of the data-base resources in a client/server environment. A typical standalone hardware configuration includes the following [ROTH91]:

- VGA graphics card with 640 by 350 resolution
- 80386 or 80486 processor
- 2M to 4M bytes of memory
- Hard disk with approximately 5M bytes of RAM available for software (additional space will be required for data-base and CAD drawings)
- Mouse or pointing device
- Printer with wide carriage (or laser printer with landscape options)
- Optional plotter

Cable management software systems can manage a variety of wiring resources, including data, voice, LAN, and, in some cases, HVAC and control cables. Ideally, the software should perform the following functions [ROTH91]:

- Cable and path identification
- Cable route presentation
- Assignment of cable facilities and routes
- Tracking conduit "fill" and usage
- Identification of unused cable facilities
- Equipment inventory for attached components
- Tracking service order activity
- Maintenance of trouble report data base
- Management and operation reporting mechanisms.

Cable management systems use a variety of data-base resources. These relational data-base systems provide superior flexibility because they can use structured queries to construct different "views" of the information. In the case of a server-resident data base in a multiuser environment, the system should also facilitate remote procedure calls (RPCs), minimizing the amount of data to be transmitted and the client workstation's processing requirements.

7.4.4 Applicability of Artificial Intelligence to Supporting Configuration Management

Artificial intelligence may help in particular in the area of change and trouble management. Products are able to accomplish a number of comparisons, such as comparing actual symptoms with historic symptoms; to analyze the configurational impacts of any changes; and to drive the graphics for displaying the configuration. Expert systems execute all these tasks with very high speed and reliability. For successful operation, however, the configuration data base has to be maintained properly. Options on the right data base structure and language are widely spread.

It is recommended to continuously analyze the progress of the object-oriented solutions. When this is done, many issues promise an interesting future:

- The object-oriented structure unifies the characteristics of hierarchical and relational forms. During processing, various masks, such as hierarchical (e.g., LISP) or relational (e.g., PROLOG) are used. The result is great flexibility at the user level.
- Physical storage forms are flexible as well; depending on the processors used, firmware speeds up processing.
- Expansion is not critical because objects may be generated and inherited very easily.
- Functions and procedures may be designed and implemented for various levels of the data-base structure, ensuring the simultaneous use of multiple masks.
- Objects may be generated automatically using special utilities, called FLAVORS.
- Easy structures of facts (e.g., PROLOG) can be implemented.
- Easy maintainability of application code.
- By means of "connection" macros, multiple data bases may be permanently and/or temporarily interlinked, offering separated and integrated views at the same time. This feature is very important for displaying configuration status for supporting fault management.
- The demand of physical storage space is expected to be lower than with other techniques.

It is expected that not only special AI languages and operating systems, but also general-purpose languages, such as C or PASCAL, and operating systems, such as UNIX, AIX, VM, and MVS, may be considered for implementations.

Some users are in the process of evaluating Hypertext as an alternative configuration documentation tool. Hypertext may be considered as a central,

TABLE 7.5.1: Involvement in Configuration Management.

Functions	Configuration management	Other Subsystems					Level of possible automation
		Fault management	Performance management	Security management	Accounting management	Network capacity planning	
Inventory management	E		A			A	medium
Network topology service	E	S		S		A	high
Service-level agreements	E	A	S	S	A	A	low
Designing, implementing, and processing trouble tickets	E	S	S	A	S	A	medium
Order processing and provisioning	E					A	medium
Change management	E	S			S	A	medium
Directory services	E		S	S		A	medium

E - Executing
S - Supporting
A - Advising

TABLE 7.5.2: Distribution of Functions Among Human Resources.

Functions	Supervisor	Inventory Coordinator	Change Coordinator	Problem Coordinator	Service Coordinator
		Organization			
Inventory management	(x)	x	(x)		
Network topology service	(x)	x			(x)
Service-level agreements	(x)			x	x
Designing, implementing, and processing trouble tickets	(x)			x	
Order processing and provisioning	(x)		x		(x)
Change management	(x)		x		
Directory services	(x)				x

x = Committment
(x) = Involvement

still very flexible repository of all texts and graphics supporting both configuration and fault management.

The applicability of various instruments by the different organizational units supporting configuration management will be addressed in the next section.

7.5 HUMAN RESOURCES DEMAND OF CONFIGURATION MANAGEMENT

The third critical success factor of network management is its human resources. The functions discussed thus far should be adapted to the present organization within the information-systems department first. Based on the functions, processes, and procedures outlined, the targets of organizational changes can be determined. Table 7.5.1 summarizes the relationship of potentional organizational units to the key functions of configuration management. The indicators in this table constitute either execution of duties, supporting, or advising the type of involvement. The same table may be used as a starting point for estimating the range of labor demand for managing the configuration.

Configuration management is usually staffed by four different types of personnel:

Tools	Supervisor	Organization			
		Inventory Coordinator	Change Coordinator	Problem Coordinator	Service Coordinator
Monitors in network elements					
Application monitors				x	x
Software monitors				x	x
Modem and DSU/CSU monitors				x	x
Multiplexer monitors				x	x
Switch monitors				x	x
Line monitors				x	x
Network monitors				x	x
PBX monitors				x	x
LAN/MAN monitors				x	x
Network element management systems					
Voice orientation				x	
Data orientation				x	
Console management systems				x	x
Integrators	x			x	
Computerized cable management systems	x	x	x		
Automated call distributors				x	
General-purpose data bases	x	x	x		
Special administration products	x	x	x		
Networking models					

- Inventory coordinator
- Change coordinator
- Problem coordinator
- Service coordinator

Table 7.5.2 shows the distribution of functions among those human resources. In order to limit the alternatives for tool selection, Table 7.5.3 gives an overview of instrument classes under consideration for configuration management and their potential users in the configuration management hierarchy.

For estimating the demand in FTE (full time equivalent), Table 7.5.4 provides the quantification for the four major customer clusters introduced and defined in Chapter 1. The numbers represent averages, and are based on the results of many surveys and personally conducted interviews by the author of this book.

TABLE 7.5.4: Personnel Requirements for Configuration Management.

| Organization | Network Range (Number of elements) | | | |
	Small (< 3000)	Medium (3000–10,000)	Large (10,000–50,000)	Very Large (>50,000)
Supervisor	1	1	1	1
Inventory Coordinator	1	2	3	5
Change Coordinator		1	3	4
Problem Coordinator	1	2	4	6
Service Coordinator	1	2	4	6
Human resource demand				
Total	4	8	15	22

TABLE 7.5.5: Profile of Network-Administration Supervisor.

Duties
1. Assists in evaluating service levels.
2. Assists in financial forecasting and budget preparation.
3. Oversees documentation and recording of network expenditures and charge-backs.
4. Analyzes security risks and assists in preparation of security plans.
5. Supervises inventory control.
6. Supervises problem-management procedures.
7. Establishes educational program for staff.

External job contacts
1. Other supervisors within network management
2. Vendors
3. Network manager

Qualifying experience and attributes
1. Has knowledge of customer's business
2. Has ability for financial administration
3. Has communication skills toward vendors
4. Has training in administrative management

TABLE 7.5.6: Profile of Inventory Coordinator.

Duties

1. Manage the on-line configuration application, including establishment of requirements for this area.
2. Maintain the network configuration.
3. Maintain vendor information.
4. Know status of program and access methods used by the system.
5. Maintain security of inventory control records.
6. Track the delivery and installation of new equipment.
7. Implement coordination.

External job contacts

1. Technical support
2. Network operation, change, and problem coordinators
3. Customer support desk
4. Customers
5. Service coordinator
6. Vendors

Qualifying experience and attributes

1. Has knowledge of communications facilities and offerings
2. Has some knowledge of systems programming and data-base structure
3. Has inventory-control skills
4. Is familiar with conversion procedures and general project management

TABLE 7.5.7: Profile of Change Coordinator.

Duties

1. Coordinate overall planning and scheduling of changes.
2. Ensure adequate test plans for changes.
3. Coordinate implementation of all major hardware and software changes, installations, and deletions.
4. Maintain a current record of all planned and implemented changes.
5. Follow up and ensure that changes are put into the system according to plan.
6. Assume responsibility for total communication network.
7. Chair change meetings.
8. Prepare management reports.
9. Provide input to inventory control.
10. Evaluate vendors.
11. Develop change management standards and procedures.
12. Assess the impact of the change on existing operations.

External job contracts

1. Vendor representatives
2. Technical support
3. Customer support desk
4. Problem coordinator
5. Inventory coordinator
6. System and application programmers

Qualifying experience and attributes

1. Has broad knowledge of hardware, software, and how a system is used
2. Has good aptitude for communication, negotiation, and coordination
3. Had good knowledge of review techniques

In order to assist with hiring and building the configuration management team, Tables 7.5.5 to 7.5.9 give the typical profiles for each of the configuration management personnel, including the supervisor of the group.

And finally, the function/skill matrix, shown in Table 7.5.10, gives an

TABLE 7.5.8: Profile of Problem Coordinator.

Duties

1. Ensure that problems are routed to proper person or function for resolution.
2. Monitor status of outstanding problems via open trouble tickets.
3. Enforce priorities and schedules of problem resolution.
4. Maintain up-to-date problem records, which contain problem descriptions, priority, and status.
5. Schedule critical situation meetings with appropriate parties.
6. Fulfill administrative-reporting requirements.
7. Cross-organize resources if required.
8. Assume responsibility for total communication network.
9. Provide input to experience files.
10. Provide input to what-if catalogs.
11. Evaluate security logs.

External job contacts

1. Vendor representatives
2. Technical support
3. Customer support desk
4. Change coordinator
5. System and application programmers
6. Network manager

Qualifying experience and attributes

1. Has broad info-system and teleprocessing background
2. Has good aptitude in communication and coordination

TABLE 7.5.9: Profile of Service Coordinator.

Duties

1. Assume responsibility for total communication network.
2. Negotiate service levels.
3. Evaluate service-oriented parameters.
4. Provide feedback to capacity planning.
5. Design and generate service reports.
6. Cost service levels and negotiate charge-back.
7. Assume responsibility for security management.

External job contacts

1. Network-capacity planning
2. Network operational control
3. Performance analysis and tuning
4. Customers

Qualifying experience and attributes

1. Has excellent communication skills
2. Has overview on communication network
3. Understands the relationship between service level, resource utilization, and costs

TABLE 7.5.10: Responsibility/Skill Matrix.

Functions	Special knowledge of function	General knowledge of communication facilities	In-depth knowledge of communication facilities	Some knowledge of business administration	Communication skills	Some knowledge of project management
			Skills			
Inventory management	x	x				
Network topology service	x					
Service-level agreements	x			x	x	x
Designing, implementing, and processing trouble tickets	x					
Order processing and provisioning	x	x	x	x		x
Change management	x	x	x	x	x	x
Directory services	x	x	x			

overview of the targeted skill levels for each individual configuration management function.

7.6 SUMMARY

Practical recommendations for configuration management include guidelines for *doing* certain things and for *avoiding* certain other activities. These guidelines are useful for both short- and long-range improvements in the area of configuration management.

Do

- Process
 Integrate existing files and data bases, not exceeding a redundancy level of 30%
- Products
 Use relational data bases
 Use data-base machine when performance requires
- People
 Use integrated data base for further integration to offload administrators

Avoid

- Process
 Delays of synchronizing existing fragmented data bases and files
 Copy redundant data into the integrated product
- People and products
 Design and develop everything on your own

8

Fault Management

Fault management is a collection of activities required to dynamically maintain the service network level. These activities ensure high availability by quickly pinpointing problems and performance degradation, and by initiating controlling functions when necessary, which may include diagnosis, repair, testing, recovery, workaround, and backup. Log control and information distribution techniques are also supported.

8.1 INTRODUCTION, STATUS, AND OBJECTIVES

The principal objectives of this chapter are:

- To discuss the major functions of fault management as a process.
- To define the interrelationship of the functions.
- To determine information export and import with other network-management subsystems and functions.
- To find the most promising instruments supporting fault management activities.
- To summarize implementation considerations, including the demand for human resources to support fault management.
- To construct a responsibilities/skill matrix to help staff fault management functions.

In addition to the issues we face in fault management today (Chapter 1), more specific problems are seen in the area, which may be characterized as follows:

- It is extremely difficult to operate fully when important network elements have failed due to the lack of appropriate backup components and procedures. Backup is simply getting too expensive, and is driving customers to consider outsourcing network management.
- Problem detection, determination, and diagnosis are in many organizations too slow. The result is that downtime is increasing, causing financial losses especially to larger organizations.
- The right instrumentation is still missing for expert-like decision making during the problem determination process, which results in uncontrolled growth of human resources.
- Due to a lack of correlating events from the physical and logical segments of the network, automated restoration and bypass of failed network elements is very difficult.
- Network control centers have to work with too many consoles, which represent single monitors of network elements, network element management systems, or integrators. Figure 8.1.1 shows a typical picture of consoles in the network control center.
- It is very difficult to limit the number of operators and customer support desk personnel, and to distribute the workload among these persons

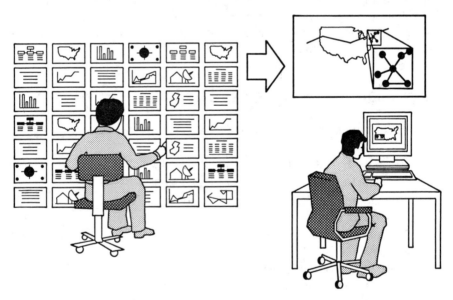

Figure 8.1.1 Typical network-control center.

over a shift, day, or week. It is often easier to build than to keep the fault management team.

In summary, fragmentation of procedures and instruments seems to be the principal burden of improving fault management efficiency.

The following sections will address the major processes, functions, and instruments of fault management.

8.2 PROCESSES AND PROCEDURES OF FAULT MANAGEMENT

Figure 8.2.1 shows the fault management process using a flowchart. As a result of trouble calls or monitored messages, events, and alarms, problems in network elements and facilities may be detected, recorded, and tagged. The dynamic trouble-ticketing process, using different agents for ticket opening, status review, consolidation, and ticket closing, is in charge of directing the steps of problem determination. Besides trivial responses on behalf of the support desk, temporary fixes are offered in the form of workarounds and switch-overs to spare elements. Problem determination on the second and third level may involve more sophisticated techniques and tools for identifying the nature and solving the problem by repair and/or replacement. Prior to restoration of a normal condition, end-to-end tests are recommended. The same or similar tests may be utilized for proactive fault management.

In order to successfully support fault management, the following information is necessary:

- Primary demand:
 Actual configuration
 Generated configuration
 Event reports and alarms
 Status indicators of network elements
 Performance indicators of network elements
 Spare components and their status and backup routes and their status
 Segments of vendor data for problems dispatch
 Global traffic volumes
 Progress of troubles resolution
- Secondary demand:
 Attributes of network elements
 Detailed vendor data
 More detailed data on performance indicators
 Message logs
 Detailed traffic volumes

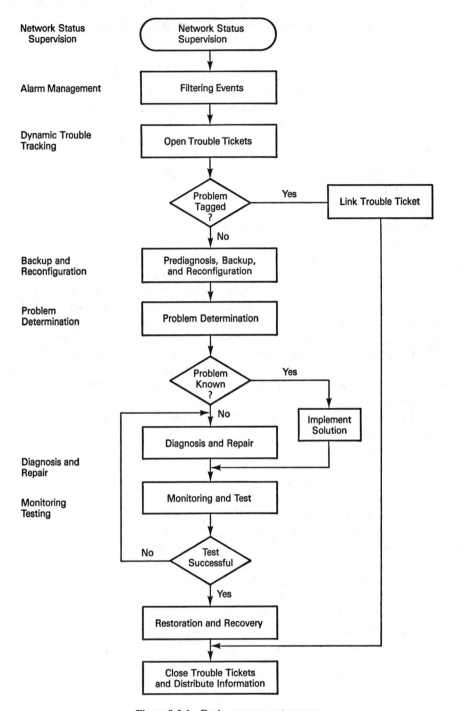

Figure 8.2.1 Fault management process.

8.3 FAULT MANAGEMENT FUNCTIONS

Fault management functions have been identified in the introductory part of this chapter. After defining the functions, typical processes, structures, and architectures, practical examples are given for better understanding how the functions work and how they are interrelated.

8.3.1 Network Status Supervision

Network status supervision includes layered configuration displays or status maps; it provides a visual display of the status of critical network elements at all times, allows user to zoom in on parts to verify and isolate problems, and provides a visual display of real-time traffic status.

This activity is tightly coupled with the topology display services of configuration management. The basis of supervising network status is provided by monitoring devices or sensors, residing in or around network elements. Examples of sensors are:

- Communication software modules
- Datascopes
- Modem, CSU, DSU monitors
- Network monitors
- Multiplexer and switch monitors
- LAN and MAN monitors
- PBX monitors
- Application monitors
- LEC and LEX monitors
- Interfaces to public or private packet networks, value-added and virtual networks

Monitored information is forwarded to the various agents or network element management systems which are in charge of processing and distributing messages, events, and alarms. In most cases, multi-layered filtering procedures are in use. Figure 8.3.1 shows this idea of filtering data generated by various sensors and of providing detected problems or alarms to the network status supervisory entity. Actually, problems or alarms are expected to drive the configuration displays.

At the lowest level, messages are generated. Messages usually report on the status of network elements or managed objects. Status means the measurement of the behavior of an object at a specific instance in time. Status is represented by a set of status information items and their assigned values at the specific time (see Figure 4.1.2).

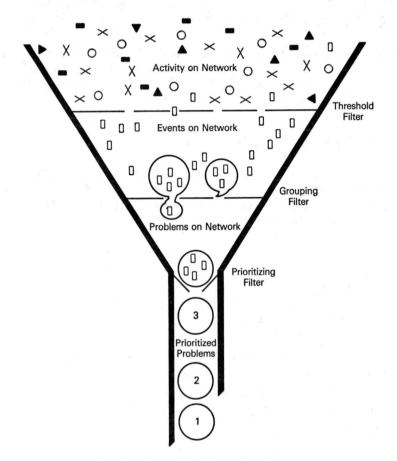

Figure 8.3.1 Multi-layered filtering.

An event is a change in the status of the element, where the change meets predefined conditions which determine that notification of the change is necessary. Typically, the status is constantly changing. An event is characterized by using changes that are of significance to the fault management.

The occurrence of an event is reported via an event report. An event report contains information about the event, such as the type of event, the status that changed, the probable cause, and the effect of the event on the managed object. Event-related activities are shown in Figure 8.3.2 [FELD89B].

Event detection monitors the status reports of managed objects for event occurrences. Any of the three types of status reports (i.e., continuous, unsolicited, or solicited) can be used. It will compare all status changes with the criteria for generating an event and will generate an event report when these criteria are met.

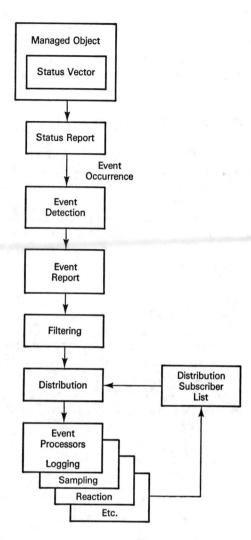

Figure 8.3.2 Event management.

Location of event detection

As shown in Figure 8.3.2, event detection can be done within a managed object, or externally from outside the object. One or both mechanisms may be used, although both forms of event detection perform essentially the same function.

Typically, internal event detection is a function of the object itself and is closely integrated with the other functions of the object. For example, the function that updates an item of the status vector may check for conditions for event generation at the time of update (e.g., check for a threshold when a counter is incremented).

External event detection uses status reports made available by the managed object, and performs event detection independently. This may be done in a process immediately adjacent to the managed object (e.g., an external monitor). It may also be done within a management system by any of the functional areas.

Status change detection

By examining status reports over time, event detection can monitor for status changes. When a change is detected, it is evaluated to see if it meets the event generation criteria. If these criteria are met, then an event is generated for the status change.

The event generation criteria are used to determine the significance of a status change to the management of the managed object. If the change is determined to be significant, an event report is generated. These criteria will need to be set for each class or type of managed object, and may vary for object instances.

Event report generation

An event report is generated by collecting and packaging information of significance to the event. An event report contains information about the status vector, status change, managed object, time of occurrence, and any other items of significance.

As shown in Figure 8.3.3, filtering of events occurs in several places

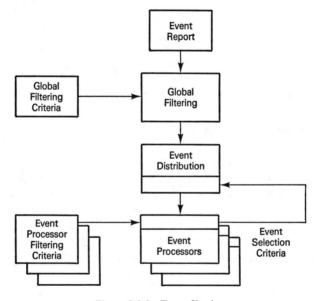

Figure 8.3.3 Event filtering.

within the proposed model. In each case, the information within the event report is analyzed to determine whether it should be kept and processed, or whether it should be ignored and discarded. This may be based solely on the information within the event report, or in addition on other information such as prior events, the availability of applications, and capacity to process the event.

Filtering criteria are set for each filtering process. These are used to analyze each event to determine whether it should be filtered. The criteria for filtering may come from any of several sources (e.g., management system customization, network operator options, and so on).

Each stage of filtering affects stages further in the event life cycle. If an event is filtered in an early stage, subsequent processes will not have an opportunity to even view the event. This consideration needs to be built into each set of filtering criteria.

Global filtering

Global event filtering is the first processing that is done on an event report. The report is examined to determine whether it needs to be processed by event management. A set of criteria is applied to examine the event report. If the report is not of interest, it will be discarded.

Global filtering has the advantage of weeding out events before any processing is done, thus reducing traffic and overhead for the downstream event management functions. However, if any event processor will need to examine an event, it cannot be filtered at this early filtering stage.

Distribution filtering

An implicit filtering function is performed by the event distribution function. Each event processor supplies information to select the events it wishes to receive. Only those events that are of interest to event processors are forwarded beyond this function. Those that are not, are discarded.

Event processor filtering

Each event processor may have its own filtering. Global filtering can only filter those events not needed by any process. The selection criteria provided by event distribution are specified by a common set of parameters, and thus cannot be too specific to a functional area. Thus, an event processor may have to provide additional filtering that is specific to its function.

Event distribution

As shown in Figure 8.3.4, event distribution receives filtered event reports and forwards selected reports to one or more event processors. Event

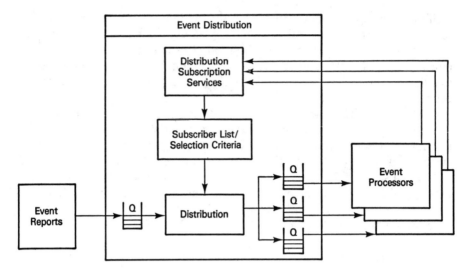

Figure 8.3.4 Event distribution.

processors use a set of services for subscribing to receive events. As events are received, the subscription list is used to determine which processors should receive the event. For each processor, the selected events are placed in queues and distributed to that processor.

Event distribution is based on a subscriber/provider principle. Each event processor must subscribe to event distribution in order to receive event reports. Subscription is accomplished by having the event processor issue a service request to event distribution. This request will identify the event processor, and will specify the type of events it is to receive. Event distribution will update the subscription list, and use this list to determine which event reports are to be sent to the event processor.

Each subscription request can contain parameters that determine the selection of events to be sent to the event processor. The selection of information provided is applied to the contents and origin of each event.

Event processors

Event processors perform various functions that examine and process event reports. This includes passive processes such as sampling and logging. It also includes proactive processes such as automatic correction for failure events.

Event management includes a common set of event processors. In addition, event reports may be sent to processors external to event management for other processing that is specific to another functional area of fault management.

Each event processor must subscribe to event distribution to receive event reports. The subscription includes selection information for event distribution to use in determining which events should be sent to the event proces-

sor. This can be used as a form of filter to limit the amount of traffic sent to the processor.

In addition to the selection filtering performed by event distribution, the event processor may also want to perform additional filtering as events are received. This will typically be filtering that cannot be performed by event distribution. This may include comparison with prior events or other information not available to event distribution.

Each event processor will take some action on each event that is received and passes through its filter. The specific action will depend on the purpose of each event processor.

Common event processors

Event management includes a set of common event processors that perform standard functions for processing events. Three of these are described below.

Logging. The logging processor will receive event reports, and store them, without further processing, in the management information base (MIB), or in other data bases for archival purposes and for postmortem analysis. A set of services shall also be provided for scanning and selecting event reports from the log, so that the event history can be analyzed and/or displayed.

The log control service allows users to choose which event reports the system will log. The log control function also enables an external managing system user to change the criteria used for logging event reports.

The application of the log control function in a network management scenario is very important. The network manager wants the ability to specify which events should be logged, but the ability to add or delete event reports to be logged is also very important. For example, the user may want to log only critical event reports, but at a later date, perhaps the need to track all reports on a historical basis will become important.

Sampling. The sampling event processor will receive events, and based on a set of prespecified criteria, will save copies of events in the MIB for later analysis, performance analysis, and many other purposes.

Event sampling provides a set of services through which other functional areas specify the sampling criteria. These services will allow the service user to select among a set of standard sampling mechanisms and to provide parameters for these mechanisms. One example of such a mechanism is to save every "Nth" event received, where "N" is any number. Another is to save events based on specified time intervals.

Status Posting. The status posting processor is used to apply the status changes represented by events to a representation of managed objects stored in the MIB. This function depends on having an up-to-date system representation in the MIB, which is maintained by other processes.

The information provided in the MIB by the function can be used by other processes. For example, this information could be used to provide a current view of a system status supported by graphics to a system operator.

External event processors

External event processors perform event processing that is specific to a functional area. These use the same services as the common event processors, and use a similar structure. However, the functions performed will be specific to the functional area in which they reside.

A standard form of event processing performed by external event processors is a reaction to events in the context of the associated functional area. Event reaction processors control the analysis of events, and perform corrective actions based on the analysis.

The following information can be provided in an event report. Note that there may be cases where some of this information cannot be provided by the managed object or the management system. In these cases, the item may be null or not included.

Time stamp

This is the time the event was generated. This should be provided by the event detection mechanism. In those cases where the time is not available, a time stamp should be generated by event management that is the closest estimate of the actual event generation time. This is required because many event processors need events to be ordered chronologically.

Reporting entity

This is the identification of the object or process that generated the event report. It may specify a managed object or a management system.

Managed object identification

This covers the identification of the managed object whose status change generated the event. Where possible, this should be a unique ID that is registered by configuration management so that other information about the object can be located by event processors.

Managed object information

This includes information (other than status) about the managed object that can be provided by event detection. It may include the object class, as well as various object attributes (e.g., vendor, serial number, software version number, and so on).

Event type

The event type is used to specify the nature of the status change that precipitated the event. It is intended for use by event processors and system operators to determine what occurrence the event represents. Other information in the event report is used to fully qualify the cause, effect, affected object, and reaction for the event.

A common mistake with event classification that should be avoided in OSI management standards is combining the object type with the event type. For example, "hardware failure" could be an event type that could be applied to many object types. This provides a more flexible, stable, and generic classification.

One approach to determining event types is to classify them by management functional area. Status changes for various generic managed objects can then be evaluated within the context of each functional area, and the corresponding events can be defined. An overview of events for each functional area is given next.

Configuration event types

Operational events report changes in the status related to those nonmanagement functions that are performed by a managed object as part of its basic operation within an open system (e.g., "failed," "connection established," "now busy," and so on). These events are based on the set of state transitions defined for managed objects. These events drive alarms.

Fault event types

Fault events report status changes related to the management of a fault in a managed object. Fault events do not report on the changes in the operational status of a managed object, such as when the object becomes non-operational. Rather, fault events report on the management activities related to the management of faults.

Fault events report the recognition of a fault, and the state changes of fault management objects, such as trouble tickets and test activities.

Performance event types

Performance events report changes related to the performance of a managed object. These are typically generated by analyzing raw status information from the managed object. This information is used to detect when the object's performance characteristics have gone outside the objective levels.

Security event types

Security events report status changes related to accessing and using system resources. These events report changes in security profiles as well as violations of security.

Accounting event types

Accounting events report status changes related to accounting activities. This includes the initiation and completion of accounting functions. It may also include notification of the need to perform an accounting function (e.g., local call record file is full and needs to be collected and reset).

Event effect

This is the resulting effect of the event on the managed object. It can be used to determine the severity of the event and the reaction to it.

The following is a proposed list of potential effects:

- Permanent (until external actions are taken to resolve it)
- Temporary (will correct automatically in a short period of time)
- Impending (has not yet occurred, but will soon)
- Abeyanced (alert is old news because it was delayed)
- Impaired (service still being provided, but at reduced levels)
- Inhibited (service cannot be provided)

Original status report

This is the status report that existed before the status change prompting the event occurred. Note that it may not always be possible to provide this information.

Resulting status report

The resulting status report includes the result of the event. This may be an incomplete status report, containing only those information items (states and parameters) that relate to the event. For example, a configuration event may provide configuration states, but not performance data. A performance statistics report may contain performance data, but no fault or configuration data.

Event priority

This indicates the priority of the event. It may be assigned by the process that generated the event (including the managed object), or may be assigned by event management based on the contents of the event report and other

information available (e.g., type of object, number of prior events on same object, and so on).

Status change cause

This includes the probable cause of the status change that precipitated the event. As with event types, these can be organized around the functional areas.

Recommended action information

This provides a description of the operator action that is recommended in response to the event. This action may be to attempt to diagnose, resolve, or circumvent a problem. It may also be a subsequent action recommended for a nonproblem event (e.g., install inventory after order received).

System action

This provides a description of the action that has or will be taken automatically as a result of this event. These actions may be performed by the managed object itself, or by a management system.

Some actions indicated here may only be initiated as a result of the event. Such an action may or may not be completed. Other events may report on the success or failure of these system actions.

Event type dependent information

Information specific to the event type, such as security violation, threshold type, and values for performance, and so on, may be added to the mandatory type of information.

In reference to Figure 8.3.2, there is a further step of consolidation. Certain events or combination of events will trigger alarms or alerts. At the moment, there is still confusion about the terminology. This book considers alarms as high or very high priority events including combination of related events.

Alarms are expected to show the following attributes:

- **Alarm time:** gives the date and time at which the alarm occurred. The value corresponds to the event time attribute.
- **Received time:** the date and time at which the network-management system received the alarm.
- **Severity:** the severity level of the alarm. It includes:
 Critical alarm
 Major alarm
 Minor alarm

Warning alarm

Information alarm (in most cases identical with event notification)

- **Alarm type:** identifies the type of alarm. Alarm types include equipment, transmission, and software. The value corresponds to the alarm type attribute of the alarm message.
- **Object class:** the class of network element to which the alarm is attributed. This value is derived from the object class of configuration management.
- **Object name:** the name of the object to which the alarm pertains. This value is derived from the object instance of the alarm message. The value should be the alias of the object. If no alias has been entered for the object, the value should be the object ID.
- **Equipment identifier**
- **Transmission identifier**
- **Software identifier:** uniquely identifies the physical unit or component that generated the alarm. For equipment alarms, the value is derived from the equipment identifier. An example of an equipment identifier is the "cabinet/shelf/slot" number. For transmission alarms, the value is derived from the transmission identifier. For software alarms, the value is derived from the software identifier.
- **Equipment type**
- **Transmission type**
- **Software type:** indicates the type of component that generated the alarm. For equipment alarms, the value is derived from the equipment type. An example of an equipment type is the "Trunk-High Speed" module. For transmission alarms, the value is derived from the transmission type. For software alarms, the value is derived from the software or application type.
- **Source:** identifies the source of the alarm. Possible sources are element management systems, an integrated network-management system, or an alarm administrator. In certain cases, event processors are the direct source.
- **Location:** identifies the location of the network element to which the alarm is attributed.
- **Problem type:** indicates the general category of the alarm. The value corresponds to the equipment transmission or software problem type of the alarm message; it may be derived from the contributing events.
- **Problem ID:** gives a unique identifier for the problem that caused the alarm. The value corresponds to the equipment transmission, or software problem identifier of the alarm message, and may be derived from events, again.
- **Text message:** gives text description of the alarm. If the text message has been redefined from the event text, the original text message will also be displayed.

- **Alarm identification number:** depending on the originator of alarms, such as network elements or management systems, administrator, or event processor, the identification number that unique to the originator may be taken over.
- **Correlation:** identifies whether the alarm has been correlated with other alarms. The value "primary" may be used to signify that the alarm has been identified as the likely source or root alarm for a set of alarms. The value "secondary" should be used to signify that another alarm has been identified as the likely source of the problem. For alarms that are not correlated with other alarms, the field should be blank.
- **Owner:** identifies the user that acknowledged the alarm. The value is usually the login ID of the user that acknowledged the alarm. The value "NEW" may be used to indicate that the alarm is a new alarm that has not been acknowledged.

Most information needed by alarms may be copied from events. Typical alarm management activities include:

- **Display alarms:** depending on the severity, the display service is unsolicited or solicited. For critical and major alarms, unsolicited operation is recommended.
- **Clear:** this command clears the alarm from the active alarm log. The clear command is only available to users with alarm administration privileges.
- **Acknowledge:** if the selected alarm has not been acknowledged, the network-management system includes an "Acknowledge" command in the menu. This command allows the user to acknowledge the alarm.
- **Change ownership:** this command allows the original owner of an alarm or an alarm administrator to change ownership of the alarm to another user. When a user selects the "Change Ownership" command, the network-management system prompts the user to enter the login ID of another user. The user shall be able to enter the login ID directly from the keyboard or select the login ID from a menu of login IDs.
- **Correlated alarms:** this command enables the user to display the correlated alarm log for the specified alarm. The command appears for alarms that are correlated with other alarms. The list of correlated alarms uses the same format as the list of active alarms. The primary alarm is shown at the top of the list. The secondary alarms are listed in order of severity.
- **Remote access:** support desk personnel or network operators may access the originator of alarms for inquiring about additional information not included in the routine display of the alarm.
- **Alarm advice:** alarm advice may be included as well. When the user selects this command, a message will be displayed that describes the

actions a user should take for the specified alarm. An alarm administrator should be able to modify the message that is presented.

- **Active alarms:** the "Active Alarms" command lists the active alarms for the selected network object in order of severity. Within a severity level, the alarms shall be ordered by time of occurrence from most recent to least recent. The user should be able to receive the alarms in chronological order, with the most recent alarms at the top of the list. When the user selects to re-order the display, label and operation are changed to allow the user to order the list by severity.

- **Alarm history:** the "Alarm History" command lists a certain number of the historical alarms for the selected network object. The alarms can be listed in chronological order from most recent to least recent. The window may contain a scroll bar if there are too many alarms for the object.

- **Inhibit:** the "Inhibit" command turns off the presentation of alarms for the selected network object in the network display. The Inhibit command appears only on the command menu of users with alarm administration privileges and only on the menu for elements that are not currently inhibited. The Inhibit command functions on a systemwide basis. When alarms are inhibited for a network object, alarms are logged but not displayed. However, the alarm does not appear in the active alarm log or the new alarm log.

- **Uninhibit:** the "Uninhibit" command turns on presentation of alarms for the selected network element. The Uninhibit command appears only on the command menu of users with alarm administration privileges and only on the menu for elements that are currently inhibited. The Uninhibit command functions on a systemwide basis.

- **Grouping alarms:** selected alarms should be grouped together in order not to open too many trouble tickets and not to start too many troubleshooting missions. Eliminating redundancy is sometimes called alarm collapsing.

- **Logging alarms:** as part of the trouble-ticketing process, alarms have to be logged for further processing.

- **Alarm export/import:** this feature should allow the user to exchange alarms with other network-management systems which are outside of the control segment of the system under consideration.

- **Alarm correlation:** if the correlation flag is on, alarms—probably related alarms—are correlated to determine the problem. In this case, detection and determination are solved in one step.

Alarms are also expected to drive the trouble tickets' opening procedures, as will be seen in the next section of this chapter.

The layout of displays should be designed with great care. The network operator does not have the time to use sophisticated procedures for problem determination. The information on the screen should be easy to understand.

Besides on-line help capabilities, on-line tutorials or other training aids such as videotape manuals may be a factor in selection. Some of the state-of-the-art network monitors dedicate a segment of each display to a network status overview. This split-screen feature enables fault management to accomplish other tasks while continuing to display the network status with the problem. The choice of hierarchical levels for continuous displays is very important. The alternatives are:

- Communication forms such as data, voice, image, word, and video
- Geographical areas
- Application groups such as data base, transaction processing, program development, test, and production
- Mainframes by identification (e.g., AB308L) or by application if dedicated (e.g., IMS084)
- Communication control processors and below, not displaying the mainframe connections
- Backbone networks, transparent segments of VANs, MANs, and LANs
- Line groups or trunks only, with eventual indication of the front-end connection
- Lines only, for a limited scale of control only
- Cluster and below, including terminal devices (such as printers and any kind of workstations)
- Application layer of the ISO architecture and, depending upon event notification, any layer below the application
- Overview about the most recent event notification and alarms by primary information sources. Upon operator request, any of the sources may be interrogated for more detailed status and performance information.

This classification is well suited for typical star networks. But present networks are increasingly distributed, and thus even greater flexibility toward status displays is required.

Many times it helps to display screens from several sources, such as a network monitor, communication software, electronic switch, application monitor, on the same physical device utilizing different windows.

This arrangement (Figure 8.3.5) allows network operational control to access and control, from a single workstation, all information extraction instruments of multiple vendors. In addition, it collects information from these monitoring subsystems and, based on a set of rules, assists problem determination. The central processor—usually a micro—coordinates the access to the different instruments. The information exchange is solved via messages and data streams. The connections are physically continuously alive, but logical paths are opened on demand only. In addition, alert logs, status messages, and exceptional messages are analyzed, filtered, formated, and forwarded to the master station. In most cases, unsolicited information is evaluated only.

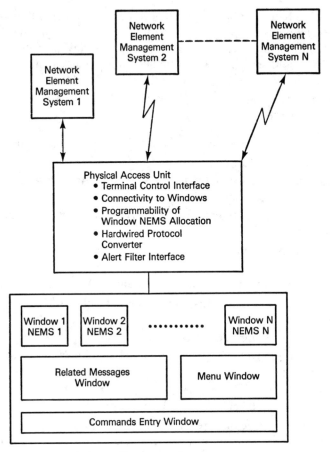

NEMS = Network Element Management System

Figure 8.3.5 Architecture of consolidating workstations.

The message parser is implemented as firmware. Network operational control may select the vendor's instrument using the top-level screen. Also, the alert for further analysis can be selected on the top-level screen. Future links to trouble-ticket processing are obvious.

Independent from the choice of the alternative, the heart of network status displays is the configuration data base (see Chapter 5 for further details). Recent results in using artificial intelligence support the object-oriented storage of networking resources. Every resource will have static and dynamic "slots." Static slots are responsible for resource identification, describing characteristics, further resources owned, and resources which own the resource under consideration. Dynamic slots are reserved for monitored variables, such as availability, response time, errors, timeouts, repolls. Figure 5.3.1 shows an example of the configuration data base represented in LISP using FLAVORS [TERP87A].

For the sake of standardization, all fault management workstations should have the same screen layout:

- Graphical part with selectable information content
- Command line for accessing multiple-information sources
- Alert line for displaying top-priority-level exceptional messages
- Help information via the function key entry, whereby the graphical part is replaced or, in other applications, a new window is opened.

An example of a user-friendly display was shown in Figure 3.1.3.

Fundamentally, fault management could be centralized or decentralized. The decision to be made is usually influenced by the following factors:

- Human resources and their skill levels at remote sites
- Availability of tools at the remote sites
- Availability of tools with remote monitoring capabilities
- Character of application
- Willingness and ability to cooperate at the remote sites
- Overall network topology
- Elapsed time between when the problem is dispatched and when somebody actually starts working on it
- Communication software capabilities to support remote problem determination and diagnosis
- Availability of secondary channels for information export/import
- Amount of information to be transferred for controlling purposes

It is not easy to provide guidelines for either of the alternatives. Table 8.3.1 compares advantages and disadvantages of both alternatives. Without evaluating the customer's environment, the final decision cannot be made. However, in any case, the customer is supposed to cooperate to a certain degree, at least in the first-level problem determination procedure. Figure 8.3.6 illustrates a typical sequence of activities at a customer site. As indicated in this figure, the customer may execute the preliminary steps of problem determination, the subject of the following section of the book.

It is certainly not desirable to create extra communication overhead for transmitting statistical information over the communication lines. However, the efficient operation of a distributed network is not possible without the availability of some on-line performance information. Even if the system does not have an automatic performance control mechanism built in, the operators of the network will have to check, from time to time, the state of the system's performance and take corrective action, if necessary, to relieve undesirable bottlenecks. Some sites in a network may not have operators on a local level; therefore, the performance of these sites can be checked only through commu-

TABLE 8.3.1: Central Versus Remote Control.

	Advantages	Disadvantages
Central Control	Overall overview Centrally located staff only Optimal networkwide reactions Centrally maintained trouble files Centrally maintained experience files Centrally maintained inventory files Unattended remote systems Better basis for automation Faster problem determination Coordination of changes Implementing standards is easier Reporting and statistics by correlating related data	Too much data to be filtered Processing overhead for the integrator Transmission overhead Necessity of secondary channels Slower correlation of problems due to volume of information
Central and Remote Control	Selective data only to central site Faster reaction in the local area Less overhead due to network management traffic	Software downloading overhead Hiring and education of remote staff Multiple tools installation Local optimization only Synchronization problems Compatibility of tools Fragmented configuration files

nication. Many times, because of security or system integrity, network control can be exercised only at selected network control centers. Some systems use dynamic statistical data collection for automatic system control.

Kleinrock [KLEI82] reports that such data collection was performed on the ARPANET every 640 ms. The additional traffic on the communication lines was negligible, provided the line utilization was high. A greater problem, preventing a satisfactory, general solution to the on-line retrieving of statistical data records, is that access methods for reading records from distributed files are rarely available in current distributed systems. Thus, the current data-communication performance monitors confine the on-line data reduction to information available in the main memory (temporary storage).

The sites of a network may be remote from each other; therefore, it may be necessary to measure events that start at one site and terminate at another, such as the information-transfer time. In such cases, the clocks of the two sites must be synchronized. There are various ways of synchronizing the clocks.

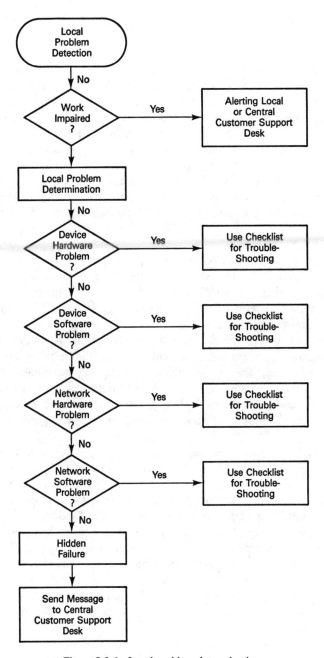

Figure 8.3.6 Local problem determination.

One of the most simple methods of synchronization is to broadcast the time from a central location to adjacent nodes, repeating the process hierarchically until all the nodes in the network have synchronized their clocks. There are other devices available for clock synchronization. The Queuepro Corporation

in Canada markets a clock [GALL83] that communicates through two ports with one or more processors. The transmission of time signals occurs through a standard comm inication protocol (RS-232). Synchronization of clocks across communica.ion lines may introduce a bias of about 50 ms. The U.S. Government Time Service offers synchronization service through satellites. The service is available for the North American continent, and it is accurate up to 1 ms. The communication protocol is again the RS-232. Processing the synchronization signals through regular software communication handlers may induce additional delays. Applying a firmware or microprocessor interface may improve the accuracy of the synchronization [GALL83].

The flexibility of a network-management system depends most on its software implementation. However, the organization of the hardware, especially the processors and memory, also affects performance. Several arrangements are possible, and two have been implemented commercially in the recent past [LYON81].

Perhaps the most obvious hardware arrangement is the totally centralized configuration. The processor is unique in the network, and all network-management devices are attached to or driven by it. This includes the mass memory on disk, operators' CRTs, printers, and physical interfaces to the network's remote-test modules.

A second structure includes two processors: one to maintain the database management system and a second that runs the network-control activities. A link between the two provides the necessary information flow to tie together the different sets of functions. The data-base management system processor has control of the mass theory, whereas the network-control processor has a smaller amount of memory attached, consistent with its real-time functions.

A third structure involves multiple computers spread throughout a shared-resource network. Here, the exact structure of each computer is not as important as the wide distribution of the data-base files themselves. This third scheme is the least practicable at the present time because of the novelty of distributed data-base technology. However, as the fundamental problems in programming these applications are solved, this approach for network management will become more viable and more attractive.

Each of the first two hardware structures has advantages that recommend it. The centralized approach has a smaller number of central-site components, which can result in higher overall reliability and simpler use for the network operators. Furthermore, the single processor and its peripherals can be relatively more powerful (faster, more extensive instruction set) than those in the two-processor approach and still maintain the same total cost. By combining data-base and network-control activities in one processor, the response time of the real-time data-base functions is potentially shortened [LYON81].

The dual-processor approach has two potential advantages. With the proper software design, the network-control function can be made operation-

ally independent of the data-base processor. Then, if a failure causes downtime on the data-base side, the basic network-control functions are still available. Also, the dual processors can be individually tailored in speed and peripheral capacity to match their respective functions. This flexibility is most beneficial when there are extraordinary demands placed on either the network-control or the data-base functions. Customer cooperation may include problem detection, determination, diagnosis, and event resolution. In some cases, the customer may as well participate in developing diagnostic procedures and programs.

8.3.2 Dynamic Trouble Tracking

The dynamic trouble tracking activity opens trouble tickets, links them together, dispatches the trouble to the proper vendors, checks on-line status on the progress of clearing and closing out trouble tickets, and creates a historical record. Trouble tickets may be opened manually or triggered by alarms.

In many organizations, trouble ticketing is considered the focal point of controlling problem determination, backup, reconfiguration, diagnostics, repair, and recovery. Figure 8.3.7 shows this example with the trouble resolution process in the center. This process drives the resolution by maintaining communication connections to a variety of functions within fault management and also outside fault management.

In the event of the nonavailability of the network or parts of it or performance implications anywhere in the network, this activity is invoked. The word problem means an incident or event that causes a system (e.g., communication network) not to function as expected. Problems may be categorized as follows [FISH90]:

- Handling errors on behalf of users due to education and training
- Device or equipment faults detected automatically or semiautomatically
- Facility faults detected automatically or semiautomatically
- Intermittent faults of equipment and/or facilities with discontinuous or fluctuating characteristics
- Chronic faults with the trend of causing more severe faults

The principal goals are to minimize the effects of problems and reduce time until restoration. Problem determination actually encompasses four steps:

- Problem detection
- Problem determination
- Problem diagnosis
- Problem resolution

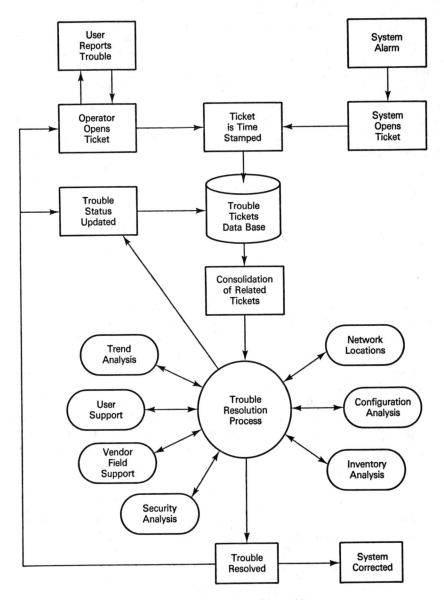

Figure 8.3.7 Dynamic trouble tracking.

Problems encountered in the network generally flow through a problem-determination process, where they are analyzed and resolved. Within the problem-determination process, six levels of problem complexity exist:

- **First level:** Problems that are handled by the customer support desk. Usually, these are of a nontechnical nature and can be resolved by troubleshooting over the phone. If education is appropriate, 80% to 85% of problems can be solved this way. The on-line trouble-ticket data

base can be interrogated to determine whether the problem has been reported by any other location in the network and if there was a known fix. Problem diagnosis is negligible.

- **Second level:** Problems handled by the network and system operators. These problems comprise about 5% to 10% of the problems reported to the customer support desk and are too technical to be resolved by the customer support desk. Typically, this problem either has been passed on by the customer support desk due to lack of expertise or it has been identified by the network operator. An example of a problem of this nature may be the restart of a malfunctioning 3725 or initializing VTAM after a system failure. Problem diagnosis is considerable.

- **Third level:** These are problems handled by the network communications specialists supporting the hardware and software. Problems administered by this group are generally of a critical and complex nature and may require involvement of vendor specialists. Problems of this nature comprise only about 2% to 5% of most problems encountered and are usually recognized immediately or referred on by network operators. Problem diagnosis requires considerable human resources and instrumentation.

- **Fourth level:** These are problems handled by application specialists. If symptoms show that application-related problems are the probable cause, trouble tickets are dispatched to application support. This level accounts for 1% to 3% of all problems recorded. Problem diagnosis usually requires considerable human resources.

- **Fifth level:** Certain problems can only be handled by vendors. When the diagnosis steps point in this direction, trouble records are dispatched to vendors. Electronic data exchange seems to be a viable technique for this purpose. Problem diagnosis is considerable but human resources requirement is not considered to be high. This level receives 1% to 2% of all problems.

- **Sixth level:** Problems affecting servers and stations in local area networks have to be dispatched to the user administrator of the local area network. Probable cause- and recommended action-type information is very helpful to administrators. They are not supposed to have detailed technical knowledge. It is early to estimate the volume of problems dispatched to this area, but it is expected to be 30% to 40% of all LAN-related problems reported.

Problem detection

As illustrated in Figure 8.3.8, two major information sources must be considered:

- Network status display with exceptional reporting on functional and/or service anomalies. Much of the network monitoring will be automated,

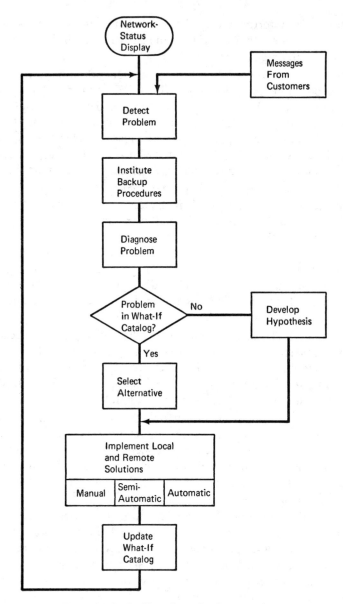

Figure 8.3.8 Problem determination procedure.

utilizing preestablished thresholds loaded by the network operators to the monitoring software and hardware (e.g., error-to-traffic ratios in Netview-Hardware Monitor, signal-to-noise-level ratios in technical control systems, or response-time warnings in network monitors). When thresholds are exceeded, messages are generated to the appropriate network console, which alerts the operators to the problem, generally

with an identification of type and location of the problem. Frequently the alarms trigger the problem determination process.

- User messages, usually filtered by a call-management system and/or by the customer support desk.

Minor information sources could become:

- Real-time status reports by network carriers
- Status reports by resource vendors
- Test results by automatic or manual testing routines

Network status displays and reports were thoroughly covered in the previous chapter. For successfully operating large networks, in particular for integrated communication, continuous supervision is increasingly becoming the only alternative.

In many cases, however, the customer community provides input regarding anomalies in terms of

- A terminal device that does not work
- A response time that is degraded
- A lost carrier
- Application and/or systems software in loop, job results lost, and so on

The most promising way is to organize local-problem determination by means of a flowchart or diagnostic tables. Table 8.3.2 shows guidelines for troubleshooting Ethernet local area networks.

Analyzing breakdowns and degraded operations helps to identify components to be considered first in backup plans or for implementing expert systems for self-healing. [JOSH90] shows a practical example of one year's observation with the following results:

Component	Degraded	Down	Total
Circuit	446	1016	1464
Terminals	362	321	683
Software	247	188	435
Control Units	41	105	146
Modems	37	63	100
Total	1135	1692	2827

This example indicates that over 50% of all incidents are due to the bad quality of circuits.

Frequently the information received is neither appropriate nor helpful. Still, the customer support desk has to react and invoke procedures for clarifying problems.

1. Power down all nodes.
2. Power down all bridges, fanouts, gateways, and repeaters.
3. Power down all file servers, print servers, and auxiliary devices.
4. Disconnect all network segments.
5. Terminate to specification all individual segments.
6. Electrically test coax components for electrical incompatibilities.
7. Electrically test transceivers for electrical incompatibilities.
8. Disconnect all network sections (institute binary search).
9. Electrically test coax components for electrical incompatibilities.
10. Electrically test transceivers for electrical incompatibilities.
11. Power up each individual network section.
12. Terminate to specification all individual segments.
13. Reconstitute segments from individual sections.
14. Power up each individual network segment.
15. Electrically test coax components for electrical incompatibilities.
16. Electrically test transceivers for electrical incompatibilities.
17. Power up all nodes on each individual segment.
18. Power up all file servers, print servers, and auxiliary devices.
19. Power up fanout units.
20. Power up gateways.
21. Power up bridges.
22. Power up repeaters.
23. Reconstitute network and reconnect all segments.
24. Power on all nodes.

Hardware or Software Problems

First, isolate the location:
1. Apply binary search method or apply sequential search method.
2. Check for failed node/nonoperation.
3. Check the software indicators.
4. Apply the multimeter.
5. Apply the transceiver tester.
6. Attach the time domain reflectometer.
7. Gather statistics and diagnose with the protocol analyzer.

On location:
1. Check to confirm that components are plugged in.
2. Jiggle components in case of short circuit.
3. Check for electrical shorts/breaks.
4. Replace failed components or interchange suspect components.

Software Problems

First, isolate the location:
1. Gather statistics and diagnose with the protocol analyzer.
2. Analyze the network software.
3. Locate failed node/nonoperation.
4. Check the software indicators.
5. Root out nonfunctioning nodes.

On location:
1. Reboot system.
2. Restart software.
3. Replace software.

4. Debug/fix software.
5. Power cycle individual hardware components.

If network software has failed, check that:
1. The network software is correct.
2. The network is not overloaded with traffic.
3. The "state" of Ethernet is not jammed.
4. Each software node is compatible.
5. Ethernet versions/variations match.
6. The network software is performing tasks.
7. The operating network software is not corrupted.
8. The software is compatible with physical devices.

If all checks succeed, then you have a network hardware failure or a hidden component failure.

If a node has failed, check that:
1. The workstation or node unit is plugged in.
2. The workstation has electrical power.
3. The workstation is functioning.
4. The workstation sees Ethernet and TCP/IP.
5. The transceiver drop cable connections are secure.
6. The transceiver drop cable is correct.
7. The transceiver electronics function.
8. The transceiver tap installation is to specification.
9. The Ethernet controller functions.
10. The Ethernet address is correct.
11. The Internet address is correct.
12. All other nodes are working.
13. Some other nodes are working.
14. The Ethernet versions/variations match.

If all checks succeed, then you have a network software failure, a network hardware failure, or a hidden component failure.

If network hardware has failed, check that:
1. The network software is correct.
2. The network print and file servers are on-line.
3. The network is not overloaded with traffic.
4. Terminators are in place.
5. End connectors are correctly installed.
6. Barrel connectors are tightly connecting.
7. No coaxial sections are broken.
8. There are no cable breaks, cuts, abrasions.
9. The "state" of Ethernet is not jammed.
10. The gateways and repeaters are functioning.
11. Fanout units are not jammed.
12. Individual network segments function.
13. Repeated segments are functioning.
14. Gateway segments are functioning.
15. Individual network cable sections are operational.
16. Transceiver tap components are functioning.
17. Transceivers are not jabbering/chattering.
18. Transceiver electronics are operational.
19. There are no software node incompatibilities.
20. Ethernet versions/variations match.
21. There is no outside electrical or radio frequency interference.

If all checks succeed, then you have a hidden component failure.

In order to facilitate work at the customer support desk, a number of instruments—partially completely new—may be considered. Examples are:

- ACDs (Automated Call Distributor) for balancing load on support desk agents. At the same time, statistics may be utilized to size customer support desks.
- ANI (Automatic Number Identification) to speed up processing; at the time of incoming calls, support desk agents receive displayed information on attributes of the calling site, including faults history and consolidated trouble-tickets.
- IVR (Interactive Voice Response) to help pre-classify faults by two ways:
 Callers dial-in and will be guided through a series of menus. Preclassification means pushing a certain combination of numbers for groups of faults, such as hardware, software, applications, etc..
 Callers leave a message with the most important symptoms of the fault.

 In both cases, faults can be routed to the right persons more rapidly than before.

- Jukebox and optical disks to help storing a large amount of data for supporting problem determination and diagnosis.
- Hypertext employs navigation techniques between information blocks stored in computer peripheral units (e.g., optical disks). Information blocks may include text, diagrams, animated diagrams, images, moving images, sound, speech, and computer applications. In the customer support desk area textual, graphical, and audio information building blocks are the most valuable. The most efficient navigation may be controlled by expert systems.

Trouble-tickets consolidation has to be implemented with great care and flexibility. Accepting user calls may drive this process from the customer support desk, network operators may detect problems by observing the single or integrated console displays and decide for opening a trouble ticket, or automated network operational control procedures may invoke the trouble-ticket initialization process. Where to place the overall responsibility of "owning" the trouble ticket depends on the organization. In particular, in an automated environment, many repetitive problems remain unnoticed due to the lack of "batch" procedures evaluating the daily operational logs. Some of the administration instruments offer expert-like links between monitored variables and their representation in a trouble-ticketing data base.

Typically, the staff will handle questions concerning applications, procedures, and operations, and will be the customer's primary contact. Based on statistics [IBM83E], 80% of all customer claims can be answered and resolved within 1 hour (Figure 8.3.9). Nevertheless, each of the calls or claims has to be

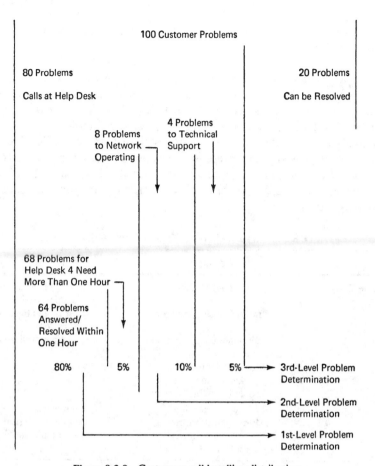

Figure 8.3.9 Customers call handling distribution.

entered into a trouble-ticket file for further processing and evaluation. Also, trouble tickets issued at remote sites should be entered accordingly. Trouble files are becoming increasingly important in

- Evaluating vendors
- Evaluating component reliability and likely reasons for failure if the experience file is assumed to be a subset of the trouble file
- Developing a powerful network-restoration mechanism
- Pinpointing needs for documentation by customers and education
- Improving the quality of network design and capacity planning

Design and evaluation are key responsibilities of the network administrator (see Chapter 7). The customer support desk is merely responsible for opening and closing trouble tickets. Fundamentally, there are two ways to do so:

1. Use of a trouble file in an on-line mode and entry with no paper trouble tickets.

2. Use of standard forms and entry of trouble tickets periodically (e.g., once a shift, day, or week).

The advantages and disadvantages are summarized in Table 8.3.3. Once trouble tickets are entered, the customer support desk may start test procedures and interrogate the experience file for further assistance. The experience file is a compressed version of closed trouble tickets. Symbolic processing may substantially facilitate the search for matches in the experience file. The symptoms may be used as key. The prerequisite is, however, that the closed trouble tickets have been properly compressed and stored using one of the powerful AI languages. In future applications, an alert may trigger the search-for-matches procedure.

TABLE 8.3.3: On-Line Versus Off-Line Trouble-Ticket Entry.

	Advantages	Disadvantages
On-Line Entry	No troubles remain unnoticed Immediate classification Faster entry Automated copying from monitors More efficient trouble-ticket linking Dynamic trouble-tracking	Overloading customer support desk User is not able to give symptoms Too many trivial entries
Off-Line Entry	Preselection possible More accurate entries No collection of trivial problems	Paperwork Additional clerical work Lack of motivation Lost notes

Figure 8.3.10 shows an example with four trouble windows, maintained on the same workstation. Window 1 displays the new ticket with an empty field. Once the originating session is filled in, it will be copied into window 2, leaving a space in window 1 for other tickets. Window 3 is used for interrogating recently solved problems, open problems, and special advice about actual problem areas. Communication with other operators is also supported. Window 4 displays the resolution session of the trouble ticket. Basically, this arrangement may be used for both voice and data. Problem resolution will, however, differ because different people and instruments are involved.

Dynamic trouble ticketing has the following benefits:

- Automatic generation by selected events, filtered alarms, user calls, segregated by time, vendor and network, based on outage severity and preselected error thresholds.
- Automated status and progress control helps accelerate problem resolution and coordinate problem resolution activities.

WINDOW 1 NEW TICKET WINDOW 2 ORIGINATING SESSION

Originating section - Symptoms
 (Symptoms) - Dispatch to operators or
 technical service
Resolution section - Automatic fill
 (Reason for outage) - Progress control
 - Identification of owner
 - Duplicate check
 - Quick close

WINDOW 3 WORK WINDOW WINDOW 4 RESOLUTION SECTION

- Accessing information about - Reason for outage
 recently solved problems - Time stamps completion
- Accessing information about
 changes
- Communication with other operators
- Communication with vendors and
 suppliers

WINDOW 5 WORK WINDOW WINDOW 6 TO BE DEFINED

- Accessing information in his-
 tory files with closed trouble
 tickets
- Accessing vendors- and suppliers-
 related information

Figure 8.3.10 Trouble-ticket windows.

- Dynamic update of fault status and severity level including trend indica-
 tion, such as fault is changing to more severe, no change, or less
 severe.
- Historical records will be maintained to allow the calculation of mean
 time to repair (MTTR) and mean time between failures (MTBF).
- The trouble-ticketing system will be used to track all user support desk
 requests for both voice and data.

- The trouble-ticketing system tracks the occurrence of all scheduled and unscheduled maintenance activities.
- User levels of escalation automatically incorporated in the system.
- Interfaces with existing management systems help integrate trouble ticketing of voice and data into existing information systems management functions, such as reporting, trending, and statistics.

Figures 8.3.11 and 8.3.12 show two practical examples of updating and closing trouble tickets.

```
format: problem.datanetwork       select option         scroll: half
Document Number   : 288     Page 1 of 4  Open   Time: 01/23/88 11:42
Category          : datanetwork           Alert  Time:
Assignment Group  : network control       Update Time: 01/23/88 15:42
Assignment Changes: 0   Status: reopened Close  Time: 01/23/88 17:22

     location: sta100        vendor:  ibm
     type: crt               model: 3277
     vtam name: a108a01      serial no.: 63235
logical name: a108a01
contact name: Robert Mugabe           phone: (213)755-0778

DESCRIPTION OF PROBLEM                    Operator: naomi
space bar is jammed.

f2=update f3=end f4=close f5=pagelist f9=last page f12=menu exit
```

Figure 8.3.11 Example for updating trouble tickets.

Problem determination

Problem determination means to answer exactly the question: What is wrong and where is the problem in the network? Using the technique of exceptional reporting, problem determination can be significantly facilitated by displaying information, whether it is a functionality or service-level problem or a problem related to processing, link, or terminal resources. For displaying purposes, graphics, verbal messages, or both may be implemented (see Figures 8.3.13 and 8.3.14).

Once the problem has been recognized, backup procedures can be invoked immediately during first-level problem determination, assuming that there are backup components available. Backup components may be physical, such as hotspare or spare capacity on existing components. Backup may also be logical, using little additional equipment but merely switching connections or routes. Switching equipment may entail costs explicitly for this purpose but

```
format: problem.datanetwork  enter problem resolution     scroll: half
Document Number   : 288____  Page_3_of_3_  Open   Time: 01/23/88 11:42
Category          : datanetwork           Alert  Time: 01/23/88 12:42
Assignment Group  : network control____   Update Time: 01/23/88 15:55
Assignment Changes: 0__    Status: closed  Close  Time: 01/23/88 17:21

        location: sta100_____   vendor:  ibm_____
            type: crt_____           model: 3277_____
       vtam name: a108a01_____   serial no.: 63235_____
    logical name: a108a01_____
    contact name: Robert Mugabe_____   phone: (213)755-0778_____

    DESCRIPTION OF PROBLEM                 Operator: naomi_____
    space bar is jammed._____
    _____

    PROBLEM RESOLUTION
    ibm replaced keyboard_____
    _____

    CODE: vendor_____

    f1=new categry f3=end f4=close f6=info f8=find f9=fill
```

Figure 8.3.12 Example for closing trouble tickets.

usually exists anyway for other purposes. Most frequently, spare components are provided in the form of

- Warm redundance in the front ends, whereby front ends are not operated at the saturation level
- Alternate routes that are both physically and logically available
- Failed nodes that may be quickly bypassed

Second-level problem determination is usually the responsibility of the network operators. Both network and software monitors can contribute a great deal.

In NetView, the probable-cause analysis facility provides several layers of problem determination screens, which offer advice about recommended actions to be taken. With the addition of SolutionPac, network operators can have access to help panels, which significantly simplify the response to the recommended action screens. Other products, such as Accumaster from AT&T, offer similar capabilities with more emphasis on physical troubleshooting.

Third-level problem determination may need inside and outside expertise. During this process a variety of instruments may be used. Inside assistance is usually provided by the on-line and off-line technical-maintenance group. Figure 8.3.15 gives an example of a third-level what-if catalogue.

Network Components	Number of Incidents				
	Last 15M	Last 1H	Last Shift	Last Day	Average Day
BACKBONE					
Front-end	—	—	1	1	2
Multiplexer	1	1	1	3	2
Modems	4	4	6	14	4
DSUs/CSUs	1	1	2	2	2
Links	5	10	22	30	25
Switches	—	—	—	—	1
Software	1	1	1	1	1
TAIL					
Controller	2	3	3	4	3
Workstations	11	20	42	55	45
Lines	2	3	4	5	5
Printer	4	4	8	10	15
Modems	2	3	3	8	6
DSUs/CSUs	1	1	2	2	2
Software	1	1	1	1	1
LOCAL AREA					
98X	1	1	1	1	1
Controller	2	3	5	12	4
Servers	2	2	2	6	3
Stations	14	16	28	28	20
Cable	2	2	4	6	5
Software	1	2	14	14	10

Components experiencing a problem are flashing and color-coded:
red = for funtionality
yellow = for performance

Figure 8.3.13 Verbal messages for supporting problem determination.

Problem determination can be substantially automated by using an expert system rather than the conventional approach, which uses sets of closed algorithms. Current status displays, procedural changes, and breakdown diagnoses are readily facilitated. In addition, expert systems may be used as a knowledge bank, summarizing experiences from multiple sources. After putting the network back into operation—many times at a lower service level—network operating deals with diagnosing the problem. The question to be addressed is: "Why has the component broken down?"

The problem-determination product should allow for preprogrammed alerts or notification of the condition of network components. Conditions should be analyzed and customers should be notified of the probable cause of the condition. Recommended actions should be provided as well. Product features should include

- Capturing failures
- Notification of hardware and software types of errors and events

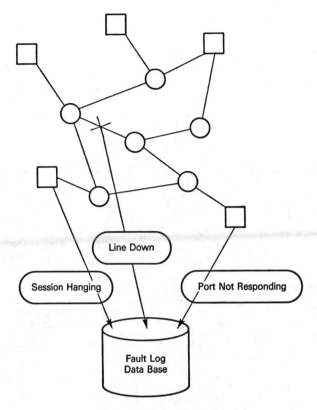

Figure 8.3.14 Message graphics.

- Early warning
- Problem analysis
- Probable-cause determination
- Recommendations for remedy
- Provision of detailed information for further analysis

As part of the problem-determination responsibility, fault management is expected to keep the customer informed about exceptional network conditions. Once parts of the network are out of order, fault management should look for the optimal alternative for message broadcasting. It is also necessary to convey information about planned outages: These can be incorporated into periodic messages. Feasible alternatives include the following:

- Use of features offered by the network architecture for each particular instance when the mainframe hardware/software are disturbed.
- Use of the secondary channel, if applicable, when the main channel to and from the customer is out of order.

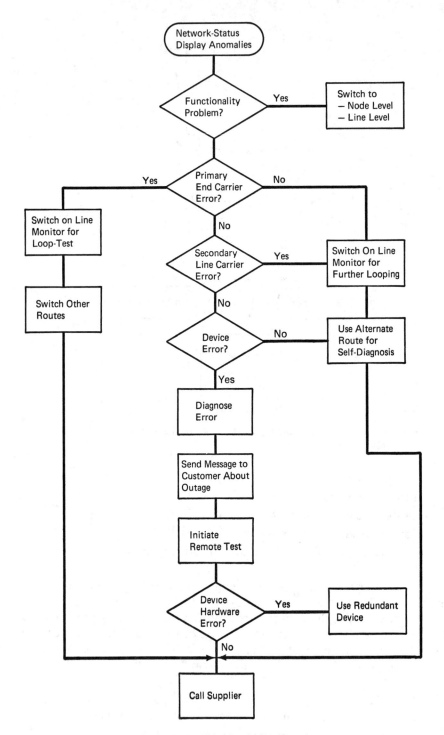

Figure 8.3.15 Third-level what-if catalogue.

- Use of special features of network monitors for automatically broadcasting messages when the host end of the communication breaks down.
- Use of special-purpose equipment for broadcasting purposes. It is very difficult to justify the cost of this alternative, because a whole secondary network involving the following items should be installed:
 Central message distributor
 Modems
 Lines (moderate speed)
 Terminal devices (with mostly unsophisticated displays)
- Use of alternative communication services, such as these:
 Phone. Easy to use but passive broadcasting only via answering service.
 Facsimile. Significant growth rates with accessibility next to phone.
 Telex. Very useful for worldwide distribution.
 Teletex. Not yet widely used but increasingly significant; depends on the country.
 Voice mail. Depends on the country.
 Line switching. For the duration of broadcasting messages.
 Viewdata. Easy to implement because television sets are available almost everywhere but is, again, a "passive" service, in which the customer is expected to interrogate the locally available data base.
 Electronic mail. Easy to use and causes no significant additional expenses once installed. International standardization is not far.
- Depending on the customer's environment, any meaningful combination may be considered and implemented.

The most important criteria for selecting the right alternative are the following:

- Human resource requirement at the customer support desk
- Technical training and expectation at the user level
- Availability of service for the geographic area
- Availability of networking components supporting the distribution
- Reliability of the alternative under consideration
- Implementation and operating costs

8.3.3 Backup and Reconfiguration

The existence of automatic backup and reconfiguration allows a department to institute a backup system and/or reconfigure around a problem using preprogrammed alternatives. Manual backup and reconfiguration require human intervention to reconfigure around a problem or institute a backup system in real time.

Figure 8.3.8 indicated this function as actually being part of the problem-

determination process. However, in most organizations it is considered a separate activity. Presently, this function is a mixture of manual, semiautomatic, and automatic procedures. The ultimate choice depends on this infrastructure of the corporation. "Infrastructure" as a generic term refers to the variety of spare components, scope of reconfiguration, and accuracy of status information provided by monitoring devices. The question of how quickly the switchover to backup components occurs is very important. Spending too much time with pre-diagnosis impacts the service level of the user; spending no or too little time with pre-diagnosis may lead to an overreaction and switching over to backup components too early. Each switchover may have an impact on the overall service level, and therefore has to be planned and executed carefully.

Table 8.3.4 illustrates the use of a decision table for facilitating backup and reconfiguration as part of the fault management process. In order to speed up the decision-making processes for restoring service to end-users, a decision matrix may be successfully implemented.

TABLE 8.3.4: Decision Matrix for Backup and Reconfiguration.

	Rules					
	1	2	3	4	5	6
Conditions						
Spare part available	Y	Y	N	Y	Y	N
Alternate route available	Y	Y	Y	N	N	Y
Spare part generated	Y	Y	N	Y	N	N
Alternate route generated	Y	Y	Y	N	N	N
Prediagnosis > 10 minutes	Y	N	Y	Y	Y	Y
Actions						
Switch to spare part	X			X	X	
Generate spare part					X	
Switch to alternate route	X		X			X
Generate alternate route						X
Continue prediagnosis		X				
Stop prediagnosis	X		X	X	X	X
Accomplish permanent fix	X				X	X

The "CONDITIONS" segment includes the five most important criteria: availability of spare parts and alternate routes, generation of spare parts, generated alternate routes, and duration of prediagnosis.

The "ACTIONS" segment lists the actions expected to be invoked by fault management personnel. The actions are: switch to spare part, generate spare part, switch to alternate route, generate alternate route, continue prediagnosis, stop prediagnosis, and accomplish permanent fix.

The "CONDITION" entries identify the status for all criteria for each of the six scenarios.

The "ACTION" entries identify the actions to be taken for each of the six scenarios.

After determining and locating problems, switching over to spare compo-

nents may help to provide continuing service to network customers. Until recently, manual switches and patches were preferred. These were easy to use and inexpensive but fairly slow. They were also subject to human errors. The installation of highly sophisticated electronic switches facilitates work significantly. The best results are often achieved by combining central- and remote-switching capabilities, as indicated in Figure 8.3.16. The network operator has the complete flexibility of switching lines among front ends and front ends among mainframes. The switches are microcomputer-based and differ in terms of

- Size of the switching matrix ($N \times M$)
- Display capabilities
- Level of network supervisory functions
- Programmability [DATA82], [TBAR82]

State-of-the-art solutions combine line switching with channel switching. It is expected that communication processors will embed the capabilities into their architecture (e.g., Amdahl and Comten processors). Another trend is visible by observing manufacturers combining switching and multiplexing capabilities by offering intelligent multiplexers. These multiplexers are able to actually manage the bandwidth by software techniques, including routing and rerouting by bypass and drop and insert. The software techniques dynamically

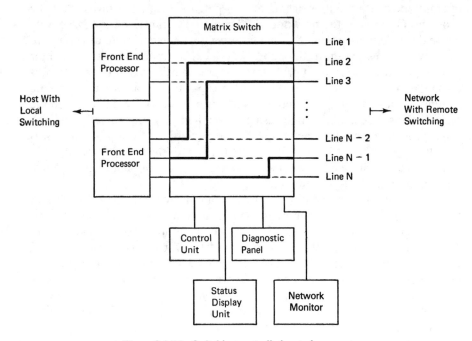

Figure 8.3.16 Switching centrally located resources.

allocate and reallocate physical bandwidth in a way similar to switching and patching.

As stated previously, providing continuing network service is a key issue in operational control. Once the problem has been identified and located, actions in accordance with prepared procedures can be executed. Basically, the problem can be twofold:

- Functionality bottlenecks, including "broken-down" nodes and/or "carrier lost" on links.
- Performance problems, such as temporarily overloaded components suggesting bypass and choosing alternate routes.

The network operator merely executes previously prepared corrective procedures. He or she does not have the time for starting inquiries and in-depth analytical procedures. The operator's objective is to coordinate the operation of the network components to achieve the most efficient utilization of resources for a specific service level. All kinds of preparational work must be done by network-performance analysts. Advanced network architectures (e.g., SNA, DCA, and DNA) provide a definite number of alternate routes in the route tables, which are activated upon breakdown or temporary overutilization. When value-added services are used, network operational control is completely relieved from dynamically rearranging routes.

When using an architecture such as SNA that allows the use of backup routes when primary routes are unavailable, it is imperative that the network operator record a trouble ticket, and dispatch someone to investigate the problem. Otherwise, the network could continue to function in progressively worse degraded modes, until a final failure causes the complete disruption of the service to a segment of the network. An expert system might be used for solving the alternate routing problem. The prerequisite is that large networks contain significant amounts of surplus of capacity. In case of an alternate routing demand, the expert router evaluates the trade-offs and decides on the most favorable secondary route using predefined performance criteria. The route properties should exactly match with performance criteria. Thus, it is not always necessary to select the fastest route with the broadest bandwidth. Expert routers will reach fast selection response and more balanced resource utilization than heuristic routers usually used.

As network complexity increases, a multicolored graphics display of total network—using one unique image of the network—indicating the impacted segments, should be provided. As reconfiguration decisions are implemented, the resultant network also should be displayed graphically. New routes and impacted components should be indicated by colors or by blinking or both. A logical zoom may help network operational control in analyzing components prior to and during configuration. Data-base elements about a particular component or segment may be displayed as well. All these requirements could easily be met by using object-oriented data-base techniques supported by symbolic processing and by artificial intelligence graphics.

8.3.4 Diagnostics and Repair

The diagnostics and repair function includes tools to isolate, fix, or provide backup alternatives to maintain the network's integrity. It provides the ability to determine a specific source of network failure, blockage, or other interference.

The status of the problem must be monitored to ascertain its disposition. The best way to facilitate this work is to use a problem status diagram. This diagram identifies three entry-level status choices (Figure 8.3.17) [FISH90]:

"Selected" = problem has been selected for diagnosis
"Covered" = problem has been caused by the problem selected for diagnosis
"Uncovered" = problem is not related to the problem selected for diagnosis

Choosing "selected," there are four opportunities for reaching the next status of diagnostics:

"Diagnosed" = problem has been successfully diagnosed
"Help required" = diagnostics and problem elimination need inside or outside help
"Suspended" = diagnosis of problem has been interrupted (e.g., due to priorities), but may be continued any time
"Went away" = the problem has disappeared; no further diagnosis is required

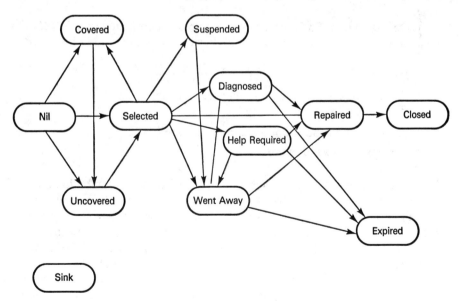

Figure 8.3.17 Problem status transition diagram.

After successful diagnosis, the problem will be considered "repaired," and the trouble ticket may be closed. Otherwise, the problem may be reselected. Problems, which disappear or are suspended, or when their timer expires, may change to an "expired" status. They will occupy a specific segment of the trouble data base. They may be used for further diagnosing problems.

Customer support desk personnel must review the trouble data base at specific short-range intervals to determine the status of outstanding problems. The trouble data base may be—as referenced earlier—part of the following products:

- Experience files
- Configuration data base
- Performance data base or files
- Special-purpose monitors such as network monitors, network element management systems
- Network-management integrators
- Special features of the network architecture and communication software

For facilitating diagnosis, tight links to the inventory control segment of the network-management data base are extremely helpful. After detecting and determining the problem and its impacted components, parts of the inventory control file may be displayed, for example, via a "mouse" option at the workstation. Expert knowledge, such as backup strategies, most frequent problems and their remedies, technical characteristics like saturation level, and recommended utilization level may easily be accessed and utilized in real time.

Development of what-if catalogs requires in-depth analysis of all components in the network to determine the level to which they may be tested by

- Users
- Central- or remote-site fault management
- Vendor representatives
- Capabilities of the communication software in use
- Existing network diagnostics

Diagnosing problems may be substantially facilitated by combining physical and logical views of the network. Usually, messages, events, and alarms are still separated by those views. Manual or automatic correlation may help to speed up the problem resolution process, as indicated in the following figures. Figure 8.3.18 [TERP88A] displays the logical configuration of the network. This display is most frequently driven by applications- and sessions-related monitors that are attached to the communication software. The physical view of the same network is shown in Figure 8.3.19, indicating each single facility and equipment, seemingly without any "logical" connection. The integrated

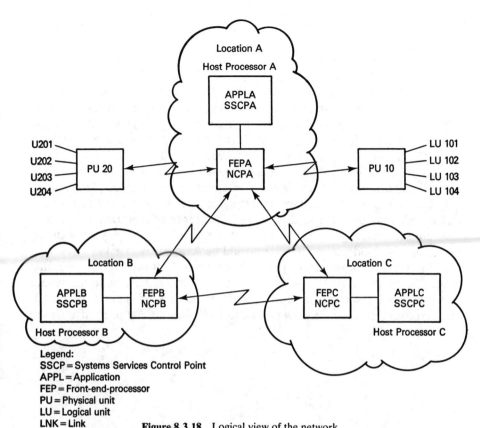

Legend:
SSCP = Systems Services Control Point
APPL = Application
FEP = Front-end-processor
PU = Physical unit
LU = Logical unit
LNK = Link

Figure 8.3.18 Logical view of the network.

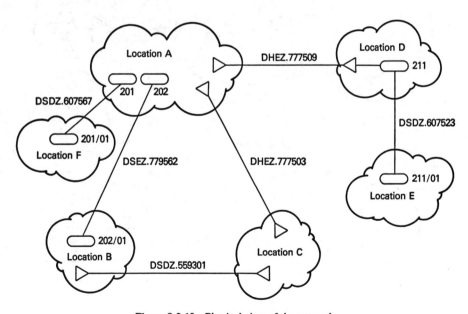

Figure 8.3.19 Physical view of the network.

view shown in Figure 8.3.20 brings both previous views together [TERP88A], offering an excellent basis for collecting messages, events, and alarms.

Similar correlative efforts have to be considered when combining diagnosis and repair of WANs, MANs, and LANs. Figure 8.3.21 displays a generic network with interconnected LANs and WANs. Monitoring and managing devices are installed in all four networks. The focal point is considered to be implemented at a central site offering supervision of bridges, routers, gateways, and dispatching escalation and diagnosis procedures to the remote locations. One example has already been referenced in Table 8.3.2.

Network recovery becomes quite expensive unless procedures for rapid network restoration after repairing failed components are set in place. Figure 8.3.22 summarizes the most important steps of network recovery. After accomplishing all required repairs, tests are executed for proving normal function. If tests are satisfactory, the repaired components and/or links may be switched on, unless the productive operation would be seriously delayed as a result of the repeated switchover. During peak hours even a few minutes of downtime cannot be tolerated, particularly when the timeliness requirements are severe (e.g., in airline reservation, banking, military control, or supervisory tasks). Such recovery procedures, as well as those that are totally disruptive to the

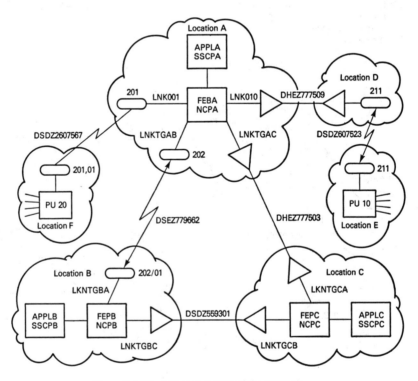

Figure 8.3.20 Integrated view of the network.

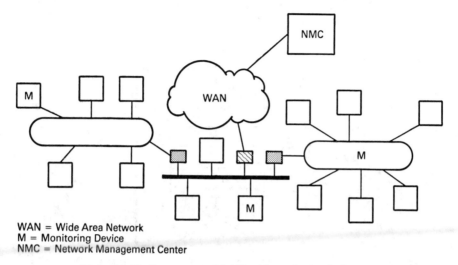

WAN = Wide Area Network
M = Monitoring Device
NMC = Network Management Center

Figure 8.3.21 Interconnected LANs with monitoring devices.

network running in its backup configuration, should be best left for execution during off-shift hours when the impact will be minimized.

The facilities provided by the communication software (e.g., NetView) and network monitors greatly facilitate the restoration procedure. NetView provides for the execution of VTAM commands by using CLISTs or REXX or NCL of Net/Master, which can be customized by the performance analyst. Technical control systems provide the restoration facility for lines and modems.

Network operation control is often tempted to ignore further responsibilities in terms of these factors:

- Closing the trouble records by commenting on problem causes
- Extending and updating the experience file
- Updating the vendor file impacted by the problem and the repair
- Updating the inventory control file by inserting additional information on the component under consideration
- Informing network customers of the restoration of the network

It is important on behalf of network management to ensure that network operators are properly educated, motivated, and not so overworked that their only concern is the symptom and its resolution rather than the cause and its resolution.

8.3.5 End-to-End Testing

End-to-end testing allows for testing on a scheduled or demand basis, and provides diagnostics of end-to-end testing from terminal to terminal across circuits, and offers testing of components and loops.

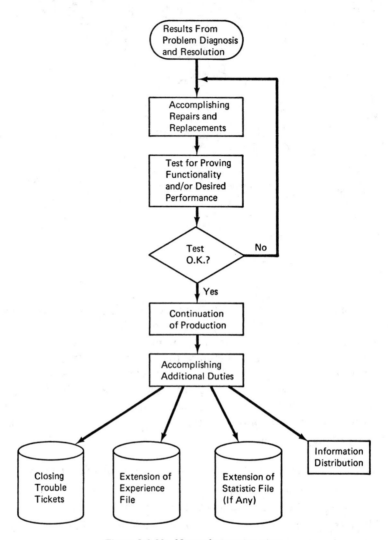

Figure 8.3.22 Network recovery steps.

Testing is necessary to verify dynamically correct network operation. Tests should include individual components, such as equipment (nodes) as well as facilities (communication links).

Monitoring, on the other hand—as discussed in earlier sections—supports proactive performance evaluation for early recognition of problems. The tests should be executed during normal operation, but they must not impair production in any way.

There are, however, still open questions, such as the following:

- What are the criteria for overhead-free testing?
- What components should be tested?

- How should tasks be assigned to the following?
 Local sites
 Central sites
- When to monitor and test?
 Continually
 Periodically
 On demand
- How to monitor and test?
 Disruptive
 Nondisruptive
- What indicators to monitor and test?
 Service level
 Efficiency
 Loops
 Circuits
- What are the instruments to be used?
 Hardware
 Software
 Analog
 Digital
- What reports have to be generated?
 Standard
 Ad hoc with special evaluations
- What are triggering events of monitoring and testing?
 Time
 Single or combined events
 Alarms

The test and control functions can be divided into the following categories [FROS83]:

- Nonintrusive tests
- Intrusive tests
- Remedial functions
- Analog measurements

Nonintrusive tests, as the name implies, are tests that do not interfere with the main-channel data traffic. A series of these tests can therefore be performed without the need for any coordination with the main application or the associated personnel. Intrusive tests, on the other hand, cause some interruption in the main-channel data traffic. However, these tests offer more precise information about the high-speed operation of modems and the quality of the whole transmission channel. Remedial functions are necessary to restore and reconfigure the network to bypass any fault that has been diagnosed. Analog measurements can provide further quantitative information

about signal strengths and signal degradation. Some of these measurements may be intrusive, such as those that need to substitute a test tone for the main-channel data signal. Others, such as those that identify changes in phase jitter and signal level, are nonintrusive. These analog measurements are not precise and may only be used to indicate problems on a particular analog circuit. Further intrusive tests are then generally required to pinpoint the source of the problem—the failing modem or the telephone line. Table 8.3.5 gives a table-format summary of all categories.

TABLE 8.3.5: Tests and Functions in a Network-Control System.

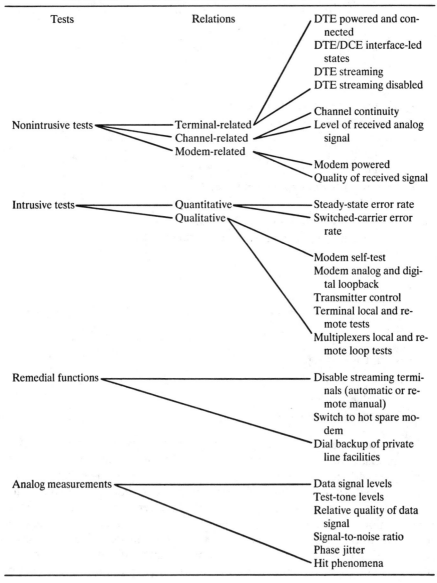

These same systems, while emphasizing powerful centralized control strengths, are characterized by an inability to manage and organize the data they generate. Their weaknesses can be summarized by these four points:

1. Storage capacity is limited and volatile. Only minimal memory is available for the data base and related configuration data.
2. Access by the data communications operator is limited because only printouts of specific files and alarm reports are available. These are generated in bulk and are not organized or accessible by field key or sorted by fault type. These reports are printouts of all day-by-day fault reports.
3. Operator analysis is nonexistent. Large amounts of alarm data are generated by the network. However, only manual and time-consuming effort by the network operator can determine performance trends or network degradation.
4. No executive summaries are produced. Management cannot compare last week's or last month's data on a given site with the current data. Also lacking are summaries of fault times and performance of the entire network over selected times.

Testing of analog and digital service lines at the circuit level is normally carried out by the service provider's centralized test facility in cooperation with central or remote network operational control personnel. The most frequently used transfer integrity tests include [FROS83] (Figure 8.3.23):

- Connectivity test (connection between two equipments is working)
- Data integrity test (equipment can exchange data without problems; also the time for connection establishment may be measured)
- Loopback test (message can be exchanged between equipment without problem):
 — Local channel loopback
 — Local composite loopback
 — Remote channel loopback
 — Remote composite loopback
 — End-to-end pass/fail test

Further tests concentrate on [FISH90]:

- Internal resource test (equipment are internally tested with the result of passed, failed or test inconclusive)
- Protocol integrity test (functionality of protocols is checked)
- Capacity test (data saturation test, connection saturation test and response time for evaluating performance under stress-conditions)

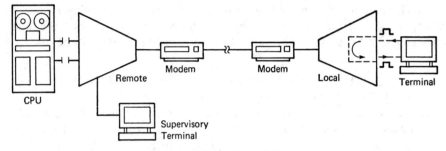

Local Channel Loop Back

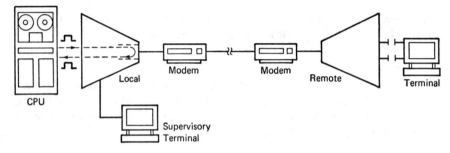

Local Composite Loop Back

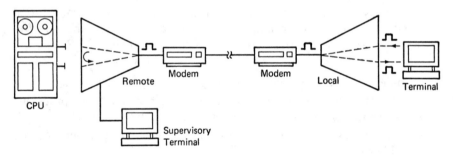

Remote Channel Loop Back

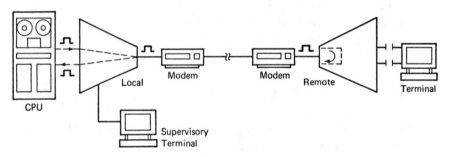

Figure 8.3.23 Loop tests overview.

Many of the tests that are built into the hardware and software are executed automatically, without any operator attention. When a specific situation occurs, the hardware or the software in the box gives control to a test routine (for example, the modem wrap test or LPDA test). The only way execution can be controlled is in the software definition.

Link Problem Determination Aid (LPDA) [IBM80A] is the line-diagnosis aid of the IBM modems 386X. LPDA can be used in the following ways:

- Modem implementation support, operated from the modem console
- On-line diagnosis aid for problem determination on the secondary line

The best problem-determination results can be achieved by using LPDA in combination with the hardware monitor of NetView. The principal additional benefits are:

- Detection of failing communication links and modems initiated at the central site.
- Test of the modem electronics.
- Determination of optimal modem configuration.
- Measurement of the analog part of transmission lines, including line quality.
- Display of the interface signals.
- Alerts when threshold reached.
- Alerts when power lost.

Furthermore, go/no-go tests and loop tests may be started by the network administrator.

LPDA is called by NetView-hardware monitor. Once called, LPDA collects error-related data on modems or multiplexers and links and sends them back to NetView for further processing. The 386X modems need not be addressed during NCP generation. They are addressed by the physical units (PUs) attached to the modems under consideration. The most important LPDA commands are:

- Self-diagnosis of local modems
- Status reports of local modems
- Loop test of local modems
- Self-diagnosis of remote modems
- Status report of local and remote modems
- Remote loop test
- Status display of remote RS-232 (V.24/X.21) interfaces

LPDA is a concrete example of a modem monitor whose collected data are embedded into the network-management software. But non-IBM products cannot be connected, unless dramatic extensions are made. Usually, components of other architectures are not understood by LPDA.

Similar ideas are implemented with the Service Point Command Facility of NetView/PC. Commands and command chains may be invoked by the NetView operator which are then translated into the native command syntax of the network element under test. The third-party component responds with the test results and sends them back to NetView using NMVT.

Some tests are controlled by the operator. These may include, for the IBM environment, the following:

- The link-level-two test is triggered by a VTAM command and consists of sending an SDLC frame from the NCP to the PU, which returns the frame if the PU received the frame correctly. VTAM informs the operator how many SDLC frames were transmitted and how many were received.
- The explicit route test is also triggered by a VTAM command. The test sends a PIU to the destination subarea, and every subarea that it passes on its way returns a PIU saying that its destination was reached.
- The connection test is available to an end customer. If the customer enters IBMTEST on the screen, VTAM runs an echo test that informs the end-user whether he or she is able to communicate with VTAM.

In order to reduce the overhead due to tests during production, special triggering mechanisms may be considered. [TERP87A] discusses an example of using abnormal networking events for initiating test cycles. As a side product, network availability may be sampled.

Other tests are available to the customer through various buttons on the keyboard, and some are specific tests for the network technician. For additional information, refer to the applicable component description manual, provided by the vendor. VTAM, NCP, and some of the subsystems provide facilities by which to trace a message through nearly all of its steps through the network. Line trace, input/output trace, buffer trace, application interface trace, and so on, show the flow on each session and can tell the customer how far the message reached and the negative response that may indicate the problem. The only problem with traces is that they normally produce a great deal of output, of which perhaps only a small part is of interest. Which trace should be run is often a point of discussion between the systems programmer and the vendor.

Of course, one seldom has a trace running the first time an error occurs, and even more seldom does one have the correct trace. One of the objectives of the NetView session monitor is to help in this respect. The session monitor keeps session-initiation commands (ACTPU, ACTLU, ACTCDRM, and BIND) and the responses to the commands. The session monitor also keeps the last *N* PIUs sent in a session and control blocks associated with the

session. The session monitor information can help determine the reason for the problem when the physical connection is not at fault and when the hardware monitor has not reported any other problems. The session monitor can help to determine what happened just prior to the customer's call to report a problem.

Normally, a dump does not provide much information, but it is often required by the network analysts to solve a problem. Unless stated otherwise in the operations guide, the dumps should be generated by the system. Scheduling is directly related to resource allocation. Network operators allocate networking resources based on a preestablished schedule. This schedule is required for other than on-line services, such as batch transmission, software fixes to implement, hardware maintenance, and tests outlined earlier.

The poll substitution method [POCE86] is based on a new technique, which allows selective local interception of host polls before they reach any terminal on the multidrop line. The intercepted polls are immediately replaced with other predefined protocol commands exercising selected protocol functions of the multidrop line. The intercepted polls are then independently acknowledged to the host as nonproductive polls, thereby satisfying the host protocol requirements before any timeout occurs. The arrangement is shown in Figure 8.3.24.

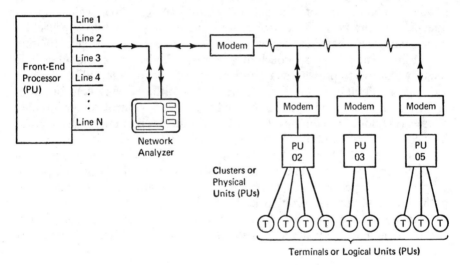

Figure 8.3.24 The poll substitution technique.

With the analyzer, testing can be performed during production, and without host or fep intervention. By carefully selecting which and how many polls may be substituted, overhead and impact on service level remain invisible to the users. Expert system extentions may help [POCE86]:

- To automate test sequence selection and assembly
- To increase accuracy of test results interpretation

- To adapt substitution frequency to actual negative polling rates
- To understand protocol rules

Many CSUs and some T1 multiplexers can monitor T1 link performance on a real-time basis while the line carries normal traffic [RUX90]. Real-time tests are facilitated by implementing bipolar coding. The DS1 pulse train at output of the T1 multiplexer is encoded with a bipolar scheme before it reaches the T1 line for transmission. In bipolar coding, alternating positive and negative pulses represent one state (a binary "1"); absence of pulses represents the other state (a binary "0"). This permits the multiplexer to detect single-bit errors. If an error occurs in a 1-bit position, thereby converting it to 0, adjacent 1s will be of identical polarity, which is easily detectable, since this violates the polarity rule. If an error occurs in a zero, converting it to a 1, there will be two successive 1s of identical polarity, which also violates the polarity rule. These events are called bipolar violations. The monitoring is continuous over time and thus is very effective. Also ES, SES, FS from ESF are available from CSUs or from AT&T Accunet Information Manager.

Some diagnostics require service-disruptive tests that insert pseudo-random bit patterns. In this context, the advantage of an advanced CSU is to provide the capability to automatically initiate loopbacks and to transmit test signals on command from the network control center. CSUs which support interfaces to the network control center may employ a dial-up approach, a polled multipoint data circuit approach, or a supervisory subchannel within the T1 link. The dial-up approach may be cost effective, but it should include security features to prevent unauthorized access. Clearly, the CSU also needs auto dial capabilities so that it can send alarms to the network control center and auto answer capabilities to respond to network control center-initiated queries (in addition to queries, the network control center may wish to download configuration parameters).

On-line and off-line technical maintenance activities are mostly involved in supporting the end-to-end function. This service is called upon by practically all other functional areas; the persons involved are knowledgeable about both routine and unique problems.

In most organizations, there is a so-called technical support group, which assists practically all areas. The principal activities of this group usually include

- Switching on diagnosis tools, unless automated or routine type of activation. In case of automation, the diagnosis tools are switched on automatically if the thresholds set are exceeded. There are implementation examples, where, for example, the network monitor's "carrier-lost indication" automatically activates the line monitor for in-depth analysis. Once the procedures have been preprogrammed and catalogued, the operational control personnel can use the tools as well. The extracted information will then be further analyzed by the technical staff.

- Analyzing and evaluating
 Traces (Figure 8.3.25)
 Dynamic dumps
 Error statistics (Table 8.3.6)
 Special tests results (e.g., loop test for the primary and/or secondary
 end [Figure 8.3.23])
- Completing preventive maintenance
 Evaluation of reliability logs
 Evaluating problems by relating symptoms to causes
- Accomplishing
 Corrections in procedures
 Reorganization of local and remote storage devices
 Limitation of problem consequences
 Switching on redundant components
- Calling on additional services, if necessary, which may include
 Off-line technical maintenance
 Network-performance analysis and tuning

When the problem cannot be resolved in the on-line mode, the technical support continues to try to solve it in the off-line mode. The responsibilities do not change much, but the detail and time frame of evaluation may be

```
■ LINE-VIEW (C)= VO1 D.K. 11/84  // ***************************** // TEST VER.01 LIRON GMBH TEL:0049-89-4314000
                                          RESPONSE TIME ANALYSIS
DATEX-L / SDLC / HDX / 2400 / MPT / CS2 ***************************** LINE=-------- TEST=--------  20.11.84/13.39.46
```

GROUP	EVENT	COMMENTS	TRANSACTION A1 START	LONG	% RSP	TRANSACTION A2 START	LONG	% RSP	TRANSACTION B1 START	LONG	% RSP	TRANSACTION B1 START	LONG	% RSP
	INQUIRY	AT KEYBOARD (*)	510	1	0.5%	1913	1	0.4%	2365	1	0.5%	2857	1	0.5%
	DIAL	DATEX (*)	511	1	0.5%	1914	1	0.4%	2366	1	0.5%	2858	1	0.5%
PREPARE	=========	(ESTIMATED)	------	2	1.1%	------	2	0.9%	------	2	1.1%	------	2	0.9%
	XID	HARDWARE - SDLC	512	48	26.2%	1915	48	21.3%	2367	48	26.1%	2859	48	22.7%
	ACTPU	MPT STATION	560	6	3.3%	1963	6	2.7%	2415	6	3.3%	2907	5	2.4%
	ACTLU	X # LUS	566	15	8.2%	1969	16	7.1%	2421	16	8.7%	2912	15	7.1%
	INIT	LU TO APPL	581	4	2.2%	1985	8	3.6%	2437	8	4.3%	2927	7	3.3%
	BIND+SDT	LOGON EXIT	585	11	6.0%	1993	10	4.4%	2445	10	5.4%	2934	9	4.3%
③ SESSION	READY	RECEIVE	596	4	2.2%	2003	4	1.8%	2455	4	2.2%	2943	4	1.9%
	=========	BUILD	------	88	48.1%	------	92	40.9%	------	92	50.0%	------	88	41.7%
	DATA IN	INQUIRY TYPED	600	4	2.2%	2007	4	1.8%		4	2.2%		4	1.9%
	PROCESSING	CPU+EDIT+DB	604	20	10.9%	2011	56	24.9% ②		12	6.5% ②		36	17.1%
	TRANSMIT	AT LINE SPEED	624	21	11.5%	2067	15	6.7%		24	13.0%		24	11.4%
	DATA OUT	AT TERMINAL	645	1	0.5%	2082	1	0.4%		1	0.5%		1	0.5%
TRANSACT.	RESPONSE	END TRANSAKTION	646	5	2.7%	2083	12	5.3%	2500	8	4.3%	3012	5	2.4%
	=========	HOST RESPONSE	------	51	27.9%	------	88	39.1%	------	49	26.6%	------	70	33.2%
	TERM	LU TO APPL	651	4	2.2%	2095	3	1.3%	2508	2	1.1%	3017	4	1.9%
	UNBIND	APPL TO LU	655	4	2.2%	2098	6	2.7%	2510	4	2.2%	3021	8	3.8%
	DEACTLU	X # LUS	659	15	8.2%	2104	17	7.6%	2514	13	7.1%	3029	17	8.1%
	DEACTPU	MPT STATION	674	6	3.3%	2121	7	'3.1%	2527	7	3.8%	3046	7	3.3%
③ SHUTDOWN	DISC	PHYSICAL LINE	680	1	0.5%	2128	1	0.4%	2534	1	0.5%	3053	1	0.5%
	=========	SESSION	------	30	16.4%	------	34	15.1%	------	27	14.7%	------	37	17.5%
DATEX	=========	LINE BUSY	------	169	92.3%	------	214	95.1%	------	168	91.3%	------	195	92.4%
	EDIT	AT TERMINAL (*)	681	1	0.5%	2129	1	0.4%	2535	1	0.5%	3054	1	0.5%
	DISPLAY	ON SCREEN (*)	682	10	5.5%	2130	7	3.1%	2536	12	6.5%	3055	12	5.7%
	END	UNLOCK KB (*)	693	1	0.5%	2138	1	0.4%	2549	1	0.5%	3068	1	0.5%
MESSAGE	=========	(ESTIMATED)	------	12	6.6%	------	9	4.0%	------	14	6.2%	------	14	6.6%
TOTAL RESPONSE TIME - END USER			① 183		100.0%	225		100.0%	184		100.0%	211		100.0%

① Transaction response time = 18.35.

② Turning the TP-Monitor slightly improves response time.

③ LineView pinpoints the real sensitive areas in session establishment and session disengagement.

Figure 8.3.25 Trace example.

TABLE 8.3.6: Error Statistics.

NETWORK PROBLEM DETERMINATION APPLICATION 10/30 14:47:40
NPDA-30B * ALERTS-STATIC *
DOMAIN: CNCCF

SEL#	DATE/ TIME	TYPE	RESNAME	ALERT DESCRIPTION:PROBABLE CAUSE
(1)	10/30 14:35	CTRL	C1241	ERROR TO TRAFFIC RATIO EX-CEEDED:COMMUNICATION:
(2)	10/30 14:35	CTRL	C1241	TIMEOUT:DEVICE OFF/REMOTE MO-DEM OFF/COMM
(3)	10/30 14:34	CTRL	C1241	TIMEOUT:DEVICE OFF/REMOTE MO-DEM OFF/COMM
(4)	10/30 14:30	CTRL	C1241	ERROR TO TRAFFIC RATIO EX-CEEDED:COMMUNICATION.
(5)	10/30 14:30	CTRL	C1241	PARTIAL OR NEGATIVE ACK.:DEVICE/COMMUNICATION.
(6)	10/30 14:27	CTRL	C1241	ERROR TO TRAFFIC RATIO EX-CEEDED:COMMUNICATION.
(7)	10/30 14:27	CTRL	C1241	TIMEOUT:DEVICE OFF/REMOTE MO-DEM OFF/COMM
(8)	10/30 14:27	CTRL	C1241	PARTIAL OR NEGATIVE ACK.:DEVICE/COMMUNICATION.
(9)	10/30 14:03	CTRL	C1251	PARTIAL OR NEGATIVE ACK.:DEVICE/COMMUNICATION:
(10)	10/30 08:22	CTRL	CA061	TIMEOUT:DEVICE OFF/REMOTE MO-DEM OFF/COMM
(11)	10/29 19:42	CTRL	C1391	FORMAT EXCEPTION SDLC DISC:OK IF NORMAL/DEVIC!
(12)	10/29 19:42	CTRL	C1301	FORMAT EXCEPTION SDLC DISC:OK IF NORMAL/DEVIC!
(13)	10/29 17:37	CTRL	C1231	TIMEOUT:DEVICE OFF/REMOTE MO-DEM OFF/COMM
(14)	10/29 16:48	CTRL	C1331	TIMEOUT:DEVICE OFF/REMOTE MO-DEM OFF/COMM

DEPRESS ENTER KEY TO VIEW ALERTS-DYNAMIC OR ENTER 'A' TO VIEW
ALERTS-HISTORY
ENTER SEL# (ACTION), OR SEL# PLUS 'M' (MOST RECENT). 'P' (PROBLEM).
'DEL'

NPDA (NetView Hardware Monitor)

ALERT(3543)	10:06	PIP	BLNJE06B 2020	NO POLLING	:RESTORE	B
ALERT(3533)	10:05	PIP	BLNJE06B 2020	NO POLLING	:RESTORE	B
ALERT(1778)	09:08	TINT	BLNJE042	NETWORK TIME	8.7	8.0
ALERT(3947)	10:43	TINT	BLNJE042	NETWORK TIME	12.3	8.0
ALERT(3854)	10:40	TINT	BLNJE042	NETWORK TIME	9.2	8.0
ALERT(2725)	05:05	TINT	BLNJE042	NETWORK TIME	8.8	8.0
ALERT(3755)	10:27	TINT	BLNJE042	NETWORK TIME	12.6	8.0
ALERT(3537)	10:05	TINT	BLNJE042	NETWORK TIME	8.9	8.0
ALERT(3745)	10:24	TINT	BLNJE042	NETWORK TIME	8.7	8.0
ALERT(2117)	07:19	TINT	BLNJE042	NETWORK TIME	8.3	8.0
ALERT(3985)	10:44	TINT	BLNJE042	NETWORK TIME	13.6	8.0
ALERT(2227)	08:07	TOB	BLNJE027	INTERNAL TIME	7.3	5.0

ALERT(3970)	10:47	IND	BLNJE041	INTERNAL TIME	5.2	5.0	
ALERT(3973)	10:48	IND	BLNJE048	INTERNAL TIME	5.1	5.0	
ALERT(2743)	09:07	#-5	BLNJE067	INTERNAL TIME	6.1	5.0	
ALERT(2714)	09:04	#-5	BLNJE067	INTERNAL TIME	8.2	5.0	
ALERT(3969)	10:46	IND	BLNJE041	INTERNAL TIME	6.3	5.0	
ALERT(1734)	09:06	#-5	BLNJE067	INTERNAL TIME	6.6	5.0	
ALERT(2226)	08:07	TOB	BLNJE027	ERROR COUNT	17.0	15.0	
ALERT(3448)	09:59	TOB	BLNJE027	ERROR COUNT	15.0	15.0	
ALERT(2779)	09:08	TOB	BLNJE027	ERROR COUNT	16.0	15.0	
ALERT(3535)	10:05	TINT	BLNJE042 C300	C. U. TIMEOUT	:RESTORE	B	
ALERT(2769)	09:08	TOB	BLNJE027 C100	C. U. TIMEOUT	:RESTORE	B	

Net/Alert Plus

substantially different. Additional activities, which may differ, may include these activities:

- Preparation for off-line dumps.
- Evaluation of dumps and error statistics, particularly on special components.
- Seeking more sophisticated errors, such as
 Protocol
 Communication software
 Line quality
- Working with vendors to document errors, and apply and test fixes.

Again, line monitors can be of great assistance.

Frequently, multiple problems are competing for testing resources, and operators or technical support have to solve the conflict. Practical guidelines for the right choice are [FISH90]:

- Allocate the testing resource to the most severe problem.
- Select the test with the highest likelihood of solving the problem.
- Select the tests next with the lowest time demand.
- Select the tests next that are the least disruptive.

8.4 INSTRUMENTATION OF FAULT MANAGEMENT

There is a wide range of instruments supporting single or more complex fault management functions. All product families introduced in Chapter 4 may be utilized separately or in combination. This section will give an overview of existing products in the categories of monitors, network element management systems, console management systems, and integrators. In addition, examples of instrumenting ISDN monitoring and testing services are given. Due to the importance of centrally supervising local area networks, an example with

multi-layer monitoring instruments is shown. Finally, the applicability of expert systems is given. The major emphasis is on product selection and comparison criteria, which may be considered generic. References and descriptions of products are kept to a meaningful minimum. However, examples are used for leading products.

8.4.1 Monitoring and Testing Devices

Table 4.1.1 gives an overview of monitoring devices. Following the sequence of the table, product examples include:

- **Accounting packages:** Systems Management Facility (IBM)
- **Special-purpose response time monitors:** Response Time Monitor (IBM), Questronics product lines, Tempo 3270
- **Modem, data service and communication service monitors:** CMF (Racal-Milgo), Analysis (Paradyne), DualView (Codex), Dataphone II Comsphere (AT&T), LPDA (IBM)
- **Line monitors:** Product lines from Hewlett-Packard, Northern Telecom, Atlantic Research
- **Multiplexer monitors:** TimeView (Timeplex), INCS (N.E.T.), StrataView (Stratacom), NetWatch (TelWatch), NMS9000 (DCA/Cohesive), Dataphone II (AT&T)
- **LAN monitors:** Sniffer (General Analysis), Ethernim (DEC), LAN Network Manager (IBM), Spider monitors
- **PBX monitors:** CSM, Mufos, Macstar (AT&T), Hicom Man (Siemens)
- **Network monitors:** Net/Alert (Boole), Smart (Memonec), Prism (Dynatech), Intellinet (DataSwitch), DataWatch (TelWatch), NMS (Emcom)
- **Software monitors:** RFM (IBM), QCM (Legent), CMF (Boole), NetSpy (Legent), Mazdamon (CA), NetView Performance Monitor (IBM), NMCC/DecNet/Mon (DEC), GTF (IBM), Net/Avail (Boole), SIP (Unisys), X-Ray (Tandem)
- **Application monitors:** Omegamon/IMS, -/CICS (Candle), IMF (Boole), TSO/MON (Legent), Control/CICS (Boole)
- **Packet switching/X.25 monitors:** 7500 and 7700 Turbo models (Atlantic Research), 620 and 820 Protocol analyzors (Digilog), Micom Box (Micom), Datatest 5EB (Navtel) X.25 Analyzor (Questronics) 8400, 8500 and 8600 Autoscopes (Telenex)

This list must not be considered complete. Product progress is very fast, and it is impossible to provide a current list in a publication such as this. However, the examples help to find at least the categories and ranges of products.

For performance and cost reasons, not all monitoring and testing de-

vices can be used continuously. Many corporations have decided on rotating measurements.

Many users, when evaluating an on-line performance measurement system, become troubled with two issues. The first is the total system cost. An expenditure of $200,000 to $300,000 is a major expense, where the average cost per line can be $1500 to $2000. The second issue is the question of whether every line needs to be monitored constantly for characteristics, when average values will often be of no value during off-peak hours and may vary only slightly over normal monthly, weekly, or daily cycles. More often, users conclude that the investment is not worth it and fail to implement valuable monitoring systems [LOWR82].

From an economic point of view, an electronic matrix switch might cost in the range of $300 per port versus the $1500 to $2000 incremental cost per port for a performance-measurement system. Thus, the cost of a 100-line system can be reduced from the $200,000 range to the $100,000 range, where 16 performance-measurement ports are rotated among the 100 lines. Figure 8.4.1 shows an additional variation of the system consisting of performance-monitoring and electronic matrix switch. In this case, the switch, instead of acting in a purely passive mode to tap into the various lines, is used for monitoring as well as for backup switching. Many networks are equipped with spare front-end processors; if an active processor fails, the spare may be

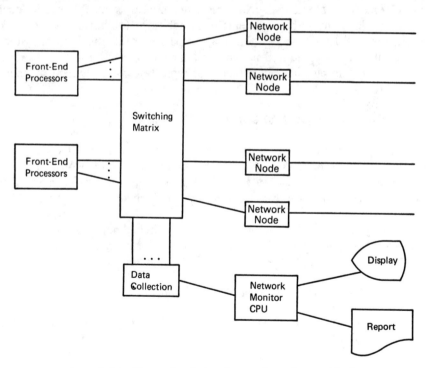

Figure 8.4.1 Electronic switch and network monitor combination.

switched quickly and efficiently into operation. In fact, this is probably the primary function for electronic switching systems, especially when one front-end processor is used to back up several others, rather than the simplest case where each has a hot spare.

In this configuration, the switch is in an active path from the modems to the various front-end processors. The switch then performs a dual function: First, it switches monitoring ports among the performance-measurement system input ports; second, it provides group switching to the spare front-end processor in the event of failure. Since the cost of the switch can be shared between both functions, there are substantial economic benefits to be gained, while total system efficiency and flexibility are enhanced. In summary, newly developed electronic matrix switches may be combined with performance-monitoring systems in such a way that the major operational benefits are achieved but total costs are substantially reduced over the measurement systems currently on the market.

8.4.2 Network Element Management Systems

There is little difference between an intelligent monitoring and testing system and a network element management system. In reference to Chapter 3, network element management systems are supervising and controlling a family of network elements, such as modems, multiplexers, PBXs, and local area networks. Thus, these systems offer solutions for horizontal network management. AT&T has been the first company to offer this kind of system for consolidating fragmented network management solutions for voice and data. A few examples are given below of typical network element management systems from AT&T.

Dataphone® II System Controller/Comsphere

Dataphone II System Controller is a network-management system that allows users to manage AT&T modems, multiplexers, and digital data sets through a single integrated system. With this system, the customer also can display network maps, produce trend reports, and schedule testing of network components.

The system supports analog, digital, and switched network applications, and two-point, multi-point, and multiplexed networks, including T1.5 facilities. Figure 8.4.2 displays the architecture of Dataphone II.

Dataphone® Acculink™ Network Manager

The Acculink Network Manager is an application software enhancement for the Dataphone II Level IV System Controller. It allows customers to monitor, control, test, and reconfigure their backbone T1 multiplexers, in addition to the network-management capabilities provided by the Dataphone II System Controller.

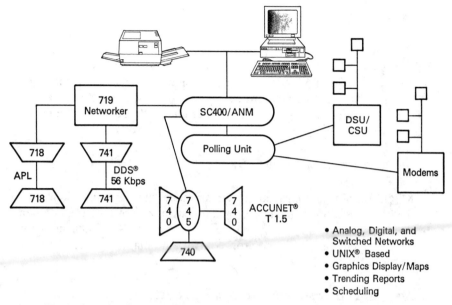

Figure 8.4.2 Dataphone II SC/Acculink network element management system.

Starkeeper® Network Management System

StarKeeper Network Management System (NMS) is a manager for DATAKIT® VCS and ISN and includes fault, configuration, and accounting management features as well as a data-base management system.

The StarKeeper system's network map gives the network manager a graphic display of the system. The map is active and changes to show new configurations or problems.

The fault management feature helps managers isolate failures, gives an active fault tally display, retains a fault history log and lets managers call up previous problems, provides fault thresholding and summary reporting, and automatically generates alarms to various central system managers and external devices.

Trouble Tracker, VMAAP

Accumaster Trouble Tracker is a "trouble desk" for managers responsible for the availability of telecommunications systems and networks. It tracks the performance of networks composed of a wide mix of PBXs and equipment related to the switches, applications processors, and local area networks.

The visual Maintenance and Administration Panel (VMAAP), coresident with the AT&T Trouble Tracker, allows the customer to locally or remotely manage PBXs.

Manager 1, 2, 3, 4

The Manager provides a wide range of network-management capabilities for System 85, Dimension® PBX Feature Package B, System 75, ISN, AUDIX, AP16, and 3B5AP. It gives large business customers control of their own communications systems networks with the following functions: facilities management, traffic management, terminal change management, and cost management.

Multi-Function Operations System

MFOS provides configuration, performance, and fault management. It is used with the 5ESS® switch and provides centralized and integrated operations, administration, and maintenance support on 5ESS switch networks. With MFOS, a customer can monitor, control, and maintain a network from one or more central locations.

Macstar End Customer Management System

The Macstar End Customer Management System allows telephone companies to provide control capabilities to Centrex customers. Customers can perform feature changes, line moves, and automatic route selection without a service order, using terminals on their premises.

Following these examples, other companies also define their systems as element managers. In many cases, this categorization can be fully accepted. Examples are summarized in alphabetical order of manufacturers:

Bytex Corp.: Unity Management System
Cabletron Systems: LANView and Spectrum
Cisco: NetCentral
Codex Corp.: INMS9800
Data Switch Corp.: TotalNet
Halley System: ConnectView
Infotron: INM
Larse Corp.: Integra-T
Micro Technologies: Lance
Racal-Milgo: CMS
Synch. Research: SyncView
SynOptics: Lattisnet Manager with Net Map and NCE
Telematics: SmartView
Timeplex: TimeView
TSB International, Inc.: HubView/PC

Chapter 13 contains a more complete overview on element management systems.

For evaluation purposes of network element management systems, the following criteria may be used:

- Class of devices supported (e.g., any with SNMP support)
- Environment supported (e.g., multi-vendor)
- Platform (e.g., SUN, workstation)
- Operating system (e.g., Unix)
- User interface (e.g., high-resolution color graphics display)
- Interface to other programs (e.g., Accumaster, NetView)
- Diagnostics (e.g., network analyses, diagnostic SW)
- Alarms (e.g., visual and audible notification, color-coded display)
- Actions (e.g., isolate source of failure, remote testing, issues trouble tickets)
- Remote reconfiguration (e.g., yes/no)
- Price (e.g., $3000–$50,000)

8.4.3 Terminal Emulation or Console Management

On the way to fully integrated network management, some of the manufacturers start with physical integration.

Users just beginning to integrate their network-management facilities are typically attracted to console management-based solutions. Console management offers an integrated workstation for "cutting through" to any existing network-management systems. Usually, console management enables users to issue commands as well as receive messages from one console.

Net/Command (Boole and Babbage) is a network center control system. Its architecture allows the user to select from a range of facilities to form a tailored system to be upgraded as future network-control tools are introduced. Net/Command can examine the logging printer message stream from a network-control tool and select from the stream those messages which an individual network-control center decides are important to it. The rules for selecting messages are declared by use of a software package called Alert Logic Filter Editor (ALFE). A customized version of this product is considered by IBM as third-party integrator for NetView. IBM intends to integrate this solution from International Telemanagement with the Graphical Network Monitor under its AIX operating system.

NetExec from Telwatch combines software and hardware components into a controlling focal point to support the information exchange between the network operator and five basic types of network elements. These types in-

clude circuits, switches, network devices, host processors (including applications), and mini/micro processors. NetExec takes information from anywhere in the network and presents it to the network manager in a common format on a workstation.

The Accumaster Consolidated Workstation consolidates on a single personal computer (PC), access to multiple AT&T and other vendor network element management systems, including Systems Center's Net/Master and IBM's NetView. All network-management systems retain their full functionalities.

This product does not displace or compromise a customer's existing network-management system. On the contrary, it protects a customer's investment in those products.

The network management systems accessible by users include (see Figure 8.4.3):

- Dataphone® II System Controller (SC)
- Dataphone® II Dial Backup (DBU) ASCII Interface
- Acculink™ Network Manager (ANM)
- Accumaster Trouble Tracker (TT)
- Starkeeper® Network Management System
- Customer Controlled Reconfiguration (CCR)/Special Services Management System (SSMS)

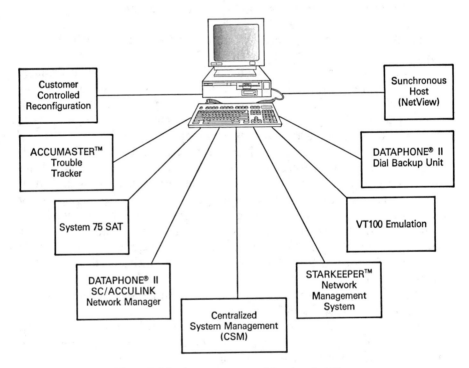

Figure 8.4.3 Accumaster consolidated workstation.

- Synchronous Host Access (e.g., Systems Center's, Net/Master, IBM's Netview)
- Systems supporting VT100 Terminal Emulation
- Centralized System Management (CSM)
- System 75/85

The VT100 feature also allows access to other vendors' element management systems. Using this system, users benefit as follows:

- Consolidated access to network-management systems allows a broader view of the network at a central point.
- Windowed interface permits more effective diagnosis, faster trouble-shooting, and better uptime, while reducing operator fatigue.
- The use of one workstation in applications where many were required reduces terminal clutter and equipment cost.
- The versatility of a consolidated interface translates into lower personnel costs because fewer operators are required.
- Easy user interface means no additional training is necessary.

Multi Terminal ASCII Emulator (MTAE) from IBM offers console management on an OS/2 platform. Besides NetView, products for systems management and network administration may be connected. Also, third-party devices may be included via NetView/PC.

Further examples include the TIC (The Integrated Control) architecture from VOTEK, the recent announcement from DEC of the consolidated workstation as a first step of EMA-implementation, Allink from Nynex, and the fully customized console management architecture from International Telemanagement. All of the solutions help to simplify the network control center and the customer support desk area.

Console emulation does not change the native, proprietary architectures and protocols. In the second step, the presentation form for all connected consoles is going to be unified. In the third step, integration and correlation are also supported, as seen in the next section.

8.4.4 Integrator Products

In reference to Chapter 3, integrators are able to supervise and control network element management systems and network element-based monitors and testing devices. Chapter 3 gives a short introduction into architectures; this section concentrates more on the products, such as NetView and Net/Master, which have already been introduced in Chapter 4.

The intention of this section is to discuss the three leading integrating products; NetView, Net/Master, and Accumaster from the perspective of supporting fault management functions. Other integrators are introduced in Chapters 3 and 13, respectively.

Figure 8.4.4 shows the NetView Architecture of IBM supporting focal, service, and entry points for network management [DANM88A]. NetView's Command Facility includes and enhances the Network Communication Control Facility's (NCCF) functions. The Session Monitor contains the Network Logical Data Manager's (NLDM) functions. The Hardware Monitor includes the Network Problem Determination Application's (NPDA) functions. The Status Monitor (STATMON) allows network operators to look at network resources' status and issues commands for any displayed resource.

NetView		
Installation Aids		
Command Facility (NCCF)		
CLISTs	Status	Help
Help Desk	Monitor	Browse
Hardware Monitor (NPDA)	4700 Support (TARA)	Session Monitor (NLDM)
NetView Performance Monitor (NPM)	Distribution Manager	Access/ SAMON

Figure 8.4.4 NetView architecture.

Graphic Monitoring Facility (GMF) is an OS/2-based system that displays the status of SNA, and eventually non-SNA, non-IBM elements. With the multi-tasking features of OS/2, users can access other interfaces such as NetView Performance Monitor, Info/System, MVS-Automated Operations Controller, and NetView/PC. For a certain period of time, GMF is expected to coexist with the NetCenter product family.

The On-line Help Facility supplies data about NetView commands and many of the NetView display panels. A Help Desk Facility offers an on-line guide about network problem diagnosis techniques. The Browse Facility allows operators to look through libraries and the network log.

The NetView Performance Monitor (NPM) collects, analyzes, displays, and reports NCP-related information as well as data on line utilization, response time, transaction, message, and retransmission counts. Release 3 includes TSO measurements, dynamic activation/deactivation of Definite Response, and collection of session- and gateway-level accounting records. NPM is growing closer to the NetView nucleus by generating performance alarms, such as PIU traffic, line utilization, and error counts, and sending them to NetView for further processing, correlation, and display.

Release 2 also added an access facility for connecting to other host-based monitors offering TAF (Terminal Access Facility) features. IBM added

the Distribution Manager (DM) feature, which has functions comparable with previous HCF and DSX products. The DM supports real-time diagnostics and collects error files from remote locations. The new release also enhanced the NetView File Transfer Program (FTP).

The Network Asset Management facility collects vital product data from network elements. Release 3 also includes support for REXX, the SAA procedural language. Systems programmers can now customize NetView using REXX instead of the more cumbersome command lists (CLISTs).

Third-party systems, PBXs, multiplexer, and LANs may be integrated as well using NetView/PC as a service point. NetView/PC is a multi-tasking personal computer subsystem that supplies the facilities to support communication of network-management data between a personal computer and NetView on a host. NetView/PC was designed to be used in conjunction with NetView to provide services that permit user-written programs to extend Communication Network Management (CNM) to non-IBM communications devices. Using NetView/PC, CNM support can be extended to non-IBM and non-SNA communications devices, voice networks (CBX/PBX), and IBM Token-Ring networks, as shown in Figure 8.4.5. It offers the basic services needed by a device dependent CNM application program and a network operator [TERP87B]. The four separate functions supported in Application Programming Interface/Communication Services (API/CS) are: Host Alert Facility, Operator Communication Facility, Service Point Command Facility, and Host Data Facility.

NetView/PC does not seem to be the strategic solution for integrating non-SNA and non-IBM devices. Offering the LU 6.2 capabilities in addition or instead of NetView/PC will alleviate writing network-management applications by third parties. The LU 6.2-interface is much easier to use, better performing, and a more secure base for implementing applications. LU 6.2 will also be used for internetworking NetViews and Net/Masters.

Management data flows over SNA sessions, which provide reliable, connection-oriented network transport. The basic SNA message unit—called Request/Response Unit (RU) and supporting network management—is called the Network Management Vector Table (NMVT).

For improving automation features, table-driven rules have been implemented based on converted NMVT messages. During the conversion, however, messages and data could be lost. The new alarm architecture, called message service units (MSU), will trigger automated actions without having to convert each MSU into a message.

In order to speed up the implementation process, IBM has signed partnerships. For the voice world TSB's HubView/PC application is able to collect alerts and traffic statistics from a variety of PBX vendors. Also, CDMR (Call Detail Maintenance Records) may be collected and processed. Carl Vanderbeck and Associates has designed and implemented a development toolkit for NetView/PC applications. The first implementation is available for the VAX alarms. Most vendors of network-management products are going to support NetView. However, the depth of support is very different; it starts with for-

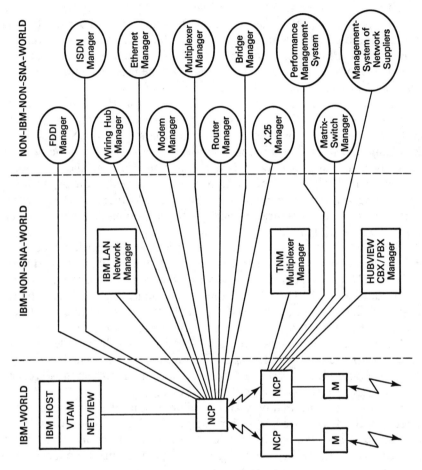

Figure 8.4.5 Integrating non-IBM, non-SNA devices.

334

warding alerts and ends with giving away the complete control of their own device family to IBM. Successful NetView/PC implementations are operational with MCIView (supervising network services) and LattisNet NetMap (supervising SynOptics'-Ethernet local area networks). Few companies consider a more efficient, peer-to-peer, solution for the NMVT conversion.

The fastest progress is expected in integrating token ring's management using NetView/PC-emulation within the LAN Network Manager. Management responsibilities include:

- Automatic detection and bypass of media and station adapter failures through mechanisms embedded in the adapters
- Controlling distributed management servers which collect error statistics and report on resource utilization, changes, and parameter settings
- Local LAN management applications including fault, configuration, and performance-management functions for stations and bridges
- Host Alert Facility by the LAN manager as service point to NetView
- Direct centralized management of SNA devices residing on the LAN from NetView.

LAN Network Manager lets customers manage multi-segment Token Ring LANs, broad-band and baseband PC networks, and—through the 8209 LAN Bridge—Ethernet segments. The application runs under OS/2 and uses both the presentation manager graphical user interface and the relational data-base manager. Local management support is provided by LAN Station Managers. Both products are connected to NetView for supporting central management. Internally, CMIP is used for information exchange between the manager and managed objects.

IBM plans to correlate fault and configuration management via a network-management repository. There is a wide expectation that the repository data base is going to be everything to everyone. The repository is assumed to support administrative and planning environments with inventory data, physical and logical configurations, accounting, user data, performance indicators, problem histories, application and change management information, and, simultaneously, real-time operations management by supporting automated systems' operations functions. It is very likely that the repository data base will not be implemented in one step, but in many, starting with the operational part under the coordination of NetView developers.

IBM offers support for OSI network management. The initial OSI network-management interface for IBM systems will be part of IBM's newly announced OSI/Communications Subsystem (OSI/CS), which will provide a full implementation of the seven layers of the OSI model [HERM89A]. IBM will implement the OSI Common Management Information Protocol (CMIP) under OSI/CS. This will allow OSI/CS to report events to other OSI management systems and/or to receive CMIP messages. OSI/CS will also be able to

translate a CMIP event message into an SNA NMVT generic alert, which can be forwarded to NetView.

The extention of functionality of OS/2 for supporting network-management applications may mean that the OSI/CS gateway can be implemented under OS/2 as well. This implementation would offer a very powerful distributed integration capability at the site level.

TCP/IP support is implemented by a direct gateway between NetView and AIX-based control units implementing SNMP in the control units and in the hosts where NetView resides.

In order to accelerate the implementation of solutions, IBM takes advantage of partnerships such as NetCenter from USWest, HubView from TSB, and a development toolkit from Vanderbeck for NetView/PC applications.

Net/Master from Systems Center

Net/Master (Figure 8.4.6) is the only serious competitor to IBM's NetView. The product offers a better user interface, a more complete file transfer package, and an extremely successful fourth-generation language called NCL. Net/Master is a comprehensive, software-based network-management system that operates as a standard VTAM application in an SNA communication network.

This provides a wide range of services to the operational parts of the

MAI	EASINET	SYS / MASTER	INFO / MASTER
NET / MAIL	Net/Master-Basis		NCL/EF
NET / STAT	NCL Panel-Service, VSAM-Support, VARTABLES		NEWS
AOM/ESF	FTS	NTS	OCS

Accronyms:
NCL = Network Control Language
EF = Extended Function
MAI = Multiple Application Interface
FTS = File Transfer Service
ESF = Expert System Foundation
NEWS = Network Error Warning System
NTS = Network Tracking System
ADM = Advanced Operations Management
OCS = Operator Console Services

Figure 8.4.6 Net/Master architecture.

system, and is the underlying strength of Net/Master. It is required before any of the other components will function and could be thought of as Net/Master's "Operating System." All the security facilities (typically used in conjunction with a standard package such as ACF2 or RACF), activity logging, interconnection with other Net/Master systems, and basic system support is provided here, together with one of the major reasons for the product's success—its customization language.

Users have a wide variety of requirements which prompt them to consider Net/Master, but a consistent factor in their choice has been the power and flexibility of Network Control Language (NCL). There can be very few sites where a system or network-management application, no matter how comprehensive, can be implemented without any tailoring or customization, and this is the role of NCL. It gives the user access to any of the information held within Net/Master or available through its interfaces and allows this to be stored, acted upon, or presented as required. Many of the Net/Master components are themselves written in NCL, which has evolved into a language highly attuned to the needs of network and system automation.

NCL has an asynchronous task structure to allow information from many sources to be absorbed, correlated, and presented in a meaningful form, and provides a rich set of specialized functions combined with a compact basic syntax. There are DO, DOWHILE, and modularization facilities to promote easy-to-maintain, well-structured code, comprehensive file I/O, inter-task communication and queues, excellent presentation management, and full debugging and testing facilities.

NCL shares the development speed of interpretive languages with the run-time efficiency of compiled code. This is due to the NCL loader, which optimizes and partially compiles each NCL procedure before use. To prevent this from occurring each time a procedure is run, Net/Master holds a dynamic in-storage pool of the most frequently used routines, into which critical procedures may be fixed.

Until one has attempted to implement a comprehensive system management application, it can be difficult to understand why the customization and tailoring facilities are so important. Experience shows that these form the difference between forcing an eventual, costly result and building an integrated, well-structured solution. No off-the-shelf package will fit seamlessly into the individual naming conventions, workload, and management structure of an organization, but NCL makes the implementation of Net/Master very straightforward.

The Foundation Component provides a routing, filtering, and authorization facility to control the distribution of all messages, commands, and information between multiple Net/Master systems. This feature, called Inter-System Routing (ISR), allows multiple domains, systems, and networks to be managed from any point. It ships all the data associated with any message, so that full information on the context and attributes are available to remote systems. This gives a central, focal system the means to properly monitor and control distributed processors and networks.

All terminal services are provided by the Foundation component. These include the management of multiple on-screen windows, the command and navigation support, based on SAA-compliant menus with "Panel-skip" fast paths for experienced users, and a Logical Screen Manager, which ensures that only the minimum required screen data is transmitted.

Advanced network management features support problem management with NEWS (see Chapter 4), session management with NTS (see Chapter 4), and Netstat. NetStat provides a complete panel-based system that monitors the status, controls the recovery, stores availability figures, and invokes problem logging for network devices in single or multiple connected domains.

All these actions are controlled by a ruleset which defines the types and specific or generic names of the devices, together with the required actions. Devices can be specified on an inclusive or exclusive basis, and the system requires no redefinition or re-initialization to include dynamically added resources.

NetStat provides dynamic status boards for the network operators that portray the health of key network resources. Each operator may view a set of resources tailored to his or her individual requirements, and from this screen jump directly to other related diagnostic information. NetStat holds its data in a global status table, which it updates with information supplied automatically by VTAM; there is no wasteful periodic polling for current device status.

The NetStat status board provides a convenient "home" screen for network operators: they are shown latest Alert message, they are notified of any failures within their area of responsibility, and they have direct access to all status and Info/Master data. The operator profile can be set to invoke NetStat immediately on entry to the system, providing a simple, tailored view of the network.

Advanced operations management is the basis of automated operations by offering integration, centralization, and automation of message processing for SNA, MVS, VM, and YES subsystems. In this process, Sys/Master is gaining access to the console messages and allows them to be processed before presentation on the MVS consoles.

Other modules address access services offering network security, Net-Mail, and user, application, and system broadcasting; multiple application interface offering session management; file transfer services including data compression and compaction; Inter Net/Master connections; and an external interface program.

Both NetView and Net/Master are host-based products that manage and control logical and physical network components from a central focal point. Each product provides a single presentation interface into the network; and both support configuration management, performance management, automated operations, problem determination, security, and other principal network-management subsystems and functions. Systems Center offers two more network management-related components. Sys/Master automates computer operations in large-scale MVS and VM environments. Info/Master is a

data-base repository system for supporting both the foundation and advanced network-management components.

Accumaster Integrator from AT&T

Figure 8.4.7 diagrams Accumaster [DANM89A]. AT&T's network-management strategy addresses the three network-management domains that exist in current communications networks: customer locations, local exchange carrier's network, and the interchange network. Corporate customers maintain voice and data equipment on the premises, use local exchange carriers (LECs) for intra-LATA services and connections, and transmit network traffic across the country through an interexchange network. AT&T provides equipment and network-management systems for customer premises, develops many components of the local exchange network, and is the premier provider of inter-exchange services, often with customer interfaces to the built-in network management capabilities. Typically, these customer networks are mixed vendor environments.

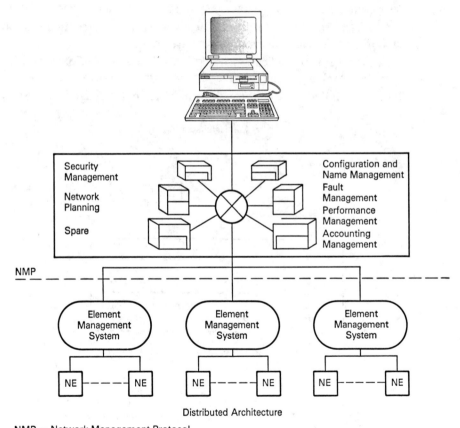

Figure 8.4.7 Accumaster Integrator architecture.

Accumaster's fault management functions and features include:

- Alarm management by differentiating and processing new alarms, active alarms, historical alarms, correlated alarms, and severity alarm logs
- Alarm conditioning and synchronization with the following features: error messages analysis, defining thresholds, and filtering and supporting alarm recognition
- Alarm correlation, with links to the configuration data base and to third-party management systems that support the Network Management Protocol
- Traces for selected activities at the integrator or network element management level
- Reports on alarms, trouble tickets, and their resolution

Figure 8.4.8 shows the presently supported interfaces:

- Alarm interface: Element management systems for alarm consolidation
- Network management protocol: Two-way OSI-based communication support from/to element management systems
- SNA management application: Links to NetView or Net/Master for information exchange using NMP and SNA carrier services
- Terminal emulation: Cut through to any element management system

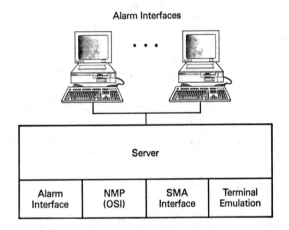

Figure 8.4.8 Interfaces of the Accumaster Integrator.

The basic server is 3B2/600 from AT&T equipped with UNIX system V operating system. The basic software includes the core software and software for the integrated workstation. The peripherals offer 3B2 administration terminals, printers, cables, connectors, and links to the Starlan local area network. The minimum configuration includes one integrated workstation, one server, and

two element management systems (EMS). The maximum configuration includes five workstations and one 3B2/600. The number of element management systems that can be supported depends on the number of network elements each EMS is managing. These EMSs can be co-located with the integrator or may be at remote locations.

The Accumaster Service Workstation (ASW) provides a single, powerful, user-friendly interface to give users greater control and functionality in managing and monitoring their network services. Both common applications, such as ticket manager, traffic manager, call information manager, electronic mail, and service-specific applications, such as AT&T 800 services, Software Network, and Accumet Digital Services, are supported. With the workstation, users can access Accumaster Network Management Services, including configuration, and fault and performance management for AT&T's networking services. The workstation helps in the following ways.

- Improving network availability by controlling call routing
- Minimizing downtime by real-time delivery of alarms and other fault management information
- Using timely traffic and performance data to identify potential problems
- Communicating with AT&T work center to create, track, and resolve trouble tickets
- Controlling and allocating costs effectively with detailed call information
- Maximizing performance with comprehensive network planning tools

The platform is the same as with other network-management products; SUN SPARCstation under Unix connected to a Informix data base.

Similar services are provided and envisoned by INMS (Integrated Network Management Services) by MCI, and by Insite from US Sprint.

8.4.5 Fault Management for ISDN-Based Architectures

ISDN (Integrated Services Digital Networks) will play an important role in near future networking. Besides fragmented monitoring solutions, there is still doubt about how to incorporate ISDN network segments into the overall network-management architecture.

This section gives an overview of how to instrument the first three layers. These considerations are based on the operations planning for the AT&T-ISDN [RUHL88].

The AT&T Integrated Services Digital Network (ISDN) provides a good example of how operations planning plays a critical role in the service offering. In order to understand the operations concepts, it is necessary to have some understanding of the ISDN architecture and features that are supported by this architecture.

The AT&T ISDN provides for integrated access from a customer's prem-

ises to an AT&T service node. This access to an AT&T service node is an alternative that the customer has in addition to ISDN access through the local exchange carriers. The ISDN architecture consists of a digital PBX, DS-1 transport to the service node, an Integrated Access Distributor (IAD), and the 4ESS™ complex. The primary function of the IAD is to distribute or groom individual circuits to a specific destination (i.e., switched and non-switched). ISDN features out-of-band signaling (transported on the D channel) for associated B channels. The primary rate interface is sometimes referred to as 23B+D. However, one D channel can support up to 20 DS-1s. The D channels are nailed up through the 4ESS switch and terminate on a D channel node on the common network interface (CNI) ring. Signaling in the network is carried out-of-band over the common channel signaling system (CCS7). The B channels transport various private line and switched nodal services. The D channel not only provides a path for signaling but can carry additional customer information such as calling party number, billing number, credit card number, or any other low-volume user-to-user information. The ISDN service also provides call-by-call service selection and wideband data capabilities.

The first layer of ISDN maintenance (see Figure 8.4.9) relies on performance monitoring and nondisruptive testing as primary tools for sectionalization. Alarms, performance, indications, and in-service testing are used and exhausted before service-disruptive methods are used, whenever possible. Labor-intensive activities, such as protocol analysis, are not used until absolutely necessary.

Layer 1 provides the physical transport to interconnect the customer equipment with the network. The electrical and formating standards of the DS-1 signal define layer 1 for AT&T ISDN. The major concerns at this layer are continuity, bit integrity, and properly operating equipment for all B and D channels. Therefore, operations support relies extensively on the performance-monitoring capabilities of the DS-1 Extended Superframe Format (ESF) and DS-1 alarms. The ESF format and associated technology are not unique to ISDN and have been growing in their acceptance and deployment due to their monitoring properties. Interface Units (IUs) are deployed at critical points on the network to collect DS-1 performance-monitoring information in 15-minute intervals for a 24-hour period.

Another quick layer 1 operations feature is the remote and nonintrusive capability of verifying the cross-connects at the IAD. This is typically done at preservice testing or soon after changes are made to the configurations of the B channels.

The D channel leaves the DS-1 facilities once it enters the AT&T service node and terminates on a D channel node. Therefore, an additional layer 1 maintenance capability was developed especially for the D channel. This capability, referred to as the link check (LC), sets up an individual D channel loopback at various points in the network, and then sends, receives, and compares bit streams. Since a loopback causes at least some service disrup-

tion, the LC is run only at preservice and under total D channel failure conditions.

Layer 2 provides the logical, or link, interface. Two capabilities have been implemented to maintain this layer (Figure 8.4.10). The first, the link check internal (LCI), is an extension of the layer 1 LC just described. The LCI requires a fraction of a second to verify D channel continuity within the D channel node. This test is activated automatically when layer 2 transmission is lost. LCI results indicate whether the trouble is within or outside the D channel node.

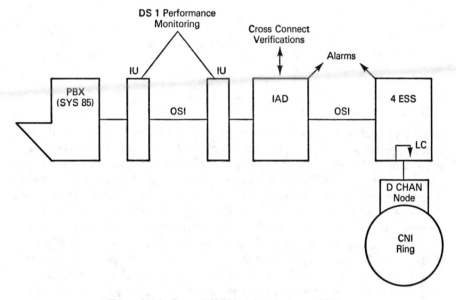

Figure 8.4.9 Layer 1 ISDN maintenance capabilities.

The second layer 2 maintenance capability consists of messages to the craft from various network equipment that indicate the health of the link. These messages come as critical events (when the layer fails) and as reports of link statistics (number of restarts, number of receive buffer overflows, and so on) when actively queried. Maintenance at layer 2 is analogous to that at layer 1 where monitoring, alarms, and nondisruptive testing are the primary tools.

Layer 3 is the message layer and, as such, relies on layers 1 and 2 for bit transport and link establishment. Layer 3 maintenance consists exclusively of monitoring the reception and transmission of layer 3 messages. There are three parts to this monitoring process, as shown in Figure 8.4.11. The first part is simply counting message types received and transmitted at a particular network element. These are D channel indicators that present a summation of various layer 3 message counts. The craft is always notified immediately of a D channel failure and/or restoral. The D channel indicators provide supplementary information as to the cause of a D channel problem. The second part

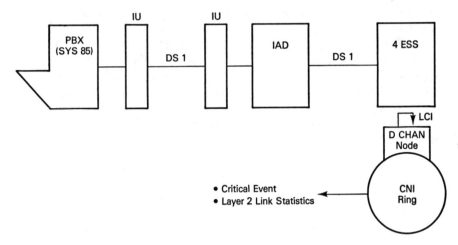

Figure 8.4.10 Layer 2 ISDN maintenance capabilities.

actually extracts maintenance information from these messages. This maintenance information is generated when a detected error occurs and is contained as an information element (called the cause information element) within specific message types (such as Disconnect) in the layer 3 protocol. The switch collects this information and delivers it for analysis to the maintenance craft.

The third part of the layer 3 monitoring is protocol analysis testing. The capability to monitor and emulate ISDN signaling messages in order to evaluate the entire call processing procedure has been developed. Technicians can study a particular call sequence of messages and identify a problem at layer 3. This capability is necessarily labor intensive and is reserved for those cases where a trouble cannot be found using any of the other techniques described earlier.

Of course, a quick check of any signaling path is simply to establish a call. Although it serves as a multi-layer capability, the B channel test call is mentioned here as a type of continuity check at layer 3. The craft initiates a call to a dial-up loopback at the PBX. The customer can also make test calls from the PBX terminating on the 4ESS to verify suspected troubles prior to making a trouble report. If the call is established (confirming signaling, i.e., layers 2 and 3 connection), then a layer 1 digital transmission test can be run to evaluate layer 1 performance.

A major challenge of ISDN is responding as a single source to a customer who has many different services. AT&T services traditionally come with associated service centers and support systems that are geared toward the individual service. Integrated access, however, allows many different services and service features over a common access arrangement. AT&T has responded to the customer's need for a *single* point of contact, regardless of service type.

The customer service center (CSC) is the customer's single point of contact. The CSC has overall responsibility to receive, verify, sectionalize, and close out a customer trouble report. This center has the capability to

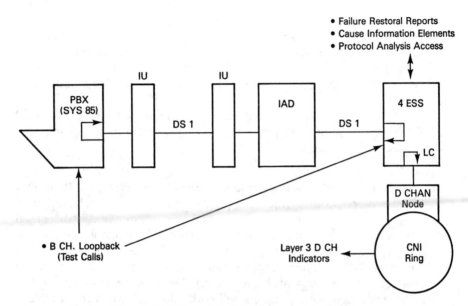

Figure 8.4.11 Layer 3 ISDN maintenance capabilities.

sectionalize troubles to the CPE, the access line, or to the network. The CSC technician can screen a trouble report, determine the nature of the problem, and proceed with sectionalization, regardless of the service in question.

In order to function as a single point of contact, the CSC has been given access to many operations systems and centers that supply the capabilities necessary to install and maintain ISDN. Each system has a distinct role in the operations process as described here:

- TOPAS (Testing Operations Provisioning and Administration System)—centralized and automated support for administration, installation, and maintenance of circuits associated with the 4ESS
- DSTS (Digital Services Test System)—access to IUs for DS-1 facility performance monitoring
- SARTS (Switched Access Remote Test System)—one-person testing of private lines circuits
- No. 2 SCCS (Switching Control Center System)—equipment alarm surveillance, analysis, and control
- SCAMIS (Schedule Control and Maintenance Information System)—trouble-ticket administrative support for the circuit maintenance process
- PROMIS-SS (PROvisioning and Maintenance Information System-Special Services)—customized formats of customer service records
- Protocol Testing—monitoring and emulation of the ISDN protocol for trouble analysis

As the single point of contact, the CSC must be able to determine the nature of a trouble report. On receipt of a customer trouble report, the CSC technician will open a trouble report and begin the sectionalization process. The CSC technician will screen the trouble report for inconsistencies. For example, the customer notes that calls are being rejected when a particular service is requested on a call-by-call channel. The CSC technician can verify whether the customer has subscribed to the service requested on that channel.

ISDN trouble reports can fall into four major categories: associated switched service troubles, associated private line service troubles, digital troubles, and signaling troubles.

1. **Associated switched service troubles.** Switched service troubles cannot always be resolved by the CSC technician and must be referred to an appropriate center or group. These problems are most easily diagnosed by listening to the customer's trouble report. For example, trouble reports such as no call attempts are reaching the customer or there is an abnormally low volume of incoming traffic, are most probably an 800 service trouble. Such problems are referred to the 800 service center. The associated service centers will notify the CSC when the trouble is cleared so that the CSC technician can close out the trouble report and report clearance to the customer.

2. **Associated private line service troubles.** If the report specifies trouble with a private line connection, the CSC, after checking the cross connect, will use SARTS to test the private line service.

3. **Digital troubles.** Digital troubles refer to transmission impairments (hiss, noise, and so on) causing errors in data transmission. The CSC technician will sectionalize these troubles to the switch (which includes the ring), the IAD, the access facilities, or the CPE before contacting the appropriate group for equipment trouble isolation and repair. DS-1 performance monitoring and the digital test call are the tools which verify digital troubles. A severe transmission problem could be caused by an incorrect cross-connect at the IAD. The CSC can verify mapping via the remote IAD access.

4. **Signaling troubles.** Anticipated signaling trouble reports include: customer cannot establish any calls, customer is receiving no switched calls, the far end is receiving incorrect station identification or user-to-user information, calls are prematurely disconnected, and so on. After ruling out the other three trouble types, the CSC technician has the tools to verify a signaling problem. D channel failure/restoral reports will indicate a particular D channel outage. Checking the D channel indicators at the ring may indicate a D channel problem coming from the CPE or from the ring. Establishing a test call will verify call set-up capability. D channel loopbacks will verify problems with the signaling transmission path between the ring node and the facility interface on the 4ESS.

The CSC technician will request protocol testing from the protocol analysis group when he or she has determined that the D channel protocol is the basis for the trouble report and/or protocol analysis testing is the only remaining option to sectionalize the problem.

8.4.6 Instrumenting Distributed Local Area Networks

More and more organizations are discovering that LANs are no longer just a limited-scope departmental resource, but a resource for mission-critical applications as well. Thanks to connectivity via bridges, routers, brouters, and gateways, most LANs are interconnected directly or via MANs or WANs.

Distributed analysors

Incorporating fault management functions for LANs into the centralized fault management applications is not easy. Due to mission-critical applications, however, downtime and delayed service may severely impact the targeted service-level agreements. There are fragmented monitoring applications supporting performance management, but continuous monitoring for supporting fault management is still very rare. A growing number of manufacturers have recognized the need and offer solutions for remote monitoring LANs. The central station or focal point may reach across via network or dial-up connections, providing the equivalent of very remote terminal and keyboard operations. They may also have additional filtering and analysis capabilities.

Figure 8.4.12 [NETW91] shows a distributed Sniffer architecture. This first release of SniffMaster software runs on any Sun SPARCstation or Sun 4 workstation, and it provides central monitoring and control of one or more Model 300 and 500 Sniffers (which are Network General's line of PC-based protocol analyzer/monitors for LANs) [DEMD89].

Each individual Sniffer attaches locally to the desired Ethernet segment; using SniffMaster, central operators can view and control these Sniffers either across a 19.2-kbit/s TCP/IP network connection, or RS-232 dial-up link, rather than having to be on-site (see Figure 8.4.12). The remote Sniffer sends only data whose change would cause a screen update, rather than simply forwarding all its monitored knowledge. Between this selective filtering and Network General's data compression techniques, the amount of actual traffic can run as low as a packet per second.

A copy of SniffMaster I software is currently priced at a reasonable level. It needs a Sun workstation to make it go, but Network General assumes that its current user base will be using one for its network operations center. The wide screen and multiwindowing, multiprocess power make this class of workstation platform well suited for network management. Users do not need to necessarily dedicate a workstation solely to SniffMaster. They are also likely to be running software from Synoptics, NET, and others, WAN management software, and perhaps even word processing [DEMD89].

Spider Systems' Remote Monitor Option is a software module that

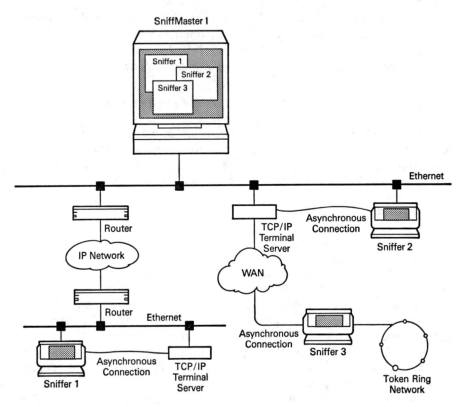

Figure 8.4.12 Distributed Sniffer architecture.

needs to be loaded onto Model 220 Spider Monitors and Model 320 Spider Analyzers that a user wants to monitor remotely. A user can then configure any analyzer to act as the central monitoring point.

Digilog (Montgomeryville, Pennsylvania) offers central monitoring of its remote LAN analyzers with its recently introduced LANVista, which runs on any DOS PC with 640 Kbytes of RAM. LANVista is available in three configurations: standalone, integrated, and distributed. In the standalone and integrated configurations, the unit monitors a LAN.

In the distributed configuration, LANVista has a master-slave architecture. A central PC running the diagnostic and management software communicates through bridges, gateways, or wide area networks with slave boxes installed on each of the remote LANs.

The slave boxes perform hardware filtering; up to eight 2048-byte filters can be set. The boxes include sufficient memory on which to store captured data. Slave boxes also test cabling, using a built-in time-domain reflectometer. Thus, network administrators can locate cable breaks on remote LANs. LANVista includes slave boxes for Token Ring and Ethernet LANs. From the

central master PC, network administrators can monitor up through all the layers of a number of different protocol stacks. Initially available from Digilog are TCP/IP, XNS, DECnet, and NetWare monitors.

The master software can be duplicated and be distributed to any PC on any of the LANs. Thus, the network administrator could theoretically monitor any of the LANs from any of the others. That means that local and remote fault management become artificial ways of defining responsibilities.

All product examples may use a variety of configuration alternatives by supporting in-band or out-band connection techniques. However, different instrumentation is used for Ethernet and Token Ring. At this time, SNMP is not yet used for exporting or importing information between central and remote locations. The reasons are the rich set of indicators and data volumes; neither the MIB, nor the SNMP-commands are able to support those at a reasonable level of performance.

Independent of the instruments chosen, fault segmentation is a key problem. In addition to the overview of Chapter 4 on LAN tools, this section will address cabling and troubleshooting in fiberoptic LANs.

Cabling [DANM89C]

Cards. Network interface cards, cables, and other low-level hardware all have an impact on the operation, performance, speed, and throughput of the LAN. If interface cards and cables are working properly, one cannot expect speeds greater than the rated throughput. If an interface card is working improperly or a cable is not correctly terminated, errors may occur. In this case, the LAN will run signficantly slower due to retransmissions of mutilated and lost packets. A defective card can significantly slow down a network.

There are a number of ways to check if interface cards and cables are working properly. Most LAN manufacturers include a basic diagnostic utility program integrated with their hardware. Although these programs can detect severe errors, they may not show subtle errors. These utilities may report that they see other workstations on the LAN and that, therefore, the LAN is "working" although a real problem may exist.

Some available products monitor traffic on the LAN and indicate trouble spots and can be used to test the cable system. These diagnostic programs will generally provide much better information about the physical LAN than the simple diagnostics included with the interface cards. There are also cases where a mixture of different vendors' Ethernet cards may not work together. Diagnostic programs included with vendors' cards may help indicate any incompatibilities; with the use of more sophisticated hardware diagnostic programs, an experienced installer should easily be able to determine compatible card mixes.

Once the data are read from the server, they must be transmitted over the LAN to the station that requested it. Unless the network itself is optimized, there may be no benefit to having a fast server; hence, performance management and fault management must be done in a cooperative fashion.

Typical fault diagnosis products evaluate the network's capacity, provid-

ing traffic monitor functions by reporting network bandwidth usage (in percent). In addition, these products detect physical problems on the network, such as impaired cables, hubs, and repeaters, as well as bad network interface cards. The cable test generates packets, then measures the success rate of the transmissions.

Some fault diagnosis products can indicate how many packets collided and the number of bits lost or dropped; certain products also report the number of reconfigurations necessitated by lost tokens. Network managers can use this information to formulate fault scenarios.

Wiring. A network manager can perform continuity, loopback, and reflectometry tests to diagnose cabling problems. Cable installation companies may also perform reflectometry tests on behalf of the manager. These tests help ensure that the cable system is working correctly. The most common problem with LAN cabling is broken cable or improper termination. Most connectors do not handle movement well and, if left lying on the floor, they may be stepped on and broken. A regular inspection of the cable ends and connectors will help identify defective terminations. There is a wide range of tools available for diagnosing cable problems.

Ohmmeters. An ohmmeter is a simple tool that gives impedance measurement. One can use an ohmmeter to locate open or shorted cable. If the impedance reading matches the rated impedance of the cable, the cable is fine. If the reading does not match the rated impedance, then the LAN has a short, a crushed cable, or a cable break somewhere along the cable run. Ohmmeters cannot be used in fiberoptic-based LANs. Ohmmeters are typically priced well under $100.

Outlet Testers. Sometimes the problem is not the cable but rather the electrical outlet. For example, if an outlet is not grounded properly, noise or even current may be introduced through the power supply into the workstation, and then through the network interface card onto the copper-based (twisted pair or coaxial) LAN cable. An outlet tester, which costs around $10, can help detect this type of problem.

Coax Connectors, T-Connectors, and Terminators. Extra terminators are a basic requirement, particularly on a bus network. Extra terminators can be used to isolate sections of the cable for testing.

Oscilloscope. An oscilloscope allows the network manager to examine the cable's waveform. An oscilloscope helps detect the existence of noise or other disturbances on the wire, such as continuous voltage spikes. Again, this applies only to copper-based LANs.

Time Domain Reflectometers (TDRs). A time domain reflectometer operates by sending an electrical pulse over the LAN cable, monitoring for signal reflections. On a good cable there will be no reflections, indicating that the cable is clean, with no breaks or shorts. If there is a break or short in the cable, however, the time it takes for the pulse reflection to return gives the

TDR a very accurate idea of where the fault is located. Many TDRs can locate cable breaks to within a few feet. TDRs have traditionally been relatively expensive instruments; a TDR with an oscilloscope costs $5000 or more. A new, less expensive generation of TDR equipment is now available which costs $1000 or less. These new instruments are more compact than their predecessors, often measuring about the size of a paperback book or smaller. The newer TDRs are also easier to use and still accurate to within a few feet.

Fiberoptic connections

Fiberoptic-based LANs require different equipment. While they provide significant advantages over conventional LANs, the fiber LAN's design necessitates more sophisticated test equipment. Fiber LAN diagnostic tools must provide comprehensive design verification, including the capability to precisely determine bandwidth, sensitivity, and linearity. These measurements can only be performed with fiberoptic test equipment that includes sophisticated parametric capabilities.

The market is experiencing an influx of test equipment that helps technicians diagnose and maintain a fiberoptic-based wiring system. These instruments vary in complexity from pocket-sized power measuring units to console-type testers. Only those instruments that are optical in nature can make performance measurements on the optical parts of any electro-optical system. Fortunately for electronics test engineers, the few optical instruments used outside research laboratories are relatively simple in design.

Fiber-optic instruments can be divided into three general categories: (1) power meters (optical loss test sets); (2) optical time domain reflectometers (OTDRs); and (3) optical bandwidth test sets (OBTSs).

Power Meters. Power meters (optical loss test sets) measure the optical power from a length of fiber in much the same way that conventional power meters measure electrical power. These tools are used to perform a one-way loss measurement. The loss may occur in the fiber, connectors, splices, jumper cables, and other system areas. Some power meters also have a built-in transmit source. Two sets, both with transmit and receive capability, are used together to make measurements in both directions without having to relocate personnel or equipment. The individual power meter is a single unit consisting of an optical receiver and an analog or digital readout. A light source, typically at the point of origination, supplies the power that is detected at the end of the fiber link or test access point. The meter displays the power detected in decibels. The wavelength range often given indicates the various wavelengths that the meter can detect. The resolution parameter indicates the smallest step that the meter will display.

Optical Time Domain Reflectometers (OTDRs). Network managers can use OTDRs to characterize a fiber wherein an optical pulse is transmitted through the fiber and the resulting light scattered and reflected back to the input is measured as a function of time.

OTDRs are useful in estimating the attenuation coefficient as a function of distance and in identifying defects and other losses. These devices operate on basically the same principles as a copper-based TDR. The difference is one of cost: OTDRs typically range from $10,000 to $18,000.

Optical Bandwidth Test Set. Optical bandwidth test sets consist of two separate parts: the *source,* whose output data rate varies according to the frequency of input current applied to the source (specified by frequency range parameter); and the *detector,* which reads the changing signal, determines the frequency response, and then displays a bandwidth measurement. The instrumentation is calibrated using a test fiber; the actual measurement results are compared to the calibrated value to display the bandwidth value.

8.4.7 Applicability of Expert Systems

The requirement for adequate service level in complex communication networks drives the demand for fast, consistent, expert quality response to operational problems. Effective, flexible automation of both routine operations and problem handling and determination would satisfy this demand by improving the productivity. However, the fault management environment is characterized by high—and usually increasing—complexity, making the automatic operator very difficult to implement. There is no doubt that more flexibility is needed than procedural software gives. Network operational control performs many routine tasks, such as data collecting, activating and deactivating components, answering user questions, starting tests, and alternating routes. In addition, they watch a number of consoles for application, processors, operating systems, communication software, and network monitor-related messages. Problem determination and resolution usually involve requesting more informational messages on network status, service status, consulting system and network documentation, and experience files, submitting corrective actions or calling for on-line and/or off-line technical support. Information-message rates are very high, and supporting documentation is not easy to handle. In certain cases, there is no opportunity to consult references or outside assistance.

Due to these complex and dynamic responsibilities, a long training period is necessary for educating help desk and network operators and technical support staff. Even the training of newly hired experienced personnel can represent substantial costs to the installation, since responsibilities vary across networks with management policy, with particular nodes and links installed, and with workload characteristics. And, in addition, fluctuation must not be ignored. Operational procedures must evolve along with the changing technical environment and personnel fluctuation. The shortage of skilled personnel, the increasing complexity and speed requirements call for more powerful support on behalf of instruments. In particular, instruments are needed to ease the load of operators, to provide fast, consistent reactions to networking problems, to decrease the installation's dependence on specific personnel, to

provide a basis for enforcing operational control methodology, and to provide a facility for integrating new procedural alternatives with old ones.

In summary, the following are true in the area of fault management:

- Human expertise is rare.
- It is difficult to educate new experts.
- There is a definite demand for this expertise.
- The activities of problem determination and resolution can be well defined, and solutions do exist.
- Problems are complex, and there is usually no time for consulting references and outside help.
- Mistakes and delays may impair the service level of all networks and, consequently, all business.

The general architecture is displayed in Figure 8.4.13 [TERP86A]. Two different sources are available for the input: filter for standardizing monitor data and an interpreter for understanding help desk-originated data. The number of integrated-control facilities is significantly increasing. The first stage of such control is to display alert screens from several sources, such as a network monitor, communication software, application monitor, electronic switch, modem monitor, packet-switching network interface information, on the same physical device. This arrangement [AVAN86A] could easily be adapted as the input filter of the expert system. The filter is implemented as a micro. It coordinates the access to the different instruments. The information exchange is solved via messages and data streams. The connections are physi-

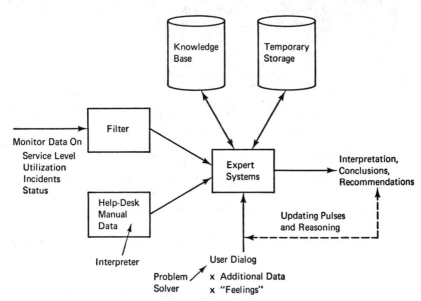

Figure 8.4.13 Expert system architecture for fault management.

cally continuously alive, but logical paths are opened on demand only. In addition, alert logs, status, and exceptional messages are analyzed, filtered, formated, and forwarded to the expert system for triggering the reasoning process. Similar triggering may be accomplished by the help desk in entering network operational anomalies. Once triggered, the expert system fires primary rules. Depending on the rule's execution, further status information may be required. This information demand is usually met by scanning the actual indicator values. Once information demand has been satisfied, further rules are activated by category; conclusion and concentrate types of statements. Table 8.4.1 shows a few examples of generic rules. These rules are prepared without explicitly indicating the network component they are dealing with. But the inference engine of the expert system is able to search in the configuration data base for identifying the failed or degraded component.

TABLE 8.4.1: Sample Operational Control Rules of the Knowledge Base.

WHENEVER RESPONSE TIME FOR ANY APPLICATION VARIES BY
 3 SECONDS
 IF INCREASE
 SEND MESSAGE "SERVICE LEVEL PROBLEM" TO OPERATOR
 ACTIVATE RULES FOR CATEGORY: RESPONSE TIME
 NETWORK TIME
 HOST TIME
 IF DECREASE
 SEND MESSAGE "LOAD ON LINKS COULD BE INCREASED"
 TO OPERATOR

IF PROBLEM WITH ANY LINK
 THEN
 DEACTIVATE THE PU-S ON THE LINE
 IF FREE BACK-UP-LINES IN THE POOL
 THEN
 SELECT THE FIRST
 EDIT THE PROPER DRDS MEMBER IN VTAM
 ACTIVATE THE DRDS MEMBER
 ELSE
 SPEED UP DIAGNOSIS
 SNBU DIAL OUT
 IF DIAL OUT OK, PU OPERATIONAL
 ELSE
 CONCENTRATE ON FEPS, MODEMS, AND CONTROL UNITS
 OF THE LINE

The expert system provides output in the following forms:

- **Interpretation:** Measurement values are combined and correlated; alerts may be issued.
- **Recommendations:** Further data and/or operator actions are required; for the while, ES execution is pending and waiting for additional input.

- **Conclusions:** Problem diagnosis either has been concluded or the opposite, requiring additional actions. In more advanced systems, problem restoration can be solved automatically, and messages are displayed about successful execution.

The first productive prototypes have been implemented in two different ways:

- **Off-line:** The network operator specifies the tasks for the expert system. The expert system responds with the most likely fault reason and also displays recommended actions. The operator accepts or rejects these recommendations.
- **On-line:** The expert system is part of the automated monitoring and control system, and works without specified tasks defined by the network operator. Results of fault diagnosis and conclusions are displayed while control actions are automatically taken. In most cases, however, the network operator can overrule the conclusions.

The inference machine with the rules base and configuration should be continuously maintained. For updating rules, source information, reasoning, and expert system output should be logged and evaluated.

In certain circumstances, additional data and even "feelings" of the master operator may be required. In other words, problem solving is interrupted for human guidance for further rules execution.

These statements justify the applicability of fault management functions for successful expert-systems implementation.

The principal benefits of using expert systems for network operational control may be summarized as follows:

- **Speed of problem determination:** Actions not requiring manual intervention are executed at computer processor speed.
- **Knowledge-intensive decision making:** The best available knowledge is available in the knowledge base. This knowledge level is probably higher than that of an average network operator.
- **Data-intensive decision making:** Problem determination may be based on large amounts of network-related information not easily organized or comprehended by a human operator.
- **Reliability:** Expert systems execute repetitive tasks without taking breaks.
- **Decreased worker requirements:** Expert systems help to avoid an explosion of human resource demand because network operational control personnel are needed only to handle exceptional incidents and to operate the expert system.
- **Stability:** Reactions to incidents are consistent and follow network-management strategy.

- **Decreased dependence on specific personnel:** Knowledge and operational rules are encoded in the knowledge base rather than in the private "nonvisible" files of the most experienced operators.

- **Flexibility:** Knowledge base and operational rules may easily be updated as a function of network evolution, tools, and changing operational conditions.

- **Avoidance of human interpretation of operational rules:** The knowledge base is applied directly; thus the effects of operational-control policy changes can be better isolated, observed, and evaluated.

- **Tool integration:** Expert systems may interface to various information extraction tools but require one information type for a certain demand. Operating in this manner, information-extraction redundancy may be avoided. Expert systems help to decide on the right source and even activate tools automatically.

But there are still unsolved problems with network operational control-oriented expert systems:

- The time period for problem determination must not be longer than such problem determination would take for the network operator.

- Volume of network elements may require thousands of rules, unless rules may be symbolically formulated.

- Dynamic network changes may require frequent updates in the knowledge base.

- The interpretation and synthesis of message groups are more complex than initially estimated due to the difficulty of determining the start and end of events relevant to a certain symptom.

- A fairly large number of instruments may be required for identifying the actual network status, and the expert system should interface all of them.

Present and near-future architecture may find the answers soon. Product examples are given in Chapter 13.

8.5 HUMAN RESOURCES DEMAND OF FAULT MANAGEMENT

The third critical success factor of network management is the quality of human resources. The functions discussed thus far should be adapted to the present organization from within the information systems department first. Based on the functions, processes, and procedures outlined, the targets of organizational changes can be determined. Table 8.5.1 summarizes the relationship of potential organizational units to the key functions of fault management. The indicators in this table constitute either execution of duties,

TABLE 8.5.1: Involvement in Fault Management.

Functions	Configuration management	Fault management	Performance management	Other Subsystems Security management	Accounting management	Network capacity planning	Level of possible automation
Network status supervision	S	E		S		A	high
Dynamic trouble tracking	S	E				A	medium
Backup and reconfiguration	S	E	S		S		medium
Diagnostics and repair		E	S				low
End-to-end testing		E	S	A		A	high

E = Executing
S = Supporting
A = Advising

357

TABLE 8.5.2: Distribution of Functions among Human Resources.

Functions	Supervisor	Customer Support Desk	Organization Network Operator	Technical Support Specialist	LAN Administrator
Network status supervision	(x)	(x)	x		x
Dynamic trouble tracking	(x)	x	x		
Backup and reconfiguration	(x)		x		x
Diagnostics and repair	(x)		x	x	x
End-to-end testing	(x)			x	(x)

x = Committment
(x) = Involvement

Tools	Organization				
	Supervisor	Customer Support Desk	Network Operator	Technical Support Specialist	LAN Administrator
Monitors in network elements					
Application monitors				x	
Software monitors				x	
Modem and DSU/CSU monitors			x	x	
Multiplexer monitors			x	x	
Switch monitors			x	x	
Line monitors				x	
Network monitors			x	x	
PBX monitors				x	x
LAN/MAN monitors				x	x
Network element management systems					
Voice orientation	x			x	
Data orientation	x			x	
Console management systems		x	x		x
Integrators	x	x	x	x	
Computerized cable management systems		x			
Automated call distributors		x			
General-purpose data bases	x	x		x	
Special administration products	x	x		x	x
Networking models					

TABLE 8.5.4: Personnel Requirements for Fault Management.

	Network Range (Number of elements)			
Organization	Small < 3000	Medium 3000–10,000	Large 10,000–50,000	Very Large > 50,000
Supervisor	1	1	1	1
Customer support-desk operator	1	4	5	10
Network operator*	2	4	8	15
Network technical support specialist	2	4	5	10
LAN administrator	2	4	10	20
Human resources demand				
Total	8	17	29	56

* = computed for one shift

TABLE 8.5.5: Profile of Network Operational Control Supervisor

Duties

1. Staffing is adequate.
2. All documentation needed by the planning group is accurately created.
3. Installation time schedules are met.
4. Required network changes and modifications are performed and are properly coordinated with users, vendors, programmers, and operating personnel.
5. All problems reported by users through the help desk are satisfactorily resolved.
6. Prepare reports documenting the effectiveness of the operations group.
7. Establishing educational program for staff.

External job contacts

1. Other supervisors within network management
2. Customers
3. Network manager

Qualifying experience and attributes

1. Knowledge of the communications system software used and the operator facilities used to control it
2. Knowledge of communications hardware (modems, lines, controllers, terminals, etc.)
3. Experience with hardware network-diagnostic aids
4. Experience with software network-diagnostic aids
5. Knowledge of problem-determination process
6. Training in administrative management

TABLE 8.5.6: Profile of Customer Support Desk Operator.

Duties

1. Network supervision
 Implement first-level problem-determination procedures
 Maintain documentation to assist customer in terminal operation
2. Problem logging
 Uses procedure guide for opening trouble tickets
 Review change activities log
3. Problem delegation
 Determining problem area
 Assigning priorities
 Information distribution
4. Additional duties when support desk activity is low
 Data entry for configuration and inventory
 Summary of active problems for problem coordinator
 Entering change information for change coordinator
 Monitoring of security
 Generating management and technical reports
5. Recommends modification to procedures

External job contacts

1. Customers
2. Vendor representatives
3. Problem and change coordinators of network administrator
4. Network operation and technical support
5. Network administrator for trouble tickets
6. LAN administrator

Qualifying experience and attributes

1. Familiarity with functional applications and terminal equipment
2. Training in personal relationships
3. Clerical rather than technical
 Data-entry skills
 Problem-determination know-how
4. Sensitivity to customers
 Understanding of their business needs
 Pleasant telephone voice
 Language know-how

supporting, or advising type of involvement. The same table may be used as a starting point for estimating the range of labor demand for managing faults.

Fault management is usually staffed by four different kinds of personnel:

- Customer support desk operator
- Network operator
- Technical support specialist
- LAN administrator

TABLE 8.5.7: Profile of Network Operator.

Duties

1. Observe ongoing operations and performance to identify problems.
2. Initiate corrective action where required, within the scope of knowledge and authority
3. Interpret console messages from network software or applications programs and perform required actions
4. Assist with network-oriented problem determination
5. Implement backup procedures
6. Implement bypass and recovery procedures for system/network problems
7. Fulfill administrative-reporting requirements on network problems
8. Maintain communications with systems control
9. Monitor all network activities
10. Use and invoke network diagnostic aids and tools
11. Use and provide input to data base for problem and inventory control
12. Do second-level problem determination
13. Do network start-up and shutdown
14. Scheduling of network activities, such as testing and maintenance

External job contacts

1. Technical support staff
2. Configuration and inventory function
3. Problem and change coordinators of network administration
4. Customer education and customer support desk
5. Vendor representatives
6. Network administration

Qualifying experience and attributes

1. Training in concepts of information system and communications systems operations
2. At least 1 year of network experience with
 Access methods
 Lines, clusters, and terminal types
 Service levels
 Distribution schedules
3. Alert, intelligent, strives for efficiency
4. Can execute bypass/recovery procedures
5. Can perform authorized network alterations
6. Understands
 Escalation procedures
 Operation of problem and change management
 Reporting requirements and procedures
7. Has communication skills
8. Can use various tools, depending on the availability of such tools

TABLE 8.5.8: Profile of Network Technical Support Specialist.

Duties

1. Provides in-depth problem determination (third-level), as necessary
2. Provides technical interface with vendors, as necessary
3. Designs and maintains up-to-date problem determination, bypass, and recovery procedures
4. Provides technical interface, as necessary, with application and system programmers
5. Uses inventory-control data base
6. Ensures valid run procedures
7. Assists with network configuration/reconfiguration
8. Reads dumps
9. Starts and evaluates special-purpose diagnostics

External job contacts

1. Change coordinator
2. Problem coordinator
3. Customer support desk operator
4. Vendor technical personnel
5. Application and system programmers
6. Network operator
7. Inventory coordinator
8. LAN administrator

Qualifying experience and attributes

1. Several years experience with a broad range of communications equipment and the tools, and aids necessary to maintain the network, including
 Network operation
 Network-control programs
 Access methods
 Generation of networks
 Configuration/reconfiguration procedures
2. Good aptitude for communicating with people
3. Can use diagnostic tools
4. Understands vendor standards and procedures
5. Has patience in pursuing problems

Table 8.5.2 shows the distribution of functions among those human resources. In order to limit the alternatives for a tool's selection, Table 8.5.3 gives an overview of instrument classes under consideration for fault management and of their potential users in the fault management hierarchy.

For estimating the demand in FTEs (full-time equivalent), Table 8.5.4 provides the quantification for the four major customer clusters introduced and defined in Chapter 1.

The numbers represent averages and are based on the results of many surveys and interviews conducted personally by the author of this book.

In order to help with hiring and building the fault management team, Tables 8.5.5 to 8.5.9 give the typical profiles for each of the fault management personnel, including the supervisor of the group. And finally, the function/ skill matrix, shown in Table 8.5.10, gives an overview of the targeted skills levels for each individual fault management function.

TABLE 8.5.9: Profile of LAN Administrator.

Duties

1. Track inventory and maintain directory
2. Control configuration
3. Monitor performance and traffic
4. Contribute data to network optimization
5. Detect, diagnose, isolate, and correct fault
6. Maintain local support desk and trouble ticketing
7. Collect usage statistics and generate reports
8. Administer local passwords and access authorization
9. Support and train users
10. Assist in applications troubleshooting

External job contacts

1. Users
2. Corporate NCC help desk
3. Corporate NCC operating
4. Corporate technical support
5. Vendor

Qualifying experience and attributes

1. Familiarity with applications, stations, and servers
2. Training in personal relationships
3. Sensitivity to users
 Understanding of their business needs
 Patience

TABLE 8.5.10: Responsibility/Skill Matrix.

Functions	Skills					
	Special knowledge of function	General knowledge of communication facilities	In-depth knowledge of communication facilities	Some knowledge of business administration	Communication skills	Some knowledge of project management
Network status supervision	x	x			x	
Dynamic trouble tracking	x	x		x	x	x
Backup and reconfiguration	x	x	x			
Diagnostics and repair	x	x	x			
End-to-end testing	x	x	x			

8.6 SUMMARY

Practical recommendations for fault management include guidelines for *doing* certain things and for *avoiding* certain other activities. These guidelines are useful for both short- and long-range improvements in the area of fault management.

DO

- Process

 Inventory all sensors, all monitors, and measurement devices

 Reduce the number of messages by filtering

 Use single point of contact

 Start building a knowledge base (e.g., expert systems)

 Implement or improve trouble-ticketing processes and instruments (e.g., trouble and resolution codes)

- Products

 Console management first and then integrators

 Properly equip user support desk

 Use proactive techniques

- People

 Properly staff user support desk

 Involve personnel in instrument selection

 Verify staff skill levels against requirements

 Train people extensively

AVOID

- Process

 Overloading operators with too much information

 Extensive testing and monitoring during primary shifts

 Substituting testing for proactive fault management

- Products

 Multiple phone numbers for assistance

- People

 Too many new operators and support desk personnel at the same time

9

Performance Management

Performance management is a set of activities required to continuously evaluate the principal performance indicators of network operation, to verify how service levels are maintained, to identify actual and potential bottlenecks, and to establish and report on trends for management decision making and planning. Maintaining the performance data base, networking models, and preparing automation procedures for fault management are also supported.

9.1 INTRODUCTION, STATUS, AND OBJECTIVES

The principal objectives of this chapter are:

- To discuss the major functions of performance management
- To define the interrelationship of the functions
- To determine information export and import with other network management subsystems and functions
- To discuss the most promising instruments supporting performance management activities
- To summarize the implementation considerations including the human resources demand for supporting performance management
- To construct a responsibility/skill matrix to help staffing performance-management functions

In addition to the situation we face today (Chapter 1), more specific problems are seen in the performance-management area, which may be characterized as follows:

- Performance management is not yet a real-time activity with the result of not being able to make ad hoc performance improvements on the basis of real-time or near real-time measurement data.
- There are no standard procedures for analyzing performance data for voice and data networks, with the result of too much redundant work.
- Experience files are not established and maintained, making development and implementation of expert systems extremely difficult.
- Statistics and historical data are automatically or semiautomatically saved in data bases or files with vendor-specific formats for further analysis.
- Too many reports are generated and there is too little use of so-called display data bases with on-line, real-time enquiry capabilities.
- The analysis of an end-user service level requires the use of multiple instruments in combination, covering LAN, MAN, and WAN-related performance indicators; there is still a shortage of powerful techniques for correlating information from various sources.
- Educating and cross-educating staff for conducting performance-related work is very time-consuming and therefore expensive.

In summary, the lack of real-time or near real-time performance analysis and a good combination of instruments seem to be the principal obstacles to improving performance-management efficiency.

The following sections will address the major processes, functions, and instruments of performance management.

9.2 PERFORMANCE-MANAGEMENT PROCESSES AND PROCEDURES

Requests for analysis and performance improvement occur when the service-level expectations (both data and voice) cannot be met or performance studies are required when proactive performance evaluations are initiated. The process starts with defining performance metrics for both data and voice, continue with monitoring in the network segment, such as CPE, LEC, and IEX, or by extracting data from the performance data base. In most cases, however, the level of detail does not satisfy the information need. The data base is considered the basis of thresholding and performance reporting. On rare occasions, the experience file of historic tuning data may help to quickly recognize similarities with past problems. Once the hypothesis has been formulated, cost efficiency and technical feasibility should be tested step by step in order to exclude uneconomical and nonfeasible alternatives. Frequently,

technical and economical performance evaluation are supported by modeling techniques. After implementation, measurements should check and prove performance improvement. In case of nonfeasibility or insufficient improvements, an additional hypothesis should be worked out. If the results are still unsatisfactory, capacity planning actions are required. Figure 9.2.1 illustrates the main body of the performance-management process.

In order to successfully support performance management, the following information is necessary:

- Primary demand:
 Actual configuration
 Generated configuration
 Performance indicators in real-time or in near real-time, including response time, congested channels, and resource utilizations over thresholds
 Performance histories for selected facilities and equipment
 Selected vendor data
 Operational procedures
- Secondary demand:
 Attributes of facilities and equipment in more detail
 More detailed data on performance indicators
 Detailed traffic volumes by communication form, such as data, voice, image, and video
 Expected workload volumes
 Detailed messages reporting flows in the fault management process

9.3 PERFORMANCE-MANAGEMENT FUNCTIONS

Performance-management functions were identified in the introductory part of this chapter. After defining the functions, typical processes, structures, and architectures, practical examples are given to better understand how the functions work and how they are interrelated.

9.3.1 Definition of Performance Indicators

This function targets the accurate definition of performance metrics for all communication forms supported. Examples of those indicators are availability, response time, throughput, utilization, grade of service, transmission volumes (calls, transactions, packets), offered load, channels' occupancy, and measures for acccuracy. Standard bodies are in the process of defining metrics for general applicability. But the standardization process is far too long and the expected number of metrics is too high.

The indicators defined in this section should be sufficient for controlling performance in most corporate environments.

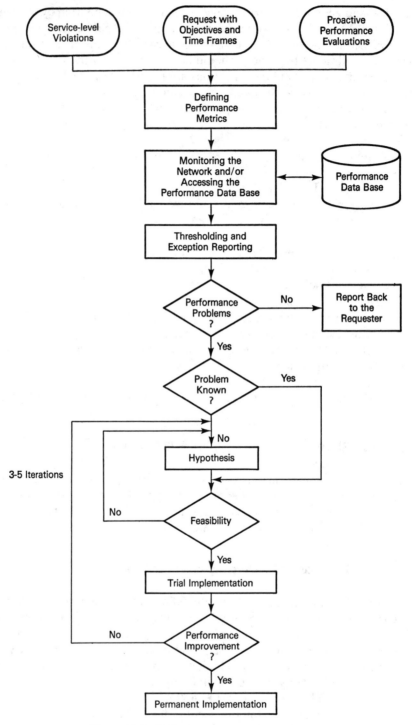

Figure 9.2.1 Performance-management process.

Communication networks cannot be managed when it is not possible to measure significant network-performance indicators. Every networking environment uses performance parameters. The customers are confronted with one or more of the following problems:

- There are too many indicators in use.
- The meanings of most indicators are not yet clearly understood.
- Some indicators are introduced and supported by manufacturers only.
- Most indicators are not suitable for comparison with each other.
- Frequently, the indicators are accurately measured but incorrectly interpreted.
- In many cases, the calculation of indicators takes too much time, and the final results can hardly be used for controlling the environment.

A key requirement in networking is that specified service levels are maintained to the customer's satisfaction. Thus, in grouping and prioritizing performance indicators, the service-oriented indicators receive higher priorities than the efficiency-oriented ones.

Service-oriented indicators

Service-oriented indicators should consider the end customer's interests only. For controlling and planning, network availability, response time, and accuracy are the most important parameters from the end customer's perspective.

Availability

Availability characterizes the functionality of the communication network as a whole. It means the percentage of time a customer may gain access to network services during the total time that those services should be available. The customer wants to get service, at whatever time he or she needs the service, for completing the daily productive type of work for the larger organization. The specific components of the network (nodes or links or both) that are out of order are not relevant. The parts of the network that are working properly are not relevant, either. It is the availability at the end customer's terminals that counts.

Outages in the communication networks or parts of them may cause substantial losses to larger organizations. The following have been reported, for example: In an airline network, a 1-minute outage may cause $10,000 in losses; and in a banking network environment, a 1-hour outage may introduce losses at a range of over $1 million.

LAN downtime studies [INFO89] show that one hour downtime may cost $30,000 on average; there are an average two disabilities per month; and the average outage time is five hours.

Availability depends on technical reliability of components. This reliability may be very high (e.g., 99.999%) but not infinitely high. In order to ensure higher availability, redundant components are frequently provided. However, the overall costs (CO) should be considered and minimized:

$$CO_{total} = CO_{redundancy} + CO_{consequences} \qquad (9.1)$$

For reporting purposes, a multi-level illustration is helpful (Figure 9.3.1), indicating the target level of availability. Considering a particular network whose availability is such that it is available to the customer for 95% of the scheduled operating time, the customer might feel that three 3-hour periods of unavailability per month is acceptable, whereas a one-time failure lasting 12 hours is not acceptable—even if it is the only outage in a year [AXEL83]. But at the present time not all levels can be accurately measured.

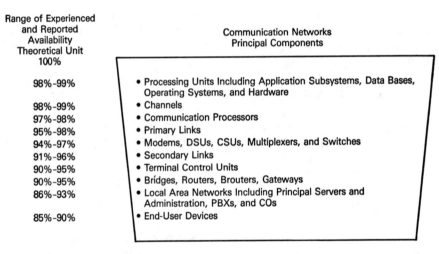

Figure 9.3.1 Availability reporting levels.

Availability can be computed as follows:

$$AV \text{ (availability)} = \frac{MTBF}{MTBF + MTTD + MTTR + MTOR} \qquad (9.2)$$

where

MTBF = mean time between failures
MTTD = mean time to diagnosis
MTTR = mean time to repair
MTOR = mean time of repair

For improving availability at any level, MTTD, MTTR, and MTOR should be kept small in comparison to MTBF.

Response time

Response time at the customer level is a very important issue. All parties agree on the importance of planning, measuring, and improving this response time. Figure 9.3.2 illustrates the complete cycle of customer interaction with the processing node and also in a peer-to-peer environment. For the customer, think time and entering time are involved. The proportion of each depends on the task to be accomplished. The network response time includes inbound, outbound, and processing time. The screen transmission time may or may not be included. In the majority of cases, the customer response time is the elapsed time between pushing the enter key and receiving the last response character on the terminal device.

For reporting purposes, at least three levels of response time should be considered:

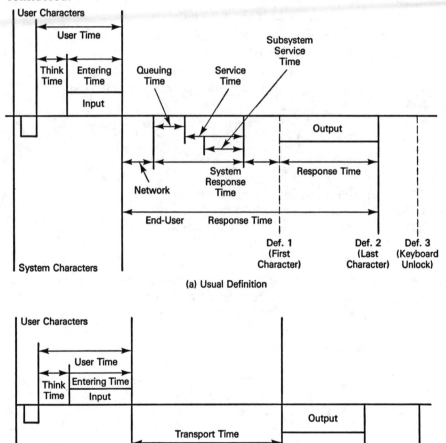

Figure 9.3.2 Response-time definition.

- Total response time
- Networking delay (including WAN, MAN, and LAN)
- Processing-nodes delay

At the present time, all levels can be measured with adequate accuracy.

Accuracy

Service includes the delivery of accurate responses at the customer's terminal device. Due to disturbances on the way between source and destination nodes, however, information delivery may be influenced [TERP83A]:

- Erroneous information characters received
- Characters transmitted but not delivered
- Characters received that were not sent
- Characters delivered in duplicated form

The residual error rate as a measure for accuracy may be computed as follows:

$$\text{ER (error rate)} = \frac{CH_E + CH_U + CH_N + CH_D}{CH_T} \tag{9.3}$$

where

CH_E = erroneous information characters
CH_U = characters transmitted but not delivered
CH_N = characters received that were not sent by the source
CH_D = characters delivered but duplicated
CH_T = total characters transmitted

At this level, the reasons for inaccuracies are not investigated any further. Although all components can theoretically be measured, frequently only estimated figures on CH_E, CH_U, CH_N, and CH_D are used.

Efficiency-oriented indicators

Efficiency-oriented indicators represent the interests of the larger organization, offering service to the customer community. In order to operate at the most efficient level and still meet the customer's service expectations, the relationships between both parameters should be periodically measured and updated. Figure 9.3.3 shows a sample of operational curves vital to each company. The service levels (1, 2, and 3) are indicated as well. For ensuring service level 1, all three critical resources should be operated below the thresholds indicated. On the other hand, for service level 3, all resources can be

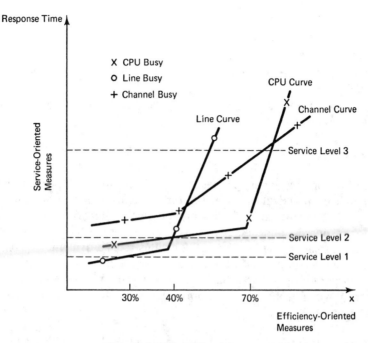

Figure 9.3.3 Operational curves.

operated beyond the thresholds. But attention should be paid to the thresholds because of the high sensitivity in this service area. Small changes in utilization may cause serious service impairments. Service level 2 is accomplished only by strictly controlling the CPU threshold (about 70% utilization). The same, or similar, curves should be used as operational standards in each shop. The service and utilization figures should be measured, controlled, and changed when necessary.

For representing the interests of the service center, throughput and utilization parameters are discussed in greater detail.

Throughput

Throughput is simply a global, static measure of the server's capacity. Capacity means the high-water mark theoretical limit might be achieved only under ideal circumstances. Examples such as an MIPS (million instructions per second) rate of CPUs or line-throughput measures in kilobits per second are useful only for configuring systems on a global basis. Frequently, when referring to capacity, the interrelationships among components of a system are included, which may reduce the throughput characteristics of an individual component. However, these are not transparent to nontechnically oriented persons. Throughput is an application-oriented measure, suggesting figures such as the following:

- Number of transactions A, B, or C for a certain period of time
- Number of customer sessions for application A, B, or C for a definite time window
- Number of calls for circuit-switched environment by customers A, B, and C
- Number of jobs provided by source node A, B, or C in a remote-batch environment.

Utilization

Utilization is a dynamic measure of the resources. Utilization provides information on practical limits of the throughput under operational circumstances. Using the utilization indicators, overlaps among components, mutual waits for resources, and delays due to queuing for certain resources can be analyzed. A system profile (Figure 9.3.4) illustrates a dynamic behavior of a system in an oversimplified fashion. The nonoverlapped resource status is the primary target for upgrades, where the throughput limit of the resource under consideration can be most closely approached. In Figure 9.3.4, there are three such targets:

- Accelerating the CPU speed for reducing the CPU ONLY part
- Upgrading the I/O subsystem for improving the I/O service time and thus reducing the CPU WAIT FOR I/O part
- Changing line speeds and/or line disciplines for eliminating the PROCESSING RESOURCES WAIT FOR TRANSFER part

For supporting implementation standards of utilization indicators, the indicators themselves—for example, nodes and links and utilization targets such as SDLC line utilization not greater than 65%, slowdown not higher than 2%, node processor utilization lower than 55%, Ethernet baseband-utilization is not higher than 40% and parameters impacting resource utilization—should be carefully determined. Impacts may come from parameter settings, workload mix, mode of access, transmission, operation, medium of transmission, node and link throughput rates, protocol, communication overhead, and number of end-user devices attached.

Communication system-independent indicators are recommended [GRUB81] by subdividing the interaction between customer and data communication systems into three fundamental phases:

- Access function
- Transmission function
- Disengagement function

The indicators are specific measures of speed, accuracy, and reliability associated with the functions introduced previously. This grouping could be aug-

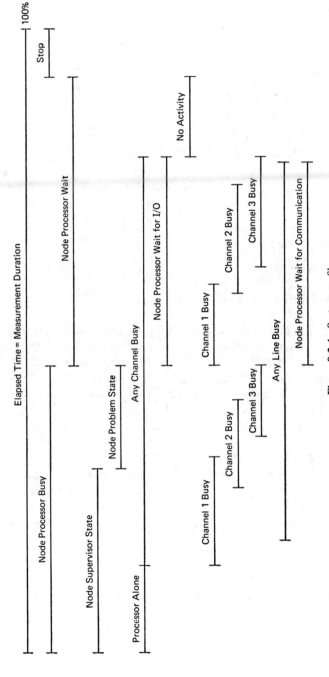

Elapsed Time = Measurement Duration

Node Processor Busy

Node Supervisor State

Node Problem State

Processor Alone

Any Channel Busy

Channel 1 Busy

Channel 2 Busy

Channel 3 Busy

Any Line Busy

Node Processor Wait

Node Processor Wait for I/O

Channel 1 Busy

Channel 2 Busy

Channel 3 Busy

Node Processor Wait for Communication

No Activity

Stop

100%

Figure 9.3.4 System profile.

mented for all communication forms. They may very likely become the ANSI performance standard for communication services.

In a typical voice environment, the following indicators may be considered:

- Call attempts
- Calls completed
- Calls failed/abandoned
- Overflow (peg count)
- All trunk busy conditions
- Average busy hour load
- Busy hour load per day/hour of week
- Incoming/outgoing network call volume
- Grade of service traffic summaries for trunk groups
- Dial tone delays
- Internal switch blockage
- Peg count (CCS)
- Call records

9.3.2 Performance Monitoring

Performance monitoring provides for measuring and testing network facilities and equipment, including analog monitoring, digital performance monitoring, analog transmission testing, node performance monitoring, LAN monitoring and testing, and performance assessment of applications efficiency.

Prior to a detailed discussion of monitoring strategies for key indicators addressed in this section, the right periodicity of taking measurement samples has to be decided upon. Arguments for continuous monitoring are:

- First failure information capture is important.
- Failure in a networking element may not impair operation until long after the occurrence. When impact is visible, failure data may no longer be available.
- Operation must not be interrupted for dumps or for waiting for the failure to recur.
- Continuous supervision of service-level indicators is required.
- Actions instead of reactions are important.
- There must be a basis for tuning and accounting.

But continuous monitoring has some drawbacks too:

- Large amount of information to be maintained
- Heavy resource demand

- Overhead of software instruments
- Accuracy of software instruments
- Overload on operators if not filtered

Which periodicity to choose may be decided by means of a decision matrix. Table 9.3.1 shows an example for a decision matrix of selecting the optimal monitoring frequency. Monitoring recommendations are addressed to the performance indicator categories.

TABLE 9.3.1: Determination of Monitoring Periodicity.

	Rules						
	1	2	3	4	5	6	7
Conditions							
Service-Level Agreements In Place	Y	N	Y	Y	Y	N	N
Processor Load Critical	Y	Y	N	Y	N	Y	N
Transmission Load Critical	Y	Y	N	N	Y	N	Y
Actions							
Install Software Techniques		X	X		X		X
Install Hardware Techniques	X			X		X	
Implement Filters	X	X			X		X
Continuous Monitoring	X		X	X	X		
Periodic Sampling		X					
Ad Hoc Monitoring						X	X

The analyst very frequently needs special measurements for preparing meaningful alternatives. In most cases, the functional dependencies among performance indicators of service and utilization are of prime importance. It is assumed that a range of instruments is available.

Availability considerations

Section 9.3.1 stated the general applicability of the multiple-layer availability structure. But, in most practical cases, it is very difficult to measure and report on availability. Continuous observation of the functionality of all communication networks' components impacts the performance due to overhead (up to 10%) when software techniques are used. Furthermore, this would require that all status and error data be compared with the inventory control file defining the resources and connectivity of the communication networks' resources. In addition to the overhead and data-reduction problems, this inventory control file should be kept updated after configuration changes. Network monitors and technical control systems may collect information on availability without overhead. However, for special-purpose investigations, these instruments can hardly be cost-justified. That is why performance

analysts usually implement solutions based on data provided by the communication or application software. In this respect, VTAM-LOG can be used as an information source. VTAM is aware of the functionality of all network components. Extended by time stamps, availability reports can be generated. For improving readability, SAS (statistical analysis system) may be used.

Using communication management configuration (CMC), the availability of the network can be sampled by status changes in the network [SOUC83]. The status is obtained through the use of commands issued by CMC. These commands are triggered by messages indicating resource activation and deactivation, successful recovery, and any kind of errors and component outages. A special task in CMC checks the messages, whether they are included in the trigger table or not. If they are, tests are started. The answers are stored in the log maintained by CMC. Formal reports can be generated on availability by networking locations, length of outages, average time between failures, number of outages by class, and exceptions where thresholds can be set by the customer. Figure 9.3.5 shows an example of an availability report.

PROD. HOST NAME	APPL. NAME	LINE NAME	LINE AVAIL. %	NETWK. AVAIL. %	APPL. AVAIL. %	END TO END %	NO. OF OUT.	CUSTOMER
atlanta								
cmc	netm2	n6861	99.46	100.00	99.83	99.29	2	#3641
mvs-a	appl-a	n6861	99.46	100.00	100.00	99.46	1	#3641
mvs-a	appl-b	n6861	99.46	100.00	100.00	99.46	1	#3641
vm-a	appl-c	n6861	99.46	100.00	98.86	98.32	2	#3641
chicago-1								
cmc	netm2	tt0a1	99.91	100.00	99.83	99.84	2	#2921
cmc	netm2	tt121	98.06	100.00	99.83	97.89	2	#2866
mvs-a	appl-a	tt0a1	99.91	100.00	100.00	99.91	1	#2921
mvs-a	appl-a	tt121	98.06	100.00	100.00	98.06	1	#2866
mvs-a	appl-b	tt0a1	99.91	100.00	100.00	99.91	1	#2921
mvs-a	appl-b	tt051	98.06	100.00	100.00	96.46	1	#2866
vm-a	appl-c	tt051	99.91	100.00	100.00	99.91	1	#2921
vm-a	appl-c	tt051	98.06	100.00	100.00	98.06	1	#2866
dallas								
cmc	netm2	dsla1	98.88	100.00	99.83	98.71	2	#6123
mvs-a	appl-a	dsla1	98.88	100.00	100.00	98.88	1	#6123
mvs-b	appl-e	dsla1	98.88	100.00	100.00	98.88	1	#6123
vm-b	appl-d	dsla1	98.88	100.00	99.26	98.14	2	#6123

Figure 9.3.5 Network components availability.

The latest technique is useful not only for special investigations but also for formal reporting on availability. In addition, network operational control may benefit by receiving catalogue procedures for network tests. This procedure is not limited to the IBM environments; any communication software can be fundamentally extended by built-in command sequences. For calculating the availability, the end-user level should be considered, expressed in host time (e.g., session hours). Using the network inventory file, the number of applications dependent on the failed network component has to be determined. Tables may be prepared in advance or during analysis. Artificial intelligence may support this analysis more efficiently than traditional table look-up

methods. Once the configuration is stored with object orientation, impacted applications by logical and physical users may be rapidly evaluated by symbolic processing.

Response-time considerations

Response-time measurements on the communication interface are, in most cases, protocol-dependent. The measurement device should interpret the way protocols work, set time stamps at certain events, and execute calculations. Figures 9.3.6 and 9.3.7 illustrate the response-time interpretation for character- and bit-oriented protocols, respectively. From the measurement device point of view, in both cases there are four principal portions of the customer's response time.

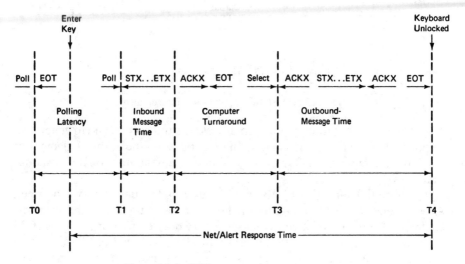

Figure 9.3.6 BSC response-time measurement.

- Polling latency (including LAN)
- Inbound time (including MAN and WAN)
- Host and front-end delay time
- Outbound time (including WAN, MAN, and LAN)

Measurement inaccuracies of certain instruments are due to the individual polling latency. It is measured as the time interval between the last nonproductive poll and the first productive poll (T1 − T0). This figure is dynamically adapted, and half of it is allocated to the individual transaction.

Inbound time (T2 − T1) is measured as the time interval between recognition of STX (BSC) and ETX (BSC) or of the first information frame (block) and the last information frame (SDLC) associated with the transaction. In the case of SDLC, this time interval includes all I-frames and any intermediate acknowledgment necessary for link control. Host and front-end delay (T3 −

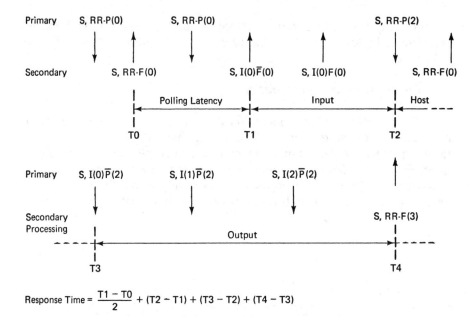

$$\text{Response Time} = \frac{T1 - T0}{2} + (T2 - T1) + (T3 - T2) + (T4 - T3)$$

Figure 9.3.7 SDLC response-time measurement.

T2) is the amount of time required to process the transaction and to generate a response. It is measured as the time interval between the acknowledgment of the inbound message [I-frame(s)] to the subsequent start of the response transmission.

Outbound time (T4 − T3) is measured as the time interval between ACK of select and EOT (BSC) or the first-response I-frame and the acknowledgment of the final I-frame by the secondary device. Measuring in the X.25 environment requires the interpretation of HDLC instead of SDLC. Moreover, certain internal performance issues of the packet network remain hidden from the user unless measurements are implemented at multiple locations, such as access points to the network. Response time will be interpreted in a different way, indicating the usual components plus transport delay in the packet-switching network. For utilization and traffic, packets are used as common denominator.

Using T1/T3 or Integrated Services Digital Networks (ISDN), slight modifications in terms of performance indicators and instruments are expected. Basically, the application-related monitoring features should be further elaborated. Response time has to be measured, displayed, and reported for each communication form such as data, video, voice, and facsimile. When information sources other than the digital interface are implemented, there is no special indication on the customer's response-time portions. Electronic signals in the keyboard or light signals on the screen can trigger response-time measurements, as well. Furthermore, special-purpose terminals may return mainframe messages to the source node, enabling the measurement of the network-delay time, excluding both customer and host-processing delay. The reverse is imple-

mentable as well, using a personal computer on the remote site for generating transactions of a preset scenario. The response times are stored at the PC and are periodically transmitted for final processing into the host. The microcode in the cluster controllers can be used for the same purpose.

Technically, all portions of the user's response time (Figure 9.3.2) can be measured with reasonable accuracy. In pursuing performance studies in networks, response-time components in LANs, MANs, and in certain WANs with packet-switching service are too difficult to measure. The best way is the combination of various tools, each responsible for certain networking segments. Thus, the master product offering performance-management services will combine and correlate response times from various sources. It is extremely helpful when measurement devices are using the same definitions and standard formats for measurement data transmission (e.g., NMVT from IBM is competing against OSI-CMISE for this format). Large corporations are considering a combination of LAN tools that measure within the LAN, network monitors that measure at the digital interface, and software monitoring that resides in communication processors or in mainframes. Section 9.4.4 will address special instrumentation of response-time measurements.

Accuracy considerations

Accuracy of communication networks may be impacted in multiple ways. Usually, hardware and software mechanisms are implemented for preventing accuracy problems. Still, in many cases, performance analysts are expected to set up and accomplish accuracy tests. Analog measurements may include [FROS86]:

- Data-signal levels
- Test-tone levels
- Relative quality of data signal
- Signal-to-noise ratio
- Phase jitter
- Hit phenomena

Tests could be classified as follows (FROS86]:

- Nonintrusive tests that may be terminal-, channel-, or modem-related
- Intrusive tests with quantitative and qualitative nature

In addition, performance analysts are expected to provide remedial functions for operational control. These may include automated procedures of:

- Disabling streaming terminals automatically or manually
- Switching to hot spare modems
- Dial backup of private-line facilities

Table 8.3.5 shows a detailed list of test alternatives. The most frequently used instruments are passive and active line monitors, covered in depth in Chapter 4. Implementation examples are given in Chapter 8, as well.

Throughput and utilization considerations

Simultaneously with service-oriented measurements, throughput- and utilization-related information should be extracted as well. Measurements are well understood in the host area, usually using software monitors. However, measuring communication-control processors and lines is not yet widely used.

Front-end processors (FEP) 37X5 from IBM (or compatible) (Figure 9.3.8) are the most frequently used ones. Their hardware and software components significantly influence measurement and measurement-data interpretation. Channel adapters are responsible for the link between the host computer and front-end processor. Channel adapters can be of various types:

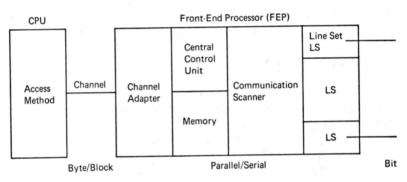

I/O Interface Channel (CHNL) — Byte (EP), Block (NCP), Selector (Special)
Channel Adapter (CA) — Hardware Interface Between FEP and CPU
Central Control Unit (CCU) — Minicomputer to Control FEP
Memory (MEM) — Storage for Programs and Data
Communications Scanner (SC) — Converts Parallel Data to Serial Data and Distributes to LS
Line Sets (LS) — Hardware Interface Between FEP and Modems
Front-End Processor (FEP)

Figure 9.3.8 37X5 architecture.

Type 1 accomodates very low volume of throughput, requiring the FEP control program to intervene for each data-transfer burst.

Type 2 requires less intervention of the control program, transferring data by *cycle-steal* and accommodating a greater volume of transactions.

Type 3 provides all the capabilities of Type 2, in addition to a dual interface to multiprocessors.

Type 4 accommodates up to 92-byte data transfers without control-program intervention and features a two-channel switch enabling attachment to two or more CPUs.

The central control unit (CCU) contains the circuits and data-flow paths required to execute FEP instructions, and to control FEP storage and the attached adapters. The CCU operates under the FEP control program. Communication scanners (CS) provide the connection between the line-interface base (LIB) and the CCU. The primary function of communication scanners is to monitor the lines for service requests.

There are three types of scanners:

Type 1 requires an interruption on each bit sent or received.

Type 2 requires program intervention for each character sent or received.

Type 3 is a cycle-steal scanner requiring program intervention at each end of the buffer or message.

The LIB drives and terminates all signals from CS to line-set interface. Communication lines are attached to the LIBs via line sets.

The FEP controller hardware has five operational program levels:

Level 1 is invoked mainly to service trouble indications and is hardware-interrupt driven.

Level 2 services only interruption from the communication lines for character or line service and is generally hardware-driven.

Level 3 facilitates CPU-CA interactions.

Level 4 performs overall management of the system's resources.

Level 5 is active only when no other levels require program resources.

The operating system of the front-end processor can be of three types:

• EP (emulation program)
• PEP (partionized emulation program)
• NCP (network control program)

Using NPM, Netspy, or Mazdamon, the customer is provided with practical and convenient systems for collecting performance-related information. These data may be very useful in evaluating a dynamic network.

Only a very low number of measurement facilities are provided for other than IBM front-end processors. In this respect the communication monitor of generalized monitoring facility (GMF) for Honeywell hardware, CENLOGs for Unisys DCPs, TRASOM monitor for Siemens DUETs, and Comalert for COMTEN front-end processors may be considered.

For measuring line load on selected lines, line monitors can also be used. They monitor the percentage of time the line is in the receive-data state, the percentage of time the line is in the transmit state, the percentage of time the

line is used for polling, and the percentage of time the line is in wait status. In addition, the number of negative acknowledgments received or transmitted can be monitored.

9.3.3 Thresholding and Exception Reporting

Thresholding and exception reporting means the analysis of stored performance information to identify changes. It allows managers to identify, analyze, and react to the changes in performance by setting thresholds and generating reports.

Performance-related data are assumed to be stored in the performance data base or in special segments of the MIB (management information base). Performance management also maintains the data base or the MIB segment. This maintenance activity in a broad sense includes:

- Definition of the indicators that will be included in the data base
- Selection of the product or data base to be populated by performance data
- Determination of maintaining frequency by indicator and the interfaces between monitors and data base; these interfaces may be defined in multiple steps: first, between network elements and management systems; second, between individual management systems and integrators.
- Definition of special threshold values for each indicator under consideration for reporting for reducing the total amount of paper-based reports
- Determination of the periodicity of data-base updates and data compression; if products are under consideration, the manufacturers usually offer guidelines for the periodicity and for synchronization.

Chapter 5 gives additional recommendations for how to select data bases and customized products. Solutions for configuration data bases (see Chapter 7) also may be extended or customized for accommodating performance management.

When designing reporting systems, several steps have to be considered:

Step 1. Determination of information areas and indicators. Information areas determine the breakdown of collected and stored data by, for example:

- Communication forms, such as voice, data, word, image
- Applications
- Customer premises equipment, such as processors, LANs, switches, PBXs
- Local exchange carriers' equipment, such as MANs, Backbone LANs, bypass, multiplexers
- Network containing multiplexers, concentrators, trunks, circuits

Indicators determine for which of the information areas under consideration the reporting system is expected to generate reports. Typical indicators are (see also Section 9.3.1), for data: response time, service level, availability, traffic volumes, resource utilization, and incidents; for voice: call attempts, calls completed/failed/abandoned, overflow, switch blockage, busy hour load, and so on. Figure 9.3.9 shows an example of this matrix, also indicating the report identifications for each individual column and/or lines.

INFORMATION AREAS	INDICATORS	Service Level	Resource Utilization	Traffic Voice Data	Incidents	Report ID
Communication Forms						
• Voice		X	X	X	X	R0001
• Data						
• Word						
• Image						
Applications						
• A				X		
• B						
• C						
CPE						
• Processors				X		
• PBX						
• Switch						
LEC						
• LAN				X		
• Bypass						
Network (IEC)						
• MUXs				X		
• Trunks						
• Circuits						
Report						
• ID				R007		

Figure 9.3.9 Information areas and indicators.

Step 2. Design of the distribution matrix. The reporting system has to serve all the organizational units of the network management. Depending on the tasks, the objectives and responsibilities of the receivers, reporting details, periodicity, and presentations, forms may be completely different.

Network management organizational units may include the manager, network operational control, administration, and analysis and planning departments, as shown in Figure 9.3.10. For each individual report identified in the previous matrix, the reporting periodicity, level of details, and the presentation forms have to be determined.

The architecture of the data base and the information needs define the most detailed level of data to be kept. The consolidation and updates are expected to be taken care of by the standard features of the data-base software. The level of detail decision has a considerable impact on the DASD

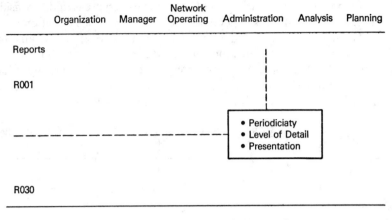

	Organization	Manager	Network Operating	Administration	Analysis	Planning

Reports

R001

• Periodiciaty
• Level of Detail
• Presentation

R030

Figure 9.3.10 Reports' distribution matrix.

requirements and on the applicability of reports by their users. The interface to on-line real-time systems supervision is recommended to be the DAY (D), detailed by hourly averages. Other levels are expected to be:

(W) Week
(M) Month
(Q) Quarterly
(Y) Year

This structure defines the data elements stored in the data base by information areas. Here, there is a strong correlation with report types to be supported. It is recommended to support four different types. They are:

- **OVERVIEW (OV)**—multiple indicators or components, long-time intervals
- **COMPARISON(CO)**—single or multiple indicators or components over medium and long time intervals
- **EXCEPTION (EX)**—correlation of indicators over medium and long time intervals
- **DETAIL (DE)**—single indicators, short time intervals

The reports' distribution strategy has to be selective for reducing the number of paper-based reports. The periodicity should correspond with the level of detail in terms of data-base data structures and type of reports. It is recommended to consider the capabilities and applicability of a display data base.

The principal presentation forms are summarized for the four major reporting types. For occasional or ad hoc reports, any or even other presentation forms may be selected. Presentation forms are:

Graphics. These offer multi-color overviews for multiple information areas and/or indicators by time.

Bar charts. There are two varieties: a two-dimensional compressed form displaying multiple indicators by time, and occasionally, a three-dimensional form that is used to improve the level of comparison.

Tables. This is a two-dimensional display of multiple indicators and/or time. There are many alternatives offering this form. It is recommended to concentrate on a few standard reports. The axis may be changed and multiple indicators may be presented in the same table. The compression levels are assumed to be extremely flexible.

Pie charts. These offer an overview on the distribution of single and/or multiple indicators. Critical segments of the chart may be colored differently or moved out slightly from the chart.

Correlation tables. These are used for a presentation with exceptional conditions for information areas and/or indicators.

Hit lists. These provide an unsophisticated alternative of summarizing certain events by time intervals. Incidents are usually reported in this way.

In order to reduce the number of paper-based reports and to increase the timeliness of information distribution, display data bases may be designed and implemented. These data bases are the subsets of the network-management or performance data base. It is updated daily and is intended to report on the previous day's performance only. Popular reports include graphics on availability, response time, workload volumes, resource utilization, incidents, call statistics, blockage overviews, and labor statistics. The methodology for maintaining this temporary data base and generating reports is shown in Figure 9.3.11.

9.3.4 Analysis and Tuning

Any anomaly can lead to the start of an analysis project. Most frequently, however, formal requests are issued by fault, security or accounting management, and capacity planning. Particular care should be taken in these areas:

- Tuning to service and performance requirements, not "best possible" alternatives
- Calculating payback in advance
- Observing the 80%–20% rule (20% of the workload is responsible for 80% of the resource demand)
- Focusing on critical resources
- Determining the point when capacity is exhausted

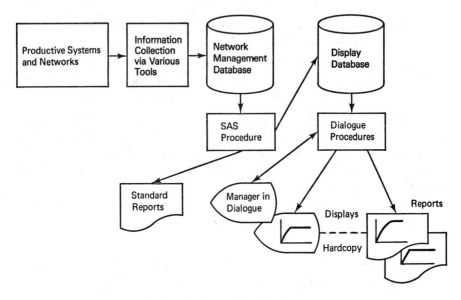

Figure 9.3.11 Display data base.

- Defining the objectives
- Determining the time frames

Usually, data required are available in the network-management data base, unless drastic data-reduction mechanisms have been implemented. On rare occasions, the experience file of historic tuning data may help for quickly recognizing similarities with past problems. Otherwise, special measurements should be obtained. Once the hypothesis has been formulated, cost efficiency and technical feasibility should be tested step by step in order to exclude uneconomical and nonfeasible alternatives. After implementation, measurements should check and prove the performance improvement. In case of insufficient improvement, additional hypotheses should be worked out. If the tuning plan is still unsuccessful, capacity planning activities should be invoked.

The first step in analyzing problems is to decide whether the performance analyst is facing a tuning task or a support activity for operational control. The second step consists of evaluating the objectives and time frame for the analysis request under consideration. Both are very important criteria for ensuring economy of tuning efforts. In the field of tuning, it is often true that "it is never too late to stop a project." The time frame required is greatly dependent on the experiences and measurement results available. If none of them is available, the time frame should be extended to a reasonable limit. In addition, checkpoints for controlling results should be determined.

Particularly in large installations, the experience file may be consulted at the beginning. Former hypotheses, whose basic problems are comparable to the problem under consideration, may assist in determining feasible sched-

ules. The prerequisite is that all former tuning efforts have been properly documented. (Table 9.3.2 shows the structure and example of an experience file.) After evaluating the experience file, final timing and distribution of responsibilities can be determined. Depending on the problem issued and the experience file content, the detailed list of information required must be determined.

TABLE 9.3.2: Experience File Sample Form.

Identification of the problem: Response time degradation

Time of study conducted: April 1990

Responsible for tuning: Department, ANA DO 2

Problem description: Response time degradation on certain multipoint lines
 No correlation with particular applications
 Some correlation with time of day

Hypothesis evaluated: Number of devices on the multipoint line
 Modem problems
 Parameter settings of the network architecture
 Inefficient control unit
 Inefficient application code

Hypothesis selected: Number of devices on the multipoint line

Time frame of execution: 4 weeks

Number of persons involved: 2

Instruments supporting tuning:
- Information extraction: Response Time Monitor (RTM)
 NetView Performance Monitor (NPM)
- Information analysis: SAS
- Performance prediction: Response Time Estimator (RTE)

Performance improvements accomplished:
- Service level: Stable response time around a level 35% below the old one
- Efficiency: Resource utilization is lower and stabilized at 45%

Costs: Additional line expenses

In the second step, data have to be extracted from existing files or data bases. In order to provide sufficient information in proper detail, the performance data base should be established. It is highly recommended that its maintenance be included in the responsibility scope of the performance analyst. Depending on the installation size, information resolution requirements, and tools available, the performance analyst is expected to address the following principal objectives:

- To define the nucleus of the network-management data base
- To determine the key performance indicators for service level and efficiency to be included in the data base
- To classify and cluster present and future workload as processing and communication demands

- To specify the nodes and links of the communication network using links to the inventory or configuration data base
- To deal with communication software overhead measures first of all for information extraction using alerts and traces
- To investigate the links with host-performance indicators and to derive correlative indicators
- To evaluate the expandability regarding inventory, vendor, and trouble-control capabilities
- To determine the levels of detail for each information area
- To set up data-base updating schedules and procedures
- To define the data-base hierarchical query capabilities and authorization of access
- To determine the timing and distribute the responsibilities to information sources
- To design reports based on requirements issued by operational control, administration, and network-capacity planning
- To determine the data-base access procedures for expert systems
- To specify the requirements of extending the data base into a knowledge base
- To estimate one's own information demand for successfully pursuing network tuning

Once the data base is operational, particular care should be taken in controlling the periodic updates. Usual cycles are daily, weekly, and monthly runs.

When the information demand—summarized during problem analysis—has been met, the performance analyst may proceed to the step of formulating hypothesis. Otherwise, special measurements should be set up and analysis tools should be evaluated and selected.

The third step is dealing with data or information collection using various monitoring and testing devices, as introduced in Chapter 4 and in Section 9.3.2. After information is available in desired details and format, the analyst starts with the formulation of the hypotheses in the fourth step. In the majority of cases, the performance analyst is concerned with the relationship between service and resource utilization-oriented indicators. Hypothetical solutions may include:

- Expand bandwidth
- Rearrange channel allocation
- Change equipment
- Change facility
- Use value-added services
- Change topology
- Change parameter settings

- Balance workload
- Implement adaptive routing
- Extend capacity of equipment
- Use compression and compaction

Communication network resources are able to process and transfer a certain amount of information within a certain period of time. Usual indicators are, for example, transactions per second for processors or bits per second for links. Depending on the actual load, the capacity indicators may be exceeded, causing an impairment on the service level. Figure 9.3.12 diagrams the link throughput capabilities in a communication network. Accessing the line-throughput limit, the transfer demand expressed by bits should be met in the next time period, hindering future demand (see shadowed areas in Figure 9.3.12). Due to additional queuing, multiple time windows may be required for transmitting "shadowed traffic." The corresponding service curve illustrating the response-time distribution may be observed in Figure 9.3.13. The customer load is characterized by number of transactions per second [MART72]. Measuring a fair number of load alternatives will help network administration to negotiate service levels and network-capacity planning for considering additional or alternative capacities. Other effects, such as line utilization, are not considered in this example.

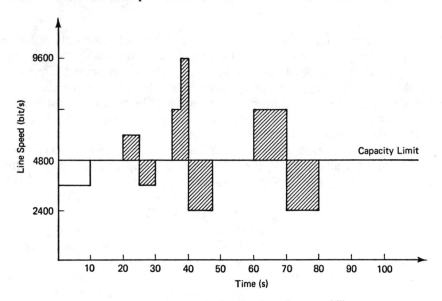

Figure 9.3.12 Communication line throughput capability.

In step number five, the efficiency and technical feasibility of the hypothetical solution has to be evaluated.

Chapter 2 and the previous sections have summarized performance implication factors in communication networks. The previous section even de-

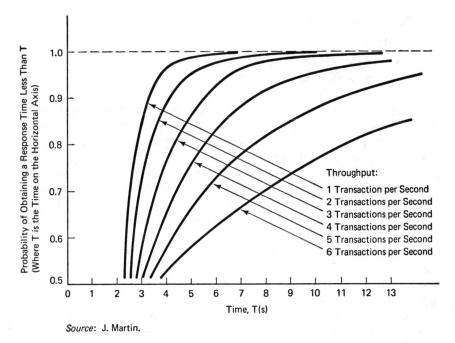

Source: J. Martin.

Figure 9.3.13 Response time distribution as a function of transaction rates.

fined key impacts for production and service level as a function of utilization profiles using mathematical equations. In such cases, the work of analysts can be significantly facilitated; the sensitivity of solutions is known. Thus, the question of efficiency of a certain hypothetical solution can be easily answered. But, in this respect, there are limitations. The equations must be used in the nonsaturated area only. Otherwise, the frequent exponential behavior of the service-utilization relationship cannot be considered. In other words, to avoid misinterpretation of such results, modeling tools can be successfully implemented. Using tools such as those based on operational analysis, the performance analyst is expected to evaluate alternatives of changing network parameters. To the contrary, the network-capacity planner (see Chapter 12) is supposed to alternate both workload and network parameters.

There are dissenting opinions as to whether efficiency or technical feasibility should be checked first. It is very difficult to issue a valid recommendation for all operating environments. In visible cases, where either the mathematical description is available or models are applicable, the gains in terms of performance can be derived within a short period of time. Using mathematical or network models, the network-performance analyst should carefully evaluate the technical feasibility. In other words, the feasibility of short-range configurations and parameter changes must be quantitatively evaluated. In this phase, there is no thought about major configuration upgrades or changes. Many times, the performance analyst is expected to propose a solution for short-term

service-level improvement or to bridge time gaps until the next release-change or network configuration upgrade without serious service-level deterioration. In other words, there is a search for ways of avoiding the capacity exhaustion point before the scheduled capacity upgrades. The majority of performance analysts are tempted to privilege sophisticated technological alternatives and deevaluate the economy of alternatives. The final goal of this responsibility should be to exclude hypothetical alternatives that are either not feasible or not economical. In doing so, the expenses can be better controlled in the implementation phase. The expected result is to have just a few alternatives for each problem.

In the following step, the actual tuning scenarios are implemented. Based on the previous sections, a number of alternatives should be considered. The examples are oriented toward the leading data network architecture: SNA from IBM. Basically, these scenarios fall into three groups:

1. Executing small configuration changes in the communication networks following detailed scenarios. Implementation examples include
 Temporary memory upgrades in network components such as front-end processors and terminal control units.
 Changing line speed.
 Changing modems and adapting modem speed.
 Changing the local or remote technical configuration or, in other words, the number of terminals being accommodated by a certain controller.
 Changing multiplexers.
 Changing line-operating mode from HDX to FDX, or vice versa.

2. Executing application program optimization, including code changes in sensitive areas pinpointed previously by measurements with application and/or software monitors. Particular care should be taken in
 Using nonproductive time windows or at least off-loaded periods.
 Assuring quality of the new piece of code.
 Checking compatibility with other applications and with modules of the same application in advance.
 Accurately identifying the operating environment for further evaluations.
 Freezing in all other tuning-related changes in order to evaluate and distribute performance improvements or losses.

3. Software tuning in the communication network involving the telecommunication access method, the control software in front-end processors, and the software of any type of control units in the network. This type of work is difficult due to insufficient manufacturer support. Any changes in the software may risk further general support by the manufacturer. That is why performance analysts should confine themselves to the proper choice of parameter settings. The proper settings show significant benefits over defaults, recommended by the vendors.

The SNA philosophy leaves a lot of room for interpretation and implementation alternatives. The following checklist will help to revisit former decisions and will force data center systems programmers to review implementation decisions.

- Nodes
 Number of SSCPs (domains) implemented in the network. Network management is impacted by this decision.
 Configuration of nodes including the definition of subareas. Network addressability is impacted by this decision.
 Definition of addressing, and address space for subareas and elements. Network expandability is impacted by this decision.
- Sessions
 Number of LOGMODE Tables. Maintainability and speed of logons are impacted.
 Grouping LOGMODE entries. LUs could be entered by PUs or individually; maintainability and speed of logons are impacted.
 Level of detail for major nodes. Performance is impacted.
 Number of additional minor nodes that are generated for backup components. Performance is impacted.
 Number of communication alternatives between domains for cross-domain communication. Performance and network management are impacted.
- Half sessions
 In general, depending on the parameter setting, the performance is impacted. The alternatives are:
 Definite or exceptional response
 Half- or full-duplex operation
 Normal or expedited data flow
 Use of chains and brackets
 Use of data compaction and data compression
 Response timing
 Selection of header profiles
 Selection of function management headers
 Construction of BIND
 Selection of LU-LU-Session-type, when more alternatives are applicable
- Path Control Network
 Number of explicit routes between two subareas. Recovery capabilities are influenced.
 Number of virtual routes between two subareas and their mapping to explicit routes. Performance is impacted.
 Entries in the class of service table establishes priorities for virtual routes. Performance is impacted.

In an IBM/SNA environment, tuning actions may fall into the following areas:

VTAM

- Adaption of buffer sizes based on VTAM/PARS reports (Figure 9.3.14)
- Adaption of size for buffer pools based on VTAM/PARS reports
- Determination of the RUSIZES for chaining messages, thus avoiding that one LU monopolizes the PU

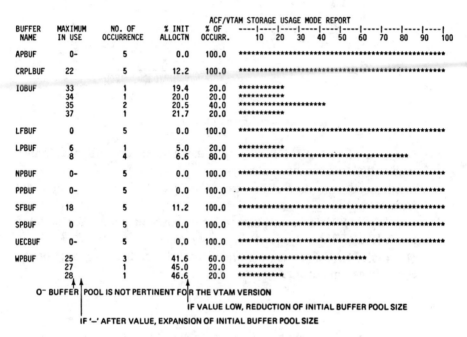

Figure 9.3.14 Buffer size adaption.

NCP

- Adaption of block size for better map with the line buffers
- Adaption of block size for inbound messages for VTAM in order to reach optimum compromise on
 Off-loading VTAM
 Not going into NCP slowdown
- Optimization of the number of PIUs segmented into BLU by intelligent selection of MAXDATA (Figure 9.3.15) [BUZE83]
- Determination of the optimal number of out frames for which acknowledgment can be outstanding by properly selecting MAXOUT

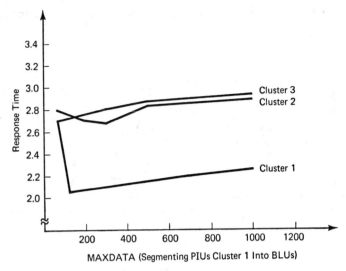

Figure 9.3.15 Optimizing Path Information Units.

- Selection of PASSLIM for limiting the number of outbound frames transmitted to a certain controller
- Intelligent composition of the service order table for considering actual terminal traffic
- Use of PAUSE for controlling the frequency of polling for inbound traffic [BUZE83]
- Use of DELAY for ensuring equal service for all participants of the communication network

Software in cluster controllers:

- Careful consideration of data compression software in order not to overload the controller but still off-load links
- Optimization of the number of frames between each acknowledgment by careful selection of MAXIN

Further details are discussed in Section 9.4.4.

Basically, (1), (2), and (3) could be accomplished at the same time, but that is not recommended. There is doubt concerning which adjustment of parameters or configuration changes or application-subsystem tuning contributed most to performance improvements. When multiple actions are needed at the same time, meaningful scenarios should be prepared. The sequence of each action is included, allowing enough elapsed time for each to deliver stabilized results of performance. Expert systems are expected to help in preparing and executing tuning actions. Initially, parameters of the knowledge base and available tools are entered into the expert system. Using expert

knowledge, the system guides the network analyst in tuning. At the least, routine drawbacks may be avoided.

In order to judge the effectiveness of the tuning alternative chosen, the final step requires continuous measurements prior to, during, and after implementing the tuning action. Measurements with proper interpretation will demonstrate the effects (e.g., Figure 9.3.16 shows the response behavior of the communication network for a certain tuning scenario, suggesting that the two tuning alternatives together guarantee the most optimal performance gain). In live experiments, the scenarios are more complex, and interpretation is not always so easy. The effort regarding logging and documenting the implementation is very frequently underestimated. Unless documentation is complete, no presentation can be accomplished for decision-making support. The final documentation or report should include

- Original tasks and objectives
- Original time frame and cost estimates
- By whom and by means of what tools measurements are executed
- Information segments used from the network-management data base
- List and rank of hypothetical solutions
- Scenario of implementation

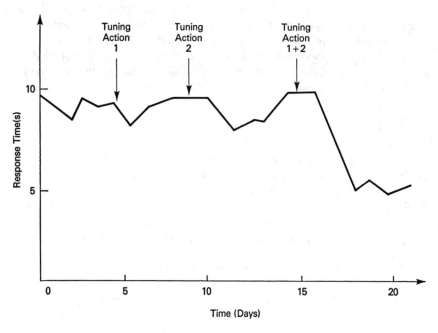

Tuning Action 1: Increase of Line Speeds by 100%
Tuning Action 2: Adaptation of the Parameters MAXOUT and PASSLIM

Figure 9.3.16 Logging of tuning implementations.

- Measurement results prior to, during, and after implementation
- Integration and interpretation
- Recommendations
- Comparison of original and actual time frames and costs for accomplishing the results

Tuning is a highly iterative process. More frequently, a number of alternatives and scenarios should be implemented before performance gain can be achieved. General experience tells us that the estimated time frames and budget limits are frequently exceeded many times over.

After successful tuning and decision for implementation, the experience file must be updated by an extract of the final documentation mentioned previously. Otherwise, alternative scenarios should be implemented. If they may fail, performance analysts should consider additional hypothetical solutions. After a definite number of experiments, the analyst may conclude that all meaningful tuning capabilities are exhausted, and thus network-capacity planning should take responsibility, as it involves the only feasible way of planning new or extending existing capacity.

For establishing operational standards, the number of iterations is very likely lower than in the case of tuning. After observation in a live environment, adaptions should be made if necessary and final documentation and training should be completed. In the case of serious operational problems, a review team can be assigned to locate the problems and shortcomings. After a certain period of time (approximately three months), the live experiences with the operating standards gathered by network operational control should be carefully evaluated and commented. Meaningful updates should be considered for the next version.

9.3.5 Establishing Operational Standards

Network software generation is one of the key issues. Based on information input from manufacturers (e.g., change of release or versions of software), from capacity planners (e.g., installing new components or changing the location of components), or from tuning results, when they are proven successful, the network-performance analyst is expected to generate the network software. In most practical cases, network-software generation can be automated.

This support function has responsibility for the development, installation, and maintenance of the network communications software. The personnel assigned to this function are communications systems programmers and the organization's experts on communications. Assistance is provided from this function to the problem-determination process to assist in third-level problem determination (see Chapter 8). The tools used by software support include diagnostic information gathered from network-monitoring software and problem symptoms from trouble tickets. Information gathered from sys-

tem traces, core dumps, and on-line monitors is used to determine contents of control blocks.

This function performs the installation of new versions of communication software and performs updates to existing software. Communications software is a generic term for summarizing all software components residing in networking nodes. Many communication-program products require modification or customization to meet the specific needs of the user. This function defines the software modification required to support the network. For example, user exits may be coded in NetView to perform automatic system generation of remote hardware. NetView may also be customized by generating detailed help panels for use by the help desk or network operations in first- and second-level problem determination (see Chapter 8). The software-support function also provides input to the network-planning function as to the performance of the network, network-user needs, and technological developments in the field of telecommunications. Recommendations are put forth by the group to counter network deficiencies and promote network growth.

For efficient support of fault management, thresholds for key network-performance indicators should be set. This procedure includes determining answers to the following questions:

- What are key parameters?
- Which parameters should be monitored continuously?
- Which indicators should be displayed continuously?
- What is in the right resolution rate?
- What are proper settings for warning and alerting network operational control?
- How frequently should warning and alerting messages be recycled?
- What is the proper life cycle for messages?
- What messages should be reacted by network operational control?
- What messages should trigger automatic and what should trigger just manual reactions?
- Who is authorized to change the thresholds?
- Where should actual thresholds be stored for further interrogations?

Table 9.3.3 gives an example for addressing this problem. The content of Table 9.3.3 can be retrieved from the parameter segment of the network-management data base. The parameter and threshold settings will then be forwarded to the instruments utilized by network operational control.

In the case of serious performance problems or of functional disturbances, operational control must react efficiently and very quickly. In doing so, performance analysts are expected to provide what-if catalogs, summarizing the most frequent events in communication networks. Criteria for these catalogs must include the following:

TABLE 9.3.3: Parameter Settings and Thresholds.

Service Level	Indicator			
	Warning Level	Alerting Level	Display Frequency	Life Cycle
Availability	98%	97%	10M	10M
Response time				
x Appl.A	3s	5s	3M	3M
x Appl.B	5s	10s	3M	3M
x Appl.C	10s	15s	3M	3M
x Average per device	7s	10s	1M	60M
Incidents				
x Serious	10/M	15/M	10M·	10M
x Major	15/M	20/M	15M	15M
x Minor	25/M	50/M	25M	25M
Efficiency				
Workload volumes				
x Appl.A	10TX/s	15TX/s	15M	15M
x Appl.B	5TX/s	10TX/s	15M	15M
x Appl.C	40TX/s	100TX/s	15M	15M
Utilization				
x Line 1 (FDX)	70%	80%	10M	10M
x Line 2 (HDX)	35%	45%	10M	10M

- Capability of prioritizing problems; it is not rare to face two different problems in large networks at the same time.
- Easily understood steps to be followed by operational control.
- Tight connection to the inventory control file in order to easily identify the component.
- Mention of not only the steps but also the most frequent outcomes or at least alternatives.
- Command sequences for the modules of the communication software and/or other instruments.
- As many routine procedures as possible for off-loading operational control so that they may devote themselves to special unexpected or unexperienced events.
- Clearly identified information sources.
- Carefully scheduled and accomplished update of what-if catalogs.

Command sequences are usually part of what-if catalogs. Network operational control does not have the time to follow up sequences in detail but can invoke and execute them. Command sequence could be a special-purpose test or measurement procedure, or a user exit of the communication software (e.g., REXX). For setting up command sequences, NetView hardware monitor is extremely helpful in the IBM environment. Figure 9.3.17 shows a symbolic example how to use such kind of user exits. This procedure is to trap and display

```
/*  DSI240I  REXX PROCEDURE                                    */
/*                                                             */
/*  CALLED BY MESSAGE AUTOMATION WHEN MESSAGE                  */
/*                                                             */
/*  "DSI240I NETWORK LOG NOW ACTIVE"  IS ISSUED.               */
/*                                                             */
/*  VALID ONLY FOR MVS/XA SYSTEMS !!!!                         */
/*                                                             */
/*                                                             */
TRACE I
'DEFAULTS NETLOG=YES,SYSLOG=NO'

'TRAP AND DISPLAY ONLY MESSAGES DSI530I,CNM563I,DSI041I'

'START TASK=CNMCSSIR'

'WAIT 60 SECONDS FOR MESSAGES'

IF EVENT = 'M' THEN
    DO
       'MSGREAD'
         SELECT

                WHEN MSGID() = 'CNM563I' THEN
                   DO
               'MSG SYSOP WAITING 5 MINUTES FOR NETVIEW SUBSYSTEM TO START'
               'WAIT 5 MINUTES FOR MESSAGES'
               'MSGREAD'
               IF EVENT = 'T' THEN
                   DO
                      'MSG SYSOP UNABLE TO START NETVIEW SUBSYSTEM'
                      EXIT
                   END
                   ELSE IF EVENT = 'M' THEN
                   DO
                      CALL START
                   END
                END

                WHEN MSGID() = 'DSI530I' | MSGID() = 'DSI041I' THEN
                   DO
                      CALL START
                   END
         END
    END
EXIT

START:
'AUTOTASK OPID = AUTO2,CONSOLE=1'
'STARTCNM NLDM'
'STARTCNM NPDA'
'STARTCNM STATMON'
'STARTCNM NETLOG'
'STARTCNM TRACELOG'
'AOPI0001' /* CALL AOPI0001 */
RETURN
```

Figure 9.3.17 REXX example of message filtering as part of network automation.

selected messages. There is no doubt that there are difficulties regarding the use of nonstandard command sequences. Particular care should be taken:

- Throughout quality checking of the command sequences in order not to cause even more serious outages than the original problem to be tackled.

- To update sequences as a function of communication software updates or parts of it.
- Training of network operational control personnel regarding how to invoke, to interpret messages, and to close down the command sequence.
- Continuous evaluation of the performance of command sequences in order to avoid further resource bottlenecks in critical circumstances.
- Continuous augmentation of the knowledge base as preparation for expert systems implementation.

9.4 INSTRUMENTATION OF PERFORMANCE MANAGEMENT

There is a relatively wide range of instruments supporting performance-management functions. All product families introduced in Chapter 4 may be utilized separately or in combination for monitoring and testing. This section focuses on monitors, data bases, and modeling devices. The monitoring part includes the comparison of SNA architecture-based monitors with each other and then with communication interface-based network monitors. The combination of a performance data base and trouble-ticketing features may be used to compute availability. The use of powerful tuning techniques, based on monitor and modeling techniques, may dramatically improve the overall performance. Expert systems are considered part of modeling devices. The major emphasis is on product selection and comparison criteria, which may be considered generic. References and description of products are kept to a meaningful minimum. However, examples are used for the leading products.

9.4.1 Comparison of Software-Based Monitors

Sometimes the selection procedure is limited to deciding what combination of software tools should be chosen from the same manufacturer. In a typical IBM environment, the frequent question is whether to choose

- NPM (NetView Performance Monitor)
- NetView Session Monitor with RTM (Response Time Monitor)
- Both NPM and the session monitor with RTM

To help answer this question, special capabilities of the instruments, such as problem determination, network-load measurements, and response-time measurements, should be evaluated. Tables 9.4.1, 9.4.2, and 9.4.3 show the comparsion. In the area of problem determination, NetView Session Monitor contributes in LU-related threshold detection only. Otherwise, NPM offers a complete repertoire on indicators. For resource utilization, NetView Session

TABLE 9.4.1: Problem Determination.

	NPM	NLDM
A. Error detection	**NPM**	**NLDM**
Error counters		
Number of temporary errors (retries)	X	
Number of transmitted messages	X	
Number of bytes retransmitted	X	
B. Threshold/alert capability	**NPM**	**NLDM**
Threshold exception monitoring		
Negative/positive poll	X	
Message rate	X	
Byte rate	X	
Line utilization	X	
Error counts	X	
Buffer shortage/excess	X	
CCU utilization	X	
Message queue length	X	
NCP slowdown	X	
C. Threshold detection	**NPM**	**NLDM**
Session response-time threshold by:		
LU	X	X
PU, line, node, APPL	X	
Response-time trend		
LU	X (G)	X
PU, line, node,, APPL	X (G)	

(G) NPM graphic subsystem under TSO

TABLE 9.4.2: Network Load Measurements.

Network Load	NPM	NLDM
A. NCP load		
CCU utilization	X	
NCP buffer counts	X	
NCP slowdown %	X	
NCP queues	X	
B. Line-utilization percentage	X	
C. Auto-refresh graphic monitoring by NCPs, lines, applications	X	
D. Network volumes		
a. Message traffic (PIUs) statistics for		
Line	X	
Cluster/PU	X	
Terminal/LU	X	
b. Byte counts (inbound/outbound messages) for		
Line	X	
Cluster/PU	X	
Terminal/LU	X	
c. Total number of positive/negative polls	X	

TABLE 9.4.3: Response Time Measurements.

Response Time	NPM	NLDM
A. Response time split up into:		
Operator	X	X
Host	X	
Network	X	
B. Response time by interval of collection and by:		
LU	X	X
LU and application	X	
C. Response-time summary by:		
LU	X	X
LU group	X	
PU	X	
Line	X	
Nodes	X	
Virtual route	X	
Application	X	
D. Response-time distribution by:		
LU (for each interval of collection)	X	X
LU (summary)		X
Session volumes		
Number of transactions by LU	X	X
Number of transactions by PU, LINE, APPL	X	
Number of user PIUs (inbound/outbound)	X	
Number of system PIUs (inbound/outbound)	X	
Total number of user Bytes (inbound/outbound)	X	
Total number of system Bytes (inbound/outbound)	X	

Monitor does not provide measurement entries. In terms of response time, NPM provides more indicators, but the accuracy of NetView Session Monitor with RTM is higher. For network operational control and network analysis, both tools are valuable. For network-capacity planning, however, NPM is the right choice. RTM results now may be called by NPM screens.

NPM is not without competitors. In particular, NetSpy (Legent) and Mazdamon (CA) offer similar functionality for a competitive price. NetView Release 3 has offered additional functionality to NetSpy and Mazdamon. In comparing the three products mentioned, the following criteria are recommended for consideration:

Need for definite response. In order to approximate the end-user level response time, for measurement purposes, the confirmation of the arriving message is necessary. All products offer the "dynamic" definite response feature, which means that a definite response may be switched off or on at will, and independently from the application. The algorithm of computing response time seems to be the most accurate with NetSpy.

Measuring and reporting TSO response time. TSO is handled differently by VTAM, requiring other probes and positions for time stamp collec-

tion. All products now offer this indicator. The accuracy grade is not yet proven with NPM.

Reporting flexibility. Usually, compatibility with SLR, SAS, MICS, and MXG is required. In this sense, NetSpy is leading. In addition, Mazdamon offers a rich set of proprietary reports. NPM is criticized for its lack of flexibility.

Resources demand. Overhead is always a critical issue with software techniques. In terms of DASD, all three products require substantial resources. Each of the products possesses some unique features in terms of CPU resource demand. Measurements are very difficult, but NetSpy seems to require the lowest overhead.

Ease of implementation. None of the products has flaws in this area, but NPM seems to have the most difficulties of operation. Mazdamon is heavily criticized for being the main stumbling block in the address attaching VTAM.

Collecting accounting information. NPM is the only product that offers collecting accounting information in front-end processors. The records are forwarded to SMI residing in one of the host computers.

Unique features. Each of them has some unique attributes. Mazdamon is able to manipulate information at the application transaction level. Sites running different applications, such as IMS, CICS, and TSO, appreciate this feature very much. NPM is the only product with VM support and with links to the umbrella product NetView. NetSpy offers total integration with the leading performance data-base product MICS.

NPM has the undeniable advantage of being supplied and supported by a powerful vendor widely recognized for its fine reputation and excellent technical support.

Other products are expected to enter the market, first of all to measure SNA-networks. Omegamon/VTAM from Candle, NetProbe from Boole and Babbage, and Net*Insight from Systems Center have to be mentioned.

9.4.2 Comparison of Software- and Hardware-Based Monitors

Based on the generic description of data collection devices, both software- and hardware-based monitors may be utilized for supporting performance management. In addition, the comparison given here may be useful for selecting the right solution for fault management, in particular the functions network status supervision and testing.

In order to decide on the most promising alternative or combination, the following criteria may be of great assistance:

1. **Availability of performance- and service-oriented indicators at the customer level.** In general, network monitors offer a full range of measures

at practically any level of detail required. Software-based monitors offer separate measures for the mainframe and for the application subsystems. Network monitors cannot make this differentiation.

2. **Features for problem detection and determination.** Table 9.4.4 summarizes the most important indicators relevant for problem determination. Network monitors are very useful for quickly detecting and locating anomalies. However, software-based monitors are the better choice for further diagnosing problems.

3. **Extraction of traffic- and utilization-related measures.** Table 9.4.5 gives a list of the most important performance indicators for traffic and utilization. Displaying these indicators helps to avoid bottlenecks for the service level. The techniques are almost equivalent, with slight benefits for network monitors.

4. **Extraction of application-related measures.** Software-based monitors are very powerful in keeping track of application-based information. But, in terms of service orientation—as stated earlier—they offer just one part, namely, the mainframe and application subsystem part. On the other hand, network monitors usually extract information by physical addresses only. Recently, vendors have made great efforts to offer solutions to the "application-switching" problem, indicating the utilization of one physical address (device) by multiple applications.

5. **Overhead.** Network monitors introduce no overhead in extracting information. The only overhead imposed is that of transmitting measurement data on the main channel—if implemented at all—from remote locations. Parameters usually can be set accordingly in order not to exceed the 1% level. Software-based techniques are very sensitive regarding overhead. In particular, alerting and tracing mechanisms in communication processors can seriously impact the productive traffic.

6. **Ease of use.** In terms of ease of use, vendors constantly improve their products. Using the mainstream concept, the comfortableness of software techniques may introduce performance bottlenecks due to overhead. At present, network monitors are slightly ahead of software techniques.

7. **Data-base support.** In both cases there are definitely data-base options. The variety and flexibility is higher when software techniques are used. However, in this regard, information may be cross-changed with ease.

8. **Installation and operating costs.** At first glance, network monitors may seem to cost a great deal of money. The price/line ratio improves by supervising a large number of communication resources. The operating costs, however, are not significant. On the contrary, the operating costs may exceed the installation costs by magnitudes for software techniques. Frequently, multiple-site rental prices and additional prices for reporting and resource demand are not properly evaluated when comparing both basic options.

TABLE 9.4.4: Problem Detection and Determination.

Criteria	Instruments NM	CS
Problem Detection		
• Nodes		
Source/Destination		
Hardware	(X)	
Software		X
Relay		
Active	(X)	(X)
Passive	(X)	(X)
Hybrid	(X)	(X)
• Links		
Interface	X	
Procedure		
Transmit	X	
Receive	X	
• Network		
Packets in Error	X	X
Packets Discarded	X	X
Procedure Violations	X	X
Packets Lost	X	X
• Transport		
Procedure Violations		X
Retransmissions	X	X
Unsuccessful Connection		X
Refused Connections		X
• Sessions		
Session Rejected		X
Aborts		X
Procedure Violations		X
Hunging Sessions		X
• Application		
Protocol Violations		X
Application Errors		X
Event Notification		
• Problem Filters	X	X
• Problem Thresholds	X	(X)
• Problem Alerts	X	(X)
• Problem Escalation		X

NM = Network Monitor

CS = Communication Software

X = Unlimited applicability

(X) = Limited applicability

9. **Reputation of the vendor.** There is no fundamental difference in terms of considering the vendor's reputation.

10. **Flexibility toward network extensions.** Network monitors may be configured for from 8 lines to about 1000 lines. Each upgrade, however, may

TABLE 9.4.5: Performance Indication for Traffic and Utilization.

Criteria	Instruments	
	NM	CS
Node Utilization		
• Source/Destination	X	X
• Relay	(X)	(X)
• Channels		X
• Memory		X
Link Utilization	X	X
Polling	X	X
Traffic Volumes		
• Nodes	X	X
• Links (Transactions/Messages)		
In	X	X
Out	X	X
Byte Count	X	X
• Network		
Null Header Packets	X	
Non-Null-Header Packets	X	
Byte Count	X	
• Transport		
Connections Number		X
Number of Expedited		X
Byte Count	X	
• Session		
Number Sessions		X
Byte Count		X
• Application		
Byte Count	(X)	X

NM = Network Monitor
CS = Communication Software
X = Unlimited applicability
(X) = Limited applicability

require the redefinition of tables, display layouts, data-base entries, and reporting versions. Similarly, when implementing software techniques, comparable activities need to be accomplished unless the scale of network management must be completely reorganized.

11. **Hardware or software dependency.** Software techniques are hardware- and software-dependent. Network monitors are not; they merely need access to the digital interface of communication.

12. **Ease of dynamic configuration changes.** Dynamic configuration changes are better and faster on network monitors than on software. The latter requires at least new generation of the network, causing the interruption of networking services.

13. **Educational requirements.** Educational requirements are continuous with software techniques, keeping track of new hardware and soft-

ware releases and new versions of monitoring service, respectively. Network monitors require a preliminary training of from 3 to 5 days and further extended training of approximately 2 days each consecutive year.

14. **Session management.** If session management tools are in use, the user is logged on the session manager and not directly to the applications. The virtual terminal is chosen from the manager' pools since this is the most efficient way to configure the session manager. Using a hardware-based monitor only, the session between the end-user and the manager may be measured. Using a software tool, a definite response between the session manager and the application may be switched on, and thus, both portions of the response time may be measured accurately.

15. **Definite response.** Hardware-based monitoring is independent of this feature; most software monitors may switch this feature on or off for controlling overhead.

Table 9.4.6 gives a summary-type evaluation using ranks of 1 through 4, where 4 is the most favorable rate. As can be seen in the final chart, both techniques have strengths and weaknesses. The optimal result is to use both techniques in a meaningful combination, such as

TABLE 9.4.6: Evaluation Summary.

- Network monitors for continuously supervising the communication network
- Software tools for diagnosing problems on an on-demand basis

9.4.3 Availability Reporting by Using a Configuration and Performance Data Base in Combination

The purpose of this example is to show how the configuration data base and the incident segment of the performance data base may be used in combination. This technique starts with the configuration shown in Figure 9.4.1.

Three applications are supported by three host processors. The wide area network is controlled by three FEPs, two of them operating in the same location. The third one is linked via a point-to-point line to FEP 02. The topology is hierarchical supported by both analog and digital circuits. Figure

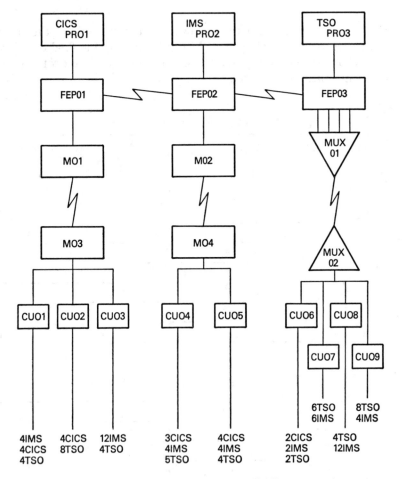

Figure 9.4.1 Configuration example for availability computation.

9.4.1 also indicates the applications supported by the individual workstations controlled by remote control units. Table 9.4.7 illustrates the results of impact analysis; in other words, how many applications and how many end-users are impacted when facilities and/or equipment have broken down? Due to the hierarchical structure, highly sensitive areas may be identified for front-ends and their links. After evaluating the impacts, the network designer is expected to make configuration changes that improve the overall network availability and reduce the impact of individual outages at the front-end level.

TABLE 9.4.7: Impact Analysis.

Network Elements	Applications			Impacted Users
	IMS	CICS	TSO	
CU 01	4	4	4	12
CU 02		4	8	12
CU 03	12		4	16
CU 04	4	3	5	12
CU 05	4	4	4	12
CU 06	2	2	2	6
CU 07	6		6	12
CU 08	12		4	16
CU 09	4		8	12
M 01	16	8	16	40
M 03	16	8	16	40
M 01–M 03 link	16	8	16	40
M 02	8	7	9	24
M 04	8	7	9	24
M 02–M 04 link	8	7	9	24
MUX 01	24	2	20	46
MUX 02	24	2	20	46
MUX 01–MUX 02 (T1)	24	2	20	46
FEP 01	16	17	16	49
FEP 02	48	9	25	82
FEP 03	24	2	45	81
FEP 01–FEP 02	16	9	16	41
FEP 02–FEP 03	48	17	25	90
PROD 01		17		17
PROD 02	48			48
PROD 03			45	45

The first improvements consisted of adding more channel connections to the front-ends. The result is that the number of impacted IMS and CICS end-users goes down (Alternative 1 in Table 9.4.8). For TSO end-users this change does not bring improvements. In the second step, a matrix switch is brought in for connecting lines owned by FEP 01 and 02. The improvement (Alternative 2 in Table 9.4.8) is significant for CICS and IMS end-users. However, when the switch is down—unlikely due to failsafe architecture—all users are impacted in locations 1 and 2.

TABLE 9.4.8: Results of Improvements.

Network	Applications			(Total number of impact end-users)
	IMS	CICS	TSO	
Present				
FEP 01	16	17	16	49
FEP 02	48	9	25	82
FEP 03	24	2	45	81
SWITCH	—	—	—	—
FEP 01–FEP 02	16	9	16	41
FEP 02–FEP 03	48	17	25	90
Alternative 1 (Channel attachments for FEP 01 and FEP 02)				
FEP 01	16	8	16	40
FEP 02	28	9	25	62
FEP 03	24	2	45	81
SWITCH	—	—	—	
FEP 01–FEP 02 (not applicable)				—
FEP 02–FEP 03	48	17	25	90
Alternative 2 (Matrix switch + Alternative 1)				
FEP 01	0	0	0	0
FEP 02	0	0	0	0
FEP 03	24	2	45	71
SWITCH	48	17	25	90
FEP 01–FEP 02 (not applicable)				
FEP 02–FEP 03 (not applicable)				
SWITCH–FEP 03	48	17	25	90
Alternative 3 (Application copies + Alternative 2)				
FEP 01	0	0	0	0
FEP 02	0	0	0	0
FEP 03	24	2	45	71
SWITCH	24	15	25	64
FEP 01–FEP 02 (not applicable)				—
FEP 02–FEP 03 (not applicable)				—
SWITCH–FEP 03	24	15	25	64
PROD 1		0		0
PROD 2	0			0
PROD 3			45	45

In order to improve applications flexibility, the third step implements additional copies of CICS and IMS in processor 3. The result is that the impact for processor failure does not exist any longer (Alternative 3 in Table 9.4.8). For further improvements, peer-to-peer implementations may be considered to circumvent the weakness of the FEP02-03 link and its impacts on many end-users.

For any of the alternatives, the number of incidents underscored by their duration have to be related to the total number of impacted end-users, computing availability for each. Such reports do not consider certain issues, such as the following:

- User may switch applications when applications or network segments are down.

- User may not want to get service when the network or its components are out-of-order.
- No differentiations have yet been made about the nature of breakdowns.
- No correlations have been made between related incidents, indicating the eventual multiple consideration of low-level device outages.

But this example demonstrates that even in a host area, such as availability reporting, progress can be made by meaningfully combining existing monitoring and data-basing resources.

9.4.4 SNA Response Time and Its Components

Each component of the SNA network may become a contributing factor of SNA response time. Thus, the following section investigates each component, and whether it may cause significant contributions to the host and network delay of the SNA response time. But, prior to the investigation, performance impacts of the SNA layers are considered. SNA was developed and implemented by IBM. During the last decade, SNA was substantially expanded and enhanced. Fundamentally, SNA consists of five networks responsible for controlling sessions, data flow, and transmission. Adding data-link and physical-control link layers results in a total of seven layers. Thus, SNA and OSI may be compared in a straightforward manner. The SNA layer definitions and principal responsibilities are summarized as follows [RUTL82] [BAER83].

SNA Layers

Layer 1: Physical Control Layer. Implementations of this layer manage the physical interface with the attached transmission medium. This includes data presentation, interface control, error detection, recovery, and notification.

Layer 2: Data-Link Control Layer. Data-link control (DLC) supports protocols for (1) executing and coordinating the transfer of message units across a link connection between a single primary DLC customer and a set of secondary DLC customers and (2) performing link-level flow management and error recovery procedures. The performance impacts of the first two SNA layers are not significantly different from those of the equivalent OSI layers.

Layer 3: Path Control Layer. Path control, found in each SNA node, provides a full-duplex path independent of the physical configuration and performs the path selection functions, ensuring that the correct transmission group or peripheral node is chosen. Path control also ensures that the message-unit format is appropriate for the transmission medium and also routes data over available links and through intermediate nodes. This enables many end-users to share common network resources. There are also path

control elements associated with the boundary function of peripheral nodes. Specific examples of path control functions include:

- Segmenting and reassembly of message units
- Routing among SNA subareas (network nodes)
- Control of multiple, parallel SDLC links (transmission groups)
- Virtual route pacing used for global network flow control
- Control of explicit routes
- Control of route extension (to peripheral nodes) in support of boundary functions

The performance impacts here are similar to those of the OSI network layer. Blocking may improve the efficiency of the use of SDLC frames. Segmenting helps in efficiently utilizing buffer spaces of low-speed communication nodes. In addition, the transmission efficiency of long messages may be improved. The more sophisticated the software involved, the more overhead is involved. In other words, meeting the same service-level objectives requires more resources with SNA than without it. Further performance impacts may appear when using the NCP Packet Switching Interface (NPSI).

Layer 4: Transmission Control Layer. There are three components of transmission control. The first relates to sessions. *Sessions* are defined as logical links among communicating parties. Session control functions include session-specific support for starting, clearing, and resynchronizing session-related data flows. Second, there are connection point manager ("mailperson") functions. They include sequence-number checking, enciphering/deciphering, separation of normal and expedited data flows, session pacing enforcement, and routing of data to data-flow control and path control layers. Finally, there is the boundary function. This is implemented within the network to support peripheral nodes (cluster controllers and terminals). Peripheral nodes are isolated from global network considerations. The functions implemented on behalf of peripheral nodes include header transformation, address translation for members of the subarea, routing to the proper link station, optional segmenting of message units, session pacing, and coordination of local flow control with global flow control.

Pacing is a technique implemented to ensure that information is not sent at a rate greater than the receiving node's capacity to handle it. Agreements on pacing in the session establishment phase will influence the operational performance in terms of exceeding high-water marks of buffers and causing local congestions, respectively. In addition to pacing, the transmission control layer requires additional control fields, including the request/response and bracket indicators, type of request unit, and the response indicator. Careful use of this indicator—privileging the "no response" option—will definitely improve the overall performance.

In interconnecting SNA networks, additional performance impacts may

be introduced in the address translation area. Each SNA network has its own name space and address space. A directory service consists of mapping names to addresses for network-addressable units in domain of control. A cooperative directory service is provided between domains as well. Transmission traffic between logical units of different SNA networks will have different addresses in the transmission-header fields, depending on which SNA network the transaction is actually passing. Due to additional address translations, performance may be influenced. But in defining multiple SNA networks, the overall limitations (e.g., in terms of number of addressable units) may be significantly alleviated.

Layer 5: Data-Flow Control. The function of the data-flow control (DFC) layer is to control the flow of data between the function management data services (FMDS) element pairs of a session. This means that network and session control data are not managed by this layer. Specific functions include the following:

- Enforcement of correct data formats
- Enforcement and checking of chaining (the grouping of a series of SNA message units into one unit of recovery)
- Correlation of requests and responses, including assignment of sequence numbers
- Enforcement of different response models, such as immediate or delayed
- Coordination of sending and receiving according to session parameters, for example, full-duplex, half-duplex contention, half-duplex flip-flop
- Enforcement of data-flow suspension when requested
- Regulation of response queuing

The performance can particularly be impacted by the meaningful use of chaining and bracketing [BAER83]. Chaining is used for delineating recoverable transmission sequences. Indicating only the last information unit of the chain may reduce overhead and avoid retransmissions. Bracketing is used for promoting integrity. Careful use will guarantee a reasonable level of performance.

For ensuring peer-to-peer communication, this layer adds a special request-response header to the request-response unit. The header introduces an additional overhead that should be considered for performance analysis. In transmitting short "useful" information, the overall overhead may even reach 50%.

Layer 6: Function Management Layer. The services provided by this layer are similar to those suggested for OSI level 6, the presentation layer. In SNA implementations, the services are provided by FMDS, acting on behalf of an end-user. The FMDS element pair provides a connection for passing message units between pairs of LUs and service managers that represent end-users.

This layer provides format translation between service managers in accordance with format or presentation services available for the session. Specific examples include the following:

- Device selection and control for multidevice workstations
- Data compression and compaction
- Formating data for diskettes when transmitting load modules for programmable devices

Additionally, the FMDS element pair representing the end-users will check and maintain current states for controlling and synchronizing some network services associated with session control.

As in the ISO architecture, any kind of transformation and conversion means off-loading transmission facilities but introducing time delay. The main functions involved are necessary services for secure information transmission. The question is to what extent resources (e.g., microcodes) can support these functions without impairing the overall network performance.

Layer 7: Network-Addressable Unit (NAU) Service Manager Layer. There are three service manager functions included in this layer: systems services control point (SSCP) service manager, PU services manager, and LU services manager. The first two categories and companion portions of the LU services manager are associated with internal network control of its resources. The remainder of the functions of the LU services manager are similar to the services suggested for OSI Level 7, the application layer.

An end customer (party to a conversation) using the services of this layer is attached via a port to the SNA network. This port represents an application entity that is referred to as an LU. This entity, or port, communicates with its peer, representing the other party of the desired two-party communication. It can communicate with network-control functions such as the SSCP or an associated PU. Accessing this port provides management services that initialize parameters for several layers. Some specific examples of functions executed on behalf of the end-user through the port provided by this layer are:

- Resolution of network addresses from network names
- Checking of end-user access authority
- Selection and matching of session parameters
- Management and maintenance services
- Support of presentation services
- Synchronization point services

Measurement services and network-operator services are topics set aside for future architectural definition. Currently, services available in these areas are defined by the product developer(s). New features embedded in PUT 2.1 and

LU 6.2 should closely be observed. In the following, SNA and networking components are analyzed in depth.

SNA Components

327X-type terminals include various devices with screen sizes in the range of 1000 up to 3500 characters, with or without graphics and color support. They usually have no built-in intelligence and hence introduce negligible amounts to the response time. The use of the terminal, however, may influence via cluster controller the performance characteristics of other customer devices. *Link between 327X terminals and 3270 cluster controller* is usually a coaxial connection. This link is operated at a very high speed (2 Mbits/s or higher) and therefore is not likely to influence the response behavior. If other techniques such as cable-oriented local area networks are implemented, the transmission delay should be recomputed.

3270 cluster controller provides control functions for up to 32 devices. Due to its intelligence, there are various features that, when implemented, may influence SNA response time. Basically there are two comments on this issue:

- The feature must have a counterpart implemented either in the mainframe or in the front-end processor.
- Augmenting the intelligence may mean off-loading the communication links at the expense of introducing additional delays. The individual response time may be worse, but service at the global level may be substantially improved.

The cluster controller must decode, understand, and interpret all SNA control-type information—headers and trailers—indicating message length and sequence, acknowledgment requirements, and so on. This kind of processing adds to the overall response time. The magnitude depends on the number and complexity of control characters. A storing of identical characters can be compressed into a lesser number of characters and sent over the links. This reduces link load and improves response time at a global level.

The Optimizer product family [BMCS86A] and on-line transmission time optimizer (OTTO) [SEGM84] optimize the on-line transmission time (first of all IMS and CICS) by using various compression alternatives. They include the following:

- Replacement of repetitive data bytes where occurrence is greater than four by a "Repeat-to-Address" command
- Replacement of trailing blanks in a protected field by a "Set-Buffer-Address" command
- Replacement of zeros where occurrence is greater than three by a "Set-Buffer-Address" command

- Merge of two consecutive protected fields into one
- Considering complete VTAM messages constructed by IMB regardless of response unit (RU) size and rechaining messages after compression

Customers report link-load reduction of up to 50%, CPU-time reduction by message chaining, and response-time improvements on the average. The improvement of response time can also be derived from the second component of Equation (6.1). Besides reduction of individual service time, substantial savings can be observed at the waiting time $T_{L.w}$:

$$T_{L.w} = \frac{(T_L - T_L') \times (U_L - U_L')}{2(1 - (U_L - U_L'))} \qquad (9.4)$$

Compression level = 50%
$U_L' = 50\%$ of U_L
$T_L' = 50\%$ of T_L

Assuming an operational level of T_L = 4s, an original transaction length of 1200 characters, and U_L = 60%, the total response-time reduction is:

$$T_{RT} - T_{RT}' = 7s - 2.43s = 4.57s \qquad (9.5)$$

or 35% in reference to the original response time.

For further reducing link load, screen addressing may be implemented. In this case, not all screens—only the changed parts—need to be transmitted [GELL82]. The screens are stored both in the mainframe and in the cluster controller. Integrity considerations require that information be checked for accuracy at the destination node. If the received information passes tests, an acknowledgment is transmitted to the source node. Otherwise, a negative acknowledgment is sent requiring retransmission. After a timeout period, information is automatically retransmitted unless acknowledgment has been received at the source node. SNA divides information in fixed-length frames, called basic link units (BLUs) in both directions prior to transmission. Each frame must pass an accuracy test at the destination, but the test results need not be acknowledged separately. The messages are assembled into frames, using the INSEG parameter. The number of frames accumulated between each acknowledgment is determined by the parameter MAXIN for inbound traffic.

In order to increase economy of host-to-host and host-to-personal computer transmissions, artificial intelligence based data compression techniques may be used. SoftCram/Net from Dynatech is an example of this class of product. The knowledge bases resident in the software are used for compressing various types of data. The decision maker decides which knowledge base has to be used on a given block of data, eliminating memory- and time-intensive tables used in other data compression algorithms. Multiple knowledge bases offer great flexibility. The other part of the software on the receiving side decompresses the data and restores it to the original form with 100% integrity. First measurement results show savings in the data transmission load of 40% and 90%.

Some SNA protocols require that the cluster controller handle all messages for one device before handling messages for another device. If, for example, one terminal is receiving a full-screen message over a 9600-bit/s line, other devices must wait for the send or receive up to about 3 s. Sometimes the acknowledgments required cannot be sent by the destination device because outbound traffic is privileged. The cluster controller must then wait until the inbound polling sequence allows the response. This fact is very frustrating because the outgoing traffic must wait for the response, experiencing a delay. After transmitting all frames, the customer has the complete response on the terminal, but the device remains locked, unable to continue with the work. Service-level agreements should take this fact into consideration.

Two techniques may help in avoiding this type of delay. The first choice piggybacks the end bracket indicator on the last PIU in a chain, not in a separate PIU. The second alternative suggests using exception response instead of definite response. The only time that definite response should be used is when the application (e.g., IMS or CICS) communicates with an intelligent device. However, the use of exception response limits the scope of measurement devices, such as NPM, NPA, and Mazdamon (see Chapter 4 for details).

Modems are responsible at each end of the link for transforming digital information into analog signals for transmission. Performance characteristics include speed, propagation delay, and turnaround time for half-duplex operation. In particular, short messages are very sensitive against propagation delay. After outages, an additional delay in the form of retraining time should be considered. Many state-of-the-art modems accomplish additional work for multiplexing, compressing, and converting information. Using these options, link loads can be lightened, but contributions to the response time can no longer be neglected.

Telecommunication Links transmit information among communicating nodes. The speed is important as in the case of modems. For transmitting, a complete 6250-bit/in. tape takes 36 h via 9600-bit/s line, 6 h via 56-kbit/s, and 15 min via satellite links. But the quality of the line is equally important. Deteriorating quality causes a large number of retransmissions, introducing unnecessary overhead. Thus, not only the messages under retransmission but all other messages are delayed. The link is usually able to handle both inbound and outbound traffic simultaneously; however, there are interactions between inbound and outbound traffic. One example is polling, which operates asynchronously on the full-duplex line. Polling messages interfere with normal outbound messages on the same link, increasing the load significantly. A further example indicates the overlap of normal inbound or outbound traffic with the acknowledgment required by SNA protocols. Dealing with parameters requires careful consideration. Otherwise, significant delays in response time may be caused by the telecommunication links.

Other functions of SNA must be comprehended completely in order to fully understand the causes of poor response times and the ways in which to

improve them. The effective bits per second of a transmission group (TG) are often misinterpreted. An NCP transmission group consists of one or more lines between two 37X5 nodes that logically appear to be on the line. The standard method of computing the data rate for a TG is to take the sum of all line speeds. While this is a valid way of measuring line throughput, the effective rate of a single message can be as slow as the slowest line in the TG. This is because the NCP does not transmit a single PIU (path information unit) over multiple TG links. Instead, it selects one link and transmits the entire PIU over that link. Thus, when computing response times, the slowest line in a TG should be used for conservative computations, not the sum of all line speeds. One could use a weighted average speed for more liberal computations.

37X5 Communication Controller most frequently accommodates the NCP. NCP controls a number of cluster controllers and repackages the messages for transmission at high speed to the mainframe computer. NCP can transmit a number of inbound messages in a batch to VTAM, offloading VTAM but introducing additional delay for the response time. When not enough buffers are available, NCP must slow down in order to free buffers. In slowdown periods, no traffic can be handled by the NCP. The choice of buffer sizes can improve the storage use, but the buffer sizes should be adapted to those of the cluster controller accommodating 256-bytes line buffers. The NCP buffer size should, therefore, map well into 256.

It is critical to understand that the 37X5 as implemented by ACF/NCP is a store-and-forward device. Before a host can begin sending a message to the next node in a path, it must have received the entire message from the previous node in the path. A series of 37X5 devices each connected by 56-kbps links do not act as a single 56 kbps link but as several separate 56 kbps links. The result is that the effective throughput from the first host in the path to the last can be much lower than the 56 kbps required to free the keyboard. Over a large network of 37X5, this can cause significant delays. For example, if two 56 kbps links run between three host nodes, a message must be received in its entirety by one 37X5 before being transmitted to the next 37X5. The end result is that the effective line speed is cut in half. In this case, the effective speed is 28 kbps. This may not be serious in a small network, but consider the case of a network that has nine NCP nodes and, hence, eight 56 kbps lines. The effective line speed from the first to the last 37X5 would be 56 kbps divided by 8, or only 7 kbps. This could be the difference between getting a 3-second response time and a 5-second response time. Other factors often overlooked in a small network that become significant in a large network include:

- 37X5 turnaround time. A rule of thumb is that the processing time for a low-use 3705 and 3725 is 0.05 seconds. Over a network with nine 37X5 nodes, the total backbone processing time could approach 0.45 seconds for each message transmitted. High-traffic 37X5 nodes can cause an

even higher turnaround time by being prone to buffer congestion or slowdown.

- Time spent while waiting for a line to become available for transmitting data. Not only would the amount of time be magnified in a large network, but long waits would also be more likely to occur where there are greater numbers of nodes and components competing for network and more nodes through which the data can travel.

- The time that an NCP spends waiting to send data. This time could be because the line is busy sending other data, for example, or for any other reason that might cause an NCP to wait before it can transmit data. This can range from as low as 0.1 second to several seconds, but will be magnified at each hop on the network. This amount of time is generally not critical in a small network, but it is magnified in a large network similar to the way that 37X5 turnaround time can have an impact on response time.

Using the parameter MAXDATA, PIUs can be segmented in BLUs or messages into link frames. There is an optimum value on MAXDATA for each environment [THAR84]. For improving response characteristics, the MAXOUT parameter can be of great assistance. MAXOUT determines the number of outbound frames for which acknowledgment could be outstanding at any time. But no additional outbound frames will be sent until an acknowledgment is received. For transmitting this acknowledgment, the polling process should reach the cluster controller under consideration. If outbound messages are privileged, as stated earlier, significant delays may be introduced.

For accomplishing properly balanced service toward all cluster controllers, the PASSLIM parameter may be used. PASSLIM limits the number of outbound frames transmitted to a cluster controller each time its address is found in the service order table. An additional tuning alternative is available under SNA, because the address entries are customer-specified. Multiple entries may help to maintain dynamically the service level for busy cluster controllers. The drawback is the increase in inbound polling frequency [BUZE83].

As stated earlier, outbound traffic is much heavier than inbound traffic, but polling-cluster controllers mean additional outbound traffic. The frequency of polling needs careful consideration. The number of negative polls may indicate the volume of inbound traffic. Low numbers suggest light traffic and indicate the need to pause prior to starting a new polling sequence. Thus, loads can be substantially reduced. The SNA parameter PAUSE assists in achieving good balance. If the inbound scan time is lower than PAUSE, an appropriate delay is automatically introduced. Thus, PAUSE controls the frequency of polling for inbound traffic, significantly reducing the outbound traffic imposed by polling.

In many communication networks, both central and remote communication processors (37X5, 3720, 3710) may be included. They are usually con-

nected to each other via high-speed trunks lines and do not contribute significantly to the response time. In addition, using module 128 (MAXOUT-127) for links between communication control processors helps in reducing transmission time, particularly for links with significant propagation delay.

But the effective transmission rate over trunk lines is often misinterpreted. Computing the data rate for a transmission group is to sum up the line speeds. The single message or transaction can be, however, as slow as the slowest line in the group. The reason is that NCP does not transmit a single PIU over multiple lines. Calculating the service time, individual line throughput has to be considered.

Communication control processors are basically store-and-forward devices. The entire message must be received before being sent to the next node in the network. Thus, the effective throughput rate may become much lower due to the chain of communication control processors, then calculated using link throughput rates. Using five nodes, the effective throughput rate becomes just 25% of the link throughput rate, a substantial increase in response time [BAUE86].

Channels connecting communication controllers with mainframes are, in most cases, high-speed channels, which do not contribute significantly to the response time. There are, however, cases where these channels are shared with other local devices, such as printers, and other controllers. If these are expected to be heavily utilized, communication controllers must be assigned the highest priority.

The Operating System is responsible for controlling all activities in the mainframe processor. Thus, it can significantly influence the overall performance and can contribute substantially to response time. Typical usual performance bottlenecks include:

- Unfavorable problem/supervisor ratio
- Excessive portion of CPU-WAIT for I/O
- Excess paging and swapping
- I/O contentions
- Lack of CPU and I/O overlap

Teleprocessing Monitors control the network from the view of application programs such as IMS, CICS, and TSO. As monitors, BTAM, TCAM, and VTAM are in use with strong migration toward VTAM. VTAM transfers the information between application subsystems and the SNA network. The most sensitive performance indicators are buffer sizes and the size of buffer pools. These parameters need intelligent consideration and continuous supervision. Information on VTAM storage use will help improve performance. The impacts of performance aids such as NetView, NCCF/NPDA, VNCA, NPM, and NLDM must not be overlooked. They are very helpful in recognizing and diagnosing network problems, but they introduce additional overhead

and delay, which is very sensitive under peak load conditions. Careful definitions of parameters and avoidance of tracing features help to keep overhead under control. Chaining may help improve average response time because of the possibility of concurrent transmission and processing [BAUE86].

Application Subsystems are responsible for the processing of customer work at the mainframe. Critical performance indicators may include number of transactions, complexity of each transaction characterized by data-base calls and processing demand, and simultaneous executability. Tuning efforts supposedly bring the most benefits in this area.

When value-added services are used, both connection establishment and disengagement phases, in other words the delay due to the dial-up protocol, have to be considered in addition.

When considering application subsystems efficiency, two facts may have an impact:

- **Relative inefficiency:** The application subsystem is not efficient enough in a given networking and/or hardware/software environment only (e.g., proper operating system not used, no balance in hardware resources, second-generation program for fourth-generation resources, etc.).
- **Absolute inefficiency:** The program leaves much to be desired in each environment.

Not all programs are, however, subject to optimization. The principal criteria for measuring, evaluating, and optimizing application subsystems are:

- Long execution or transmission time
- Frequency of runs
- Long life expectancy
- Large demand on system and networking resources
- Program size that allows the simultaneous run of application monitors

In certain cases it is not beneficial to optimize programs. These cases are:

- Before sytem redesign
- With nonsufficient documentation
- With vendor-supplied software (compilers, utilities, sorts, and so on)

Fundamentally, there are two techniques for optimizing application programs. Either the source code is evaluated and revised or the object code will automatically be made more efficient. In the first case, appropriate tools tell what actions must occur at the source level. Changes can be made automatically or manually, depending on the sophistication of the application and of the tools implemented. A program profile is an example for dynamically

evaluating the performance in a productive environment. Other techniques are tracing, simulation, and source analysis [FERR83]. In terms of source analysis, significant improvement may be achieved for applications within COBOL and FORTRAN.

In the second case, the nonoptimal object code is audited and automatically improved. Some optimizing compiler and commercially available tools may be implemented as postprocessors. In most cases, optimization consists of reducing the number of object instructions to be executed, whereby the host-related resource demand can substantially be reduced. But the best results can be achieved, without any doubt, by implementing performance engineering tools in early stages of application design, such as Workload Analyzer and Crystal (see Chapter 12 for details). Based on multiple tuning projects with SNA users, the following recommendations may be given to other users [BAUE86]. These recommendations may be considered a knowledge base of future expert systems supporting performance management.

Use of chaining

Clarification of the difference between chaining and segmenting is required first. Simply stated, chaining is implemented in the application node (for example, IMS-DC—Information Management System-Data Communications—or CICS) and it is the splitting of a data stream into multiple PIUs. Segmenting, on the other hand, is implemented in a boundary NCP node (the node that the DTE—data terminal equipment—is attached to), and it involves splitting up a PIU into smaller basic information units (BIUs). Data are sent between NCP nodes exactly as received. If an NCP received a 4-kbyte PIU, it sends a 4-kbyte PIU to the adjacent NCP. Data are not changed within an NCP transmission group; they are sent out exactly as received.

By using chaining at the applications level, it is possible to obtain a large degree of concurrent processing. Consider the network previously described in which data traveled from the host to a 37X5, over eight links through other 37X5s and 37X5s, and finally to a remote 3274. Assume that CICS or IMS (Information Management System) sends a message 1536 bytes long to a terminal node. Each 37X5 along the route must receive the full 1536 bytes before it can send the data to the next node. The SNA network in this case is strictly store and forward. Compare this to an example in which CICS sends six messages, each being 256 bytes in length instead of one large message to VTAM. Upon receipt of the smaller data, VTAM can send it to the 37X5 network. CICS then continues to send the other five messages in the chain. When the 37X5 receives the first 256-byte message, it can immediately send it to the next NCP or host in the route. The end result is six simultaneous independent messages routed through the network instead of one large message. This technique is similar to one used in X.25 networks that sets packet sizes to a fixed value, such as 128 bytes.

There are two ways to force an application to use chaining:

1. In applications that do not predefine terminal nodes, such as TSO (time sharing option), the modetab table sets the groundrules for transmission, telling the end points what protocol and what size data to expect. The request unit size determines the maximum message size and the point at which chaining takes place.

2. In applications that predefine terminals, such as CICS or IMS, it is often necessary to modify and assemble a table. In CICS, for example, the predefined TCT (terminal control table) buffer is equivalent to the modetab Rusize (request unit size) parameter.

Use of chaining improved transmission time in networks by over 30%. The more intermediate routing nodes on a network, the more chaining data will help. Chaining is recommended for LU 1, LU 2, and LU 3 devices. The LU 6.2's use of chaining is essentially the same as that of the LU 2.

Most emphasis has been placed on data sent from the host to the terminal LU because there is little flexibility in changing the transmission characteristics of 3270 cluster devices. In addition, incoming messages are usually much smaller than outgoing messages. As a result, there is a much greater chance for improving transmission of outgoing messages.

Use exceptional response instead of definite response

When definite response is used, the workstation keyboards are not freed until all responses are received at the 3274, and in the case of CICS, transactions will not end until the responses are received by the application. This will cause unnecessary traffic in the network and may adversely affect the application's operation or storage, potentially causing network degradation. The use of definite response would cause most problems under the following circumstances:

1. When a line has high traffic. Consider a high-traffic line where the Primary LU (PLU is the application LU) sends a message to a terminal requesting definite response. If, before the 3274 is ready to respond, the PLU sends data to another LU on the line, the definite response must wait at the 3274 until the line is free before it can send the positive response acknowledging receipt. Thus, even though the size of a response from a terminal may be very small, it cannot be sent until the line is free. In this case, a high-traffic line could cause lengthy delays.

2. When the network is very large and there are many intermediate nodes over which a response must be sent. As was discussed, there are many pause and delay values (as well as line and mainframe congestion problems) that could cause a small message or response to take a relatively long time to transmit.

Use of exceptional response instead of definite response does not decrease network integrity because the design of SNA ensures that messages are routed properly and that the application will be notified of a failure to send the message. In a CICS configuration, for example, when a transaction program issues a SEND command, CICS will sometimes send the data after the transaction ends. If the message cannot be transmitted properly, CICS will be notified, but the transaction will not be notified because, in most cases, it will already have ended. The only time that definite-response mode should be used is if the application communicates with an intelligent, programmable device. CICS uses exception response as the default for transactions running on 3270 devices and allows transactions to run in definite-response mode through use of the PCT optgrp (processing control table option group) on the transaction entry.

Send end bracket indicator on the last PIU in a chain, not in a separate PIU

Bracket protocol is used in LU-to-LU sessions to set up rules about who can transmit data and when. In a typical transaction, the following scenario often occurs:

The user keys in data and hits the ENTER or CARRIAGE RETURN key to transmit the data. The 3274 locks the terminal keyboard and transmits the data to the host with the begin bracket (BB) indicator turned on. The host receives, processes, and returns the data to the terminal. Since the application will send more data, it cannot end the bracket immediately, for it is a protocol violation to send data after a bracket is ended. When the transaction ends, the application can assume that there are no more data destined for the terminal and will send the EB indicator to the terminal in a separate PIU. Upon receipt of the EB, the 3274 frees the keyboard, which allows the operator to enter more data.

As in the last example, where exceptional response was used in lieu of definite response, the amount of time it takes the application to send the EB on a highly used line or in a large network with many intermediate nodes can be significant. Since the indicator most often used to measure response time is when the keyboard is freed, the response time can be significantly improved by sending the EB, thus freeing the keyboard, with the PIU containing the last data sent. Fortunately, the design of SNA allows piggybacking, but the application program must use it properly.

CICS is designed to send the EB with the last data PIU as the default. The PCT MFGPOPT (one option task facilities operand) ensures that the EB is sent with the first data SEND command, thus freeing the keyboard. Other applications, however, may require table changes or code modifications to implement this function.

Since the operands necessary to piggyback the EB to the data PIU are relatively easy to implement, it is wise to implement it in all cases—not just for highly utilized lines or large networks.

Set the right priorities for interactive traffic

This is done in two ways:

1. Boundary NCP nodes should define printers or batch LUs as batch = yes. At the NCP to which the device is attached, the batch operand on the LU macro specifies the relative priorities a device should have. By specifying batch = no, an LU will get more priority than a LU defined as batch = yes. Therefore, interactive devices, such as terminals, should be defined as batch = no, while batch devices, such as printers or remote job entry stations, should be defined as batch = yes.
2. For intermediate routing nodes we can assign transmission priorities by giving a class of service name, which is implemented through the COS name (class of service name) parameter of the log-on mode table. This can allow messages on the network to take different paths between the same two points, with some being more efficient and speedy. Many installations assign priorities correctly at the boundary node, but fail to do so for intermediate nodes (e.g., 37X5 links) in the network.

Use Modulo 128

Use Modulo 128 for links between 37X5 nodes, especially those using satellites where turnaround is slow due to propagation delay. This is done by setting maxout= 127 (maximum number of messages sent out) on the PU (physical unit) macro defining remote 3705s and 3725s.

Use SCS (LU type 1) mode

SCS (LU type 1) mode should be used instead of DSC for LU type 3 mode for printers whenever possible. SCS devices use exceptional response and can achieve a degree of synchronous processing, printing data while additional data are being transmitted to the device through the use of NCP pacing. This often allows the printer to operate continuously without stopping to wait for data to be transmitted. DSC devices, on the other hand, use a definite response to acknowledge receipt of the data. This means that after data are transmitted, the application will not send more data until the LU acknowledges receipt of the previous PIU. This usually requires a delay in which the printer had finished processing the first message and is waiting until more data are transmitted. It is not unusual for printers to double their print speed simply by switching from DSC to SCS mode. In addition, devices

switched through software to SCS mode offer a greater range of functions than DSC devices. SCS mode is implemented through Logmode modetab parameters or table entries in applications that predefine terminal nodes.

Use data compression techniques within application programs

Modern communications subsystems, such as CICS or IMS, use screen development productivity aids that free the programmer from needing to know device-dependent characteristics. However, efficiently written programs are often inefficient in their use of network resources. There are often many spaces or binary values embedded in the data stream. A good way to remove these characters is to use a data compression package. These packages usually run as program exits and make data streams more efficient. This saves both transmission time and buffer space in all nodes because the message sizes are smaller. Savings realized by the installation of data compression packages are usually 10% to 40% of message size. There are a variety of data compression packages available for both CICS and IMS. The price is often less than the cost that is required to develop one in-house.

Some of the newest data compression packages claim to achieve 60% reduction in data characters transmitted. By using such techniques as careful manipulation of 3270 modified data tags, they can compress both inbound and outbound data.

Topological design

In terms of topology, there are two major recommendations:

1. The number of intermediate routing nodes has to be kept to minimum in order to avoid unnecessary delays in those nodes. Depending on the data center, there are circumstances where intermediate nodes cannot be avoided.
2. Channel-attached control units will guarantee better performance. Fiber-based channel extenders, or even local area networks, may be considered for significantly improving response time.

Select RU-size

The request unit (RU) size has a significant impact, whether LUs are able to monopolize PUs. Depending on the nature of applications, small RU sizes have to be selected for interactive applications and large sizes for file transfer-oriented functions.

Selection of PASSLIM and MAXOUT

Both parameters have to be selected very carefully. Operations indicate that PASSLIM must not be greater than MAXOUT; otherwise, significant

delays may occur during serving all physical units on the same communication link.

Construct service order tables for PU4 and PU2

The entries into the service order tables determine the sequence of service to a particular PU2 and LU. The frequency of entry controls the actual service level for a particular application or user. Fluctuating load or traffic rates may be balanced by the number of entries.

IBM has been trying to dynamically control and change key SNA parameters. Assuming continuous service-level surveillance, parameters may be reset dynamically for optimizing overall performance. The first results are summarized for flow control in [CHOU89].

9.4.5 Use of Modeling Instruments for Optimizing Performance

The use of personal computers emulating SNA terminals and control units may impact the overall performance in the network segment under consideration. In order to avoid performance bottlenecks, two types of monopolization need to be eliminated.

First, the PC/logical unit should not be allowed to monopolize its physical unit to the extent that other logical units sharing that control unit suffer degraded service. Second, the PC/physical unit should not be allowed to monopolize the resources of the transmission link to the extent that other physical units sharing the resources of that link suffer degraded service. Fortunately, SNA permits the control of data to both logical units and physical units through a number of data-flow parameters, such as RUSIZE, chaining, segmentation, MAXDATA, entries in the Service Order Table, PASSLIM, MAXOUT, and partially MAXIN.

The following case study is based on [MCDO84]. For modeling purposes, Best/Net from BGS was implemented. Throughout the case study, "what-if" considerations are addressed. The benefit of using models instead of real experiences is the speed of answers and the noninterruption of operations.

Modeling the PC as a 3270 terminal

Figure 9.4.2 shows the response time experienced by users before PCs are added to the network. The values shown here represent total end-to-end response time including bid-to-poll, link and modem transmission delays, cluster control unit delays, front-end time, and host and I/O time. (A fixed delay has been chosen to be used in the host rather than model host time—1390 msec for CICS workloads and 1300 msec for TSO workloads.)

Figure 9.4.3 shows the effect of adding PCs emulating 3270 terminals (attached by coax) to two major clusters. These PC workloads are defined to

LINE	CLUSTER	WORKLOAD	SYS RESP (SEC)	THROUGHPUT (ARR/HR)	% UTILIZATION IN	OUT
MIDWEST	AVG/TOT		2.77	1200.0	11.5	28.9
	CHI	AVG/TOT	2.76	600.0	5.7	14.4
		CICS	2.84	400.0		
		TSO	2.61	200.0		
	MSP	AVG/TOT	2.78	600.0	5.7	14.4
		CICS	2.85	400.0		
		TSO	2.52	200.0		

Figure 9.4.2 Basis results.

PC OUTBOUND MSG SIZE = 380BYTES
PC TOTAL ARRIVAL RATE = 1200/HR
PASSLIM = 7

LINE	CLUSTER	WORKLOAD	SYS RESP (SEC)	THROUGHPUT (ARR/HR)	% UTILIZATION IN	OUT
MIDWEST	AVG/TOT		3.14	2400.0	14.6	49.3
	CHI	AVG/TOT	3.13	1200.0	7.3	24.7
		CICS	3.28	400.0		
		TSO	3.05	200.0		
		PC	3.05	600.0		
	MSP	AVG/TOT	3.14	1200.0	7.3	24.7
		CICS	3.30	400.0		
		TSO	3.07	200.0		
		PC	3.07	600.0		

Figure 9.4.3 PCs emulating 3270 terminals.

be the same interactive TSO work as the other terminals on the line. Consequently, the performance impact is identical to adding other 3270 terminals to the control unit and shows only a marginal increase in response time.

It is useful to further explore what will happen to performance if the PCs are all allowed to emulate multiple logical units. It now appears to the network that three logical units have been added for every PC, tripling the arrival rate from 1200/HR to 3600/HR. By re-running the model with this increased message rate, one can see a more dramatic effect on performance, as illustrated by the response times in Figure 9.4.4.

One can now discover what will happen to performance if a PC attempts to download a large file while emulating a 3270 terminal. As mentioned before, the PC will receive the file in message sizes of approximately 2K, the maximum chain element size for the terminal emulator. Figure 9.4.5 shows the effect that this increased outbound message size will have on system response time.

Chaining would be an effective way to improve performance for the

LINE	CLUSTER	WORKLOAD	SYS RESP (SEC)	THROUGHPUT (ARR/HR)	% UTILIZATION IN	OUT
				PC OUTBOUND MSG SIZE = 380BYTES		
				PC TOTAL ARRIVAL RATE = 3600/HR		
				PASSLIM = 7		
MIDWEST	AVG/TOT		5.29	4800.0	21.2	68.4
	CHI	AVG/TOT	5.38	2400.0	10.6	34.2
		CICS	5.58	400.0		
		TSO	5.35	200.0		
		PC	5.34	1800.0		
	MSP	AVG/TOT	5.40	2400.0	10.6	34.2
		CICS	5.60	400.0		
		TSO	5.37	200.0		
		PC	5.37	1800.0		

Figure 9.4.4 PCs emulating multiple logical units.

LINE	CLUSTER	WORKLOAD	SYS RESP (SEC)	THROUGHPUT (ARR/HR)	% UTILIZATION IN	OUT
				PC OUTBOUND MSG SIZE = 2K		
				PC TOTAL ARRIVAL RATE = 600/HR		
				PASSLIM = 7		
MIDWEST	AVG/TOT		5.69	1800.0	9.0	70.1
	CHI	AVG/TOT	5.68	900.0	4.5	35.1
		CICS	5.12	400.0		
		TSO	4.89	200.0		
		PC2K	6.94	300.0		
	MSP	AVG/TOT	5.70	900.0	4.5	35.1
		CICS	5.14	400.0		
		TSO	4.91	200.0		
		PC2K	6.97	300.0		

Figure 9.4.5 Increase of outbound message sizes.

other users. This would be accomplished reducing the value of RUSIZEs so that the PC file transfer message would be broken into chain elements.

Modeling the PC as a 3274 control unit

Figure 9.4.6 illustrates the network performance implications of adding a PC emulating a 3274 control unit. (The workload and arrival rates are the same as those used in Figures 9.4.2 and 9.4.3).

In Figure 9.4.7 we further explore what happens when the PC/3274 transfers large files. Our workload changes to an outbound message size of 2K, the usual maximum chain element size for 3274 emulation. By changing the PASSLIM value of the PC/3274, its performance impact can be limited when in file transfer mode. In Figure 9.4.8, the PC's PASSLIM value is

			SYS RESP	THROUGHPUT	% UTILIZATION	
LINE	CLUSTER	WORKLOAD	(SEC)	(ARR/HR)	IN	OUT
				PC OUTBOUND MSG SIZE = 380BYTES		
				PC TOTAL ARRIVAL RATE = 1200/HR		
				PASSLIM = 7		
MIDWEST	AVG/TOT		3.20	2400.0	14.7	49.4
	CHI	AVG/TOT	3.22	600.0	4.4	13.1
		CICS	3.30	400.0		
		TSO	3.07	200.0	,	
	MSP	AVG/TOT	3.25	600.0	4.4	13.1
		CICS	3.33	400.0		
		TSO	3.10	200.0		
	PC3274	AVG/TOT	3.17	1200.0	5.8	23.2
		PC	3.17	1200.0		

Figure 9.4.6 PCs emulating control units.

			SYS RESP	THROUGHPUT	% UTILIZATION	
LINE	CLUSTER	WORKLOAD	(SEC)	(ARR/HR)	IN	OUT
				PC OUTBOUND MSG SIZE = 2K		
				PC TOTAL ARRIVAL RATE = 600/HR		
				PASSLIM = 7		
MIDWEST	AVG/TOT		8.08	1800.0	9.0	68.4
	CHI	AVG/TOT	5.48	600.0	3.7	12.4
		CICS	5.55	400.0		
		TSO	5.33	200.0		
	MSP	AVG/TOT	5.50	600.0	3.7	12.4
		CICS	5.68	400.0		
		TSO	5.45	200.0		
	PC3274	AVG/TOT	13.16	600.0	1.6	43.0
		PC2K	13.16	600.0		

Figure 9.4.7 Use of maximum chain element.

decreased to 2 while keeping the CHI and MSP PASSLIM values at 7. As a result, two control units (CHI and MSP) experience reduced response times.

Modeling the PC as a 3770 control unit

In Figure 9.4.9, the PC is configured as a 3770 control unit. The outbound message size in this case is 4K. Even at a message rate further reduced to 380 messages per hour, response time is at a crisis point. Figure 9.4.10 shows the result of changing the PASSLIM value of the PC/3770 to 2.

Figure 9.4.11 shows the effect of reducing the RUSIZEs to the PC/3770 while restoring PASSLIM to 7. If the RUSIZE is reduced to a maximum of

			PC OUTBOUND MSG SIZE = 2K			
			PC TOTAL ARRIVAL RATE = 600/HR			
			PASSLIM = 2			

LINE	CLUSTER	WORKLOAD	SYS RESP (SEC)	THROUGHPUT (ARR/HR)	% UTILIZATION IN	OUT
MIDWEST	AVG/TOT		9.7ı	1800.0	8.9	68.4
	CHI	AVG/TOT	4.34	600.0	3.7	12.4
		CICS	4.42	400.0		
		TSO	4.19	200.0		
	MSP	AVG/TOʻ	4.45	600.0	3.7	12.4
		CICS	4.53	400.0		
		TSO	4.30	200.0		
	PC3274	AVG/TOT	23.52	600.0	1.6	43.0
		PC2K	20.52	600.0		

Figure 9.4.8 Changing PASSLIM.

			PC OUTBOUND MSG SIZE = 4K			
			PC TOTAL ARRIVAL RATE = 380/HR			
			PASSLIM = 7			

LINE	CLUSTER	WORKLOAD	SYS RESP (SEC)	THROUGHPUT (ARR/HR)	% UTILIZATION IN	OUT
MIDWEST	AVG/TOT		10.81	1570.0	8.2	75.5
	CHI	AVG/TOT	6.54	600.0	3.7	12.4
		CICS	6.72	400.0		
		TSO	6.49	200.0		
	MSP	AVG/TOT	6.80	600.0	3.7	12.4
		CICS	6.87	400.0		
		TSO	6.65	200.0		
	PC3274	AVG/TOT	24.06	600.0	0.8	50.8
		PC2K	24.06	600.0		

Figure 9.4.9 PCs emulating 3770 control units.

1K, an improvement in response time to other users on the line can be seen. Finally, by reducing the PASSLIM value of the PC/3770 to 2 the response times in CHI and MSP are further decreased (see Figure 9.4.12).

PCs have been introduced into the SNA network environment, performance scenarios have been presented and various solutions have been modeled. Although the PC plays a problematic role in this case, it should be noted that local processing is not without its benefits to network performance. Although the PC has the potential to degrade service when downloading a large file, it also has the ability to stand alone. The network-performance manager should take into account the number of transactions the PC user is able to perform locally instead of interactively through the network. He or she should

			PC OUTBOUND MSG SIZE = 4K PC TOTAL ARRIVAL RATE = 380/HR PASSLIM = 2			
LINE	CLUSTER	WORKLOAD	SYS RESP (SEC)	THROUGHPUT (ARR/HR)	% UTILIZATION IN	OUT
MIDWEST	AVG/TOT		14.18	1570.0	8.0	75.5
	CHI	AVG/TOT CICS TSO	5.43 5.50 5.27	600.0 400.0 200.0	3.6	12.3
	MSP	AVG/TOT CICS TSO	5.58 5.65 5.43	600.0 400.0 200.0	3.6	12.3
	PC3770	AVG/TOT PC4K	42.15 42.15	370.0 370.0	0.8	50.9

Figure 9.4.10 Impact of PASSLIM.

			PC OUTBOUND MSG SIZE = 1K PC TOTAL ARRIVAL RATE = 1300/HR PASSLIM = 7			
LINE	CLUSTER	WORKLOAD	SYS RESP (SEC)	THROUGHPUT (ARR/HR)	% UTILIZATION IN	OUT
MIDWEST	AVG/TOT		9.18	2500.0	8.6	68.8
	CHI	AVG/TOT CICS TSO	6.39 6.47 6.24	600.0 400.0 200.0	3.7	12.4
	MSP	AVG/TOT CICS TSO	6.53 6.61 6.38	600.0 400.0 200.0	3.7	12.4
	PC3770	AVG/TOT PC1K	11.70 11.70	1300.0 1300.0	1.1	44.0

Figure 9.4.11 Impact of RUSIZEs.

also consider the positive impact of reduced cycle utilization on the mainframe processor. These benefits can best be realized when PC users communicate with network-performance managers in order to avoid unnecessary performance crises.

9.5 HUMAN RESOURCES DEMAND OF PERFORMANCE MANAGEMENT

The third critical success factor of network management is human resources. The functions discussed thus far should be adopted to the present organization from within the information systems department first. Based on the

			SYS RESP	THROUGHPUT	% UTILIZATION	
LINE	CLUSTER	WORKLOAD	(SEC)	(ARR/HR)	IN	OUT
MIDWEST	AVG/TOT		13.83	2500.0	8.5	68.7
	CHI	AVG/TOT	5.26	600.0	3.7	12.4
		CICS	5.34	400.0		
		TSO	5.11	200.0		
	MSP	AVG/TOT	5.39	600.0	3.7	12.4
		CICS	5.47	400.0		
		TSO	5.24	200.0		
	PC3770	AVG/TOT	21.67	1300.0	1.1	43.9
		PC1K	21.67	1300.0		

PC OUTBOUND MSG SIZE = 1K
PC TOTAL ARRIVAL RATE = 1300/HR
PASSLIM = 2

Figure 9.4.12 Response-time reduction.

functions, processes, and procedures outlined, the targets of organizational change can be determined. Table 9.5.1 summarizes the relationship of potential organizational units to the key functions of performance management. The indicators in this table constitute one of the following: execution of duties, or supportive or advising type of involvement. The same table may be used as a starting point for estimating the range of labor demand for managing performance.

Performance management is usually staffed by three different types of personnel:

- Performance analyst
- Data-base coordinator
- Modeling coordinator

Table 9.5.2 shows the distribution of functions among these people. In order to limit the alternatives for a tool's selection, Table 9.5.3 gives an overview of instrument classes under consideration for fault management and of their potential users in the fault management hierarchy.

For estimating the demand in FTEs (full-time equivalents), Table 9.5.4 provides the quantification for the four major customer clusters introduced and defined in Chapter 1. The numbers represent averages, and are based on the results of many surveys and interviews personally conducted by the author of this book.

In order to help with hiring and building the fault management team, Tables 9.5.5 to 9.5.8 give a typical profile for each performance management staff member, including the supervisor of the group.

And finally, the function/skill matrix shown in Table 9.5.9 gives an

TABLE 9.5.1: Involvement of Performance Management.

Functions	Other Subsystems					Network capacity planning	Level of possible automation
	Configuration management	Fault management	Performance management	Security management	Accounting management		
Definition of performance indicators		S	E	S		S	low
Performance monitoring	A	S	E		S	A	high
Thresholding and exceptional reporting			E			S	medium
Analysis and tuning	S	S	E			S	low
Establishing operational standards		S	E	A			low

E = Executing
S = Supporting
A = Advising

Functions		Organization		
	Supervisor	Network-Performance Analyst	Data-Base Coordinator	Modeling Coordinator
Definition of performance indicators	X			(X)
Performance monitoring			X	X
Thresholding and exceptional reporting	X		X	
Analysis and tuning		X		(X)
Establishing operational standards		X		

X = Commitment
(X) = Involvement

TABLE 9.5.3: Tool-Applicability Matrix by Personnel.

Tools		Organization		
	Supervisor	Network-Performance Analyst	Data-Base Coordinator	Modeling Coordinator
Monitors in network elements				
Application monitors		X	X	
Software monitors		X	X	
Modem and DSU/ CSU monitors		X	X	
Multiplexer monitors		X	X	
Switch monitors		X	X	
Line monitors		X	X	
Network monitors		X	X	
PBX monitors		X	X	
LAN/MAN monitors		X	X	
Network element management systems				
Voice orientation	X	X		X
Data orientation	X	X		X
Console management systems		X		
Integrators	X	X	X	
Computerized cable management systems				
Automated call distributors				
General-purpose data bases			X	
Special administration products		X	X	
Networking models	X			X

X = Recommended use

TABLE 9.5.4: Personnel Requirements for Performance Management.

Organization	Network Range (Number of elements)			
	Small <3000	Medium 3000–10,000	Large 10,000–50,000	Very Large >50,000
Supervisor	1	1	1	1
Performance Analyst	2	3	6	10
Network Management Data-base Coordinator	1	2	3	4
Modeling Coordinator		1	1	2
Human resources demand				
Total	4	7	11	17

Table 9.5.5: Profile of Performance-Management Supervisor.

Duties
1. Supervises setting objectives and time frames.
2. Assists network operational control in daily operations.
3. Decides about access authorization for the network-management data base.
4. Establishes educational program for staff.

External job contacts
1. Other supervisors within network management
2. Modeling coordinator
3. Network manager
4. Network operation

Qualifying experience and attributes
1. Excellent knowledge of communication networks
2. Skill in using different kinds of instruments
3. Understanding of expert systems
4. Training in administrative management

TABLE 9.5.6: Profile of Network-Performance Analyst.

Duties
1. Accomplishes tuning tasks
2. Executes special measurements.
3. Designs and tests catalogued procedures.
4. Defines performance indicators.
5. Selects network-performance-oriented instruments.
6. Executes simple feasibility evaluations.
7. Tailors expert systems.
8. Supports access methods to customers.
9. Analyzes system and network trends.
10. Modifies thresholds and filters of network-management hardware and software.
11. Assists in third level of problem determination

External job contacts
1. Network-management data-base coordinator
2. Vendors of measurement devices
3. Service coordinator
4. Modeling coordinator
5. Network operator

Qualifying experience and attributes
1. Thorough technical know-how of
 Access methods
 Performance impacts from parameters
 Networking components
2. Creativity
3. Patience in pursuing problems
4. Detailed knowledge of instruments
5. Understanding of expert systems

TABLE 9.5.7: Profile of Network Performance
Data-Base Coordinator.

Duties

1. Maintains the data base.
2. Selects the data-base product.
3. Decides on data-base content and resolution.
4. Selects information sources.

External job contacts

1. Network-performance analyst
2. Modeling coordinator
3. Service coordinator
4. Vendors for measurement devices and data bases

Qualifying experience and attributes

1. Thorough technical knowledge of
 Data-base design
 Data-base maintenance
2. Communication skills
3. Creativity for ad hoc problems
4. Understanding expert systems

TABLE 9.5.8: Profile of Modeling Coordinator.

Duties

1. Builds baseline models.
2. Verifies WAN, MAN, and LAN models.
3. Validates WAN, MAN, and LAN models.
4. Interprets modeling results.
5. Prepares input data.
6. Conducts performance testing.
7. Conducts pilot tests.
8. Evaluates ability of existing network configuration to meet current needs.

External job contacts

1. Modeling administrators
2. Network performance analyst
3. Service coordinator
4. Vendors of modeling and emulation instruments
5. Application-systems developers
6. Advanced technology analyst

Qualifying experience and attributes

1. Understand how models and emulator work
2. Communication skills for getting information on
 Application load volumes
 Resource demand on communication resources
3. Skills of project management

TABLE 9.5.9: Responsibility/Skill Matrix.

Functions	Skills					
	Special knowledge of function	General knowledge of communication facilities	In-depth knowledge of communication facilities	Some knowledge of business administration	Communication skills	Some knowledge of project management
Definition of performance indicators	X	X	X			
Performance monitoring	X	X	X			
Thresholding and exceptional reporting	X	X	X	X		
Analysis and tuning	X	X	X		X	X
Establishing operational standards	X	X	X		X	

X = Skill is requested by function

overview of the targeted skills levels for each individual fault management function.

9.6 SUMMARY

Practical recommendations for performance management include guidelines for *doing* certain things and for *avoiding* certain other activities. These guidelines are useful for both short- and long-range improvements in the area of performance management.

DO

- Process
 Use few indicators only
 Combine history and configuration data bases
- Products
 Use measurable indicators only
 Start with simple model
- People
 Set time frames and objectives for tuning
 Make performance data items and reports accessible to users

AVOID

- Process
 Writing statistical packages relevant to the company's specific situation
- Products
 Starting with sophisticated modeling instruments
 Too many paper-based reports
- People
 Simultaneously changing too many parameters

Security Management

Security management is a set of functions that ensure the ongoing protection of the network and its components in all aspects of security such as entering the network, accessing an application, transferring information in a network, protecting network-management tools by analyzing risks, minimizing risks, implementing a network security plan, and by monitoring success of the strategy. Special functions include the surveillance of security indicators, partitioning, password administration, and generating warning or alarm messages on violations.

Companies must establish security policies and guidelines for the use of computer and telecommunications resources and for safeguarding information while it is stored or processed by a system. The policy must also address misuse or theft of company telecommunications and computing equipment as well as the software, data, or documentation associated with it. Major security management activities help to:

- Minimize the possibility of intrusion by using a layered defense system (i.e., a combination of policies, and hardware and software solutions that build a uniform barrier to unauthorized users).
- Provide a means of quickly detecting unauthorized use and determining the original violation entry point. This should provide an audit trail of the violator's activity.
- Allow the network manager to manually reconstruct any damaged files or applications and restore the system to the state just prior to the

violation. This reconstruction feature helps to minimize damage and allows system recovery.

- Ultimately, allow the violators to be manually monitored and trapped by a network operations group, ending with a reprimand or prosecution.

10.1 INTRODUCTION, ISSUES, AND OBJECTIVES

The principal objectives of this chapter are:

- To discuss the major functions of security management
- To define the interrelationship of the functions
- To judge the applicability of smart cards and biometrics
- To determine information export and import with other network-management activities
- To summarize the implementation considerations including the human resources demand for supporting security management
- To construct a responsibility/skill matrix to help staff security management functions

In addition to the issues prevalent today (Chapter 1), more specific problems are seen in the security management area which may be characterized as follows:

- For most people involved in voice or data communication it is an unknown area; there are no violation indicators, techniques are considered complicated, responsibilities are not clearly assigned.
- There are no clear guidelines regarding what should be protected in a complex networking environment; whether applications, data bases, files, nodes, communication links, end-user devices, or a combination of all these need to be protected. Without an adequate sensitivity analysis, budgets cannot be properly assigned to any of these areas.
- Little awareness of who commits security violations and why; no or very few reports and records are available from organizations on this topic. The reasons are:
 — Violations are not detected by the network operations group.
 — They are detected but not reported because admitting to a violation may cause the public to have a lack of confidence in the company that owns and operates the network.
 — They are committed by legitimate users of the network that have found ways to access applications and data that they should not have the authority to access.
 The last reason may not even be considered a problem in some organizations. Indeed, the users may not believe they are committing a

security violation. They are simply using a password and log-on code that belongs to a co-worker or manager because it is convenient.

- Far more violations of computer systems security occur with company employees (approximately 75%) than outsiders (approximately 25%).
- Little acceptance of upcoming new techniques such as biometrics.
- Poor instrumentation lacking monitoring devices for facilities, LANs, and end-user devices. The majority of available solutions are protecting the host processor and its applications.
- Security management is considered overhead and treated with low priority, with a resulting insufficient budget. The issues and direction for each company may be characterized by Figure 10.1.1.

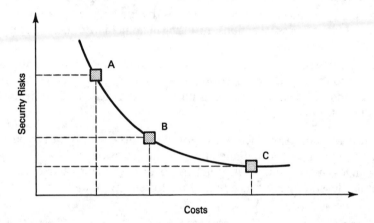

Security risks and costs are determined by the techniques implemented for logical and physical security.

Figure 10.1.1 Security risks and costs.

The graph illustrates three examples:

A. Low Costs—High Security Risk. A indicates the company's policy of not spending enough on security. This policy may be justified in cases where the impact of violations is very low

B. Moderate Costs—Moderate Security Risk. B indicates that the company is willing to spend for physical and logical protection, and the overall costs are still reasonable. This may be appropriate when there are only occasional security violations.

C. High Costs—Low Security Risk. C indicates the company (e.g., the military and government) cannot compromise on security violations. Very likely a combination of techniques and instruments are in use.

Depending on the impact of security violations, the companies can determine their appropriate location on the curve of Figure 10.1.1.

In summary, lack of security goals and instrumentation seems to be the principal stumbling block to improving security management efficiency.

The following sections will address the major processes, functions, and instruments of security management.

10.2 SECURITY MANAGEMENT PROCESSES AND PROCEDURES

A typical security management environment is shown in Figure 10.2.1. Three segments may be clearly differentiated:

- Segment of potential penetrators who violate both passively and actively
- Monitoring and surveillance functions that detect the violation and execute active or passive actions, resulting in immediate or delayed response to the penetrator
- Segment of security officers; this includes the definition of security indicators and their thresholds, issuing report generation guidelines, analyzing logs and reports, and deciding on the actions to be taken against the penetrator.

Violation detection includes capturing or accessing information about changes of user profiles, modifications of the hardware/software configuration, changes in access authorization, turnover in currently active users, and last but not least, any reference by anyone to sensitive data.

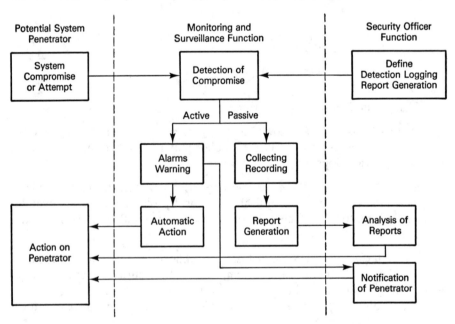

Figure 10.2.1 Monitoring and surveillance functions.

It is recommended to log at least the following events:

- All access denials
- All user log-ons and log-offs
- All violations of memory bounds or privileged instructions
- Any use of critical resources
- Any change of access control profiles
- Initialization of user-invoked network maintenance processes
- Network startups, downs, and restarts
- All transmissions involving sensitive data
- All passive penetration actions identified
- All active penetration actions identified
- All physical damages and threats of resources

Depending on the networking environment and strategic mission of the corporation, these events must be prioritized. Depending on the priorities, active or passive actions have to be invoked by the security officer.

Reports and reporting formats may be tailored to the special needs of the corporation. It is recommended to produce daily reports that allow the expedient identification of the source of attempted violations and the resources involved, and also aids in reconstructing the events leading to a potential isolation.

In order to successfully support security management, the following information is necessary:

- Primary demand
 Actual configuration
 Active and generated users
 Access authorization by users
 Security violation events in real time
 Security logs of all security-related events
 Change requests and executed changes about configuration, access authorization, and generated users
- Secondary demand
 Performance indicators
 Middle-range capacity plans
 New applications under development
 Business plans about acquisitions and mergers

10.3 SECURITY MANAGEMENT FUNCTIONS

Security management functions were identified in the introductory part of this chapter. In the following section, after defining the functions, typical processes, and structures, architectures and practical examples are given to de-

velop a better understanding of how the functions work and how they are interrelated.

10.3.1 Risk Analysis

Risk analysis is expected to be a continuous function with frequent updates. The objective is to keep ahead of hackers and security violators. Risk analysis has to include all relevant parts of a communication network. The major parts are:

- End-user
- End-user workstation
- Local area networks
- Metropolitan area networks
- Wide area networks
- Processing components, including operating systems, data bases, files, and applications

The most promising way is to construct a so-called threat matrix showing each part and its potential active and passive threats. Table 10.3.1 shows an example. Passive threats include:

- Listening to communication traffic for the purpose of identifying each communicating party. Such information gives the violator information about the nature and contents of messages.
- Listening to data traffic for the purpose of identifying passwords for future unauthorized use and for evaluating exchanged data.
- Analyzing traffic flows which enables the penetrator to gain information about volumes, directions, and time windows that may be vital information (e.g., for military intelligence and in the financial industry).

In most cases, passive threats may be avoided. On the other hand, active threats may cause more serious damage. They include:

- Repetition or delay of information transfer with the intention of confusing one of the communicating parties.
- Insertion or deletion of information segments during transmission resulting in false reactions on behalf of the receiver of the message.
- Congesting the transmission system by inserting too many information segments which may result in the prevention of useful data transmission.
- Modification of data (e.g., account numbers), which may cause serious damage on the receiver side, as they react to a completely false transmission.

- Using a false identity, which enables the intruder to access information he or she is not authorized to access. The result is the confusing reaction of authorized users.
- Damaging communication connections with the receiving party, which may cause confusion and serious business damage (e.g., changing electronic data: this change may be substantial and have disastrous consequences.

Practically speaking, active threats may be limited to a manageable minimum, but cannot be completely avoided. A third threat group includes random events which may cause serious damage. The first priority is to deal with false routing, which results in delivering information to the wrong destination. The second priority is to deal with faulty operations (e.g., deleting files before they are distributed or printing and distributing sensitive data by accident). More powerful communication software may avoid such instances.

10.3.2 Evaluation of Security Services

In order to avoid security violations, a number of security services are available. The services differ in terms of

- Sophistication
- Cost
- Implementation efforts
- Maintenance efforts
- Demand for human resources

There is no single service that can prevent all types of security violations. But careful selection of combined services may help guarantee an adequate solution for security management. Services are addressed here for all parts of the network previously mentioned [RULA87].

Authentication Check on Communication Partners. Using this service, the partners who are going to communicate with each other identify themselves prior to starting the communication establishment phase. It may mean persons and also applications.

There are two alternatives:

- Single authentication indicating that one communicating party checks on the identity of the other.
- Mutual authentication whereby both communicating parties check the identity of the other.

TABLE 10.3.1: Threat Matrix.

Threats	Passive			Active						Unintentional Operating Problems	
	Listening to user connection	Listening to data exchange	Traffic flow analysis	Repetition	Modify	Insert	False identity	Congest network	Deny communication	False routing	Faulty operation
End-user	H	M	L	H	H	H	H	H	H	—	M
End-user workstation	H	H	M	H	H	H	H	H	H	—	
Local area networks											
Cable	M	M	M	M	M	M	M	M	M	M	M
Fiber	L	L	L	L	L	L	M	M	M	M	M
Metropolitan area networks											
Cable	L	L	M	L	L	M	M	M	M	L	—
Fiber	L	L	L	L	L	L	M	M	M	L	—

Wide area networks										
Cable	H	H	H	H	H	M	H	M	—	—
Microwave	H	H	H	H	H	M	M	M	—	—
Fiber	L	L	L	L	L	M	L	M	—	—
Satellite	M	M	M	M	M	M	M	M	—	—
Processing components										
Operating systems	L	L	M	L	M	M	M	L	L	M
Data bases/files	L	L	M	M	M	M	M	L	—	H
Applications	M	M	H	H	H	H	H	L	—	H

H = High threat
M = Medium threat
L = Low threat

The authentication process may be repeated at random even during the active communication phase.

Authentication Check of the Data Sender. There must be a guarantee that the data sent are from an authorized source. This check cannot avoid duplication of data. The service is recommended only for a connectionless communication establishment. For connection-oriented communication, it is already a part of data security.

Access Control. Access control must guarantee that only authorized partners gain access to network partitions, such as LANs, MANs, and WANs, and to selected resources, such as operating systems, files, data bases, applications, and processing periphery.

Ensuring Data Privacy. This service protects data from being read by unauthorized parties. Privacy may relate to the connection, to special files, or even to selected fields of files.

Avoidance of Traffic Flow Analysis. This special service helps prevent unauthorized users from making conclusions based on an analysis of the pattern of communication traffic between different kinds of users. Traffic analysis protection must be considered for end-to-end encryption [COOP90]. The intent of traffic analysis protection is to mask the frequency, length, and origin destination patterns of the message traffic. If encryption were performed in the presentation layer, an analyst could determine which presentation, session, and transport entities could be associated with a particular traffic pattern. Performing encryption at the transport layer would limit the information association by not identifying higher-level entities. Additional protection can be provided by continually or randomly flooding the communication channel with dummy traffic. The price paid is lost channel efficiency.

Ensuring Data Integrity. Similar to link-level data communication protocols, this service offers protection against the deletion, change, insertion, and repetition of data segments or selected fields. As an option of this service, automated recovery may be invoked whereby people can request that requesting messages identified as disrupted can be retransmitted. Integrity may relate to the connection, to special files, or even to selected fields of files.

Sender and/or Receiver Acknowledgment. The sender/receiver receives a confirmation or acknowledgment that a certain amount of information has been sent/received. This service helps to avoid occasional debates about information exchanges not properly protocolled by either sender or receiver.

The next section will address generic solutions that support single or combined services.

10.3.3 Evaluation of Security Management Solutions

In order to constitute powerful services as addressed in the previous section, adequate solutions—a combination of tools and techniques—are required.

Encoding (Encryption). This technique can significantly safeguard the security of the transmission against passive security violations. Usually this technique is used in combination with others, such as preventing traffic flow analysis. Basically, there are two alternatives:

- Use of private keys, called the symmetric technique: one key is used for both sending and receiving parties. Whoever owns this key is able to encrypt and reconstruct. Thus, the key has to be kept private (Figure 10.3.1).
- Use of public keys, called the asymmetric technique: Two keys are used, one for encrypting and the second one to reconstruct on the receiver side. One key is little help to the penetrator; that is why one of the keys is publicly available. Usually, the key on the receiver side is private (Figure 10.3.2).

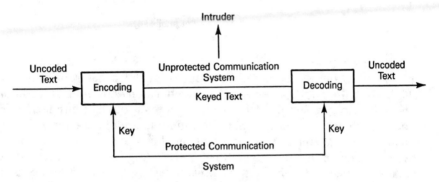

Figure 10.3.1 Use of private keys.

Basically, there are two levels of encryption: [RULA87]

- **Link encryption:** Link encryption means a separate encryption process for each node-to-node transmission link. Full text, including headers and routing information, can be encrypted on the links. This process involves only the first two OSI layers. At each intermediate node, decryption and reencryption take place, thereby exposing the information to some node processes.
- **End-to-end encryption:** This kind of encryption (including packet and datagram encryption) protects information from source to destination. This may be essential if the source node and/or the destination node require protection within intermediate nodes because of concern over proprietary or sensitive data exposure or because the intermediate nodes may have less robust security features than desired. End-to-end encryption is generally performed at the higher layers (e.g., the transport layer) so that address information necessary at intermediate nodes will not be packaged within the encrypted data. This usually requires software encryption. In case of misrouting, there will be no information compromise using end-to-end encryption.

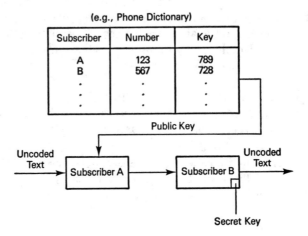

Figure 10.3.2 Use of public keys.

Digital Signature. In order to identify the sender beyond any reasonable doubt to the receiver, the technique of digital signature may be used. The basis is the public key method in combination with using an additional private key for preventing any unauthorized reads during transmission. The process is shown in Figure 10.3.3, indicating three different versions of the original text: the source (original) text, modified source text, and encoded text. The sender has to advise the receiver (e.g., special header of the modified source text) which of the private keys is to be used to reconstruct the document.

Hash Function. In order to reduce the computation needs of public key techniques, the hash function concentrates only on certain segments of the source message. Checksum is computed and added to the critical segment prior to transmission. It is partially impossible to find another message segment with exactly the same checksum. The same hash function will be used at the receiver to reconstruct the source message, as shown in Figure 10.3.4.

Authentication for Identifying Authorized or Unauthorized Users. As indicated earlier, communicating parties usually want to identify each other prior to establishing the communication connection. This technique checks on the validity of authorizations. Authentication may use attributes or behavioral characteristics.

The subjects are:

- Communicating parties, such as users, applications, processes, entities
- Communication and processing media corresponding to the parts of the network
- Messages representing data and information

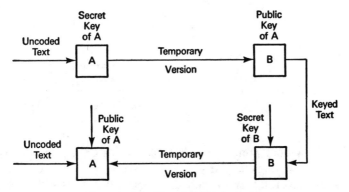

Figure 10.3.3 Use of digital signature.

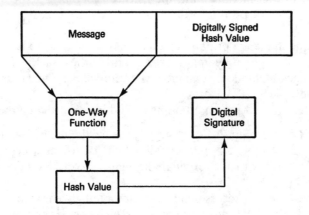

Figure 10.3.4 Use of the hash function.

The following alternatives may be differentiated:

- Simple authentication using passwords—the most widely used technique. If password is recognized as incorrect access, networking resources will be denied. Guidelines to password administration are:

 Difficult to guess; using exotic names or words with spelling errors may help in this respect.

 Easy to recall; taking the first letters of each word of a sentence seems to be a good solution.

 Inexpensive by limiting the length of the password. The following example helps to demonstrate how to determine the right length by displaying the number of combinations for a length between 2 and 8 characters

Number of characters	Number of combinations
2	936
3	33 696
4	1 213 056
5	43 670 016
6	1 572 120 576
7	56 596 340 736
8	2 037 468 266 496

Using random number generators, breaking the password is a very time-consuming exercise.

Unique over the supported user population to avoid confusion by double usage.

Protection is absolutely necessary; using encryption for storing and while in transmission limits the risks considerably.

No display or printout to prevent unauthorized parties from reading it.

Frequent change of password may further help to reduce the risk of being deciphered by unauthorized third parties.

Changes at random, unannounced intervals and when an employee leaves.

Successive bad log-on attempts should lock out the end-user device.

Use of Cryptography. Cryptography means the method and process of transforming intelligible text into an unintelligible form and reconverting the unintelligible form into the original through a reversal of the process of transformation.

The information process that transforms intelligible text to unintelligible text is known as enciphering or encryption. The reverse is known as deciphering or decryption.

An algorithm for encryption or decryption is referred to as a cipher system. One or more of the following methods may be used:

- Transposition method
- Substitution method
- Algebraic method

The Data Encryption Standard (DES) (also see section 10.5.2) works with the following mathematical algorithms:

- 64-bit key to encipher 64 bits of information
- 56 bits of the 64-bits key are used for the encryption process and the remaining bits are used as parity error-detecting bits
- With 56 bits, there are over 70,000,000,000,000,000 or seventy quadrillion possible combinations.

Figure 10.3.5 shows the place of the encryption device. Basically, single facilities encryption or end-to-end encryption technique may be used. The same device can be used to cover message, data, or voice traffic, limited only by the maximum data rate for which the device is sized. Most devices can be used at varying data rates up to their maximum capability. Since the output of the encryption system is a digital signal, it can be transmitted without difficulty over either conventional or packet-switched data networks.

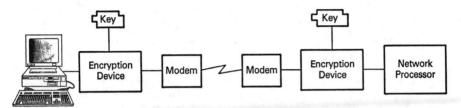

Key is usually 64-bit pattern introduced to device by means of thumbwell switches, card with magnetic stripe, prewired card, or external electrical signal.
Length of nonrepeating period from 21 days–several months.

Figure 10.3.5 Encryption diagram.

Automatic Dial-Back. Upon password receipt, the receiver disconnects and after table-lookup dials back using a prestored number. In this case, only the sender is authenticated. The advantage is that the availability of specialized audit trails and real-time monitoring may deceive the intruder by playing along in order to trace the physical location and escalate alarm actions. The disadvantages are the need for an additional network element (hardware or software), the restriction to a specific device location, readability of the called number—if not encrypted—and, probably, higher costs. Figure 10.3.6 shows the arrangement.

Authentication by Special Equipment. Recently, new solutions have been introduced for identifying the user to his or her workstation or terminal. The use of chipcards is based on a personalized set of information hardcoded into the chip. Loss of the card or key may still lead, however, to unauthorized use [BRIG90].

Authentication by Personal Attributes. In very sensitive areas, personal attributes, such as keystroke dynamics, signature dynamics, voice, color of eyes, hand scans, fingerprints, and the like, may be utilized as the basis for identification. This technique can, however, very rarely be cost justified.

Access Control. This function is usually implemented in addition to authentication to further limit the use of certain networking or processing resources. The scope of access control embeds all networking partitions introduced in 10.3.1. It is recommended to establish and maintain a table in the following form:

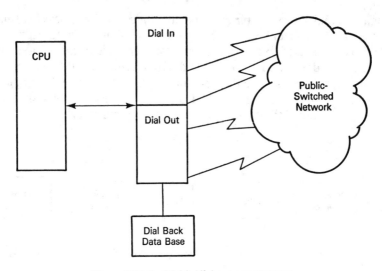

Figure 10.3.6 Dial-in/dial-out arrangement.

	Pass-words		
Networking resources	1	2	3
A	1	0	1
B	0	0	1
C	1	1	0

Entry "1" indicates that access is granted for a particular password to a particular networking resource.

Improving Data Integrity. Similar to data protection, this technique deals with solutions based on a checksum computation. The results are used to expand the message that will be sent to the destination address. The techniques are expected to be sophisticated enough not to be broken easily. The original message and the checksum are encrypted together. Also, time stamps and message identification have to be added to help reconstruct the message. Those additional flags may be encrypted as well (Figure 10.3.7).

Prevention of Traffic Flow Analysis Using Fillers. Fillers may be used to fill time gaps between real data transmissions. If both communications can be encrypted together, the penetrator cannot recognize any rationale or trend, random, periodic, or other pattern by listening to the traffic. But, on the other hand, the use of fillers is not unlimited. It may become very expensive, and communication facilities may be temporarily overloaded, resulting in serious performance bottlenecks.

Routing Control By Dynamic Bandwidth Management. State-of-the-art networking services enable users or the security officer to dynamically change or adapt the bandwidth assignment. This reassignment ensures higher secu-

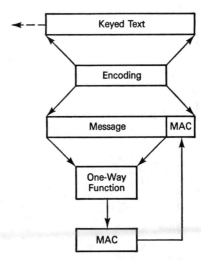

Figure 10.3.7 Improving data integrity by message authentication code.

Message-Authentication-Code (MAC)

rity, when for example communication forms, applications, or users are temporarily separated in order to avoid security risks due to resource sharing.

Use of an Arbiter (Judge) Function. For ensuring the reconstruction of all transactions and messages sent and received, a central administration function may be required. The function is similar to the control entity in a message switching system. The function may be implemented as one of the responsibilities of the security officer.

Table 10.3.2 gives an overview of how the various services identified in Section 10.3.2 may be supported by the techniques discussed in their section.

OSI standards are making good progress in penetrating networking. But there is no single OSI layer responsible for all security management functions and services. The best way to make progress is the step-by-step implementation of services supported by various OSI layers. Table 10.3.3 defines guidelines for this process.

10.3.4 Alarming, Logging, and Reporting

Security management techniques introduced in Sections 10.3.2 and 10.3.3 may significantly reduce security risks, but they cannot eliminate them. If possible, many security violation sensors have to be implemented to continuously monitor security status. The general flow of messages, events, and alarms is the same as discussed for fault management functions. The specific actions to be taken are, however, different from those of fault management. General guidelines for choosing the right actions are:

- Minimize impact on operational network
- Maximize chances of catching the violator

TABLE 10.3.2: Security Management Services and Solutions Overview.

Security Services	Security Management Solutions								
	Encryption	Digital signature	Hash function	Authentication	Access control	Improving data integrity	Use of fillers	Routing control	Use of arbiter function
Authentication check on communication partners	(Y)	(Y)	(Y)	Y					(Y)
Authentication check of data sender	(Y)	(Y)	(Y)			(Y)			(Y)
Access control					Y				
Ensuring data privacy	Y							Y	
Avoidance of traffic flow analysis	Y						Y	(Y)	
Ensuring data integrity	Y	Y	Y			Y			
Sender and/or receiveracknowledgment		Y	(Y)			(Y)			Y

Y = applicable
(Y) = limited applicability

TABLE 10.3.3: Distribution of Security Management Services in OSI-Layers.

Security Services	OSI Layers						
	1	2	3	4	5	6	7
Authentication check on communication partner	N	N	Y	Y	N	N	Y
Authentication check of data sender	N	N	Y	Y	N	N	Y
Access control	N	N	Y	Y	N	N	Y
Ensuring data privacy	Y	Y	Y	Y	N	N	Y
Avoidance of traffic flow analysis	Y	N	Y	N	N	N	Y
Ensuring data integrity							
of links	N	N	Y	Y	N	N	Y
of selected fields	N	N	N	N	N	N	Y
Sender and/or receiver acknowledgment	N	N	N	N	N	N	Y

Y = Service is supported by the layer

N = Service is most likely not supported by the layer

- In case of suspicious events, state immediate recovery for networking segments/applications impacted
- Protocol everything for future in-depth analysis
- If recovery does not seem meaningful or possible, communication connections have to be shut down

Expert systems of the future will have to choose the right solution from among these partially contradictory guidelines.

In the majority of cases, security logs are the most helpful for the security officer. The log entries should contain:

- All communication events and incidents preselected by the security officer (e.g., access denials, log-on attempts)
- User IDs for sender and receiver indicating the initiator of communication connections
- Date/time
- Physical resources involved in the communication
- Keys used as far as available for logging
- Security functions invoked manually or automatically

In the voice-only environment, SMDRs (Station Message Details Records) play a similar role for evaluating potential security violations with the voice network. SMDRs usually track:

- Station IDs
- Authorization codes
- Remote access codes

- Length of calls and times originated
- Facilities used to complete the call

SMDRs may also be used for accounting.

In order to facilitate the audits, applications may be written for processing the security logs and SMDRs using various criteria set by the security officer. For designing reports, the guidelines from the performance management segment (Section 9.3.4) may be used. In Figure 10.3.8, one example is shown of a security violation printout.

10.3.5 Protection of the Network-Management Systems

Network-management systems are powerful devices for administering and operating communication networks. These systems contain sensitive data, such as passwords, user profiles, change procedures, recovery and re-start procedures, network shutdown codes, algorithms for alternate routing, and they can be commanded to take networking segments out of service.

Secure management of the network may require partitioning to allow several members of the network-management staff to manage discrete parts of the network. Unfortunately, there are just a few instruments offering this capability. Partitioning may be implemented by using the following qualifying criteria:

- Network-management functions grouped into configuration, fault, performance, security, accounting, and planning
- Communication forms
- Principal applications
- Various networks, such as LANs, MANs, WANs
- Network partitions, such as end-user area, transmission, and the processing area.

The administration of security indicators and their thresholds, user passwords, user group profiles, change authorization of security-related data, and profiles needs careful attention. It is recommended to implement various security layers, such as

- General use of authorized network-management personnel, such as accounting functions, performance-measurement results, access to reports, and access to models.
- Restricted use for authorized network-management personnel, such as alarms, selected configuration and fault management functions, security violation logs, and access to the performance and telemanagement data base.

```
Scheme DEMO1                    OmniGuard: OSILOG2

11:24 T158 OSSN        STEVE1 selected new password
11:25 T158 OSSN   STEVE1   User STEVE1 signed on. Unrestricted
11:27 T162 OSSN        Incorrect password for user CHRIS
11:27 T162 OSSN        Incorrect password for user CHRIS
11:28 T162 OSSN        Incorrect password for user CHRIS
11:28 T162 OSSN        Terminal T162 put out of service
11:42 T158 XRAY   CHRIS   CHRIS may not access program XRAY because of Rule 6
```

(a) Online log monitor displays log entries as they are created.

```
N E T V I E W          SESSION DOMAIN: CNM02      P185161      08/07/89   14:12:08
NPDA-31A                    * ALERTS-HISTORY *                   PAGE  2 of  25
SEL* DOMAIN RESNAME   TYPE  TIME   ALERT DESCRIPTION:PROBABLE CAUSE
( 1) CNM02  PALOALTO  OSI   08:59  THRESHOLD HAS BEEN EXCEEDED:OSI COMMUNICATIONS
( 2) CNM02  PALOALTO  OSI   08:59  THRESHOLD HAS BEEN EXCEEDED:OSI COMMUNICATIONS
( 3) CNM02  PALOALTO  OSI   08:59  THRESHOLD HAS BEEN EXCEEDED:OSI COMMUNICATIONS
( 4) CNM02  PALOALTO  OSI   08:59  THRESHOLD HAS BEEN EXCEEDED:OSI COMMUNICATIONS
( 5) CNM02  PALOALTO  OSI   08:59  THRESHOLD HAS BEEN EXCEEDED:OSI COMMUNICATIONS
( 6) CNM02  PALOALTO  OSI   08:59  MANAGMNT SERV REQ UNKNOWN:OSI COMMUNICATIONS
( 7) CNM02  PALOALTO  OSI   08:59  MANAGMNT SERV REQ UNKNOWN:OSI COMMUNICATIONS
( 8) CNM02  PALOALTO  OSI   08:59  UNAUTH ACCESS ATTEMPT:OSI COMMUNICATIONS
( 9) CNM02  PALOALTO  OSI   08:59  THRESHOLD HAS BEEN EXCEEDED:OSI COMMUNICATIONS
(10) CNM02  PALOALTO  OSI   08:59  THRESHOLD HAS BEEN EXCEEDED:OSI COMMUNICATIONS
(11) CNM02  PALOALTO  OSI   08:59  THRESHOLD HAS BEEN EXCEEDED:OSI COMMUNICATIONS
(12) CNM02  PALOALTO  OSI   08:59  THRESHOLD HAS BEEN EXCEEDED:OSI COMMUNICATIONS
(13) CNM02  PALOALTO  OSI   08:59  THRESHOLD HAS BEEN EXCEEDED:OSI COMMUNICATIONS
(14) CNM02  PALOALTO  OSI   08:59  THRESHOLD HAS BEEN EXCEEDED:OSI COMMUNICATIONS
(15) CNM02  PALOALTO  OSI   08:59  THRESHOLD HAS BEEN EXCEEDED:OSI COMMUNICATIONS
(16) CNM02  PALOALTO  OSI   08:59  THRESHOLD HAS BEEN EXCEEDED:OSI COMMUNICATIONS
ENTER SEL* (ACTION), OR SEL* PLUS M (MOST RECENT), P (PROBLEM), DEL (DELETE)

???
CMD = = ▲
```

(b) NetView Session Monitor as a tool for reporting security violations.

Figure 10.3.8 Examples of security logs.
(a) On-line log monitor displays log entries as they are created. (b) NetView session monitor as a tool for reporting security violations.

- Very restricted use for authorized network-management personnel such as security alarms, change measurement, operational control, business plans for network design and planning, and user passwords and profiles.

These restrictions may seem irksome, but they are absolutely necessary for secure network-management operations.

10.4 INSTRUMENTATION OF SECURITY MANAGEMENT

There is a relatively wide range of instruments supporting various functions of security management. Some products introduced in Chapter 4 and further referenced in Chapter 8 may be utilized in the monitoring functions of security management. However, encryption devices, network access management instruments, LAN security solutions, and end-user device-oriented special authentication instruments are unique to security management. The major emphasis is on product selection and comparison criteria, which may be considered as generic. References and descriptions of products are kept to a meaningful minimum. However, examples are given of leading products in the areas of monitoring, encryption, LAN, and end-user security instruments.

Before going into instrumentation details, logical and physical protection of communication networks must first be explained:

- Logical protection represents methods of protecting unauthorized users from accessing applications and their related data bases and files. The schemes include passwords, access codes, closed user group definitions, and encryption techniques. These protection schemes are usually managed by the data-processing and data communications departments. A LAN administrator may also perform this function with the proper guidance. Voice switching systems may also protect some user features using access codes.
- Physical protection refers to methods of preventing access to host, network devices, public dial-up ports, and transmission facilities. This responsibility is shared with building security, property managers, users, and the telecom and data communications organizations.

10.4.1 Monitoring Devices

Monitoring devices may be considered a combination of an access control device and a traditional monitor with data collection, alarming, and reporting features. They may be placed in network elements, such as processing components, facilities, and devices. These special devices may be categorized as follows:

- Residing in the processors as part of the operating system or the access management service, or as standalone product interfacing users, the operating system, or further systems resources
- Placed in the network with an active access control and monitoring function

There are many examples of both solutions. RACF (Resource Access Control Facility) from IBM provides host access security for IBM MVS and VM installations. Also, leading applications, such as IMS, TSO, and CICS, are protected. RACF is characterized as a horizontal security solution. RACF has five major functions:

1. User identification and verification by password
2. Authorization checking for access requests
3. Journaling, logging, and reporting of security violations and access to system resources
4. Facilities for delegating the control of resources to the appropriate organizational level
5. Programs to report the status of MVS and VM security and integrity

Figure 10.4.1 shows a simplified scheme of the RACF architecture. There is a link to NetView, routing alerts to the hardware monitor, and a connection with the NetView Access Services component by verifying access authorization between the Access Manager and the application. In addition to protecting systems resources against unauthorized users, RACF provides password control for system operators, remote job entry, or local job entry. Multilevel security is also supported, enabling users to label data by confidentiality level or by category. RACF has some serious competitors for applications security management, but just a few products, such as ACF 2, and Topsecret for the horizontal level. For full integration with other network-management subsystems, in particular with fault management, the NetView link has been further improved.

Similar solutions are available for other architectures [e.g., ALSP (Integrated System, Inc.), Ansbak (Precision Computer), LOOK (On-track Systems) for DEC, QTS (Formula Consultants) for Unisys, On-Guard (Pansramic) for Tandem, and Interface 3000 (Satcom) for Hewlett-Packard].

Standalone products are preferred in dial-up environments. Those products actively control the network connections to end-users in addition to supporting security management. Many users want to access networking applications and resources, occasionally increasing security risks by more complex surveillance and security violation prevention techniques. Feasible alternatives have been realized by Defender II (Digital Pathways) and Net/Guard (Boole, formerly Avant-Garde).

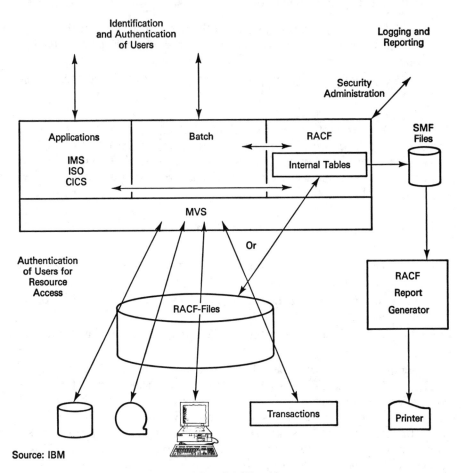

Figure 10.4.1 RACF architecture.

This system integrates, monitors, and controls access of personal computers to central networks, data bases, and computers. Service problems and security breaches are dynamically recognized. The system enables communication with customers by broadcasting messages or using direct, two-way communication. Any type of dial-up devices may be connected, regardless of protocol. Figure 10.4.2 shows the general architecture of the security guard. The principal features include the following:

- Real-time status displays (similar to network monitors NET/ALERT [AVAN84B]
- Application and customer transparency
- Three types of alerts:
 Security alerts, when an invalid log-on is attempted
 Equipment alerts, which identify hardware malfunctions or failures
 Threshold alerts, when a dial-in customer exceeds a specified connect-time limit or idle-time limit

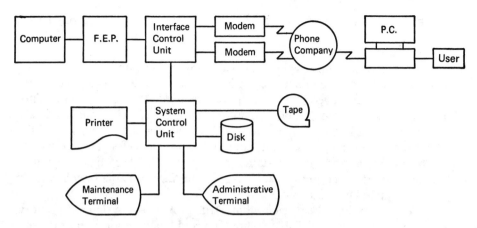

Figure 10.4.2 Net/Guard architecture.

- A history of log-ons and alerts provided by audit trials
- Hackers trap via
 Artificial response delay
 Offering pseudosystem mode
- Call-back, using specific phone numbers assigned to authorized customers.
- Usual audit trails provided include:
 Date and time of all attempts
 Which line the call came in on
 Which line the call went out on
 Entry and disconnect time
 Password used
 Reason for disconnection
 User associated with the call

The system can also be augmented to available security control of all kinds of users.

Some of these features may be supported by "regular" network elements, such as front-end processors equipped with special control software supporting table lockup and dial-out services. With the two products mentioned, integration into master network-management systems, such as NetView and Accumaster, are fully supported.

10.4.2 Encryption Devices

The strength of a cryptographic algorithm, as already mentioned, lies in its complexity, and computers have made complexity cheap. Yet every increase in the strength of the coding process calls for perhaps several orders of magnitude more computing power to "break" the code. Worst of all, the

complexity of the algorithm is a negligible factor in the cost of a crypto device. Systems that channel data through a crypto chip could upgrade to a different or more complex chip at minimal cost. For a decade, the crypto issue has been buried in a compromise where the U.S. government and private industry endorsed and promoted the use of an NSA- (National Security Agency of the United States) approved Data Encryption Standard (DES). DES was created in 1976 as a standard product definition for U.S. agencies that needed to protect nonclassified data. Designed by IBM and modified by NSA, the DES algorithm is public information. Adopted as a private sector standard in 1981 by the American National Standards Institute (ANSI), DES quickly came to dominate the U.S. crypto market, largely because it was the only algorithm with the implied guarantee of NSA.

Yet it has long been clear that DES provided only limited security, certainly far less than available technology could have produced at the same price. The DES was purposely crippled. Wed to a short key, designed to be slow and clumsy when implemented in software, it also had a hidden pattern, a subtle inner design weakness that was only last year discerned by nongovernment cryptographers. DES will probably stymie criminals for years to come, but it can no longer be trusted to withstand attack by sophisticated intelligence agencies.

New standards in this area will have a significant impact on future products.

10.4.3 Limiting Access to End-User Devices

Early prevention of unauthorized access may be supported by limiting access opportunities to end-user devices, such as terminals, personal systems, workstations, and so on. Chipcards and chipkeys are in the process of replacing an older version called the magnet card. Frequently, this technique is called smart card [BRIG90], in reference to the intelligent control logic burned into those cards. One of the most important application areas is the authentication of users for accessing networking and communication resources. Chipcards can be characterized as follows:

- They have a large storage place with 4 KBytes and more.
- They have little resilience against electrical fields.
- Readability is very strongly limited.
- Active processing within the card is possible.
- Changes from outside are limited or completely disabled.
- Customization of cards is possible depending on the user's authorization class.

In the authentication process, the chipcard or chipkey provides all the information necessary to indicate whether access is granted or not. In order to prevent unauthorized use of the chipcard or chipkey, additional questions may

be asked during the process by the resource. Usually, these questions cannot be answered by an unauthorized user. Password administration can be substantially enhanced with longer passwords which may even be randomly generated. Access denials due to entry mistakes may be eliminated as well.

In summary, initial experience shows substantial improvements in terms of ensuring access security. It is of course not limited to special devices; LANs and communication services may be supported the same way.

Security is probably the most important feature offered by the smart card [BRIG90]. In any environment where sensitive or confidential information is stored, it can provide a high degree of security by cost-effective means. This applies particularly in the modern PC-LAN where the intelligent workstation has created an open system that is vulnerable to intrusion. With estimates that up to 50% of most business's confidential information is stored on PCs, the size of the problem becomes apparent.

The high degree of security that can be achieved in smart card applications hinges on the computing and processing capability of the microprocessor. The smart card facilitates the decentralization of security devices down to the individual user through the application of cryptographic algorithms, and levels of security above and beyond those provided by the PIN alone. Individual access to anything from a single device or PC, to a complex multivendor network, can be controlled by a process of individual identification and authentication.

In addition to the PIN, security logic takes the form of a number of access keys. The security access to these keys is controlled by the chip manufacturer, and the authorized applications users. A number of different applications can be run on a single card, with each having its own discrete security logic. Personalization data are supplied by the card issuer in encrypted and certified form, in order that the card can be programmed for its active life. The card manufacturer's key contained in the batch card is also required before a card can be unlocked for personalization.

Before applications held on the card can be run, the cardholder's identity must be verified at the terminal or card reader. Card holder identification can employ an individual's biometric information such as signature pattern, palm or fingerprint, or retinal pattern. The main criteria for deciding which method to use are cost and public acceptability. Most of us are familiar with the use of a PIN number or personal signature as a means of verifying our identity.

The use of the PIN and the personal signature are currently the most popular techniques, while widespread use of more sophisticated methods of identification will depend on the progress of public education.

Once the user identity procedure has been initiated, and the cardholder's identity established either by PIN or biometric verification, mutual authentication between the smart card and the host can be carried out using encryption techniques. After this, the transaction can proceed.

General biometric technologies are not yet convincing in improving network security [CASA90].

Handscans, the oldest biometric technology, are used today primarily for physical access. The technology looks at both the top and side views of a person's hand using a built-in video camera.

The fingerprint's reputation as a unique identifier makes it a natural for biometrics. Machines that identify a single digitized fingerprint from a data base of thousands are much larger and more expensive than devices used only to verify that people are who they claim to be.

Using the first device involves finding one fingerprint in a huge data base of fingerprints; the other involves making sure the fingerprint of the person putting their finger in the device is the same as the print on the smart card, as opposed to the data base blindly trying to figure out who the person is. The latter verification technique requires smaller digital records and can take place in the software or plug-in hardware of a personal computer.

Eye pattern biometrics use low-intensity infrared light to scan an individual's retina, or the back part of the eye, which has a unique series of blood vessels. Eye patterns encounter the most user resistance because the technology requires that a beam of light be shined through a user's pupil. However, companies are working on developing an eye biometric device that saves users from the infrared beam by examining the iris, located on the eye's surface, instead.

Eye patterns, along with fingerprint and hand scans, are physiological biometrics because they measure stable physical characteristics. Physiological techniques require larger, costlier devices but are judged to be more consistent than behavioral techniques—such as signature dynamics, voice verification and keystroke dynamics—which can vary depending on a user's emotional state.

Also called typing rhythms, keystroke dynamics lends itself most naturally to computer and network access. The technology uses software that analyzes the way a user types a word or phrase and matches it to a stored version. No commercial product is currently available, however, because developers are still struggling with how to overcome differences in keyboard construction.

The devices focus on the voice's frequency spectrum according to time intervals and not on aspects such as inflection that potential intruders might try to imitate. Thus, the technology is not easily fooled by impersonators.

Because signatures are ubiquitous in the banking industry, signature dynamics seem to have found a home in securing financial transactions over data networks. There are more than 100 patents and several products in the signature dynamics market. Approaches to the technology are diverse, and each product takes a different perspective on how individuals sign their names. IBM, for instance, is using a security interface unit in its PS/2 devices. This solution combines a smart card with signature dynamics.

10.4.4 Improving LAN Security Management

Security on LANs must be discussed separately because those networks are used more publicly than wide area networks. LAN security risks involve tapping, radiation leakage, file and program protection, and physical security.

Authentication, audit trails, and encryption may be handled similarly to WANs and other networking resources. The reasons for different security measures and instrumentation are the following:

- PC LAN users are more sophisticated than terminal users: with more knowledge about the LAN and operating systems, they generally have an increased understanding of internal security structures.
- In the LAN environment, more devices store and maintain data. Protecting these data becomes increasingly difficult.
- There are far too many utilities available to bypass copy protection, expose disk structures, and perform sophisticated file/disk copying. For all practical purposes, data are exposed to security risks.
- Cables are one of the primary and easiest places for security violations to occur. Both copper-based and fiber-optic cables can be tapped, each using different technology and at different cost. Tapping in combination with monitoring devices allows the violator to read passwords, analyze traffic patterns, and actually capture sensitive information. In addition, electromagnetic signal leakage causes additional vulnerability for LAN security.

Usually, low-security LANs are less expensive and allow the choice of a wider selection of software and hardware, while high-security requirements may force the selection list to only a few options. Additional hardware and more expensive software are generally required for the more secure LAN installations. Implementation of a very secure LAN is considerably more costly than a single workgroup LAN. LAN security issues fall into the following three major areas [DANM89C]:

- **Physical access.** Security in any data-processing environment starts with controlling access to the equipment. Although intrinsically distributed in topology, LAN security requires installing the file servers and printers in secured access rooms. Access to the LAN's cabling system is also a concern because of the potential to "tap" into the network, insert new nodes, or monitor network data traffic. Access control to the PC workstation itself must be considered. Even without the network or server available, the local hard disk of the workstation can pose a security risk for loss of data.
- **Logical access.** Physical access techniques are designed to keep unauthorized users off the network. Logical access techniques are designed to keep authorized network users away from unauthorized files. Access to the data is the responsibility of the network operating system. It is via the NOS (Network Operating System) that the logical control for information access is carried out. Password access to servers, I/O rights to directory or file structures represent typical support features provided by a network operating system. The level of security required by any site will dictate the LAN manager's final choice of LAN software.

- **Administrative control.** An important but often neglected aspect of LAN security is the role of the LAN manager. It is this individual who is responsible for physical and logical access control, in addition to undertaking fault recovery procedures, performing backup, and monitoring for potential security infractions.

A protocol analyzer in the hands of the wrong person can be a security threat. If an infiltrator can get access to a LAN port or is able to tap the cable, the analyzer can reveal useful penetration information. An analyzer can capture the entire dialogue taking place over the LAN, and can display passwords in an easily readable form. Appropriating passwords is easy with analyzers, but passwords may not always be useful in a properly designed LAN. It is possible, for example, to restrict the station(s) a user can log in from; thus, although the infiltrator may have the manager's password, he or she cannot log in as the supervisor without using the actual manager's terminal. In addition, audit trail utilities can report log-ins and log-outs, with special attention paid to the manager's ID. This is the reason why reliable security measures that go beyond basic password protection are needed.

While protocol analyzers can present problems for LAN security, they can in turn be used to monitor the network for infractions. One simple technique involves looking for stations that are not supposed to be on the network. The manager can set the display to depict unknown stations. This is done by declaring an easily readable name for each LAN station. If a program claims to lock certain files, for example, the analyzer can be used to test that claim. With some analyzers, the network manager can write programs in C for specialized functions, such as monitoring compliance with security procedures. For example, such a program might look through the data to find stations that are logged on to a file server but show no activity for long periods of time. This may indicate a station where the user has walked away without logging off, which is a violation of security policies in most institutions.

10.5 HUMAN RESOURCES DEMAND OF SECURITY MANAGEMENT

The third critical success factor for network security management is its people. The functions discussed thus far should first be adopted to the present organization form within the information systems department. Based on the functions, processes, and procedures outlined, the targets of organization change can be determined. Table 10.5.1 summarizes the relationship between potential organizational units and the key functions of security management.

The indicators in this table constitute one of the following types of involvement: execution of duties, supporting, or advising type of involvement. The same table may be used as a starting point for estimating the extent of labor demand for managing security.

TABLE 10.5.1: Involvement in Security Management.

Functions	Configuration management	Fault management	Performance management	Security management	Accounting management	Network capacity planning	Level of possible automation
Risk analysis	S			E		A	low
Evaluation of security services		S	S	E		S	low
Evaluation of security management solutions				E			low
Alarming, logging, and reporting		S	S	E	S		high
Protection of the network-management systems		A		E		A	low

Other Subsystems

E = Executing
S = Supporting
A = Advising

Security management is usually staffed by four different kinds of people:

- Security officer
- Security auditor
- Security analyst
- LAN coordinator

Table 10.5.2 shows the distribution of functions among those human resources. In order to limit the alternatives for a tool's selection, Table 10.5.3 gives an overview of instrument classes considered for security management and of their potential users in the security management hierarchy.

TABLE 10.5.2: Distribution of Functions among Human Resources.

Functions	Organization				
	Supervisor	Security Officer	Security Auditor	Security Analyst	LAN Coordinator
Risk analysis	X	X	X	X	X
Evaluation of security services	X	X			
Evaluation of security management solutions	X	X			
Alarming, logging, and reporting			X	X	X
Protection of the network-management systems	X			X	

X = Commitment
(X) Involvement

For estimating the demand in FTEs (full time equivalent), Table 10.5.4 provides the quantification for the four major customer clusters introduced and defined in Chapter 1. The numbers represent averages, and are based on the results of many surveys and interviews conducted personally by the author of this book.

In order to help with hiring and building the fault management team, Tables 10.5.5 to 10.5.9 give typical profiles for each of the security management personnel, including the supervisor of the group.

And finally, the function/skill matrix, shown in Table 10.5.10, gives an overview of the targeted skill levels for each individual security management function.

TABLE 10.5.3: Tool-Applicability Matrix by Personnel.

Tools	Organization				
	Supervisor	Security Officer	Security Auditor	Security Analyst	LAN Coordinator
Monitors in network elements					
Application monitors					
Software monitors					
Modem and DSU/CSU monitors				X	
Multiplexer monitors					
Switch monitors					
Line monitors					
Network monitors					
PBX monitors				(X)	X
LAN/MAN monitors				(X)	X
Network element management systems					
Voice orientation	(X)	X			
Data orientation	(X)	X			
Console management systems					
Integrators	X	X			
Computerized cable management systems					
Automated call distributors					
General-purpose data bases			X	X	
Special administration products			X	X	
Networking models					
Security monitors	X	X	X	X	
Access devices	X	X	X	X	
Encryption devices	X	X	X	X	X

X = Unlimited applicabilty
(X) = Limited applicability

TABLE 10.5.4: Personnel Requirements for Security Management.

Organization	Network Range			
	Small <3000	Medium 3000–10,000	Large 10,000–50,000	Very Large >50,000
Supervisor	1	1	1	1
Security officer	1	1	2	3
Security auditor		1	1	2
Security analyst	1	1	2	4
LAN coordinator+		1	2	3
Human resources demand				
Total	3	5	8	13

+shared with other organization

TABLE 10.5.5: Profile of Security Management Supervisor.

Duties

1. Evaluates security risks.
2. Prepares security plans.
3. Supervises security log evaluation procedures.
4. Assists in defining security violation thresholds.
5. Assists in elaborating on security plans for the network-management system.
6. Establishes educational program for staff.
7. Supervises products' selection process.

External job contacts

1. Other supervisors within network management
2. Vendors
3. Network manager

Qualifying experience and attributes

1. Has knowledge of customer's business
2. Has knowledge of security impacts for the larger organization
3. Has some knowledge of security management tools and techniques
4. Has a superior personal record
5. Has communication skills toward vendors
6. Has training in administrative management

TABLE 10.5.6: Profile of Security Officer.

Duties

1. Evaluates security risks.
2. Supervises security in real time.
3. Decides about actions against penetrator.
4. Helps evaluate surveillance logs.
5. Helps in elaborating on security plans.
6. Supervises the security of the network-management system.
7. Manages passwords.
8. Helps to select instruments.

External job contacts

1. Security auditor
2. Security analyst
3. Customers
4. Vendors of security-related instruments
5. Other companies

Qualifying experience and attributes

1. Has knowledge of customer's information flows
2. Has knowledge of security impacts for the larger organization
3. Has a superior personal record
4. Ability to make decisions rapidly
5. Has some communication skills
6. Has in-depth knowledge of security-related instruments

TABLE 10.5.7: Profile of Security Auditor.

Duties

1. Evaluates surveillance logs.
2. Helps in estimating security risks.
3. Helps to set violation thresholds.
4. Categorizes security risks.
5. Helps to find the right mix of physical and logical precautions.
6. Helps in selecting instruments.
7. Writes report on how security plans are met.

External job contacts

1. Security officer
2. Security analyst
3. Customers
4. Vendors of security-related instruments
5. Other companies

Qualifying experience and attributes

1. Has knowledge of customer's information flows
2. Has knowledge of security impacts for the larger organization
3. Has a superior personal record
4. Ability for detailed clerical work
5. Has some communication skills
6. Has in-depth knowledge of security-related auditing guidelines

TABLE 10.5.8: Profile of Security Analyst.

Duties

1. Defines monitoring and surveillance functions.
2. Evaluates and selects security management services.
3. Evaluates the performance impacts of security techniques.
4. Constructs threat matrix.
5. Recommends instruments to be selected.
6. Supervises installation of instruments.
7. Customizes passwords and access authorization.
8. Programs instruments.
9. Establishes procedures for securing the network-management system.

External job contacts

1. Security officer
2. Vendors
3. Security auditor
4. Other users

Qualifying experience and attributes

1. Has superior personal record
2. In-depth knowledge of security management services and instruments
3. Has technical skills to customize products
4. Has some communication skills toward vendors

TABLE 10.5.9: Profile of LAN Coordinator.

Duties

1. Tracks inventory and maintains directory.
2. Controls configuration.
3. Controls access authorization to applications, servers and gateways/routers/brouters, and bridges.
4. Reviews surveillance logs for LAN/MAN stations and servers.
5. Administers local passwords.
6. Educates users on security management products and techniques.
7. Assists in taking actions against penetrator.

External job contacts

1. Users
2. Security officer
3. Security analyst
4. Security auditor

Qualifying experience and attributes

1. Familiarity with applications, stations, and servers
2. Training in personal relationships
3. Communication skills
4. Up-to-date knowledge of LAN/MAN-related security management instruments and techniques

TABLE 10.5.10: Responsibility/Skill Matrix.

Functions	Special knowledge of function	General knowledge of communication facilities	In-depth knowledge of communication facilities	Some knowledge of business administration	Communication skills	Some knowledge of project management
				Skills		
Risk analysis	X	X	X	X	X	X
Evaluation of security services	X	X	X		X	
Evaluation of security management solutions	X	X	X		X	X
Alarming, logging, and reporting	X	X	X			
Protection of the network-management systems	X					

X = Skill is required by function

10.6 SUMMARY

Practical recommendations for security management include guidelines for *doing* certain things and for *avoiding* certain other activities. These guidelines are useful for both short- and long-range improvements in the area of security management.

DO

- Process
 Consider security management as a prime corporate objective
 Allocate sufficient funds and people
 Clearly define security objectives
 Analyze major threats: inside/outside
 Set up closed loop: monitor—detect—fix—report
 Formulate four-layer security system
 Give highest security to Network Management Center systems/procedures
 Emphasize security procedures within the organization
- Products
 Select products as part of closed loop
 Select products as part of multi-layered security
 Select products with good audit trail function
- People
 Involve all corporate personnel
 Motivate users by explaining damage that may be caused by security failures

AVOID

- Process
 Single-layer security procedures
 Considering security management as overhead
 Being satisfied with present security status
 Giving unlimited access to any individual
 Maintaining passwords/codes and so on, for extended periods
 Failing to adequately follow up on security violations
- Products
 Those products that can be defeated or bypassed easily
 Those not designed with security as an essential part of them
- People
 Hiring Network Management Center personnel without stringent investigation
 Continuing network access to repeated security violators

11

Accounting Management

Accounting management is the process of collecting, interpreting, and reporting costing- and charging-oriented information on resource usage. In particular, processing for SMDRs, accounting records, bill verification, and charge-back procedures are included as part of accounting for data and voice services.

In general, the corporation's accounting policy defines the financial strategy and procedures that will best meet overall corporate objectives. Collecting information, analyzing cost elements, and processing and verifying vendor bills are absolutely necessary. However, to establish charge-back policies, define charge-back procedures, and integrate network accounting management into corporate accounting depends on corporate management; these functions are optional, but most corporations have some solution in place.

11.1 INTRODUCTION, STATUS, AND OBJECTIVES

The principal objectives of this chapter are:

- To discuss the major functions of accounting management
- To define the interrelationship of the functions
 To determine information interchange with other network-management activities

- To summarize implementation considerations, including what human resources are needed to support accounting management
- To construct a responsibility/skill matrix to help define accounting management functions.

In addition to the issues prevalent today (Chapter 1), more specific problems are seen in the accounting management area, which may be characterized as follows:

- The most difficult problem in accounting management is accurately determining telecommunications costs and then equitably charging these costs back to the user.
- It is difficult to determine costs accurately because many direct and indirect factors make up true costs of a device, service, product, or system. Additionally, modern accounting practices and tax issues further complicate the correct calculation of costs. When numerous elements such as hardware, software, systems, personnel, and overhead costs are included, as is true in all large telecom networks, completely accurate cost determination is simply not possible.
- In a similar way, it is difficult to accurately and fairly charge back those costs to end-users who are provided with network services. In most—if not all—cases, only charge-back approximations are possible.
- It is a difficult, if not impossible, task to equitably allocate switching and transmission costs to voice information and data information carried over the same physical network. This is especially true when voice is digitized at 64 Kbps or digitized and compressed to 32 Kbps or 16 Kbps.

 Factors to be considered are quality of service, bandwidth, message contents, gateways, technology options, off-net tariff requirements, and unit costs of support hard- and software.

- Accurate accounting requires continuous and detailed monitoring, with a resulting unnecessarily high overhead.
- Bill verification is very difficult due to frequent tariff changes and differences between carriers, countries, and even by states.
- The present life cycle of processing accounting released information is too long; real-time or near real-time processing results are expected by most users.

In summary, the great complexity of factors influencing actual costs and the difficulties of allocating costs in a timely and equitable fashion seem to be the principal challenges for improving accounting management efficiency.

The following sections will address the major processes, functions, and instruments of accounting management.

11.2 ACCOUNTING MANAGEMENT PROCESSES AND PROCEDURES

The accounting management process consists basically of five segments (Figure 11.2.1):

- Identification of cost components including various network elements, networking services, personnel, and facilities overhead. Network elements and services are generic and include all communication forms supported. Via network elements, LANs, MANs, and WANs may be analyzed together. Cost analysis—the following step—includes the identification of hidden costs up to a reasonable level of detail.
- Establishing charge-back policies is dealing with whether to charge back to users and, if so, what the basis is of this charge-back decision. For a

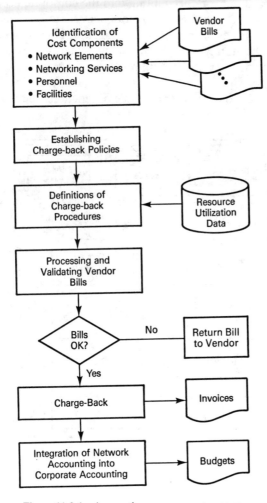

Figure 11.2.1 Accounting management process.

basis, resource utilization in some form is recommended; examples are number of packets transmitted, number of calls completed, call duration, length of time circuits used, and how long the bandwidth is switched on. Exclusive use of resources by users, user groups, or applications makes the decision easy.

- Definition of charge-back procedures enables the calculation of a charge-back, depending on the policy defined in the previous step. Procedures have to be simple, stable, and visible to users. Part of the procedure is how to receive and process accounting data from various network elements.
- Processing of vendor bills identifies the process of receiving, validating, interpreting, and computing the bills and transferring the compensation to the vendor. The periodicity has to be the same as with charge-back procedures.
- Integration of network accounting into the corporate accounting policy. It is a one-time effort and is recommended to be done after careful analysis of all cost components. Budgeting is considered part of the corporate accounting policy for allocating financial resources in order to plan and implement networking resources.

Figure 11.2.2 shows another example of functions and related data bases and files.

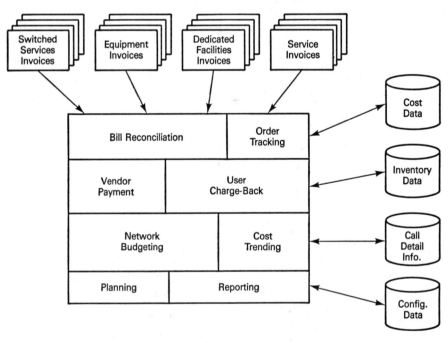

Figure 11.2.2 Accounting management: Functions, data bases, and invoice examples.

In order to successfully support accounting management, the following information is necessary:

- Primary demand
 Resource utilization data by user, user group, and application
 Message volumes
 Transactions volumes
 Call volumes (SMDRs)
 Time stamps
 Costs for network elements, network services, personnel, and facilities
 Actual and generated configuration
 Priorities
- Secondary demand
 Active and generated users
 Service indicators

11.3 ACCOUNTING MANAGEMENT FUNCTIONS

Accounting management functions were identified in the introductory part of this chapter. Now, typical processes, structures, architectures, and practical examples are given to gain a better understanding of how the functions work and how they are interrelated.

11.3.1 Identification of Cost Components

Cost components may be categorized as follows:

Hardware. Computers; PBX systems, T1/T3 MUX; LANs, WANs; modems—DSU/CSU; CO switch; packet switch; network-management system; DCS; DACS; cables; interfaces; microwave; satellites; repeaters; front-ends; common controllers; terminals; microprocessors; and so on.

Software and Systems. Includes all software in the data center, network, or end-user site. Involved are operating systems, communications protocols; gateway software; application programs; switching software; network management software; monitors; network node; and many other diverse system programs.

Services. Includes all network services available to corporate network users. This covers both tariffed public services such as Accunet T1.5, 800 Service, MTS, and private services such as electronic mail and voice message systems. Will eventually include ISDN Enhanced Services. Consideration must be given to the fact that approximately 70% of the costs are for voice.

Personnel. Includes all corporate personnel directly or indirectly involved in providing or supporting hardware, software, and service elements. Some people are with the Network Management Center, some with diverse corporate groups, and others with outside carriers, vendors, or consulting firms.

Facilities Overhead. Includes costs for buildings, utilities, maintenance, insurance, taxes, and other ancillary services.

In a few cases, analysis of network costs can be simple, but more often it is a complex process. Both tangible and intangible factors are involved. Moreover, costs may change rapidly and must therefore be recalculated often.

Hardware costs depend on:

- Purchase/lease agreements
- Maintenance costs
- Useful life projections
- Interest factors
- Depreciation
- Tax credits
- Residual value

The next example is intended to illustrate the complexity and "hidden" costs of installing network components, whether these are new additions or modifications of an existing configuration.

It is important to understand that it would be unreasonable to estimate and/or track all costs—hidden or direct—associated with an installation. In many cases most of these processes are handled directly by the vendor, transparent to the end customer.

This point emphasizes the importance of understanding the order process and the value of carefully reviewing vendor contracts prior to placing an order. It is often helpful to conduct this type of preview with the vendor present, so agreement can be reached regarding reasonable expectations for various vendor deliverables.

Once the implementation process is well understood, determining what items should be tracked, and establishing key checkpoints should be relatively straightforward.

This example uses the following server cost categories: ordering, methods and procedures, training, delivery, staging, acceptance, and testing. Besides these activities, the person responsible and the estimated cost components are identified in Table 11.3.1.

In another approach to categorization, cost components are differentiated as follows: fixed or facilities costs, fixed operating costs, and variable costs.

The first category comprises those costs associated with building or office lease or purchase, preventive maintenance, and the rental, purchase, or lease

TABLE 11.3.1: Cost Analysis Example.

	Responsibility	Cost
ACCEPTANCE		
Product acceptance	Management	Personnel time to confirm product acceptance with vendor
Process bill	Management	Personnel time to ensure that bills are processed correctly
Disassemble	Technician	Personnel time to disassemble components at staging area
Pack	Technician	Personnel time to pack components for shipping
Transport to destination		Cost to ship product to final implementation site
Accept	Management	Personnel time for management to be on-site to accept delivery
Unpack	Technician	Personnel time to unpack components, including ensuring that all components are present and undamaged
Assemble components	Technician	Personnel time to assemble components for installation
Install	Technician	Personnel time to install components
	Management	Personnel time to supervise installation
TESTING		
Test final configuration	Technician	Test product to ensure that the final installation was successful
TRAINING		
Technician training	Management	Personnel time to arrange for appropriate training
		Personnel time for technicians to attend training
DELIVERY		
Delivery acceptance	Management	Personnel time to be on-site when delivery is made and to accept delivery

STAGING

Unpack	Technician	Personnel time to unpack shipment and verify that all components are present
Assemble components	Technician	Personnel time to assemble components into configuration for staging
		Leasing cost, if any, for space to conduct staging
Conduct staging	Technician	Personnel time to configure system for staging, initiate process, and track progress
		Power costs.
	Management	Personnel time to supervise staging
Review of results	Technician/ management	Personnel time to review staging data and release product for installation

ORDERING

Order request	Management	Personnel time to interface with vendor and technical support to review proposed configuration and ensure that all required components are included. Review and adjust standard maintenance contract if necessary.
Order tracking	Clerical	Time to enter order into local service request tracking system
		System access time
	Clerical	Time to determine status of order and update tracking system
Closing	Management	Accept order as complete (post implementation)

METHODS AND PROCEDURES

Implementation plan	Management	Personnel time to prepare implementation plan or to review standard implementation plan provided by vendor.

Operation plan	Management	Personnel time to prepare operational plan or to review standard operational plan provided by vendor
Maintenance plan	Management	Personnel time to prepare operational plan or to review standard operational plan provided by vendor

of devices. Fixed operating costs include personnel, energy, and transmission fees. Variable costs refer to the costs of dial-up lines, packet switching, and so on.

11.3.2 Establishing Charge-Back Policies

A charge-back system can be defined as the assignment of communication costs to users. In some organizations, real dollars change hands; in others, bookkeeping entries are made, or statements are issued, but money transfers do not take place.

To be successful, a charge-back system must:

- Be understandable to the user
- Be predictable so the managers can plan effectively
- Reflect economic reality

The benefits of charge-back system are:

- It is a proven way of allocating expensive resources.
- It encourages users to make economical use of services.
- It promotes efficient service by controlling demand.
- It decentralizes control to enable users to make choices.

Potential drawbacks of a charge-back system are:

- It entails overhead costs that reduce profits.
- It makes life difficult for Network Management Center/Telecom groups.
- It usually results in complex rates and rules.
- It may result in underutilized resources.
- It encourages large groups to seek special benefits.
- It may remove an essential resource for some users.

Management has to decide on the network usage indicators that will be used as the basis of the charge-back system. Depending on this decision, usage information has to be collected and processed.

Corporate policies differ. Three alternatives may be distinguished:

Zero Charge-Back. Some corporations do not charge users with any telecommunications costs. These are simply considered corporate overhead, similar to the company cafeteria or company newspaper. Other corporations use a variation of this in "showback accounting," whereby user groups are provided with "average cost" information, but no actual charge-back.

Partial Charge-Back. Most corporations levy partial charge-backs against users. In these situations, some Telecom costs are absorbed by the corporation, some by certain groups such as data centers, and the remaining costs are charged directly to the user based on specific rates and usage factors.

Full Charge-Back. A few corporations attempt to charge all telecom costs to the user based on services provided. Very often these charges involve negotiated costs and prices. Profit center Network Management Centers may use this approach.

11.3.3 Definition of Charge-Back Procedures

Assuming the charge-back system has been developed, procedures have to be defined, developed, and implemented.

The following criteria are of principal interest in designing charging algorithms:

1. **Simplicity:** Costing and charging should be easily understood by all parties, thereby resolving problems between customer network and data-processing experts. Both standard costing and charge-back algorithms should be well understood by users.
2. **Accuracy:** Network accounting should deliver accurate results. In the design phase, however, criteria of economy should also be considered. The expenses should be worth the benefits realized.
3. **Responsibility:** Charging must be proportional to the service demanded by the user community. The data collection on resource usage by different users is a technical problem. Depending on the accuracy requirements, various data collecton techniques and tools may be employed.
4. **Stability:** The end-user expects the same charges for the same service being demanded. The charges have to be independent from the computer used and the transmission path selected. In order to meet user satisfaction, average values are computed and used in charging algorithms.
5. **Visibility:** Network accounting should assist in determining better workload forecasts and budget information. When accounting is visible

enough, information can also be used for resource planning, for defining new service requirements, for correcting design deficiencies, and for eliminating hardware, software, and communication malfunctions.

For collecting data communications-related data the following items are important:

- **User identification:** Provided by the originator of batch or dialog.
- **Receiver:** Identifies the network component to which a connection is made or attempted (this requirement may establish a standard accounting record, which may be processed in all hosts).
- **Number of messages:** Count of messsage units.
- **Messages:** Sent/received between network components, breaking down total characters transmitted into net data and control data.
- **Security level:** Identifies the transmission and processing priorities.
- **Time stamps:** Associated with each principal transmission and processing event (e.g., process start time, process stop time).
- **Network-status codes:** Indicate the nature of the errors or malfunctions that are detected.
- **Resource-demand mode:** Identifies the data-processing resources demands introduced by host processes (CPU, I/O).

Voice-oriented accounting requires call detail data. Call detail is associated with an individual call or event, whereas traffic data reflects data associated with a circuit group. Information is needed on both voice and data applications. Call data elements are source ID, destination ID, network facilities, cost of service, and other diverse elements. Traffic data include peg count, overflow, usage, maintenance, and other diverse elements.

There are three basic methods for determining unit costs in a network environment (Figure 11.3.1). A *proportional* costing system lumps all costs into a whole and then divides them equally among all the customers of the information resource. There are obvious inequities with this straightforward averaging system, although it has the virtue of simplicity and is very amenable to trending. A more sophisticated method is to establish costs per equipment class and to divide them by users by (probably service) class. This is referred to as *responsibility* costing: it basically just applies a weighting factor to the proportional average costs. The third method is that of *standard* costing [HOWA81], in which the planned expenses by resource type are divided by the work by resource type to derive the unit cost.

The work by resource type to be accomplished depends on availability and utilization. *Availability* depends on the technical reliability of the resource, expressed by MTBF, on the topology determining the escalation of component's outages, and on the speed of diagnosis and repair, frequently added up to MTTR. MTBF and MTTR are usually provided by the equip-

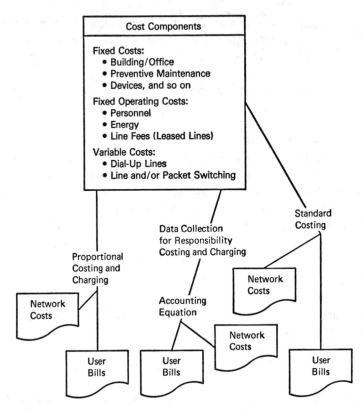

Figure 11.3.1 Accounting-related data collection.

ment manufacturer. Considering all networks and the customer-level availability, the number of terminal hours should be computed first [FROST83]:

$$T_{\text{hours}} = \sum_{K=1} T_{HK} \times M_K \qquad (11.1)$$

where

T_{HK} = number of operational hours for terminal cluster K
M_K = number of members in terminal cluster

For all other networking components, similar computations should be made. Depending on the topology, the breakdown of components will cause nonavailability for other components if neither alternate routes nor backup components are available. Considering customer-level availability, the average number of unavailable terminal hours, affected by the failure of each component type using Equation (11.1), should be calculated next:

$$T_{\text{hours,nonavailable}} = \sum_{i=1}^{P} \frac{T_{Hi} \times \text{MTTR}_i}{\text{MTBF}_i + \text{MTTR}_i} \times L_i \qquad (11.2)$$

where

T_{Hi} = number of operational hours for component i
L_i = number of terminals affected by the failure of component i
$MTTR_i$ = MTTR for component i
$MTBF_i$ = MTBF for component i

Total network availability (AV) for the customer level can be calculated as follows:

$$AV_{network} = \frac{T_{hours} - T_{hours, nonavailable}}{T_{hours}} \qquad (11.3)$$

The other factor, utilization, can be controlled by the network manager. By multiplying the unit cost by the expected volume of customer work, the customer cost associated with the utilization of the information resource can be determined. Once identified, these standard costs can be used to establish a charge-back system. Figure 11.3.2 illustrates the principal steps.

It is clear that the first method requires virtually no performance statistics and that the last method requires a sophisticated instrumentation system. It is important to emphasize that the independent variable in the standard costing methodology is the volume of work to be processed. Any change in this volume will serve only to increase the unit cost. It is a common fallacy that money can be "saved" by reducing the volume of work. On the contrary, the company still has to pay for the budgeted expense throughout the fiscal period. Thus, if the volume decreases, the total expenses are then divided by a smaller N, which causes the unit cost to increase. If the volume is higher than planned and response-time levels are to be maintained, the capacity of the resource must be increased, thus increasing total expenses. Once again, the unit cost will rise—this time because the generator (total expenses) has increased. It is also important to note that standard costing deals with planned costs. Actual unit costs will always be a function of actual expenses divided by the actual volume of work.

In the next example [ALLE84], the standard costing procedure is used to solve a typical network administration problem: predicting the additional costs associated with customer demands for better service. A simple example has been chosen deliberately for purposes of illustration: a single-customer, standalone system running a transaction-driven data base. The customer currently experiences an average 5-s *response time* (R1) but demands 3-s (R2) (Figure 11.3.3). Resource analysis studies reveal that the CPU is the critical resource in providing improved response time, since utilization of the high-speed lines is far below saturation and DASD queuing is in acceptable ranges. The capacity analysis of the CPU reveals that *utilization* currently averages 70% during the peak periods (U1). Modeling studies show that for providing 3-s response time, utilization cannot exceed 50% (U2). These relationships are shown in Figure 11.3.3. The third factor to consider is the average number of *hours of operation* per year (AV(max)). In this case, it is 5500 hours. On the

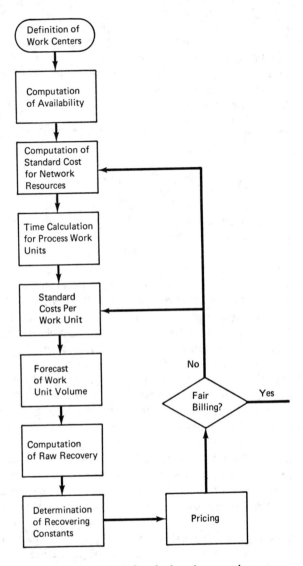

Figure 11.3.2 Standard costing procedure.

average, 10% of that figure is *lost time* (AV(loss)) due to holidays, preventive maintenance, scheduled downtime, and so on.

In order to evaluate the host of 3-s response time, the overall *availability* (AV) for the work center CPU—that is, the planned time to use the machine—must be computed. Availability can be calculated by taking the total number of hours the CPU is available for operation minus the lost time. More simply

$$AV = AV(max) - AV(loss) \tag{11.4}$$

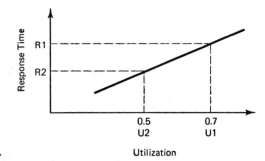

Figure 11.3.3 Costing service levels.

Utilization

In this instance, the availability of the CPU over the course of the fiscal period (1 year) is 4950 h:

$$5500 \text{ h} - (0.10 \times 5500) \text{ h} = 4950 \text{ h} \qquad (11.5)$$

Next, the *standard cost* (SCO) at each utilization level needs to be computed. To do so, the central processor's total *budget* (BU) for the fiscal period must be considered. This includes, at a minimum, maintenance, depreciation or equipment rental, floor space, and administrative overhead. In this case, this amounts to $1,250,000 per year. This figure is divided by the availability level times the utilization level:

$$\text{SCO} = \frac{\text{BU}}{\text{AV} \times \text{U}} \qquad (11.6)$$

$$\text{standard cost}_{u1} = \frac{\$1,250,000}{\$4950 \text{ h} \times 0.70} \qquad (11.7)$$

$$= \$360.75/\text{h or } \$0.10/\text{s}$$

$$\text{standard cost}_{u2} = \frac{\$1,250,000}{4950 \text{ h} \times 0.50} \qquad (11.8)$$

$$= \$505.05/\text{h or } \$0.14/\text{s}$$

Utilization and availability are both efficiency measures. There are two additional factors that are important influences on network services: *volume* and *mix*. In the last calculation, it is clear that the change in unit cost was due to a change in utilization level required by the desired improvement in response time. To assess customer cost, these unit costs are multiplied by resource consumption per transaction.

In this simplified scenario, all transactions fall into two categories based on CPU usage. The measure is CPU seconds, available from the given system-accounting data. Inquiry transactions (TR1) consume an average of 6 CPU seconds for every 10 transactions; thus, TR1 = 0.6. There is a rate of 9 CPU seconds for every 10 update transactions; thus, TR2 = 0.9. The standard cost for processing each transaction type at each utilization level can be calculated

by simply multiplying the CPU seconds rate by the standard cost at each utilization level. This analysis yields the following results. At service level 1 (5-s response time)

$$\text{standard cost} = 0.6 \times \$0.10 = \$0.06 \text{ (TR1, U1)} \qquad (11.9)$$

$$\text{standard cost} = 0.9 \times \$0.10 = \$0.09 \text{ (TR2, U1)} \qquad (11.10)$$

At service level 2 (3-s response time)

$$\text{standard cost} = 0.6 \times \$0.14 = \$0.08 \text{ (TR1, U2)} \qquad (11.11)$$

$$\text{standard cost} = 0.9 \times \$0.14 = \$0.126 \text{ (TR2, U2)} \qquad (11.12)$$

Thus, reducing the transaction response time by 60% results in an approximate 33% increase in the standard cost for both update and inquiry messages. This percentage figure should be utilized in discussions with the customer because it is ultimately reflected in the information systems' budget and, possibly, in the customer's bill.

As stated earlier, these increased information system costs must be balanced against the productivity gains associated with improved response time. Use of this methodology allows for quantifying this trade-off and providing a basis for business-based decision making. This was a single-customer, standalone system with a certain projected volume and a 50/50 split between update and inquiry transactions in which the CPU was the critical resource. Any of these assumed factors could change for a given system, thus affecting unit costs. For instance, if the single customer produced more volume than had been expected, service might have had to be degraded to the 5-s level if overall costs were not to increase. If volume remained stable but the mix changed such that update transactions were a proportionately greater factor, the 50% utilization level would be reached earlier in time. Once again, models (see Chapters 6 and 12 for more details) can determine what that utilization threshold would be. Based on this, a weighting factor could be applied to the planned unit costs.

In this study, the independent variable was CPU utilization. However, the same logic could be applied for other component variables (lines or devices) by modeling the utilization thresholds and calculating the budget associated with this set of resources. Once done, the cost pairs could be calculated easily enough. If there were multiple customers, the demands of one group for better response time should not affect the customer costs for the other groups. In other words, if these demands engender a higher cost by requiring greater capacity or accelerating the upgrade schedule, the entire incremental expense should be reflected in the unit costs associated only with the requesting group's transactions. If this is unacceptable, the data center might budget for a longer fiscal period and not change the rate. Either way, the principle is to isolate customer work by class and establish unit costs for that class.

11.3.4 Processing of Vendor Bills

Correctly processing vendor bills is principally a question of establishing well-defined procedures which are then carried out by trained Network Management Center accounting personnel. No significant problems exist in this area, as they did with costing and charge-back.

What is most important, however, is the procedure to verify the accuracy of vendor bills before these bills are paid. Significant overcharges can be found through precise, written procedures that analyze and verify vendor bills. Additionally, to prevent duplicate charges and/or penalties, clearly defined procedures for tracking and recording all bills are necessary.

Usually, bill processing is part of more complex billing systems, as shown in Figure 11.3.4. Network billing systems can capture call data directly from voice switch SMDR ports. Calls can then be grouped for reconciliation and user billing. A central data base also permits call pattern studies and exception monitoring of network abuse. Some systems can even help the manager estimate and prepay call charges, and avoid carriers' late payment penalties.

Attention has to be paid to correctly linking this billing system to configuration management—in particular inventory control and order processing.

11.3.5 Integration of Network Accounting into the Corporate Accounting Policy

Network accounting is part of corporate accounting and must therefore follow the same policies and procedures. Two common elements are especially important in this area: the use of data bases and of application programs.

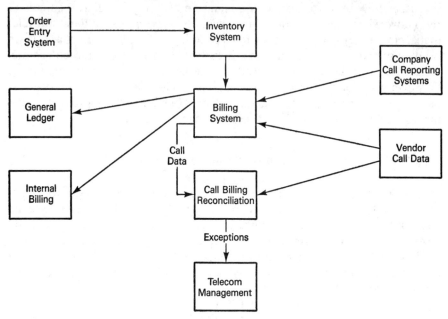

Figure 11.3.4 Network billing system and its connections.

As far as possible, network-management centers' accounting data bases should be integrated into corporate accounting data bases. Data base systems and procedures should be similar or identical. It should be noted, however, that the network-management centers' Telecom data bases for network control and monitoring are not part of this integrated accounting structure.

Applications programs

- Should be shared
- Should be useful to all groups
- Should support on-line reports tailored to all groups

Full integration will show another benefit: Budgeting will be considered part of this activity. Budgeting is the process of financially defining network design and capacity planning decisions. Therefore, this function has to be combined with the considered resource demand phase of capacity planning in Chapter 12. Accounting management helps with providing long-range resource demand statistics; their comparison with actual needs helps attain objective planning and implementation.

11.4 INSTRUMENTATION OF ACCOUNTING MANAGEMENT

There is a relatively wide range of instruments supporting key accounting management functions. A number of products introduced in Chapter 5 may be successfully used for accounting management. In particular, segments of the network-management data base, such as resource usage data and tele-management, are of great help to accounting. The major emphasis is on product selection and comparison criteria, which may be considered generic. References and description of products are kept to a meaningful minimum. However, examples are used for the leading products in the area of processor-based accounting packages, general-purpose administration products, tele-management solutions, and LAN accounting alternatives.

11.4.1 Processor-Based Accounting Packages

This group of products provides accounting information for host-controlled data networks, such as SNA and DCA. They have been designed and implemented for accounting using scarce processing, storage, and I/O resources. Over time, records of the accounting packages are also considered as the basis for performance management. Value-added packages have also been designed and implemented for improving readability and offering statistical capabilities.

System Management Facility (SMF) is actually the de facto standard for IBM-oriented mainframes and networks. The SMF implementation is de-

signed to be tailored by the installation. Data generated into the SMF buffer and subsequently recorded on the SMF data sets are provided by

- Operating systems routines, including MVS, VM, TSO, SES, VSAM, VTAM, TCAM, and so on.
- System routines that provide data to user-coded routines that interface with SMF exits.
- User-written exit routines.

These data are then buffered through the SMF buffering facility to a dump data set generated from the system's SMF data set. User-written or commercially available programs are then used to generate the accounting and performance management reports desired by the installation. SMF provides over 70 different types of records on a continuous basis. The records vary in size from 20 bytes to thousands of bytes. There are over 1200 different fields or unique pieces of data. For accounting purposes, network-related usage data from NPM (NetView Performance Monitor) and partially from RMF (Resource Management Facility) are applicable. For example, NPM provides the following:

- Byte counts (in and out)
- Line utilization
- Service-level indicators
- Workload unit volumes by application and by user

In order to remain compatible, most third-party vendors are using SMF record formats for their products. By doing so, value-added products that process SMF data may be utilized for their records as well. Besides IBM products, SAS and MICS seem very popular user choices. In the case of SAS, the user is expected to invest time and money for home-grown solutions. In the case of MICS, a special accounting module helps customize accounting management. Other examples are PMS from Legent, Resource Accounting System from Computer Associates, and Kommand III from Pace Technology. At the moment, network-related accounting needs more customization than accounting associated with processing facilities and storage devices.

11.4.2 General-Purpose Administration Products

This group of products was addressed and evaluated in greater detail when we were discussing configuration management, since the products are a combination of generic data-base features with special accounting characteristics. Product examples are TMIS from Telwatch, Monies from Stonehouse, Netman from Computer Associates, and PNMS from Peregrine. With these products, however, accounting is just a side benefit.

11.4.3 Telemanagement Products

The generic architecture of processing call details has been discussed in Chapter 7 and shown in Figure 5.5.1. Assuming that source data are generated in PBXs or in Centrex systems, there are basically four options of telemanagement software:

- Mainframe-based software
- Mini-based software
- Micro-based software
- Use of service bureaus

Table 11.4.1 shows the comparison of these alternatives [DANM89E and DANM89F].

Mainframe-based software

The use of a mainframe computer may be dictated by virtue of its existence in the company, or it might be the favored environment for complex systems that require sophisticated MIS support. Mainframes can handle the batch processing of high-volume call-accounting systems while providing fully integrated telemanagement applications with sophisticated functions for large organizations and communications networks. (See Table 4.4.1.)

If centralized management and control is required, mainframes can be used as the focal data-base point (e.g., NetView from IBM), working in a distributed data processing mode to provide individual locations with some level of telemanagement functionality through the use of microcomputers. The remote locations can then interact with the central data base to maintain a corporate network profile.

Mainframe telemanagement systems have many advantages. Not only do they have more processing power and higher speeds, they also have virtually no capacity limitations. They allow for multiple users and can run a variety of sophisticated applications. Generally, MIS departments are familiar with mainframe computing and will have little or no trouble supporting it—meaning less support responsibility for the telecommunications staff.

Real-time or near real-time processing is supported by NetView/PC links for the IBM environment for both PBX-type and Centrex-type services by IBM partners, such as TSB, DMW, and ITM.

Mainframe telemanagement systems have drawbacks, however. The telecommunications department has less direct control over the system, and consequent job scheduling, and will have to interact with MIS more. Although MIS is familiar with the mainframe environment, it has less operational expertise when dealing with telemanagement system support and maintenance. Users will have to put up with slower responses to change requests. They will also find higher costs associated with mainframe usage for the initial software

purchase, and, if the organization practices CPU charge-back, they will have higher internal costs.

Top industry providers of mainframe telemanagement systems include Telco Research Corp. of Nashville; Stonehouse and Co. of Dallas; Communications Design Corp. of Stamford, CT; and Cincinnati Bell Information Systems' Communications Management Systems of McLean, VA.

Mini-based software

Although the minicomputer telemanagement software option has commonly been used as a departmental solution that provides applications as sophisticated as the mainframe, the traditional distinctions between minicomputers and supermicrocomputers are becoming more and more hazy. For organizations with systems requiring multiple users, multiple applications, and high-volume capability, as well as those requiring multi-tasking and system partitioning, the minicomputer presents a viable alternative.

Using minicomputers for telemanagement allows users to have departmental autonomy, as well as immediate control over report and request turnaround times. The minicomputer operating environment can also accommodate multi-tasking and multi-user capabilities, and it has lower processing costs than the mainframe. Recent cost reductions in the minicomputer market have also enhanced the practicality of the minicomputer telemanagement solution.

The disadvantages of minicomputer software include possible limits on system capacity, greater capital investment than a microcomputer solution, and more telecommunications expertise and training in administering such an autonomous system.

The price range for minicomputer software packages is very wide. They can be found at prices comparable to both high-end microcomputers and low-end to mid-range mainframe packages.

Micro-based software

The microcomputer market for telemanagement software is growing quickly. The introducton of the more powerful Intel Corp. 80386 processing chips and local networks, as well as the promise of multi-user capabilities through IBM's OS/2, removes many of the traditional limitations of microcomputer processing.

Today, call collection buffers and background/foreground operations make multi-tasking possible. Multiple users can access microcomputer telemanagement systems today by operating in a local network environment, using multi-user personal computers, and by operating in a UNIX environment. The predominant telemanagement application served by traditional personal computer systems, such as the IBM Personal Computer XT and AT, remains single-function call accounting.

TABLE 11.4.1: Telemanagement Software Options.

	Mainframe	Minicomputer	Microcomputer	Service bureau
Advantages	• Maximum capacity limits • Multiple users • Processing power and speed • Less telecommunications support responsibility • System partitioning • Experienced mainframe support and system backup	• High capacity levels • Multiple users • Dedicated departmental processor • System partitioning	• Less capital expense and maintenance expense than mainframe or minicomputer • Dedicated departmental processor • Full system autonomy • User-friendly • Most common DOS interfaces	• Unlimited capacity • High level of telemanagement system expertise • Off-load telemanagement system responsibility • No capital expense
Disadvantages	• Less direct system control • MIS less responsive to change requests • Less MIS familiarity with telemanagement • Higher purchase and support costs • Higher operational expertise necessary	• Require more operational expertise from telecommunications staff • Limits on system capacity • Minicomputer market challenged by new microcomputer capabilities • Higher capital expense than microcomputer or service bureau	• Number of users limited by system configuration • Limits on system capacity • Slower processing and printing • Most critical backup procedures necessary	• Report lag times • User rarely has on-line capability • Applications generally limited • Data security hampered

| Political Profile | • Mainframe telemanagement system requires a strong level of interdepartmental co-operation, more technical expertise and financial investment | • Departmental system control still requires sophisticated computer and software support
• Cost varies with both hardware and software | • Direct telecommunications control over telemanagement system at the microcomputer level; telecommunications will have full system responsibility
• Most responsive to price-sensitive market | • Users have no control over system administration and are totally dependent on vendor for service
• Recurring costs |

During the last few years, management have focused much attention on the development of expanded functionality for microcomputer-based systems. The workstation is evolving into the dominant user interface to telemanagement: For example, AT&T's NetPartner product for Centrex, Software-Defined Network, and Integrated Services Digital Network management uses Sun workstations. This evolution has created a new generation of telecommunications and net management based on distributed DP approaches.

Microcomputer-based telemanagement systems require less capital investment than those based on minicomputers or mainframes, and they have lower processing costs.

Users also have the advantages of more user-friendly interfaces and more direct control over report and request turnaround times. Another important advantage is that the users have total autonomy over the system.

However, there are several disadvantages. System capacity and processing power are limited. With traditional personal computers, call record costing and report printing processes can be slow, depending on volume. Also, if not operating in a local network or UNIX environment, only one user can assess the system at a time. Total telecommunications departmental responsibility means an increased need for internal computing knowledge and training.

Again, it is important to notice the extent of improvements possible as microcomputer capabilities expand. Quite a few systems now available provide real-time call costing, allowing faster call processing when ad hoc reporting is necessary. The increasing availability of on-line inquiry eliminates the need to generate full reports. Multi-user systems can be configured around a local network using UNIX and, in the future, OS/2.

DMW Commercial Systems is one of the leading companies providing solutions to processing call detail records (CDR or SMDR) data. Data is managed by a personal computer and in some cases transferred to the mainframe for other applications such as network accounting and network design.

TeleBox [DMW89] is a microcomputer connected to the PBX that collects, compacts, and stores the data in solid-state memory. The internal modem is the communication link to the other components of the micro-based telemanagement architecture (see Figure 11.4.1). TeleBox does not have disks or tapes, making it very reliable and secure.

TelePoll is the central polling software that automatically calls each of the TeleBoxes and gathers the call records and alarm information. Critical PBX alarms are immediately reported to TelePoll by each remote TeleBox using a dial-up telephone line facility. All data collected may be forwarded to the mainframe for further processing.

This product combination is equipped with menu, status inquiry, CDR/SMDR inquiry, critical alarm list, and historical log features. In addition, polling status may be interrogated and the polling schedule may be parametrized. TelePoll keep tracks of the TeleBox data base and the calendar.

The other top vendors of integrated software applications designed to run on a microcomputer-based system are Communications Group; Comsoft Management Systems; Softcom, Inc. of New York; Telecommunications Sys-

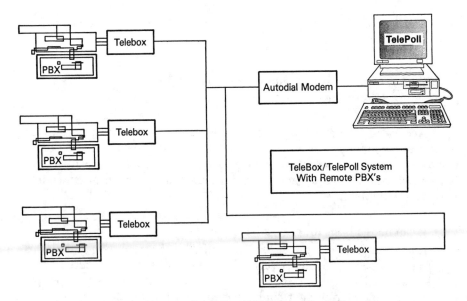

Figure 11.4.1 TelePoll and TeleBox architecture.

tem Management of Harvester, MO; TelWatch, and Xtend Communications of New York.

Service bureaus

Although the overall trend in telemanagement is toward customer-owned software, the service bureau marketplace can still provide a viable solution. For either internal or resale billing, a service bureau can handle the responsibilities of managing systems. Also, off-loading management tasks to a service bureau will obviously eliminate the high capital expenses associated with an on-site telemanagement system. Service bureau providers have also begun to sell on-site facilities management software as well as to provide off-site call accounting services.

The advantages include less internal responsibility for start-up and system cut-overs, and greater vendor familiarity and expertise with telemanagement functions. Cost savings can also be realized by off-loading the need for internal staff time, training, and capital expense.

The disadvantages center around the inability to directly access and manipulate the system applications. This can include slow turnaround times and reporting, lack of report feature customization often provided with custom report generators, threatened data security, and higher processing costs than with internal utilization.

New technology, including fourth-generation languages, portability, distributed processing, relational and object-oriented data bases, and expert systems will offer telemanagement value-added functionality and new features. In the short term, progress is expected with Electronic Data Inter-

change and host-level integration of data. In both cases, the timeliness of voice-usage related technology can substantially be improved.

11.4.4 Accounting Instruments for Local Area Networks

Accounting management enables network managers to establish fees for the use of communications resources, and to identify the cost of using those resources. Generating a report detailing each user's access to applications and LAN resources is an important tool for the LAN manager for at least three reasons: [DANM89D]

- It can be the basis for charge-back activities.
- It provides a hard copy list of all activities for that reporting period; this can also be employed for security monitoring. If subtle security problems arise later (e.g., discovery of sabotage of data), this type of report may aid in determining what happened and who did it.
- It can be a basis for LAN usage statistics, a support in planning for network expansion.

Such statistical reporting features, however, are lacking in all but a few of the currently available network operating systems. Unfortunately, no standards are available, either.

Software meters

PC software vendors are particularly concerned about product licensing; they want to keep tight control over illegal copying of their software. Obviously, a vendor does not want to sell one copy of a product to a large company, only to have hundreds of employees copy it. On the other hand, it would be quite inefficient for the LAN manager to buy as many copies of the software as there are employees. At any time, it is unlikely that thousands, or even hundreds, of people need a given application.

Vendors have devised software meters as a way of deterring illegal copying. Certain PC applications now come with built-in meters. A meter works on the same principle as a lending library. When a user starts an application, he or she checks it out of the license library and returns it when finished. If all copies are lent out, the meter returns a temporary denial.

The LAN manager may consider using meters to monitor and control software usage, as well as to provide users with enough copies without purchasing volumes of software. The LAN manager can also use the meter to keep usage statistics; this can assist "traffic engineering" of the software library.

Audit trail management tools

Audit trail systems are a key component of security management, although the function can be considered part of accounting management. Audit trail systems provide information on user activity on the LAN. Additionally, these systems can assist in billing management by providing the data needed to charge back usage.

For an audit trail system to be effective, it must provide the LAN manager with streamlined and useful information (rather than mountains of raw data). The manager may wish to audit only certain users; operations on files with certain extensions or in certain subdirectories; only certain types of operations; or certain servers. All file and directory creations, deletions, and renames may need to be reported. A system error log report, listing all system error messages to alert the LAN manager of potential problems, may be advantageous. A sophisticated audit tool must allow for this management flexibility.

Most vendors provide some form of support for accounting management, but the level of sophistication is much lower than with SMDRs. Substantial development is needed and expected in this area.

11.5 HUMAN RESOURCES DEMAND OF ACCOUNTING MANAGEMENT

The third critical success factor of network management is how people throughout the organization adapt to change. The functions discussed thus far should be adopted in the existing organization, starting with the information systems department. Based on the functions, processes, and procedures outlined, targets of organizational change can then be determined. Table 11.5.1 summarizes the relationship of potential organizational units to the key functions of accounting management. The letters in this table represent execution of duties, supporting, or advising.

The same table may be used as a starting point for estimating the range of labor demand for managing the accounting processes. Accounting management is usually staffed by three different kinds of personnel:

- Costing specialist
- Accounting clerk
- Charging specialist

Table 11.5.2 shows the distribution of functions among those human resources. In order to limit the alternatives for a tool's selection, Table 11.5.3 gives an overview of instrument classes under consideration for accounting management and of their potential users in the accounting management hierarchy.

TABLE 11.5.1: Involvement in Accounting Management.

Functions	Other Subsystems						
	Configuration management	Fault management	Performance management	Security management	Accounting management	Network capacity planning	Level of possible automation
Identification of cost components	S	S	S	S	E	S	low
Establishing charge-back policies			A		E	A	low
Definition of charge-back procedures			A	S	E	A	low
Processing of vendor bills	S	S			E		high
Integration of network accounting into the corporate accounting policy					E	S	medium

E = Executing
S = Supporting
A = Advising

TABLE 11.5.2: Distribution of Functions Among Human Resources.

Functions	Organization			
	Supervisor	Costing Specialist	Accounting Clerk	Charging Specialist
Identification of cost components	(x)	x	(x)	
Establishing charge-back policies	(x)			x
Definition of charge-back procedures	(x)			x
Processing of vendor bills			x	
Integration of network accounting into the corporate accounting policy	x	x		

x = Commitment

(x) = Involvement

TABLE 11.5.3: Tool-Applicability Matrix by Personnel.

Tools	Organization			
	Supervisor	Costing Specialist	Accounting Clerk	Charging Specialist
Monitors in network elements				
Application monitors		x	x	x
Software monitors		x	x	x
Modem and DSU/CSU monitors				
Multiplexer monitors				
Switch monitors				
Line monitors				
Network monitors				
PBX monitors		x	x	x
LAN/MAN monitors		x	x	x
Network element management systems				
Voice orientation	x	x	x	x
Data orientation	x	x	x	x
Console management systems				
Integrators	x			
Computerized cable management systems				
Automated call distributors				
General purpose data bases			x	x
Special administration products			x	x
Networking models				
CDR/SMDR tools	x	x	x	x

X = Applicability

(X) = Limited applicability

TABLE 11.5.4: Personnel Requirements for Accounting Management

| | Network Range | | | |
Organization	Small <3000	Medium 3000–10,000	Large 10,000–50,000	Very Large >50,000
Supervisor	1	1	1	1
Costing specialist	1	2	2	3
Accounting clerk		1	2	3
Charging specialist	1	1	3	3
Human resources demand				
Total	3	5	8	10

TABLE 11.5.5: Profile of Accounting Management Supervisor.

Duties

1. Assists in financial forecasting and budget preparation.
2. Oversees documentation and recording of network expenditures and charge-backs.
3. Assists in bill verification.
4. Integrates network accounting into corporate accounting.
5. Judges the level of accounting accuracy.
6. Unifies voice and data accounting procedures.
7. Supervises the product selection process.
8. Establishes educational program for staff.

External job contacts

1. Other supervisors within network management
2. Corporate accounting
3. Network manager

Qualifying experience and attributes

1. Has knowledge of customer's business
2. Has financial administration ability
3. Has in-depth knowledge of accounting procedures
4. Has ability to communicate well with vendors
5. Has training in administrative management

TABLE 11.5.6: Profile of Costing Specialist.

Duties

1. Identifies cost components.
2. Collects information on costing items.
3. Activates monitors for data collection.
4. Customizes monitors to the specific needs of the larger organization.
5. Follows corporate guidelines for costing.
6. Helps in defining the accounting policy.

External job contacts

1. Charging specialist
2. Corporate accounting
3. Accounting clerk

Qualifying experience and attributes

1. Training in business administration
2. Ability to handle clerical work
3. Specific know-how of advanced costing techniques
4. Knows SMDRs

TABLE 11.5.7: Profile of Accounting Clerk.

Duties

1. Helps in identifying cost components.
2. Evaluates accounting information.
3. Determines the accounting equation.
4. Supervises the periodic accounting processing.
5. Checks accounting accuracy.
6. Verifies vendor bills for voice and data.

External job contacts

1. Costing specialist
2. Charging specialist
3. Corporate accounting
4. Vendors

Qualifying experience and attributes

1. Training in business administration
2. Ability to handle clerical work
3. Specific know-how of advanced accounting techniques
4. Knows SMDRS

TABLE 11.5.8: Profile of Charging Specialist.

Duties

1. Determines the charge-back policy.
2. Implements and supervises the charge-back policy.
3. Helps in identifying cost components.
4. Helps in establishing the accounting equation.
5. Supports service-level negotiations.
6. Trains users in charge-back.

External job contacts

1. Costing specialist
2. Accounting clerk
3. Corporate accounting
4. Vendors
5. Corporate internal users

Qualifying experience and attributes

1. Training in business administration
2. Ability to handle clerical work
3. Specific know-how of advanced charge-back techniques
4. Communication skills

For estimating the demand in FTEs (full-time equivalent), Table 11.5.4 provides quantification of the four major customer clusters introduced and defined in Chapter 1. The numbers represent averages, and are based on the results of many surveys and interviews conducted by the author.

In order to help in the hiring and building of the accounting management team, Tables 11.5.5 to 11.5.8 give typical profiles for each of the accounting management personnel, including the group's supervisor. And, finally, the function/skill matrix, shown in Table 11.5.9, gives a summary of the targeted skill levels for each individual accounting management function.

TABLE 11.5.9: Responsibility/Skill Matrix.

Functions	Skills					
	Special knowledge of function	General knowledge of communication facilities	In-depth knowledge of communication facilities	Some knowledge of business administration	Communication skills	Some knowledge of project management
Identification of cost components	x	x	x	x	x	x
Establishing charge-back policies	x				x	x
Definition of charge-back procedures	x					
Processing of vendor bills	x	x		x		
Integration of network accounting into the corporate accounting policy	x			x	x	x

X = Skill is required by function

515

11.6 SUMMARY

Practical recommendations for accounting management include guidelines for *doing* certain things and for *avoiding* other activities. These guidelines are useful for both short- and long-range improvements in the area of accounting management.

Do

- Process
 Define Network Management Center accounting policy through representative corporate steering committees. Document the policy. Circulate it. Get signoffs, if possible.
 Remain flexible on cost and charge-back policies.
 Define and document explicit accounting procedures: costing, billback, vendor verification.
 Investigate Network Management Center status as a profit center.
- Products
 Continually review new products. When cost/benefit is justified, purchase and install these products.
- People
 Cross-train, where appropriate, Network Management Center personnel in cost, billback, budget, and verification principles and procedures.

Avoid

- Process
 Politicizing costing and charge-back policies.
 Neglecting to write and document procedures and policies.
 Bypassing corporate accounting policies.
- Products
 Using products that do not support an integrated accounting policy.
 Buying products without on-line inquiry functions.
- People
 Underestimating accounting personnel requirements.
 Allowing personnel to keep procedures "in their heads" only.

12

Network-Capacity Planning

Network-capacity planning is the process of determining the optimal network, based on data for network performance, traffic flow, resource utilization, networking requirements, technological trade-offs, and estimated growth of present and future applications. Sizing rules and interfaces to modeling devices are considered parts of the planning process.

12.1 INTRODUCTION, ISSUES, AND OBJECTIVES

The principal objectives of this chapter are:

- To discuss the major functions of network-capacity planning
- To define the interrelationship of the functions
- To determine information interchange with other network-management activities
- To summarize the implementation considerations, including the demand for human resources to support network-capacity planning
- To construct a responsibility/skill matrix to help in identifying network-capacity planning functions

In addition to the issues prevalent today (Chapter 1), more specific problems are seen in the network-capacity planning area, which may be categorized as follows:

- Lack of proactive contingency planning, resulting in severe capacity and performance bottlenecks during emergencies and outages of key network components
- Unsatisfactory connections to business plans which may cause serious delays in provisioning resources to support new applications, new locations, or both
- Unsatisfactory quantification of user's needs in terms of future networking services, resulting in planning overcapacity or failure to plan for sufficient capacity. In both cases, unnecessary expenses will be incurred.
- Lack of integrated tools to help in the capacity planning process; instruments usually address segments only, such as cost, performance, facilities, or equipment. Furthermore, links are usually missing to the actual configuration data base and to valid tariff data bases.
- There are very few people available who understand strategic plans, user needs, and state-of-the-art technology combined with the know-how to design and size communication networks.

In summary, difficulties in quantifying user needs and demand for resources seem to be the principal challenges involved in improving network-capacity planning efficiency.

The following sections will address the major processes, functions, and instruments of network-capacity planning.

12.2 NETWORK-CAPACITY PLANNING PROCESSES AND PROCEDURES

It is time-consuming and labor-intensive to plan the changes required to keep the corporate communication network effective as a strategic asset while maintaining acceptable expenses. Capacity planning requires extensive knowledge of changing corporate business plans, their impact on the existing communication network, and advances in communications technology and architecture.

The ultimate goal of network resource planning is to meet service-level agreements using optimal resource capacity at reasonable cost. Network optimization can be viewed as the process of balancing design factors to attain the best network configuration within the constraints of such factors as availability, performance (response time), and cost. During the optimization process when one factor is held constant, the interaction of the others must be quantified, since each variable, when held constant, affects all the others [HAVE88].

Figure 12.2.1 shows a simple example explaining the interaction of the indicators mentioned. The curve itself is a nonlinear, quasi-step function. Cost will produce a discrete step on a curve, but performance and availability may produce nonlinear steps. This is shown in greater detail in the close-up view in Figure 12.2.1(c). Changes in components, hosts, modem speeds, and line topology produce changes on the X and Y axes. If the speed of one network

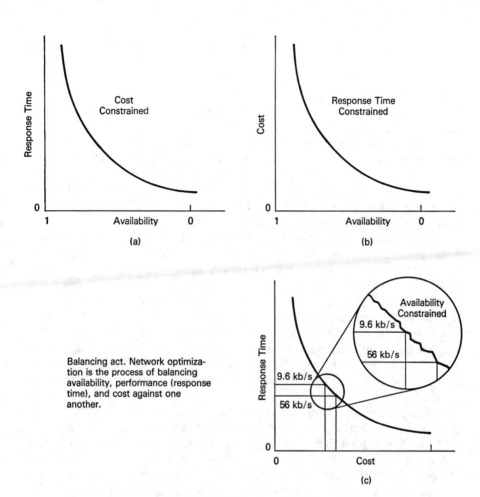

Figure 12.2.1 Network optimization.

line is increased to 56 kbps from 9.6 kbps, the user will notice the difference. But the change may have a minor effect on total system performance for a network composed of many lines. The net effect of minor changes may almost appear to produce a continuous curve.

In Figure 12.2.1(a), the same cost will produce greater availability with lower performance or lower availability with greater performance. The figure applies to a large backbone system with alternate routes. The failure of one route can force the data to travel over multiple node hops, thus increasing the response-time delay. There is a cost built into the network configuration for a level of availability since the alternate routes have to be sized to handle the newly routed traffic. Voice traffic may not have to be sized because it can be off-loaded to the public switch. The higher the availability, the greater the data capacity that must be held in reserve for possible alternate routing. This will also apply to having two 9.6 kbps lines operating in parallel. This provides greater availability but less performance than one 19.2 kbps line.

In Figure 12.2.1(b), the same performance produces greater availability with increased cost, or lower availability with decreased cost. An example of a response-time constraint is when an analog line modem is replaced with a modem of the same speed but a newer technology. Cost has increased because of the cost of the new modem; availability should be improved because of the new technology. Response time has stayed constant.

Network availability can be improved through several means: redundancy, alternate routing, using higher availability digital lines, and minimizing the length of any outage by automating network operations. Network managers will always strive to maximize availability and performance within cost constraints but in the long term any increase in availability or performance generally requires a corresponding increase in cost.

In voice networks, approximately 75% of the cost is allocated to tariff charges. After all, standard telephone instruments have little bearing on the total system communications cost. Generally, data networks have a reversed relationship, with approximately 25% being spent on link tariff charges and the remainder spent on front-end processors, communications controllers, modems (or office channel units—a combination of DSUs and CSUs), remote control units, multiplexers, host and remote terminal hardware, hardware and software maintenance, and, of course, help desk support for the communication network. Data networks also use such hardware as concentrators, multiplexers, modem technologies, and multi-point line bridging to lower network costs.

The percentage of communications costs allocated to links should start to shift as voice and data networks are integrated. In a digitally integrated network, the differentiation of voice and data line charges will blur. The Integrated Services Digital Network (ISDN) will also blur voice and data networks by combining voice and data connections over one physical line. The availability optimization processes for voice and data networks have similar goals.

Even though a line may be point to point, there are many private-line tariffs. Before AT&T's divesiture in 1984, there were about two hundred special tariffs for pricing local circuits. Today there are more than eight hundred special private-line tariffs.

The private-line pricing structure has been evolving since divestiture. With the escalation of installation charges and multiple tariff changes each year, a network manager will think twice before making network changes to take advantage of tariff pricing abnormalities; since they can change again within a few months.

In Figure 12.2.1(c), the same availability produces better performance with increased cost or worse performance with decreased cost. If a digital 9.6 kbps line is increased to 56 kbps, the system cost will increase as a result of the higher tariff and more advanced equipment cost, but response time will be decreased (improved performance). The assumption is that the availability of the two digital services is about identical. This is shown in the close-up view of the "availability constrained" chart, Figure 12.2.1(c). In this example, the

new 56-kbps line should provide extra capacity to provide greater throughput and improve response times. This assumes a similar workload before and after the installation.

Figure 12.2.2 shows the general process of network capacity planning in four phases:

Phase 1. Determining and Quantifying Current Workload. This step measures the current workload and provides a technique for decomposing it into components that represent discrete business segments. This first phase in planning network capacity should also be repeated periodically (e.g., quarterly, semiannually, or as needed), and followed by a comparison of actual vs. projected resource consumption for that period which was made as part of the last long-range planning cycle. Measurement tools and procedures need to be identified and, if needed, developed and documented so the characteristics of the current workload can be understood. Comparing calculated and measured resource utilization helps highlight planning gaps, avoid resource consumption misinterpretation, and identify overhead components.

Phase 2. Projecting Future Workload. This requires the planning analyst to communicate with the end-user community, with application developers, and with strategic business planners to obtain input regarding future application workload. The planner's interpersonal and analytical skills are needed to transform into valid workload components the subjective data supplied by people with little understanding of network operational issues. This is the most critical and difficult phase in any capacity study.

Phase 3. Developing the Network Capacity Plan. This phase relies heavily on technical guidelines for characteristics of the hardware/software environment—consisting of the network's links and nodes. Interfaces to the processors' capacity planning and network design are included. After the update points are determined, implementation schedules must be planned which take into consideration lead times for design and provision of facilities and equipment.

After all three phases are completed, the capacity plan is documented and presented to information systems management.

Phase 4. Implementation. This phase includes requests for proposals, the selection process, preparing operations and conversion plans, elaborating backup and recovery procedures, schedule cutover, prototype and stress testing, and finally dealing with the actual customer.

In order to successfully support network capacity, the following information is necessary:

- Primary demand
 Actual network
 Actual workload and its characterization for resource demand
 Business plans
 User needs

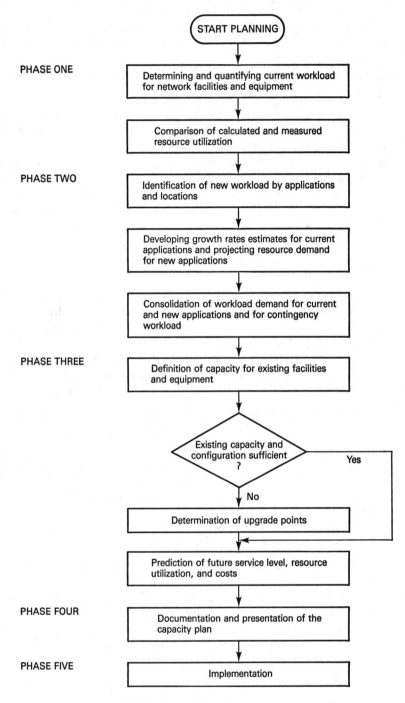

Figure 12.2.2 Network-capacity planning process.

Resource demand of future application
Future workload volumes and growth rates
Latent resource demand
Overhead of present and future communication applications
- Secondary demand
In-depth knowledge of network facilities and equipment
Performance indicators and measurement results
Resource utilization figures
In-depth knowledge of state-of-the-technology for facilities and equipment

12.3 NETWORK-CAPACITY PLANNING FUNCTIONS

Network-capacity planning functions were identified in the introductory part of this chapter. Now, typical processes, structures, architecture, and practical examples are given to foster better understanding of how the functions work and how they are interrelated.

12.3.1 Determining and Quantifying Current Workload

Figure 12.3.1 illustrates the principal steps involved in the process of determining and quantifying current workload.

Determining the number of studies to perform

Prior to performing a network-capacity planning study, the number of individual studies required for a business unit must be determined. This depends on the nature of applications supported for a given business unit.

The following list gives alternatives for segregation of the communication load:

- Workload type (application groups)/(similar to CPU studies)
Data processing
Process control
Scientific
Engineering
Office automation
Factory automation
Test
Housekeeping
Military
Others
- Communication forms
Video
Data

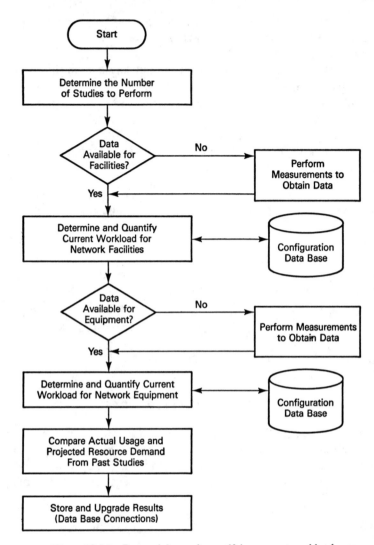

Figure 12.3.1 Determining and quantifying current workload.

Voice
Facsimile
- Communication architectures
 SNA
 DNA
 Others
- Communication facilities
 Leased lines
 SDN (Software Defined Network)
 Switched links
 Packet switching

T1, T3, ISDN
Dial-up

- Communication equipment
 Front-end processors
 Modems
 Multiplexers
 Electronic matrix switches
 Private branch exchanges
 Local area networks

Quantifying current network facilities workload

The first step in performing the network capacity study consists of collecting, analyzing, and classifying resource data that reflects recent usage. "Resource" is used as a generic term and means network *facilities* and network *equipment*. The purpose is to build a profile of the application systems that make up the current workload.

Workload characterization involves developing a statistically valid description of host system and network workloads that is intelligible to the organization and can form the basis for projection techniques. This consists of understanding past (historical) workloads. The following workload characteristics are relevant:

- Deadline requirements
- Application cycles
- Daily cycles
- Weekly, monthly, yearly cycles
- Service requirements, such as availability and response time
- Intensity of use of certain applications

The second step involves clustering techniques to categorize resource demand. For each business unit, the workload characteristics of each application on the individual facilities and equipment used to transport transaction data to/from the application has to be clearly described.

The third step correlates business elements with the resource demand, known as natural forecast unit, or NFU. The results—the factors in the equations—are utilized for workload projection.

Preparation of Input. Forms 1 and 2 (Tables 12.3.1 and 12.3.2) must be completed to identify input for resource demand consolidation.

Determine Application Groups. The classification has to be generic in nature. Not only existing data-processing applications, but also more general applications supported by other than just data communication forms (such as voice, imagery, or video) will be identified. For example, individual configurations of transmission facilities, such as line speeds, communication equip-

TABLE 12.3.1: Form 1

APPLICATION RESOURCE DEMAND

Month_____ Year_____

Network Resource Demand Information

Transaction Profile for Workload elements	Appl. Code	NFU	Length In	Out	TX/Day	TX/Hr	TX(peak)/Hr
WORKLOAD							
PRODUCTION							
IMS							
CICS							
TSO							
APS							
AS							
TEST							
IMS							
CICS							
TSO							
APS							
AS							

Data prepared:

Prepared by:

Network resources study period:

Business Unit:

Appl. code includes: Job group code, subgroup code and account codes.

ment, and so on, would be identified. For level three (see Table 12.3.3), specific applications will be further broken down by specific resource demand.

The process involved in breaking down the total workload from a given CPU complex into workload groupings consists of an initial grouping of applications, followed by a review of data based on these groups, and then a refinement of the initial job groupings. These steps apply to any computer complex and are explained in detail next.

Application group development: The applications processed in a particular installation may satisfy a number of different business objectives. Because

TABLE 12.3.2: Form 2

DISTRIBUTION FREQUENCIES by LOCATION

Month_____ Year_____

Geographical Locations	TX/Day	TX/Hr	TX(peak)/Hr	TX(peak/s)
Location 1				
Controller 1				
Application 1				
Application 2				
Application n				
Controller 2				
Application 1				
Application 2				
Application n				
Controller n				
Application 1				
Application 2				
Application n				
Location 2				
Location 3				
Location n				

Data prepared:

Prepared by:

Network distribution frequency study period:

Business Unit:

of this, any prediction of changes in workload can most easily and accurately be made by identifying and grouping applications that satisfy similar business objectives.

Grouping of on-line applications may be accomplished through a hierarchical approach as follows:

1. Separate test and production applications.
2. Within the production grouping of on-line and batch applications, separate similar major applications into groups according to their business objectives. Testing may also be separated into groups if the load is sufficiently large to warrant detailed resolution.
3. Separate ad hoc end-user processing into appropriate job groupings.
4. Separate bulk transmission of batch information.

TABLE 12.3.3: On-Line Workload Grouping.

LEVEL 1

LEVEL 2

LEVEL 3

```
                          ONLINE
                    /       |       \
                   /        |        \
          PRODUCTION      TEST      END-USER           BATCH BULK
            /    \                   /      \          TRANSMISSION
           /      \                 /        \
    HR INQUIRY   SALES    BILLING  INFO     OFFICE
                 ORDER    INQUIRY  CENTER   SERVICES
                 ENTRY
```

Each job group should consist of applications that share a common growth factor or that are driven by a common facet of the business. A growth factor is the expected rate of change (either increase or decrease) of the resource requirements for an application. Such growth factors apply to natural forecasting units (NFUs), such as number of employees, number of checks processed, tickets issued, time cards entered, or programs compiled.

This hierarchical grouping of on-line workload is illustrated by Table 12.3.3.

When separating applications into job groups, several factors should be considered. It must be emphasized that applications should be grouped to identify current usage and to predict growth in future usage. As such, the load levels for each of the applications in a job group are summed to represent the overall group workload requirements. Thus, in order to predict the growth of the job group, the applications within that group must share a common growth factor. For example, payroll and personnel applications would both be dependent on the growth in number of employees. Increases in testing may be related to the number of programmers or the number of new products. Ad hoc end-user processing workload may show a dependency on the number of PCs with mainframe linkages, or upon the number of users trained in the use of certain information center offerings.

For some areas of production work, it may be found that resource usage grows at a rate similar to a particular business activity, such as sales volume, inventory level, or the creation of service orders. Such relationships should be identified and are important because of the emphasis on the relationship between increases in business, increased computer usage, and computer hardware requirements. In other words, analyzing the correlation strength between the indicators of the business plan and the network-capacity plan is extremely important.

Group sizing: Ensure that the number of application job groupings are large enough to gain sufficient growth resolution, while small enough to be easily studied and manipulated. Furthermore, each job group should, in itself, represent a significant amount of the total workload. Nominally, 20 job groups will represent the workload in a large data center. Installations providing a small number of discrete services to a single user community may need less than 10, while data centers serving a multiple customer base (e.g., an area data center) may require more than 20.

Taking the hypothetical workload breakdown previously illustrated in Table 12.3.3 as an example, each category is shown with its percent of total load and the factor that influences growth in workload as described in Table 12.3.4.

A brief description of each application group (e.g., on-line testing, batch bulk transmission, inquiry, and so on is recommended.) The NFU of each job group should also be documented. The monthly growth percentage of the NFU should be entered in the network resource demand column.

Method of Grouping. After identifying application groupings (on-line testing, office systems, and so on), the next step is to determine what job

TABLE 12.3.4: Workload Characterization Example.

Category	% of Total	Growth Factor (NFU)
Human Resource Inquiry (Personnel)	10%	Number of corporate employees
Batch Production—Billing (Bill transactions for remote printing)	20%	Quantity of product sold and number of customers
On-Line Test	10%	Size of future application and number of remote programmers
On-Line Production—Sales Order Entry	20%	Quantity of product sold
On-Line Production—Billing Inquiry	15%	Quantity of product sold
End-User—Info Center	10%	Number of service offerings and number of trained users
End-User—Office Systems	15%	Number of workstations connected

accounting or data collection information is best suited to accomplish the accumulation of detailed usage data into this high-level grouping.

For accumulating the existing resource demand of facilities and equipments, the known techniques may fail due to lack of information about facilities at the physical usage level and about equipment not included in the data collection facility employed. Resource consumption for voice communication requires completely different techniques. As described later, resource utilization data may be collected by a variety of instruments.

Validate Grouping. The planning analyst must now validate and verify that the initial jobs selected adequately depict the current computer resource load. The application grouping information must be input to the forecasting program, after which a trial run of the program against actual network, and application-related accounting data must be conducted to verify that the data collection process is complete and that the forecast program is correct. This may be accomplished because the actual measurements should coincide with the output of the forecast program since the existing configuration is being modeled. Typically, some modification in the initial application groupings will result from this process. Form 1 (Table 12.3.1) should be modified to reflect these changes.

The grouping is important for forecasting networking needs, but only when those needs can be broken down further by geographic areas (e.g., identification by line); otherwise, the grouping is only important for resource utilization forecast at a global, probably processor, level.

Base Month Selection. After examining data from several months, a base month can be determined. The purpose of this step is to ensure that the utilization levels for most of the application groups are representative of all the months examined. Individual groups that have utilization levels that are not typical for the selected month may be manually adjusted to be more representative prior to executing the forecasting step. Use of the regression

technique should reduce the need for manual adjustment of specific application groups which may be atypical in any given month.

Shift Percentages. The next step involves analyzing the workload during different times of the day, week, and month. The cumulative information for all months of accounting data examined is used to determine a percentage distribution of the workload on a shift-by-shift basis for each application group. Providing multiple months of data as input will average out shift differences due to minor scheduling changes that occur from month to month.

Busy Hour. Due to the different time zones, peak load considerations are more important than just looking at shift averages. In all data centers, the goal is to offer adequate service even in peak load periods. Heavy load may occur occasionally, due to bulk data transfer if alternate processors have to be used for availability and/or for financial reasons.

The concept of peak (busy) hour is helpful in designing networks. This hour refers to a continuous period of any day during which the intensity of traffic is at its maximum. The peak (busy) hour is a statistical tool that allows the system planner to accommodate and engineer for peak traffic and avoid long delays during system peaks. There are two common ways to determine the busy hour (for further details, see Table 12.3.5):

- **Time constant busy hour:** Record the transaction and character volumes transmitted during each hour of the business for the specified study time. The example uses one week, but most studies utilize a period of at least one month. Total the transaction and character volumes for each hour during days studied. Choose the hour with the highest average transaction and character counts and engineer for that hour.
- **Bouncing busy hour:** Record the transaction and character volumes transmitted during each hour of the business for the specified study time. Determine which hour per day has the highest volume. Total all the hours with the highest volume and divide the sum by the number of days studied. The final solution should be used when engineering the system. More circuits may be required when utilizing bouncing busy hour, but peak traffic patterns may not suffer from delays as rapidly as other designs.

Collecting Workload Data to Arrive at the Busy Hour. In the process of characterizing workloads by resource demand and service level, several instruments can be very helpful:

- **Application monitors** (e.g., IMSLOG, Performance Analyzer, IMF, CONTROL/CICS) help to extract information for the application subsystems in the mainframe computer that indicates elapsed time, processing, queue length, and processing frequencies.
- **Communications software** (e.g., VTAM, NCP, and NetView) assists in extracting communication-oriented resource information such as avail-

TABLE 12.3.5: Comparing Constant and Bouncing Busy Hour.

	Time Constant Busy Hour										
	8	9	10	11	12	1	2	3	4	5	6
Monday	67	81	93	101	98	96	123	131	104	86	42
Tuesday	62	76	89	102	96	98	122	119	110	96	54
Wednesday	71	84	86	88	94	92	121	123	112	87	49
Thursday	64	82	83	110	94	92	119	126	110	98	55
Friday	71	87	88	115	102	91	112	108	96	72	39
Total:	335	410	439	516	484	469	597	607	532	439	239
÷ 5	67	82	88	103	97	94	119	121	106	88	48

Choose load during the largest average hour (121 in this example)

	Bouncing Busy Hour										
	8	9	10	11	12	1	2	3	4	5	6
Monday	67	81	93	101	98	96	123	131	104	86	42
Tuesday	62	76	89	102	96	98	122	119	110	96	54
Wednesday	71	84	86	88	94	92	121	123	112	87	49
Thursday	64	82	83	110	94	92	119	126	110	98	55
Friday	71	87	88	115	102	91	112	108	96	72	39

Highest Hour for Each Day

Monday	131
Tuesday	122
Wednesday	123
Thursday	126
Friday	115
Total:	617
÷ 5	123 = Load for Bouncing Busy Hour

ability, message length, and sent or transferred information by application and by resource, such as CPU, FEP, TCU, and CRT.

- **Network monitors** extract information on digital interfaces (e.g., RS-232, V.24, X.21, V.35, and RS-449) for supervising networks and reporting service levels and transmission-oriented resource demand, such as user response time, line load, and accuracy by physical and logical network users.

- **Hardware monitors** (e.g., TITN, Questronics) collect information on the resource demand and utilization wherever electronic signals are available.

- **Software monitors** gather data on resource utilization, such as lineload (e.g., NPM, NetSpy, Mazdamon) and channel and processor utilization (RMF, QCM, CMF) by physical and/or logical network users.

A more advanced approach uses a network-management data base instead of single instruments for generating the desired communications facilities workload. The network-management data base is typically fed data issued by several of the above instrument types. The capacity planner acquires several segments of the network-management data base and generates reports and displays. As with past workload characterization, the traffic figures in the network should be evident. These figures show the resource demand on transmission components of the network such as front-end processors, modems, multiplexers, concentrators, control units, lines, and so on. Included in the network-management data base must be an awareness of the network configuration (e.g., equipment and location, and the facilities used to connect them).

Traffic recording machines provide a summary of the transmission traffic flow. This traffic is an acceptable approximation of the offered traffic if the measured circuit group experiences a low level of congestion. As congestion increases, it becomes desirable to measure the number of call attempts, the duration of periods during which no circuits are available, and the number of call attempts experiencing poor service as a result of congestion. It should be noted, however, that it is very difficult to use anything but the carried traffic to configure circuit groups because not many measurements are available to identify blocked traffic waiting to gain access to the network. In addition, most information provided is concerned with the specific component or chain of components constituting a route, as opposed to a group of routes (e.g., measurements for individual FEP-to-FEP trunk lines do not describe the dynamics of the transmission group of the lines combined).

Usually, there are noncoincident busy hours throughout the network. This is obvious in a network spanning a large country, such as the United States, where several time zones are involved. This may also be true for local networks due to different patterns of calling from business and residential networking locations. Traffic call logs are available in almost all countries. The traffic log data, usually supplied in the form of a magnetic tape, is furnished by the telephone company providing that data.

Shortcomings and Uncertainties. The next step in characterizing present traffic consists of determining the peak hour traffic for the busiest days under consideration. The traffic data are then associated with each customer's terminal or even with logical applications. However, some shortcomings of traffic data collection should be considered as they may result in an incomplete understanding of traffic flow:

- Registration only of traffic carried; the demand traffic must be estimated
- Malfunction of the traffic data recording equipment
- Data-handling errors

These shortcomings also influence the accuracy of network-capacity planning.

Traffic-oriented information may be stored in a specific area of the network-management data base. Traffic-oriented performance measurements

may acquire a changing role in the near future. Information networks will carry all types of digital information, supporting new services such as videotex, electronic mail, teleconferencing, voice mail, image communication, digital speech, ad hoc PC file transfer and graphic downloads, and motion picture communication. The structures may remain similar with respect to distributing functions (concentrating, multiplexing, switching, and transmitting), but the evolutionary development of measurements is required to allow for separation and differentiation among the various types of traffic.

Uncertainties about traffic characteristics arise because of several factors:

- Unknown traffic volumes, for example, the traffic behavior of interactive videotex users and the (probably very impatient) office communication users are hardly known. Most of the new traffic types show a very low utilization factor ("bursty" traffic); this requires careful resource multiplexing based on live environment monitoring.
- Growing importance of message lengths regarding distributed storage requirements.
- Mixed traffic; different types will be merged at various performance relevant network points and levels (e.g., at ISDN access points, where different services can be called successively), by multiplexing on transport or network real-time traffic. Mixed traffic requires extraordinary optimizations.
- Uncertainty about varying loads of new traffic (busy hour depends on several conditions).
- Supporting new network types, which includes local area networks, public branch exchanges, and satellite and terrestrial links. The collection of traffic-oriented indicators is difficult due to various speeds, highly variable distance, differentiation in bandwidths, and uncertain performance characteristics.
- New network components with time-critical or unknown performance or traffic behavior; for these units, either usual model assumptions do not hold or only insufficient performance models exist. These components are:
 — Small, distributed systems or multi-user workstations because Poisson assumptions of job arrival rates do not apply or are insufficient. Network gateways will always have unsatisfying performance.
 — Stations imposing mixed traffic.
 — Personal computers; their traffic behavior is uncertain, especially if they access a common shared resource.
 — Mail and archive accessing systems.
 — Routers, bridges and protocol converters may alter network addressing, making it difficult to trace a transaction through the network. Also, they may add additional protocol layers that extend message sizes.

Quantifying current network equipment workload

At present, it is extremely difficult to obtain quantitative resource utilization data on network equipment such as front-end processors, multiplexers, modems, switches, and gateways connecting local and/or wide area networks.

Front-End Processors. For IBM and compatible front-end processors, there are certain measurement capabilities, including NPM, NetSpy, and Mazdamon (see Section 9.4 for details). However, application unit level is almost impossible to detail. The instruments provide global utilization level indicators only. Otherwise, the procedures for capacity planning are identical to those of CPUs. As advanced peer-to-peer communications (LU6.2) transactions become more prevalent, the capacity planning for FEPs will become more similar to planning for gateways.

Multiplexers. The application relevance is nonexistent. Depending on the global load and multiplexer's capacity, application entities may be supported. But, at the moment, there are no techniques to determine the resource demand of certain applications within the multiplexer. Multiplexer protocols are often vendor-proprietary, and in cases where data substitution is utilized to protect control information, it is difficult to judge the overhead required to transmit an application's traffic across the multiplexed link.

Modems. The application relevance does not exist. Depending on the global load and modem speeds (capacity), application entities may be supported. But, at the moment, there are no techniques to determine the resource demand of a certain application.

Switches. There is no application relevance and there is no actual load. The switch provides a physical path between parts of the front-end processors and the digital side of communication facilities.

Gateways. Gateway is a generic term describing conversion between different architectures. For network-capacity planning, the high-level gateways—operating at the application layer—are relevant. Without special monitoring software, it is almost impossible to get the resource demand broken down by application units.

End-user devices. For end-user devices (workstations and terminals), the following data need to be collected:

- Response time for end-users
- User time (thinking and key-in time)
- Number of devices

Using these data as source, both total life cycle of transactions and busy hour usage per device can be calculated, as described in the following equation:

Busy hour usage = Number of transactions per device
$$\times \text{ Total life cycle of transaction} \qquad (12.1)$$

Figure 9.3.2 shows the components of the end-user level response time, which represents the total life cycle of the transaction.

In summary, it is assumed that this equipment is operating at the physical level and that its resource demand is "driven" by communication facilities. Sizing is accomplished by implementing static-defaults values recommended by manufacturers.

Comparing actual usage with projected resource demand

This section applies to those corporations that have previously produced network-capacity planning studies using the methodology.

Using data collection techniques, the deviations between projected and actual resource consumption can be shown. If deviations are significant (greater than 15%), the capacity planner is expected to identify the reasons. Possible reasons are:

- Too global data for workload projection
- Underestimation of contingency workload
- Overestimation of the impact of data compression and compaction
- Forecasting errors for the workload volumes
- Planning errors in terms of selecting the base month, week, or hour
- Resource capacities have not been accurately estimated
- Underestimation of overhead
- Inaccurate availability estimates for the resources
- Wrong selection of NFUs
- Wrong selection of quantities
- Wrong characterization by application groups

In most cases, a combination of reasons applies. After several planning cycles are studied, the most probable causes for deviation become more identifiable.

Determination of present resource utilization

In order to focus on the most important information to be collected, the following example will work with an oversimplified network, supporting four applications. The applications are supported by two processors. Figure 12.3.2 contains the configuration. Table 12.3.6 gives a summary of resource demand by applications. Table 12.3.7 summarizes frequency as found in accounting or monitoring packages for geographical locations and represented by control units (CU) 2, 3, and 4.

Using the information available, the following computations can be accomplished:

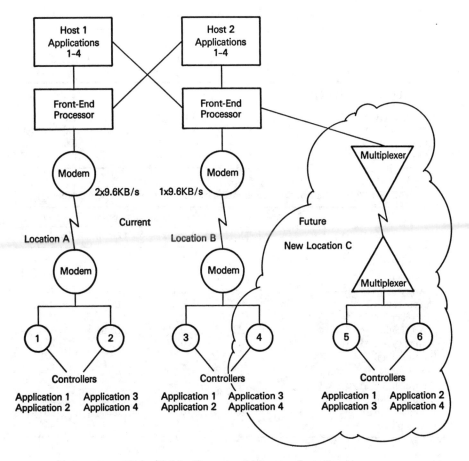

Figure 12.3.2 Current and future configuration.

- Number of transactions per hour and per day by application and by location
- Number of transactions during peak hours by applications and by location
- Number of transactions during one average second during peak hours by application and by location
- All the preceding at the global focal data center level, distributing application load by processors as indicated in Figure 12.3.2
- Computation of utilization of communication facilities as indicated in Figure 12.3.2

Assuming the configuration shown in Figure 12.3.2 and Tables 12.3.6 and 12.3.7 with actual resource demand and volume data, the results are:

1. Resources available for both locations 1 and 2 are 9.6 KB/s communication lines.

TABLE 12.3.6: Resource Demand by Application.

Transaction Profile for Workload Elements	Appl	NFU	Length (Bytes) In	Out
WORKLOAD ELEMENTS				
APPLICATION	1		200	800
APPLICATION	2		300	1200
APPLICATION	3		100	1100
APPLICATION	4		400	1000

TABLE 12.3.7: Distribution Frequencies by Location for Current Workload.

Locations	Transaction Profile TX/H	TX(peak)/s	Length	Total char/s
LOCATION A				
Controller 1				
Application 1	300	0.17	1000	170
Application 2	400	0.22	1500	330
Controller 2				
Application 3	200	0.11	1200	133
Application 4	300	0.17	1400	238
Location total				871
LOCATION B				
Controller 3				
Application 1	500	0.28	1000	280
Application 2	200	0.11	1500	165
Location total				445

2. Net resource utilization = (0.871×8) KB/s / 19.2 KB/s = 0.36, corresponding to 36% utilization of the line for location 1.

3. Measured line utilization = 49%.

4. Difference = 13% due to overhead caused by control characters (headers and retransmissions).

5. Net resource utilization = (0.445×8) KB/s / 9.6 KB/s = 0.37, corresponding to 37% utilization of the line for location 2.

6. Measured line utilization = 53%.

7. Difference = 16% due to overhead caused by control characters (headers and retransmissions).

Results

Summarizing what has been discussed so far, companies need to follow these guidelines in preparation for understanding the capacity requirements of the network:

- Visibility of the number of studies to be performed by selecting the most suitable criteria for categorization (e.g., what might be changed to affect network capacity in reaction to the evolution of the business demands on the network)
- Quantification of current workload for network facilities and equipment by:
 Characterizing workload by application groups, resource demand, and by identifying NFUs
 Validating the application groups selected
 Selecting base month and shift percentages
 Selecting peak busy hour
- Summary of how to collect workload data for communication facilities and network equipments
- Comparison of actual usage and projected resource demand from past studies helping data centers to evaluate the quality of past workload and resource projections

In summary, after completing this phase, the current workload and its resource demand is very likely known for network facilities and partially known for all network equipment. Without sufficiently accurate quantification of current workload, projection of future resource demand of current and new workload is not possible.

12.3.2 Projecting Future Workload

At this point in the capacity study process, current processing loads have been defined. The next phase will identify and quantify virtually all future events that will affect load requirements. Then projections will be made of the total future workload.

Determination of future workload requirements is possibly the most difficult task in performing a network-capacity study. To accomplish this task successfully, the planning analyst may need to communicate with several areas within the company. The capacity planning analyst should review the company's strategic plan, which identifies all the activities required to support major business objectives and strategies. The objective is to identify potential increases in the use of existing applications, potential new applications, and an assessment of future ad hoc end-user activity.

Data must be collected for each new or changing application, and must be summarized into batch and on-line groups that are driven by natural forecasting units. The data required consist of workload requirements for facilities and equipment and any other significant hardware needed in support of these planned applications. Figure 12.3.3 shows the process of developing future workload estimates and projection of total workload.

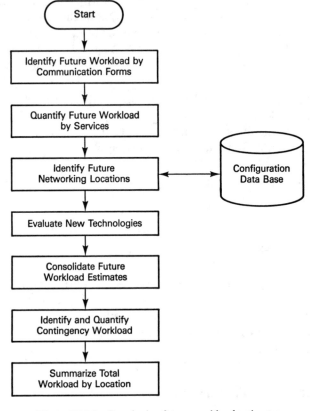

Figure 12.3.3 Developing future workload estimates.

Collecting information

The method used for gathering information is influenced by the applications planning process at individual locations. Planning methods can vary from informal to highly structured and formalized. There are three major steps in collecting information: identification of future workload, identification of future networking locations, and the actual projection of the future workload. It is assumed that there are no formal planning procedures available and information has to be extracted from interviewing managers, end-users, and application development personnel. Figure 12.3.4 identifies crucial steps of the procedure.

Identifying Future Workload. A description of the current workload will build an important part of the consolidated workload. The activities will concentrate on new workload and its resource demand. Capacity planners are expected to start with service identification by interviewing end-users and managers.

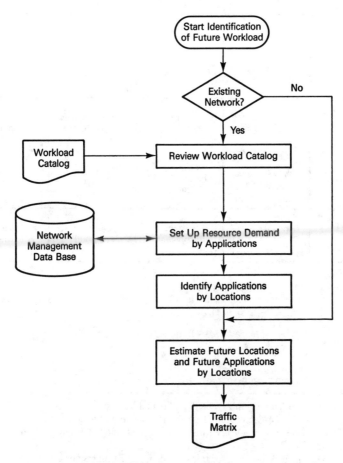

Figure 12.3.4 Identifying future workload's resource demand.

Services Overview. Communications no longer means simply transmitting data between various locations. Figure 12.3.5 gives an overview of how to start identifying desired or existing services (e.g., teleconferencing) with network traffic requirements (e.g., television). Table 12.3.8 defines all cells of Figure 12.3.5. In the first step, management and end-users identify the services they will need for the duration of the planning life cycle (estimated from three months to one year). Then a decomposition of services to their related traffic requirements, and finally their associated loads, is performed.

Mixed Services. For supporting certain applications, even more complex services are required. A few examples are identified in Figure 12.3.5.

Quantification. Most important, capacity planners have to identify the quantities of each workload item. For the individual net resources demand on facilities, Table 12.3.9 is helpful. This table is just a general guideline; results

Output / Input	Video	Data	Voice	Facsimile
Video	Television 1	Radar Analysis 2	Surveillance System 3	Freeze Frame Video 4
Data	Computer Aided Design Videotex 5	Data Processing 6	Voice Response Credit Author 7	Hard-Copy Terminal 8
Voice	Voice-Actuated System 9	Voice Compression and Storage 10	Phone, Voice Mail 11	Voice-Actuated System 12
Facsimile (Word and Fixed Image)	Computer Aided Design Videotex 13	Pattern Recognition 14	Voice Response (Output) 15	Document Transmission 16

Teleconferencing: 1, 9, 10, 11, 16
Computer Aided Design: 5, 6, 8, 13, 14
Credit Author: 10, 11, 14, 15, 16
Videotex: 5, 6, 11, 13

Figure 12.3.5 Requirements analysis.

TABLE 12.3.8: Requirements Analysis.

1. *Television:* Video-Video with expected quality and bandwidth
2. *Radar analysis:* Video-Data for military applications, in particular
3. *Surveillance systems:* Voice-Voice for supervising installations including alarm and alert management
4. *Freeze-frame video:* Video-Fax for transmitting information framewise
5. *CAD-Videotex:* Data-Video for information distribution
6. *Data-processing:* Data-Data for processing information
7. *Voice response credit author:* Data-Voice for output processing or decision-making results
8. *Hard-copy terminal:* Data-Fax for displaying and storing data displays on paper
9. *Voice-actuated system:* Voice-Video, using voice as a trigger for displaying and distributing information
10. *Voice compression and storage:* Voice-Data for storing voice-based information in computing systems
11. *Phone, voice mail:* Voice-Voice for straight or delayed transmission of voice
12. *Voice actuated system:* Voice-Fax, see item 9
13. *CAD, videotex:* Fax-Video, see item 5
14. *Pattern recognition:* Fax-Data for analyzing word or fixed images using data output for results
15. *Voice response:* Fax-Voice, whereby voice output will be triggered by fax
16. *Document transmission:* Fax-Fax for serving office automation in particular

TABLE 12.3.9A: Throughput Requirements by Communication Forms.

Communication Form	Application Area	Throughput Rates
Data	Low volume	4.8 kbps
	Medium volume (data entry, word processing)	9.6 kbps
	Line printer	19.2 kbps
	High volume (data enquiry, laser printer)	64–256 kbps
	Net server/hosts	100 kbps–20 Mbps
Voice	Digital voice	32 kbps
	Analog voice	64 kbps
	Store and forward	8–32 kbps
Image	OCR	2.4 kbps
	Facsimile	9.6 kbps
	Compressed graphics	64 kbps
	Noncompressed graphics	256 kbps
Video	Freeze-frame	64 kbps
	Compressed motion	400 kbps–1.5 Mbps
	Noncompressed motion	30 Mbps
	Digital video	30 Mbps
	Television-grade color video	92 Mbps

TABLE 12.3.9B: Typical Message Volumes.

Message Type	Volume (Bits)
Color picture	2,000,000
Television picture	1,000,000
Short phone message	1,000,000
One-page document	200,000
Newspaper picture	100,000
One-page document (coded)	10,000
Typical interoffice memo	3000
Typical telegram	2000
Transaction inbound	500
Transaction outbound	1500
Airline reservation	200
Fire alarm	40

of the previous chapter may and will refine these results, especially for well-understood existing applications.

Identifying Network Locations. For complex networks, this activity usually involves drawing maps with a large number of connecting individual sites. The information source for the current status is the inventory and/or configuration data base or file. The current status may be extended manually or (by

means of graphical packages) by adding new locations. The process is illustrated in Figure 12.3.6.

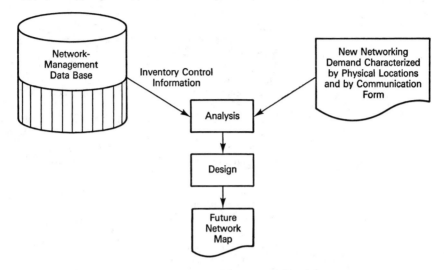

Figure 12.3.6 Identifying network locations.

Workload Projection. The resource demand of present workloads may be projected on the basis of accurate workload characterization techniques. When the growth of business elements is known, or can be estimated with a high degree of accuracy, business growth can be translated into resource demand. In the case of new workloads, the prediction is more difficult. A classification of new workloads includes the following:

- **Software extension:** Equipment software extension may be caused by a new operating system release, by new or modified network software, or by extending general-purpose software. Most of the system overhead can be estimated by using sophisticated measurement techniques, such as protection key analysis with a hardware monitor, or by using rules of thumb, such as capture ratios.
- **Software packages:** Vendors should be (and increasingly are) required to provide accurate measures on resource demand of new applications in terms of transmission, processor time, I/O exceptions, and memory. These figures can be verified during trial installation.
- **Software modifications:** In this case, one is dealing with an application whose resource demand has already been determined. The more accurate the resource demand clusters, the lower the risk for the capacity planner.
- **Software conversion:** The resource demand may change drastically after implementing the converted version. In many cases, the new demand will be significantly higher because changes made have caused the appli-

cation to perform better, or have added needed functionality. Higher level languages or software engineering tools or techniques are used.

- **Improvements by application tuning:** The resource demand of applications before tuning is known. During tuning, parts of applications, such as programs and transactions, are analyzed and improved. The degree of improvement is measurable.

- **Latent applications:** These applications are completely designed and programmed but not yet in production. The latent phase (e.g., while the application is being introduced to the end-user community), however, provides good opportunities for tracking the future resource demand.

- **New applications:** Without cooperating with users, the future resource demand can hardly be predicted. The capacity planner asks for information but not at a detailed level. Three fundamental pieces of information are required:

 Frequency of execution (daily, weekly, monthly, yearly)
 Pattern of the frequency distribution
 Future resource demand for the application expressed in natural forecast units (NFUs)

Planning data that represent the results of both business planning and communication planning are frequently expressed in terms of NFU volume forecasts. NFUs may be business-oriented (sales dollars, checks processed, parts manufactured) or communication processing oriented (number of terminals, programmers, or transaction counts). An NFU is an item associated with the growth or decline of the workload. NFUs are usually workload drivers; that is, changes in NFU volumes are indicators of changes in that workload's demands for processing, storing, and transmission resources.

The key to successful implementation of NFUs is the ability to associate quantitative communication resource demand and transaction rates with NFUs so that a forecast of NFUs results in a projection of communication resource demands. Principal inputs include:

- Clearly documented communication and data-processing plans
- Historical data base of communication system resource demands
- Historical data base of NFU volumes

It is very beneficial to use the network-management data base for storing both resource demand and NFU volume types of data.

In general, effective NFUs for an application workload are associated with stable, predictable resource demands when analyzed on a "per-NFU" basis. Frequently, they are even logically connected to the functions of an application. The banking industry, for example, may use the NFU *checks* as a business-forecasting entity used to predict resource demands of check-processing applications. And in the airline industry, for example, one may have to combine NFU candidates such as *reservations, cancellations,* and *inquiries.*

The final selection of NFUs should be based on successful statistical analysis of NFU-transaction arrival rate relationships. The best way to automate this procedure is by means of the statistical features of the data base or by the use of a separate program.

When measured resource utilizations and arrival rates for transactions are analyzed in conjunction with NFU-related historical data, the primary goal is to establish equations of the following form:

$$\text{(Workload resource demand and/or transaction arrival rate)} = K_0 + K_1(NFU_1) + K_2(NFU_2) + \ldots K_1(NFU_1) \quad (12.2)$$

where

K_1 = constant (computed as regression factor as a result of observations)

NFU_1 = selected NFU (e.g., number of employees, number of compilations, number of checks processed)

Using statistical techniques, the dependency can be determined with high accuracy. In the final equation, the most relevant NFUs will be considered. The constants of Equation (12.2) are calibrated by means of historical data. Once they have been determined, the equation can be utilized for predicting future demand based on the business forecast of the NFUs.

This type of data may be obtained from:

- The company's business plans
- Business elements expected
- User and IM department interviews
- Number of application units for certain time periods
- Discovered similarities with present applications

Later on, during development, questions concerning resource demand may be answered as well. Using the installation's internal correlation procedures, the resource demand of further components may be computed.

The principal focus in this section is on predicting the transmission demand caused by growing traffic from present locations resulting from

- Increasing run frequencies
- Additional application service
- New equipment
- New communication service
- Establishing new locations

In order to predict some of the resource requirements, estimating mechanisms are available. The mechanism used is dictated by the complexity, timing, and workload impact of the planned application. Several of these methods follow:

- **System tests:** Estimating future requirements by extrapolating the loads from test results can be useful.
- **Simulation:** Some simulation processes will provide information concerning resource requirements of the system. Vendors often provide simulation capabilities to users of their hardware. Also, centralized development groups within the company may provide this type of service.
- **Current Application Comparisons:** In some cases, the only method available for application projection is to estimate new application requirements based on those of existing applications that are similar in scope and function.

New applications, only recently conceived, or in their early stages of development, may have undergone no workload sizing activity. In such instances, the computer system capacity planning analyst may be of assistance in sizing the application, or at a more basic level, even determining the type of hardware resources it should run on.

The most important questions to be asked are:

1. Identification of networking locations:
 a. Is work localized to one geographic area, or one department of the business unit? How far is that location from the existing, or proposed, data-processing facility?
 b. Is data logically partitioned by geographic area or department?
 c. Where are the people located who will interact with the system?
2. Identification and quantification of workload volumes and resources demand:
 a. Are there any known peak periods (daily, weekly, monthly, seasonally)?
 b. What is the maximum number of terminals that will be connected?
 c. How many users may be active simultaneously (on the average and during the peak period)?
 d. How much interaction will there be from end-users (via high-level or query languages)?
 e. Could this on-line activity be best characterized as: simple inquiry (e.g., credit check), complex inquiry (e.g., display a list of items), computational or compute intensive, data entry, or other?
 f. How many different screen formats will likely be required? (And as design progresses, the number of characters to be transmitted per screen and the number of transmissions per business transaction must be determined.)
 g. Determine the types of transactions.
 h. Determine the size of each transaction (characters in and out).
 i. Determine number of data-base accesses per transaction type.
 j. Determine frequency of transactions of each type (peak period and average).

3. Identification and quantification of service-level requirements:
 a. Is there a need for immediate access to the data?
 b. What is the response-time requirement by transaction type? ["Customer contact" transactions may require quicker response time than transactions serving internal (back-office needs).]
 c. How many hours per day and days per week must this on-line system be available?
 d. What is the on-line system's availability requirement?
 e. Is there a requirement for backup processing capability and, if so, can this backup provide degraded service?
4. Determination of the growth rate of transaction frequency by application and by location:
 a. Determine rate of growth of transaction frequency over time.
 b. Determine frequency of usage.

Consolidating future workload estimates

As the planning analyst determines the future resource estimates for each newly identified application, these future workloads should be added to Form 1 (Table 12.3.1) which already contains relevant information for the existing workload.

When workload estimates have been completed for all future applications, it is also necessary to determine how these workloads are to be implemented. The additional workload required for system testing and parallel processing is usually significant. The proposed dates for these activities, and the scheduled production implementation should be entered on Form 2 (Table 12.3.2) for eventual entry into the forecasting system.

Also, growth projections (e.g., expected yearly growth percentages) must be determined for these new applications and entered on Forms 1 and 2, as was done for existing load groupings. Remember, these projections should be in terms of natural forecasting units (NFUs), or those growth factors that typically drive the business.

Existing Workload and Growth. The previous function provides the results for the resource (facility and equipment) demand and quantification for the distribution over time. Growth rates can be estimated using NFUs as a result of interviews with managers.

New Workload and Growth. New workload projections have already been discussed. Growth rates of workload projections are expected to be estimated at the time of workload projections. Global quantification of requirements is extracted from user interviews as part of identifying future workload.

In order to determine the resource demand on any of the time windows under consideration, the application impact matrix should be plotted against time. This enables the capacity planner to get a feeling for volumes of informa-

tion as well as timing. Questions concerning such factors as distribution between real time and batch, decentralized or centralized processing, and degree of interdependency of load clusters should be addressed first. In terms of determining the distribution over time, customers may contribute a great deal. Using questionnaires or interviews, it is promising to use techniques for comparing future distribution with present distribution. Thus, the customer has only to compare and not to determine absolute figures. An example is shown in Figure 12.3.7. This step may be embedded into the software development phase as well. Using a project progress file, the future customer is prompted to enter the expected distribution figure.

Impact of New Technologies. Technologies considered here are:

- Information center (e.g., ad hoc end-user activity)
- Personal computers for supporting end-user computing
- LANs for supporting end-user computing by connecting personal computers and end-user devices
- Communication services with value-added features

Information Center. The workload due to ad hoc end-user access will continue to grow as more users are brought on-line, and as software becomes more user-friendly. Growth will not be steady or smooth, but will more likely increase in waves or steps. As new facilities are provided, the user community will increase, eventually reaching a new saturation level calling for further extension to existing facilities or for new facilities altogether. A similar phenomenon can occur with a decreasing user community where facilities will become underutilized and may be freed for use elsewhere in the network.

The addition of relational data bases, associated with development of advanced applications, provides ready-made capability for ad hoc end-user access. In addition, new applications tailored specifically for end-user access (e.g., decision support software) will be added to current information centers.

Personal Computers. Microcomupter-to-mainframe linkage packages may turn every personal computer user into an end-user of mainframe resources. The potential acquisition of such software should be identified for planning purposes. Individuals in the end-user community or in information center administration could assist in identifying the impact.

Distributed data-processing offers new structures and new hierarchical processing capabilities. In certain application areas, such as insurance and manufacturing, there are promising efforts to extend nodal intelligence in order to decrease transmission load. The computing functions are dispersed among several physical computing elements operated by a single, homogeneous, networkwide software package.

It may mean the extension of the multi-layer communication architecture above Layer 7 by word- or document-oriented features. As a practical example, the SNA environment can be considered with high-level services,

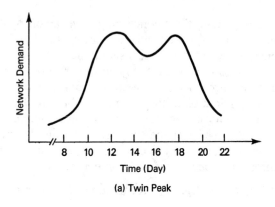

(a) Twin Peak

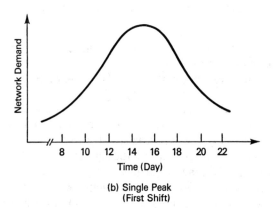

(b) Single Peak
(First Shift)

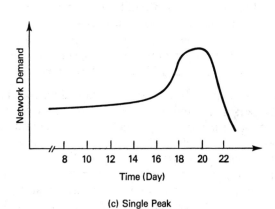

(c) Single Peak
(Second Shift)

Figure 12.3.7 Workload distribution.

such as LU 6.2 (advanced program-to-program communication), SNADS (SNA distribution services), DIA (document intercharge architecture), and DCA (document contents architecture).

Personal computers are usually installed originally to accomplish special-

purpose activities; however, they may also be linked to each other via local and wide area networks. Capacity planning in this context requires a new methodology. It is not appropriate to define limits of personal computers in terms of hardware capabilities (e.g., 8-bit, 16-bit, or 32-bit processors), or even in terms of the application areas under consideration (e.g., dedicated calculator, source/destination device for electronic mail, intelligent terminal for general-purpose computers, word processing extension, graphic data-processing, multi-purpose workstation). The ability to integrate communication forms emphasizes the importance of these devices for designing highly economical networks in the future.

Unfortunately, PC vendors do not provide systems software supporting PCs as an intelligent network device. To connect the personal computer to a network, the micro must often emulate another device, sacrificing local intelligence during a working session. The major emulators for the IBM or compatible environment are:

- Start/stop terminal emulator (e.g., with the most common TTY protocol)
- Protocol converter (synch to asynch terminal emulation)
- SNA 3274 emulator
- Emulator of IBM 3278 terminals
- VT 100
- Local area network file server emulation

Another possibility is to gain access via connections to local area networks. Historically, the first networks of personal computers grew from the need to share access to expensive disk drives. At the present time, users go beyond this point and purposefully use the local area network as a medium for multiplexing access demands for a remotely located host facility. Economy and ease of use are the most important criteria in selecting the right alternative. The costs involved are related to three different factors:

- Direct costs associated with acquisition of any hardware and software for establishing links between the PC and the host computing facilities
- Incurred costs include maintenance, lease costs, and fees associated with the lines connecting the PC and hosts
- Off-network costs involve any additional costs not covered in the first two categories

Real progress is hard to measure without a networking operating system standard supported by the majority of software vendors and running on a wide range of networks. Most of the vendors have already announced networking versions, such as MS DOS 3.1, NetWare, NetShare, 3Server, and so on.

In general, the network-capacity planner may face the following problems when deciding on a PC package:

- Lack of standards for selecting and maintaining PCs
- Misuse of PCs, hindering resource planning on behalf of the capacity planner
- Controlling the use and the communication demand due to PC usage
- Conflicting technological trends imposed by a very large number of vendors
- Ensuring data integrity
- Software validation and quality assurance owing to conflicting and uncontrolled software design and development
- Security for accessing sensitive data by unauthorized use of PCs
- PCs overloading communication facilities

Local Area Networks: Local area networks—both cable-oriented ones and PBXs—create a demand that is very difficult to predict on wide area communication resources. First of all, gateway and communication resources are demanded for supporting regular and ad hoc communication with other LANs and WANs.

Communication Services with Value-Added Features. More frequently than ever before, corporations may decide for the use of value-added communication services provided by third-party suppliers. In these cases, the raw data rates are the same, but overhead figures may have to be added. Contingency workload will cover those items.

Contingency Workload. Due to the possibility that new work will surface in the future, of which there is no knowledge when the network-capacity study is performed, a contingency factor should be included. To some extent, human factors may influence this portion of uncertainty in the network.

In considering additional application services, the capacity planner has to follow the methodology for predicting resource demand of new applications in terms of transmitting devices. However, before installing new equipment in the network or offering new communication services, two factors should be carefully considered:

- **The stimulation factor:** It has been observed that upon implementation of new, more intelligent components, there is an upsurge of traffic. This is caused by the improved performance, availability of new features, and psychological factors that cause users to increase their use of the facilities; in other words, the so-called pent-up demand on resources emerges. Estimated numbers are 10% to 30% additional resource demand, depending on the discipline of network users.
- **The controlling factor:** If the new environment provides detailed control that the old one did not, abuse of the network is discouraged and the traffic does not increase. Estimated numbers are 5% to 10% less resource demand, depending on organizational discipline.

In the event that new locations are added to the network, the additional traffic may be estimated by comparing the requirements of the new sites with known locations and their traffic profiles. However, new locations can influence the whole topology, resulting in modifications to the established rules for scaling, allocation, and routing.

Other components include:

- **Retransmission rates:** Based on monitored observations, certain segments of the load have to be retransmitted due to quality problems in the communication facilities. The volume differs by geographical area, facilities selected, and the parameter settings of the communication software. Results are available for low- and medium-line speeds. For high-speed services, such as T1 and T3, and for fiber connections, existing information accuracy is not yet satisfactory. Ranges of 5% to 10% are realistic, based on line quality.
- **Communication overhead:** Information to be transmitted has to be augmented by control type of information identifying services, routes, addresses, and so on. Multiple protocol conversions created by gateways, routers, and protocol converters may add additional overhead. The overhead figure depends on many factors. The most important factors are:
 Communication form (video, voice, data, facsimile)
 Application (interactive and noninteractive)
 Communication architecture selected
 Protocols implemented
 Parameter settings
 Ranges of 15 to 80% are realistic, depending on the size of information related to frame.

The global resource demand has to be augmented by the contingency workload prior to sizing communication resources. Table 12.3.10 contains demand estimates by contingencies, in a summarized form.

TABLE 12.3.10: Demand Estimates Due to Contingency Factors.

	Low (%)	High (%)
Pent-up demand	10	30
Controlling factor	5	10
Retransmission rate	5	10
Overhead factor	15	80

Total Workload Demand by Facilities and Equipment. As a result of developing workload estimates, the capacity planner is able to construct the application/location matrix (Figure 12.3.8). This matrix is helpful to highlight the impact of resource outages for a certain geographic area, as well as to evaluate change management alternatives.

APPLICATIONS	PRODUCTION					TEST				
	IMS	CICS	TSO	APL	AS	IMS	CICS	TSO	APL	AS
LOCATIONS										
Tampa										
FEP 01										
Line 01										
CU 01										
Devices	2	5	4	1	1	2	8	2	1	1
CU 01 Total										
CU 02										
Line 01 Total										
Line 02										
FEP 01 Total										
FEP 02										
Line 01										
CU 01										
Devices										
CU 01 Total										
CU 02										
Line 01 Total										
Line 02										
FEP 02 Total										
Tampa										

Figure 12.3.8 Application location matrix.

This phase adds the contingency workload to the consolidated workload estimates accomplished for communication facilities (links, circuits) and equipment (processing and relay nodes).

Projecting Workload and Resource Demand. Using the same basic configuration as in Section 12.3.2, the network-capacity planner may have identified the following additional and new needs:

- More applications (not applied in this example)
- More users, served by control units 5 and 6
- Growth of volume for existing locations and existing applications

A changed workload profile is shown in Table 12.3.11. Without going into planning details, it is obvious that the location has to be served by new facilities and equipment.

The demand is met in three steps. In step 1, only location A will contribute. In step 2, location B will also contribute to the local workload. Finally, in step 3, location C will introduce the new workload. Table 12.3.12 summarizes the new total consolidated workload demand. This demand should be compared with existing capacity in the next capacity planning phase.

TABLE 12.3.11: Distribution Frequencies by Location for New Workload.

Locations	TX/H	TX(peak)/s	Length	Total char/s
		Transaction Profile		
LOCATION B				
Controller 4				
Application 3	200	0.11	1200	133
Application 4	400	0.22	1400	308
Location total				441
LOCATION C				
Controller 5				
Application 1	200	0.11	1000	110
Application 3	300	0.17	1200	200
Controller 6				
Application 2	400	0.22	1500	330
Application 4	500	0.28	1400	392
Location total				1032

TABLE 12.3.12: Resource Demand Total.

	Location A	Location B	Location C
Workload demand			
Existing + Growth	974.00	445.00	
New		441.00	1,036.00
Total	974.00	886.00	1,036.00
Retransmission rate (5%)	48.70	44.30	51.80
Overhead of SDLC protocol	18.20	16.70	17.16
Consolidated demand	8.32 KB/s	7.58 KB/s	8.84 KB/s

Results

Results of this step are:

- Realistic concept of the nature of future applications and communication needs between existing and new locations
- Estimation of the load on facilities and equipment classified by the resource demand of the following workload categories:
 Current + growth
 Future + growth
- Estimation for the volume of workload categories
- Distribution of the workload over time clearly indicating peak load resource requirements separated by:
 Facilities
 Equipment

- In most cases, contingency workload demand is included as well
- Schedule of implementing new and/or additional workload

In summary, after completing this phase, a concept of the resource demand by date is known for facilities and equipment.

12.3.3 Developing the Network-Capacity Plan

As a result of the previous phases, the following information base is available prior to starting this phase:

- Actual resource utilization broken down to:
 Average
 Peak
- Resource demand of each principal application (the rest of the applications will build a "summary" cluster)
- Workload projection broken down by average and peak for:
 User (geographical location)
 Applications
- Overhead estimates by
 Resource
 Load (utilization—only for equipment)
 Operating systems
 Network programs
- Existing configuration

Additional activities in this section will include:

- More detailed information on end-user's working environments
- Determining utilization ceilings
- Elaborating on overhead components
- Estimating downtimes for facilities and equipment on the basis of trouble tickets

Figure 12.3.9 gives an overview of the process of defining the capacity of existing facilities and equipment and developing an upgrade plan.

Facilities general procedure

A facility is a transmission path between two or more locations, not including terminating or signaling equipment. The addition of terminating equipment would produce either a channel, a central office line, or a trunk.

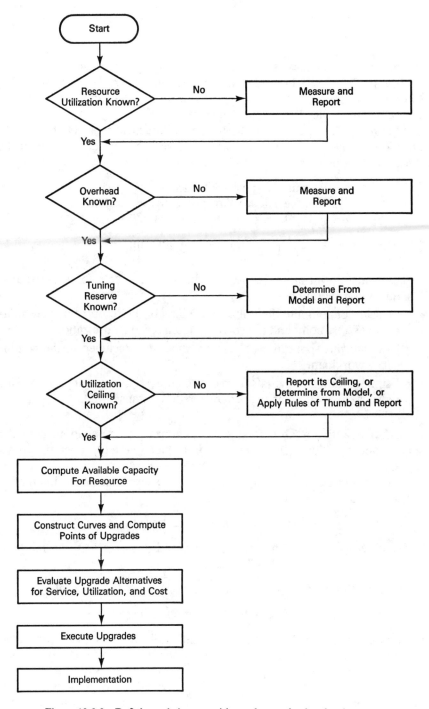

Figure 12.3.9 Defining existing capacities and upgrade plan development.

Signaling equipment controls the transmission process. Various types of signaling would be used depending on the application.

To determine the capacity of facilities, it is necessary to first define the capacity. Facility capacity is the utilization level beyond which the facility is unable to perform work in a timely manner within the service-level limits. The facility has reached its capacity when its utilization has attained a level at which targeted service levels cannot be met.

In order to compute the accurate value of practical capacity of facilities, utilization ceiling, overhead, and downtime have to be considered. The practical capacity can be computed as follows:

$$\text{Resource Capacity Coefficient (RCC)} =$$
$$(\text{Available Time} - \text{Downtime}) \times (\text{Utilization}$$
$$\text{Ceiling \%}) \times (1 - \text{Overhead \%}) \tag{12.3}$$

The following steps are required for the computation:

- Estimate downtime by consolidating trouble tickets for the resource under consideration.
- Measure or compute the utilization ceiling of the resource by determining the stress point and the corresponding resource utilization.
- Estimate the application-related overhead not included in the contingency workload.
- Estimate tuning potentials from data compression and compaction. This reduces the total number of characters to be transmitted.

After quantifying all components of the preceding equation, both the capacity and workload lines can be constructed, and the upgrade points determined.

Before finalizing the upgrade strategy, the service level for interactive applications must be computed as follows:

$$\text{Response time} = \text{service time} + \text{waiting time}$$

$$\text{Service time} = \text{transmission time} + \text{poll transmit tine} + \text{select transmit time}$$
$$+ \text{poll/select wait times}$$

$$\text{Waiting time} = (\text{service time} \times \text{utilization}) / [2 \times (1 - \text{utilization})]$$

$$\text{Utilization} = \text{utilization ceiling}$$

If response time is less than the response time objective, it may be concluded that the utilization ceiling is acceptable. Otherwise, the utilization ceiling must be reduced until the response time meets service expectations.

In the case of multi-drop lines, the service-level degradation due to additional control sequences must be considered. Degradation estimates are:

A. Without time-out consideration:

	FDX	HDX
5 drops	6%	9%
10 drops	16%	21%

B. With time-out consideration of control units:

	FDX	HDX
5 drops	20%	23%
10 drops	47%	52%

It is recommended to not use more than 5 drops.

For noninteractive applications, it is recommended to compute the Transfer Rate of Information Base Units (TRIB):

$$\text{TRIB Unit} = [B \times (L - C) \times (1 - P)] \div \{B \times [(L + R) + T]\} \qquad (12.4)$$

where

B = Number of information bits per character
L = Total block or transaction length
C = Average number of noninformation characters per block or transaction (link protocol level only)
P = Probability that a block will be retransmitted (retransmission of additional blocks is included in the contingency workload)
R = Modem (line) transmission rate (speed)
T = Time interval between blocks or transactions, where
 T = Forward propagation + Reaction of receiver + RTS/CTS*
 + Reverse propagation (ACK) + ACK transmission time
 + Reaction time of transmission + RTS/CTS
 *Reverse transmission signal/carrier transmission signal

If information cannot be gathered for computing the utilization ceiling, use 75% for bit-oriented protocols, and 50% for character-oriented protocols utilized by the facility.

The determination of upgrade points for noninteractive applications requires the identification of time windows requested for noninteractive transmissions; in other words, the practical capacity hours are limited to certain time windows.

In this case, Section 12.3.2 determines the total number of blocks to be transmitted. Blocks include data and overhead characters. Overhead depends on protocol type and on whether HDX or FDX circuits are in use. For each BSC and HDLC block, 12 and 6 characters have to be added, respectively.

The total number of blocks includes the retransmitted ones as well. The total transmission time may be computed as follows:

$$\text{Total transmission time} = \text{Total number of blocks} \times \text{Total time for one block} \quad (12.5)$$

Total time for one block includes block transmit time, propagation delays, line turnaround time, and acknowledgments.

Utilization Ceiling. The theoretical capacity of the communication facilities is identified by the speed of the resource in determining how many bits can be transmitted within each second. Although a facility may process at close to 100% utilization for periods of time, meeting service objectives with a consistently saturated link (circuit) is highly unlikely. Figure 12.3.10 demonstrates the relationship between service level and resource utilization.

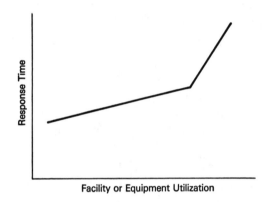

Figure 12.3.10 Service curve.

Due to more estimated traffic during certain time intervals (e.g., two major peaks and two minor peaks over the day), the peak-hour consideration is recommended. In other words, sizing has to be repeated for peak and average hours. There must be no compromise on service-level agreements during the average hour, but occasional violations during peak hours may be tolerated. If adequate financial resources are available, resource utilization may be reduced for improving performance.

Overhead. Resource estimates on behalf of users and application designers include the "useful" part of information to be transmitted. But, even when using just one communication connection for transmitting user and control information, additional overhead has to be considered. Overhead estimates have to be done on the basis of measurements. The previous paragraphs give some estimates on global overhead figures. This part of the overhead includes applications-related headers and trailers (see Figure 12.3.11).

Downtime. The availability of facilities is also important in determining current capacity and future facilities requirements. While downtime has

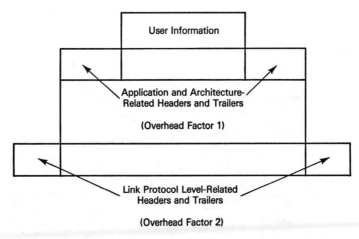

Figure 12.3.11 Application and link-level protocol overhead.

decreased significantly over the past years due to better quality lines, better conditioning, and wider use of digitalization, it should still be considered in evaluating overall category. Instead of available time, expected usage time may also be used.

Downtime can be computed by consolidating trouble tickets by each facility. This assumes that trouble-ticketing system(s) is (are) in use. The same trouble tickets—combined with the configuration data base—may be used for computing end-user availability.

For example, let us consider the following values:

- Available time = 100 hours
- Downtime = 1% = 1 hour
- Utilization ceiling = 85%
- Overhead = 25%

For practical capacity hours, one receives for RCC:

$$(100-1) \times 0.8 \times 0.85 = 67.32\% \text{ of the theoretical bandwidth of the communication facility}$$

A capacity line can be superimposed on the facility load or demand graph to highlight points in time where the capacity upgrades are required (see Figure 12.3.12). Reserve capacity is also identified in the curve.

Tuning. Tuning techniques can be successfully implemented for both communication facilities and equipment. In both cases, either parameters of the communication software are analyzed in-depth or specific techniques are implemented for compacting and compressing data. Certain architectures support compaction and compression by properly setting parameters, by using

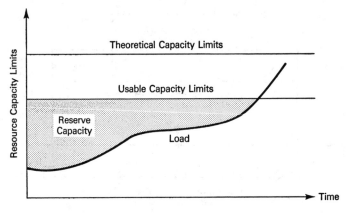

Figure 12.3.12 A. Capacity demand for facilities.

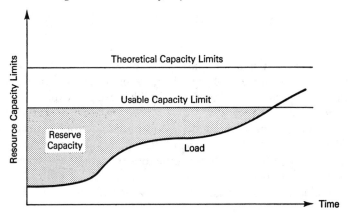

Figure 12.3.12 B. Capacity demand for equipment.

external devices, or through use of computing capacity on the computers at each end of the network.

Section 9.4 discusses some SNA tuning parameters and suggests how they should be used. The other parameters may be either derived from those under consideration or their average impact is irrelevant for planning purposes.

The most obvious results are expected to arrive from compression and compaction techniques.

Compression/compaction may require the consumption of computing capacity on computers at both ends of the network facilities. Whether this capability is invoked is a matter of cost trade-offs between the network and computing equipment. As part of a network capacity plan, the potential savings of employing such techniques should be calculated so it can be determined if the savings exceed the associated computing costs.

Compression means the suppression of unnecessary characters for the transmission. At the same time, however, the communication partner must be notified of the suppression techniques in use. At the other end of the transmission, the original sequence of characters has to be restored. Screen addressing

may be considered as part of this category. In most cases, application-related packages (e.g., IMS, CICS) are in use. Expected resource utilization reduction is in the range of 30% to 50% against an untuned environment.

Compaction means the change of code set representing characters. For the most frequently used characters, a repetition count and/or bit substitution technique (e.g., 8 bits into 7 bits) will be used. Altogether, the total number of bits to be transmitted can be substantially reduced. Both software and hardware techniques are in use. Expected resource utilization reduction is in the range of 20% to 30%.

The capacity planner is not expected to guide and execute tuning. But, he or she has to be aware of the impact of tuning. Successful tuning will lower resource load and postpone the point of upgrade. The proper mix of compaction and compression will achieve the same effect. Actual changes have to be made in host and front-end-processors, but the impacts are partially in facilities. The expected result is the quantification of resource demand reduction. After quantifying capacity level, available hours for facilities, overhead, and expected tuning results, the capacity planner is able to project and evaluate the needs for capacity upgrades by drawing the graph for facilities. A comparison with the practical capacity hours graph will indicate the upgrade points in terms of unsatisfactory service level, requiring lowering the utilization ceiling percentage.

Equipment general procedure

Equipment is a generic term for all network components not defined as the facility. Examples are source, relay, and destination nodes of the network. To determine the capacity of equipment, it is necessary to first define capacity. Equipment capacity is the utilization level beyond which it is unable to perform work in a timely manner. An item of equipment has reached its capacity when its utilization has attained a level at which targeted service levels cannot be met. Several components enter into estimating equipment capacity, as explained next.

Utilization Ceiling. Although equipment may process at 100% utilization for periods of time, meeting service objectives with consistently saturated equipment is highly unlikely. The utilization of equipment is expressed as an average over an entire shift. Therefore, determining a ceiling for equipment utilization over an entire shift must take into account fluctuations in loads throughout the shift.

In general, capacity ceilings are a function of the equipment under consideration. Planning for a utilization ceiling by peak hour is recommended as outlined in Section 12.3.1. The load will follow the fluctuations over the networking facilities due to users' performance with interactive applications. Peak load may be higher by 50% to 100% (or even greater) than the average load.

Overhead. Equipment utilization data that are collected at the global level are generally incomplete and inadequate to understand overhead introduced for specific equipment. "Supervisor" functions that service transactions are not always recorded, and certain supervisor functions are not accounted for. This additional time is estimated, and referred to, as overhead. Also, overhead is the complement of another commonly used term, "capture ratio" (i.e., overhead + capture ratio = 1). Currently, overhead figures are very difficult, if not impossible, to measure for the majority of devices. Similar to SMF and RMF for host processors, NPM, NetSpy, and Mazdamon are expected to measure the communications-related capture ratio.

Downtime. The availability of the machine is also important in determining current capacity and future hardware requirements. Although downtime has decreased significantly over the years due to more reliable software and hardware, it should still be considered in evaluating overall capability. It is also possible for equipment to be unavailable due to an inoperative peripheral.

Downtime can be computed by consolidating trouble tickets by equipment. This assumes that trouble-ticketing systems are in use. The same trouble tickets, combined with the configuration data base, may be used for computing end-user availability. Instead of available time, expected usage time may be used as well.

Values for equipment ceiling, overhead, and downtime must be determined to properly arrive at the practical capacity. This can be expressed as follows:

$$\text{Equipment Capacity hours} = (\text{Available Time} - \text{Downtime}) \times (\text{CPU ceiling } \%) \times (1 - \text{overhead } \%) \tag{12.6}$$

Equipment capacity is derived using the same unit of measure (hours) as the equipment load. Thus, equipment capacity can be superimposed on the equipment load graph to highlight points in time where the equipment capacity upgrades are required. This is illustrated in Figure 12.3.12.

Tuning. Tuning techniques can be successfully implemented for both communication facilities and equipment. In both cases, either parameters of the communication software are analyzed in-depth or specific techniques are implemented for compacting and compressing data. Certain architectures support compaction and compression by properly setting parameters. Chapter 9 gives ideas on what and how to tune SNA parameters for host and front-end processors. Recommendations are given for a subset of parameters only. The other parameters may be either derived from those to be considered, or their average impact is irrelevant for planning purposes.

The capacity planner is not expected to guide and execute tuning. But he or she has to be aware of the impacts of tuning. Successful tuning will lower resource load and postpone the point of upgrade. The expected result is the quantification of resource demand reduction. After quantifying capacity level, available hours for equipment, overhead and expected tuning results, the capacity planner is able to project and evaluate the need for capacity upgrades.

Sizing End-User Devices (Workstations and Terminals). Assuming the workload profile for each geographical area is known, the number of end-user devices may be determined. Adding total response time (facilities and equipment together) per transaction, thinking time, and key-in time, the transaction life cycle can be computed. Considering the practical device capacity hours (Equation 12.3), the number of transactions per device can be computed. Dividing the total number of transactions during peak hours by this number, the required number of end-user devices may be calculated.

Evaluating configuration alternatives

As a result of the comparison between the resource demand and the available capacity, the points of capacity upgrades are determined. The gaps identified have to be filled by planning additional or new capacity. In both cases, configuration alternatives have to be evaluated quantitatively. Four different alternatives may be considered:

- Use of spreadsheets
- Use of PC-based unsophisticated modeling packages
- Use of advanced modeling packages
- Use of simulators (very likely in cooperation with the supplier of the network architecture)

Figure 12.3.13 shows the general flow of modeling steps. Verification and calibration of models may significantly be accelerated by expert systems. Validation of a model in a changing environment may take many months, if not years. However, there are alternatives for the network-capacity planner. There are many ways of considering modeling. Based on the basic queuing equations, spreadsheets of multiple configuration alternatives may be provided. Usually, configuration properties and transaction volumes are the independent variables. The cells provide answers for service level and utilization in Figure 12.3.14.

The second way consists of packaging the same ideas into a model with substantially improved user interface. For selected sets of parameters, such as protocols, various delays, number of drops, distance, line speed, and mode of operation, the response time, as a function of the transaction volume, is displayed by graphics or tables (Figure 12.3.15). The evaluation runs linewise, and complex networks still require substantial labor.

The third way suggests the use of intelligent models, such as BEST/NET or ACK:TOP. This category of models provides network-wide evaluation, consideration of usual and technically oriented parameters, and breakdown of response time into processing, backbone, and boundary segments. Figure 12.3.16 shows a BEST/NET example for an SNA-MSNF-type network, incorporating portions of the model and of principal results.

Traditional capacity planning techniques may be expanded by expert

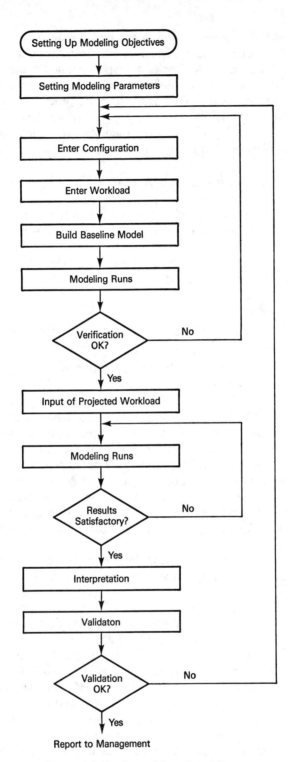

Figure 12.3.13 General flow of modeling steps.

Secondary Link	Service Time	Utilization	Service Time	Utilization	Response Time 1	Response Time 2	Cycle Time 1	Cycle Time 2
Volume of Transactions Per s	Ts1	Tw1	Ts2	Tw2			Response Time + Think Time	Response Time + Think Time
0.01	1.67	0.02	0.83	0.01	1.68	0.84	31.68	60.84
0.02	1.67	0.03	0.83	0.02	1.70	0.84	31.70	60.84
0.04	1.67	0.07	0.83	0.03	1.73	0.85	31.73	60.85
0.05	1.67	0.08	0.83	0.04	1.79	0.85	31.74	60.85
0.08	1.67	0.13	0.83	0.07	1.83	0.86	31.79	60.86
0.10	1.67	0.17	0.83	0.08	1.94	0.87	31.83	60.87
0.15	1.67	0.25	0.83	0.13	2.06	0.89	31.94	60.89
0.20	1.67	0.33	0.83	0.17	2.26	0.92	32.08	60.92
0.25	1.67	0.42	0.83	0.21	2.50	0.94	32.25	60.94
0.30	1.67	0.50	0.83	0.25	5.83	0.97	32.50	60.97
0.50	1.67	0.83	0.83	0.42		1.13	35.83	61.13
0.75	1.67	1.25	0.83	0.63		1.53		61.53
1.00	1.67	1.67	0.83	0.83		2.92		62.92
1.25	1.67	2.08	0.83	1.04				
1.50	1.67	2.50	0.83	1.25				
1.75	1.67	2.92	0.83	1.46				
2.00	1.67	3.33	0.83	1.67				

Ts1 Service Time (Alternative 1)
Ts2 Service Time (Alternative 2)
Tw1 Waiting Time (Alternative 1)
Tw2 Waiting Time (Alternative 2)

Response Time = Service Time + Waiting Time
Waiting Time = (Service Time × Utilization) / 2 × (1-Utilization)
Cycle Time = Response Time + Think Time

Figure 12.3.14 Lotus modeling example.

systems for evaluating a large number of alternatives, where after each run the next run is selected based on the results of the previous run.

Modeling techniques help to determine the capacity reserves and convert them into load units or into the number of additional workstations that may be supported. At the same time, the traffic rate table may be composed for various numbers of workstations supported by control units.

The fourth way suggests the use of simulation techniques. The prerequisites are the same: Accurate configuration and workload data are required. In most cases, the package is provided by the supplier of the communication architecture, such as SNAP-SHOT from IBM for SNA users. The reported accuracy of the results is rated fair. Usually, prior to major network changes, users take advantage of this service. For more frequent evaluations, home-grown techniques or analytical packages are preferred.

In this phase of the network-capacity process, the design and evaluation of alternative technology, such as LANs, LAN-to-LAN connections, software-defined networks, voice-data integration, mobile communication, T1/T3-based backbone techniques, and ISDN capabilities are not yet evaluated quantitatively.

The dominating factor behind capacity planning is the decision for new or extended facilities. The planned bandwidth between locations serves as

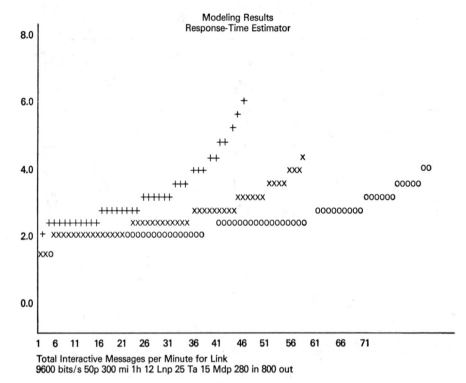

Figure 12.3.15 RTE example.

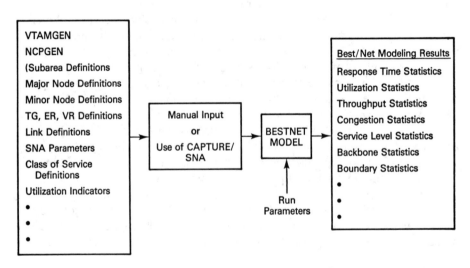

Figure 12.3.16 BEST/NET example.

input for configuring and sizing equipment. Usually, the guidelines by manufacturers guarantee reasonable and fair results. Very frequently, the number of available options for equipment is large (e.g., modems), and financial considerations will most likely determine the solution.

With multiplexers, modeling techniques are expected to be expanded. Few manufacturers offer modeling guidance on the basis of load estimates or bandwidth requirement of facilities. The manufacturer responds with the optimal size of the multiplexers and their optimal topology.

In summary, the present status of modeling and simulating complex networks is unsatisfactory. There are options, but the capacity planner is expected to guide the integration of existing instruments. Rapid success with existing tools is unlikely.

Developing a facilities and equipment upgrade plan

The upgrade points have been identified in Figures 12.3.12A and B. The selection of the right upgrade point must satisfy two contradictory objectives. First, cost must be minimized, implying that unused capacity should be held low. Second, disruptions to operations must be minimized by installing resources with sufficient capacity in such a way that frequency of upgrading is minimized. The following recommendations attempt to satisfy these conflicting objectives. The results of this section are expected to serve as input for the implementation phase, covered in Section 12.3.4.

Facility and Equipment Installation. (Adding facilities and/or equipment to a complex, or replacing an existing facility and equipment with another.) When equipment or facilities are planned for installation in an established complex, the capacity should be sufficient so that additional upgrades to, or purchases of, facilities and equipment, or replacement with more powerful facilities and equipment are not required for a reasonable time, as determined by the cost of holding excess capacity, versus the cost of frequent disruptions to add additional capacity.

Field Upgrades. Field upgrades are divided into the following three categories:

- **Minor Impact.** This is an upgrade that may be accomplished through the replacement of a few plug-in circuit boards in the equipment without requiring any (or negligible) rewiring. The entire upgrade can be accomplished and completely checked out within an 8-hour period during a weekend. Also, no changes in operational procedures would result. Example: Additional line servers for front-end processors.

- **Moderate Impact.** This is an upgrade that is accomplished through the replacement of several plug-in circuit boards and a moderate amount of rewiring. In some instances, this upgrade could also include additional electronics in a separate cabinet; however, this addition should be suffi-

ciently small so that no movement of currently installed hardware is required to accommodate the addition. Operational procedures should stay essentially unchanged with modifications only to cover extraordinary circumstances (e.g., recovery from hardware failures). The entire upgrade can be accomplished and completely checked out within a 24-hour period during a weekend. Examples: Change of servers in front-end processors, multiplexers or in-matrix switches, a change of line speed, or a change of modems.

- **Major Impact.** This is an upgrade that is accomplished through extensive modification, usually requiring additional electronics in separate cabinets. Rearrangement of existing hardware may be required to accommodate the added cabinets. The upgrade may require an entire weekend to accomplish, or may span multiple weekends. There may also be changes in operational procedures.

 Example: Upgrade of IBM 3725 to 3745 or reassigning resources and regeneration of the entire network.

Determining upgrade points

When the additional resource demand is considered, three major upgrade points may be identified (Figure 12.3.17).

In the first step, the capacity limit for lines 1 and 2 has to be computed using the RCC equation.

Assuming the same conditions, the same results are applicable in both cases:

$$\text{Utilization ceiling} = 75\%$$
$$\text{Downtime} = 1\%$$
$$\text{Overhead} = 25\%$$

Thus, the capacity limits are:

$$\text{Line 1—19.2 KB/s} \times 0.557 = 10.69 \text{ KB/s}$$
$$\text{Line 2— 9.6 KB/s} \times 0.557 = 5.35 \text{ KB/s}$$

Capacity lines are drawn in Figure 12.3.17. It is assumed that the capacity demand for each facility appears on different dates requiring a multi-step capacity augmentation.

$$\text{Capacity demand for line 1} = 8.32 \text{ KB/s}$$
$$\text{Capacity demand for line 2} = 7.58 \text{ KB/s}$$

The second step identifies the capacity demand for location C. The capacity demand for a new facility at location C = 8.84 KB/s.

In conclusion (Figure 12.3.17)

A. Line 1: The capacity installed is still sufficient, but is approaching the capacity limit. There is a warning signal to the capacity planner.

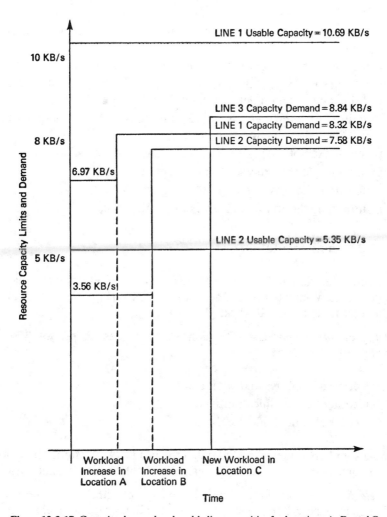

Figure 12.3.17 Capacity demand and usable line capacities for locations A, B, and C.

B. Line 2: The capacity must be doubled, indicating the installation of an additional 9.6 KB/s line.

C. Line 3: The intention is to install a 19.2 KB/s link to support a fast-growing location. Unchanged growth indicates that a second upgrade is expected soon.

The new configuration is shown in Figure 12.3.2.

Results

Results of this step, are:

- Accurate calculation of the practical capacity limits of facilities and equipment
- Determination of upgrade points for facilities and equipment
- Guidelines regarding how to evaluate various technological alternatives by using analytical models, emulators, and simulators
- Definition of interfaces for future extensions by other models and for more detailed evaluation techniques
- Practical example for extending and sizing network facilities
- Description of the process of implementation
- Determining reserve capacity after upgrades
- Determining the traffic rate tables for workstations

12.3.4 Implementation

Implementation is the planning and execution of all activities related to upgrades or new installations. The activities include partially clerical-type work and partially technical work.

Request for Proposals. This consists of requesting proposals on the following terms:

- Selection of facilities and equipment
- Selection of communication services
- Selection of value-added services

Potential suppliers are expected to detail the products' functions, price, availability, support, security, and conformance with international standards.

Selection and Weighting Criteria. Selection criteria, and the priority weightings of each criterion, should be determined prior to evaluation. For weighting criteria, the preference matrix technique is very useful. Rather than comparing each criterion against all others at the same time, the preference matrix compares only two criteria at a time. Expert systems may be used as well for configuring complex networks, considering a fairly large number of design alternatives.

Operational Manuals. Based on guidelines from Phase 1 and hardware-software decisions from Phase 2, operational manuals should be prepared. They will describe how the network is going to be used. An operational manual is extremely useful in helping someone to understand what he or she is supposed to accomplish in the operational control and administration areas. In particular, standards and procedures for the following areas may be included:

- Problem determination and management
- Version control

- Fallback or failure planning
- Inventory control
- Financial analysis and budgeting
- Configuration and management
- Change management

Conversion Plans. Assuming that one is dealing with a complex network, whereby the operation of the larger organization may be impaired once the network has broken down, it is quite unlikely that the new network will be implemented without careful scrutiny. It will more likely need a step-by-step approach, perhaps running parallel, doubling volumes and operation for a certain period of time. That means that the old network should remain operational until the new one has been thoroughly tested and proven. These functions involve plans detailing the necessary products to be installed and time frames for the development of standards and procedures, education, and installation management.

Prototyping. When the user has custom engineering and/or custom software development, he or she is expected to take responsibility for testing by using prototypes of the network. Based on the testing results, the principal requirements may or may not be met. If not, the capacity planner must go back to Phase 2 in order to do more planning and the engineering effort must continue. The whole planning process is strongly iterative (in other words, previous phases and steps within the phases may be repeated many times). When the functionality and/or the service requirements are not met, there are several alternatives to be implemented:

- Return to the planning phase and include more alternatives.
- Return to the optimization and modeling phase and evaluate additional alternatives within the original hardware or software capabilities.
- Tune the prototype, evaluate the results, and decide on further actions.

This procedure may be observed in Figure 12.2.2 as part of the overall capacity planning methodology.

Backup and Recovery Plan. Due to the reliability behavior of a complex network, it is not a matter of whether the network will break down as much as when. When the network does fail, network operational control must be ready with a preconceived action plan. Contingency and recovery planning become key elements of operating a network with on-line service. Since the various components of the network are heavily relied upon by the user community, it is essential that there are predefined plans restoring service in the case of unusual circumstances. The two plans required are as follows:

- **Contingency Plan.** A contingency plan must deal with ways in which the network can be temporarily reconfigured to overcome individually fail-

ing network components and allow for continued operation during the time taken to resolve the problem. Each operational level of the network should be considered in this plan and a full range of automated and manual methods included. There will be some situations that can be handled by network operations alone through dynamic reconfiguration; others will require that a combination of automated and manual steps be performed both centrally and remotely. The contingency plans should prescribe the various combinations of these steps and should also define alternate procedures in the event that the primary method is unworkable. Examples of situations that should be addressed in the plan include the handling of the following situations:

- A failing line (primary and/or secondary)
- A failing regional concentrator
- A failing communication controller
- An errant application or system program

Any significant change in the network components will require that the contingency plan be reevaluated and updated as appropriate. The addition or deletion of hardware or software components in the network could have an impact on the alternatives available in contingency planning. The impact of such changes should be reflected in the contingency plan. "Dry run" testing of the plan should be used to verify its workability and to train the network staff in the identified methods. The complexity of the contingency plan becomes a reflection of how well the components are isolated from one another. The network should be designed to minimize the impact that the failure of one component will have on the remainder of the network. Such a network will result in fewer variables to be considered in the contingency plan and perhaps simplify modeling if the independence also applies to the component's functionality.

- **Recovery Plan.** The recovery plan differs from the contingency plan in that it defines the methods available to restore either a single component of the network or the entire network to an operational status. The recovery plan should contain detailed procedures to be used in returning the component back to service. Topics that should be covered in this plan include preferred approach, acceptable alternatives, critical steps to be performed (along with their priorities), personnel responsibilities, and target deadlines. The plan should take into account the fact that system failure may result from equipment malfunction, natural disaster, fire, and sabotage, as well as from other, unforeseen causes. Therefore, the identified procedures must be able to deal with as little as a single component to as much as the entire network.

 Procedures developed as a result of the recovery planning process should become a permanent portion of guides for network operational control. To the extent possible, the recovery plan should also be tested to familiarize personnel with the effort and validate the effectiveness of the plan.

Examples of issues that should be covered in the recovery plan are the following:

- Emergency procedures for the recovery of critical items such as on-line files and programs.
- Assignment of responsibility
- Who should be contacted first
- Recovery procedures for operator errors that destroy files and programs
- Recovery from application software failures
- Availability of backup computer facilities
- Availability of backup power
- How to diagnose the problem
- Off-site storage of duplicates of customer-sensitive information
- How to guarantee network security
- How to inform customers about anomalies

Cutover Scheduling. Based on the conversion plan, the implementation usually takes many steps. The best way is to phase the implementation by location or application. The cutover must be prepared with great care and should be accomplished overnight or over a weekend. The best time to start is Saturday morning, and use the rest of the weekend for debugging. For extensive debugging, test transactions are expected to be ready for trial runs. These could be the same transactions used previously in the prototyping phase. They may be generated and composed as part of the remote terminal emulation.

Stress Testing. As stated earlier, network design is an iterative process. Using remote terminal emulation for existing subsets of communication networks (e.g., for prototypes) is a promising technique for reducing the time requirements for designing and modeling. A remote terminal emulator is an external, independent driver that is connected to the system and network under test via standard communication interfaces. The emulator generates messages and transactions for the network under test, based on a set of representative scripts defined by the user's application.

Using this technique, not only the functionality but also the service-level requirements can be evaluated. By attempting to use as many of the new network's facilities as possible, the chances of identifying potential bottlenecks are significantly improved. Operations and communication networks personnel must be trained to face all eventualities before actual cutover. Help desk, administration, and technical support personnel should be prepared as well. CPM and PERT techniques are useful in timing the cutover.

Paralleling Actual Volumes and Cutover. It is recommended that actual volumes and transaction types be emulated as closely as possible prior to cutover. The new network and the old network (or old procedures) should work simultaneously for a definite period of time. If results are satisfactory, service levels are met, and personnel are properly trained, complete cutover may be executed.

12.4 INSTRUMENTATION OF NETWORK-CAPACITY PLANNING

There is a relatively wide range of instruments supporting network-capacity planning functions. All product families introduced in Chapter 6 may be utilized separately or in combination for sizing communication networks and their components. This segment focuses on modeling devices for data and voice provided by mainframe manufacturers, network service suppliers, and by independent companies for WANs, MANs, and LANs. The major emphasis is on product selection and comparison criteria, which may be considered generic. References and descriptions of products are kept to a meaningful minimum. However, examples of state-of-the-art solutions are referenced by name.

There are four basic techniques for performance prediction:

1. Analytical models are programs using analytic queuing equations for predicting performance of a design. Heuristics are employed to reduce the number of possible network designs to a manageable level. Most frequently, segments of networks are evaluated separately. The model integration happens in the final design and optimization step. Usually, the integration has to be accomplished manually.

2. Traffic engineering techniques usually use voice-related load estimates and Erlang B equations for sizing communication facilities. These techniques can be automated by using precalculated spreadsheets and tables.

3. Simulation means that the estimated traffic is routed through a discrete event simulator representing the topology and network element attributes. These attributes include speed, estimated queuing and processing delays, distance propagation, turnaround times, segmentation of message units, and overhead due to control characters. Simulation may be very accurate, but it requires considerable preparation and long run times. On the other hand, when there is too much simplification—for increasing economy—the results may not be accurate enough.

4. Emulation employs segments of life workload in a manner similar to benchmarks. Measurement devices are cutting "scripts"—meaning typical transactions and/or batch applications—during normal operations. After careful adaption of those scripts, typical scenarios are programmed for the driver that will initiate the scripts of given types and volumes. During emulation, key indicators are measured and interpreted. Using the same scripts, scenarios for stress tests may be constructed as well.

12.4.1 IBM's Solutions for Network-Capacity Planning [TERP90B]

IBM has been reemphasizing the importance of network design and capacity planning solutions by offering packages for voice and data, and supporting customers by Snap/Shot runs. This chapter presents a brief summary

of the most important products. The products are at the moment standalone solutions. The users are expected to do the customization, integration, and fine-tuning.

TARDIS

TARDIS (Tariff Definition System for Network Design) is a set of subroutines for handling telecommunications tariffs. TARDIS is intended to be incorporated in network design packages, and is used by the MESH and MAZE programs. The subroutines perform the following functions:

- Read a file of tariff definitions. These definitions are constructed with TARDIS macros, which are described in the "TARDIS Tariff Definition Macros" section of the TARDIS User's guide.
- Produce a report listing of all the tariff definitions.
- Calculate the cost of a communications link, taking the following factors into account:
 Geographic location
 Telephone number
 Distance
 Speed
 Time of day
 Connection time
 Data volume
- Allow the user to define a series of test cases, have TARDIS calculate the costs involved, and produce a detailed breakdown of the costs. This is intended for testing the TARDIS code, and as an aid to creating new tariff files. The tariff information needed during cost optimization is extracted from TARDIS. TARDIS has to be populated with actual tariffs provided by the major networking services suppliers or by the PTTs in "regulated" countries.

MESH

In the area of network design, it is often difficult to choose the most economical alternative for connecting terminals to main computers, to determine the best topology for a multi-point network, and/or to determine the best place to locate a concentrator.

MESH helps the network designer make these decisions without having to do repetitive and tedious calculations. It is a tool for cost optimization of networks that use point-to-point and/or multi-point links, with or without concentrators.

The design algorithms in MESH can perform the following primary tasks:

- Select the most economical communications facility from among the available services. These services can be dial-up, analog, digital, or packet switching.
- Select concentrator sites. The user nominates potential concentrator sites, and MESH selects the best subset of concentrators.
- Configure multi-point circuits where this would reduce the cost of the network.

MESH requires tariff information that is supplied by a TARDIS tariff file, MESH/TARDIS, which can handle multiple services of a particular kind, determining, for example, the cheapest point-to-point digital service for a particular link. MESH/TARDIS can also handle international tariffs defined in different currencies. MESH requires the maximum data-link utilization for the different speeds as an input parameter. This information may be provided by the use of other tools such as RTE (response time estimator).

The output of MESH is a script format document that includes several output reports such as a line summary, cost report, and network report. In addition, MESH provides a geographical map as one of its outputs. It shows the network configuration with node locations, concentrator locations, line type between nodes and/or concentrators, and multi-drop line layout.

MESH generates the following reports:

- **Line Summary:** This report shows how many lines have been created by MESH, the speed of the lines, and what tariffs they are using, together with the line total.
- **Cost Summary:** This report summarizes the cost of the network by cost categories, as defined by TARDIS. Depreciation is also considered and is added to the annual cost, to give the real annual cost.
- **Network Report.** This report shows all the links created, grouped by different network segments:
 Point-to-point section (contains all the remote nodes that have been connected to its corresponding host)
 Packet-switched section (contains all the remote nodes connected via packet switching to its corresponding host)
- **Detailed Cost Report.** This report itemizes costs considered during optimization.

NETDA

In the case of a distributed network or backbone design, it is assumed that all multiplexer/concentrator locations are known, and the objective is merely to choose a set of interconnecting or intermediate network node (INN) links which produces a least-cost design (subject to some performance constraints).

Adhering to these objectives actually means choosing a set of routes

such that sessions will have a minimal route delay (say, for example, less than 1 second), and the availability of routes is a minimum of, say, 90%.

Choosing the best set of routes for even a relatively simple backbone network (say three hosts and four intermediate nodes) out of the many possible assignments along the interconnecting links is a complex and tedious task best solved with tools with NETDA.

Based on the premise that whatever physical network design has been chosen, NETDA with its Optimal Route Capability can bring the existing network configuration up to a maximum efficiency, the task on hand is reduced to an iterative process consisting of the following steps:

1. Choose a topology, depicting a probable least-cost design based on the topology as defined to MESH.
2. Analyze the configuration for the performance constraints.
3. Perform an optimization of the network and employ the results to make changes to network elements based on least cost.

To put the preceding steps to use efficiently and to develop a cost-optimized backbone network, the following subjects will have to be considered and will therefore be further discussed:

- Design considerations for a backbone network and what Transmission Groups to select in the following sections.
- Running NETDA based on the outcome of MESH.
- The use of a utility to help find the most cost-effective result for all INN links.

In NETDA, the following data have to be prepared:

- Topology
 Define the subareas
 Define the transmission groups
 Define the attributes for transmission groups
- Class-of-service (COS) table
- Traffic
 Traffic types
 Assign applications to hosts
 Distribute traffic
 Create a traffic table

Once the previously described input specifications have been completed, the following NETDA functions can be invoked:

- Route generation
 Based on transmission group (TG) definitions

- Virtual route (VR) selection/numbering
 Route selection based on window/order
- Explicit route (ER) numbering
 Not necessary for design purposes
 Used only for implementation

Furthermore, the following NETDA functions can be used:

- Performance analysis
 Route delays
 Component utilization and delays
- Route availability
- Optimal route selection/COS selection
- Component failure analysis
 Failed components
 Automated failure and analysis
 Traffic flow analysis
 Component availability

In order to effectively run NETDA, the following points need to be considered further:

- Selection of transmission groups (TGs) as part of the topology specification for NETDA.
- Some method of defining traffic for the backbone network as a reflection of the cumulative traffic of the combined boundary networks.
- Use of NETDA as an automated help facility for generating the network.

Response time estimator (RTE)

RTE can be used to determine the response time of a given set of transactions for a specific type of link.

It is particularly useful when using MESH for a network design study, since it gives the maximum link utilization data that have to be provided to MESH as an input parameter in order to achieve, as a minimum, the desired average response time.

Characteristics of RTE:

- Licensed PC software
- Provides response-time estimates and link utilization for 327X interactive links
- Supported protocols are.
 SDLC full-duplex
 SDLC half-duplex
 BSC half-duplex

- Provides graphic and tabular output (see Figure 12.3.15), including graphic comparisons between different runs
- Support of printer activity
- Projection of stress message volumes, to determine excessive utilization of the link. The stress point is where the percentage increase in 90th percentile response time is greater than the percentage increase in volume. The following example quantifies this definition:

Message rate × minute	90th percentile response time
23	3.42
24	3.86

% increase in volume = 4.2 % increase in response time = 12.8

The following indicators have to be specified prior to running the model:

- Different message lengths and SNA response modes for CICS, IMS, ISO, mixed, and other
- Definite response for IMS, and exception response for ISO and other type of applications
- Supported link speeds from 1200 to 64,000 bps
- Corresponding modem turnaround time and propagation delays
- Average number of miles from 0 to 3000
- According link propagation delay (up to 325 milliseconds for satellite)
- Host and NCP processing time (added up, but not used for stress-point calculations)
- Number of drops per link
- Percentage of printer activity, with lengths varying from 1 byte to 2000 bytes

Cooperative use of MESH, NETDA, and RTE

Present network configurations usually require the design and implementation of two-layered networks. Those networks consist of a powerful backbone connecting many boundary networks. For optimizing the configuration, all three available tools have to be used in combination, using the following design steps:

1. Use RTE to determine the maximum boundary link utilization.
2. Use MESH to optimize the boundary networks.
 - Using analog point-to-point links
 - Implying concentrator placement
3. Use NETDA to design the backbone links.
 - Using multi-link TGs or
 - Using digital point-to-point connections

4. Use NETDA to design routes.

5. Use NETDA to optimize performance/availability:
- Adhere to a maximum route delay (say 8 seconds or less) and
- Adhere to a minimum route availability (say 90% or better)

6. Use TARDIS for cost optimization of the INN links.

Steps 3 up to and including 6 will comprise an iterative process; that is, the backbone links will have to be redesigned if the outcome of steps 5 and 6 is not in accordance with performance objectives or the price goal is not met.

RTE provides for both MESH and NETDA the utilization ceiling values, where the performance represented by the response time has not yet degraded.

MESH interfaces to NETDA by the so-called grid matrix (Figure 12.4.1), detailing the summary load for each backbone link by the processors of the MESH model.

Load Originating Subarea	Application Processing			
	Host A	Host B	Host C	Host D
Subarea 1				
APPL 1	10 × 1.2	5 × 1.2	25 × 1.2	20 × 1.2
2	20 × 0.9	5 × 0.9	5 × 0.9	10 × 0.9
3	20 × 1.5	5 × 1.5	10 × 1.5	5 × 1.5
4	—	5 ×	—	—
Total	50	20	40	35
Subarea 2				
APPL 1	10 × 1.2	10 × 1.2	—	10 × 1.2
2	10 × 0.9	10 × 0.9	—	10 × 0.9
3	—	20 × 1.5	30 × 1.5	10 × 1.5
4	10 × 1.4	20 × 1.4	30 × 1.4	10 × 1.4
Total	30	60	60	40
Subarea 3				
APPL 1	30 × 1.2	15 × 1.2	20 × 1.2	5 × 1.2
2	20 × 0.9	15 × 0.9	20 × 0.9	5 × 0.9
3	—	15 × 1.5	20 × 1.5	5 × 1.5
4	—	15 × 1.4	20 × 1.4	10 × 1.4
Total	50	60	80	25

Resource demand is given in K6ytes for each application cluster.

Figure 12.4.1 Grid matrix for connecting MESH and NETDA.

MAZE

MAZE is a voice design tool that optimizes the trunk lines required between PABX nodes in a network. The input consists of call density between end-users in all nodes (in Erlangs) and the location of nodes.

MAZE considers how best to route traffic over intermediate nodes.

That is, it decides on the number of voice channels, the kind of topology to be applied, and the type of network facility to be used which minimizes the cost and satisfies the required grade of service.

MAZE uses a traffic file that is created with TARDIS macros. The tariff file should be defined such that MAZE has options to choose from; that is, there should be at least two communication facilities that support voice traffic.

MAZE provides a script format document that includes a traffic table, a facility table, and several other reports. In addition, MAZE provides a geographical map of the network configuration, including the PABX locations and links between the PABXs.

MAZE provides cost calculation and simple design techniques for PABx networks as follows:

Analyzing the Cost of a Specific Network. To do this, the user specifies the network and MAZE calculates the cost of all the links defined by the user. Each link must be specified in one of the following ways.

- Traffic to be carried. The user specifies the traffic (in Erlangs) that a particular link should be designed to carry. MAZE calculates the number of voice channels needed to provide the grade of service defined by the user, and then selects the least-cost communication facilities needed to provide this number of voice channels.
- Number of voice channels wanted. MAZE will choose the least-cost selection of communication facilities needed to provide the number of voice channels wanted. MAZE is using Erlang B tables during the optimization process.
- Specific set of communication facilities. The user can completely define the way each link is to be implemented. MAZE calculates the cost of the communication facilities.

Costing a Specified Network and Calculating Traffic Flows. In addition to defining the network, information about the traffic to be carried by the network can be provided by the user. MAZE can then allocate the traffic to the network, using a shortest-route algorithm, and calculate the load and blocking probabilities for each link and route in the network.

Designing a Network of Specified Topology for Given Traffic. The user can specify the topology of the network. This means the user says that certain links are to exist in the network, but the number of voice channels for each link does not have to be specified. The traffic to be carried by the network is also defined by the user. MAZE allocates this traffic to the network and then calculates link capacities needed to give the required grade of service, and the lowest cost way of implementing each link.

Minimum Hub-Spanning Tree Network. A minimum spanning tree network provides a route between any pair of nodes, but with the minimum total length of links required to do this. The nodes with HUB=YES are linked with

such a network, and then each node for which HUB=NO is linked to its nearest hub node. Traffic is then assigned to the shortest routes, and link capacities and costs calculated.

Fully Connected Hub Network. Any node with HUB=YES is linked to all other nodes with HUB=YES. Each node for which HUB=NO is linked to its nearest hub node. Traffic is then assigned to the shortest routes, and link capacities and costs are calculated.

Choosing Best Simple Topology. Many PABX networks have simple topologies, and MAZE can choose the lowest cost topology from a set of possible topologies in order to provide the grade of service wanted. The topologies from which MAZE will choose are single-star, two-linked star, and three-linked star.

MAZE reports include cost and traffic analysis for each connection; utilization in Erlangs, blocking percentage, number of voice channels, distance tables between hubs, traffic loading tables for various service grades.

SNAP/SHOT

SNAP/SHOT is a capacity planning tool available in many countries through Telecommunications Marketing Centers. It is a discrete simulation model that may be used to model a total communications system or parts thereof.

The host or CPU portion of the SNAP/SHOT model simulates CPU activity based on definitions of CPU types, subsystem definitions such as IMS, CICS, and TSO, I/O definitions, application program definitions, and work to be performed. Results of the CPU simulation consist of utilization and queue information, along with the times associated with processing each message.

The network portion of SNAP/SHOT simulates the 37XX transmission control unit under the control of ACF/NCP to obtain a report of buffer and processor utilization. Input is a definition of the channel, communication line attachments, and terminals, along with NCP parameters such as buffer size and channel delays, and the 37XX model and storage size.

SNAP/SHOT can model CPUs, DASDs, and networks with a great level of detail, so it is normally used as an analysis tool for data network performance. It is specifically well suited for use after having designed a network, in order to gain insight to the network's response time and line utilization under a specific workload.

Running several SNAP/SHOT simulations provides information about the relative capacity and performance of different hardware and software alternatives for a given workload; furthermore, the information can then be used in the planning process to attempt to ensure adequate capacity where needed.

It was explained in previous chapters how to design a network study for boundaries with MESH, and how to extend it to the backbone links with the

use of NETDA. This chapter explains how to proceed after completing a design in order to use an analysis tool like SNAP/SHOT. It is especially useful to analyze a network design for end-user response-time evaluation.

An existing procedure interfacing NETDA to SNAP/SHOT can be used to automatically build a SNAP/SHOT model using as input the files created by the I/O output processor of NETDA. This bridge is available in all countries supporting the use of SNAP/SHOT, and is an integral part of SNAPNET, a procedure used to invoke SNAP/SHOT, NETDA, and other related tools.

Figure 12.4.2 shows the most important results and statistics from a

```
S. N. A. P. / S. H. O. T.   R E S P O N S E   T I M E   S U M M A R Y  .

        NUMBER OF CPU S       =    7   NUMBER OF 3705 S      =    8
        NUMBER OF PCLUSTERS   =    0   NUMBER OF LCLUSTERS   =    0
        NUMBER OF SERIES/15   =    0   NUMBER OF LCC RINGS   =    0

TOTAL SYSTEM MESSAGES                      MESSAGE RATE (MSGRATE)
                                           COUNT   MSG/SEC  MSG/HR

TOTAL USER REQUESTED GENERATION.     =    15390     8.55    30780

TERMINAL  GENERATED   MESSAGES       =     2526     1.40     5052
3705NCP   GENERATED   MESSAGES       =    12980     7.21    25960
PROCESSOR GENERATED   MESSAGES       =        0     0.0        0
                                          -------  -------  -------
TOTAL     GENERATED   MESSAGES       =    15506     8.61    31012

COMPLETED LINE INPUT  MESSAGES       =     2523     1.40     5046
COMPLETED LINE OUTPUT MESSAGES       =     2516     1.40     5032

PROCESSOR ORIGINATED  MESSAGES       =        0     0.0        0
PROCESSOR COMPLETED   MESSAGES       =        0     0.0        0

            RESPONSE TIMES FOR ALL MESSAGES.    AVERAGE

            TOTAL SYSTEM RESPONSE          =    4.636 SECONDS
            NETWORK RESPONSE               =    4.636
            LINE RESPONSE                  =    4.187
            INITIAL NETWORK RESPONSE       =    3.803
            3705 RESPONSE                  =    3.020
            ACF NETWORKING RESPONSE        =    3.313
            PROCESSOR RESPONSE             =    0.500
            APPLICATION RESPONSE           =    0.500
```

MESSAGE.NAME	NETWORK SAMPLE	TOTAL	NETWORK	90 PER-CENTILE	LINE	INITIAL NETWORK	3705 SAMPLE	TIME
H020H21	257	6.674	6.674	10.750	6.174	6.057	1067	3.309
H020H22	219	7.841	7.841	11.250	7.382	6.586	1039	4.722
H020H23	254	7.133	7.133	10.750	6.699	6.293	1023	4.229
H020H24	90	5.543	5.543	9.250	5.183	5.543	355	3.325
H030H31	250	3.029	3.029	4.750	2.566	2.393	689	1.916
H030H32	248	3.896	3.896	5.250	3.461	2.637	727	2.671
H030H33	227	3.317	3.317	4.750	2.860	2.478	715	2.300
H030H34	77	2.345	2.345	3.750	1.905	2.345	228	2.191
H040H41	29	5.037	5.037	6.250	4.738	3.899	485	2.426
H040H42	26	7.704	7.704	9.250	7.272	5.335	439	3.192
H040H43	25	5.922	5.922	7.250	5.683	4.359	390	2.830
H040H44	10	3.318	3.318	5.750	3.221	3.318	145	2.070
H050H51	243	3.191	3.191	4.750	2.695	2.553	599	1.544
H050H52	241	3.853	3.853	5.750	3.439	2.593	599	1.779
H050H53	233	3.533	3.533	5.250	3.055	2.696	563	1.653
H050H54	87	2.405	2.405	3.750	1.957	2.405	210	1.426

The table above is headed:

```
        AVERAGE RESPONSE TIMES IN SECONDS FOR EACH NAMED MESSAGE
                  NETWORK                    90 PER-    INITIAL        3705
MESSAGE.NAME SAMPLE  TOTAL NETWORK  CENTILE  LINE   NETWORK SAMPLE TIME
```

Figure 12.4.2 SNAP/SHOT results and statistics.

SNAP/SHOT run. Response time reported is actually not the end-user response time, but just portions of it. This report may be utilized as a basis for various performance studies including multiple iterative steps with NETDA.

In summary, SNAP/SHOT will

- Provide information about trunk delay, response times, 37XX configuration, and queues built in the system.
- Allow the user to experiment with different options in the same or different analysis runs.

Teleprocessing Network Simulator (TPNS). TPNS is a telecommunications testing package that enables a user to test and evaluate application programs before actual terminal installation. The purpose of TPNS is to provide controlled generation of message traffic into a telecommunications subsystem or application through the use of processing rather than by large amounts of terminal hardware and terminal operator time. TPNS provides the ability to simulate a specified network of terminals and their associated messages, allowing the user to alter network conditions and message loads during a run. Thus, TPNS can be used to stress test telecommunications application programs with volume messages to evaluate the reliability and approximate performance characteristics under expected operating conditions.

The principal use of TPNS is to drive the on-line application program in the following manner:

- Simulate start/stop (S/S), airlines line control (ALC), binary synchronous control (BSC), or synchronous data-link control (SDLC) terminals and the networks to which they would be attached.
- Generate data from descriptions of application messages and transmit those real messages to a running teleprocessing application program.
- Vary the frequency of message transmission within desired limits.
- Timestamp and log all messages sent from and received by the simulated terminals.
- The customer may analyze the message contents for accuracy of data transmitted. The customer may also analyze the sending and receiving times to approximate application performance in response times and message rates.

Comprehensive scripting facilities are provided by the scripting language to specify TPNS simulation options at execution time. The script describes the terminal, network configuration, and message rates desired by the user. In addition, the script defines teleprocessing messages meaningful to the on-line application program under test. Individual segments of information in the messages may be generated by different methods, including random, table look-up, and constants. It provides a comprehensive logic test capability to compare certain data or tests received or sent by TPNS. Thus, scripts can vary

message data from the simulated terminals based on the content of a prior response from the application program.

Preparation of scripts is simplified by providing common default values for the keyword parameters used in the scripting language. Furthermore, there is an automated interface to NetView Performance Monitor for providing scripts from the live environment. A facility exists to allow message generation from a single script for multiple terminals. This facility is especially useful in a time-sharing environment. Multiple networks may be simulated concurrently to provide messages for driving multiple telecommunication applications or multiple processors.

A script generator program is provided as a part of TPNS. This program allows the user automatically to generate TPNS message texts from data captured during the running of an on-line application. The user needs to specify only the network configuration statements and provide these, along with the captured data, as input to the script generator. The network configuration statements may be updated by the script generator program to reflect the message decks generated.

TPNS can operate in either simplex or duplex mode. In simplex mode, TPNS and the subsystem (the driven telecommunication application) under test reside in a single processor and execute in separate regions. In duplex mode, two or more processors are required. TPNS resides in one and drives various telecommunication applications in the other(s). Neither simplex nor duplex operation requires that either processor be dedicated to the test run. Dedicated duplex processors would be used primarily for critical application-performance evaluation. In either mode, a dedicated communication controller (37XX) and the application under test requires another transmission control unit (TCU) of the appropriate type required by the application programs.

A preprocessor program is provided to check syntax of network- and message-configuration script statements. Two postprocessor programs are provided: one to list out the TPNS log tape in formated report and one selectively to calculate a response-time analysis by network communication line. The response time calculated by the postprocessor is the time required for the application to respond to an input message. The customer has the ability to write his or her own response-time analysis program using the various TPNS time stamps. TPNS also provides functions for graphing the results of the analysis program.

The log tape formating program has the capability of analyzing the message traffic on the log tape for display terminals and of constructing formated screen images to be printed. A device-level option is available to specify that special display records are to be written to the log tape, and these special records are used in producing the screen image outputs. The screen-formating feature is available for all terminals in the IBM 3270 Information Display System and for IBM 8775 Display Terminal.

TPNS can provide repeatability for functional testing, a collection of comprehensive transaction messages for regression testing, and message-rate

statistics for approximating application performance, response times, and evaluation of telecommunication network design.

In addition to all the preceding functions, TPNS is now supporting stress testing Token Ring local area networks, and SNA Physical Unit 2.1 Type end nodes, and TPNS is also able to drive X.25 networks.

Status with the IBM network design and planning package, consisting of TARDIS, MESH, MAZE, NETDA, RTE, SNAP/SHOT, and TPNS, is far from satisfactory. The principal shortcomings may be summarized as follows:

- There is no integration yet between the single products.
- Data are fragmented in various files, such as Info/System, NPM, SLR, TARDIS; repository is absolutely necessary in the future.
- There is no connection between voice and data design when sizing shared resources.
- The use of RTE as a go-between for MESH and NETDA may be accepted as only a very temporary solution.
- There is no solution yet for including SNA parameters, such as MAX-DATA, RUSIZE, MAXOUT, MAXIN, PASSLIM, PACING, DELAY, and PAUSE, into the network optimization process of MESH and NETDA.
- There are no accurate recommendations for front-ending the instruments: how to determine resource demand, how to compute overhead, how to project workload, and how to compute practical resource capacity limits.
- There are no directions given on how to include value-added services, such as private/public packet switching, ISDN, and virtual networks.
- There are no links to design and to size local and metropolitan area networks.
- No interfaces to third-party products, data bases, and design procedures.

IBM is supposed to work on some of these issues, but at this moment, it is very difficult to estimate time frames for new announcements. The first result is GRANDS, an umbrella product for the analytical tools. In the meantime, the majority of customers try to develop their own solutions by combining instruments from IBM and from third parties. The next sections will give a brief overview of the other players which may help with solutions in certain design and planning areas.

12.4.2 AT&T's Solutions for Network-Capacity Planning

The Interactive Network Optimization System (INOS) is the computerized tool AT&T Communications uses to design and optimize networks for users of AT&T Services. The INOS system consists of three modules: Voice, Data, and Integrated Networks. Within those modules is a set of compatible

programs that allows the designer to examine various network alternatives that will best meet a company's communications needs.

INOS-DATA (Figure 12.4.3) is the newest member of the INOS design family. It was developed by AT&T Bell Laboratories to replace and improve upon several existing data design tools. It can be used to design:

- Analog private line data networks
- Digital data networks (DDS and ACCUNET® T 1.5)
- Dial-up networks
- ACCUNET® packet-switched networks

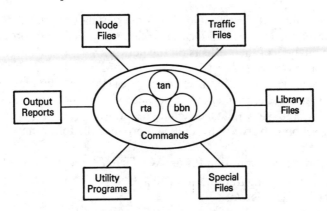

Figure 12.4.3 INOS-DATA structure.

The structure of INOS-DATA is basically a two-level hierarchical network. The first level consists of the Terminal Access Network (TAN) Module and the Response Time Analyzer (RTA) Module. The second level of the hierarchy consists of Backbone Network Design (BBN).

The Terminal Access Network (TAN) Module is the entrance vehicle into the INOS-DATA system. It is in this module that the data base and the basic cluster topology is built. It designs minimum cost access networks connecting remote terminals and other pollable devices to homing points. The homing points may be CPUs, multiplexers, concentrators, or data switches.

TAN will produce the following:

- Optimal terminal access configuration
- Number and type of circuits needed to carry the volume of input traffic
- Estimated cost figures for the configuration
- Average response time for the network

Due to the flexibility resident in TAN, selected design parameters can be changed and the program run several times with different specifications. AT&T Communications can then help the customer choose the configuration that is most effective in terms of price and response time.

The Response Time Analyzer (RTA) Module of INOS-DATA analyzes the response time and line utilization of the network circuit configurations produced by the Terminal Access Network and Backbone Network Modules.

For each leg of the basic network input into RTA, this module will produce the following:

- An actual response time for the input leg of the network, given the input volume of traffic and network equipment
- The percentage of line utilization for each leg of the circuit
- The response time for each data application transmitted over the network

The flexibility of this module allows the designer to change any of the data describing the circuit, add locations, change line speed or protocol, and perform an analysis of their effects on the network.

The Backbone Network (BBN) Module of INOS-DATA designs minimum cost networks connecting backbone nodes (the TAN homing points). It designs private-message-switched or packet-switched networks through the use of the customer's own data-switching facilities.

The Backbone Network Module will produce the following:

- A backbone configuration for an ACCUNET® Packet Network
- A backbone configuration for an ACCUNET® T1.5 or DATAPHONE® Digital Service Network
- The estimated cost of the configured network
- The number of circuits required
- The average response time for the configured network

The results of the BBN Module can be further refined by running it through the RTA Module of INOS-DATA.

In summary, INOS is a powerful design tool that will design the optimal network for both large and small users of AT&T facilities. It accommodates many protocols and is flexible enough to permit changes in usage and design criteria and quickly evaluate their effect on the whole network operation.

The Enhanced Interactive Network Optimization System (E-INOS) is a tool used by AT&T to design communications networks for its customers as a value-added part of new products and services. E-INOS is a family of interconnected design tools used for voice, data, and integrated voice/image/data networks. This analytic modeling tool has an Integrated Transport Network module to design networks that combine multiple circuit requirements (both data and voice) into common telecommunications facilities.

E-INOS is a network design package that supports AT&T's customer base. Automated data collection capabilities are provided in the design of voice networks through an interface using SMDR (station message detail recording) tapes. Since this is a tool internal to AT&T, the tariff data base for AT&T says it is committed to making E-INOS an industry leader in network

design and administration. Network designs using E-INOS are still a free service provided to AT&T customers through regional customer response centers.

12.4.3 Third-Party Solutions for Network-Capacity Planning of Voice and Data Networks

Van Norman provides an excellent user's guide to network design tools in [NORM88] and in [NORM90]. Leading competitive products are categorized in terms of the communication form(s) they support.

Support of data and voice

Aries Group—MPSG (Rockville, Md.). Aries is a telecommunications consulting firm that offers four interactive programs and data bases for designing and pricing both voice and data telecommunications networks: a circuit pricing system, separate design systems for voice and data networks, and specialized design aids for unique applications. Originally developed 14 years ago, these tools have been substantially updated. Because the Aries offerings treat data and voice design problems independently, they cannot be used for consolidated access and transport services. The user interface is command-driven rather than menu-based. And Aries does not provide for multiplexer cascading or multiple multiplexer types. The circuit pricing system, called DEXUS, is available through an on-line lease arrangement. For those who need extensive design studies, such an arrangement can become quite expensive. The tariff data is extensive and complete, including options for local exchange carrier (LEC) bridging and optimized customer-specified routing.

Contel Business Networks (Great Neck, N.Y.). The Modular Interactive Network Designer (MIND) is an integrated set of software tools that design and analyze voice, multi-point data, and packet data networks. MIND-Data is an interactive design tool for private-line, multi-point data-communications networks. MIND-Packet addresses the design and analysis of packet-switched or distributed mesh networks. MIND-Voice is used to design least-cost voice networks. MIND-Pricer is an on-line service providing up-to-date tariff information for both data and voice networks. The tools are generally accessed through an on-line lease arrangement.

General Network Corp. (New Haven, Conn.). CADnet is a computer-aided design tool using interactive graphics to design, analyze, and optimize voice and data networks. It is targeted for companies with large networks where annual expenses for communications technology exceed $1 million. CADnet permits dynamic simulation modeling of evolving configurations, which includes both network equipment and transmission costs. This is an integrated software tool with a modular architecture that allows users to customize capabilities to their level of networking needs. CADnet accommo-

dates the following networks: voice, centralized and distributed data, packet, local area, and hybrid. CADnet may be accessed through either purchasing a license for the software or obtaining an on-line lease.

Telco Research Corp. (Nashville, Tenn.). The Network Pathfinder is a set of tools for designing and refining voice, data, and integrated voice/data networks. Three menu-driven software modules can be used separately or together to answer what-if questions, assist in determining optimal network changes, improve service, and reduce costs.

The Voice Pathfinder tool provides multi-node network design capabilities, including backbone topology, line sizing, and T1- and virtual-network applications. The Exchange Carrier Optimizer II tool provides least-cost design of long-distance services at a single location. The Data Pathfinder tool has an interactive graphics design interface to configure multi-drop, multiplexed, and public packet-switched networks.

Integrated voice/data network designs are performed automatically using both the Voice Pathfinder and Data Pathfinder. The tools support error recovery and provide reporting capabilities, including on-line graphics. Access to Pathfinder is obtained through purchasing a license for the software.

Data only

BGS Systems (Waltham, Mass.). Two basic tools, Best/NET and Capture/SNA, are the main components of the capacity- and performance-management products. These two tools can operate in an integrated fashion or on an individual basis. Best/NET is an interactive software tool that describes, evaluates, and predicts the performance of the various components within SNA networks. Best/NET can be used to "test-drive" alternatives, allocate workloads, decide when and where to upgrade, and assist with network design and reconfiguration. Capture/SNA is a data collection and analysis tool that extracts information and aids in managing the performance and capacity of networks based on VTAM (Virtual Telecommunications Access Method). These tools, which run on an IBM (or compatible) mainframe, are accessed through purchasing a license for the software.

Comdisco Systems Inc. (Rosemont, Ill.). Comdisco's BONES (Block Oriented Network Simulator) is a network simulation system for predicting performance of packet-switched, circuit-switched, packet radio, and store-and-forward networks. BONES supports the development of complicated network and protocol models with simulation modeling written in the C language, but it does not require extensive simulation programming. The Comdisco product is more of a research and development tool for those who need highly precise customized modeling of network protocols, algorithms, and communications components. BONES uses hierarchical data-flow block diagrams and hierarchical data structures to define models and simulate layered architectures of standard (OSI, SNA, TCP/IP, DNA) networks, and it checks automatic translation of the graphical network model into user-

specified C-language values for modeling parameters. Network managers can use the results from BONES to determine excess capacity needed to accommodate catastrophic effects such as link and node failures. BONES has an interactive graphical interface. It does not perform cost analysis based on tariff tracking.

Connections Telecommunications (West Bridgewater, Mass.). Two data-network design tools, Multipoint Network Design System (MINDS) and distributed Network Design System (DNDS), are the main offerings for network optimization. Both tools are microcomputer-based and provide performance modeling, design, and pricing of data networks. MINDS supports multi-point network design under a least-cost algorithm with as many as five different performance "weights."

DNDS is used to design distributed networks—such as X.25 packet switching—and other dynamic-routing, multiple-path configurations. An on-line service supplies tariff information about the telecommunications environment, such as monthly rates for leased-line or dial services, details of the services and boundaries of LATAs (Local Access and Transport Areas), and competitive offerings of OCCs and LECs (local exchange carriers).

The company provides training and consulting services to users purchasing a license for its software.

Economics and Technology Inc. (Boston, Mass.). The ETI Private Line Pricer is a microcomputer-based tool that provides leased-line tariff information and network analysis. Pricing and routing of point-to-point and multi-point networks are the main features of this network design tool. ETI has also been active in telecommunications public policy and tariff proceedings. The Private Line Pricer is accessed through purchasing a license for the software.

C.A.C.I. (Los Angeles). provides various instruments written in Simscript for performance analysis and design of communications networks. COMNET II.5 simulates the routing of calls or packets in a network, and predicts network performance in terms of call blocking probabilities, call or packet delay statistics, and circuit group utilization. Voice, data, and ISDN can be modeled, including packet-switched networks with virtual circuits (e.g., SNA) or Datagrams, for example, DECnet operation. The company has recently begun offering a modeling solution to LANs, called SIMLAN.

Network Design and Analysis Corp. (Markham, Ontario). NDA's Autonet line comprises five tools for data network design and analysis. Autonet/Designer, using a network's configuration constraints, calculates networking costs based on the amount of traffic, line characteristics, service type, and equipment costs. Autonet/Performance 1 is a queuing theory-based analytic model for network performance, capacity, and sensitivity analysis. Autonet/Performance 2 is a simulation model based on general-purpose simulation system (GPSS), which is generally more accurate than the analytic model because traffic and performance measurements incorporate the dynamic behavior of data communications. Autonet/Manager is an inventory manage-

ment system that tracks work orders and helps prevent inconsistent records. This system is limited to data networks and does not provide for multiplexer cascading. The user-friendly interface is menu and panel-driven.

Quintessential Solutions (San Diego, Calif.). Decision support software tools that run both on microcomputers and UNIX-based minicomputers provide design and analysis capabilities for data-communication networks. These tools are based on an architecture that allows the network designer to customize input and output modules. The compute kernel (the lowest level of the operating system) is separated from the input and output modules, and standard interfaces are applied.

Thereby, capabilities exist to read input configuration information directly from a data base and to read input performance constraints directly from performance monitoring devices.

The same standard interfaces are available with capabilities for output into data bases, spreadsheets, or standard report formats. The compute kernel includes modules for multi-point network designs, circuit designs, and mesh/packet designs. Complete tariff information is included in a data-base design. Cross-validation of network optimizations is obtained through interconnection of the family of design tools. Access to the design tools is through purchasing a license for the software.

Technetronic Inc. (Ottawa, Ontario). A supplier of performance and capacity management design tools for IBM mainframes and SNA networks, Technetronic offers four tools under the Explicit family: Mainframe Performance Analyzer for MVS, Mainframe Capacity Planner for MVS, Network Performance Analyzer for SNA, and Network Capacity Planner for SNA. These tools analyze and predict the response time, utilization, and throughput of SNA and MVS networks. The Explicit tools differ from the BGS tools in that Explicit does off-line analysis by downloading performance analysis information from the mainframe to a microcomputer. This tool does not provide cost analysis through tracking tariffs, nor can it prioritize transmission groups or workloads. Explicit does have excellent graphical representation of topology, utilization, response time, and throughput.

Voice only

HTL Telemanagement (Burtonsville, Md.). Two series of microcomputer-based tools are offered for voice networking: Network Tools for Design (NTD) and Master (Manage and Simplify the Telecommunications Environment Reliably). NTD chooses the optimum mix of long-distance voice communications services for least-cost routing. Master is used for telecommunications resource management. In the NTD series, the tools include modules for long-distance analysis, switch and automatic-call distribution designing, WATs optimization, and private-line planning. Tariff data are provided. The tools are accessed through purchasing a license for the software.

In order to select the appropriate instrument the following criteria may be useful:

Platform	(e.g., PC, Sun, IBM)
Operating system	(e.g., DOS, UNIX, MVS)
Graphics	(e.g., mapping, reports, various output displays)
Features	(e.g., TR, PC-net, monthly tariff updates, SNA, SQL graphical interface)
LAN/WAN	(e.g., either or both)
Communication forms supported	(e.g., data, voice, image, or combination)
Price	(e.g., low–$80,000.00)

12.4.4 Modeling Local Area Networks

Recently, designing LANs has been happening more or less intuitively. Due to the prices of products and human time requirements, users were not really eager to design and size local area networks. Connectivity and compatibility items were much more highly prioritized than properly sizing the servers and properly determining the bandwidth required for satisfactory performance. But load and local area networks are increasing, topologies are getting more complex, and performance is being evaluated more critically. The capabilities of modeling are shown using LANNET II [CACI89B] as an example. Basically, LAN is expected to support clients, servers, and a gateway. A client is a generic user without explicit storage capability. Each client or client group has an action list representing the application initiated by the client; frequency and resource demand have to be identified. A server represents all common types of LAN servers, files, printers, and administrations. Servers have storage capacity and, like clients, have a server action list, each having a unique name, with a generation time, length, and destination. A gateway is the generic element used to model a link to another LAN, MAN, or WAN.

The local area network to be simulated is described in LANNET II by the data structure consisting of the LAN backbone, clients, servers and gateways. The baseline model is built by a powerful menu hierarchy supported by graphics. Besides workload identifications, the architecture, such as Ethernet, Token Ring, and Token Bus, the backbone bandwidth, and overhead also have to be identified. LANNET II offers the following reports:

- LAN statistics including transfer time, transit, system waiting time, overhead time, information overhead, information throughput, system throughput, message loss, and time to complete
- Client statistics show queue length, waiting time, and blocking

- Server statistics concentrate on queue length, waiting time, blocking, utilization, and storage capacity
- Gateway statistics focus on queue length and blocking

Graphs and plots can be generated showing throughput, delay, and resource utilization.

Metasan from the Industrial Technology Institute is a UNIX-based network modeling tool, and applicable to any type of local area networks. It may be expanded to accommodate wide area networks as well. Metasan uses stochastic activity networks (SANs) which are an extension of Petri-nets, which permit the representation of timeliness (real-time requirements), fault tolerance, degradable performance, and parallelism in a single model. Models developed with Metasan consist of descriptions of network structure and desired performance and solution options to be used in the evaluation process [FRAN90].

Internetix offers two network modeling products for LANs, LANSIM and Softbench [FRAN90]. LANSIM models the major LAN protocols, including Ethernet, Token Bus, Token Ring, FDDI, and TCP/IP, through the transport layer of the OSI model. LANSIM is a bottom-up, simulation offering in-depth modeling traffic flows in the LANs. Softbench is an analytical model that assists in computing throughput and delays. It includes message and packet sizes, but it cannot model actual traffic. The best results may be accomplished when both PC-based products are used in combination.

Internetix tries to link LAN design and modeling tools to LAN monitors. If it is applicable, the LAN monitor will provide live workload to the model. Also expert systems extensions are under consideration. The first implementation experiences are expected from Network General with the Sniffer product family.

12.5 HUMAN RESOURCES DEMAND OF NETWORK-CAPACITY PLANNING

The third critical success factor of network management is its human resources. The functions discussed thus far should be adapted to the present organization from within the information systems department first. Based on the functions, processes, and procedures outlined, the targets of organizational change can be determined. Table 12.5.1 summarizes the relationship of potential organizational units to the key functions of network-capacity planning. The indicators in this table consist of duty execution, or supportive or advisory types of involvement.

The same table may be used as a starting point for estimating the range of labor demand for network-capacity planning.

Network-capacity planning is usually staffed by four different kinds of people:

TABLE 12.5.1: Involvement in Network-Capacity Planning.

Functions	Configuration Management	Fault Management	Performance Management	Security Management	Accounting Management	Network-Capacity Planning	Level of Possible Automation
			Other Subsystems				
Determining and quantifying current workload	S		S		S	E	medium
Projecting future workload			A			E	medium
Developing the network-capacity plan	S		S	A		E	low
Implementation		S	S	S		E	low

E = Executing
S = Supporting
A = Advising

TABLE 12.5.2: Distribution of Functions among Human Resources.

Functions	Organization				
	Supervisor	Business Planner	Advanced Technology Analyst	Modeling Administrator	LAN Planner
Determining and quantifying current workload	(x)	(x)	x	x	
Projecting future workload	x	x			x
Developing the network-capacity plan	(x)		x	x	x
Implementation				x	x

x = Commitment

(x) = Involvement

TABLE 12.5.3: Tool Applicability Matrix by Personnel.

Tools	Organization				
	Supervisor	Business Planner	Advanced Technology Analyst	Modeling Administrator	LAN Planner
Monitors in network elements					
Application monitors		x		x	x
Software monitors				x	
Modem and DSU/CSU monitors				x	
Multiplexer monitors				x	
Switch monitors				x	
Line monitors				x	x
Network monitors				x	
PBX monitors				x	x
LAN/MAN monitors				x	x
Network element management systems					
Voice orientation			x	x	
Data orientation			x	x	
Console management systems					
Integrators	x		x	x	
Computerized cable management systems					
Automated call distributors					
General-purpose data bases			x	x	
Special administration products			x	x	
Networking models					
Voice orientation	x	x		x	x
Data orientation	x	x		x	x

X = Recommended use of instrument

TABLE 12.5.4: Personnel Requirements for Network-Capacity Planning.

| | Network Range | | | |
Organization	Small < 3000	Medium 3000–10,000	Large 10,000–50,000	Very Large > 50,000
Supervisor	1	1	1	1
Business planner	1	2	3	3
Advanced technology analyst	2	3	4	5
Modeling coordinator	2	3	3	4
LAN planner	2	3	6	10
Human resources demand				
Total	8	12	17	23

TABLE 12.5.5: Profile of Network-Capacity Planning Supervisor.

Duties

1. Identifies events requiring response from the planning group.
2. Develops a strategy for producing the required response.
3. Assigns priorities to the projects to be completed.
4. Monitors the progress of each project.
5. Prepares the migration/installation plan.
6. Ensures that staffing is adequate and that the expertise level is supplemented by a development training program.
7. Establishes education program for staff.

External job contacts

1. Other supervisors within network management
2. Network manager
3. Vendors with advanced technology
4. Business planners of the larger organization

Qualifying experience and attributes

1. In addition to managerial skills, good understanding of the current environment and how changes in that environment may affect the network
2. Good understanding of the principles of network design and of communications hardware and software
. ⁻raining in administrative management

- Business planner
- Advanced technology analyst
- Modeling coordinator
- LAN planner

Table 12.5.2 shows the distribution of functions among these people. In order to limit the alternatives for a tool's selection, Table 12.5.3 gives an overview of instrument classes under consideration for network-capacity planning and of their potential users in the network-capacity planning hierarchy.

For estimating the demand in FTEs (full-time equivalents), Table 12.5.4

TABLE 12.5.6: Profile of Business Planner.

Duties

1. Pursues business plans of the larger organization.
2. Defines and works with natural forecast units.
3. Characterizes and represents present workload.
4. Projects workload.
5. Develops installation and migration plans.
6. Assigns due dates for installations.
7. Supervises pilot installations.
8. Prepares network design alternatives that will meet future needs.
9. Produces fallback plan.

External job contacts

1. Business planner of the larger organization
2. Network performance analyst
3. Vendors of projection tools
4. Modeling coordinator
5. Application systems developers

Qualifying experience and attributes

1. Communication skills
2. Knowledge of the business of the larger organization
3. Some experience in communication networks
4. In-depth knowledge of projection techniques
5. Political skills
6. Planning and scheduling skills
7. Communication skills in working with vendors
8. Detailed knowledge of fallback procedures

TABLE 12.5.7: Profile of Advanced Technology Analyst.

Duties

1. Prepares feasibility studies for application development.
2. Evaluates
 Communication forms
 Communication services
 Communication networks
3. Makes reference visits.
4. Evaluates utilization and service.
5. Accomplishes communication analysis.
6. Performs hardware and software selection.

External job contacts

1. Application systems developers
2. Service coordinator
3. Carriers
4. Vendors
5. Inventory coordinator

Qualifying experience and attributes

1. Communication skills
2. Overview on communication forms, services, and networks
3. In-depth knowledge of service level

TABLE 12.5.8: Profile of Modeling Administrator.

Duties

1. Maintains model alternatives.
2. Interprets modeling results.
3. Prepares input data.
4. Conducts stress testing.
5. Conducts pilot tests.
6. Prepares conversion plans.
7. Evaluates ability of future network configuration to meet future needs.

External job contacts

1. Modeling administrator
2. Vendors of modeling and emulation instruments
3. Service coordinator
4. LAN planner
5. Advanced technology analyst

Qualifying experience and attributes

1. Understanding how models work
2. Communication skills for getting information on
 Application load volumes
 Resource demand on communication resources
3. Skills of project management

TABLE 12.5.9: Profile of LAN Planner.

Duties

1. Pursues business plan of larger organization.
2. Defines and works with natural forecast units.
3. Characterizes LAN-related present workload.
4. Projects LAN-related workload.
5. Develops installation and migration plans.
6. Assigns due dates for installations.
7. Supervises pilot installations.
8. Prepares network design alternatives that will meet future needs.
9. Produces fallback plan.
10. Interfaces WAN-planning activities.

External job contacts

1. Business planner
2. Modeling administrator
3. Application systems developers
4. Vendors of LANs and MANs
5. Network performance analyst
6. Advanced technology analyst

Qualifying experience and attributes

1. Communication skills
2. Knowledge of business of the larger organization
3. Some experience in LANs and MANs
4. In-depth knowledge of projection techniques
5. Political skills
6. Planning and scheduling skills
7. Detailed knowledge of fallback procedures

TABLE 12.5.10: Responsibility/Skill Matrix.

Functions	Skills					
	Special knowledge of function	General knowledge of communication facilities	In-depth knowledge of communication facilities	Some knowledge of business administration	Communication skills	Some knowledge of project management
Determining and quantifying current workload	x	x				x
Projecting future workload	x	x		x	x	x
Developing the network-capacity plan	x	x				x
Implementation	x	x	x		x	x

X = Skill requested for function

provides the quantification for the four major customer clusters introduced and defined in Chapter 1. The numbers represent averages, and are based on the results of many surveys and interviews conducted personally by the author of this book.

In order to help with hiring and building the fault management team, Tables 12.5.5 to 12.5.9 give typical profiles for each network capacity planning position, including the supervisor of the group.

And, finally, the function/skill matrix, shown in Table 12.5.10, gives an overview of the targeted skill levels for each individual management function.

12.6 SUMMARY

Practical recommendations for network-capacity planning include guidelines for *doing* certain things and for *avoiding* certain others. The guidelines are useful for both short- and long-range improvements in the area of network-capacity planning.

DO

- Process
 Consider network management centers as a business
 Cost/benefit analysis prior to building system
 Quantify user service-level targets
 Utilize configuration/fault/performance data bases
 Identify present traffic and load profiles
 Use stress testing
 Quantify resource demand of all applications
- Products
 Become familiar with all planning products
 Use correct tool for each planning task
- People
 Clearly identify all personnel needed for planning process

AVOID

- Process
 Building models that are too accurate
 Using cost as only design objective
 Underestimating implementation activities and time
- Products
 Depending on products to provide all planning process answers
- People
 Leaving users, business planners, and project leaders out of planning
 loop

13

Network-Management Directions and Solutions

Users are in search of network-management solutions that are available now or in the near future. Concentrating on overall solutions instead of single, fragmented network-management functions means recommending applications across network-management subsystems; recommending solutions across communication forms, including data, voice, and image; and making recommendations across various vendors. After addressing mission-critical network-management directions, such as integration, centralization, automation, and data-base support, leading solutions are discussed in some depth. Solutions are grouped according to whether they are proprietary or on OSI-based architectures, or whether they are provided by vendors or by users. Not only products but also network-management services may help users in solving their actual network-management problems. In order to facilitate decision making, services and outsourcing criteria are also discussed. This chapter concludes with product selection criteria and estimated network-management trends.

13.1 NETWORK-MANAGEMENT INTEGRATION

More than ever, the direction network management is taking is an integrated approach. This can be seen by analyzing the limitations encountered in even the newest of network components. Today, with the availability of software-controlled modems, DSUs, CSUs, multiplexers, switches, bridges, routers and even with software defined networks, complex monitoring and testing of

facilities and equipment can be performed. Such services can provide data on any level of detail, as addressed in Chapter 4. Having collected these data, such software-defined components can be transmitted to a central collection point where they can be stored, analyzed, or acted upon if a problem is reported. However, this environment cannot yet accomplish horizontal integration across various products. Most component-level vendors provide products that engender useful individual functionality, but they are limited in that they cannot be easily integrated into a system vendor's network-management offering. Future integrated solutions are expected to solve this problem by offering horizontal integration across:

- Communication forms (data, voice, image, video)
- WANs, MANs, and LANs
- Private, public, and virtual networks
- Multi-vendor architectures
- Processing and communication systems

Figure 13.1.1 shows an example with horizontal integration. System vendors have developed single network-management protocols (e.g., NMVT from IBM) to facilitate data collection and integration about both physical and logical components, as long as data may be collected from the components supported by the protocol. But this type of vertical integration is not easy, in particular owing to the proprietary nature of applications and logical session management. Future integrated solutions are expected to solve this problem by offering vertically integrated applications across:

- Logical and physical network components
- Applications and network components

Figure 13.1.2 shows an example with vertical integration. In addition, users and suppliers are expected to work more closely together by co-managing their instruments (e.g., by using electronic data interchange techniques).

Integration will require multiple steps in terms of depth of integration. One will start at the physical terminal level by emulating multiple consoles' images in various windows of an intelligent workstation. In this case, the native protocols, messages, and commands of the emulated vendors are in use. But concentrating the "screens" in one area on a few workstations helps to substantially improve efficiency. In the second step, the emulated third party or the Integrator, or both, will convert to a unique protocol or format, such as, for example, NPM from AT&T or NMVT from IBM. In this case, messages and commands are unique up to the demarcation line of the third party. In the ultimate step, real integration is targeted by two approaches (Figure 13.1.3), both offering horizontal or vertical integration, or even both [HERM91].

- HORIZONTAL - Integration of equipment from multiple vendors doing similar functions

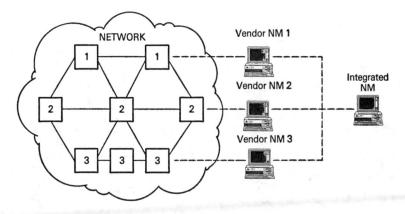

- Degree of Integration
 - Alarms
 - Windowing
 - Input/Output
 Displays
 Controls
 - Intelligence

Figure 13.1.1 Horizontal integration.

Aspects of Telecommunications

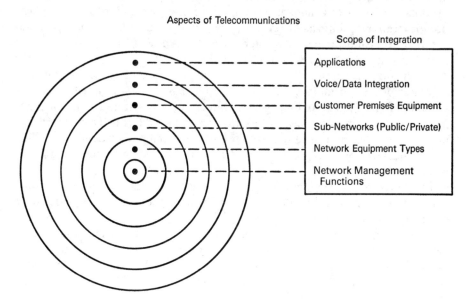

Figure 13.1.2 Vertical integration.

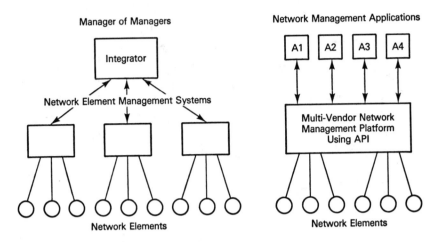

Figure 13.1.3 Hierarchical versus platform network-management integration approach.

The first is the manager of managers approach, which is a hierarchical approach in which an integrated manager interfaces to lower level element management systems. The premier examples of such a system are NetView from IBM, the AT&T ACCUMASTER Integrator and the Nynex Allink products. The second general approach is the platform approach, in which multiple vendors write network-management applications to a standard set of application programming interfaces (APIs). The premier examples of this approach are the DEC Enterprise Management Architecture (EMA), SunNet Manager from SUN, and OpenView from Hewlett-Packard.

The platform approach to integrated management offers the possibility of a greater degree of multi-vendor integration than the manager of managers scheme. In the manager of managers architecture, interactions among management systems from different vendors are accomplished through a standardized protocol interface and a standardized set of management data definitions. This hierarchical way of aggregating management information requires that a single vendor—the provider of the integrated manager—develops all the multi-vendor network management application software. Other vendors merely provide raw data to the integrated manager through open interfaces and accept commands through open interfaces.

In practice today, only a few applications exist on the integrated manager, so most functionality is obtained through windowed access to device manager applications, called cut-through or terminal emulation. Moreover, this approach multiplies management systems at a time when operations centers are looking to reduce the number of management systems they use. It may also result in multiple network-management data bases.

In the platform strategy, the eventual goal is to develop a single manage-

ment system that can handle a diverse, multi-vendor network. Rather than do it all alone, the platform vendor creates an open development environment in which multiple vendors can write software that shares common user views and a common data repository. If the platform offers a rich set of services and advanced capabilities, such as an object-oriented user interface or a relational data base, many vendors may find it attractive to implement their management software on such a platform rather than developing their own base at considerable cost and risk.

The advantage of the manager of managers approach is that it builds on existing management systems. Using the manager of managers approach, IBM shows the way how to integrate WAN and LAN management. Token Ring has a stand-alone management capability using the LAN Network Manager. Fault, performance and configuration management are supported also without NetView. But, the more complete solution is with using NetView as the focal point. In this structure, bi-directional information exchange is supported. The platform strategy in its pure form requires writing all new management software. In practice, the two approaches can be combined, if necessary. But the platform strategy aims at reducing the number of management systems, which is highly appealing to network owners. The manager of managers approach, on the other hand, is necessary to preserve an installed base of management systems. The platform concept is most appealing when all new software has to be written anyway.

The other argument against the proprietary or OSI-based manager of managers solution to multi-vendor network management is that no one vendor can meet all the management application needs of a large enterprise. With the platform approach, many vendors can simultaneously work on management software that will all play together. If a particular platform achieves a critical mass of important applications, then there is a good chance that users will choose it, since applications are what the users really want. If users start buying a particular platform, then more application software developers will want to write for that platform since the market for their creations will be large.

13.2 NETWORK-MANAGEMENT CENTRALIZATION

In order to take advantage of economies of scale and also have a single view on the corporate network, network management will become more and more centralized, while control will be distributed to intelligent devices and to designated users as appropriate. Two approaches are competing for being implemented as the centralized network management solution. Mainstream and sidestream network management are two important, contrasting approaches to managing large communication networks. There is no clear-cut distinction as to which approach is best.

Mainstream network management is essentially a host-based approach. It primarily implements network-management functions as a part or an extension

of the host's communications software. In contrast, the sidestream approach places some or all network-management components in a special-purpose management processor.

A sidestream approach can complement a mainstream approach, however. There are certain management functions that are best integrated into the host, such as network problem determination applications, display exception monitoring facilities, network performance applications, and interactive problem control systems. Users can create an overall system management approach or *hybrid* solution by integrating these functions into the host and complementing that with the sidestream approach. Moreover, recent evaluations present feasible alternatives for designing and implementing the sidestream approach around an artificial intelligence processor.

Both mainstream and sidestream network management seek to achieve six major goals: address all important network components; anticipate network failures; implement centralized control; effectively use resources; support a data base; and support customers (end-users). The philosophy guiding the manner of achieving these goals is different for each approach.

Mainstream network management

The mainstream network-management philosophy is summarized in the following paragraphs:

Address All Components. Communications networks can operate properly only when all management areas and components are satisfactorily addressed. These components include hardware, system applications, and communications software.

Anticipate Network Failures. To reduce the time between failures and their restoration, users should prepare customized recovery procedures prior to installation. With the mainstream approach, these procedures are centrally distributed and maintained. Recovery procedures are invoked by certain types of solicited or unsolicited messages.

Implement Centralized Control. Depending on how the user defines the span of control, network outages may be reported to one location only. The processing power in one or more of the host computers provides sufficient management tasks support. The information gathered at remote sites is usually time-division multiplexed onto the productive circuits.

Resource Sharing. Mainstream network management uses existing processors to run special-purpose management tasks. This may save users from purchasing additional hardware (see "Sidestream Concept"). However, users should carefully evaluate and control the additional overhead this places on processors that are already supporting applications.

Data Base. With the mainstream approach, users can employ existing data bases or files to centrally store and maintain all relevant configuration and performance data. Network management-oriented data may be inte-

grated or kept separate. An authorized user group may directly access this data base. Users must exercise caution, however, to assure that the additional data base use will not impair performance for production users. Program-to-program links may be used for completing problem-related records, as part of the trouble file.

End-User Support. Mainstream network management incurs overhead on applications processors. In order to keep this overhead in balance, the mainstream approach does not encourage special features, such as formats, panels, displays, reports, and scripts. Standardized features may be used network-wide, however, reducing the danger of using out-of-date options.

Sidestream concept

With the sidestream concept, some or all components used in accomplishing the network-management tasks reside in a special-purpose management processor.

The specific philosophy guiding the sidestream approach to achieving network-management goals is described in the following paragraphs:

Address All Communication System Components. A communications system consists of all system-related components. The sidestream approach defines a component as anything that, when not functioning properly, impacts the end customer. This includes terminals, modems, lines, multiplexers, storage devices, processors, system software, and applications software used to support a network. The definition also includes sources of power, air conditioning, water chillers, and numerous operational procedures, because their failures may also impact the end-user.

Anticipate Problems. As with mainstream network management, the sidestream approach dictates that users set up recovery procedures in advance to minimize problem impact. This applies for any computer system. However, outages are more easily managed (and end-users are thereby shielded from a number of problems) when the computer systems are contained in one location and a select group of computer operation personnel (e.g., customer support desk, host control, network control, master terminal operator) interface with that one location.

Attaching computer terminals greatly increases the span of control. The computer operation is more visible, and it is more obvious to the end customer when things are not working properly. In sidestream network management, element management systems support problem restoration.

Centralized Management. Customers call in problems to one central location. This implies that it is necessary to accept anything the end customer wants to categorize as a problem (this is consistent with the sidestream approach to "address all components"). It also implies that the sidestream processor is able to promptly collect the customer-provided data concerning that problem. The process of recording all problems in one centralized location

helps to solve problems. For example, if a line fails and all the customers connected to that line call the central location, the cause will be fairly evident. The information collected at remote components is usually frequency-division multiplexed onto the same circuit used by the primary data channel.

Separate System. The sidestream approach implements problem management on a processor that is separate from the managed system. Thus, one can insert the sidestream processor tool into the communication system's operational process without disrupting any applications. The tool is not dependent on host hardware or software configurations, so the customer can change applications, hardware, or control software without disrupting the tool. The tool can, in fact, manage such changes. Furthermore, the tool is available during most system outages. Processor tool installation and maintenance do not compete for resources used to run the communication system. This avoids contention for system resources and critical programming skills. Users can install, test, or reconfigure physical network facilities (lines and modems) prior to attaching them to the operational host CPU or to a properly generated communications multiplexer.

There is another separate-system approach benefit. Frequently, other departments outside of the data-processing organization (such as customer service, quality control, or others) are responsible for network stability. A separate system provides a tool that is totally controlled by that organization.

Finally, there is an element of simplicity associated with a separate-system approach. The sidestream processor tool becomes stable after installation and provides reliable service for long periods before there is a component failure. Because it is separate, it also frees management from addressing interactions that might occur with the business application systems.

Single Data Base. The sidestream processor maintains a data base that reflects the communications system's current state, including all problems and changes affecting the communication system. Any customer group within the data-processing organization, supplier, or contractor has access to relevant data from this data base. This prevents each group from having a separate list of problems and priorities. Recent alternatives are keyed to both physical and logical addresses.

Customer Advocate. A final and key sidestream design philosophy principle is that the communications system management staff must view itself as a customer advocate rather than as a data-processing center advocate. Many of the sidestream processor tool functions are oriented to this view. Flexible formats, alerts, scripts, and data bases are major examples of the end-customer advocate philosophy.

Comparison and evaluation

It is difficult to determine which concept—mainstream or sidestream—is superior. To assist in evaluating which approach is best suited for a user's network, this report presents 13 comparison criteria.

Figure 13.2.1 summarizes, in graphic form, the comparisons discussed next. Both approaches are rated on a scale of 1 through 4 for each criterion, where 4 is the most favorable rate. The chart illustrates that both alternatives have strengths and weaknesses. The optimal solution is to use both techniques in combinations that support both physical and logical management. Utilizing the D-channel of ISDN for network-management related data may bring both alternatives together. ISDN-support has been announced by the majority of companies offering mainstream network-management solutions.

This figure compares mainstream and sidestream network management against 13 criteria. Each approach is given a rating of 0 to 4 in each category; 4 indicates outstanding performance, 0 indicates poor performance.

Figure 13.2.1 Mainstream and sidestream.

The criteria are:

1. **Scope of features:** There are practically no limitations to either technique; in this respect, they are equivalent.
2. **Span of control:** Mainstream gives a more complete network view and usually addresses more areas than the sidestream approach.
3. **Overhead:** Using mainstream, the management overhead can be quite high. In order to avoid and reduce overhead, users may consider employing dedicated mainframes. Otherwise, sidestream is generally the better choice for reducing the total impairment due to management overhead.
4. **Portability:** Mainstream network-management systems are generally less portable, since the operating environment depends on both hardware and software. Moving the network-management location into another environment may require less expense using the sidestream approach.

5. **Alerting:** Sidestream provides rapid means of detecting problems without necessarily indicating the cause.

6. **Problem determination:** Mainstream provides a wider range of determining problems that may occur in the networking environment. In addition, more sophisticated logical tests may be invoked using the mainstream approach.

7. **Measuring performance:** This includes addressing both response time and availability measurements. Both techniques provide a wide range of indicators. Using mainstream, the degree of overhead is important; using sidestream equipment, cost may limit the range.

8. **Choice of location for networking center:** Users can implement mainstream network management only at locations where mainframes are available. In contrast, the sidestream approach requires an appropriate interface.

9. **Extendability:** Substantial network extensions may exceed optimally sized sidestream processor capabilities. Thus, extending the network may require significant sidestream management system upgrades.

10. **Data-base option:** Both approaches are similar, although the mainstream approach provides slight benefits over the sidestream approach.

11. **Costs:** The short-range costs are higher for the sidestream approach. However, over the long range, the break-even point may be reached sooner than expected.

12. **Reliability:** Mainstream network management depends on the availability of the mainframe housing the network-management software. If this computer is down, the communications network management breaks down as well. With the sidestream approach, however, network-management services can be continued in the event of a mainframe failure.

13. **Ease of use:** There is no significant difference between the two techniques.

In terms of alternative topologies, there are four choices:

- Hierarchical structure with one integrator
- Hierarchical structure with cooperative integrators
- Distributed structure with many subintegrators
- Fragmented structure with occasional links between subintegrators and integrators

At the moment, it is very difficult to predict the dominant alternative, but the hierarchical structure with cooperative integrators seems to be the best choice right now.

13.3 NETWORK-MANAGEMENT AUTOMATION

Automation is considered the number one solution for increasing network-management efficiency and for stabilizing the number of human resources in

the network-management environment. The evolutionary steps, however, have to be clearly separated in the following way:

Step One: Automated Operations. The application of software to perform routine operational tasks in network management centers with greater speed and accuracy than would normally be performed by humans.

Step Two: Unattended Operations. The use of intelligent hard- and software to manage a network control center environment with minimal intervention by human operators.

Step Three: Lights-Out Operations. The physical separation of the network control center staff from the "machine" room and its equipment.

In most environments, the near future target is only automated operations. More accurate objectives of automation are:

- Simplify the operator's task by monitoring and filtering messages.
- Increase accuracy and productivity by executing scheduled actions at the appointed time and by following procedures.
- Absorb accelerating growth by a relatively stable number of staff by automating routine types of activities, allowing more time for solving complex problems.
- Speed up recovery by automated IPLs and system start-ups, also remotely.
- Improve management control by better procedures, up-to-date documentation, and by replacing popular, but obsolete, tools.

But automated operations are not the solution to all problems, are no replacement for human thought and intelligence, and do not mean immediately unattended operations. Leading vendors target network-management automation as a high priority. IBM considers NetView as the central point in automating operations starting with the message processing facility. Figure 13.3.1 shows the architecture which may help to filter messages, offer access to voluminous reference material, accelerate responses to problems, and educate personnel by logging messages and actions taken on the basis of messages.

Considering the network-management functions addressed in Chapters 7 through 12, the most promising targeted functions for automation are:

- Data collection
- Message filtering and interpretation
- Alarm consolidation, grouping, distribution, and, to some extent, correlation
- Opening, tracking, and closing trouble tickets
- Switching to alternate configurations
- Recovery

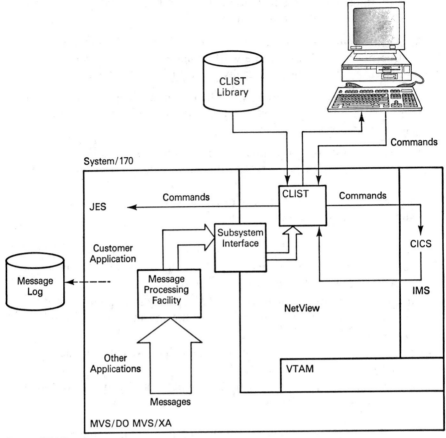

Source: IBM Corp.

Figure 13.3.1 NetView in center of automated operations.

- Generating reports
- Scanning logs
- Detecting security violations

Automated operations can be supported in a further stage of development by artificial intelligence. The present status of this support can be characterized as follows:

- There are many prototypes, but very few productive systems.
- Fault management is the primary target for almost all vendors.
- The majority of applications and prototypes are dealing with messages, events, and alarms, and are trying to interpret and correlate them.
- Building the knowledge base requires more time than previously estimated; a combination of closed trouble tickets with messages, events,

and alarms, and human reactions is recommended as the knowledge base for expert systems.

- Use of shells seems to have had a breakthrough; KT, ESE, ADS, S1, and so on, are promising examples of shells.
- Maintainability of systems and education of personnel are key criteria for justifying investments in this area.

A few product examples are:

- Dantes (Texas Instruments) for managing an X.25-based network for a large Belgian bank
- Virtual Route Analysis (IBM) for optimizing SNA networks
- Spark (Sumitomo-IBM) for managing interconnected SNA networks for the largest metal corporation of Japan
- Network Problem Determination Expert System (NPDES) (Harris) for supporting fault management in mostly SNA-oriented networks
- Network Advisor (Boole) for assisting the troubleshooting process in an offline modus of SNA networks
- Princess, Nemesys, Starkeeper (Bell Labs and AT&T) for problem determination of voice and data networks; both real-time and batch types of operation are supported
- ACE (Automated Cable Expertise) from AT&T; Preventive maintenance of cables
- EXT (Expert Tester) from AT&T
- GEMS-TTA (Generalized Expert Maintenance System Trunk Trouble Analyser) from AT&T
- Designet (Bolt, Barenek and Newman) for designing the company's packet-switching network
- RTES (Real Time Expert System) from Bellcore; diagnostics for switches
- COMPASS (Central Office Maintenance Printout Analysis) from GTE; Offline maintenance of communication circuits
- KRITIC (Knowledge Representation and Inference Techniques in Industrial Control) from Esprit; Maintenance of telecommunication systems
- DAD (Datapac Adviser) from Telecom Canada; Maintenance of Datapac network
- DRES (Data Route Expert System) from Telecom and Bell Canada; Simulation for operators training
- NTS (Network Troubleshooting Consultant) from DEC; Ethernet service-level control
- CENTAURE (CENTre d'Assistance aux Utilisateurs du REseau) from Cognitech; Control system for the proprietary network RETIPAC of French railways

There is another trend of offering network-management services based on expert systems; examples are Network Support from IBM, NETsupport from DEC, and Expert Fault Management Service from N.E.T.

When considering automated operations with or without expert systems, up-front costs of hardware, software, and training, plus hidden costs due to the lack of a critical mass of operators, pioneering solutions, and the time to sell ideas to their own staff, must not be underestimated. On the other hand, significant benefits may be expected:

- Stabilized number of staff
- Better service delivered
- Motivated and skilled staff
- More reliable service

Chapter 14 will show examples of techniques for cost-justifying investments in network management. The techniques are easily adaptable to the automated operations field.

13.4 NETWORK-MANAGEMENT DATA BASE

The network-management data base is expected to play a central role in implementing and using advanced network-management solutions. Some of the vendors name this data base as repository, and intend to include voluminous data sets—far beyond the needs of network management. Network management needs three principal segments of a repository:

- Configuration-related data with object-attributes, connections, and status
- Performance-related data with key service and efficiency indicators
- Telemanagement data with station message detail records

Standardization bodies have been publishing promising structures and architectures, but the gap to applicable solutions is still very deep. Vendors agree with users not to wait too long. Vendors and users are developing their own answers, which increases the confusion even more. At the moment, only the following facts and trends may be summarized:

- IBM's direction is a relational solution based on DB2.
- DEC's solution is based on MIR (Management Information Repository); everybody hopes it is not too far from OSI-MIB (Management Information Base).
- AT&T's direction is Informix at the Integrator level and for some of their proprietary Element Management Systems; in addition, a directory service based on X.500 is targeted.

- Other vendors target relational solutions for the configuration data base with a handful of "popular" products as outlined in Chapter 7.
- Performance data-base solutions are rare; both vendors and users prefer ad hoc solutions with a complex and unmanageable file structure.
- Telemanagement is separated and optimized in its own way by distributing processing and storing tasks between mainframes, minis, and micros as discussed in Chapter 11.

13.5 LEADING NETWORK-MANAGEMENT PRODUCTS

Network-management products may be categorized by different criteria. This section of the book will use three major groups:

1. Proprietary solutions that may become de facto standards when the number of supporters grows beyond the critical mass. Besides IBM, the Simple Network Management Protocol (SNMP) seems to represent this category. SNMP goes beyond just offering management to TCP/IP-based networks. Also client-server processing with communicating software implementations of various stand-alone devices may be included here. De facto standard solutions are also offering application programming interfaces (API) allowing users to customize management systems with device-specific, function-specific, and network-specific applications.

2. OSI-based solutions that may become the real de facto standards when interpretation and implementation differences at the CMISE, SMF, and SMFA layers can be eliminated.

3. User solutions that try to combine both previous alternatives by customizing existing products and modules. Most solutions have been designed for internal use, but external sales are not excluded any longer. The advantage of these solutions is also a disadvantage: They are only addressing the practical needs of a particular networking environment and culture.

13.5.1 Proprietary Products

The leading product in this category is NetView. Previous chapters may be referenced for further technical details: Chapter 3 for the architecture, Chapter 4 for the NetView monitors, Chapter 8 for the command facility, and Chapter 11 for NPM. Here, the objectives are more strategic in terms of clustering users according to how they take advantage of NetView's functionality and how the product compares with Net/Master.

Figure 13.5.1 helps to delineate all the product offerings of IBM for network management in a broader sense. Competitive products are also included.

(a)

VOICE ACCOUNTING APPLICATIONS	IBM INFO/MAN INFO/SYS	NETVIEW DISTRIBUTION MANAGER	NETVIEW ACCESS SERVICES, SAMON	INSTALLATION TOOLS (SOLUTIONPAC)			NETVIEW PERFORMANCE MONITOR (NPM)	NETVIEW FILE TRANSFER PROGRAM (FTP)	IBM NETWORK DESIGN AND ANALYSIS TOOLS	IBM SERVICE LEVEL REPORTER (SLR)	IBM TELE-PROCESSING NETWORK SIMULATOR
				NETVIEW COMMAND FACILITY							
				REXX/CUST*	STATMON	ON-LINE HELP					
				HELP DESK	TARA	BROWSE					
				HARDWARE MONITOR		SESSION MONITOR					
				VTAM							

(b)

VOICE ACCOUNTING APPLICATIONS	PNMS-3 OR CA-NETMAN	NETVIEW DISTRIBUTION MANAGER	NETVIEW ACCESS SERVICES, SAMON	INSTALLATION TOOLS (SOLUTIONPAC)			METSPY OR MAZDAMON OR NET INSIGHT	NETVIEW FILE TRANSFER PROGRAM (FTP)	IBM NETWORK DESIGN AND ANALYSIS TOOLS	IBM SERVICE LEVEL REPORTER (SLR)	IBM TELE-PROCESSING NETWORK SIMULATOR
				NETVIEW COMMAND FACILITY							
				REXX/CUST*	STATMON	ON-LINE HELP					
				HELP DESK	TARA	BROWSE					
				HARDWARE MONITOR		SESSION MONITOR					
				VTAM							

(c)

VOICE ACCOUNTING APPLICATIONS	PNMS-3 OR CA-NETMAN	NETVIEW DISTRIBUTION MANAGER	TPX, CL/SUPERSESSION CA-VMAN OR TELEVIEW	INSTALLATION TOOLS (SOLUTIONPAC)			NETSPY OR MAZDAMON OR NET INSIGHT	NETVIEW FILE TRANSFER PROGRAM (FTP)	IBM NETWORK DESIGN AND ANALYSIS TOOLS	IBM SERVICE LEVEL REPORTER (SLR)	IBM TELE-PROCESSING NETWORK SIMULATOR
				NETVIEW COMMAND FACILITY							
				REXX CUST*	STATMON	ON-LINE HELP					
				HELP DESK	TARA	BROWSE					
				HARDWARE MONITOR		SESSION MONITOR					
				VTAM							

(d)

VOICE ACCOUNTING APPLICATIONS	INFO/MASTER	SYS/MASTER	NET/MASTER MAC	NET/STAT	NCL	NET/MAIL	NET/MASTER TRANSFER COMPONENT	NETSPY OR MAZDAMON OR NETX INSIGHT	IBM NETWORK DESIGN AND ANALYSIS TOOLS	IBM SERVICE LEVEL REPORTER (SLR)	IBM TELE-PROCESSING NETWORK SIMULATOR
				OCS	EASINET	MAI					
				NEWS	PANEL SERVICES	NTS					
				VTAM							

Figure 13.5.1 IBM and competitive network-management system products.

Users of SNA may be clustered into four groups regarding their "relationship" to NetView. These groups are [TERP90A]:

Group 1: Very true IBM users—no interest in anything other than IBM products (Figure 13.5.1A), for example, NetView, NPM, SLR, Voice applications from IBM, NetView/PC. IBM tries to strengthen its position by partnerships. In particular, voice applications seem to be interesting to the company. HubView's principal function is to collect alarm, traffic, and SMDR information from diverse types of PBXs and transport it via NetView/PC to management applications on a host IBM mainframe.

Group 2: True IBM users—no interest in replacing NetView subsystems, but some interest in related products (Figure 13.5.1B), NetView, NetView/PC, third-party voice products, NetSpy, SAS, MICS should serve as an instrumentation mix examples.

Group 3: True IBM users, but no longer completely satisfied with NetView—no interest in replacing NetView, but some interest in related products (as Group 2) plus interest in replacing NetView subsystems. For example, NetView core, Supersession or TPX, Graphical Network Monitor (GNM), NetView/PC, third-party voice products, NetSpy, SAS, MICS would meet the expectations of this group (Figure 13.5.1C).

Group 4: Net/Master users who have declined to use NetView. But some of them may license core NetView for getting IBM support. Full use of Net/Master subsystems plus use of related products of third parties (Figure 13.5.1D), for example, Net/Master, SAS, MICS, NetSpy, Net*Insight or NPM, third-party voice products are the likely choices of this group. Also, NetView/PC may be used for integrating non-SNA and non-IBM components.

Corporations expend considerable human resources and funds to determine the most favorable solution in terms of joining either one of the groups identified previously. Table 13.5.1 helps in terms of comparing the two principal choices: NetView or Net/Master; benefits are listed for both products [CSI88].

Other companies providing and supporting network architectures have yet to decide which direction to take. Companies like DEC, Unisys, Bull, Tandem, Siemens, and Hewlett-Packard have been supplying communication software for many years. In the process of migrating to more advanced solutions, network-management products and applications are key issues. But this is actually the problem. At the moment, for these companies the issues are:

- Network architectures are in operation with a fair number of clients.
- Usually, the existing network-management products and solutions are weak.

TABLE 13.5.1: Performance Comparison of NetView and Net/Master.

- BENEFITS FOR NET/MASTER
 Ease of use
 Ease of installation
 Flexibility (adding new operators, password changes, changing span of control)
 Fourth-generation language
 More functions; modular design
 More automation; combination with Sys/Master
 Less human resources requirements
 Less overhead
 Integrity with Info/Master
 Very efficient file transfer
 More flexible marketing (discounts, free trial)
 Use of LU 6.2 for connecting distributed Net/Masters
 Integrated management with AT&T, DEC and Tandem
- BENEFITS FOR NETVIEW
 Strategic nature of NetView
 Performance monitoring subsystem
 Links to TPNS
 Integration and centralization of Non-IBM and Non-SNA world ensuring end-to-end control
 Intention to move to a DB2-based repository system instead of VSAM files
 Entry-point service to IBM modems
 Problem determination support
 Change management support using NetView Distribution Manager
 Remote IPLs support including remote diagnostics
 Early integration of local area networks
 Links to network reports with SLR
 Use of MSUs to simplify automated operations
 Use of console emulation by MTAE
 Trend to integrate fragmented data files via SystemView
 Use of LU 6.2 as an option to NetView/PC
 Reputation, maintenance and education

- Clients are pushing these vendors to design and implement a state-of-the-art OSI-based network-management solution, but at the same time to provide gateways to de facto standards, such as NetView, Accumaster, and SNMP-based products.
- Budgets for network management are tight, and network management is considered as a differentiator, but not necessarily a money maker.
- Existing clients must not be abandoned in terms of network-management solutions.

Expected reactions are very different: DEC and HP are in the front line of OSI-based solutions; Tandem, Bull, and Siemens try to navigate in pleasing everybody and communicating with anybody; Unisys has declared the full support of the UNMA architecture from AT&T.

But all companies are members in the OSI Network Management Forum and will try to find the common denominator.

Providers of network element management systems are in an easier situation. In order to sell their mainline products, such as modems, DSUs, CSUs, multiplexers, switches, LANs, and PBXs, they are also expected to provide network-management products. But, in these cases, users may not yet push too hard toward standard-based solutions. Usually vendors announce gateways to either NetView, Accumaster, or EMA, or even to all of them. Thus they conduct business with their proprietary products, such as Time-View (Timeplex), INCS (NET), DualView (Codex), Globalview (Stratacom), CMS (Racal), Masternet (Dataswitch), and so on, plus differentiate themselves from their competition by providing links to integrator products.

Console management products may build a special group: Vendors are usually not selling network elements, but supplying a platform for low-level network-management integration. Product examples are Net/Command (Boole), NetExec (TelWatch), TIC (Votek), Accumaster Consolidated Workstation (AT&T), and the DEC solution. After significant hardware and software upgrades, these products may become real integrators.

SNMP makes fast progress [HUNT90]. Today, a variety of networking devices are supporting SNMP:

Routers	76%
Bridges	52%
PCs/Hosts	48%
Terminal Servers	40%
LAN hubs	28%

Network-management features are not yet rich, but offer basic solutions for high-priority applications, such as:

Alert Log	68%
Alert filtering	56%
Report generation	56%
Real-time diagnostics	53%
Bar/Strip Charts	48%
MIB extensibility	32%
Autotopology	32%
Network partitioning	20%
E-mail	12%

However, users report on serious voids in terms of network-management functionality. The most important missing functions are:

No data base for historical comparison

No proxy agents

No API (mentioned several times)

No report generator

Not enough diagnostics

No token ring support

No SQL interface

No real-time capacity planning

No trouble-ticket support

No network partitioning feature

Poor support for MIB extensions

No support for "set"

Slow system response

Unwieldy format of information generated

Lack of extensibility

Poor response time reporting

Requires SNMP agent at each node

Alerts are too limited

Limited scope and functionality

Unusable for large MIBs

Lack of drawing capability

DOS-based (prefers UNIX)

For managing mixed Token-Ring and Ethernet networks, IBM and 3COM have defined the Heterogeneous LAN Management (HLM) architecture that will allow vendors to develop common Token Ring/Ethernet protocols. These protocols will be based on a subset of OSI/CMIP running over LLC. CMIP over LLC is known as CMOL. Servicing up to layer 2, it will probably monitor only basic data such as frame sizes, packets, and physical connections. Similar to SNMP, CMOL will serve near-term user needs, but does not close the door for migrating to other de facto or open standards.

Cabletron Systems offer new avenues with combining a SNMP-based management system and expert systems technology for managing enterprise networks. Spectrum uses inductive modeling technology creating programming models that define the intelligence and interrelationship of each network element and builds an object-oriented knowledge base. As a result, the product can correlate information such as multiple alarms for multi-vendor network elements to identify the cause of a problem and solve it. Spectrum is very user-friendly in this type of maintenance and changing network configuration and its graphical mapping.

SynOptics is transitioning its DOS-based network management solution to a SunNet Manager platform called LattisNet network management under UNIX. This emerging network management philosophy of using a platform and putting more network management intelligence out on the network contracts sharply with Cabletron's method of using its own-developed platform. This architecture allows the use of generic components for connectivity and internetworking for all key areas, such as Ethernet, Token Ring, FDDI, and LAN wiring concentrators.

The wiring hubs and concentrators are becoming increasingly popular for

structuring enterprise wiring schemes. The concentrator market is competitive, and network management is a differentiating factor. In fact, the wiring concentrator is becoming the focus of network management in a local area. Many analysts predict that bridge and router-based network management will give way to hub-based solutions. Vendor behavior confirms this, as router/bridge vendors prefer using platform solutions for network management. Leading router and bridge vendors, such as Cisco, CrossComm, Wellfleet, Proteon, Halley, Retix and Hughes are offering SNMP-based solutions, implementing agent or manager software, or both. The real differentiator is the value-added functionality with the database including SQL-capability. NetCentral from Cisco is one of the strongest products in this respect.

13.5.2 OSI-Based Products

Many companies have decided to interpret and implement the OSI recommendations for network management. Three companies are considered leaders: AT&T with its Accumaster Integrator has the intention of coordinating the existing element management systems of the company first. DEC with EMA has the intention of designing and implementing an almost-perfect network-management architecture; EMA will be populated with operational WAN and LAN from DEC tools first. Hewlett-Packard with Openview has the intention of selling an excellent platform with some fault and performance management-oriented tools in the background. AT&T has concentrated on configuration and fault management first, and other subsystems will follow soon. EMA and Openview are considered still empty in terms of functionality. Most interestingly, the battle among these leading solutions may be decided in the field of how to manage local area networks. The growth rates are substantial, and solutions are unsatisfactory. CMOT is competing against SNMP; should SNMP win, OSI standards will suffer a significant slowdown. That is the reason why leading manufacturers consider supporting both. On the other hand, the resources of even the leading three companies are not unlimited.

On the way to a ratified standard, OSI-based network-management products are expected to offer gateways to de facto standards; now, those gateways are offered to NetView for information export and import. They offer a peer-to-peer communication solution. IBM's solution is a hierarchical one offering OSI/CS as an internal service point to NetView. It is early to say which architecture will prevail.

Using NetView for managing OSI-networks brings a number of value-added-features. The most important ones include:

- Monitoring all alerts
- Display of probable cause of faults
- Display of recommended actions
- Automated network operations

- Network management reporting
- Network assets management
- Network simulation and emulation.

On the way to fully integrated architectures, also bilateral solutions are likely. Joint network management for IBM and DEC is supported by the Interlink product family; joint management of IBM and Unisys is supported by the SNA/net gateway product.

Besides the joint ventures referenced earlier between Systems Center and AT&T, DEC and Tandem, IBM and AT&T are about to meet user requirements of working together. The links between their integrated network management systems will initially support the following functions:

- Network configuration data interchange
- SNA alerts flow from IBM NetView to the Accumaster Integrator
- NetView users can issue commands to the Accumaster Integrator
- Accumaster Integrator alerts flow from the Integrator to NetView.

13.5.3 User Solutions

A large number of users need special customization of existing products combined with completely new applications not addressed by the available products at all. This section of the book is going to show a few examples of tailored network-management products from Boeing Computer Services, Nynex, and British Telecom.

Boeing Solution

Integrated network management has long received high priority at the Boeing Company. Boeing systems integration projects have provided sophisticated voice, data, and transmission capabilities—all under the control of a network management center. Now, Boeing Computer Services offers effective tools and applications that will integrate with quality vendor network-management systems. Designed specifically for medium- to large-scale, multi-product, multi-vendor networks, the Boeing system answers daily real-time operational needs and comprehensive administrative needs.

The Boeing integrated network-management system caters to the varying technologies of many different vendors. It meets domain-unique voice, data, and transport requirements and looks beyond to meeting requirements common to all domains. Boeing has developed an overall solution to the management of all these technologies.

- The Boeing integrated network-management system provides the ability to integrate existing vendor network-management products and take

advantage of their unique capabilities. This avoids duplication of network operator efforts.

- The creation of effective network environments is facilitated even while responding rapidly to new requirements. New network-management system equipment can be added incrementally as network or management center requirements increase.
- The network manager gains a uniform interface to all segments of administration, surveillance, and control. From one point, from one database, a user can study the operating costs and assets of all equipment in a network. Performance data relative to such equipment or purchased network services can also be studied.

The Boeing integrated network-management system underwent long and careful development. Its capabilities are proven.

Administrative activities across the network are linked through the system data base. All actions and network changes are entered and tracked as they are made, no matter where they originate.

Centralized management means faster problem resolution, reduced downtime, and increased network operational efficiency. There is no need to maintain duplicate management information, hardware, and software at every major facility served by the network. However, management personnel at remote sites can access the network-management system to control their own operations and determine network configuration, identify major node failures, and resolve local problems.

With Boeing network management, users have real-time visibility of network's configuration—plus the power to modify it from a single workstation. Users can maintain, track, and control facilities locally and at remote sites. High-resolution graphic displays present a comprehensive view of the current network configuration. There is no need to rely on quickly outdated configuration listings and circuit layouts.

To protect sensitive data and information, users can reserve access to those with a legitimate need to know. Users enter ID codes when logging on, then call up the information needed. Other information and types of data remain protected.

Finally, the Boeing integrated network-management system works with existing hardware and software. And it will continue to work well as the networks evolve and grow.

For the network operator, there is a single, all-encompassing view of all communication domains. This greatly reduces the labor required to operate the total communication system. Additionally, the large amount of data produced by the various network devices is brought together in standard form through the Data Exchange System. The resulting data base is accessed by the full-function management applications to provide consolidated network information and ensure more effective use of the corporate communications resource.

Owing to its distributed approach, the Boeing architecture permits the

network-management system to be readily configured to specific end-user needs. Over time, additional user workstations can be added as needed. As new devices are added to the corporate network, they can easily be brought under the control of the network-management system.

Systems characteristics include:

User interfaces

- Based on the evolving X-window standard for compatibility and portability over the widest range of vendor hardware
- Provide consistent, flexible user access across the full suite of network-management applications
- Allow the user to view multiple windows at the same time
- Improve operator productivity through the use of a mouse, graphics icons, and integrated HELP facilities
- Provide customized views of corporate network data
- Provide single terminal access to all network-management functions
- Reduce operator training time because the interface is intuitive and easy to use and all applications react the same way.

Interfaces

- Provide intelligent interfaces to network devices and vendor management systems
- Translate vendor-specific commands and data into vendor-independent forms for subsequent correlation and combined analyses
- Advance beyond simple terminal passthrough to provide true integration of vendor management systems
- Employ emerging OSI and CCITT network-management protocols
- Provide connectivity with IBM SNA network-management systems through NetView
- Customize to integrate installed equipment that does not conform to standards interfaces

Data Exchange System

- Brings all network management data into an extendable repository to maintain a consistent, accurate picture of the multi-vendor network.
- Uses modern data-management standards today to exploit tomorrow's data-base management advances.
- Allows access to all network data through modern, easy-to-use, relational DBMS facilities.
- Provides a common interface between all elements of the network-management system for easy access to corporate network data.

- Supports the distributed nature of Boeing network management to ensure ready expandability concurrent with the high-performance requirements of network management.

Correlation Applications

- Assisted by artificial intelligence, provide a more global view than is possible with an individual network interface.
- Analyze fault, configuration, and performance data within and among network domains.
- Analyze alarm and configuration information from the data exchange system to determine possible diagnostic actions.
- Maintain multi-domain connectivity information, device configuration, and operational status in addition to enforcing configuration control.
- Monitor network performance to advise the user of performance-related conditions and actions.

Network-Management Applications

- Provide real-time network control and a full range of administrative functions.
- Provide direct access to current network configuration to ensure faster problem resolution, reduced network downtime, and more efficient network operation.
- Can be used individually or as a fully integrated capability owing to modular design.
- Eliminate duplicate efforts and conflicting information through use of a single information repository.
- Provide comprehensive cross-domain views plus domain-unique capabilities—at the same time.

Altogether, the product centers applications around seven subsystems, addressing fault, performance, configuration, inventory and financial management, service order processing, and network user administration. Figure 13.5.2 gives an overview of systems components.

NYNEX Solution

The NYNEX solution offers comprehensive control of the network by providing the manager of managers. ALLink Operations Coordinator interfaces with the existing managers of each network element regardless of vendor or protocol. It uses artificial intelligence to filter, integrate, consolidate, and prioritize the information it receives from these element managers, displaying the information in a coherent, easy-to-read format to help in making

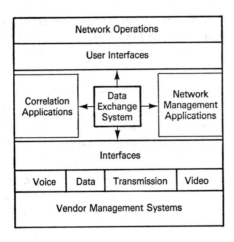

Network Operations
User Interfaces

Correlation Applications	Data Exchange System	Network Management Applications

Interfaces

Voice	Data	Transmission	Video

Vendor Management Systems

Figure 13.5.2 Network-management architecture of Boeing.

accurate network-management decisions. Figure 13.5.3 shows the place of managers in managing public and private networks.

The ALLink Operations Coordinator is a client/server software application that runs under the UNIX operating system. Its major architectural elements include the following:

- **Element Manager Handlers** are conversion gateways that transform status alert and alarm messages from various vendors' network element managers into the common ALLink format.
- **Network Operations Control** manages the graphical user interface for each operator workstation to provide user access to the modules for problem determination, device recovery and restoration, operation control, event notification, and network status display.
- **Management Information Base** stores and manages information about the configuration of network elements, as well as data on vendors, resource utilization, and performance indicators.
- **Dynamic Alert Processing** uses an artificial intelligence rule base to process, analyze, and classify events, declare alarms, and relay information to the user interface and the data base.

Principal characteristics include:

The Manager of Managers. NYNEX ALLink Operations Coordinator is a manager of managers. It monitors and controls heterogeneous network-element managers through a single user interface—*end-to-end* and *in real time.*

Interfaces with Existing Element Managers. NYNEX ALLink Operations Coordinator is not a replacement for existing element managers. It interfaces directly with the existing element managers on the network, using the suppliers' own protocols. And it integrates these systems to provide more comprehensive and accurate decision-making information.

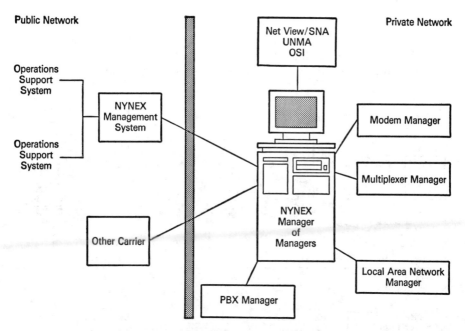

Figure 13.5.3 Manager of managers from NYNEX.

Provides Global Access to Network Information. The network contains many network-management systems—such as IBM's NetView, modem managers, LAN managers, PBX managers—each reporting on the operation of a subset of network elements. NYNEX ALLink Operations Coordinator presents all this information in a single, consistent, seamless view which maintains complete management functionality for each element.

Artificial Intelligence allows customization of the Network Management Solution. NYNEX ALLink Operations Coordinator uses artificial intelligence to filter, integrate, consolidate, and prioritize information. This lets users customize the type of information and the way it's presented to meet unique network operations needs.

Keep NetView But Improve Functionality. NYNEX ALLink Operations Coordinator can utilize NetView as its interface to all existing SNA protocol elements—and interface with non-SNA elements through other existing element-management systems. Users continue to get the benefit of the information NetView supplies, but with added value: the friendly, standardized ALLink user interface, plus AI-generated alarm filtration, consolidation and classification for both the SNA and non-SNA elements in the network. Armed with this improved information, managers will be equipped to make more effective decisions, more efficiently, more often.

ALLink Improves Public Switched Network Management Information: Many public carriers offer network-management systems for private use. These managers can be integrated within ALLink. The ALLink Operations

Coordinator gives the flexibility of integrating appropriate network-management functions, whether for regulated or unregulated services.

The distributed architecture shown in Figure 13.5.4 guarantees flexibility for growth, reconfiguration, and partitioning of operational control responsibilities.

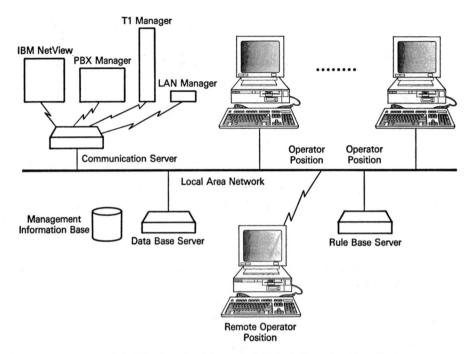

Figure 13.5.4 Distributed architecture of ALLink Operations Coordinator.

British Telecom Solution

British Telecom does not generally develop its own network-management products for the corporate market, although it has developed customized corporate network-management systems, and many of the tools used to manage the public network are in-house developments.

Main network-management related products include:

- 7500 series network-management system for T1 multiplexers
- Datel Control 1000 series
- Datelmux 3200 network management for the 3100 and 3300 packet-switching family of products
- The BT modem management system
- Switchman, which monitors transmission quality on lines in a private data network and provides rerouting and service restoration when necessary The product was developed by Technel Data Products

- Watchman, which is a data network performance monitor. It was developed by Avant Garde and sold outside the UK under the name Net/Alert
- A variety of call logging products, such as the CM7500 and the CM6000 for logging traffic on large- and medium-sized PBXs, respectively
- Primex, a third-party network-management service for international organizations

Over the past few years, British Telecom has come to realize that network-management features will play an increasingly important role in all of its product lines—both network- and customer premises-based.

Like AT&T, with whom it is working closely in the OSI/Network Management Forum, BT has a network-management architecture—the ONA Management Architecture (ONA-M). ONA-M is a set of rules on how to procure, develop, and build communications management functionality for information networks and systems. It is a layered architecture, as shown in Figure 13.5.5. At the bottom are the network elements, for example, modems, lines, public data network connections, and so on.

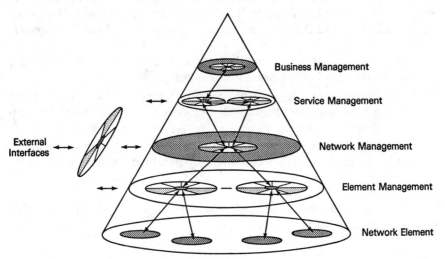

Figure 13.5.5 Open Network Architecture from British Telecom.

Elements are managed by element management systems, which may simply be a chip or software inside the element or a separate system (e.g., Racal CMS). Network-management systems supervise a number of element management systems (e.g., AT&T's Accumaster Integrator). Service management systems manage the information passing over the network and are less concerned with the physical details of the network and much more with its functions. Finally, business management systems are responsible for the management of the whole undertaking and are, like service management, part of the overall management of the company.

Within this layered architecture, BT has defined seven functional areas,

such as event, resource performance, planning and design, configuration, access and security, and financial management. Each function is carried out at each layer in the architecture, but the tasks performed at each layer are very different.

To pass information around the architecture, there is BT's protocol, the Systems Management Protocol (SMP), which is OSI-based, as indeed are nearly all of BT's activities. The first implementation example is Concert connecting elements by element-management systems.

Other Solutions

Regional Bell Operating Companies are getting very much involved with network management. Besides Nynex, also Ameritech and Bell Atlantic are offering network-management solutions.

In summary Table 13.5.2 shows an overview of the products, their vendors, and their characteristics. Products are grouped in this table by communication software, modems, multiplexers, matrix switches, performance monitors, PBXs, LANs, network-management services, and special products. This categorization is independent from the standards, the products support. The product characteristics are clustered into at least one of the following categories:

- Network element means that the product works at the network element level indicating built-in or built-around solutions.
- Network element management system indicates that the product is able to supervise a family of network elements. There are simple and advanced subcategories.
- Integrator means the capability of the product to supervise and coordinate multiple network element management systems or network elements.

This table should be considered a guideline only. Periodic updates of this table are absolutely necessary.

13.6 NETWORK-MANAGEMENT SERVICES

It is not simply products that may help users improve network management and networking efficiency. Network-management services offered by mainframe vendors and network suppliers may also help to offload users in all or in some network-management areas. The alternative offerings are very broad at the moment. They start with opening a window into the physical network of the supplier for users in order to provide additional physical network management data for correlation by clients. These choices are offered by INMS (MCI) and Accumaster Services (AT&T). In other words, segments of data and/or use of applications are offered. In another case, network-management

TABLE 13.5.2: Overview of Network-Management Products.

Product Category	Vendor	Product	Competitive Matrix					Support for Integration		
			Product Characteristics							
			Element	Element Simple	Management Advanced	Integrator	NetView	ACCUMASTER Integrator	EMA	
A. COMMUNICA-TIONS SOFT-WARE	IBM	NetView				X	X			
		NetView/PC		X			X			
	IBM/US WEST NSI	Net Center GNM		X			X			
	DEC	DecMon	X						X	
		NetPath	X						X	
		NetResponse	X						X	
	UNISYS	Cenlog	X					X		
		TNAS		X				X		
	GROUPE BULL	NEM	X							
	SYSTEMS CEN-TER	Net/Master				X	X	X		

TABLE 13.5.2: (Continued)

Competitive Matrix

Product Category	Vendor	Product	Product Characteristics				Support for Integration		
			Element	Element Simple	Management Advanced	Integrator	NetView	ACCUMASTER Integrator	EMA
	CANDLE	Omegamon/VTAM	X				(X)		
	TANDEM	Distributed Systems Mgt.			X		X		
B. MODEMS, DSU/CSU	AT&T	Comsphere 6800			X			X	
	CODEX	DNCS		X					
		INS 9800			X		X	X	X
		INS 9300		X					X
		INS 4840		X					X
	RACAL MILGO	CMS 2000			X				
	AT&T/PARADYNE	Analysis			X			X	
	NETQUEST	NetQuest		X			X		

Vendor	Product					
FUJITSU	FMS View, REM View					X
MEMOTEC	Net Access 900					X
C. MULTIPLEXER AT&T	Comsphere 6800		X		X	
	Customers Network Controllers		X			X
AVANTI	DNMS		X		X	
N.E.T.	INCS			X	X	
TIMEPLEX	TimeView		X	X	X	
DCA/COHESIVE	ONMS 9000				X	
NEWBRIDGE	Main Street	X	X	X	X	
VITALINK	WAN Managers				X	
HALLEY	Connect View				X	
GENERAL DATACOM	MegaView			X	X	
INFOTRON	INM		X	X	X	
STRATACOM	Strataview				X	

TABLE 13.5.2: (Continued)

Competitive Matrix

Product Category		Product Characteristics				Support for Integration		
Vendor	Product	Element	Element Simple	Management Advanced	Integrator	NetView	ACCUMASTER Integrator	EMA
UNIVERSAL DATA SYS.	Global View		X	X				
TELWATCH	TlWatch					X	X	
D. MATRIX SWITCHES								
DATASWITCH	Totalnet			X		X		
DYNATECH	Focus		X			X		
BYTEX	Unity			X		X		
E. PERFORMANCE MONITORS								
BOOLE & BABBAGE	Net/Alert	X						
	Net/Guard	X						
EMCOM	NMS	X						
DATASWITCH	Intellinet	X				X		
DYNATECH	Prism	X						

Company	Product					
MEMOTEC	Smart	X				
TELWATCH	DataWatch		X		X	X
F. PBX/CENTREX AT&T	Trouble Tracker		X			X
	VMAAP		X			X
	Centralized System Managemt		X			X
	Multi-Function Operations Sys.		X			X
	MACSTAR		X			X
TSB	HubView			X	X	
ROLM/SIEMENS	HICOM			X	X	
GANDALF	StarPatrol		X		X	
DEC	PBX/Facilities Manager		X			
G. LOCAL AREA NETWORKS AT&T	Starkeeper			X		X

TABLE 13.5.2: (Continued)

Competitive Matrix

| Product Category | | | Product Characteristics | | | | Support for Integration | | |
Vendor	Product	Element	Element Simple	Management Advanced	Integrator	NetView	ACCUMASTER Integrator	EMA
AT&T	Stargroup			X			X	
BANYAN	NMS	X						
IBM	LAN Network Manager, LAN Station Manager			X		X		
MICROSOFT	LAN Manager			X		X		
DEC	Ethernim, LTM			X				X
SYNOPTICS	NetMap, Lattisnet Network Management			X		X	X	
NOVELL	LANterm, LANAlert			X				
CISCO	NetCentral		X					
UNGERMANN-BASS	Access One Net Director		X					
3COM	OMA-NMS		X					
SUN	SunNet		X					

Company	Product					
NETWORK GENERAL	Sniffer, Watchdog	X				
PROTEON	OverView, Token View	X				
FIBRONICS	Finex-NMS		X		X	
SYNERNETICS	Viewplex		X		X	
TEKELEC	ChannelLAN	X				
MICRO TECHN.	Lance/NMS		X		X	
DIGILOG	LanVista	X			X	
SIEMENS	ISOLAN		X		X	
CABLETRON	LANView, Spectrum	X		X	(X)	X
HEWLETT-PACKARD	LANProbe, ProbeView	X		X	X	X
SPIDER	Analyzer	X				
VANCE	ATS 1000	X		X	X	X
NETWORK LEGEND SOFTWARE COMPLETING	LANPatrol	X				
LEGENT	LanSpy	X				

TABLE 13.5.2: (Continued)

Competitive Matrix

Product Category	Vendor	Product	Product Characteristics			Support for Integration			
			Element	Element Simple	Management Advanced	Integrator	NetView	ACCUMASTER Integrator	EMA
	CROSSCOMM	ILAN		X			X		
	DAVID SYSTEMS	ExpressView			X				
	VITALINK	WANManager		X					X
	WELLFLEET COMM.	SNMP-NMO		X					X
	THE WOLLONGONG GROUP	WIN Manager Station			X				
	NCR	NCRNet Manager		X					
	CONCORD COMMUNICATIONS	Trakker		X					
	CHIPCOM	ONline Network Control System		X					
	CHEYENNES	Monitrix		X					
H. SPECIAL SYSTEMS AT&T		Integrator				X	(X)	X	
	HEWLETT-PACKARD	OpenView				X	X	X	

Company	Product							
DEC	Enterprise Management Architecture	X			X	X		
AT&T	StarKeeper		X	X	X			
NYNEX	Allink / Customate	X	X	X	X		X	
BOOLE & BABBAGE	Net/Command				X			
AMERITECH	CMS II / Customate	X	X	X	X		X	
MIROR	RARS			X		X		X
BBN	NetScope					X		
TELWATCH	NetExec				X			
VOTEK	TIC	(X)	(X)	(X)				
BRITISH TELECOM	Concert	X	X	X	X			
BOEING/NEC	Vision			X	X			
SOUTHWESTERN BELL	Customate		X				X	
US WEST	Customate		X				X	
HARRIS	NPDES			X	X			
ITM	MAXM				X			

TABLE 13.5.2: (Continued)

Competitive Matrix

Product Category	Product	Product Characteristics				Support for Integration		
Vendor		Element	Element Simple	Management Advanced	Integrator	NetView	ACCUMASTER Integrator	EMA
MCI	INMS			X		X		
US SPRINT	INSITE			X				
NORTHERN TELECOM	Meridian Network Management			X		X		X
FREDERICK ENG.	FECOS				X			
HUGHES NETWORK SYSTEMS	IPN-NCS			X		X		
MICOM COMM. CORP.	XNMS			X				

subsystems are completely supported on-premise or using special management instruments of the supplier off-premise. The ultimate alternative is to outsource network management completely to third parties, leaving the overall supervisory and control functions with users. The suppliers are industry giants, like IBM, DEC, and AT&T, or service companies, like EDS (Electronic Data Systems) or smaller start-up companies, like International Telemanagement, I-Net, or Network Management, Inc.

What services to take and from whom are difficult questions to answer. Table 13.6.1 helps to identify what network-management subsystems may be considered for outsourcing. "Yes" is likely for fault, configuration, and accounting management; "no" is likely for network design; and "uncertain" for performance and security management, and network capacity planning.

TABLE 13.6.1: Which Network-Management Functions to Outsource.

Functions	Yes	No	Uncertain
Fault management	x		
Configuration management	x		
Performance management			x
Security management			x
Accounting management	x		
Network design		x	
Capacity planning			x

Before deciding for or against outsourcing, the following criteria have to be evaluated very carefully [TERP91A]:

1. What are present costs of network-management equipment, communications, and people.

2. Full visibility of existing processes, instruments, and human resources in order to decide which functions may be considered for outsourcing. Outsourcing is a good excuse to audit present operations and address areas that need improvement. The result of outsourcing may be insourcing.

 Internal analysis by internal or external analysts may result in substantial savings in operating expenses (30%–40%), in staff reduction (25%–50%), and in stabilizing network budgets.

3. Dependence on network availability indicating the highest level of risks the customer has to include into the service contract; many times certain vendors will fall short at the very beginning, not being able to guarantee the targeted availability.

4. Grade of service required by users and applications may dictate a certain type of outsourcing company not sharing their resources among multiple clients.

5. Security standards and tolerable risks may prohibit that third-party vendors gain access to the network and to its carried traffic.

6. Level of concentration on own business may require that the corporation does not build a sophisticated network-management system and organization, but concentrate on the technology of the business.

7. Availability of network-management instruments may facilitate the decision. If the company had to invest substantial amounts into instrumentation, outsourcing should be favored; if not, outsourcing may still be considered, but with lower priority.

8. Availability of skilled network-management personnel is one of the most critical issues; most frequently, the only driving factor for outsourcing. Not only present status, but future needs and their satisfaction have to be quantified prior to the outsourcing decision.

9. Stability of environment and growth rates have serious impacts on the contract with the vendor. Acquisitions, mergers, business unit sales, application portfolio changes need special and careful treatment in the contracts.

10. Intention of offering value-added services to other third parties. In certain corporations, under-utilized bandwidth of communication resources may be utilized for offering "low-priority" services to third parties who cannot afford to build a network on their own (e.g., point-of-sale applications).

11. Ability of constructing good outsourcing contracts is one of the key issues. The length of outsourcing contracts—often 7 to 10 years—means that the wording of the contract is extremely important.

12. Philosophy of network management including horizontal and vertical integration, centralization, automation and the use of a network-management repository should be in concert with the offer and capabilities of the outsourcer.

Answering the question about the right type of service partner, Table 13.6.2 may be referenced. The final decision depends on the networking environment and the budgets for third-party network management. Summarizing the expectations, outsourcers are expected to meet the following requirements:

- Financial strength and stability over a long period of time
- Proven experiences in managing domestic and multinational networks
- Powerful pool of skilled personnel
- Tailored network-management instruments which may be used exclusively or in shared modus for the clients under consideration
- Proven ability of implementing the most advanced technology
- Outstanding reputation in conducting business
- Willingness for revenue sharing
- Fair employee transfers

TABLE 13.6.2: Service Provider Evaluation.

	PROs	CONs
Mainframe vendor	Know-how for data networks Reputation Know-how for logical network management Vertical integration	Dependency Proprietary architecture Data orientation Horizontal integration Physical network management
Carrier	Know-how for voice network Reputation Know-how for physical network management Horizontal integration	Dependency Proprietary architecture Vertical integration Logical network management Voice orientation
Integrator	Know-how for both data and voice networks Know-how for both vertical and horizontal Know-how for both logical and physical Actual doing	High costs Reputation Project driven
Consultants	Know-how for both data and voice networks Know-how for both vertical and horizontal Know-how for both logical and physical Leading edge of technology	High costs Reputation No actual doing

The weights of these criteria have to be set by the client during the evaluation process.

There are multiple choices for the service contract, including on-premise, off-premise, or simply monitoring functions. Table 13.6.3 compares these three choices.

The fate of human resources is a difficult question. Many times, the cost of personnel is what forces people to consider outsourcing at all. It is very difficult to estimate the most likely path people's careers will take. From today's perspective:

- 20% of staff may be cross-educated and kept; this number may increase to 30% in the future.
- 50% of staff may be taken over by the network-management service provider; this number will peak at approximately 60% in the future.
- 30% of staff may be laid off; the trend for this figure is estimated to decrease to approximately 10%.

TABLE 13.6.3: Service Alternatives.

	PROs	CONs
On-site (on-premise)	Rapid troubleshooting Dedicated personnel Continuous consultations	High costs No shared instru- mentation Space requirements
Monitoring (local, re- mote, or both)	On-demand activity Indicators selected by users and suppliers Shared instrumentation	Fragmented network management No dedicated personnel
Off-site (off-premise)	Full scope of network management Shared instrumentation Combination with virtual networking services	Moderate costs No dedicated personnel Longer troubleshooting No continuous consultations

In establishing an agreement, the customer is made as responsible as the outsourcers for ensuring that the outsourced services are supplied adequately. Since the outsourcer should be promoting business goals, the service levels identified in the contract should support these goals [TERP91A].

Who is Authorized for Modifications? Somewhere in the agreement, preferably in the beginning, the provisions for modifying the agreement should appear. Basically, the provisions should allow for either the outsourcer or the customer to reopen negotiations and for management approval if the priority of the work is to be changed. Generally, changes should be made only after an analysis has demonstrated that the problem is not an aberration. Trial agreements for new outsourcing services could be a meaningful approach.

Duration of Agreements. The agreement should be written as ending after a certain period of time, such as a certain number of years. Alternatively, all outsourcing agreements might be scheduled for revision after expected changes to hardware, networking nodes, facilities, or software. Above all, no one should be under the impression that the agreement is a commitment for eternity despite changes in the business or networking environment.

Reviews. Reviews are necessary to consider impacts of a dynamically changing environment. For mutual benefits, those impacts have to be openly discussed and the necessary changes have to be written in the existing contract.

Service-Level Indicators. Service may be agreed for various levels of details including on-premise monitoring and off-premise solutions. Table 13.6.3 summarizes the benefits and disadvantages for each of these service alternatives.

Principal service indicators should include:

- Availability for users and for networking components—differentiation by applications is preferred.

- Response time segmented by users, applications, devices, communication forms, such as data, voice, image, and video.
- Grade of service including physical parameters of network facilities.
- Distribution of faults identifying short and long outages.
- Mean time between failures (MTBF).
- Mean time to repair (MTTR).

User Commitments. These commitments include informing the outsourcers about lines of business, strategic goals, critical success factors, networking environments, organizational changes, application portfolios, service expectations and indicators, directions of technology in networks design, and early warning of the need to renegotiate the contract if necessary.

Reporting Periods. Performance reports on key service indicators should be regular (weekly, monthly, etc.), and copies should go to the organization entity in charge, and to Information Technology (IT) or Information Systems (IS) management. Reports have to have a format agreed upon by both parties. Performance reports provide an opportunity for identifying impending problems and proposing solutions in advance. They are key tools for avoiding crisis management.

Costs and Charge-Back Policy. Contracting parties have to agree on the conditions of payments, charge-back report, alternatives of bill verification, and expected inflation rates. The transfer of human resources also has to be negotiated and agreed upon.

Penalties for Noncompliance. Using an appropriate costing and charge-back policy, creating penalties for noncompliance is relatively simple. For noncompliance of service objectives, payments have to be reduced to outsourcers. But, in most cases, the damage caused by noncompliance is much more severe than the penalty reimbursed in monetary units.

Employee Transition. Somewhere in the agreement, usually in the closing section, questions of employee transition have to be addressed. This section has to include the names of employees transferred to the outsourcers, and the conditions of takeover, such as salaries, job security, title, position, and so on. Training and education to be provided also have to be identified.

13.7 SELECTION OF NETWORK-MANAGEMENT PRODUCTS AND SERVICES

Prior to making a decision about network-management investment, both the selection criteria and products must be carefully evaluated.

It is recommended to use the following criteria:

Support of Configuration Management. Configuration management is a set of middle- and long-range activities for controlling physical, electrical, and logical inventories, maintaining vendor files and trouble tickets, support-

ing provisioning and order processing, managing changes, and distributing software.

Directory service and help for generating different network generations are also provided.

Support of Fault Management. Fault management is a collection of activities required to dynamically maintain the network service level. These activities ensure high availability by quickly recognizing problems and performance degradation, and by initiating controlling functions when necessary, which may include diagnosis, repair, test, recovery, workaround, and backup. Log control and information distribution techniques are also supported.

Support of Performance Management. Performance management defines the ongoing evaluation of the network in order to verify that service levels are maintained, identify actual and potential bottlenecks, and establish and report on trends for management decision making and planning. Building and maintaining the performance data base and automation procedures for operational control are also included.

Support of Security Management. Security management is a set of functions to ensure the ongoing protection of the network by analyzing risks, minimizing risks, implementing a network security plan, and by monitoring success of the strategy. Special functions include the surveillance of security indicators, partitioning, password administration, and warning or alarm messages on violations.

Support of Accounting Management. Accounting management is the process of collecting, interpreting, processing, and reporting costing and charging oriented information on resource usage. In particular, processing of SMDRs, bill notification, and charge-back procedures are included for voice and data.

Support of Network-Capacity Planning. Network planning is the process of determining the optimal network, based on data for network performance, traffic flow, resource utilization, networking requirements, technological trade-offs, and estimated growth of present and future applications. Sizing rules and interfaces to modeling devices are also parts of the planning process.

Integration Capabilities. These capabilities include the ability of interfacing different kinds of products that use proprietary or standard architectures.

- Multi-vendor capability: ability to integrate other vendors' products
- Space covered which needs integration: (WAN, LAN, MAN; private, public; logical, physical; processing and networking components; data and voice)
- Depth of integration: (physical terminal level, protocol conversion, full integration)
- Conformance to standards, including support of CMISEs from OSI and TCP/IP management capabilities (SNMP)

- Electronic Data Interchange used for improving communications with customers
- Peer-to-peer to other network-management systems: capability of interconnection to other vendors' network-management systems using advanced communication techniques

User Interface. The user interface defines the quality level of presenting network-related information and characterizes the flexibility of changing product features.

- Presentation services: features that characterize the level of users' support by the network-management workstation including graphics, zooms, windowing, business graphics combined with text windows, colors keyed to content, automated generation of network pictures, standardized commands, and information reports
- Programmability: defines the languages supported for customization and value-added functions

Automated Operation. Automated operations indicate the level of support for message handling, volume of automated reactions, support by expert systems, and the level of support for unattended and lights-out operations.

Repository Support. Repository support summarizes what sort of data are included in the repository, performance and integrity across network-management functions, and the techniques used. The criteria are:

Static and dynamic elements support
Relational or object-oriented techniques
Integrity across network-management subsystems
Performance

Customer Support. Customer support differentiates manufacturers in terms of depth of customizing the product and of providing consulting services.

- Development kit: help for design, development, and implementation
- Customization: ability to tailor applications
- Consulting: service provided by the manufacturer for supporting planning, configuring, sizing, and testing the network-management system

Costs. Costs include all components of purchasing, implementing, and operating the product.

Availability of Products. Availability indicates what features are applicable now or in the near future and how easy the migration will be.

Network-Management Services. Network-management services define the ability of the manufacturer to manage customers' networks either on or off the premises.

It is recommended to use the following four ratings in evaluation:

3 Good, indicating outstanding performance against criteria (e.g., automated procedures for fault management, well-proven procedures for change control, integrated inventory management, end-to-end testing capabilities, excellent user platform, easy customization of the product)

2 Fair, indicating a performance level that is supporting operations, but either the performance and/or ease of use is not yet satisfactory (e.g., semi-automated procedures for backup and recovery, semiautomated trouble tracking, sectionalized performance monitoring, no data integrity between network-management subsystems, multiple network generation procedures)

1 Poor, indicating the mere existence of a feature with serious gaps in terms of user friendliness (e.g., manual trouble ticketing, segmented accounting, linewise modeling, segmented configuration file management, sectionalized testing, manual statistics)

0 Not available, indicating that the feature under consideration is not yet available

In order to categorize products according to the support they need, different levels of support quality are defined:

A Low level, indicating a rating level for absolutely necessary functions. Below this level, management systems cannot be considered for implementation.

B Middle level, indicating the watermark for a fair solution with support of most of the criteria, but not necessarily at the "good" level

C High level, indicating the watermark for a predominantly "good" level solution for most of the criteria

In order to compare different solutions, criteria need to be weighted. For the weights, five different categories are recommended:

10–absolutely necessary
7–very important
5–important
2–limited importance (certain user groups, future importance)
1–nice to have
0–unimportant

Table 13.7.1 is an example of quick evaluations of NetView, Net/Master, Accumaster, and EMA against the four principal criteria of automation, cen-

TABLE 13.7.1: Product Comparison using a Subset of Criteria.

	Products			
Criteria	NetView	Net/Master	Accumaster	Enterprise Network Management
AUTOMATION				
Multi-level filtering	Good	Good	Good	Fair
Consolidation	Fair	Fair	Fair	Fair
Correlation	Fair	Good	Fair	Poor
Ease of Implementation	Fair	Good	Good	Fair
CENTRALIZATION				
Hierarchical	Good	Good	Fair	Poor
Distributed	Fair	Fair	Fair	Good
Central with distributed implementation	Fair	Fair	Good	Fair
INTEGRATION				
Scope				
Communication form	Fair	Fair	Fair	Fair
Service	Fair	Fair	Good	Fair
Ownership	Fair	Fair	Fair	Good
Geography	Good	Fair	Good	Good
Vendor products	Good	Good	Fair	Poor
Depth				
User's view	Fair	Fair	Good	Fair
Designer's view	Fair	Fair	Fair	Good
DATA BASE				
Configuration	Fair	Fair	Fair	Good
Performance	Fair	Poor	Poor	Fair
Telemanagement	Fair	Poor	Good	Poor

tralization, integration, and data-base support. This table is a subset of the full evaluation using ratings and weights.

13.8 SUMMARY

The principal trends for network management are integration, centralization, and automation. Integration has to be accomplished across multiple communication forms, vendors, and network architectures; private, public, and virtual networks; LANs, MANs, and WANs; and across multiple processors, applications, data bases, and network-management products. Centralization offers the opportunity of central control supported by shared or dedicated processors in combination with distributed implementation of certain network-management functions, such as filtering, problem detection, data compression, and change management. Automation aims at simplification of the operator's tasks by speeding up recovery and improving productivity, error-minimization, and problem prediction and prevention, using vari-

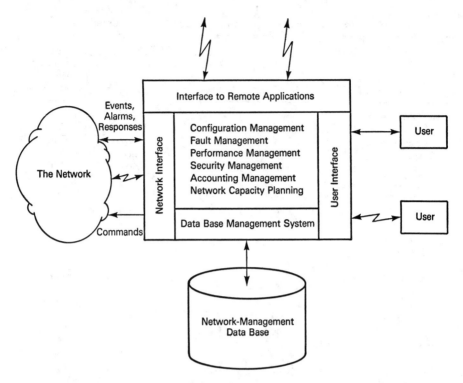

Figure 13.8.1 Fully integrated and centralized network-management system.

ous tools, techniques, and facilities. Artificial intelligence is expected to play an important role in future automation.

Figure 13.8.1 summarizes a greatly simplified architecture of a future fully integrated, centralized, but decentrally implemented network-management system.

<div align="right">

14

</div>

Cost Justification
of Implementing
Network-Management Solutions

14.1 INTRODUCTION

Corporate management frequently have to pass judgment on the effectiveness and efficiency of projects. Network management is no exception. It is assumed that communication networks are an integral part of a larger organization, which typically has goals and objectives that are in most cases far removed from the usual concern of network-management specialists. To meet organization goals using networking, one needs to deal with effectiveness. On the other hand, when one investigates the ratio of time spent on transmitting useful information to the total amount of characters transmitted, one is dealing with efficiency. Cost-effectiveness of networking cannot be achieved unless efficiency in information transfer is high. Thus, any attempt to increase efficiency while not impairing the agreed-upon service level affects an improvement in cost effectiveness. But the time for merely considering efficiency as a key indicator for feasibility studies is over. On the contrary, service level may be considered as a primary criterion to be met. These service-related goals should be met at optimum capacity with reasonable costs. The problem is, however, that top management rarely understands the term "reasonable"; that is the principal reason why feasibility studies must be accomplished for justifying expenses prior to deciding for any major project. Nowadays, the majority of customers rank (e.g., acceptable response time, high availability, information delivered on time, security, connectivity) much higher than reducing overall costs by reducing and/or replacing hardware and software resources.

Nevertheless, network-management-oriented projects should also be justified by means of financial analysis. After outlining the tangible and intangible effects of network-management solutions, such as integrated control, better service level, stabilized human resources requirements, reduced risks, improved integrity and security, automated operations, dynamic trouble ticketing, proactive performance management, and near-real-time accounting, the most important cost components are discussed in depth. They include human resources, instrumentation, and computing resources. Financial analysis is accomplished by means of payback, cash flow, and return on investment analysis.

14.2 QUANTIFICATION OF EFFECTS

Cost-effectiveness of communication-related services can be improved by successively implementing network-management components. However, the improvement may not meet management expectations in every case. To complete the decision-making procedure for implementing network-management modules, careful financial analysis must be undertaken—on the one hand, the savings and potential savings; on the other, the costs.

It would be beneficial to define all achievable effects in monetary units. The evaluation of the following is very difficult, unless one is able to use proven artificial weighting and conversion figures:

- Up-to-date configuration visibility
- Better documented vendor contracts
- Higher accuracy information delivery
- Increased stability of human resources demand
- Better visibility of performance via analysis and reporting features
- Improved load balancing between networking facilities
- Separation of CPU-related activities from network-related activities
- Increased credibility with users
- Use of electronic data interchange to accelerate information exchange speed

But the following classes can be quantitatively defined for financial analysis:

1. **Response-time improvement:** The effects due to this improvement are twofold:
 A certain amount of work can be completed faster, freeing workers for additional work.
 The improved overall service level can guarantee a better position for the larger organization over the competition.
 Both aspects can be translated into monetary units.

2. **Improved availability:** If user-level availability can be improved, work can be accomplished in desirable time intervals, avoiding overtime requirements. In most cases, MTBF can be increased and MTTR reduced by powerful expert-like problem determination procedures. Graphics may speed up problem detection and increase the accuracy of problem identification. Also, a problem dispatched to the right person will be solved more easily.

3. **Fewer personnel for the same (or higher) service level:** The use of automation can free personnel for other responsibilities because of the existence of automated features and the avoidance of overlapping in activities.

 Notifying users about network status automatically saves the time required for manual information distribution. In summary, operating costs may be reduced.

4. **Reduction in communication equipment:** Analysis may discover that some presently installed communication equipment is not really needed and can be sold/rented because the workload growth and networking requirements are lower than expected. Reconfiguration may also be investigated; this represents an actual and immediate cost reduction.

5. **Change in equipment:** Savings can often be made by changing equipment in node and transmission facilities (e.g., splitting transmission links among multiple logical users or integrating voice and data may guarantee a higher utilization while not impairing service level).

6. **Software reduction:** Using network management, redundant software can be eliminated. The immediate effects are
 Less overhead in networking
 Reduction of the rental outflow
 In particular, the use of E-Mail or Electronic Data Interchange may substantially lower the throughput time and the components involved in handling information export and import.

7. **Reduction of resource demand:** Savings can be achieved by maintaining only one data base. Doing so, there is no redundancy in the data files for inventory control, vendors, trouble tickets, and resource utilization indicators that are usually maintained separately in organizations. Further optimization is possible by assigning authorization for remote sites in terms of "read-only" or "update" access of the centrally located data base. Using proper instrumentation, the network-management-related transmission load can be reduced as well.

8. **Postponement of purchases:** This savings component is applicable only if plans already exist for additional expenditure. If capacity increase is required, upgrading may be avoided for a while by using the performance analysis component of network management.

9. **Reduction in risk of communication-related decisions:** By providing accurate measurement data, the decision-making procedure can be better prepared and supported. Thus, the throughput time of the decision will be shorter than previously.

10. **Better contracts with vendors:** Due to accurate information on equipment for the MTBF and MTTR segments of the network-management data base, the contracts can be more favorable to the larger organization.

11. **Network integrity and security:** The avoidance of violating the integrity and security requirements in the communication network may save a substantial amount of money to the larger organization.

12. **Integrated management for all communication forms:** Savings can be achieved by offering one system instead of at least four, each responsible for one communication form (e.g., voice, data, word, image).

13. **Accounting of services offered:** Using accurate accounting information, service-level costs can be determined and charged back to customers.

14. **Long-distance phone calls:** Because most problems show up on the network status displays before customers know about them, many fewer phone calls must be made from remote sites saving time and money.

15. **Control over trouble resolution:** Powerful trouble-ticketing solutions help control the progress of problem determination, diagnosis, repair, and recovery. Setting time thresholds helps to control priorities and reassign problems depending on severity and availability of personnel.

16. **Preventing undetected problems:** The implementation of alarming features, combined with automation, helps to avoid undetected problems, which may otherwise go unobserved due to too many events and messages reported to operations.

17. **Proactive performance analysis.:** Continuous monitoring of key performance indicators helps in early recognition of "soft" failures, such as deteriorating line quality or reduced modem speeds. Thus, "hard" failures may be prevented by instituting the right procedures.

18. **More accurate fault diagnosis:** Using advanced event consolidation and correlation techniques, the hit/miss ratio for accurate diagnosis can be substantially improved resulting in better rerouting and fewer troubleshooting actions in parallel.

Tables 14.2.1 through 14.2.6 show the relationships between actions and effects for selected areas of network management, such as configuration, fault, performance, security, accounting management, and network-capacity planning. The tables indicate the impact on savings qualitatively first. For pursuing financial analysis, all indications should be quantified as well.

14.3 ANALYSIS OF COST COMPONENTS

For accomplishing the saving effects discussed previously, the following cost components should be carefully evaluated:

1. **Human resources:** Fundamentally, personnel costs must be grouped into development and operating costs. The assignment of personnel to a

TABLE 14.2.1: Functions and Effects for Configuration Management.

Functions	Actions																	
	1	2	3	4	5	6	7	8	9	10	11	12	13	14	15	16	17	18
Inventory management			x	x	x	x	x			x		x	x					
Network topology service	x	x	x											x				
Service-level agreements	x	x	x	x			x	x							x		x	
Designing, implementing, and processing trouble tickets		x						x							x			
Order processing and provisioning			x	x			x	x		x								
Change management		x	x	x	x		x			x		x						
Directory services		x	x				x											

X = Action applies for function

TABLE 14.2.2: Functions and Effects for Fault Management.

Functions	\multicolumn{18}{c}{Actions}

Functions	1	2	3	4	5	6	7	8	9	10	11	12	13	14	15	16	17	18
Network status supervision	x	x	x	x					x		x	x	x	x	x	x		x
Dynamic trouble tracking	x	x	x							x				x	x		x	x
Backup and reconfiguration	x	x										x		x	x			
Diagnostics and repair	x	x		x		x	x					x		x	x	x		
End-to-end testing	x	x	x		x	x	x		x			x						

X = Action applies to function

TABLE 14.2.3: Functions and Effects for Performance Management.

Functions	Actions																	
	1	2	3	4	5	6	7	8	9	10	11	12	13	14	15	16	17	18
Definition of performance indicators										x							x	
Performance monitoring		x	x							x	x		x		x		x	x
Thresholding and exceptional reporting		x	x							x				x			x	
Analysis and tuning		x	x	x	x		x	x	x							x	x	
Establishing operational standards		x	x												x			

X = Action applies to function

TABLE 14.2.4: Functions and Effects for Security Management.

Functions	\multicolumn Actions																	
	1	2	3	4	5	6	7	8	9	10	11	12	13	14	15	16	17	18
Risk analysis									x									
Evaluation of security services											x							
Evaluation of security management solutions											x							
Alarming, logging, and reporting		x	x								x					x		
Protection of the network-management systems											x							

X = Action applies to function

TABLE 14.2.5: Functions and Effects for Accounting Management.

Functions	1	2	3	4	5	6	7	8	9	10	11	12	13	14	15	16	17	18
								Actions										
Identification of cost components			x	x	x	x		x	x				x					
Establishing charge-back policies													x					
Definition of charge-back procedures				x	x	x							x					
Processing of vendor bills				x	x	x							x					
Integration of network accounting into the corporate accounting policy													x					

X = Action applies to function

TABLE 14.2.6: Functions and Effects for Network-Capacity Planning.

| Functions | | Actions | | | | | | | | | | | | | | | | | |
|---|---|---|---|---|---|---|---|---|---|---|---|---|---|---|---|---|---|---|
| | 1 | 2 | 3 | 4 | 5 | 6 | 7 | 8 | 9 | 10 | 11 | 12 | 13 | 14 | 15 | 16 | 17 | 18 |
| Determining and quantifying current workload | x | x | | x | x | x | x | | | | | | | | | | | |
| Projecting future workload | x | x | | x | x | x | x | x | x | | | | | | | | | |
| Developing the network-capacity plan | x | x | | x | x | x | x | x | x | | x | | | | | | | |
| Implementation | x | x | | x | x | x | x | | | | | | | | | | | |

X = Action applies to function

project during development involves a cost, even where no outside personnel are hired. It would be a mistake to ignore these expenses because such personnel will be taken away from other projects, causing projection delay or overtime elsewhere. In order to avoid temporary overload, contract service capacity may frequently be used for this purpose. On the other hand, personnel are needed for operating the network-management system. Estimates for small, medium, and large networks are given in Tables 7.5.4, 8.5.4, 9.5.4, 10.5.4, 11.5.4, and 12.5.4, respectively. The numbers are surprisingly high at first glance, but experience shows that they are substantially lower than any alternatives without an automated or semiautomated network-management approach.

2. **Instrumentation:** Substantial expense may be incurred as a result of implementing monitoring devices, network-element management systems, and integrated solutions tools; there is a wide range of tools available with very different prices, as indicated in Chapters 4 through 6. The use of at least two independent tools is proposed—at least temporarily—for the purpose of validation. The applicability of tools for the principal network-management components and responsibility areas are listed in Tables 7.5.3, 8.5.3, 9.5.3, 10.5.3, 11.5.3, and 12.5.3, respectively. These figures and tables should serve as a basis for estimating costs of instruments. There is a wide price range for almost all instrumentation classes. In the area of tuning and planning, the best way to estimate is to proceed gradually from unsophisticated devices to more complex and integrated instruments. But, for fault and configuration management, it is more meaningful to select the right instrument at the beginning. Thus, additional training and conversion may be avoided. Furthermore, a high level of stability can be guaranteed.

3. **Computing and networking resources:** Using the mainstream approach, overhead of computing and networking resources should be considered. As with personnel, the resources used represent a shortage for other areas. The run time can be considerable in running inventory updates, simulation models, or models of operational analysis, and the time for running remote emulation cases can become considerable as well. The general overhead of the communication software in any of the nodes should also be taken into consideration. On the other hand, when applying the sidestream approach, the operating costs can become significantly lower for the price of purchase for the sidestream processor and its periphery. This processor can be a powerful personal computer or minicomputer with proper data-base and storage facilities. In both cases, the additional transmission load must not be ignored. The estimated magnitude is about 1% to 3% of the production load. This load may be carried in production or in side channels.

In general, costs may be calculated by adding vectors representing tools, personnel, and computer/networking resources. The size of the vector is determined by the number of functions to be considered for configuration, fault,

performance, security, accounting management, and network-capacity planning, respectively. The total costs can be determined by simply adding up the subtotals.

14.4 FINANCIAL ANALYSIS

After analyzing the components of savings and costs, the feasibility of the implementation of a typical network-management project should be investigated in greater detail. In order to demonstrate how financial analysis works, it is intended to walk through the reader in quantifying savings, identifying costs and applying financial analysis techniques. There are three techniques [COUG75] and [TERP87A], used mostly in combination, for evaluating such projects, and for building the business case:

- Payback analysis
- Cash-flow analysis
- Return-on-investment—present-value analysis

These techniques are applied for a network, incorporating 300 leased data lines and 4500 terminals, and for the implementation of fault management functions only.

Considering the cost elements, the operational staff is expected to consist of 17 persons (Table 8.5.4), the supervisor, customer-support-desk personnel, network operators, technical support personnel, and LAN administrators, 4 each. The salary ranges are estimated between $35,000 and $80,000. In the development and implementation period, the network-performance management group can or should contribute as well. It is assumed that two persons will tailor procedures and adapt the instrumentation. In terms of instrumentation, the following configuration is targeted:

- Integrated network-management system; the system is expected to be leased for a monthly rate of $22K.
- Three LAN monitors purchased for diagnosing and troubleshooting Token Ring and Ethernet-type local area networks; the total purchase price is $60K.
- Software tools in addition to the integrated network-management system, which is oriented toward physical level management only; all software products are rented at the total monthly rate of $2.5K.
- Network administration tool for supporting dynamic trouble-ticketing for a monthly rate of $1.5K.
- Two line monitors purchased for diagnosing and troubleshooting; the total purchase price is about $60K.
- Compression software feature for a monthly rate of $0.5K.

- Customer support desk call recording and distribution system with a monthly rate of $0.5K.

Computing resources are required for operating the software-based tools in nodes and for transmitting network-management-related information if the main channel is under consideration. The software overhead is estimated in the range of 2%, in contrast to the usual estimation of 5%. The transmission overhead must not exceed 1% in accordance with the productive line load. During implementation, an additional load factor should be considered when testing and tailoring operational procedures. Using an integrated network-management system, the processor for offloading mainframe resources is available. But additional loads should be carefully examined with the vendor of the monitor.

In estimating the fault management saving components quantitatively, Table 14.2.2 should be used as a basis. All components whose effects will become significant at different intervals are listed. In terms of response time, an improvement of 1 s is assumed. This result is achieved in four consecutive steps. The quantification is based on calculating the total throughput gain for a 1-s response-time reduction for all terminals accommodating all transactions. The customer-level availability can be improved via real-time alerts and improved maintenance procedures by 3.08% on the average, realized in four steps. For the calculation, Table 14.4.1 is of great help. Four key applications are considered with their current availability. Using estimated costs of service outage and target availability level, the value of improved service can be computed to a maximum of $14,000 each month. The personnel during operating are approximately two-thirds of the requirements without network-management instrumentation. Based on preliminary analysis, there is a potential of a one-time equipment reduction in the magnitude of $50,000 due to reducing concentrators and control units. In addition, experience shows a line reduction rate of about 3% to 7% and a terminal reduction rate of 5% to 10%. Taking the pessimistic values, approximately $35,000 can be saved on direct costs after the first period in the third year. The remaining part of the equipment savings may be considered as changing the operational environment of the equipment mentioned. Assumed are line fees of approximately $1700 and terminal fees of $100 each month. Using the instruments indicated, changes in equipment can be continuously accomplished. The implementation of compression software will result in another savings factor of $20,000 per year. The combination of instruments will guarantee a minimal overhead of 2%. The savings are estimated at 8%, based on the practical capacity limit of host and front-end processors. Thus, continuous savings may be accomplished at a level of $6000 each month after the second year. Important savings can be targeted by resource demand reduction. By using just one data base, time for inquiries, preparing correlative reports, and statistics can be significantly reduced. The savings are in the range of $5000 each month. Via basis information collected by fault management, decision-making risks—early and/or late

TABLE 14.4.1: Indirect Savings Through Availability Improvement.

Key Application	Estimated Cost of Service Outage [year]	Current Availability (A)	Target Level	Difference (B)	Percentage of Improved Service B 100 − A	Value of Improved Service
Type A	$200,000.00	93.7%	98.00%	4.3%	68%	$136,000.00
Type B	$150,000.00	95.2%	98.00%	2.8%	58%	87,000.00
Type C	$100,000.00	94.8%	98.00%	3.2%	62%	62,000.00
Type D	$ 80,000.00	96.0%	98.00%	2.0%	50%	40,000.00
Total value				12.3%		325,000.00

Value of improved service for each month: $27,083.33

deliveries—can be substantially reduced. Postponements are also important, if plans already exist for additional expenditures. The calculation of equipment indicators based on continuously collected information guarantees favorable conditions on vendor contracts for the larger organization. Technological innovation can also be included in vendor agreements. Potential security violations can also be included for the larger organization; to avoid this, a continuous savings component can be included. Further resource demand reduction can be achieved via integrated management for all communication forms. These savings continuously increase until total integration is achieved. If charge-back must be applied, continuously captured basic information may contribute to accurately tracking service levels. The quantitative benefit is that all relevant networking resources can be included. Annual savings of $60,000 can be achieved by reducing long-distance phone calls from remote sites.

Figure 14.4.1 shows the costs associated with network outages [COLE89]. Using this figure, the approximate number of daily problems is around 250. This is the reference number used in the following calculations.

Devices	Problems/Day	Cost/Year
100	5	$62,500
500	25	$312,500
1,000	50	$625,000
5,000	250	$3,125,000
10,000	800	$11,000,000
50,000	11,500	$143,750,000
100,000	40,000	$500,000,000

Source: Peregrine Systems

This figure shows the average costs associated with outages due to network problems. The cost calculation assumes that an average call translates into an outage of one half user-hour, that it takes one half technician-hour to resolve, and that a full-time equivalent person (FTE) costs $100,000 per year.

Figure 14.4.1 Costs associated with outages.

Control over trouble resolutions helps to speed-up problem resolutions. Considering 0.5 hours gain for each complex problem (approximately 1% of all reported problems), and estimating $0.6K savings for 30 minutes, $0.6K may be saved for each occurrence. Using long-range statistics for the number of troubles in the networking environment under consideration, the savings per annum may be as high as $375K. Even distribution is assumed over the year, starting with year 2. The number of occurrences is 625 per year, considering 250 working days and 2.5 subtle problems each day, as indicated in Figure 14.4.1.

Undetected problems may cause serious impacts on a service level. Considering avoiding 30-minute delays for just 0.5% of all problems by the use of a network-management system, the annual savings may be as high as $187.5K. The same statistics are used as in the previous item, indicating 1.25

undetected problems for each day. This component may be considered immediately after implementing the tools.

Proactive performance analysis may reduce the total number of occurrences by at least 10%. This corresponds to a value of $312.5K per year, starting in the second year (see Figure 14.4.1).

More accurate fault diagnosis helps to streamline the trouble resolution actions. Assuming 8% less trouble-tracking actions will result in time savings. Time saving corresponds then with money saving in the range of $252K per year, starting in the third year.

Table 14.4.2 illustrates all savings and cost components over time, whereby 2-month periods are considered as a basis for evaluation. The monetary unit is $1000.

14.4.1 Payback Analysis

Payback analysis is used for determining when the network-management system for fault management will pay for itself. The payback period can be computed as follows:

$$\text{payback period} = \frac{\text{one-time development costs}}{\text{net savings}}$$

For the one-time development costs, the following components are considered:

1. **Personnel:** Performance analysts prepare the procedures and test the equipment and procedures prior implementation. For the first year, $120K, for the second year $60K are estimated. For the rest of personnel, on-the-job training and external education is estimated as high as $160K.
2. **Instrumentation:** The LAN monitors and the line monitor combined are considered as high as $120K (see Table 14.4.2).
3. **Computing and transmission resources:** For testing, approximately $15K has to be considered.

One-time-development costs are $475K.

For calculating net savings, year 3 is representing a stable environment with gross annual savings of $2503K and annual operating costs of $1176K, resulting in net savings of $1326K. The payback period is

$$\frac{\$\ 475}{\$1326} = 0.38 \text{ years}$$

Most organizations have some policy on payback computation; frequently the policy is that a project must pay for itself in from 1 to 3 years. The present result is much more favorable than the average target.

TABLE 14.4.2: Analysis of Savings and Costs.

YEAR/2 months		1	2	3	4	5	6	1	2	3	4	5	6	1	2	3	4	5	6
COST ELEMENTS																			
Personnel																			
Supervisor	(1)		12	12	12	12	12	12	12	12	12	12	12	12	12	12	12	12	12
Customer sup. desk	(4)		5	5	10	10	10	15	15	15	20	20	20	20	20	20	20	20	20
Network operator	(4)		6	6	12	12	12	18	18	18	24	24	24	24	24	24	24	24	24
Technical support	(4)		10	10	10	25	25	20	20	20	30	30	30	40	40	40	40	40	40
Network analysts	(2)	25	25	25	25	25	25	15	15	15	15	15	15	5	5	5	5	5	5
Subtotal		25	65	65	76	76	76	94	94	94	125	125	125	129	129	129	139	139	139
INSTRUMENTATION																			
Integrated network-management system				44	44	44	44	44	44	44	44	44	44	44	44	44	44	44	44
LAN monitor purchase					20			20			20								
Software monitor				5	5	5	5	5	5	5	5	5	5	5	5	5	5	5	5
Administration tool				3	60	3	3	3	3	3	3	3	3	3	3	3	3	3	3
Line monitor purchase					1			1	1	1	1	1	1	1	1	1	1	1	1
Compression software					1	1	1	1	1	1	1	1	1	1	1	1	1	1	1
Call management system					1	1	1	1	1	1	1	1	1	1	1	1	1	1	1
Subtotal				52	133	53	53	73	53	53	73	53	53	53	53	53	53	53	53
COMPUTING AND TRANSMISSION																			
Operating software tools		1	1	1	3	3	3	3	3	3	3	3	3	3	3	3	3	3	3
Design/testing					1	1	1	1	1	1	1	1	1	1	1	1	1	1	1
Transmission load					5	5	5	5	5	5	5	5	5	5	5	5	5	5	5
Subtotal		1	1	1	9	9	9	9	9	9	9	9	9	9	9	9	9	9	9
TOTAL COSTS		26	66	118	218	138	138	176	156	156	207	187	187	191	191	191	201	201	201

TABLE 14.4.2: (Continued)

YEAR/2 months	1	2	3	4	5	6	1	2	3	4	5	6	1	2	3	4	5	6
SAVINGS																		
Response time shorter							2	2	4	4	6	6	8	8	8	8	8	8
Availability higher					7	7	14	14	14	21	21	21	28	28	28	28	28	28
Fewer personnel							30	30	30	40	40	40	50	50	50	50	50	50
Equipment reduction							50			35	35	35	70	70	70	70	70	70
Change in equipment				5	5	5	10	10	10	10	10	10	10	10	10	10	10	10
Software reduction						6	6	6	6	12	12	12	12	12	12	12	12	12
Reduction of resource demand				5	5	5	10	10	10	10	10	10	10	10	10	10	10	10
Reduction of risks				5	5	5	15	15	15	15	15	15	15	15	15	15	15	15
Better contracts with vendors							5	5	5	5	5	5	5	5	5	5	5	5
Network integrity							3	3	3	3	3	3	3	3	3	3	3	3
Integrated management							1	1	1	2	2	2	3	3	3	3	3	3
Accounting with services				5	5	5	5	5	5	5	5	5	5	5	5	5	5	5
Calls reduction							4	4	6	6	8	8	10	10	10	10	10	10
Control over resolution							63	63	63	63	63	63	63	63	63	63	63	63
Avoidance of undetected problems				31	31	31	31	31	31	31	31	31	31	31	31	31	31	31
Proactive performance analysis					31		52	52	52	52	52	52	52	52	52	52	52	52
More accurate fault diagnosis													42	42	42	42	42	42
TOTAL				51	58	64	301	251	253	312	314	314	417	417	417	417	417	417

TABLE 14.4.3: Cash-Flow Analysis.

YEARS/2 months	1	2	3	4	5	6	1	2	3	4	5	6	1	2	3	4	5	6
COSTS																		
Personnel	25	65	65	76	76	76	94	94	94	125	125	125	129	129	129	139	139	139
Instrumentation	1	1	52	133	53	53	73	53	53	73	53	53	53	53	53	53	53	53
Computing/transmission	1	1	1	9	9	9	9	9	9	9	9	9	9	9	9	9	9	9
Total	26	66	118	218	138	138	176	156	156	207	187	187	191	191	191	201	201	201
SAVINGS																		
Total	0	0	0	51	58	64	301	251	253	312	314	314	417	417	417	417	417	417
Net Cash Flow	-26	-66	-118	-167	-80	-74	125	95	97	105	127	127	226	226	226	216	216	216
Cumulative Cash Flow	-26	-92	-210	-377	-457	-531	-406	-311	-214	-109	18	109	335	561	787	1003	1219	1435

14.4.2 Cash Flow Analysis

The cash flow of the first 2.5 years is shown in Table 14.4.3. It can be observed that although annual savings of $144,000 are forecast, savings do not accrue immediately upon implementation of the system. Cash flow analysis permits the manager to determine the effect on the firm's cash position if the project is undertaken.

14.4.3 Return-on-Investment (ROI) Present-Value Analysis

Management must rank various investment alternatives, since there is always a limit to the investments that the company can finance. The ROI analysis is given in Table 14.4.4. But the average ROI of 36% over 5 years is misleading. What if the same amount were invested in another project that earned 10% compounded annually? When the same approach is used for the fault management project, it can be seen that it takes more than 2 years to produce ROI comparable to the other project. In order to compare project efficiency, the savings are factored to the present value (Table 14.4.5).

The financial evaluation can be visualized by means of the break-even analysis (Figure 14.4.2). Although traditional break-even charts are based on volume rather than time, the procedure remains the same. Any improvement effort involves both fixed (initial expenses and procurement of measurement tools) and variable (computer time, personnel) costs. The increase of variable costs depends on the phase of the project. The objective is to make a go/no-go management decision on a particular project before all the facts are known.

TABLE 14.4.4: Return-On-Investment Analysis.

Year	1	2	3	4	5
Savings	173	1745	2502	2502	2502
Costs	579	1069	1176	1176	1176
Cumulative savings	173	1918	4420	6922	9424
Cumulative costs	579	1648	2824	3994	5164
Return on investment	0.3	1.2	1.6	1.7	1.8

Average ROI over 5 years = 0.36 = 36%.

TABLE 14.4.5: Present-Value-Analysis.

End of year	Present value per dollar		Net savings	Present value of savings	Cumulative present value
2	$1/(1+0.1)^2$	x	270	223.14	223.14
3	$1/(1+0.1)^3$	x	1326	996.24	1219.38
4	$1/(1+0.1)^4$	x	1326	920.19	2139.57
5	$1/(1+0.1)^5$	x	1326	836.59	2976.16

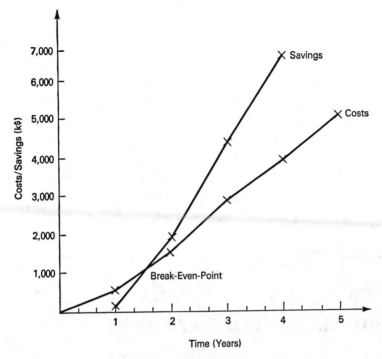

Figure 14.4.2 Breakeven analysis.

This requires making an estimate of potential savings (curve 1) before those savings can be observed. There are some risks involved, and if curve 2 does not behave in a proper manner, at certain checkpoints, the project can be stopped. The actual savings, after the project has been completed, may be greater or less than estimated. This fact determines the exact location of the break-even point (BEP in Figure 14.4.1). More complicated calculations may be significantly facilitated by using spreadsheets.

14.5 SUMMARY

One of the most promising methods for improving the cost-effectiveness of overall network management is by the use of projects for automating network operational control, administration, performance analysis, and capacity planning. Often, however, network-management staff are not able to express the expected payoffs in management-related terms. In order to facilitate management decisions on the feasibility of such projects, a detailed financial analysis should be included in the network-management improvement procedure. Future work should be concentrated primarily in the following fields: more precise estimates on costs and savings; using advanced statistical methods for data evaluation; determining standard measures of performance; observing and evaluating projects in terms of actual payback; and setting up history files to enable better estimating of future network-management projects.

15

Future Trends
of Managing
Communication Networks

Networks are becoming increasingly critical to the majority of corporations for various reasons, such as providing faster and more reliable end-user application services; interlinking with other corporations and service providers; distributing computing intelligence and data bases; providing total connectivity across communication forms, network architectures, and network components; supporting brand new applications which require the multiple of presently available bandwidth; and as a combination of all the preceding, corporations are saying they offer the ultimate advantage over their competition.

For supporting these ambitious goals, new network components and services provided by a considerably high number of suppliers have to be carefully considered. Corporate network planning has to concentrate on

- New networking elements which support the overall connectivity at various levels of intelligence, and include gateways, routers, brouters, and bridges
- New hierarchy of local and metropolitan area networks, including PBXs and central office offerings
- Changing role of front-end processors, matrix switches, and bandwidth management components
- New services supporting international networking
- Enhancement and expansion of existing bearer services for offering more bandwidth to users including T1, T3, E1, J1, and various forms of

ISDN and B-ISDN. New standards on the basis of optical communication, such as SONET, will also be implemented.

- Availability of application-level services, such as E-Mail, EDI, X.500, and so on.
- Availability of network-management services, which may completely off-load corporations from management responsibilities.
- Segmentation of network-management responsibilities among several groups within the enterprise, or third parties.

But new networking solutions, installation of new components, and implementation of new services may and will fail without adequate network-management solutions.

In local, metropolitan, and wide areas, technological trade-offs will support the integration of communication forms, but how fast is not yet predictable. To begin with, voice and data will be integrated first. Depending on the customer's need, special services may appear faster than integrated services. The principal concerns of the customer evaluating alternatives, besides quality manufacturing and advanced concept, are efficiency, growth, connectivity, service level, and control.

In terms of network architectures, present solutions will slowly migrate to international standards and to each other. But market leaders will insist on not losing the leading edge. In any case, vendors and customers will talk the language of peer-to-peer communication, supported at multiple levels. Communication software segments of WAN, MAN, and LAN architectures are expected to be substantially extended:

- Security will control the access of any user or group of users to any specified resource, application, or to any other user.
- The functions will more clearly be allocated to the individual layers of the communication architecture.
- Path hunting will assist the customer to access networking resources by symbolic names.
- Resource eligibility listing service will identify available resources to the customer.
- Queuing facility will govern the queues of users for any specified resource.
- Load balancing will be a dynamic function that connects a user to an appropriate resource with the lowest traffic.
- Log-off service will provide key information on the recent connection to the user.
- Services will be offered to access applications and/or system modules in a user-friendly manner.
- Management of applications (e.g. Electronic Mail) will become part of logical network management.

No systems, architectures, or products are expected on the marketplace without some sort of management capabilities. The implementation of integrated communication services such as ISDN will not eliminate requirements for features. The success of network management for both homogeneous and heterogeneous architectures will depend on three critical factors: methodology as a well-organized set of network-management functions allocated and assigned to tools and human skills, proper instrumentation with integrating information extraction, analysis, and performance prediction, and personnel understanding duties and qualifying skills.

In terms of methodology, the distribution of network-management functions into fault, configuration, performance, security, accounting management, and capacity planning will remain valid over a long period of time. Naturally, responsibilities will be constantly added and deleted depending on actual user needs. However, a nucleus with standard features will continuously be provided.

Network-management standards are targeting the same subsystems, called Specific Management Application Areas, which are supported by System Management Functions and by Common Management Information Service Elements. The way of implementation is still vendor dependent, but will migrate to a common denominator. The migration may be delayed by powerful and widely used de-facto standards, such as ONMA from IBM and SNMP.

In terms of instrumentation, three different groups may be distinguished very clearly:

- Proprietary solutions for the network elements, or for the network-element management level, represented mostly by modem, DSU, CSU, multiplexer, bridge, router, brouter, hub, and switch vendors.
- De facto solutions for the network-element management and for the integrator level represented by leading providers of network architectures, computer systems or by powerful user groups.
- OSI-based solutions for the network-element management or for the integrator level represented by companies dedicated to the OSI standards. SNMP is no replacement for OSI-based solutions that offer a much richer functions and command set. SNMP offers a rapid start for integration, followed by more elaborate solutions on CMIP-basis. Performance and overhead have to be compared and weighted against each other. [TERP91B] compares both alternatives in depth.

In terms of instrumentation, there is a definite trend toward integration, with the following special expectations:

- Manufacturers of network-management integrators will try to simplify the handling of multiple tools by providing a user-friendly network-management platform and application access services.

- Software monitor vendors will still be hesitant to penetrate the front-end and cluster monitoring market; they will improve the accuracy and reduce the overhead of application and system monitoring.
- The modem, data, and channel control units, multiplexer, switch-based network element management systems will get smarter and soon reach the bottom line of integrated network-management systems.
- LAN monitors will be offered first to fault and performance management support.
- Wiring hub vendors concentrate on network management even more than vendors of bridges, routers, brouters and gateways; the wiring hub is becoming the real focus of network management in the LAN area by controlling Ethernet and Token Ring segments, FDDI-nodes, and the actual cabling.
- PBX monitors will be integrated step by step into overall management architectures.
- Network monitor's features will be substantially extended by inventory control, vendor control, and trouble-ticketing options, thus offering a complete sidestream network management concept.
- Network monitor vendors will offer upward support of integrator products or at least links for total network management by offering console emulation.
- The gap between network monitors and network-element management systems will disappear.
- All vendors will offer some sort of a network-management data base, serving as a central point for maintaining the configuration data (inventory, connectivity, and status), for analyzing and predicting network performance (indicators for data/voice/imagery), and for supporting various functions of telemanagement. The solutions will differ, but the use of relational or object-oriented representation seems likely. These vendors recognize the limited life cycle of standalone products in comparison with integrated architectures.
- Vendors concentrating on extraction and analyzing tools will provide additional features for answering what-if questions about future workload, hardware, software, and service level; they will use spreadsheets on personal computers.
- Vendors concentrating on planning tools will provide information collection tools for facilitating the building and verification of baseline models.
- Future models will integrate mainframe and networking features by combining node and link models for both voice and data.
- In terms of integrated, automated, and centralized network management, integrated tools supported in a sidestream processor or at least in a dedicated processor seem to be the better choice in the long term.

At the present time, there are approximately 200 serious vendors involved in the network-management area. Within the next 5 years, a major shake-out is expected. Vendors with integrated products will most likely survive. Figure 15.1 shows a two-dimensional graph that investigates the capabilities of various vendors to offer element management and integration capabilities. Due to the dynamic nature of the industry, this table needs frequent upgades.

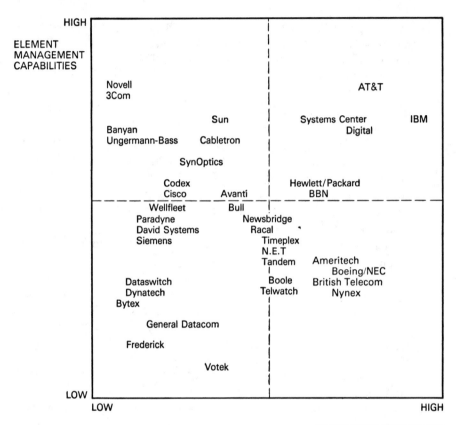

Figure 15.1

Completely new technologies for supporting various network-management functions are likely. Examples may include hypertext and hypermedia for help, training, and problem sectionalization; voice annotation of trouble tickets and voice messaging, optical storage for historical data, storing graphical images for helping problem resolution, intelligent user interfaces with flexible customization features, language translation capabilities for supporting dynamic trouble tracking in international networks.

The distribution of human responsibilities will follow the methodology of network management. Depending on the size of communication networks,

the staffing will greatly vary. Table 15.1 summarizes the human resources demand for the four user clusters, defined in Chapter 1, and evaluated individually in Chapters 7 through 12. In terms of the network-management team, two subjects have to be remembered: building the team and keeping the team require a number of managerial skills. The area supervisors will report to the network manager, who may report either to the information system's manager or the chief information officer of a larger organization. In both cases, a total integration of information and communication services is assumed. Network-management personnel will use the tools, but future application will go beyond this point. They will offer expert systems in automating certain responsibilities and integrating those with instruments.

TABLE 15.1: Human Resources Demand for Network Management Considering Four Company Sizes Characterized by the Number of Network Elements.

Network-Management Subsystems	Company Sizes			
	Small < 3000	Medium 3000–10,000	Large 10,000–50,000	Very Large > 50,000
Configuration management	4	8	15	22
Fault management	8	17	29	56
Performance management	4	7	11	17
Security management	3	5	8	13
Accounting management	3	5	8	10
Network capacity planning	8	12	17	23
TOTAL	30	54	88	141

The automation of network-management functions and integration of instruments will work side by side. As an example, exits from communication software will be developed for extending the management features for a mainstream approach. But personal computers with powerful data-base options will penetrate network management as well. The transfer from mainstream to sidestream approach will be smooth, and it will very likely begin with using segments of the network-management data base on a personal computer. Later, additional responsibilities can be taken over by the computer. In addition, some standard features can be provided as firmware, thus reducing overhead and simplifying operational procedures. The major criteria of any of the alternatives are flexibility, portability, and extendability. The full implementation of an automated network-management system takes time and is expected to be accomplished in several steps.

Besides automation of network-management functions, expert systems will become key components of problem determination and network design. They will act as a sophisticated computer program that has expert knowledge of operational control and network design. This expertise will be used to solve problems at a high level of performance, similar to human experts. The ulti-

mate performance depends on the knowledge base and on combining principles. The true return on investment in network management will not come until these expert systems produce better performing networks requiring less staff to operate.

Using the blackboard paradigm technique, several expert system segments may be integrated for simultaneously supporting all key network-management responsibility areas. Information systems management will benefit from a network-management system in many ways. The most important results to be expected are summarized as follows:

- Complete visibility in networking operations supported by up-to-date information on status
- Substantial improvements in service level, characterized by availability and response time
- Well-balanced resource utilization for both networking facilities and equipment
- Improving economy by exchanging information with suppliers and other users
- Proactive performance management helps to avoid service impairments and resource congestions
- Multi-vendor coordination and integration
- Controllability of new technology challenges
- Management-driven rather than event-driven network management
- Avoidance of explosion of qualified support personnel
- Specific software controls connectivity and access
- Quantitative evaluation of networking alternatives using analytical and simulation techniques
- Dealing with all types of hot buttons in the networking area
- Up-to-date costing helps to decide whether outsourcing is a realistic alternative

Network-management-related projects and solutions should in every case be cost-justified by applying financial analysis techniques, such as return-of-investment analysis, cash-flow requirements, and computing the payback period.

Presently, the average corporation spends approximately 3% of its communication (voice and data communications) budget for network-management-related functions, instruments, and human resources. Due to the requirements to consistently improve and expand network management, the expenditures are expected to reach 18% to 23% by 1995. Many users and service providers see these numbers as a driving force to start considering the outsourcing of some or all network-management responsibilities.

References

[ALLE84] Allen, L. E., and K. Terplan. "Costing Service Levels." Newsletter, Institute for Information Management, Sunnyvale, Calif., 1984.

[ALLE86] Allen, L. E., and K. Terplan. "Network Design: A Decision Matrix Approach." *Telecommunications* 20 (May 1986) 63–71.

[ANDE86] Anderson, H. "Moving toward Intelligent Networks." *Telecommunication Products + Technology.* February 1986, 32–36.

[AXEL83] Axelrod, C. W. "The User's View of Computer System Reliability." *Journal of Capacity Management.* vol. 2, no. 1 (1983): 24–41.

[BACH82] Bachmann, C. W., and R. G. Ross. "Toward a More Complete Reference Model of Computer Based Information Systems." *Computer Networks,* 6 (1982): 331–343.

[BAIL83] Bailey, R. M., and R. C. Soucy. "Performance and Availability Measurement of the IBM Information Network." *IBM Systems Journal* 22, no. 4 (1983): 404–416.

[BAUE86] Bauer, T. "Tuning Large Distributed SNA Networks," *Data Communication 15,* no. 3 (1986), 297–306.

[BENJ83] Benjamin, J. H., M. L. Hess, R. A. Weingarten and W. R. Wheeler. "Interconnecting SNA Networks." *IBM Systems Journal* 22, no. 4 (1983): 344–366.

[BIAR83] Biardo, S. L., and V. A. K. Mayrhauser. "Structure and Design Considerations for a Generalized Performance Analysis and Capacity Planning Tool." ICCCM. Conference Record, New Orleans, LA 1983. 68–83.

[BIRD80] Bird, R. A., and C. A. Hofmann, "Systems Management." *IBM Systems Journal* 19, no. 1 (1980): 140–159.

[BLAC82] Blackmarr, B. R., "Local Area Nets," *Computerworld* (December 1, 1982): 42–44.

[BRAD89] Brady, S. "Management User Interfaces," IEEE Network Management and Control Workshop, Tarrytown, N.Y. 1989.

[BRIG90] Brigth, J. "The Smart Card: An Application in Search of a Technology." *Telecommunications*. March 1990, 63–68.

[BRON80] Bronner, L. "Overview of Capacity Planning Process for Production Data Processing." *IBM Systems Journal* 19, no. 1 (1980): 4–27.

[BULL81] Bullen, Ch. V., and J. F. Rockart. "A Primer on Critical Success Factors." *CISR* 69, Sloan WP No. 1220-81, 1981.

[BUZE83] Buzen, J. P., S. C. Agraval, and A. K. Thareja. "Modeling IBM SNA Networks." CMG XIII. Conference Record. San Diego, Calif. 1983, 403–407.

[CACI89A] C.A.C.I. *Comnet II.5 Product Review.* La Jolla, Calif. 1989.

[CACI89B] C.A.C.I. *Simlan Product Review.* La Jolla, Calif. 1989.

[CARU90] Caruso, R. E. "Network Management: A Tutorial." *IEEE Communications Magazine.* March 1990, 20–25.

[CASA90] Casatelli, Chr. "Open Sesame." *Network World.* April 23, 1990.

[CHES86] Cheslow, R. "The Prospect for Expert Assistance in Telecommunications." *Telecommunication Products + Technology,* February 1986, 40–44.

[CHOU81] Chou, W. "ACK/TOPS—An Integrated Network Design Tool." International Conference on Communications. Conference Record, vol. 1. Denver, Colo., 1981, 4.1.1–4.1.7.

[CHOU83] Chou, W. *Computer Communications.* vol. 1, *Principles.* Englewood Cliffs, N.J.: Prentice Hall, 1983.

[CHOU89] Chou, W., and L. Bennett. An Expert System for Diagnosing Performance Problems in SNA Networks, Network Management and Control Workshop, IEEE Communications Society and Polytechnic University, Tarrytown, 1989, p. 114–126.

[CHU83] Chu, V. "Monitoring Network Performance." *Computerworld* (May 18, 1983).

[COLE89] Cole, Chr. "Management by Preparedness." *Datapro Research Corporation.* NM10-100, Delran, N.J., 101–103.

[COLL89] Collins, W. "The Reality of OSI Management." *Network World.* October 9, 1989.

[COOK83] Cook, G. W. "Using SAS for Data Communications Management." *CMG* XIII, San Diego, California, (1983): Conference Record 17-22.

[COOP90] Cooper, J. A. "The Network Security Management." *Datapro Research Corporation.* NM20-200, Delran, N.J., 1990.

[COTT79] Cotton, I. W. "Technologies for Local Area Computer Networks." *Proc. Local Area Communication Network Symp.* (May 1979), 25–45.

[COUG75] Couger, H. D., and F. R. McFadden, *Introduction to Computer Based Information Systems,* New York: John Wiley, 1975.

[CSON84] Csontos, E. "Workload Prediction Using Time Series Analysis." *Computer Performance Journal,* 5, no. 2 (1984): 70–79.

[CSI88] Communications Solutions, Inc. "NetView versus Net/Master." *Network Management Perspective.* 1(8), September 1988.

[DANM87A] Datapro Research Corp. *T1 Multiplexers* CA80-010, Delran, N.J., 201–216.

[DANM87B] Datapro Research Corp. *An Overview of Channel Banks* CA80-010, Delran, N.J., 901–920.

[DANM88] Datapro Research Corp. *NetView and NetView/PC,* Delran, N.J., 1988.

[DANM89A] Datapro Research Corp. *AT&T's Unified Network Management Architecture* NM40-313, Delran, N.J., 1989, 101–114.

[DANM89B] Datapro Research Corp. *The LAN Troubleshooting Sequence* NM50-300, Delran, N.J., 1989, 101–106.

[DANM89C] Datapro Research Corp. *Managing Local Area Networks: Fault and Configuration Management* NM50-300, Delran, N.J., 1989, 410–412.

[DANM89D] Datapro Research Corp. *Managing Local Area Networks: Accounting, Performance, and Security Management* NM50-300, Delran, N.J., 1989, 501–509.

[DANM89E] Datapro Research Corp. *Telecommunications Management Software* NM50-500, Delran, N.J., 1989, 101–109.

[DANM89F] Datapro Research Corp. *The Telemanagement Symphonie* NM50-500-Delran, N.J., 1989, 210-28.

[DANM89G] Datapro Research Corp. *An Interactive Network Display System for Network Management Systems* NM20-200, Delran, N.J., 1989, 201–211.

[DANM89H] Datapro Research Corp. *DEC Enterprise Management Architecture (EMA)* NM40-325, Delran, N.J., 1989, 101–110.

[DANM89I] Datapro Research Corp. *OpenView's Architectural Model* NM40-325, Delran, N.J., 1989, 101–107.

[DANM89J] Datapro Research Corp. *IBM SNA and NetView* NM40-491, Delran, N.J., 1989, 101–108.

[DANM89K] Datapro Research Corp. *A Look at Selected LAN Management Tools* NM50-300, Delran, N.J., 1989, 701–708.

[DANM90A] Datapro Research Corp. *An Overview of Simple Network Management Protocol* NM40-300, Delran, N.J., 1990, 201–207.

[DANM90B] Datapro Research Corp. *SNMP Product Guide* NM40-300, Delran, N.J., 1990, 301–316.

[DANM90C] Datapro Research Corp. *An Introduction to Expert Systems in Network Management* NM20-200, Delran, N.J., 1990, 301–310.

[DANM90D] Datapro Research Corp. *Gaining Control of the Network Using an Administrative Database* NM20-300, Delran, N.J., 1990, 301–314.

[DANM90E] Datapro Research Corp. *Standardizing Network Management for TCP/IP Environments* NM40-300, Delran, N.J., 1990, 101–104.

[DANM91A] Datapro Research Corp. *SNMP Query Language* NM40-300, Delran, N.J., 1990, 401–404.

[DELL81] Dellarosa, R. J. "Network Management—What Is It?" *Telecommunications* 15 (December 1981), 83–84.

[DEMD89] Dem, D. P., and J. Till. "Monitoring LANs from a Distance," *Data Communications,* McGraw-Hill, New York November 1989, 17–20.

[DENN79] Denning, P. J., and J. P. Buzen. "The Operational Analysis of Queuing Network Models," *Computing Surveys*, 10, no. 3 (September 1978): 225–261.

[DIXO83] Dixon, R. C., N. C. Strole, and J. D. Markow. "A Token-Ring Network for Local Communications." *IBM Systems Journal* 22, no. ½ (1983).

[DMW89] DMW Commercial Systems, Inc. *Telebox/Telepoll, PBX Data Management System, User Manual.* Ann Arbor, Mich., 1989.

[DOLL84] Doll, D. R. "Strategic Planning." *Computerworld* (April 11, 1984).

[DORT83] Dortok, B. "A Methodological Approach to Network Design." *Telecommunications* 17 (November 1983).

[DRIV79] Driver, H. H., H. L. Hopewell, and J. F. Iaquinto. "How the Gateway Regulates Information Flow," *Data Communications* 8, no. 9 (September/October 1979), 1–11.

[FELD89A] Feldkhum, L. *Integrated Network Management Systems.* Elsevier Publishers, 1989. IFIP Congress, 279–300.

[FELD89B] Feldkhum, L., and J. Ericson. *Event Management as a Common Functional Area of Open Systems Management.* Elsevier Publishers, 1989. IFIP Congress, 365–376.

[FERR83] Ferrari, D., G. Serazzi, and A. Zeigner, *Measurement and Tuning of Computer Systems.* Englewood Cliffs, N.J.: Prentice Hall, 1983.

[FIBS78] FIBSB57. *Guidelines for the Measurement of Interactive Computer Service Response Time and Turnaround Time.* Washington, D.C., 1978.

[FISH90] Fischer, U. *Use of Expert Systems for Managing Networks,* Technical University Munich, Lebnitz Computer Center, Master Thesis, Germany, 1990.

[FRAN83] Frank, H.: "Broadband versus Baseband Local Area Networks." *Telecommunications* 17 (March 1983), 35–38.

[FRAN83] Frank, H. "LANs: Who Needs One?" *Management Technology* (July 1983), 24–30.

[FRAN90] Francett, B. "Are You on the Brink of Losing LAN Control?" *Software Magazine,* July 1990, 78–85.

[FRAN85] Frank, A. L. "New Tools Address the Problems of Managing Network Facilities." *Data Communication* (September 1985), 14, no. 9, 249–254.

[FRED85] Frederick Engineering, Inc,: *FELINE Product Overview.* Gaithersburg, Maryland, 1985.

[FRIE89] Fried, S., Tjong, J.: Implementing integrated monitoring systems for heterogeneous networks, IEEE Network Management and Control Workshop, Tarrytown, 1989, p. 56–69.

[FROS86] Frost and Sullivan, Inc. *Data Network Management and Remote Test Systems Market in Europe,* N.Y. 1986.

[GANT88A] Gantz, J. "The Network of 1998." *TCT/Networking Management,* January 1988, 22–36.

[GANT88B] Gantz, J. "How Networks Get Built." *TCT/Networking Management,* October 1988, 33–44.

[GELL82] Gell, K. "Improving SNA Response Time, In Depth." *Computerworld* (November 1982).

[GILB83] Gilbert, J. "Smart Modems Offer Control of Functions." *Computerworld*. Special Report (January 31, 1983) 7.

[GILB88] Gilbert, E. E. "Unified Network Management Architecture—Putting It All Together." *AT&T Technology* 3 (2): 1988.

[GILE80] Giles, H. L. "Communication Systems Management." *Performance Evaluation Review*. 9, no. 1 (1980): 46–51.

[GOLD81] Goldberg, R. P., A. H. Sarasohn, and J. J. Posner, "A Tool that Forecasts Effects of Network Growth." *Data Communications* 11, no. 11 (November 1981).

[GOLD89] Goldsmidt, S., and U. Vizcaino. *Enterprise Network Management*. Elsevier Publishers, 1989. IFIP Congress, 541–552.

[GOYA85] Goyal, S. K. et al. "COMPASS: An Expert System for Telephone Switch Maintenance." *Expert Systems*, July 1985, 2, no. 3, 122–126.

[GRUB81] Grubb, D. S., M. D. Abrams, and N. B. Seitz. *User Oriented Data Communication Performance Parameters*. Amsterdam, Holland: North Holland Publishing Company, 1981, 145–154.

[GURU85] Guruge, A. "SNA Theory and Practice," Maidenhead, England: Pergamon Press, 1985.

[HAMM82] Hammond, L. W. "Management Considerations for an Information Center." *IBM Systems Journal* 21, no. 2 (1982): 131–161.

[HAMM89] Hammond, R. "Using NetView to Report on Network Availability." *Technical Support Journal* 3 (4): April 1989.

[HARR88] Harrison, B. "OSI Standards: To Wait or Not to Wait." *TPT* 1/1988, 51–54.

[HAVE88] Haverlook, P. M. "The Formula for Network Immortality," *Data Communications*, McGraw-Hill, New York, August 1988.

[HELD86] Held, G. "No More Guesswork for Sizing Network Components." *The Executive Guide to Data Communications*. 7 N.Y. 1986.

[HERM89A] Herman, J. *NetView: IBM's Enterprise-Wide Manager*. Northeast Consulting Resources, Inc., April 1989.

[HERM89B] Herman, J. *AT&T's Network Management Strategy*. Northeast Consulting Resources, Inc., April 1989.

[HERM89C] Herman, J., and R. Weber. *The LAN Management Market*, Northeast Consulting Resources, Boston, 1989.

[HERM90] Herman, J. "Enterprise Management Vendors Shoot It Out," *Data Communications*, McGraw-Hill, N.Y. November 1990, 92–110.

[HERM91] Herman, J., and N. Lippis. "The International Decade," *Supplement to Data Communications*, McGraw-Hill, N.Y. January 1991, 2–32.

[HORW85] Horwitt, E. "The Great LAN Software Breakthrough." *Business Computer Systems* (February 1985), 54–57.

[HORW84] Horwitt, E. "Looking for the Promised LAN." *Business Computer Systems* (June 1984), 112–148.

[HOWA76] Howard, P. C. "Evaluation and Comparison of Software Monitors." *EDP Performance Review* 4, no. 2 (1976).

[HOWA80A] Howard, P. C. *EDP Performance Management Handbook*. Vol. 1, *Analytical Methods—Communication*. Phoenix, Ariz. 1980, 6.20.1, and continuous updates. Applied Computer Research, Inc.

[HOWA80B] Howard, P. C. *EDP Performance Management Handbook*. Vol. 2, *Tools and Techniques*. Phoenix, Ariz. 1980, and continuous updates. Applied Computer Research, Inc.

[HOWA81] Howard, P. C. "Standard Costing in Data Processing." *EDP Performance Review* 9, no. 6 (1981).

[HOWA89] Howard, P. T. C. Understanding the Erlang, *EDP Performance Review,* March 1989, Applied Computer Research, Phoenix, Ariz.

[HUNT89] Huntington, J. A. "OSI-Based Net Management." *Data Communications,* March 1989, 111–129.

[HUNT90] Huntington, J. A. "SNMP/CMIP Market Penetration and User Perception." *Interop 1990,* San Jose, Calif. October 1990.

[IBM82A] IBM Corp. *Network Logical Data Manager, General Information Guide.* Armonk, N.Y., 1982.

[IBM82C] IBM Corp. *Performance Analysis Reporting System, Programs and Reports Implementation Guide.* Yorktown Heights, N.Y., 1982.

[IBM82D] IBM Corp. *Operator Communication Control Facility, General Information Guide.* Armonk, N.Y., 1982.

[IBM82E] IBM Corp. *Systems Network Analysis Program/Simulation Host Overview Technique, General User Guide.* Armonk, N.Y., 1982.

[IBM82F] IBM Corp. *Teleprocessing Network Simulator, Implementation and Customization Guide.* Yorktown Heights, N.Y., 1982.

[IBM83A] IBM Corp. *Communication Network Management, Using SLR* 6G24-1590-0, Melbourne, Australia, 1983.

[IBM83E] IBM Corp. *System/Network Control Center Overview.* G226-3551-3, Kingston, N.Y., 1983.

[IBM84A] IBM Corp. *Network Performance Monitor, General Information Manual.* GH20-6359-0, Kingston, N.Y., 1984.

[IBM84B] IBM Corp. *Personal Computer Response Time Estimator.* G320-0334, Information Systems Group Documentation, White Plains, N.Y., 1984.

[IBM85A] IBM Corp. *CNM Performance Management Tools.* 6624-1673-0, Raleigh, No.Car., 1985.

[IBM86A] IBM Corp. *NETVIEW Product Overview.* Armonk, New York, 1986.

[INFO89] Infonetics, Inc. *The Cost of LAN Downtime, Santa Clara, CA,* 1989.

[ISO81] International Standards Organization: *Draft Proposal ISO/DP 7498 on Data Processing Open Interconnection Basic Reference Model,* Geneva, Switzerland, 1981.

[JONE84] Jones, F. N., and P. A. Watson, "Expert Systems and the Telecom Manager." *Telecommunications* 18 (September 1984), 61–90.

[JORD88] Jordan, B. "Network Management: How Integrated is Your System?" *Telecommunications,* February 1988, 36–37, 40, 91.

[JOSE90] Joseph, C. "Network Management: A Manager's Perspective." *CMG Transactions,* Winter 1990, 53–59.

[JOSH90] Joshi, N. "Expert Systems in Network Diagnostics." *Technical Support,* October 1990.

[KAUF89] Kauffels, F. J. "Network Management Series." *Datacom Journal,* Cologne, Germany, March–July 1989.

[KENI88] Kenig, D. *LineView Technical Users Manual,* Munich, Germany 1988.

[KING83] King, J. "Future Networking with IBM." *Computerworld* (September 28, 1983).

[KLEI76] Kleinrock, L. *Queuing Systems.* Vol. 2, *Computer Applications.* New York: Wiley Interscience, 1976.

[KLEI82] Kleinrock, L., "A Decade of Network Development." *Journal of Telecommunication Networks* 1, no. 1 (1982): 1–11.

[KUBE83] Kube, C. B. *Network Performance Management,* IBM Washington Systems Center, Washington, D.C., GG22-9307, 1983.

[LEAC80] Leach, J. R., and R. D. Campenni, "A Sidestream Approach Using a Small Processor as a Tool for Managing Communication Systems." *IBM Systems Journal* 19, no. 1 (1980): 120–139.

[LEAC82] Leach, J. R., "Installation and Management of a Modern Communication Network," Proceedings of the 1982 Computer Measurement Group International Conference, December 14–17, 1982.

[LEVY84] Levy, A. *Performance Engineering Course Documentation.* Sunnyvale, Calif., Institute for Information Management, 1984.

[LIPN83] Lipner, L. *Five Risk Factors in Planning Information Centers.* BGS Systems Inc., Special Publication, Waltham, Mass., 1983.

[LOPE82] Lo. T. L., and J. Peng, "Performance Analysis of Line Capacity in a Multipoint Network," Proceedings of the 1982 Computer Measurement Group International Conference, December 14–17, 1982.

[LOPE85] Lo, T. L., and J. Peng, "Network Simplification: A Prudent Approach for Managing Communication Networks." CMG XVI. Proceedings. Dallas, Texas, 1985, 187–192.

[MACH85] Machlin, R. N. "Managing a Local Area Network." *Telecommunications* 1 (1985), 84–88.

[MALE88] Malek, M. "Service Provisioning for Intelligent Networks with Distributed Control." NOM 1988, 1–11.

[MANT86] Mantelman, L. "AI Carves Inroads: Network Design, Testing, and Management." *Data Communication,* 15, no. 7 (1986), 106–123.

[MART72] Martin, J. *Systems Analysis for Data Transmission,* Englewood Cliffs, N.J.: Prentice Hall, 1972.

[MATE84] Materna, A. T. "Local Area Networks in Corporate Planning." *Managerial Planning* (November/December 1984), 32–41.

[MCCA89] McCann, J. "OSI-Based Network Management." *Datapro* CMS20-010, Delran, N.J., 1989, 801–815.

[MCDO84] McDonald, T. W. "Implications of the Personal Computers on Capacity Planning and Performance Tuning of an SNA-Network." ECOMA-12. Conference Proceedings. Munich, Germany 1984, 101–111.

[MCDO85] McDonald, T. W. "Principles of SNA Performance Management." CMG XVI. Proceedings. Dallas, Texas 1985, 462–467.

[MEIJ82] Meijer, A., and P. Peeters. *Computer Network Architecture,* London: Pitman Publishing Limited, 1982.

[MERR80] Merrill, H. W. *Merrill's Guide to Computer Performance Evaluation.* Cary, No.Car., SAS Institute Inc., 1980.

[MERR84] Merrill, H. W. *Merrill's Expanded Guide to Computer Performance Evaluation Using the SAS System.* Cary, No.Car., SAS Institute, Inc., 1984.

[MILL82] Miller, G. G. *Manager Telecommunication Networks,* London: Touche Ross and Co., 1982, 5–11.

[MILL89] Miller, H. *LAN Troubleshooting Handbook.* M&T Books, Redwood City, Calif., 1989.

[MINO89] Minoli, D. "Network Monitoring and Control." *Datapro* NM20-300, Delran, N.J., 1989, 301–314.

[MOHR81] Mohr, J., and S. Penansky. "A Forecasting-Oriented Workload Characterization Methodology." Proceedings of the Third International Conference on Computer Capacity Management. Chicago, Ill., 1981.

[MOTL88] Motles, L., and W. Conner. "Network Monitoring Issues." *Technical Support Magazine* 2 (4): April 1988.

[NETW91] Network General Corp. *Sniffer Network Analyzer Product Family User's Guide,* Menlo Park, CA, 1991.

[NORD83] Nordling, K. "Design and Benefits of Modem Data Compression." *Telecommunications* 17 (1983), 61, 62, 74.

[NORM88] Norman, H. J. van. "A User's Guide to Network Design Tools." *Data Communications,* McGraw-Hill, New York, April 1988.

[NORM90] Norman, H. J. van. "WAN Design Tools: The New Generation." *Data Communications,* McGraw-Hill, New York, October 1990.

[NORT86] Northern Telecom/Spectron, Inc. *Network Management System Implementation Guide.* Marlton, N.J., 1986.

[NUCI89] Nuciforo, T. "What a Computerized Cable Management System Should Do." *Business Communications Review,* July 1989, 22–26.

[OSIN90A] OSI/Network Management Forum: Forum 002—Application Services, Bernardsville, N.J. 1990.

[OSIN90B] OSI/Network Management Forum: Forum 003—Objects Specification Framework, Bernardsville, N.J. 1990.

[OSIN90C] OSI/Network Management Forum: Forum 006—Forum Library of Managed Object Classes, Name Bindings and Attributes, Bernardsville, N.J. 1990.

[PERE86] Peregrine Systems, Inc. *PNMS III Implementation Guide,* Irvine, Calif., 1986.

[POCE86] Pocek, S. "Poll Substitution: A Basis Artificial Intelligence in Network Testing and Management." *Data Communication,* 15, no. 7 (1986), 203–216.

[PYBU83] Pybus, R. J. "Fiber Optics—The Logical Choice for Users," *Computerworld* (January 5–6, 1983).

[QUES82] Questronics, Inc. *Model 3xx, 4xx, 5xx Products' General Information Guide.* Salt Lake City, Utah, 1982.

[QUES86A] Questronics, Inc. *COMMQUEST General Implementation Guide.* Salt Lake City, Utah, 1986.

[QUES86B] Questronics, Inc. *Communication Performance and Multiple Line Analyser Specification.* Salt Lake City, Utah, 1986.

[RACA82] Racal-Milgo Limited. *Communication Management Series, General Information Guide,* Fleet, U.K., 1982.

[RICH85] Richardson, E. M. "Test Measurement, and Control." *Telecommunications,* 19 (July 1985), 40/1–54/1.

[ROBB80] Robbins, C. R. "Data Communications Management Trends and Innovations." *Telecommunications* 14, no. 9 (1980).

[ROBB81] Robin, G., and S. R. Treves. "An Introduction to Integrated Services Digital Networks." *Electrical Communication* 56, no. 1 (1981), 4–15.

[ROCK82] Rockart, J. F. "The Changing Role of the Information Systems Executive: A Critical Success Factors Perspective." *Sloan Management Review* (1982), 15–25.

[ROSE90] Rose, M. T. *The Open Book—A Practical Perspective on OSI.* Prentice Hall, Englewood Cliffs, N.J., 1990.

[ROTH91] Rothberg, M.L.: Cable Management Systems, Datapro Reports on Network Management Systems, NS60-020-101 to 301, Delran, N.J. March 1991

[RUHL88] Ruhland, K., M. Padula, and T. F. Kelleher. "Operations Planning for the AT&T-ISDN." *NOMS88,* 1–12.

[RULA87] Ruland, Chr. "Security of Communication Systems." *Datacom* ISBN 3-89238-004, Cologne, 1987.

[RUTL82] Rutledge, J. H. "OSI and SNA, a Perspective." *Journal of Telecommunication Networks* I (1982): 13–27.

[RUX90] Rux, P. T., and C. V. Liles. "ESF—Rx for Healthy T1 Nets." *Data Communications,* McGraw-Hill, New York, May 1990, 81–94.

[SALA89] Salazar, A. C. "Network Management Systems for Data Communications." Datapro Research Corporation NM50-600, Delran, N.J., 1989, 201–208.

[SAND81] Sandberg, G. "A Primer on Relational Data Base Concepts." *IBM Systems Journal* 20, no. 1 (1981): 23–40.

[SAS80] SAS Institute Inc. *Statistical Analysis System User Guide,* Cary, No.Car., 1980.

[SCHI81] Schindler, M. "Networks May Look Alike, but Software Makes the Difference." *Electronic Design* (1981), 121–140.

[SEAM82] Seaman, J. "Controlling Network Traffic." *Computer Decisions* (1982), 133–193.

[SEAM83] Seaman, J. "Controlling Complex Networks." *Computer Decisions* (1983), 141–162.

[SHAR82] Sharma, R. L., P. J. T. de Sousa, and A. D. Ingle. *Network Systems.* New York: Van Nostrand Reinhold Data Processing Series, 1982.

[SIEM82] Siemens, AG. *Transdata—Program System for Teleprocessing and Network Control,* D 12/2553-0, Munich, Germany, 1982.

[SIMW86] Simware, Inc. *SIM/RTM Users' Guide.* Nepean, Ontario, 1986.

[SOUC83]	Soucy, C. R., and M. R. Bailey. "IBM Information Network Performance and Availability Measurement." National Computer Conference. Conference Proceedings. 1983, 655–662.
[STAC85]	Stach, J. F. "Expert Systems Find a New Place in Data Networks." *Data Communications* 14 (November 1985), 245–261.
[STEW79]	Steward, H. M. "Performance Analysis of Complex Communication Systems." *IBM Systems Journal* 18, no. 3 (1979).
[STIM74]	Stimler, S. *Data Processing Systems—Their Performance, Evaluation, Measurement and Improvement.* Motivational Learning Programs, Inc. 1974.
[SULL83]	Sullivan, T. P. "Communication Network Management Enhancements for SNA Networks—An Overview." *IBM Systems Journal* 22, no. 1 (1983): 129–142.
[TANN83]	Tannenbaum, A. S. *Computer Network.* Englewood Cliffs, N.J.: Prentice Hall, 1983.
[TERP80C]	Terplan, K. "Real-Time Performance Management." *Computer Performance* 1, no. 1 (1980): 16–21.
[TERP81A]	Terplan, K. "Use of Network Monitors for Capacity Planning." International Conference on Computer Management. 1981, Conference Record. Chicago, Ill., 147–157.
[TERP82B]	Terplan, K. "Network Accounting." International Conference on Computer Capacity Management. Conference Records. San Francisco, Calif., April 19–22, 1982, 87–103.
[TERP82C]	Terplan, K. "Organizing a Network Administration Center." *EDP Performance Review,* 10, no. 8 (August 1982): 1–9.
[TERP83A]	Terplan, K. "Network Performance Management." Course documentation. Sunnyvale, Calif.: Institute for Information Management, 1983.
[TERP83B]	Terplan, K. "Network Capacity Planning." *Journal of Capacity Management* 2, no. 1 (1983): 59–87.
[TERP83C]	Terplan, K. "Performance Data Base Concepts." International Conference on Computer Capacity Management. Conference Records. New Orleans, Louisiana, April 19–21, 1983, 278–284.
[TERP83D]	Terplan, K. "Communication Systems Performance Management." *Computer Performance Journal* 4, no. 1 (1983): 29–34.
[TERP84B]	Terplan, K. "Performance Impacts of Network Architectures." *Journal of Capacity Management* 2 (September 1984): 226–252.
[TERP85D]	Terplan, K. "Critical Success Factors in Network Management." ECOMA-13. Conference Proceedings, Zürich, Switzerland, October 1985, 305–319.
[TERP86C]	Terplan, K. "Expert Systems for Network Operational Control." *CMG XVII Conference Proceeding.* Las Vegas, Nevada, December 1986.
[TERP87A]	Terplan, K. *Communication Networks Management.* Prentice Hall, Englewood Cliffs, N.J., 1987.
[TERP87B]	Terplan, K. "NetView and NetView/PC Advanced Tutorial," Proceedings, CMG 1987, Orlando, Fla. 1987, 865–879.

[TERP88A] Terplan, K. "Network Management Evolution." *Computer Communications.* Butterworth & Co., United Kingdom, 11 (5): 267–274, 1988.

[TERP88B] Terplan, K. "Network Management—Evaluation of Leading Products, Advanced Tutorial." Proceedings, CMG 1988, Dallas, Tex. 1988, 967–976.

[TERP89A] Terplan, K. *NetView Directions, Insight IBM.* Xephon Publications, United Kingdom, March 1989.

[TERP89B] Terplan, K. "Critical Success Factors of Network Management" Proceedings, CMG 1989, Reno, Nev. 1989, 885–894.

[TERP89C] Terplan, K. "Integrated Network Management." *Datapro Research Corporation* NM40-100, 201–219.

[TERP90A] Terplan, K., and J. A. Huntington. "Can Third Parties Change SNA Stripes?" *Data Communications,* McGraw-Hill, New York, April 1990, 74–82.

[TERP90B] Terplan, K. "Network Design and Planning Tools." *Datapro Research Corporation* NM30-300, 101–111.

[TERP91A] Terplan, K.: Should You Outsource Network Management? *Chief Information Officer Journal,* Winter 1991, vol. 3, No. 3, p. 23–33.

[TERP91B] Terplan, K.: Effective LAN Management, Technology Transfer Institute, Course Documentation, Santa Monica, Calif. February 1991

[THAR84] Thareja, A. K. "Impact of Network Parameters on the Performance of Single Domain SNA Networks." CMG XIII. Conference record. San Diego, Calif., 1983, 115–125.

[THUR82] Thurber, K., "Local Area Networks In Depth." *Computerworld* (April 12, 1982), 1–6.

[TSCH89] Tschammer, V., and H. Klessmam. "Local Area Network Management Issues." Datapro Research Corporation NM50-300, Delran, N.J., 1989, 100–108.

[ULRI84] Ulrich, W., and R. Bohm. "Digital Termination Systems." *Computerworld* (June 6, 1984), 35–38.

[VINC83A] Vincent, D. R. "Information as a Corporate Asset." *Computerworld* (September 26, 1983), *In Depth,* 1–12.

[VINC83B] Vincent, D. R. "Information Economics, Information Executive." *The Journal of Information Economics,* 1 (1983): 31–45.

[WEIN83] Weingarten, R. A., and E. E. Iagobucci. "Logical Problem Determination for SNA Networks." *IBM Systems Journal* 22, no. 4 (1983): 387–403.

[WIGG83] Wiggins, R., "Intelligent Networking." *Telecommunications* 17 (January, 1983), 40–46.

[WITZ83] Witzel, C. N. "Service-Level Agreements: A Management Tool for Technical Staff." *Journal of Capacity Management* 1, no. 4 (June 1983): 344–362.

[ZACH82] Zachmann, W. F., "Planning and Designing a Communication System." *Computerworld* (May 17, 1982), 42–47.

Index